Northern European Paintings

in the Philadelphia Museum of Art

THIS PUBLICATION WAS MADE POSSIBLE BY THE
NATIONAL ENDOWMENT FOR THE ARTS, THE GETTY
GRANT PROGRAM, AND THE ENDOWED FUND FOR
SCHOLARLY PUBLICATIONS AT THE PHILADELPHIA
MUSEUM OF ART, ESTABLISHED BY GRANTS FROM
CIGNA FOUNDATION AND THE ANDREW W. MELLON
FOUNDATION.

Northern European Paintings

in the Philadelphia Museum of Art

*From the Sixteenth through
the Nineteenth Century*

PETER C. SUTTON

PHILADELPHIA MUSEUM OF ART

Distributed by the University of Pennsylvania Press

Edited by Jane Iandola Watkins
Composition by Circle Graphics, Inc., Harmans, Maryland
Printed in Great Britain by Balding + Mansell, Wisbech, Cambs.

© Copyright 1990 by the Philadelphia Museum of Art
26th Street and Benjamin Franklin Parkway, P.O. Box 7646
Philadelphia, Pennsylvania 19101

Library of Congress Cataloging-in-Publication Data

Philadelphia Museum of Art.
 Northern European paintings in the Philadelphia Museum of Art /
 Peter C. Sutton.
 412 p.
 Includes bibliographical references.
 ISBN 0-8122-8239-6
 1. Painting, European—Europe, Northern—Catalogs. 2. Painting,
Modern—Europe, Northern—Catalogs. 3. Painting—Pennsylvania—
Philadelphia—Catalogs. 4. Philadelphia Museum of Art—Catalogs.
I. Sutton, Peter C. II. Title.
ND625.P48 1990
759.9492'074'74811—dc20 89-72149
 CIP

CONTENTS

In the entry on the Philadelphia Museum of Art in his book *Guide to Dutch Art in America,* published in 1986 by the Netherlands-America Amity Trust, Peter C. Sutton refers to the vast holdings of Dutch paintings housed in this Museum as "a connoisseur's dream and a cataloguer's nightmare." Fortunately, as both connoisseur and cataloguer of uncommon discernment and diligence, he has himself now provided readers of this volume with ample evidence for their enjoyment of a remarkable range of pictures, from Steen to Mauve, and from Van den Eeckhout to Van Gogh.

With the appearance of this catalogue, a second and substantial section of the European paintings collection of the Philadelphia Museum of Art is published in depth, following Richard Dorment's volume on *British Painting,* which was issued in 1986. As part of an ongoing program to publish important strengths of the Museum, this book also owes much to the generosity of the National Endowment for the Arts, a federal agency, and The Getty Grant Program, which provided handsome grants for its realization. The preparation of the manuscript at the Museum was supported by an endowment for scholarly publications established by a grant from The Andrew W. Mellon Foundation and matched by CIGNA Foundation.

Peter C. Sutton, now the Mrs. Russell W. Baker Curator of European Paintings at the Museum of Fine Arts, Boston, began his work on this project in 1979, when he was Assistant (later Associate) Curator of European Painting at the Philadelphia Museum of Art. His devotion to the art of the seventeenth-century Netherlands has been richly demonstrated by a pair of exhibitions he organized in 1984 and 1987: the first, assembling masterpieces of Dutch genre painting for this Museum, the Royal Academy of Arts, London, and the Staatliche Museen Preussischer Kulturbesitz at Berlin-Dahlem; and the second, celebrating Dutch landscape painting, which traveled from Amsterdam to Boston to Philadelphia. This Museum has particular reason to be grateful not only to his scholarship, enthusiasm, and persistence, but also to his patience, which combined to produce this impressive catalogue eleven years after he was encouraged to launch his research.

The Museum's Department of Publications, under the guidance of George H. Marcus, has carried out the ambitious aim of scholarly publication of the collections with admirable style. Jane Watkins, Senior Editor, has seen this book through to completion with her characteristic thoroughness and devotion to detail. Peter Sutton elsewhere acknowledges the contributions of so many scholars and colleagues to the completeness of this catalogue; we add our warm thanks to his and trust that his book will bring this lively and diverse group of paintings to the wider audience they deserve.

Anne d'Harnoncourt
The George D. Widener Director

Joseph J. Rishel
*Curator of European Painting before 1900
and the John G. Johnson Collection*

The Philadelphia Museum of Art's holdings of Northern European paintings are among the most extensive in the United States. Since it houses the John G. Johnson Collection (more than twelve hundred paintings) it is easily the largest repository of Dutch seventeenth-century painting (nearly three hundred works) in this country. Although this catalogue includes only those paintings in the Museum's permanent collection with cross references to the previously catalogued [1972] Johnson paintings, it attests to remarkable strengths; works such as Peter Paul Rubens's *Prometheus Bound* (no. 91), Gerard ter Borch's *Officer Writing a Letter, with a Trumpeter* (no. 10), or Vincent van Gogh's *Sunflowers* (no. 35) and *Rain* (no. 36) would be highlights of any collection. The joy of Philadelphia's collections is in their diversity and depth. While there is no Vermeer, no Frans Hals, indeed no certain Rembrandt, the cabinet-sized works by Paulus Potter (see no. 85), Meindert Hobbema (no. 40), Nicolaes Maes (no. 66), and Salomon van Ruysdael (no. 99), or lesser known painters such as Cornelis Lelienbergh (no. 59) and Bonaventura Peeters (no. 83)—artists of the type to which the nineteenth century referred without condescension as "little masters"—rival any on this continent.

Philadelphia's collections vividly reflect the late nineteenth and early twentieth-century tastes of the era of their formation. Naturalistic Dutch landscapes, genre scenes, and still lifes greatly outnumber history paintings or Dutch Italianate works, which were then regarded as "un-Dutch" or inconsistent with the nineteenth-century's narrowly literal concepts of realism. These omissions have been filled only in recent years through purchases of works such as Gerbrand van den Eeckhout's *Continence of Scipio* (no. 28) and Jan Baptist Weenix's *Rest on the Flight into Egypt* (no. 130), and gifts such as Gérard de Lairesse's *Bacchus and Ariadne* (no. 57). Earlier purchases by the Museum's advisers and staff had laid a firm groundwork in the Flemish Baroque, including important paintings by Frans Snyders (no. 106), Cornelis de Vos (no. 122) and, of course, Rubens (no. 91). Another characteristic of the early Philadelphia collectors' enthusiasms is the strong representation of Hague School paintings—notable works by Jozef Israëls, Jacob Hendricus Maris, and Anton Mauve—tastes that gave way in the early and middle decades of this century to a preference for the Impressionists and the Post-Impressionist Van Gogh.

When the Philadelphia Museum of Art was founded in 1875 and took up residence two years later in Memorial Hall—the original Art Gallery of the U.S. Centennial Exposition of 1876—benefactors were scarce. The first major supporter was William P. Wilstach who made a fortune in saddlery and hardware during the Civil War and whose will emphasized his abiding admiration for the Gemäldegalerie in Dresden. Following his death in 1870, his widow bequeathed his collection of more than one hundred fifty nineteenth-century paintings, most of which were French and American, to the Commissioners of Fairmount Park in 1893. Among the few Northern paintings in the Wilstach bequest were nineteenth-century anecdotal and historicizing genre scenes, including Karl Friedrich Lessing's *Robber and His Child* (no. 61), Emanuel Leutze's *Oliver Cromwell and His Daughter* (no. 62), Reinhard Sebastian Zimmermann's *Too Late for the Cars* (no. 139), and Alfred Emile Léopold Stevens's *Departing for the Promenade (Will You Go Out with Me, Fido?)* (no. 112)—the titles of the latter two typical Wilstach sobriquets—as well as landscapes like Wilhelm Ludwig Friedrich Riefstahl's

Return from the Christening (no. 88) and Oswald Achenbach's *Street Scene, Naples* (no. 1). With few regrets, many of the Wilstach pictures were sold, the largest sale (one hundred thirty-two paintings) being held at Freeman's auction house in Philadelphia in 1954. Of greater lasting utility was the purchase fund established in the name of W. P. Wilstach, which was used, for example, to acquire the great *Prometheus Bound* by Rubens (no. 91) and Dutch paintings such as Jan Steen's early *Fortune-Teller* (no. 110). The fund's earliest administrators (who included John G. Johnson, serving as chairman of the Wilstach Collection) set to work filling cavernous Memorial Hall with big pictures; in the first dozen years they purchased the two large Melchior de Hondecoeters (nos. 41 and 42), Frans Snyders's vast *Still Life with Terms and a Bust of Ceres* (no. 106), Jacob Isaacksz. van Ruisdael's *Landscape with Waterfall* (no. 95), Cornelis de Vos's life-size *Portrait of Anthony Reyniers and His Family* (no. 122), as well as monumentally scaled works by artists of other European schools. Happily these early advisers had discriminating as well as expansive tastes; some of the early purchases remain highlights of the permanent collection.

The Museum's corporation was planning the construction of the new museum building (completed in 1928) on the promontory at the entrance to Fairmount Park when they received the gift (officially registered in 1924) of the single greatest importance for their Northern European paintings collection. At his death in 1919, George W. Elkins bequeathed to the Museum his collection of European paintings, which had mostly been formed by his father, William L. Elkins (died 1903) and housed at Elstowe in Montgomery County, Pennsylvania. In the 1840s, William had come to Philadelphia, where he was involved with the refrigeration and transport of produce before turning his attentions by 1875 to developing Standard Oil's new fields in western Pennsylvania. By about 1880 he had refineries in Philadelphia and diversified into gas street lighting and street transportation (traction). The latter led to the formation of the Philadelphia Transportation Company, founded with P.A.B. Widener, and its successor, the Philadelphia Rapid Transit. The Elkinses' taste in Old Masters ran to English portraiture and landscape, Italian *vedute,* and good quality Dutch landscapes and genre scenes. The last mentioned provided the core of the Museum's own Dutch collections, including the great Gerard ter Borch (no. 10), Paulus Potter (no. 85), Hendrick van der Burch (no. 16), two Adriaen van Ostades (nos. 79 and 80), Anthonie Palamedesz. (no. 81), Jan van Goyen (no. 37), Meindert Hobbema (no. 40), Aert van der Neer (no. 77), Salomon van Ruysdael (no. 99), Philips Wouwermans (no. 138), Jacob Isaacksz. van Ruisdael's *Boats in a Stormy Sea* (no. 98), and Abraham van Beyeren's *Banquet Still Life* (no. 7). Even the few Dutch paintings from the Elkins Collection that did not come to the Philadelphia Museum of Art eventually found homes in other distinguished museums: Jacob Duck's *Mountebank* is now in the Los Angeles County Museum (no. 58.50.1) and Willem Buytewech's *Merry Company* (Elkins 1887–1900, no. 99, as Dirck Hals) is in the Bode-Museum, Staatliche Museen zu Berlin [East] (no. 1983). The Elkinses' nineteenth-century French paintings included Barbizon School and early Impressionist pictures (Millet, Daubigny, Boudin, Monet, and Raffaëlli). Consistent with these tastes are their excellent Hague School paintings (Israëls's *Old Friends,* no. 45; Jacob Maris's *View of the Schreierstoren in Amsterdam* and *Fishing Boat with Horse on the Beach at Scheveningen,* nos. 67 and 68, and two fine Anton Mauves, nos. 71 and 72),

and their works by Johan Barthold Jongkind (nos. 47 and 49), and Frits Thaulow (no. 115). Similarly complementing the Elkinses' interest in historized genre scenes by Eugène Isabey and lesser French artists was their ownership of Hendrik Jan August Leys's *Faust and Marguerite* (no. 63). In addition to donating his collections, George Elkins, like Mrs. Wilstach, set up a purchase endowment, which was used to buy, among other works, the Van den Eeckhout (no. 28).

The Elkinses not only had business alliances with the enormously wealthy Wideners (P.A.B. and Joseph) of Lynnewood Hall in Elkins Park but also close social and personal ties. William Elkins's daughter married a Widener (of the *Titanic* disaster, book collecting, and Harvard library fame). In no small way P.A.B. Widener's collections formed the basis of the National Gallery of Art in Washington, D.C. The dynastic history of the Delaware Valley collectors of Old Master paintings has yet to be written, but the interaction of Elkins, Widener, and the latter's lawyer, John G. Johnson, is one of the most productive and dynamic chapters in the history of U.S. collecting. Had the collection of Widener (with its masterpieces by Rembrandt, Van Dyck, Hals, Hobbema, Ruisdael, Vermeer, De Hooch, and so forth) and other Pennsylvanians such as Chester Dale been donated to their local museum in Philadelphia rather than the fledgling National Gallery, the region's distinction as a cradle of American masterpiece collecting would be clear.

The interior of the Philadelphia Museum of Art's grandly neoclassical building still shows the hand of its first director. During Fiske Kimball's thirty-year reign (1924–54), art and interior design were to be united in a single architectural context. Among the period rooms for which Kimball was famous is a tiny Dutch interior known as Het Scheepje (The Little Ship, named for the owner's brewery in Haarlem)—the only such space in this country—once part of the home of the Olycan family in Haarlem whose members were immortalized by Frans Hals. Kimball also claims the distinction of having purchased for the Museum on the occasion of the Diamond Jubilee celebration in 1950 Rubens's *Prometheus Bound* (no. 91), surely the greatest single Northern European Old Master painting in the collection. During these years, the Museum's Northern collections also benefited from gifts, notably those of Mrs. Gordon A. Hardwick and Mrs. W. Newbold Ely (in memory of Mr. and Mrs. Roland L. Taylor), of Nicolaes Maes's *Woman Plucking a Duck* (no. 66), Rubens's *Portrait of Burgomaster Nicolaes Rockox?* (no. 92), and a pair of decorations by Jacob de Wit (nos. 136 and 137). In 1957 Nicholas Biddle presented the Museum with a hunting scene by Paul de Vos (no. 128), which is of special interest for having descended from the collection of Joseph Bonaparte (Napoleon's brother and briefly king of Naples and Spain before his exile in 1814 to his estate at Point Breeze, New Jersey), one of the earliest Old Master collections to reach these shores.

In recent decades the most notable acquisitions have been a stunning series of gifts of works by Vincent van Gogh, beginning with *Mme Augustine Roulin and Her Baby, Marcelle* (no. 33) bequeathed by Lisa Norris Elkins (the daughter of George Elkins), and followed by the *Sunflowers* (no. 35) presented by Mr. and Mrs. Carroll S. Tyson, Jr., and a later gift from Mr. and Mrs. Rodolphe Meyer de Schauensee (no. 34) and a bequest of Charlotte Dorrance Wright (no. 32). Henry P. McIlhenny's bequest in

memory of his mother Frances P. McIlhenny of Van Gogh's powerfully beautiful *Rain* (no. 36) greatly strengthens the collection, as of course do his other highly important Impressionist pictures—together perhaps the single most generous gift of art to an American museum in the 1980s. In 1943 Henry McIlhenny's father, John D. McIlhenny, had bequeathed several minor seventeenth-century Dutch and Flemish paintings to the Museum (nos. 53, 75, 94, 100, and 129). These Henry McIlhenny supplemented and upgraded with the bequest of two exceptionally rare Dutch paintings: his father's Frans de Momper, *Valley with Mountains* (no. 74), as well as his own *Vanitas Still Life* (no. 84, purchased in Paris in 1950) by the little-known but exceptionally talented N. L. Peschier, the latter gift proof of the breadth and diversity of McIlhenny's taste.

Like the collections of America's other preeminent museums, Philadelphia's Northern European paintings constitute a history of extraordinary beneficence supplemented with judicious purchases. As the supply of Old Master paintings inevitably dwindles, the growth of the collections so essential to their vitality will demand a renewed spirit of civic largesse—a spirit no less generous in its magnitude than that of the legendary benefactors who preceded the advent of the graduated income tax—and an ever more creative curatorial role. With that growth will also come advances and refinements of our art historical knowledge, progress that can only expose this catalogue for what it is, a mere report of the present state of research. Corrections, clarifications, and amendments, as always will be welcome.

LITERATURE: Rudolf Wiegmann, *Die königliche Kunst-Akademie zu Düsseldorf* (Düsseldorf, 1856), pp. 377ff.; Boetticher (1891–1901) 1969, vol. 1, pp. 10–14; Stadtische Kunsthalle, Düsseldorf, *Oswald Achenbach,* 1905; Kustos Board in Thieme-Becker 1907–50, vol. 1 (1907), pp. 43–44; Georg Biermann, "Oswald Achenbach," *Der Cicerone,* vol. 17, no. 15 (August 1925), pp. 719–27; Irene Markowitz, *Kataloge des Kunstmuseums Düsseldorf,* vol. 2, *Die Düsseldorfer Malerschule* (Düsseldorf, 1969), pp. 28–40; Kunstmuseum, Düsseldorf, *Die Düsseldorfer Malerschule,* May 13–July 8, 1979, and Mathildenhöhe, Darmstadt, July 22–September 9, 1979, pp. 247–56.

Born in Düsseldorf on February 2, 1827, Achenbach studied at the academy in that city for two years before becoming a pupil of his brother, the landscapist Andreas Achenbach (1815–1910). He traveled to the Bavarian Alps, Switzerland, and Italy in 1845, 1850, and 1851, years during which he often painted mountain scenes. Later he concentrated on Italian scenes, depicting street scenes with processions, festivals, and religious fetes. He visited Rome and Naples in 1857, 1871, and 1882, and Verona, Venice, and Padua in 1885, making nature studies and sketches that later, in the Rhineland, he incorporated into his painting. Like his brother, he became a professor at the academy in Düsseldorf in 1872. He died in his native city on February 1, 1905.

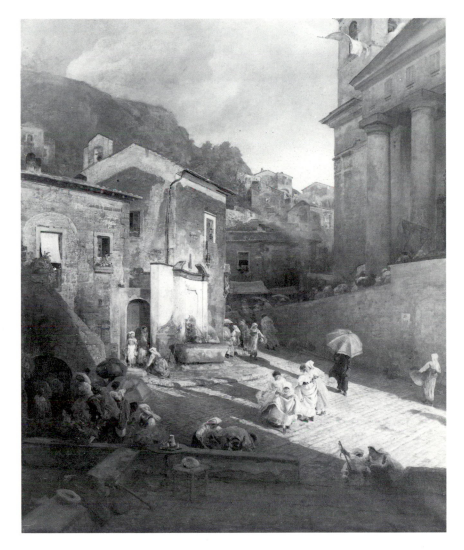

1 OSWALD ACHENBACH

STREET SCENE, NAPLES, c. 1876–80
Signed lower right in red script: *Osw. Achenbach*
Oil on canvas, 43 x 51″ (109.2 x 129.5 cm.)
The W. P. Wilstach Collection. W93-1-3

FIG. 1-1 Oswald Achenbach, *Marketplace in Amalfi*, signed and dated 1876, oil on canvas, 50⅜ x 43⅝" (128 x 111 cm.), Nationalgalerie, Staatliche Museen Preussischer Kulturbesitz, Berlin (West), no. 399.

A small square illuminated by slanting, late afternoon sun is bordered by a fountain, low dwellings, and on the right a large church with a classical facade. The most brilliantly lit of the numerous figures on the street are four young girls who dance or play a game in gaily colored dresses of yellow, red, and white, which contrast with the bright green of the umbrella held by the figure in black seen from the rear. Such anecdotal details often figure in Achenbach's many picturesque, romanticized images of life in the streets and squares of Naples, Rome, and Venice. Achenbach began painting these street scenes by 1857,[1] and they became a central concern of his art beginning with the sketchbooks of 1871.[2] In his paintings, cityscapes with animated staffage and strong contrasts of light and shade became favored subjects by 1876, the date of *Marketplace in Amalfi* (fig. 1-1), a work with stylistic parallels to the Philadelphia painting.[3] Also close in style is the undated *Market Day in an Italian Town* in the Rijksmuseum, Amsterdam.[4]

NOTES

1. See *Funeral in Palestrina,* watercolor on paper, Kunstmuseum, Düsseldorf, inv. no. 28/341. See also the painting *Subject in Palestrina,* dated 1859 (repro. in Georg Biermann, "Oswald Achenbach," *Der Cicerone,* vol. 17, no. 15 [August 1925], p. 724).
2. See Irene Markowitz, *Kataloge des Kunstmuseums Düsseldorf,* vol. 2, *Die Düsseldorfer Malerschule* (Düsseldorf, 1969), pp. 35–36.
3. Later dated street scenes include *Rocca d'Arci,* 1877, oil on canvas, 25¼ x 36" (65.5 x 91.3 cm.), Museum der bildenden Künste, Leipzig, no. 495; *Square before San Pietro in Vincoli,* 1882, Westfälisches Landesmuseum, Münster; *Flower Procession in Genzano,* 1889, private collection, Düsseldorf.
4. Signed, oil on canvas, 43¼ x 52¼" (110 x 134 cm.), no. A1798.

PROVENANCE: The W. P. Wilstach Collection, Philadelphia, by 1886.

LITERATURE: Wilstach 1886, no. 2, 1893, no. 3, 1900, no. 3, 1903, no. 3, 1904, no. 3, 1906, no. 3, 1907, no. 3, 1910, no. 3, 1913, no. 3, 1922, no. 3; PMA 1965, p. 3.

CONDITION: The canvas support is loose on its stretcher and buckling in the corners. The paint shows some cupping along the lower edge and some drying crackle in the thicker passages but is generally sound. The varnish is extremely dirty.

Born in Amsterdam in 1628 or 1629, Van Aldewerelt was the son of a *snijder* (textile worker), Antonis van Aldewerelt (born c. 1596), from Middelburg. Although little is known of his life, he is known to have married Fietje Jans in Amsterdam on August 8, 1662, when he was living on the Heerenstraat. He was said to be forty years of age when he was buried on July 17, 1669, in the Nieuwe Kerk in Amsterdam.

Works by his hand are rare and Kramm hypothesized that he might only have been an amateur painter. Although he executed history paintings (such as *The Prodigal Son,* signed and dated 1651, Staatliches Museum, Schwerin, and a *Nativity,* which appeared in an eighteenth-century sale), genre scenes (such as *The Concert,* signed and dated 1652, The Hermitage, Leningrad, no. 3334), and an animal scene (*Slaughtered Pig,* dated 1656, formerly Galerie Novak, Prague), the majority of his works are portraits. Michiel Mouzijn made engravings after his portraits of M. A. de Ruyter, Jan Evertsen, Jan van Galen, Maarten Harpertsz.Tromp, and Witte Cornelis de Witte. He seems often to have signed his works "H.V. Alde" followed by a tiny orb like a globe, or *wereldbol,* doubtless as a sort of rebus for his name. There is no confirmation, however, for Alfred Wurzbach's claim that he was called H. van Alde in his day.

LITERATURE: Kramm 1857–64, vol. 1, p. 9; A.D. de Vries Az., "Biografische aanteekeningen betreffende voornamelijk Amsterdamsche schilders . . . verwanten," *Oud Holland,* vol. 3 (1885), p. 58; Wurzbach 1906–11, vol. 1, p. 10; E.W. Moes in Thieme-Becker 1907–50, vol. 1 (1907), p. 244; H. F. Wijnman in *Nederlandsche Leeuw,* vol. 49 (1931), col. 210; De Roo van Aldewerelt in *Nederlandsche Leeuw,* vol. 61 (1934), cols. 30–34.

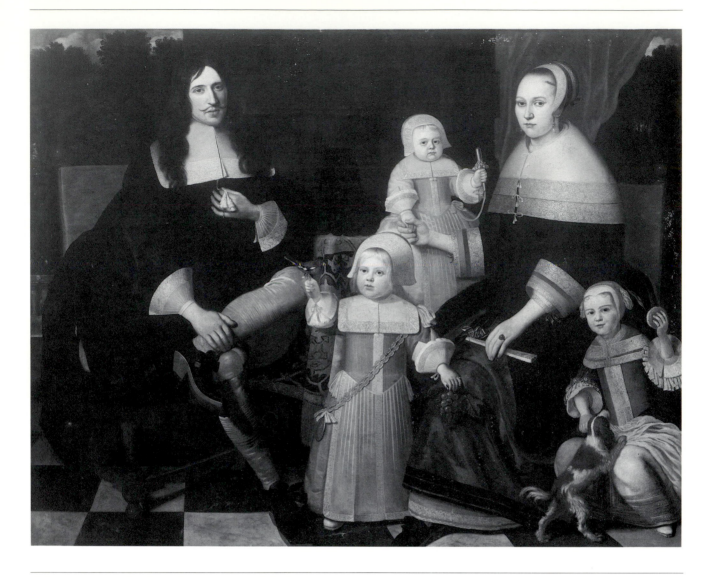

2 HERMANUS VAN ALDEWERELT

FAMILY PORTRAIT GROUP, 1664
Signed and dated upper center: *H. V. Alde* [symbol of a globe] *1664*
Oil on canvas, 61 x 77½" (155 x 197 cm.)
Gift of Mrs. Al Paul Lefton, Sr. 72-264-1

A family of five is assembled on a terrace with black and white tiles, a
column draped with a curtain and a view at the upper left to a balustrade
and trees. The father, seated on the left with his legs crossed and his left
hand held to his chest, fingers the tassels that hang from the collar of his
black and white costume. His tall hat is on a central table that is covered
with a turkish carpet. On the right sits the mother holding a closed fan in
her left hand and offering a steadying hand to the youngest child, who is
perched on the edge of the table. The infant holds a silver pacifier decorated
with bells. To the right an older girl squats, restraining a small dog by the
ear as it jumps for a biscuit in her left hand. In the center foreground stands
the middle child, wearing a heavy gold christening medal. Medals of this
type frequently were worn by children in Dutch family portraits.[1] She or he
(seventeenth-century Dutch costumes of very young children do not confirm
gender identification) raises aloft a small bird in one hand and holds a

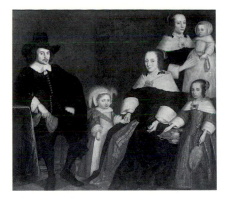

FIG. 2-1 Hermanus van Aldewerelt, *Family Portrait,* oil on canvas, 37⅛ x 42⅛″ (95 x 107 cm.), Maj. Simon Whitbread, Southill.

bunch of grapes by the stem in the other. The latter gesture often appeared in Dutch portraits. According to emblematic literature it could be a symbol of a maiden's chastity; in a family portrait such as this, however, it alludes more generally to familial virtue.[2] Whether other common objects in the scene function symbolically is unclear. Small birds (particularly finches, but also robins and sparrows) were favored children's pets in the seventeenth century. Frequently, as seen in portraits by Cornelis de Vos and Nicolaes Maes (qq.v.), birds were tethered by strings or tiny chains secured to small perches that the child could hold. Birds were often symbolic of love, in some contexts erotic and prurient while in others chaste and pure.[3] The child's pet bird was often interpreted in emblematic literature as an allusion to the positive rewards of "captive" or committed love.[4] For example, in J. J. Deutel's *Huwelijckx Weegh-Schael* (Hoorn, 1641, pp. 36–37), a sparrow on a string alludes to the bonds of marital love. Although the tame bird held by the child in this portrait group is not secured by a string, it conceivably could have prompted the seventeenth-century viewer to reflect on the fruits of familial ties and the "sweet slavery" of marital love.[5] Similarly, the dog, a traditional symbol of fidelity, could allude to marital fealty.[6]

The sitters have not been identified. Another unidentified family portrait by Aldewerelt with a similar design but with the addition of a second woman standing at the right is in the collection of Maj. Simon Whitbread, Southill (fig. 2-1). A similar, highly formalized but rather naive style appears in the artist's pendant portraits of Gerrit Cock (b. 1636) and his wife, Gertruyd van Schuylenburch, painted in 1661.[7]

NOTES

1. See Jacob Ochtervelt's *Family Portrait,* oil on canvas, 29⅞ x 24⅛″ (76 x 61 cm.), Wadsworth Atheneum, Hartford, no. 1960.261, and Nicolaes Maes's *Happy Child,* oil on panel, 43¼ x 31½″ (109.8 x 80 cm.), Toledo Museum of Art, no. 61.12.
2. See E. de Jongh, "Grape Symbolism in Paintings of the 16th and 17th Centuries," *Simiolus,* vol. 7, no. 4 (1974), pp. 166–91.
3. See E. de Jongh, "Erotica in vogelperspectief," *Simiolus,* vol. 3, no. 1 (1968–69), pp. 22–74.
4. See De Jongh 1967, pp. 42–49.
5. See De Jongh 1967, p. 19, where he discusses Jacob Cats's emblem of a parrot in a cage from the *Proteus ofte minne-beelden verandert in sinne-beelden* (Rotterdam, 1627), p. 74.
6. On Dutch marriage and family portraiture generally, see E. de Jongh, "De Familiekring," in Frans Halsmuseum, Haarlem, *Portretten van echt en trouw: Huwelijk en gezin in de Nederlandse kunst van de zeventiende eeuw,* February 15–April 13, 1986, pp. 202–67.
7. Sale, Alewijn, Sotheby's, London, December 14, 1920, lots 222 and 223. See Ernst Wilhelm Moes, *Iconographia Batava* (Amsterdam, 1897–1905), no. 1595.

PROVENANCE: Sale, Baron van den Bogaerde, Castle Heeswijk, 's Hertogenbosch, June 19, 1900, lot 76 [as Hermanus ten Oever]; sale, Gustave Maes of Lokeren, Brussels, November 10, 1920, lot 8 [as Hermanus van Aldewerelt, signed and dated 1664]; sale, Brussels collection et al., A. Mak, Amsterdam, April 12–15, 1921, lot 1 [as Hermanus van Aldewerelt]; sale, Estcourt, Christie's, London, December 9, 1927 [as Hermanus van Aldewerelt]; Mrs. Al Paul Lefton, Sr.

CONDITION: The painting has an aqueous lining and is faced with wax and tissue. The tacking edges are missing. The paint is in good condition beneath a discolored varnish film.

A genre painter, Amberg was born in Berlin on February 25, 1822, became a student of Wilhelm Herbig (1787–1861), studied at the Berlin academy, and worked between 1839 and 1842 in Karl Bega's workshop. He exhibited for the first time in Berlin in 1842 and two years later went to study with Léon Cogniet (1794–1880) in Paris. He later traveled to Italy where he visited Rome, Venice, Naples, and Perugia. Returning to Berlin by way of Munich, he became a member of the academy in 1869 and was appointed to its senate in 1886. During the 1860s and 1870s he was one of the most sought-after genre painters in his native city and was much admired for his sentimental themes. Amberg also painted at least one religious painting and several murals; he was active as a lithographer. He died in Berlin on September 10, 1899.

LITERATURE: Boetticher (1891–1901) 1969, vol. 1, pp. 31–33; Müller-Kaboth in Thieme-Becker 1907–50, vol. 1 (1907), p. 387.

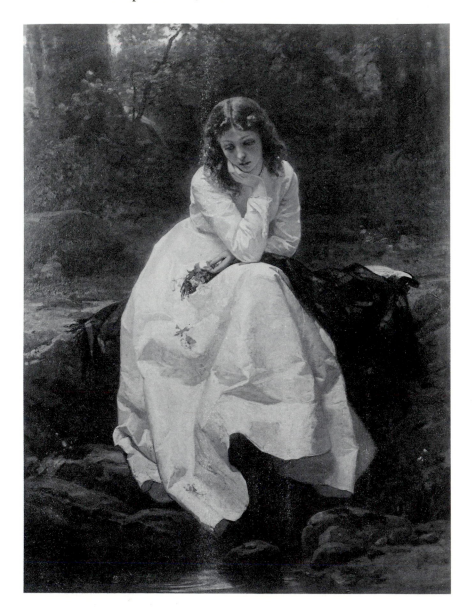

3 WILHELM AMBERG

YOUNG WOMAN SEATED BY A STREAM (CONTEMPLATION)
Signed lower left in script: *W. Amberg*
Oil on canvas, 32⅛ x 24″ (81.6 x 61 cm.)
The W. P. Wilstach Collection. W93-1-4

A young girl, head in hand and wearing a white dress, is seated on a shawl that she has spread out over some rocks by a stream. In her left hand she holds a small bunch of flowers, one of which has fallen into the water. Her abstracted gaze is directed toward the spreading ripples around the flower floating on the pool at her feet.

While it is not certain that the artist called the picture *Contemplation,* it carried this sobriquet when first acquired for the W. P. Wilstach Collection by 1886. The title, moreover, is typical of anecdotal titles favored by the artist and his contemporaries. Amberg painted many variations on the theme of love, ranging from mythological period pieces (such as *Island of Cythera,* dated 1879, sale, Berlin, April 25, 1934, lot 48) to literary subjects (*Ophelia,* location unknown) and pure genre. The young woman's sad reverie is prompted in all likelihood by romantic thoughts.

PROVENANCE: The W.P. Wilstach Collection, Philadelphia, by 1886.

LITERATURE: Wilstach 1886, no. 64, 1893, no. 4, 1900, no. 5, 1903, no. 5, 1904, no. 5, 1906, no. 5, 1907, no. 5, 1910, no. 5, 1913, no. 5; PMA 1965, p. 3.

CONDITION: The unlined, preprimed canvas support is dry, loose, and buckling in the lower-right corner. The paint film is cupping in several areas and shows losses associated with the buckled corner. The varnish is dull and deeply discolored.

Born in Augsburg around 1475, Beck presumably was the son of the painter and illuminator Georg (Jörg) Beck, who is known to have worked together with a son in executing miniatures for two psalters of 1495. Leonhard was documented several times as an illuminator. A document of 1501 mentions his being in Frankfurt, where he evidently assisted Hans Holbein the Elder (c. 1465–1524) in the completion of the high altarpiece commissioned for the Dominican church there. In 1503 he became a master in Augsburg. Two years later he was married to Dorothea Lang. In the city's tax registers of 1512 he is mentioned as a homeowner. Until 1536 Beck appears repeatedly in Augsburg documents and the painters' registers. He died in 1542. A son was awarded nobility by Karl V in 1540.

Principally active as a designer of woodcuts, Beck was one of the most prodigious of the circle of artists employed by Emperor Maximilian I for his ambitious publications projects. Beck produced seventy-seven sheets for *Theuerdank* and one hundred twenty-six for *Weisskunig,* both commissioned by the emperor about 1512. He also designed the title page for Johann Geiler von Kaisersberg's *Navicula penitentie* (The Boat of Repentance), published in Augsburg in 1511. Since no signed or documented oil paintings of his are known, works in Beck's painted oeuvre have been hypothesized from his woodcuts. The paintings attributed to him seem to reflect not only the influence of his father and Holbein the Elder but also that of Hans Burgkmair (1473–1531).

LITERATURE: Simon Laschitzer, "Die Heiligen aus der Sipp-, Mag-, und Schwägerschaft des Kaisers Maximilian I," *Jahrbuch der Kunsthistorischen Sammlungen des Allerhöchsten Kaiserhauses,* vol. 5 (1887), p. 169; Simon Laschitzer, "*Der Theuerdank* (pt. 3), Die Holzschnitte des Theuerdank, Der Antheil Leonhard Beck's," *Jahrbuch der Kunsthistorischen Sammlungen des Allerhöchsten Kaiserhauses,* vol. 8 (1888), p. 89; A. H. Schmid, "Ein Gemälde von Leonhard Beck im Wiener Hofmuseum," *Zeitschrift für bildende Kunst,* n.s., vol. 4 (1893), p. 76; Friedrich Dörnhöffer in Thieme-Becker 1907–50, vol. 3 (1909), pp. 140–41; Ernst Buchner, "Leonhard Beck als Maler und Zeichner," in *Beiträge zur Geschichte der deutschen Kunst,* vol. 2, *Augsburger Kunst der Spätgotik und Renaissance,* edited by Ernst Buchner and Karl Feuchtmayr (Augsburg, 1928), pp. 388, 390; Ludwig Baldass, "Studien zur Augsburger Porträt-Malerei des 16 Jahrhunderts, Bildnisse von Leonhard Beck," *Pantheon,* vol. 6 (July–December 1930), pp. 395–402; Alfred Stange, "Zwei unbekannte Tafeln von Leonhard Beck," *Pantheon,* vol. 21 (1963), pp. 158–63; Rathaus, Augsburg, *Hans Holbein der Altere und die Kunst der Spätgotik,* August 21–November 7, 1965, n.p.; Max Geisberg, *The German Single-Leaf Woodcut: 1500–1550,* vol. 1 (Munich, 1923; rev. ed., New York, 1974), pp. 115–22.

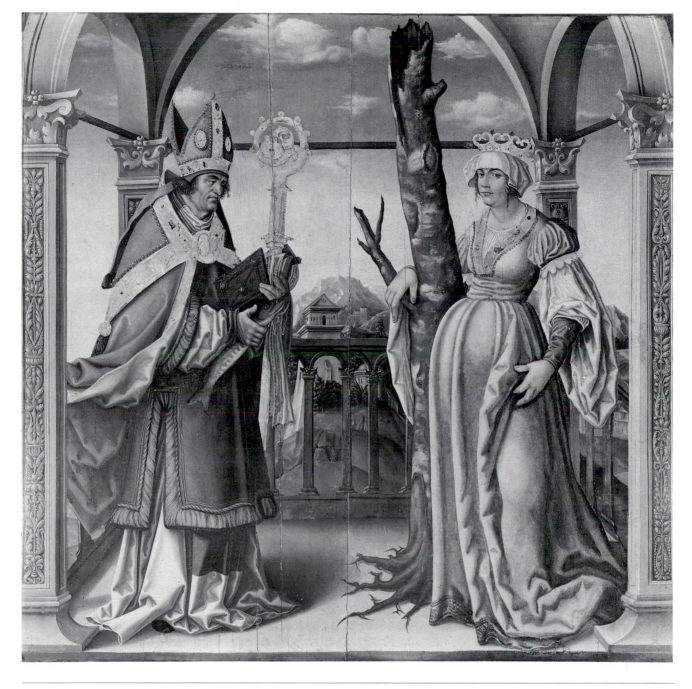

4 ATTRIBUTED TO LEONHARD BECK

SAINTS ULRICH AND AFRA, 1523?
Remnants of a monogram on the crozier
Oil on panel, 41¼ x 39¼" (105 x 100 cm.)
The W. P. Wilstach Collection. W07-1-25

Two saints stand beneath the vaulted archway of an open portico enclosed by a low stone balustrade. The saint at the left is identified as Saint Ulrich of Augsburg by his bishop's robes, crozier, book, and the fish that he holds.[1] Born in 890 to the family of the dukes of Dillingen, Ulrich succeeded his uncle as the bishop of Augsburg in 923. A great supporter of the clergy and protector of the poor and sick, he helped to defend his city against the Hungarians in 955. He died in 973 and was already canonized in

FIG. 4-1 Currently attributed to Jörg Breu
the Elder, *Saints Bartholomew and Nicholas,* oil
on panel, 42⅛ x 28½″ (107 x 72.5 cm.),
Staatliche Kunsthalle, Karlsruhe, inv. no. 73.

FIG. 4-2 Currently attributed to Jörg Breu
the Elder, *Saints Sebastian and Eustace,* oil on
panel, 42⅛ x 28½″ (107 x 72.5 cm.), Staatliche
Kunsthalle, Karlsruhe, inv. no. 72.

FIG. 4-3 Attributed to Leonhard Beck, *Christ
as the Man of Sorrows with Saint Martin* from
the "Epitaph of the Family of Martin Weiss,"
oil on panel, 60⅞ x 47¾″ (154.7 x 121.4 cm.),
Staatsgalerie, Augsburg, inv. no. L.1051.

993 by John XV. The fish that he holds is an allusion to a story about him:
in a moment of forgetfulness he rewarded a ducal messenger with a piece of
meat on a Friday, whereupon it promptly turned into a fish.

Saint Afra was also an inhabitant of the town of Augsburg, but during
the earlier Roman period.[2] Before being converted by Bishop Narcissus, she
was a prostitute. Subsequently confessing her faith during the persecution
of Diocletian (c. 304), she was burned to death on a funeral pyre. Her
crown is a symbol of her martyrdom, and the partially charred tree trunk
she holds alludes to her death by fire. A church in Augsburg on the
Maximilianstrasse, the foundation of which was laid in 1500, is dedicated to
the popular saints Ulrich and Afra.

Undoubtedly this picture was once two panels that were joined by a
later hand; a large vertical crack runs down the center of the panel, and the
balustrade and the loggia are irregular at the points where the two panels
meet. The separate panels probably once formed the outer wings of a
triptych of which the central scene is now lost. Hans Rupé published the
two paintings as works by Jörg Breu the Elder (c. 1475–1537) and
hypothesized that they once formed the reverse of two panels in Karlsruhe
of nearly identical vertical dimensions, one depicting saints Bartholomew
and Nicholas (fig. 4-1) and the other, saints Sebastian and Eustace (fig.
4-2).[3] The picture was catalogued in Philadelphia in 1922 as in the manner
of Hans Burgkmair (1473–1531), the attribution that it carried upon
acquisition. In 1936 Charles Kuhn published the picture for the first time as
the work of Leonhard Beck, an attribution that he noted had been
proposed by Otto Benesch and Hans Tietze.[4] The catalogue of the 1955
exhibition in Augsburg stated that Jan Lauts doubted that the pictures were
connected with the Karlsruhe panels.[5] Apparently unaware of the evidence
indicating that the two Philadelphia panels were joined at a later date,
Alfred Stange in 1963 wrongly assumed that they were the central panel of
an altarpiece in which the two Karlsruhe panels served as wings. Stange
attributed the entire work to Beck, noting that earlier Karl Feuchtmayr and
Walter Hugelshofer had verbally supported the attribution.[6] Although
Lauts also upheld the attribution of the Philadelphia pictures to Beck in his
1966 catalogue, he remained convinced that the Karlsruhe panels were by
Breu and bore no connection with those in Philadelphia.[7]

When the Philadelphia panels were joined some time before 1922, an
additional plywood support was attached at the back; thus the grain of the
wood has not been examined to determine whether it is the same as the
panels in Karlsruhe. The stylistic discrepancies that Lauts claimed to
observe in the two pairs of the works are not obvious. Both employ the
amply proportioned figure types, the drapery with distinctive tubular folds,
and the bright, festive coloration associated with Augsburg painters of
Albrecht Dürer's time. Even details such as the treatment of the faces, the
glovelike hands, and the foliage appear to be similar. Without having
personally studied the Karlsruhe panels, however, this author would not
presume to refute Lauts's claim that they are by different hands.

FIG. 4-4 Attributed to Leonhard Beck, *The Virgin and Child with Saint Elizabeth* from the "Epitaph of the Family of Martin Weiss," oil on panel, 60½ x 47⅞" (153.7 x 121.1 cm.), Staatsgalerie, Augsburg, inv. no. L.1052.

FIG. 4-5 Attributed to Leonhard Beck, *Saint Valentine,* c. 1516–18, oil on panel, 46⅜ x 19¼" (118 x 49 cm.), with dealer Julius Böhler, Munich, 1963.

FIG. 4-6 Attributed to Leonhard Beck, *Saint Ulrich,* c. 1516–18, oil on panel, 46⅜ x 19¼" (118 x 49 cm.), with dealer Julius Böhler, Munich, 1963.

Affirming the assignment of the work to Leonhard Beck also presents problems, mainly because of the speculative nature of the artist's painted oeuvre. While Beck's activity as a designer of woodcuts is well documented and understood, the paintings that have been assigned to him are attributed only on the basis of a stylistic connection with the prints—a notoriously faulty method. A. H. Schmid first attributed *Saint George Fighting the Dragon*[8] to Beck and plausibly connected it with *The Adoration of the Magi.*[9] Ernst Buchner then further expanded Beck's oeuvre of painted altarpieces and portraits.[10] Not all the attributions to him are equally convincing, but two major panels comprising the "Epitaph of the Family of Martin Weiss"—*Christ as the Man of Sorrows with Saint Martin* (fig. 4-3) and *The Virgin and Child with Saint Elizabeth* (fig. 4-4)—are probably by the same hand as the one responsible for *Saint George Fighting the Dragon* and *The Adoration of the Magi.* Kuhn first remarked upon the close stylistic resemblance of the Philadelphia painting to the Weiss panels.[11] Yet another pair of altar wings depicting saints Valentine and Ulrich (figs. 4-5 and 4-6), first assigned to Beck by Stange in 1963, also shows points of resemblance to the Philadelphia painting.[12] Inasmuch as these works form a consistent stylistic group, they seem to be by the same painter, although there is no certain proof that the artist was Beck.

Some support for the Philadelphia painting's being attributed to Beck might be seen in the fact that Beck produced woodcut illustrations for the lives of saints Ulrich, Simprecht, and Afra, published in Augsburg in 1516.[13] Many other Augsburg painters, however, also represented these saints. Compare, for example, Burgkmair's painting of Saint Ulrich[14] or a painting of Saint Afra by an unknown artist (wrongly ascribed to Burgkmair).[15]

Before the Philadelphia picture was cleaned and retouched in December 1940, it bore the date 1520 or 1523 and Burgkmair's monogram, "HB," which could easily have been altered from that of Beck, "LB." Only remnants of a monogram are now visible. Although the chronology of Beck's painted oeuvre is even more speculative than its contents, a date in the early 1520s is acceptable, since, as Stange observed, the Philadelphia picture shows traits of a transition to a more Mannerist style associated with a later period.[16] Conceivably, therefore, the fugitive date reflected a trustworthy tradition. At the time that the picture was cleaned, extensive overpaint in the figure of Saint Afra was removed, transforming her dress from a dark to a light color. Much of the detail in the gilded areas of the painting was also lost. Familiar with the works only through photographs, Hans Rupé, nonetheless, correctly assumed that they had been heavily restored before the time of his writing in 1912.

NOTES

1. See Joseph Braun, *Tracht und Attribute der Heiligen in der deutschen Kunst* (Stuttgart, 1943), cols. 702–3.

2. Ibid., cols. 33–36.

3. Hans Rupé, *Beiträge zum Werke Hans Burgkmairs des Alteren* (Borna-Leipzig, 1912), p. 64 n.5.

4. Charles L. Kuhn, *A Catalogue of German Paintings of the Middle Ages and Renaissance in American Collections* (Cambridge, Mass., 1936), p. 67, no. 281.

5. Schaezler Haus, Augsburg, *Augsburger Renaissance,* May–October 1955, p. 23.

6. Alfred Stange, "Zwei unbekannte Tafeln von Leonhard Beck," *Pantheon,* vol. 21 (1963), p. 163.

7. Jan Lauts, *Katalog Alte Meister bis 1800,* vol. 1 (Karlsruhe, 1966), p. 64.

8. *Saint George Fighting the Dragon,* c. 1515, oil on panel, 52⅞ x 45⅝" (134.5 x 116 cm.), Kunsthistorisches Museum, Vienna, inv. no. 5669.

9. *The Adoration of the Magi,* oil on panel, 72 x 45½" (183 x 115.8 cm.), Städtische Kunstsammlungen, Augsburg, inv. no. 5345. See A. H. Schmid, "Ein Gemälde von Leonhard Beck im Wiener Hofmuseum," *Zeitschrift für bildende Kunst,* n.s., vol. 4 (1893), p. 76.

10. Ernst Buchner, "Leonhard Beck als Maler und Zeichner," in *Beiträge zur Geschichte der deutschen Kunst,* vol. 2, *Augsburger Kunst der Spätgotik und Renaissance,* edited by Ernst Buchner and Karl Feuchtmayr (Augsburg, 1928), pp. 388–413.

11. Kuhn (see note 4), p. 67.

12. Stange (see note 6), pp. 158–63.

13. Berno and Adilbertus, *Gloriosorum Christi confessos Vldarici & Symperti: Necnō beatissime martyris Aphre . . . historie . . .* (Augsburg, 1516); F.W.H. Hollstein, *German Engravings, Etchings, and Woodcuts, ca.1400–1700,* vol. 2 (Amsterdam, n.d.), p. 172.

14. *Saint Ulrich,* c. 1518, oil on panel, 41 x 15¾" (104 x 40 cm.), Gemäldegalerie, Staatliche Museen Preussischer Kulturbesitz, Berlin (West), inv. no. 569.

15. Oil on panel, 22 x 15¾" (56 x 40 cm.) (dimensions as a pair with another female saint), sale, Sotheby's, London, December 10, 1975, lot 72, repro. [wrongly as Hans Burgkmair].

16. Stange (see note 6), p. 163.

PROVENANCE: Charles Schlaar, Washington, D.C.; John G. Johnson, Philadelphia; gift of John G. Johnson to the W. P. Wilstach Collection, Philadelphia, 1907.

LITERATURE: Hans Rupé, *Beiträge zum Werke Hans Burgkmairs des Alteren* (Borna-Leipzig, 1912), p. 64 n. 5 [as Jörg Breu and monogrammed HB and dated 1520]; Wilstach 1922, no. 43 [as in the manner of Hans Burgkmair the Elder and monogrammed HB and dated 1523?]; Charles L. Kuhn, *A Catalogue of German Paintings of the Middle Ages and Renaissance in American Collections* (Cambridge, Mass., 1936), p. 67, no. 281, pl. LVII [as Leonhard Beck]; Schaezler Haus, Augsburg, *Augsburger Renaissance,* May–October 1955, p. 23, under cat. no. 53; Alfred Stange, "Zwei unbekannte Tafeln von Leonhard Beck," *Pantheon,* vol. 21 (1963), p. 163 [as Leonhard Beck]; Jan Lauts, *Katalog alte Meister bis 1800,* vol. 1 (Karlsruhe, 1966), p. 64, under inv. nos. 73/72.

CONDITION: This panel painting with a vertical grain was originally two wings of an altarpiece that were later joined and mounted on a plywood backing. The large vertical crack in the center of the composition indicates where the two panels were brought together. Large vertical splits in the original support run through Saint Ulrich's crozier and Saint Afra's tree trunk. Several small splits also rise from the lower edge. Extensive abrasion is evident in the paint film, especially in Afra's gown and all gilded passages. Retouches have discolored throughout, as has the varnish layer.

LITERATURE: Boetticher (1891–1901) 1969, vol. 1, p. 87; Kustos Board in Thieme-Becker 1907–50, vol. 3 (1909), p. 380.

A little-known history, genre, and portrait painter, Berendt was born in 1803 in Berlin, entered the studio of Professor Wach in 1827, and then in 1834 undertook studies with Friedrich Wilhelm von Schadow-Godenhaus (1788–1862) at the academy in Düsseldorf. Two years later he exhibited *Elijah in the Desert* in Düsseldorf. He seems to have remained in that city during his later years, but repeatedly participated in the exhibitions of the academy in Berlin between 1826 and 1844. His few known works include *Portrait of the Painter Adolf Henning*, *The Invention of Painting*, and *Luther as a Choirboy Receiving Alms in the Street*, 1836 (locations unknown).

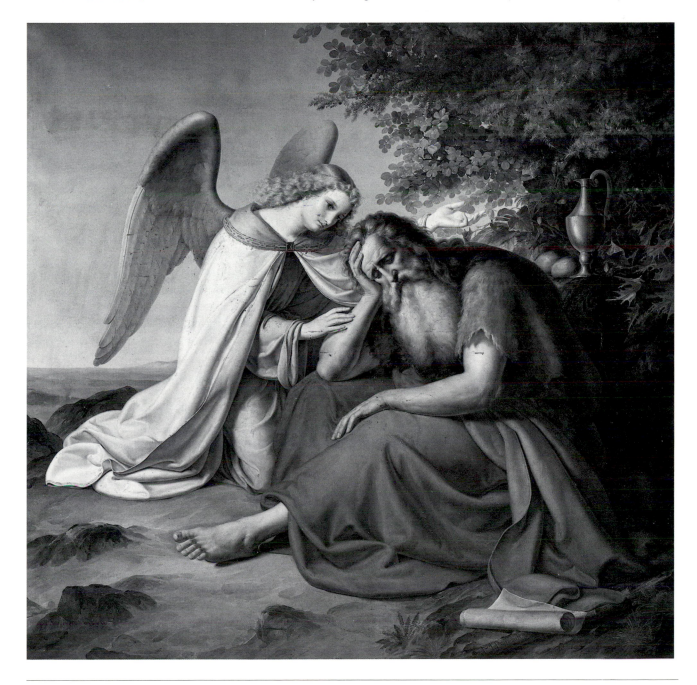

5 MORITZ BERENDT

ELIJAH IN THE DESERT, 1834
Signed and dated lower right on the staff: *1834 M. Berendt*
Oil on canvas, 62½ x 66″ (159 x 168 cm.)
Gift of Abner Schreiber in memory of Mary Schreiber. 1978-8-1

A great prophet and reformer, Elijah has consistently been one of the most popular figures in the Old Testament. After his triumph over the false prophets of Baal, Elijah was compelled to flee from the anger of Jezebel, the vindictive and jealous wife of King Ahab. He sought refuge in the desert of Judah, where he remained, broken-spirited, pouring out his complaint before God until he was aroused by "a still small voice" (I Kings 19:12). The Bible describes the episode: "But he himself went a day's journey into the wilderness, and came and sat down under a juniper tree: and he requested for himself that he might die; and said, It is enough; now, O Lord, take away my life; for I am not better than my fathers. And as he lay and slept under a juniper tree, behold, then an angel touched him, and said unto him, Arise and eat. And he looked, and, behold, there was a cake baken on the coals, and a cruse of water at his head. And he did eat and drink, and laid him down again. And the angel of the Lord came again the second time, and touched him, and said, Arise and eat; because the journey is too great for thee. And he arose, and did eat and drink, and went in the strength of that meat forty days and forty nights unto Horeb the mount of God" (I Kings 19:4–8). For Elijah, his retreats to the wilderness were always a source of revelation and restoration. Earlier in the biblical narrative he had been sustained by ravens that miraculously fed him in the wilds.

In the Philadelphia painting the despairing prophet, wearing a red robe and his traditional skin garment, sits on the ground with head in hand, assuming the time-honored attitude of Melancholia. The angel who kneels beside him wears white robes secured by an emerald clasp and gestures toward the vessel and loaves behind the prophet. In addition to the juniper tree mentioned in the Bible, Berendt included a thistle bush, a traditional symbol of austerity and defiance, and possibly a prefiguration of Christ's Passion. At the left opens the desert that Elijah will shortly cross.

The picture's light tonality, intense color scheme, and full but carefully contoured forms, as well as details such as the figures' facial types, recall the art of the Nazarenes, the society of artists founded by Johann Friedrich Overbeck (1789–1869) and colleagues in Vienna in 1809 and transferred to Rome the following year. These painters were dedicated to the revival of the medieval religious brotherhood of Saint Luke and were influenced by Italian Renaissance painting. A relatively late practitioner, Berendt probably learned this style from his teacher, Friedrich Wilhelm von Schadow-Godenhaus (1788–1862), who had joined the Brotherhood of Saint Luke of the Nazarenes in Rome in 1813. The Old Testament theme of Elijah in the desert was a popular subject among the Nazarenes.[1]

NOTE

1. For a drawing of this theme by Overbeck, see *The Angel Waking Elijah under the Juniper Bush,* 1807–8, pen and ink with wash over pencil on paper, 9⅛ x 9″ (23.1 x 23 cm.), Museen für Kunst und Kulturgeschichte der Hansestadt Lübeck, inv. no. AB 437 (repro. in Städtische Galerie im Städelschen Kunstinstitut, Frankfurt, *Die Nazarener,* April 28–August 28, 1977, p. 235, cat. no. E46).

PROVENANCE: Abner Schreiber, Philadelphia.

EXHIBITION: Probably Düsseldorf, 1836 [as "Der Prophet Elias in der Wüste"; see Thieme-Becker 1907–50, vol. 3 (1909), p. 380].

LITERATURE: Boetticher (1891–1901) 1969, vol. 1, p. 87; Thieme-Becker 1907–50, vol. 3 (1909), p. 380.

CONDITION: The canvas support is unlined and very slack, with corner draws, stretcher creases, and bulges along the lower edge. The paint film, however, is in good condition, with some abrasion from the frame on the lower-left edge. The varnish layer is extremely discolored, and prominent darker drips of varnish are scattered throughout the figures.

LITERATURE: Boetticher (1891–1901) 1969, vol. 1, pp. 91–92; H. Holland in Thieme-Becker 1907–50, vol. 3 (1909), pp. 460–61.

A landscape and architecture painter, Berninger was born in Arnstadt, Thüringia, on July 8, 1843. Initially trained as a pharmacist, he turned to art around 1870 in Weimar under Theodor Hagen (1842–1919). In 1874 he departed on travels that took him to England, Holland, France, and Italy; later he visited North Africa, Turkey, and Greece. Although he painted some German and English scenes, the majority of his landscapes are of Mediterranean and especially Italian scenery.

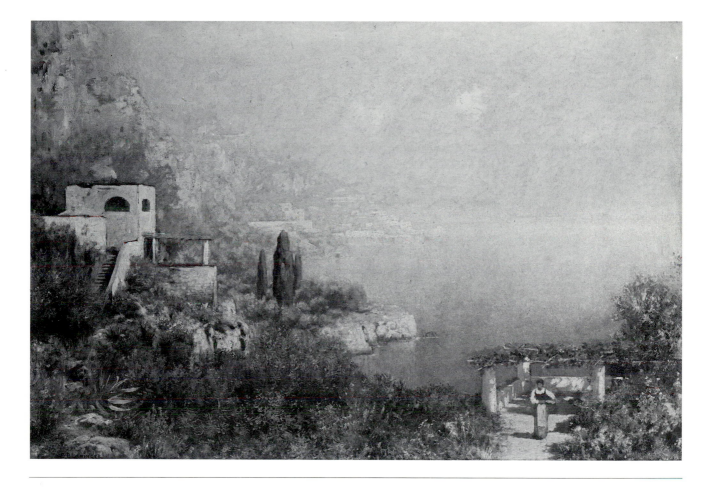

6 EDMUND BERNINGER

VIEW OF CAPRI, c. 1877
Signed lower left: *E. Berninger*
Oil on canvas, 21¾ x 32″ (55.2 x 81.3 cm.)
Gift of Jay Cooke. 55-2-3

An inlet on the rocky coast of Capri is viewed from a point on a hillside overlooking a simple white dwelling on the left and an arbor-covered terrace with a woman on the right. Like Berninger's other scenes recalling his visit to Capri, this work was probably executed about 1877.

PROVENANCE: Jay Cooke.

LITERATURE: PMA 1965, p. 5.

CONDITION: The painting's surface is now faced with wax and translucent paper, their presence indicating serious condition problems in the past. The deeply discolored varnish has been removed from the right half of the painting.

Born the son of Hendrick Gillisz. van Beyeren in 1620 or 1621 in The Hague, Abraham van Beyeren was living in Leiden in 1639 when he married Emerentia Staecke. He apparently moved frequently and suffered financial difficulties during his life. In 1640 he entered the guild in The Hague and was married a second time there in February 1647 to Anna van den Queborn, a daughter of the portraitist Chrispiaen van den Queborn (1604–1652) and granddaughter of Daniel van den Queborn (active 1590s). This union has been assumed to have enhanced Van Beyeren's social standing. Through the marriage he also became the brother-in-law of the fish painter Pieter de Putter (c. 1600–1659), who, like Pieter Verbeeck (c. 1610–c. 1654), may have been his teacher. In 1656 he was one of the founders of the painters' association "Pictura" in The Hague; on October 15, 1657, he entered the guild in Delft. He reappeared in The Hague in 1663, lived in Amsterdam from 1669 to 1674, and entered the guild in Alkmaar in 1674. From 1675 to 1677 he was in Gouda and in 1678 moved to Overschie, where he died in 1690.

Van Beyeren was primarily a still-life painter. Unlike many of his contemporaries, he did not specialize within this category but executed banquet, fruit, and breakfast pieces, as well as *vanitas,* fish still lifes, and, more rarely, flower still lifes. His work shows the influence of Jan Davidsz. de Heem (1606–1683/84) and Jacques de Claeuw (active 1642–d. after 1676). In addition to still lifes, he executed several marines in the style of Van Goyen (q.v.). Few of his works are dated. His fish still lifes are usually horizontal in format (see *Still Life,* monogrammed, oil on canvas, 28 x 36¼″ [71 x 92 cm.], John G. Johnson Collection at the Philadelphia Museum of Art, cat. no. 639) and date from 1651 to 1667. The banquet pieces for which he is best known date from 1653 to 1673. He almost always signed with a monogram and frequently introduced self-portraits as reflections in the gleaming objects of his still lifes.

LITERATURE: E. W. Moes in Thieme-Becker 1907–50, vol. 3 (1909), p. 570; Ima Blok, "Abraham van Beyeren," *Onze Kunst,* vol. 17 (1918), pp. 117ff; B. C. Helbers, "Abraham van Beyeren, Mr. Schilder tot Overschie," *Oud Holland,* vol. 45 (1928), pp. 27–28; H. E. van Gelder, *W. C. Heda, A. van Beyeren, W. Kalf* (Amsterdam, 1941), pp. 21ff.; Ingvar Bergström, *Dutch Still-Life Painting in the Seventeenth Century,* translated by Christina Hedström and Gerald Taylor (London, 1956), pp. 229–46; E. de Jongh in Auckland City Art Gallery, New Zealand, *Still-Life in the Age of Rembrandt,* 1982, pp. 79–83; Stedelijk Museum het Prinsenhof, Delft, *A Prosperous Past: The Sumptuous Still Life in the Netherlands, 1600–1700,* Fogg Art Museum, Cambridge, Mass., and Kimbell Art Museum, Fort Worth, 1988–89, pp. 165–77.

For additional works by Van Beyeren in the Philadelphia Museum of Art, see John G. Johnson Collection cat. nos. 637, 639, 638 (attributed to).

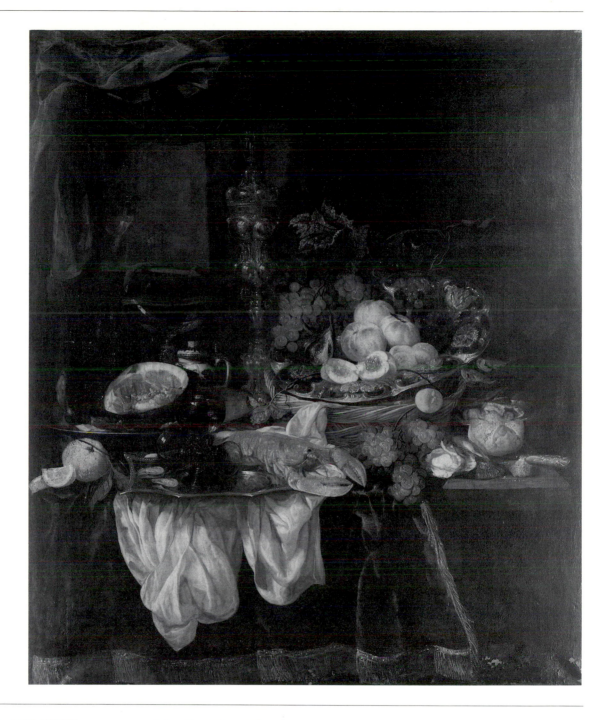

7 ABRAHAM VAN BEYEREN

BANQUET STILL LIFE, c. 1654–67
Oil on canvas, 42⅛ x 50″ (108.3 x 127 cm.)
The William L. Elkins Collection. E24-3-23

On a table draped with a blue cloth with gold trim and a white napkin, are
a sectioned and a whole orange, an octagonal silver dish with two shrimp,
two roemer glasses, a red lobster, a bunch of green grapes, shelled oysters, a
roll, a plate of oysters, and a silver knife; behind are a circular silver platter
with a stemmed glass and a ham, a footed glass bowl, a ceramic tankard, a
very tall silver-gilt Augsburg chalice, and a straw basket in which rests a
silver platter decorated with flower patterns and filled with whole and sliced

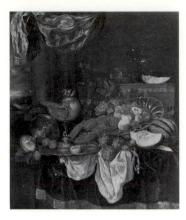

FIG. 7-1 Abraham van Beyeren, *Banquet Still Life,* signed and dated 1653, oil on canvas, 49⅜ x 41¼" (125.5 x 105 cm.), Alte Pinakothek, Munich, no. 1620.

FIG. 7-2 Abraham van Beyeren, *Banquet Still Life,* monogrammed and dated 1666, oil on canvas, 54½ x 45¼" (138.4 x 114.9 cm.), The Fine Arts Museums of San Francisco, acc. no. 51.23.2.

FIG. 7-3 Abraham van Beyeren, *Banquet Still Life,* oil on canvas, 46⅜ x 37" (118 x 94 cm.), location unknown.

peaches and green and purple grapes. In the background at the upper left is a niche in which rest a wineglass, a pipe, and a rope used to light it. A red curtain covers the niche.

By the late 1630s and increasingly after mid-century, when the Netherlands achieved unrivaled prosperity as Europe's foremost trading and financial center, a taste arose for large banquet still lifes. These elegant pictures were called *pronkstilleven: pronk* is perhaps best translated as "show" or "ostentation." The early Dutch painters of this still-life type, such as Jan Davidsz. de Heem (1606–1683/84), usually employed large, open compositions of ornamentally arranged objects painted in bright, delicate colors. These works were indebted to the Flemish painters Frans Snyders (q.v.), Adriaen van Utrecht (1599–1652/53), and Daniel Seghers (1590–1661). Van Beyeren developed a more monumental banquet piece with large, mostly upright and more closed compositions of costly pieces of glass and metalware and rich foods and fruit painted with a darker, more saturated palette.

Van Beyeren's earliest dated banquet piece is from 1653 (see fig. 7-1) and reveals vestigial elements of the more decorative Flemish manner of De Heem.[1] Several dated works from the mid- to later 1650s[2] suggest that Van Beyeren sought a greater concentration by reducing the prominence and number of background elements; but it is difficult to plot a precise formal development from c. 1654 to his latest dated works of this type of 1666 (fig. 7-2) and 1667.[3] The objects themselves also offer little help in assigning a work like the Philadelphia painting a more precise date. Although the tall covered drinking cup can be identified as a German vessel known as a *Buckelpokal* (named for the bulbous protrusions at top and bottom), it cannot be dated more accurately than the second third of the seventeenth century, and the silver platter resting on the basket is of a type made in Amsterdam and Haarlem in the 1650s.[4] Thus an approximate date of c. 1654–67 for this painting seems most acceptable.

While De Heem's art served Van Beyeren as a point of departure, he rapidly asserted his own personality, revealing gifts as a colorist and a great capacity for variation. He clearly employed a stock repertory of objects and motifs; the tall covered chalice, the silver platters, the straw basket, the cloth and napkin, even the niche with the wineglass and the drawn curtain all reappear in different arrangements in other paintings. Obviously, in addition to working from real objects, he also painted from a stock of compositional studies, since isolated groups of objects within the larger arrangement of the still life recur in the same relation to one another. An undated painting that most closely resembles the Philadelphia work in design and in the variety and arrangement of objects was sold at the Nya Konstgalleriet in Stockholm in 1918 (fig. 7-3). Another closely related painting was in the collection of Sir Max Michaelis, Cape Town.[5]

Van Beyeren's specialization in *pronkstilleven,* continually varying and refining his theme, was a typical feature of Dutch painting generally and has been regarded as the source of the exceptional productivity and virtuosity of Dutch still-life painters.[6] However, whether Van Beyeren's rich still lifes were merely an exultation of splendor or also carried an exhortation to temperance and moderation is unclear. He inscribed still lifes with the motto "vanitas vanitatum" (vanity of vanities), and Ingvar Bergström has interpreted the small watch that often appears among his rich objects as an admonition to temperance.[7] E. de Jongh in discussing

Van Beyeren's banquet pieces recalled the condemnations of sumptuosity, gourmandizing, and elegant household furnishings by Dutch preachers such as Godefridus Udemans (1640) and Petrus Wittewrongel (1661), and also pointed to Roemer Visscher's emblem entitled "Ad Tragoedias" berating elegant, metal vessels and tableware that "do not serve the daily wants."[8] Though De Jongh rightly cautioned that Van Beyeren's still lifes do not offer a context in which the rich objects are easily interpreted by modern viewers, he concluded, "whatever the intention of Van Beyeren's banquet-pieces...some of his contemporaries will have regarded these paintings...not just [as] renderings of comestibles and objects but [as] remonstrances against excess and ostentation."[9]

NOTES

1. Ingvar Bergström (*Dutch Still-Life Painting in the Seventeenth Century,* translated by Christina Hedström and Gerard Taylor [London, 1956], p. 240) claimed that this was the earliest known banquet piece; Scott A. Sullivan, however, in "A Banquet-Piece with Vanitas Implications," *The Bulletin of the Cleveland Museum of Art,* vol. 61 (October 1974), p. 282 n. 9, asserted that a still life that sold at Lepke's in Berlin, March 20, 1900, was dated 1651.

2. As examples, see *Banquet Piece,* signed and dated 1654, oil on canvas, 49½ x 41⅛" (126 x 106 cm.), Museum Boymans–van Beuningen, Rotterdam, inv. no. St. 90; *Banquet Still Life,* signed and dated 1655, oil on panel, 44¾ x 33½" (113.7 x 85.1 cm.), Worcester Art Museum, acc. no. 1953.1; and a painting dated 1654, oil on canvas, 43¼ x 40¼" (110 x 102.5 cm.), with dealer A. Staal, Amsterdam, in 1968 (photograph, Rijksbureau voor Kunsthistorische Documentatie, The Hague).

3. Thomas P. Lee, former Curator-in-Charge of Painting, The Fine Arts Museums of San Francisco, has kindly confirmed the date on figure 7-2. A larger and more elaborate banquet piece, monogrammed and dated 1667, oil on canvas, 55¾ x 48" (141.5 x 122 cm.) was recently acquired by the Los Angeles County Museum of Art, inv. no. M86.96 (repro. in Stedelijk Museum het Prinsenhof, Delft, *A Prosperous Past: The Sumptuous Still Life in the Netherlands,* 1988–89, p. 175).

4. Cups of this sort were used throughout the Renaissance and Baroque periods as commemorative objects marking important social events. Some artists even painted portraits of some of the more lavishly decorated covered cups; see Ingvar Bergström, "'Portraits' of Gilt Cups by Pieter Claesz," *Tableau,* vol. 5, no. 6 (summer 1983), pp. 440–45. The cup in the Philadelphia painting often reappears in Van Beyeren's art; for comments on its appearance in Van Beyeren's *Still Life with a Silver Wine Jar and a Reflected Portrait of the Artist* (c. 1655, oil on canvas, 39¼ x 32½" [99.7 x 82.6 cm.], The Cleveland Museum of Art, no. 60.80), see Sullivan (note 1), p. 275, and p. 272 fig. 1. Its style can be compared to that of several cups

datable to the mid-seventeenth century: see Konrad Hüseler, *Hamburger Silber, 1600–1800* (Darmstadt, n.d.), pl. 13; Roger M. Berkowitz, "Objects of Precious Metal," *The Toledo [Ohio] Museum of Art Museum News,* vol. 13, no. 1 (spring 1970), n.p.; and Otto von Falke, *Alte Goldschmiedewerke im Zürcher Kunsthaus* (Zurich, 1928), no. 307, pl. 77. For discussion of the *plooi*-platter in Van Beyeren's art, see Stedelijk Museum het Prinsenhof (note 3), p. 177, and for a comparable platter with floral motifs by Lucas Draef, Amsterdam, 1657, see Rijksmuseum, Amsterdam, *Nederlands zilver/Dutch Silver, 1580–1830,* Toledo Museum of Art, and Museum of Fine Arts, Boston, 1979–80, no. 66, repro.

5. *Still Life with Fruit,* oil on canvas, 46 x 43¼" (126 x 107 cm.), Old Town House, Cape Town (repro. in *Apollo,* n.s., vol. 102, no. 164 [October 1975], p. 273, fig. 7). Compare also *A "Pronck" Still Life,* oil on canvas, 46 x 40¼" (117 x 102 cm.), from the J. A. van Dongen Collection, sale, Sotheby's, London, December 11, 1974, lot 107A (repro. in *Art at Auction: The Year at Sotheby Parke Bernet 1974–75* [New York, 1975], p. 36); *Still Life,* oil on canvas, 49½ x 41⅛" (126 x 106 cm.), Rijksmuseum, Amsterdam, no. A3944; *A Banquet Still Life with Silverware and Fruit,* monogrammed, oil on canvas, 37½ x 43¼" (95.5 x 110 cm.), sale, Sotheby's, London, July 6, 1983, lot 90, repro.; oil on canvas, 47¼ x 40⅛" (120 x 102 cm.), Krannert Art Museum, University of Illinois, Champaign, acc. no. 72-2-2 (for discussion, see Mark M. Johnson, *Bulletin of the Krannert Art Museum,* vol. 1, no. 2 [1976], pp. 10–26); *Still Life,* oil on canvas, 39 x 35" (99 x 89 cm.), Musée Royal de Belgique, Brussels, cat. 1953, no. 36; 42⅛ x 33¾" (107 x 86 cm.), formerly with Lycett Green, York (photograph, Witt Library, London); and oil on panel, 32⁵⁄₁₆ x 29⅞" (81.5 x 68.5 cm.), with Galerie S. Lucas, Vienna, 1972.

6. See E. de Jongh, "Realisme enschijnrealisme in de Hollandse schilderkunst," in Palais des Beaux-Arts, Brussels, *Rembrandt en zijn tijd,* 1971, pp. 159–60; Joseph Lammers, "Innovation und Virtuosität," in Westfälisches Landesmuseum, Münster,

Stilleben in Europa, November 25, 1979–February 24, 1980, and Staatliche Kunsthalle, Baden-Baden, March 15–June 15, 1980, pp. 507–12.

7. Bergström (see note 1), pp. 189–90. For literature on *vanitas* still lifes, see Stedelijk Museum "de Lakenhal," Leiden, *Ijdelheid der ijdelheden Hollandse vanitas—voorstellingen uit de zeventiende eeuw,* June 26–August 23, 1970.

8. See De Jongh in Auckland City Art Gallery, New Zealand, *Still-Life in the Age of Rembrandt,* 1982, p. 82, fig 7c; Roemer Visscher, *Sinnepoppen* (Amsterdam, 1614; reprint, The Hague, 1949), p. 53: "groote silvere vergulden Schalen, Koppen, Beckens, Lampetten" [die] "niet tot de dagelijcxse nootdruft dienen." De Jongh also cites Hendrick Gerritsz. Pot's painting (Rheinisches Landesmuseum, Bonn) personifying greed as an old woman with precious gold and silver vessels like those in Van Beyeren's paintings.

9. De Jongh (see note 8), pp. 32, 82. On the *pronk* still life's allusions and potential admonition to moderation, see also Stedelijk Museum het Prinsenhof (note 3), pp. 29–38.

PROVENANCE: William L. Elkins Collection, Philadelphia, by 1900.

EXHIBITION: The Metropolitan Museum of Art, New York, *Catalogue of a Loan Exhibition of Paintings by Old Dutch Masters Held at The Metropolitan Museum of Art in Connection with the Hudson-Fulton Celebration,* September–November 1909, no. 2, repro. p. 36.

LITERATURE: Elkins 1887–1900, vol. 2, no. 78, repro opp. p. 78; Elkins 1924, no. 23; PMA 1965, p. 5.

CONDITION: The canvas support has an aged aqueous lining and is dry but stable. Prior to being faced with microcrystalline wax and tissue paper in June 1978, the paint film was flaking in the lower-right corner and beneath the niche at the upper left. The wax facing is still in place.

LITERATURE: Cornelis de Bie, *Het Gulden Cabinet van de edele vry Schilderconst* (Antwerp, 1661; reprint, Soest, 1971), pp. 362–64; Weyerman 1729–69, vol. 2, p. 211; F. Joseph van den Branden, *Geschiedenis der Antwerpsche Schilderschool* (Antwerp, 1883), pp. 1095–96; H. Hymans in Thieme-Becker 1907–50, vol. 4 (1910), pp. 199–200; Edith Greindl, *Les Peintres flamands de nature morte au XVII^e siècle* (Brussels, 1956; rev. ed., Sterrebeek, 1983), pp. 112–16; Scott A. Sullivan, *The Dutch Gamepiece* (Totowa and Montclair, N.J., 1984), pp. 21, 22, 31, 60, 64.

For an additional work by Boel in the Philadelphia Museum of Art, see John G. Johnson Collection cat. no. 706.

Son of the engraver, publisher, and dealer Jan Boel (1592–1640), Pieter Boel was baptized in Antwerp on October 22, 1622. His brother Quirin (Coryn) Boel (1620–1668) was active as a printmaker. Pieter Boel became a master in the Guild of Saint Luke in 1650–51. He is said to have spent several years in Italy, where he visited Genoa and Rome. Wenzel Hollar engraved one of his still lifes of dead game as early as 1649. His still lifes resemble those of Frans Snyders (q.v.) and Jan Fyt (1611–1661). After 1668 Boel worked with Charles Le Brun (1619–1690) in the Gobelins tapestry factory in Paris. He was named "Peintre ordinaire du Roi" in 1674, the year of his death. His portrait was engraved by Coenrads Lauwers (1632–c. 1685), after Erasmus Quellin (1607–1678) for Cornelis de Bie's *Het Gulden Cabinet* (Antwerp, 1661).

An animal and still-life painter, Pieter Boel executed *vanitas* scenes and dead game and hunt pieces. He collaborated on paintings with Jacob Jordaens (1593–1678) and Gonzales Coques (1614–1684). He was also active as a draftsman (more than two hundred sheets are preserved in the Louvre) and as a printmaker; his two series of six prints each are entitled "Diversi uccelli a Petro Boel."

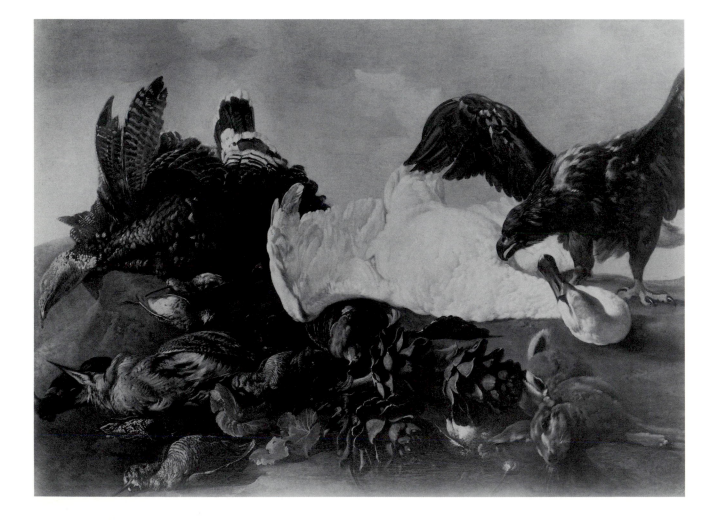

8 ATTRIBUTED TO PIETER BOEL

DEAD GAME WITH EAGLE
Oil on canvas, 48½ x 65¼ (123 x 165.7 cm.)
Purchased for the W. P. Wilstach Collection. W04-1-35

To the right of a pile of dead game and vegetables, stands a live eagle with its wings outstretched, its beak bent down to the breast of a dead white swan. Below a dead turkey on the left are a heron, bitterns, and several smaller fowl. To the right, beside three artichokes, is a rabbit. The game is placed on the ground beneath a lighted sky.

Names of various artists, most frequently Adriaen van Utrecht (1599–c. 1652/53), have been mentioned in informal discussions of the attribution of this unsigned painting, but until now its traditional assignment to Frans Snyders (q.v.) has been upheld. The attribution finds some support through comparisons with his certain works. Snyders played a pioneering role in the development of the Flemish gamepiece, specializing in sumptuous horizontal compositions of piles of dead birds and other game, often with one or more live animals. Frequently a large white swan figures as a central motif in these arrangements. The dead swan first appears in Snyders's still lifes in 1614;[1] it may have been derived from Rubens (q.v.)[2] and was to become a popular detail in the gamepieces of later Flemish and Dutch painters such as Adriaen van Utrecht, Jan Baptist Weenix (q.v.), the rare artist Matthijs Bloem (active c. 1640–66), and Jan Weenix (q.v.), as well as Pieter Boel.[3] The motif of the eagle standing over dead game or prey also appears in Snyders's work.[4] The blank sky in the background, however, is unusual for the artist, as is a certain dryness and lack of vitality in the technique. Of Snyders's various followers, Pieter Boel produced dead gamepieces that most closely resemble this work in style and design. His *Hunting Still Life with Dead Swan* (fig. 8-1) employs comparable motifs and a similar technique. A painting of eagles with a dead deer, included as one of the scenes Boel etched for his "Diversi uccelli" (fig. 8-2) and formerly owned by the Städelsches Kunstinstitut in Frankfurt, employs a design similar to that of the Philadelphia painting.[5] However, the reassignment of the latter work to Boel is here only tentatively proposed.

The circumstances surrounding the work's commission are unknown. The game depicted were typical prizes of the hunt, which in the seventeenth century was an upper-class pursuit regulated by law.[6] The hunting of swans, or any fowl larger than common songbirds (geese, ducks, partridges, bitterns, or pheasants) as well as rabbits, was restricted to the aristocracy. Poaching was severely punished. Thus the patron of such a work was probably well-to-do or at least aspired to privilege. Although the possibility of additional symbolic reference ought to be considered (perhaps allusions to transience and predation, or to the "swan song" of life), such meanings become secondary to the work's associations with aristocratic elegance.

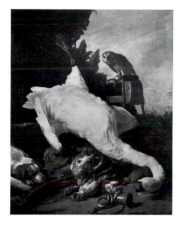

FIG. 8-1 Pieter Boel, *Hunting Still Life with Dead Swan,* signed, oil on canvas, 53⅛ x 42⅛" (135 x 107 cm.), Museum Boymans–van Beuningen, Rotterdam, inv. no. 1069.

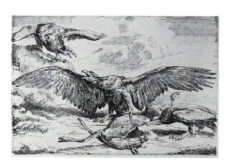

FIG. 8-2 Pieter Boel, *Eagles* from "Diversi uccelli," etching, 6½ x 14⅞" (164 x 380 mm.).

NOTES

1. See *Still Life with Birds,* signed and dated 1614, oil on canvas, 61⅜ x 85¾″ (156 x 218 cm.), Wallraf-Richartz Museum, Cologne, no. 2894; and *The Gamekeeper,* also signed and dated 1614, oil on canvas, 90½ x 122″ (230 x 310 cm.), Jean Olléon Collection, Brussels. Both are reproduced in Hella Robels, "Frans Snyders' Entwicklung als Stillebenmaler," *Jahrbuch Wallraf-Richartz Museum,* vol. 31 (1969), pp. 43–94, figs. 31 and 32. See also the swans in *Storeroom with Hunter,* signed, oil on canvas, 51½ x 69¼″ (131 x 176 cm.), Schloss Pommersfelden, inv. no. 956, and *Storeroom with Maidservant,* signed, oil on canvas, 67 x 114″ (170 x 290 cm.), Musée Royal des Beaux-Arts, Brussels, inv. no. 433. There is also an undated *Still Life with a Swan,* oil on canvas, 40¼ x 56″ (102 x 142 cm.), in the National Gallery of Canada, Ottawa, no. 362; the attribution of that work, however, has rightly been questioned.

2. See the oil sketch *The Recognition of Philopoemen,* oil on panel, 19⅞ x 26⅛″ (50.5 x 66.5 cm.), Musée du Louvre, Paris, inv. no. 2124; Julius S. Held, in *The Oil Sketches of Peter Paul Rubens: A Critical Catalogue,* vol. 1 (Princeton, N.J., 1980), p. 374, cat. no. 278, has dated it c. 1609–10. A large finished version, *Philopoemen Recognized by an Old Woman,* oil on canvas, 79⅛ x 122⅛″ (201 x 311 cm.), The Prado, Madrid, inv. no. 1851, is questionably attributed to Snyders and Rubens.

3. See, for example, Jan Baptist Weenix's *Still Life with a Dead Swan,* c. 1651, oil on canvas, 60 x 60½″ (152.4 x 153.7 cm.), The Detroit Institute of Arts, inv. no. 26.22; *The Dead Swan,* 1650, oil on canvas, 61 x 55⅛″ (155 x 142 cm.), H. E. Hannema-de Stuers Collection, Nijenhuis; *Hunting Booty with a Swan,* 1652, oil on canvas, 54⅜ x 76¾″ (138 x 195 cm.), Bayerische Staatsgemäldesammlungen, Munich; *Still Life with a Dead Swan,* 1657, oil on canvas, 54 x 75″ (137 x 190.5 cm.), North Carolina Museum of Art, Raleigh, no. 73, repro.; and Matthijs Bloem's *Gamepiece with a Dead Swan,* dated 1650, oil on canvas, 43⅝ x 53¾″ (111 x 136.7 cm.), Museum der bildenden Künste, Leipzig, no. 1628. With the exception of the Raleigh painting, these works are illustrated and discussed by Scott A. Sullivan, "Jan Baptist Weenix: 'Still Life with a Dead Swan,'" *Bulletin of the Detroit Institute of Arts,* vol. 57, no. 2 (1979), pp. 64–71, figs. 1, 6, 7, and 5, respectively.

4. See, for example, *Eagles with a Dead Fox,* c. 1640s, oil on canvas, 64½ x 93⅝″ (164 x 238 cm.), Château Chambord, on deposit at the Musée de la Chasse de Paris, inv. no. 71-1-1 (repro. in *Le Siècle de Rubens dans les collections publiques françaises* [Paris, 1977], cat. no. 173).

5. *Three Eagles Devouring a Roe,* oil on canvas, 57⅜ x 80¼″ (146 x 204 cm.), appeared in the 1892 catalogue of the Städelsches Kunstinstitut, Frankfurt, as no. 163; in *Les Peintres flamands de nature morte au XVIIe siècle* (Brussels, 1956; rev. ed., Sterrebeek, 1983), p. 116, Edith Greindl gives the catalogue number as 224. The painting was sold in 1934, however, and the Städelsches Kunstinstitut retains no photographic negative. The print appears in *The Illustrated Bartsch,* vol. 5 (New York, 1979), p. 192, no. 3. Compare also Boel's *Game Still Life with Dead Swan and Dog,* oil on canvas, 64⅛ x 91⅜″ (163 x 232 cm.), Baron H. Descamps Collection, Brussels (Greindl, see above, fig. 66; repro. in Scott A. Sullivan, *The Dutch Gamepiece* [Totowa and Montclair, N.J., 1984] fig. 37).

6. See Sullivan (note 3), p. 69; and Scott A. Sullivan, "Hunting and Dutch Society," in *The Dutch Gamepiece* (Totowa and Montclair, N.J., 1984), pp. 33–45. See also Johan Huizinga, *Holländische Kultur des Siebzehnten Jahrhunderts. Eine Skizze* (Basel and Stuttgart, 1961), p. 60; and E. de Jongh in Auckland City Art Gallery, New Zealand, *Still-Life in the Age of Rembrandt,* 1982, p. 140.

PROVENANCE: Purchased for the W. P. Wilstach Collection, Philadelphia, January 8, 1904.

LITERATURE: Wilstach 1904, no. 236, 1906, no. 259, 1910, no. 383, 1913, no. 398, 1922, no. 293, repro.; Charles Simpson, *Animal and Bird Painting: The Outlook and Technique of the Artist* (London, 1939), p. 124, pl. 79; PMA 1965, p. 63; Joseph Rishel, "Landseer and the Continent: The Artist in International Perspective," in Richard Ormond, *Sir Edwin Landseer* (Philadelphia and London, 1982), p. 29, fig. 37.

CONDITION: The original canvas support is composed of two pieces with a vertical seam 24″ (61 cm.) from the left edge. Its tacking edges are missing. It has an old aqueous relining and is slack on its stretcher. An old tear in the swan's beak and a puncture in the artichoke in the lower-right center have been repaired. The paint film shows scattered, small losses throughout. Discolored overpaint is apparent along the seam, in the white swan, and throughout the sky. The varnish layer is very thick, uneven, and deeply discolored. The surface is dull.

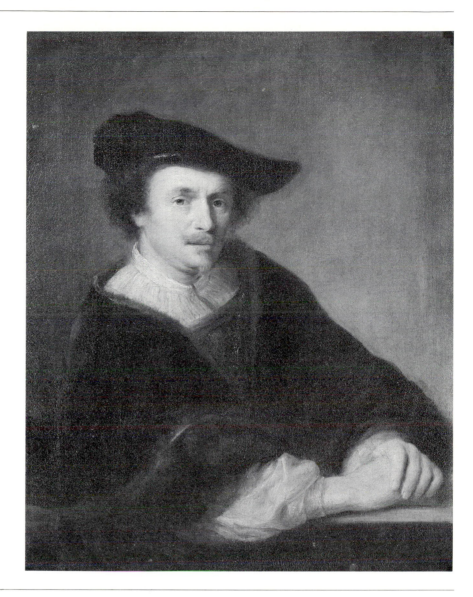

9 COPY AFTER FERDINAND BOL

PORTRAIT OF A MAN, c. 1648
Oil on canvas, 35 x 28¼″ (89 x 71.5 cm.)
Gift of Mr. and Mrs. William H. Donner. 48-95-2

The sitter is viewed half-length with his right forearm resting on a sill and his hands clasped. He wears a black beret, a fur-lined black cape over an embroidered garment and a white shirt, and a gold courtier's chain.

Albert Blankert has correctly observed that this painting is a copy of *Portrait of a Man* (fig. 9-1)[1] by Ferdinand Bol (1616–1680), which, together with *Woman with Plumed Hat,*[2] he dates about 1648. The rectangular frame of the window is somewhat clearer in the original. The latter belongs to a series of half-length portraits situated in square or arched windows that were executed by Rembrandt and his pupils in these years.

Bol, baptized in Dordrecht on June 24, 1616, was the son of a middle-class barber-surgeon. He may have studied under Jacob Gerritsz. Cuyp (1594–1651/52). In 1635 he was mentioned as a painter in Dordrecht.

FIG. 9-1 Ferdinand Bol, *Portrait of a Man,*
c. 1648, oil on canvas, 34⅛ x 28½" (87.5 x 72.5
cm.), Alte Pinakothek, Munich, no. 609.

Soon thereafter he must have moved to Amsterdam, where he was a pupil of Rembrandt and lived for the remainder of his life. The greater part of his oeuvre is composed of portraits, which at first closely resemble his teacher's and after about 1650 reveal greater similarities with the portraiture of Bartholomeus van der Helst (1613–1670). His history paintings, on the other hand, resemble Rembrandt's.

Here, Rembrandt's etched and painted self-portraits of 1639 and 1640 undoubtedly were Bol's primary inspiration.[3] The pose, with the arm resting on the sill, however, was commonly used at that time for artists' self-portraits.[4] Its popularity probably reflects Dutch painters' admiration for two Italian pictures—Raphael's *Portrait of Baldassare Castiglione*[5] and Titian's so-called *Portrait of Ariosto*[6]—that passed through Amsterdam during this period.[7] The pose is actually closer to that of the latter work, which, it should be noted, was thought in the seventeenth century to be a self-portrait by the great Venetian master.

NOTES

1. See Albert Blankert, "Ferdinand Bol (1616–1680), een Leerling van Rembrandt," diss., Utrecht, 1976, cat. no. A144, and Albert Blankert, *Ferdinand Bol (1616–1680): Rembrandt's Pupil,* translated by Ina Rike (Doornspijk, 1982), p. 144, cat. no. 143. Blankert's 1976 dissertation (nos. 144b–d) and 1982 monograph (nos. 143b–d) list other copies: oil on canvas, 35 x 29½" (89 x 75 cm.), Leigh sale, Sotheby's, London, July 25, 1934, lot 81; Kriegelsteyn Collection, Kreuznach, 1903 (photograph, Rijksbureau voor Kunsthistorische Documentatie, The Hague); oil on canvas, 21⅝ x 16½" (55 x 42 cm.), Amalienstift, Dessau, no. 237.
2. *Woman with Plumed Hat,* c. 1648, oil on canvas, 34¼ x 28½" (87 x 72.5 cm.), Alte Pinakothek, Munich, no. 610.
3. *Rembrandt Leaning on a Stone Sill: Half-Length,* 1639, etching, first state, 8 x 6⅛" (205 x 164 mm.); *Self-Portrait at the Age of Thirty-four,* 1640, oil on canvas, 40⅛ x 31½" (102 x 80 cm.), National Gallery, London, no. 672.
4. Bol used the pose on several other occasions; for example, his *Self-Portrait,* 1640, oil on canvas, 32¾ x 36¾" (83.2 x 93.3 cm.), Museum of Fine Arts, Springfield, inv. no. 42.02 (see Albert Blankert, *Ferdinand Bol [1616–1680], een Leerling van Rembrandt,* diss., Utrecht, 1976, cat. no. A66; and Albert Blankert, *Ferdinand Bol [1616–1680]: Rembrandt's Pupil,* translated by Ina Rike [Doornspijk, 1982], cat. no. 64).
5. Oil on canvas, 32¼ x 26⅜" (82 x 67 cm.), Musée du Louvre, Paris, inv. no. 611.
6. Oil on canvas, 32 x 26" (81.2 x 66.3 cm.), National Gallery, London, no. 1944.
7. See E. de Jongh, "'The Spur of Wit': Rembrandt's Response to an Italian Challenge," *Delta,* vol. 12 (1972), pp. 49ff.

PROVENANCE: Charles T. Yerkes, Chicago; Charles T. Yerkes sale, American Art Association, New York, January 22, 1910, lot 118; Yerkes sale, New York, April 5, 1910, lot 2; Ambrose Monell sale, American Art Association, New York, November 28, 1930, lot 58; Mr. and Mrs. William H. Donner.

LITERATURE: *Catalogue of the Paintings and Sculpture in the Collection of Charles T. Yerkes,* vol. 1 (New York, 1904), no. 2, repro.; H. van Hall, *Portretten van Nederlandse beeldende kunstenaars* (Amsterdam, 1963), no. 48.95.2; PMA 1965, p. 6; Albert Blankert, "Ferdinand Bol (1616–1680), een Leerling van Rembrandt," diss., Utrecht, 1976, cat. no. A144; Albert Blankert, *Ferdinand Bol (1616–1680): Rembrandt's Pupil,* translated by Ina Rike (Doornspijk, 1982), cat. no. 143a.

CONDITION: The canvas support has a fairly recent aqueous lining and is dry but stable. The tacking edges are missing. The paint film shows some abrasion but generally is in satisfactory condition. The upper-right corner and all edges are retouched; in addition, a few losses are found along the lower edge. All retouches are mismatched. An extremely dark, discolored varnish obscures the picture, and older varnish residues are visible in the interstices of the light tones.

Gerard ter Borch (often he signed Geraert ter Borch) was born in Zwolle, the son of Gerard ter Borch the Elder (1584–1662), an artist who worked in Italy in his youth. As Arnold Houbraken stated, Ter Borch first studied with his father. In 1632 he evidently was in Amsterdam and in 1634 in Haarlem, where he was a pupil of Pieter de Molijn (1595–1661). He is said to have entered the Haarlem guild in 1635; in July of that year he was in England but may have been back in Zwolle by April 1636. According to Houbraken, Ter Borch studied at Haarlem and traveled in Germany, Italy, England, France, Spain, and the Netherlands. He may have visited these countries after 1635 and certainly traveled to Münster, where he painted portraits of the representatives to the peace negotiations held there between 1646 and 1648. Houbraken claimed that a Spanish envoy who had been attending the meetings took Ter Borch with him to Madrid, but there is no trace of the artist in Spain. Further, he was recorded as being in Amsterdam in 1648 and in Kampen in 1650. On April 22, 1653, he signed a document together with the famous painter Johannes Vermeer (1632–1675) in Delft. In February 1654 he was married to Geertruyt Matthijs in Deventer, where he acquired citizenship in the following year and evidently remained a resident until his death in 1681.

In his early years Ter Borch painted guardroom scenes in the manner of Haarlem and Amsterdam painters Pieter Codde (1599–1678) and Willem Duyster (1598/99–1635). In the 1640s he executed miniature portraits. During the following decade he was instrumental in developing an elegant new type of genre painting characterized by great technical and psychological refinement. These works had a great impact on his contemporaries and served, more than the works of any other genre painter, to define the forms taken by late seventeenth-century Dutch painting. Ter Borch enjoyed the patronage of many prominent people of his day.

LITERATURE: Houbraken 1718–21, vol. 3, pp. 32, 34–40; Weyerman 1729–69, vol. 2, p. 376; Smith 1829–42, vol. 4, pp. III–42; Immerzeel 1842–43, vol. 3, p. 132; Kramm 1857–64, vol. 6, p. 1612; Van der Willigen (1870) 1970, p. 352; Carl Lemcke, "Gerhard Terborch," in *Kunst und Künstler des Mittelalters und der Neuzeit,* edited by Robert Dohme (Leipzig, 1875); E. W. Moes, "Gerard ter Borch en zijne familie," *Oud Holland,* vol. 4 (1886), pp. 145–65; Emile Michel, "Gérard Terbourg (Ter Borch) et sa famille," *Gazette des Beaux-Arts,* 2nd ser., vol. 34 (1886), pp. 388–404, vol. 35 (1887), pp. 40–53, 125–41; Abraham Bredius, "Gerard ter Borch, 1648 te Amsterdam," *Oud Holland,* vol. 17 (1899), pp. 189–90; Hofstede de Groot 1908–27, vol. 5 (1913), pp. 1–145; Abraham Bredius, "Schilderijen uit de nalatenschap van den Delft'schen Vermeer," *Oud Holland,* vol. 34 (1916), pp. 160–61; Wurzbach 1906–11, vol. 2, pp. 698–702; Walter Rothes, *Terborch und das holländische Gesellschaftsbild, Die Kunst dem Volke,* nos. 41–42 (Munich, 1921); F. Hannema, *Gerard Terborch* (Amsterdam, 1943); Eduard Plietzsch, *Gerard Ter Borch* (Vienna, 1944); S. J. Gudlaugsson, "De datering van de schilderijen van Gerard ter Borch," *Nederlands kunsthistorisch jaarboek,* vol. 2 (1949), pp. 235–67; Gudlaugsson 1959–60; S. J. Gudlaugsson et al., *Gerard Ter Borch, Zwolle 1617–Deventer 1681* (The Hague, 1974); J. M. Montias, "New Documents on Vermeer and His Family," *Oud Holland,* vol. 91 (1977), pp. 285–87; S.A.C. Dudok van Heel, "In presentie van de Heer Gerard ter Borch," in *Essays in Northern European Art Presented to Egbert Haverkamp Begemann on His Sixtieth Birthday* (Doornspijk, 1983), pp. 66–71; Alison McNeil Kettering, "Ter Borch's Studio Estate," *Apollo,* vol. 117, no. 256 (June 1983), pp. 443–51; Sutton et al. 1984, pp. XLIV–XLVI, 142–54.

For additional works by Ter Borch in the Philadelphia Museum of Art, see John G. Johnson Collection cat. nos. 504, 493 (copy after), 1177 (copy after), inv. no. 377 (copy after).

10 GERARD TER BORCH

OFFICER WRITING A LETTER, WITH A TRUMPETER, c. 1658–59
Signed lower right on table crosspiece: *GT Borch* (first three letters ligated)
Oil on canvas, 22¼ x 17¼" (56.5 x 43.8 cm.)
The William L. Elkins Collection. E24-3-21

Seated at a table, an officer is absorbed in the act of writing a letter while a trumpeter, evidently the messenger, waits at the left. The messenger wears a blue tabard with black and gold stripes over a long-sleeved, tan-colored garment and brown pants and boots. He holds a tall-brimmed tan hat in his hand. Suspended by a strap, his trumpet hangs down his back just above the hilt of his sword. A white dog with brown spots stands before him. At the right the officer, wearing a cuirass over a gold-ribbed jerkin and gray pantaloons and stockings, sits working with a quill pen and paper at a table covered with a deep-red cloth. On the table are an inkwell, a stick of red sealing wax, a seal, and the officer's tall, black, plumed hat. Behind at the right are a fireplace with wooden pilasters and a mantel on which rests a powder horn and a bottle of brown liquid. In the distance there is a bed covered with a blue-black canopy in the shape of a baldachin. On the floor in the immediate foreground are the shards of a broken white clay pipe and an ace of hearts playing card.

Images involving letters—their writing, dictation, reading, and reception—were some of Gerard ter Borch's favorite themes. While letter themes had appeared earlier in Dutch genre painting (for example, Dirck Hals's woman with a letter),[1] Ter Borch played the greatest role in popularizing these subjects. The artist most often depicted elegant young women as the principal figures in these scenes,[2] but particularly in the late 1650s also introduced letter themes into his paintings of soldier life. This brought an element of reflection and stillness into these often rather rowdy guardroom scenes. An example of a more boisterous guardroom scene in the John G. Johnson Collection at the Philadelphia Museum of Art[3] is dated 1658 and has been cited by S. J. Gudlaugsson in efforts to date the present picture as well as several undated but related soldier scenes involving letters, which are in museums in Warsaw (fig. 10-1), Dresden,[4] and London (fig. 10-2). The paintings in Warsaw and London treat the same theme as the present painting, and the officer and trumpeter in all three works wear very similar costumes. The model for the writing officer also reappears in the London picture as well as in other works of the period, such as *The Suitor's Visit* in the National Gallery of Art in Washington, D.C.,[5] and has been identified by Gudlaugsson as Ter Borch's student Caspar Netscher (c. 1639–1684).[6] A copy of the present work, now in Aix-en-Provence, has even been attributed to Netscher by Gudlaugsson and suggests that the original was executed before the conclusion of Netscher's tutelage, hence at the latest c. 1658–59. Gudlaugsson further noted that the inventory of the estate left by Netscher's widow and drawn up on September 11, 1694, mentions a picture "In the small side room below . . . no. 69. An officer, writing a letter to send off [with] a trumpeter," which may be identical with the original or with Netscher's copy.[7]

FIG. 10-1 Gerard ter Borch, *Officer Dictating a Letter,* c. 1657–58, oil on panel, 16⅛ x 11⅛" (41 x 28.5 cm.), Muzeum Narodowe w Warszawie, Warsaw, inv. no. 158664.

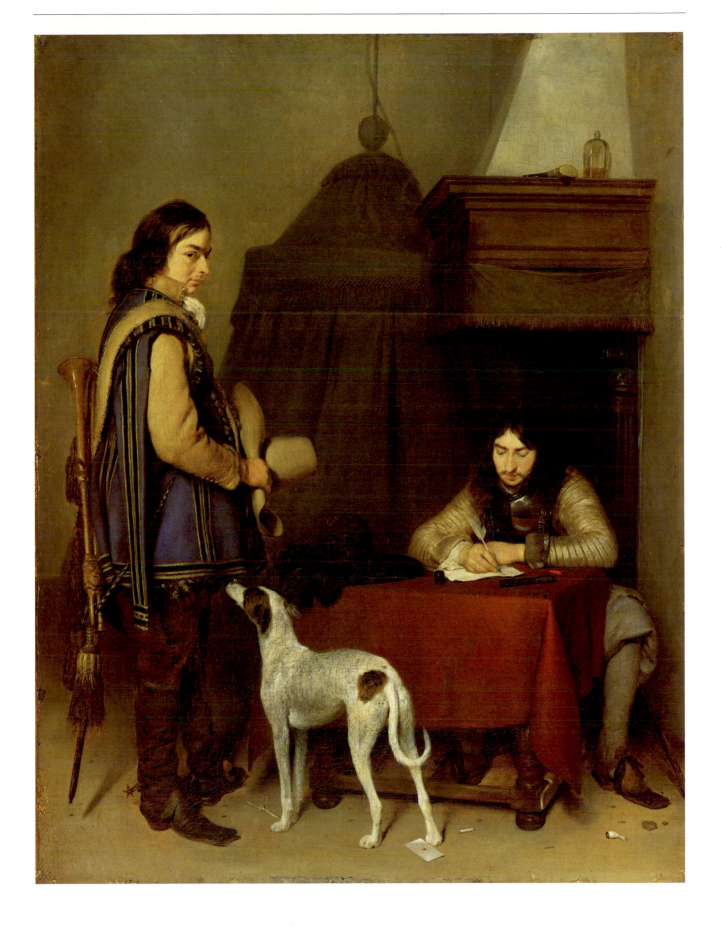

FIG. 10-2 Gerard ter Borch, *An Officer Dictating a Letter,* c. 1658–59, oil on canvas, 29⅜ x 20″ (74.5 x 51 cm.), National Gallery, London, no. 5847.

FIG. 10-3 Gerard ter Borch, *Woman Reading a Letter,* c. 1658, oil on canvas, 20 x 14⅞″ (51 x 38 cm.), Musée des Beaux-Arts, Lyons, inv. no. A109.

The background of this work is lighter in tonality and more clearly defined than Ter Borch's earlier guardroom and interior scenes. There the figures dominate their very dark surroundings. In design, figure type, tone, and color, the picture is especially close to a painting of a *Woman Reading a Letter* with a rustic courier waiting beside her, now in the Musée des Beaux-Arts, Lyons (fig. 10-3).[8] Despite the complementary aspects of these works—the writing and receiving of letters—Gudlaugsson has concluded that the discrepancy in their measurements eliminates the possibility of their being regarded as pendants.[9] Nevertheless, the prominent appearance of the ace of hearts playing card[10] on the floor naturally has led viewers to speculate that the letter penned by the officer is a billet-doux. Card games in Dutch genre were often an occasion for amorous dalliance between the sexes, and the ace of hearts frequently functioned as a romantic symbol.[11] Ter Borch's scene of *An Officer Dictating a Letter,* in the National Gallery, London (fig. 10-2), also originally had an ace of hearts on the floor, but the artist painted it out, perhaps feeling that it was an overly conspicuous sign. Whatever the painter's motivation, the earnest way in which the officer in the London painting gestures and seems to speak to his scribe, and the concentration with which his counterpart in the Philadelphia picture composes his message, confirm that they address their respective recipients "from the heart." The popularity of love-letter writing at this time, much of it inspired by the French, is related to contemporary letter-writing manuals and emblem books.[12] Love letters were taken seriously; indeed, they were admissible evidence in breach-of-promise suits. Collections of exemplary love letters with names like "Post Office of Cupid and Mercury" were consulted by lovers in search of the bon mot. Dutch literature and drama were filled with episodes involving love letters and other epistolary activity. Some authors of love letters perfumed their missives or even signed their names in blood.

As Gudlaugsson first observed, the later seventeenth-century Dutch genre painter Jacob Ochtervelt (1634–1682) seems to have taken the design of the room and bed in this picture in a painting he executed around 1680.[13] Arthur Marks also observed that John Burnet (1784–1868), who engraved it, commended the present work, then in the Hope Collection, for its composition, and that, in turn, it became the source for David Wilkie's *Letter of Introduction.*[14]

NOTES

1. *Young Woman Seated in a Chamber,* 1633, oil on panel, 13½ x 11⅛″ (34.3 x 28.3 cm.), John G. Johnson Collection at the Philadelphia Museum of Art, cat. no. 434.
2. See, for example, *Woman Writing a Letter,* c. 1655, oil on panel, 15¼ x 11⅛″ (39 x 29.5 cm.), Mauritshuis, The Hague, no. 797; *A Lady Reading a Letter,* oil on canvas, 17¾ x 13⅛″ (45.1 x 33.3 cm.), The Wallace Collection, London, no. P236; *The Letter,* oil on canvas, 32¼ x 26¾″ (81.9 x 68 cm.), Collection of Her Majesty Queen Elizabeth II, Buckingham Palace, no. 1406.
3. *The Guardroom,* oil on canvas, 38⅝ x 32¾″ (98.2 x 83.2 cm.), John G. Johnson Collection at the Philadelphia Museum of Art, cat. no. 504.

4. *Officer Reading a Letter,* oil on panel, 14¾ x 11⅜″ (37.5 x 29 cm.), Gemäldegalerie Alte Meister, Dresden, no. 1833 (Gudlaugsson 1959–60, vol. 2, no. 130 [as c. 1657–58]).
5. *The Suitor's Visit,* c. 1658, oil on canvas, 31½ x 29⅝″ (80 x 75 cm.), National Gallery of Art, Washington, D.C., no. 58 (Gudlaugsson 1959–60, vol. 2, no. 139 [as probably 1658]).
6. The identification is based on the model's resemblance to Netscher's lost *Self-Portrait,* known through the mezzotint by Wallerant Vaillant (repro. in Gudlaugsson 1959–60, vol. 2, pl. XV, fig. 3). Both figures have shoulder-length dark hair, a long slender nose, a full mouth, and a wispy black moustache.

7. "Int Zykamertje beneden...No. 69 een Officier, schrijvende een brieff om een trompetter aff te vaerdigen." See Gudlaugsson 1959–60, vol. 2, p. 151, no. 141b; see also Abraham Bredius, "Een en ander over Caspar Netscher," *Oud Holland,* vol. 5 (1887), p. 269.

8. Gudlaugsson 1959–60, vol. 2, no. 142 [as c.1658].

9. Ibid., vol. 1, p. 116.

10. Not a letter, as it has sometimes been identified; see Hofstede de Groot 1908–27, vol. 5 (1913), no. 31.

11. See De Jongh et al. 1976, under cat. no. 35; Sutton et al. 1984, pp. 191–92, 320–21. In *Gerard Ter Borch, Zwolle 1617–Deventer 1681* (The Hague, 1974), no. 41, S. J. Gudlaugsson et al. have noted the personal and amorous atmosphere of the scene but perhaps overstress the erotic aspect of the covered bed; separate bedrooms were not a common feature of Dutch domestic architecture until the last third of the century.

12. See G.D.J. Schotel, *Het oud-Hollandsch huisgezin der zeventiende eeuw* (Arnhem, 1903), pp. 234–35, pp. 248–65; Gudlaugsson 1959–60, vol. 1, pp. 107, 115–17, 126–27, vol. 2, pp. 107, 120, 126; E. de Jongh, "Realisme enschijnrealisme in de Hollandse schilderkunst," in Palais des Beaux-Arts, Brussels, *Rembrandt en zijn tijd,* 1971, pp. 178–79 n. 133; De Jongh et al. 1976, cat. nos. 2, 71; Sutton et al. 1984, p. 147 nn. 3, 4. In literature, see Jan Puget de la Serre's *Le Secrétaire à la mode* (which appeared in Dutch in 1651 as *Fatsoenlicke Zend-brief-schryver*), and Jan Hermansz. Krul's *De Pampiere Wereld* (Amsterdam, 1644); see also in Otto van Veen, *Amorum Emblemata* (Antwerp, 1608), an emblem depicting cupid with a letter inscribed "Sic imagines amantibus, etiam absentium iucunde sunt...quanto iucundiores sunt litterae quae vera amantis vestigia, veras notas afferunt."

13. Sale, Robertson, London, May 19, 1911, lot 116; Gudlaugsson 1959–60, vol. 2, under no. 143.

14. 1813, oil on panel, 24 x 19¾″ (61 x 50.2 cm.), National Gallery of Scotland, Edinburgh, no. 1890; see Arthur S. Marks, "David Wilkie's 'Letter of Introduction,'" *The Burlington Magazine,* vol. 110, no. 780 (March 1968), p. 130.

PROVENANCE: Possibly sale, Petronella de la Court, widow of Adam Oortmans, Amsterdam, October 19, 1707, lot 31 [as "Een trompetter en een krijgsoverste"];[1] Jan and Pieter Bisschop, Rotterdam, as of 1752 (after Jan's death, collection sold as a whole to Adriaen and Jan Hope, Amsterdam);[2] Henry Philip Hope, 1833;[3] Henry Thomas Hope, 1854;[4] Lord Francis Pelham Clinton Hope, London; the entire Hope Collection sold to dealer P. & D. Colnaghi and A. Wertheimer, London, 1898;

William L. Elkins Collection, Philadelphia, by 1900.

NOTES TO PROVENANCE

1. See also the painting entitled *Unwelcome News,* 1653, oil on panel, 26¼ x 23⅜″ (66.7 x 59.5 cm.), Mauritshuis, The Hague, no. 176 (Gudlaugsson 1959–60, vol. 2, no. 99). Concerning Petronella de la Court, see I. H. van Eeghen, in *Jaarboek Amstelodamum,* vol. 47 (1960), pp. 159–67.

2. See Gerard Hoet, *Catalogus of naamlyst van schilderyen,* vol. 2 (The Hague, 1752–70; reprint, Soest, 1976), p. 528; *Oud Holland,* vol. 28 (1910), p. 168.

3. Compare Smith 1829–42, vol. 4, no. 11.

4. Compare G. F. Waagen, *Treasures of Art in Great Britain,* vol. 2 (London, 1854), pp. 115–16.

EXHIBITIONS: Victoria and Albert Museum, London, 1891–98 (on loan from Lord Francis Pelham Clinton Hope); Union League of Philadelphia, May 11–27, 1899; Mauritshuis, The Hague, *Gerard Ter Borch, Zwolle 1617–Deventer 1681,* March 9–April 28, 1974, and Landesmuseum, Münster, cat. no. 41; Philadelphia, Berlin, London 1984, cat. no. 10, pl. 69.

LITERATURE: Gerard Hoet, *Catalogus of naamlyst van schilderyen,* vol. 2 (The Hague, 1752–70; reprint, Soest, 1976), no. 528; Smith 1829–42, vol. 4, p. 121, under no. 11; John Burnet, *Practical Essays in Various Branches of the Fine Arts* (London, 1848), p. 115, repro.; G. F. Waagen, *Treasures of Art in Great Britain,* vol. 2 (London, 1854), pp. 115–16, no. 2; *The Hope Collection of Pictures of the Dutch and Flemish Schools* (London, 1898), no. 70, repro.; Elkins 1887–1900, vol. 2, no. 129; Hofstede de Groot 1908–27, vol. 5 (1913), p. 16, no. 31; Elkins 1924, no. 21, 1925, no. 39; Pennsylvania Museum (Philadelphia Museum of Art), *A Picture Book of Dutch Painting of the XVII Century* (Philadelphia, 1931), p. 7, fig. 9; Eduard Plietzsch, *Gerard ter Borch* (Vienna, 1944), p. 41, under cat. no. 22; Neil MacLaren, *The National Gallery Catalogues: The Dutch School* (London, 1960), pp. 45, 46 n. 17; Gudlaugsson 1959–60, vol. 1, pp. 114–17, pl. 143, vol. 2, pp. 154–55, no. 143; Arthur S. Marks, "David Wilkie's 'Letter of Introduction,'" *The Burlington Magazine,* vol. 110, no. 780 (March 1968), p. 127, fig. 15, p. 130; PMA 1965, p. 7; Rishel 1974, pp. 30–33, fig. 7; Franklin W. Robinson, *Gabriel Metsu (1629–1667): A Study of His Place in Dutch Genre Painting of the Golden Age* (New York, 1974), p. 40; Peter C. Sutton, *A Guide to Dutch Art in America* (Grand Rapids and Kampen, 1986), p. 229 fig. 335.

CONDITION: The aqueous-lined canvas support is in good condition; the tacking edges are missing. Severe abrasion to the paint film is evident overall, but is more

notable in the darker areas. Small, old losses have been repaired along the upper-right and lower-left edges. Some strengthening of the form of the hat on the table is visible with ultraviolet light. The tablecloth was previously overpainted with a turkish carpet; these later additions were removed around 1940. The varnish is colorless.

COPIES AND VERSIONS

1. Replica or copy, Baron Hirsch de Gereuth, Paris; Baron de Forest, London; Graf Bendern (de Forest), Ghent, as of 1959 (see Gudlaugsson 1959–60, vol. 2, no. 143 IIA [as, according to Neil MacLaren, more probably a copy than a replica, and possibly identical with copy no. 2]).

2. Copy with small alterations, 29⅛ x 24″ (74 x 61 cm.), sale, Brooks, Paris, April 16–18, 1877, lot 79; sale, Max Kann, Paris, March 3, 1879, lot 65; dealer C. Sedelmeyer, Paris, 1898; Baron Königswarter, Vienna; see etching by Le Rat in Sedelmeyer Gallery, Paris, cat. 1898, p. 237, no. 214, and etching by Adolphe Lalauze (see Hofstede de Groot 1908–27, vol. 5 [1913], under no. 31; Gudlaugsson 1959–60, vol. 2, 143b).

3. Copy with small alterations in the figure of the officer, oil on panel, 20⅜ x 16⅞″ (52 x 43 cm.), Musée Granet, Aix-en-Provence (bequest of J.B.M. de Bourguignon de Fabregoules, 1863), inv. no. 860.1.195, cat. 1900, no. 373 (compare Hofstede de Groot 1908–27, vol. 5 [1913], no. 25; Gudlaugsson 1959–60, vol. 2, no. 143c, pl. 16, fig. 1 [as "possibly by (Caspar) Netscher"]).

4. Copy, oil on canvas, 25¼ x 20″ (66 x 51 cm.), Jac. Swaab Collection, Amsterdam, in 1953 (Gudlaugsson 1959–60, vol. 2, 143d [as copy of the above]).

5. Copy, oil on canvas, 21⅝ x 17¼″ (55 x 44 cm.), M. C. Baker, Leicester, in 1982 (with the oriental carpet that was overpainted in the Philadelphia original as well as other changes: a stone floor, an additional brown spot on the dog [possibly identical with Gudlaugsson 1959–60, vol. 2, nos. 143h or 143i]).

6. Probable copy, oil on canvas, 25⅛ x 12⅞″ (64 x 53 cm.), sale, Vincent Biondi of Florence, Paris, January 19, 1839, lot 53; sale, Brun, Paris, November 30, 1841, lot 46 (Hofstede de Groot 1908–27, vol. 5 [1913], no. 33d; Gudlaugsson 1959–60, vol. 2, 143e).

7. Probable copy of painting in Aix-en-Provence, oil on canvas, 20½ x 15¼″ (52 x 39 cm.), J. B. Coulson, 1833; sale, Sir Gray Hill, London, February 11, 1911, lot 145 (Smith 1829–42, vol. 4, under no. 11; Hofstede de Groot 1908–27, vol. 5 [1913], no. 33b; Gudlaugsson 1959–60, vol. 2, no. 143f).

8. Probable copy with alterations, D. W. Acraman, in 1833 (Smith 1829–42, vol. 4, under no. 11; Hofstede de Groot 1908–27, vol. 5 [1913] under no. 33a; Gudlaugsson 1959–60, vol. 2, no. 143g).

9. Copy?, possibly identical with previous work, oil on canvas, 20¾ x 16⅞″ (53 x 43 cm.), sale, London, June 12, 1896, lot 149 (Gudlaugsson 1959–60, vol. 2, 143h).

10. Copy?, oil on canvas, 20⅜ x 17″ (52 x 43.2 cm.), sale, Edward Brown Lees et al., London, December 6, 1912, lot 97 (Gudlaugsson 1959–60, vol. 2, no. 143i).

11. Copy, probably identical with one of the previous examples, sale, Amsterdam, June 5, 1765, lot 3 (Hofstede de Groot 1908–27, vol. 5 [1913], no. 31b; Gudlaugsson 1959–60, vol. 2, no. 143j).

12. Copy, probably identical with previous example, oil on panel, 22¾ x 18⅞″ (58 x 48 cm.), sale, Amsterdam, June 4, 1766, lot 19 (Hofstede de Groot 1908–27, vol. 5 [1913], no. 31c; Gudlaugsson 1959–60, vol. 2, no. 143k).

13. Copy?, probably identical with one of the previous examples, inventory of the widow De Leeuw in Monnikendam (without date), appraised by Fouquet, ten Kate, and Van der Schley, no. 18 [as "Een zittend Officier, waarbij een trompetter door G. ter Burg fl. 125"] (Mss., Rijksbureau voor Kunsthistorische Documentatie, The Hague [Gudlaugsson 1959–60, vol. 2, no. 143l]).

LITERATURE: A. D. de Vries Az., "Biographische aanteekeningen betreffende voornamelijk Amsterdamsche schilders, plaatsnijders, enz. en hunne verwanten," *Oud Holland*, vol. 3 (1885), p. 69; Wurzbach 1906–11, vol. 1, pp. 142–43; E. W. Moes in Thieme-Becker 1907–50, vol. 4 (1910), p. 378; Neil MacLaren, *The National Gallery Catalogues: The Dutch School* (London, 1960), pp. 46–47; Friedrich Gorissen, *Conspectus Cliviae: Die klevische Residenz in der Kunst des 17. Jahrhunderts* (Kleve, 1964); Heinrich Dattenberg, *Die Niederrheinansichten holländischer Künstler des 17. Jahrhunderts* (Düsseldorf, 1967), pp. 50–53; Laurens J. Bol, *Holländische Maler des 17. Jahrhunderts nahe den grossen Meistern: Landschaften und Stilleben* (Brunswick, 1969), pp. 173, 230, 340; Werner Sumowski, *Drawings of the Rembrandt School*, translated by Walter L. Strauss (New York, 1979–85), vol. 2, pp. 617–779; Werner Sumowski, *Gemälde der Rembrandt-Schüler*, vol. 1 (London and Pfalz, 1983), pp. 426–31; Sutton et al. 1987, pp. 274–76.

The son of Cornelis van Borssom, a mirror maker from Emden, Anthonij van Borssom was baptized on January 2, 1631, in Amsterdam. He was living on the Rozengracht in Amsterdam with his father on October 24, 1670, when he married Anna Crimping, who was also from Emden. The following year, when he made a will, he was living on the Prinsengracht. Still later he moved to the Beerenstraat. From drawings that Van Borrsom made of Kleve, Emmerich, and the surrounding Rhineland, we know he made a trip to the area sometime between 1651 and 1656. On March 19, 1677, he was buried in the Westerkerk.

Van Borssom's known oeuvre is not large but is eclectic, encompassing a wide variety of themes and styles. The majority of his works are landscapes with cows in the manner of Paulus Potter (q.v.), nocturnal and winter scenes in the style of Aert van der Neer (q.v.), and panoramas reminiscent of those of Philips Koninck (1619–1688). Some of his early paintings also reflect the influence of Cornelis Vroom (c. 1591–1661) and Jacob van Ruisdael (q.v.). A warm palette of browns, greens, and yellows dominates in these works; his technique is often rather dry. He also executed still lifes of plants, insects, and reptiles that recall Otto Marseus van Schrieck (1619/20–1678) and church interiors in the style of Hendrick Cornelisz. van Vliet (q.v.). His drawings are chiefly landscape studies and reflect the influence of Rembrandt and Koninck. He also was active as an etcher. Though clearly influenced by many artists, Van Borssom was more than a slavish imitator, achieving independence in his own interpretations of others' themes and styles.

11 ANTHONIJ VAN BORSSOM

VIEW OF SCHENKENSCHANZ, WITH THE ELTENBERG, NEAR EMMERICH, c. 1656
Oil on canvas, 38¾ x 49⅛" (98.4 x 124.8 cm.)
Purchased for the W. P. Wilstach Collection. WO1-1-2

In the foreground of a panoramic Rhineland landscape with a river winding through the middle ground and a mountain peak at the right appears a road with cows, dogs, and a traveler with a horse-drawn cart filled with wood. A shepherd and herd of sheep with a ram tupping a ewe are at the left. In the center of the picture on the banks of the river is a walled town with a prominent church spire and a windmill. In the distance and somewhat farther to the right is another town. The tans and browns of the dirt road dominate the foreground while greens prevail in the middle distance and light blues and grays appear at the horizon.

The picture sold in the nineteenth century and was catalogued as recently as 1965 as a work by the Rembrandt pupil Philips Koninck (1619–1688).[1] While aspects of the composition recall Koninck's panoramic designs,[2] Horst Gerson correctly rejected the attribution in his monograph on that artist; the technique is much less painterly than that of Koninck. In rejecting the attribution Gerson noted that the landscape resembled those of Joris van der Haagen (c. 1615–1669)[3] and Mattheus Withoos (1627–1703), and the animals, those of Anthonij van Borssom. Van der Haagen, a widely traveled artist who settled in The Hague around 1640, also painted comparable Rhineland panoramas, but his palette is darker and his

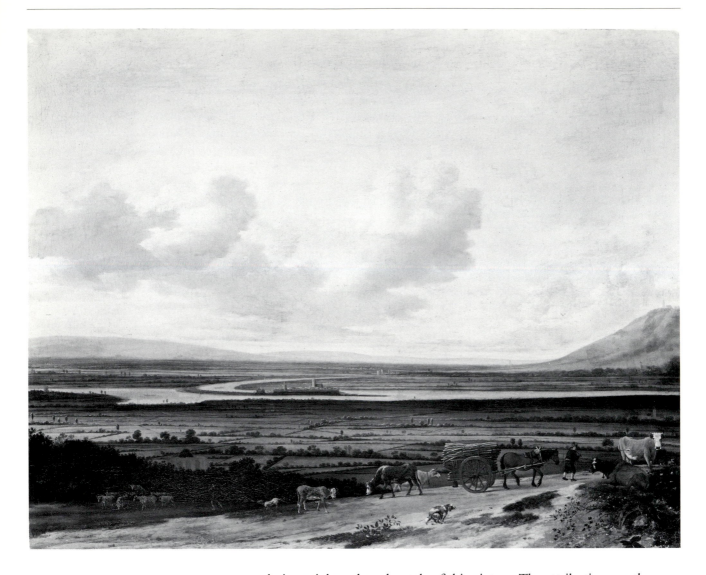

FIG. II-I Anthonij van Borssom, *View of Schenkenschanz*, 16[5?]6, oil on canvas, 35⅝ x 49½″ (90.5 x 126 cm.), Staatliche Kunstsammlungen, Düsseldorf, inv. no. 121.

technique tighter than the style of this picture. The attribution, on the other hand, to the many-sided Van Borssom that, according to Gerson, Hofstede de Groot wished to extend to the entire picture, is entirely convincing. Not only do the animals and staffage figures reappear in Van Borssom's work,[4] but he also painted exactly the same view on at least one other occasion. As Marijke C. de Kinkelder of the Rijksbureau voor Kunsthistorische Documentatie, The Hague, first observed (verbally), the panoramic view is repeated in a painting in Düsseldorf of similar dimensions (fig. II-I), which is signed by Van Borssom and dated 16[?]6. The third digit of the date on this painting cannot be deciphered; Werner Sumowski believed it was a six while Alan Chong argued plausibly that it could be a five, since Van Borssom had returned from his trip to the Rhineland at the latest by 1656.[5] Friedrich Gorissen first recognized the site in the Düsseldorf painting as a view of Schenkenschanz, with the Eltenberg, near Emmerich, a site in Germany on the Rhine near the modern border with the Netherlands and not far from Kleve.[6] Sketches that Van Borssom made in the Rhineland provided the basis for several of his painted panoramas, including besides these two works, the *Panoramic Landscape near Rhenen with the Huis ter Leede*[7] and two unidentified scenes (figs. II-2

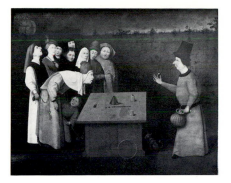

FIG. 12-2 After Hieronymus Bosch, *The Conjurer,* oil on panel, 20⅞ x 25⅝" (53 x 65 cm.), Musée Municipal Saint-Germain-en-Laye, inv. no. 872/1/87.

document his early conception of the scene. It includes all the major features of the composition—the conjurer gesturing at the right and the gawking crowd leaning forward at the left, as well as individual motifs like the cutpurse.[1] The best and the earliest painted version is generally considered to be the one in Saint-Germain-en-Laye (fig. 12-2), but among recent specialists, only Charles de Tolnay, Mia Cinotti, and Carl Linfert support it unconditionally as an autograph work; others are inclined, probably correctly, to see it as a copy of a lost early work or, in Lotte Brand Philip's case, of a work from Bosch's mid-career.[2] The Philadelphia painting is more elaborate than the one in Saint-Germain-en-Laye and three other variants of the original design (see Copies and Versions, nos. 2–4), as it opens a view at the right of a city, a canal, and a building with figures. Gerd Unverfehrt correctly traced two pictorial traditions stemming from Bosch's original—the first offering a view of a landscape on the right, and the second, initiated by the Philadelphia painting and continued by a weaker variant, featuring an urban vista (see fig. 12-3).[3] The additions to these two works serve to place the conjurer in the center of the picture, while in all other versions he appears at the right of the design. Although Brand Philip believed that Bosch's original resembled the present, more extensive version, Dirk Bax and De Tolnay argued that these additions were the inventions of a later sixteenth-century copyist.[4]

Interpretations of the painting have varied, but most point to its satire on human folly. Medieval and sixteenth-century sources stress that itinerant entertainers—called *spiellieden* or *varende luyden,* designations including conjurers, tightrope walkers, animal trainers, swordsmen, jugglers, and wandering minstrels—except in those rare cases in which they were in the service of eminent persons or the municipal authorities, were considered the dregs of society, morally corrupt and perennially devious.[5] The cutpurse on the left, very possibly the conjurer's accomplice, illustrates the dangers of being deceived by street entertainers. Other details, such as the three owls in the scene, may allude to the sin and folly of the subject. Owls are nocturnal birds that were often used as decoys for other fowl and thus could be symbols of sin or of temptation.[6] Roggen and De Tolnay related the crowd's sin of credulity to literary sources,[7] and Jacques Combe, describing the frog jumping from the mouth of the pickpocket's victim in the painting in Saint-Germain-en-Laye (a detail overpainted in the Philadelphia version), cited the expression "coughs up a frog"—the idiom "to swallow a frog" meaning to show great credulity.[8]

Other interpretations include Wilhelm Fraenger's implausible theory that the scene is a satire in the form of a sexual allegory of ritual circumcision.[9] Andrew Pigler first proposed connections between Bosch's art and astrology, likening several of the artist's works to a series of fifteenth-century pictographs known as *Planetenkinderbilder,* images that depict the influence exercised by the planets on earth and mankind.[10] Thus he believed that the conjurer in the painting in Saint-Germain-en-Laye might be inspired by representations of the children of Luna, a category frequently including itinerant sorcerers and magicians. Brand Philip developed this theory, assuming that the pictures in Philadelphia and Jerusalem (fig. 12-3) pointed to a more elaborate version conceived by Bosch himself, belonging to a series of medallions originally on the wings of a large altarpiece and alluding to a cycle of the four temperaments and

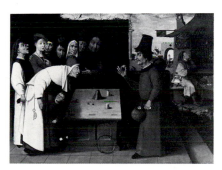

FIG. 12-3 After Hieronymus Bosch, *The Conjurer,* oil on panel, 33 x 44⅞" (84 x 114 cm.), Muze'on Yiśra'el, Jerusalem, no. 6977.

the four elements.[11] The paired fish on the table at the right, arranged so as to symbolize the zodiacal sign Pisces, alluded, in her opinion, to the element of water and the phlegmatic humor. Further, she saw the conjurer as a sluggish, fat individual who, like the sleeper at the right (doubtless a dentist neglecting his profession, as is suggested by the teeth and the medicine bags overhead), was typical of a phlegmatic person. Thus she concluded that *The Conjurer* originally represented a "child" of Luna as a symbol of *phlegma* and *aqua*. Her argument for the circular format of the original composition is based upon a medallion-shaped version of the design (see *The Charlatan,* under Copies and Versions, no. 2) and further upon the cycle that she believes the work formed with three other circular works: *The Peddler, The Stone Operation,* and *The Hog Hunt of the Blind.*[12] Bax, like De Tolnay,[13] correctly rejected Brand Philip's theory, reasserting that the painting was a satire of human folly, a moral condemnation of stupidity. In Bax's view, the sleeping man indicates laziness, the ox reading a music book refers to the Latin saying "Bos, asinus faciunt musicam" (Fools [literally, the ox and the ass], fancy their song beautiful music), and the execution scene intimates that frauds do not escape punishment.[14]

Still another theory, advanced recently by Daniela Hammer-Tugendhat following Rosemarie Schuder,[15] centers on the attire worn by the cutpurse. His cowl and scapular may identify him as a member of one of the preaching orders, possibly a Dominican. She further noted that toads could be emblems of witchcraft, thus concluding that the painting represents the conspiracy of the church with sorcery, witchcraft being the means by which the Inquisition blinded mankind to the advantages of Christianity. Walter Gibson, however, argued that the inclusion of the cutpurse in the scene constitutes simply another of Bosch's many thrusts at dissolute monks.[16]

The measurements for the present picture were misquoted in the Wilstach Collection catalogue of 1922, with the result that the catalogue's authors assumed that the painting that had been in the Crespi Collection in Milan was a different picture. In fact, it is identical with the painting now in Philadelphia.

NOTES

1. See Ludwig von Baldass, *Hieronymus Bosch* (Vienna and Munich, 1943), pp. 15, 231, fig. 122; and Charles de Tolnay, *Hieronymus Bosch,* rev. ed., translated by Michael Bullock and Henry Mins (London, 1966), pp. 16–17, 388 (no. 3).

2. First published by Henri Hymans, "Les Musées de Madrid. Le Musée du Prado. V. Les écoles du nord.—Les primitifs.—La renaissance," *Gazette des Beaux-Arts,* 3rd ser., vol. 35, no. 3 (September 1893), pp. 234–35. The attribution was supported by F. Schmidt-Degener, "Un Tableau de Jérôme Bosch au Musée Municipal de Saint-Germain-en-Laye," *Gazette des Beaux-Arts,* 3rd ser., vol. 35, no. 584 (February 1906), pp. 147–54; Ludwig von Baldass, "Die Chronologie der Gemälde des Hieronymus Bosch," *Jahrbuch der Königlichen Preussischen Kunstsammlungen,* vol. 38 (1917), p. 194; Jacques Combe, *Jérôme Bosch* (Paris, 1946; 2nd ed., Paris, 1957); Jacques Combe, *Jerome Bosch,*

translated by Ethel Duncan (Paris and London, 1946; reprint, New York, 1957), p. 81, no. 16; in 1966 by De Tolnay (see note 1), pp. 344–45, repro. pp. 86–89; Mia Cinotti, *Classici dell'Arte,* vol. 2, *L'opera completa di Bosch* (Milan, 1968), p. 89, pl. VIII; Carl Linfert, *Hieronymus Bosch,* translated by Robert Erich Wolf (New York, 1971), p. 48, repro.

The attribution was rejected in 1927 by Max J. Friedländer, *Die Altniederländische Malerei,* vol. 5, *Geertgen van Haarlem und Hieronymus Bosch* (Berlin, 1927; reprint, Leiden and Brussels, 1969), p. 56, no. 105a; in 1937 by Charles de Tolnay, *Hieronymus Bosch* (Basel, 1937), pp. 18, 89, cat. no. 6; Ludwig von Baldass, *Hieronymus Bosch* (Vienna, 1943), p. 231; Lotte Brand Philip, "*The Peddler* by Hieronymus Bosch, a Study in Detection," *Nederlands Kunsthistorisch Jaarboek,* vol. 9 (1958), p. 29; Dirk Bax, "Bezwaren tegen L. Brand Philips' interpretatie van Jeroen Bosch' marskramer, goochelaar, keisnijder en

voorgrond van hooiwagenpaneel," *Nederlands Kunsthistorisch Jaarboek,* vol. 13 (1962), pp. 14–20.

The attribution was questioned in Noordbrabants Museum, 's Hertogenbosch, *Jheronimus Bosch,* September 17–November 15, 1967, no. 33; by Patrik Reuterswärd, *Uppsala Studies in the History of Art,* vol. 7, *Hieronymus Bosch* (Stockholm, 1970), p. 260, repro. no. 7; and by Daniela Hammer-Tugendhat, *Theorie und Geschichte der Literatur und der schönen Künste,* vol. 58, *Hieronymus Bosch: Eine historische Interpretation seiner Gestaltungsprinzipien* (Munich, 1981), pp. 155–56 n. 1.

3. See Gerd Unverfehrt, *Hieronymus Bosch: Die Rezeption seiner Kunst im frühen 16. Jahrhundert* (Berlin, 1980), pp. 115–17, fig. 4. The version in fig. 12-3 omits the two men and the table with fish on the extreme right of the painting in Philadelphia, together with the owl on the perch at the upper left, but adds a sign before the house on the right. It

shows a dog with its head in a pot and is inscribed "In den flawen hond" (At the hungry dog).

4. See Bax (note 2), p. 17; and De Tolnay (note 1), p. 345.

5. See D. T. Enklaar, *Varende Luyden* (Assen, 1937); Dirk Bax, *Hieronymus Bosch: His Picture-Writing Deciphered,* translated by M. A. Bax-Botha (Rotterdam, 1979), pp. 92, 201–4; and H. Pleij, "Het beeld van de buitenmaatschappelijke in de late middeleeuwen," *Spiegel Historiael,* vol. 12, no. 9 (September 1977), pp. 464–70.

6. See Bax (note 5), pp. 208–13. Many popular expressions of the day, such as "Iemand bekijken gelijk een uil" (Stare at someone like an owl [i.e., fool]) stressed the folly of the owl.

7. D. Roggen, "J. Bosch: Literatuur en Folklore," *Gentsche Bijdragen tot de Kunstgeschiedenis,* vol. 6 (1939–40), pp. 102–26; De Tolnay in 1937 (see note 2) p. 60, n. 36. Underscoring the notion of credulity, De Tolnay (see note 1, p. 345) quoted from Freidank's *Bescheidenheit:* "Woe to the frogs, when they go into the stork's house," pointing out that a stork is painted on the wall in the left background.

8. See Combe (note 2), p. 57, n. 37. The author's theory that this theme and others are related to Tarot cards seems unlikely, however. Regarding the frog, Lotte Brand Philip argued that the figure, whom the author assumes to be female, might be undergoing the mountebank's quack treatment for ailments suffered by neurotic women; see Brand Philip (note 2), p. 35 n. 67.

9. Wilhelm Fraenger, *Die Hochzeit zu Kana: Ein Document semitischer Gnosis bei Hieronymus Bosch* (Berlin, 1950), pp. 67–72.

10. Andrew Pigler, "Astrology and Jerome Bosch," *The Burlington Magazine,* vol. 92, no. 566 (May 1950), pp. 132–36. Further note the comments on this topic in Hammer-Tugendhat (note 2), pp. 45–48.

11. See Brand Philip (note 2), pp. 1–38.

12. *The Peddler,* also known as *The Prodigal Son,* oil on panel, octagonal, 27⅞ x 27¾" (71 x 70.6 cm.), diameter 25⅜" (64.6 cm.), Museum Boymans–van Beuningen, Rotterdam, no. 1079; School of Hieronymus Bosch, *The Stone Operation,* oil on panel, 16⅜ x 12⅛" (41.5 x 32 cm.), Rijksmuseum, Amsterdam, inv. no. A1601; *The Hog Hunt of the Blind,* oil on canvas, according to a document of 1570, now lost, but last recorded as belonging to Philip II of Spain, from the collection of Don Felipe de Guevara. See De Tolnay (note 1), p. 398, under no. 13d; and Brand Philip (note 2), p. 55 n. 119.

13. See Bax (note 2), p. 19; Bax (note 5), p. 70; and De Tolnay (rev. ed. 1966, see note 1), pp. 16, 86.

14. Bax (note 2).

15. See Hammer-Tugendhat (note 2), pp. 129–31; she cites Rosemarie Schuder, *Hieronymus Bosch* (Berlin, 1975), pp. 31, 35, 53, 54, 63.

16. Walter S. Gibson, review of Hammer-Tugendhat [see note 2], *The Art Bulletin,* vol. 66, no. 1 (March 1984), p. 163.

PROVENANCE: Cav. Ferdinando Meazza, Milan; sale, Meazza, Milan, April 15, 1884, lot 150 (presumably bought in); sale, Cav. Ferdinando Meazza, Milan, April 24–26, 1893, lot 18; Galleria Crespi, Milan, before 1906; sale, Crespi, G. Petit, Paris, June 4, 1914, lot 92; purchased for the W.P. Wilstach Collection, Philadelphia, December 5, 1914.

LITERATURE: F. Schmidt-Degener, "Un Tableau de Jérôme Bosch au Musée Municipal de Saint-Germain-en-Laye," *Gazette des Beaux-Arts,* 3rd ser., vol. 35, no. 584 (February 1906), pp. 151–52 n. 4 [as a replica or copy]; G. Frizzoni, "Appropos du tableau 'le Jongleur' de Jérôme Bosch," *La Chronique des Arts et de la Curiosité,* 1906, p. 241; Louis Maeterlinck, *Le Genre satirique dans la peinture flamande,* 2nd ed., enl. (Brussels, 1907), p. 234; Salomon Reinach, *Répertoire de peintures du moyen âge et de la Renaissance (1280–1580),* vol. 2 (Paris, 1907), p. 750, fig. 2; Walter Cohen in Thieme-Becker 1907–50, vol. 4 (1910), p. 389; Wurzbach 1906–11, vol. 3, p. 34; Paul Lafond, *Hieronymus Bosch—son art, son influence, ses disciples* (Brussels and Paris, 1914), pp. 77–78, 114 [as a version], pl. 67 (opp. p. 60); Wilstach 1922, no. 25 [as attributed to Bosch]; Max J. Friedländer, *Die Altniederländische Malerei,* vol. 5, *Geertgen van Haarlem und Hieronymus Bosch* (Berlin, 1927; reprint, Leiden and Brussels, 1969), no. 105a [as a copy]; Lotte Brand Philip, "The Peddler" by Hieronymus Bosch, a Study in Detection," *Nederlands Kunsthistorisch Jaarboek,* vol. 9 (1958), p. 24 n. 50, 29, 32–33, fig. 20 [as a copy]; Dirk Bax, "Bezwaren tegen L. Brand Philips' Interpretatie van Jeroen Bosch' marskramer, goochelaar, keisnijder en voorgrond van hooiwagenpaneel," *Nederlands Kunsthistorisch Jaarboek,* vol. 13 (1962), pp. 35–37 [as a copy by a follower of Bosch]; L. Ninane in Musées Royaux des Beaux-Arts, Brussels, *Le Siècle de Bruegel,* September 27–November 24, 1963, under cat. no. 34; PMA 1965, p. 7 [as a variation on Bosch]; Charles de Tolnay, *Hieronymus Bosch,* rev. ed., translated by Michael Bullock and Henry Mins (London, 1966), p. 345; Noordbrabants Museum, 's Hertogenbosch, *Jheronimus Bosch,* September 17–November 15, 1967, p. 123; Karl Arndt, "Zur Ausstellung 'Jheronimus Bosch,' 's Hertogenbosch, 1967," *Kunstchronik,* vol. 21, no. 1 (January 1968), p. 6; Gerd Unverfehrt, *Hieronymus Bosch: Die Rezeption seiner Kunst im frühen 16. Jahrhundert* (Berlin, 1980), pp. 116, no. 21d, fig. 58.

CONDITION: The original panel support is composed of four horizontally grained wooden planks joined together horizontally. The support is cradled, but is badly warped and worn at the edges. Numerous horizontal splits—the worst being in the second plank from the bottom, where it runs through the bottom of the table on the right and extends through the conjurer's table—have been filled and inpainted in the past. The paint surface shows extensive losses and overpaint. Particularly disfiguring are the losses and old retouches across the lower quarter of the picture, in the sky, in the building at the left, and in the crowd at the left, as well as in the original joins of the support. In December 1981 various areas of cleaving paint were consolidated. The paint layer has suffered general abrasion. The varnish is uneven and moderately discolored, and the surface is dirty.

COPIES AND VERSIONS
1. After Hieronymus Bosch, *The Conjurer,* Musée Municipal Saint-Germain-en-Laye (identical to fig. 12-2) (see Unverfehrt [note 3], no. 21, fig. 55).
2. *The Charlatan,* medallion within a rectangular panel with fantastical decorations on the corners, 14 x 11¾" (35.6 x 29.9 cm.). Sale, Christie's, London, November 29, 1974, lot 96, repro.; formerly Langton Douglas, London; private collection, San Francisco (see Noordbrabants Museum [note 2], cat. no. 34, repro.; and Unverfehrt [note 3], no. 21a, fig. 56).
3. Nicholson Gallery, New York (see Brand Philip [note 2], fig. 27; and Unverfehrt [note 3], no. 21b).
4. Balthazar (Sylvius) van den Bos (1518–1580), print after *The Conjurer,* copperplate engraving, 9⅜ x 12⅝" (238 x 320 mm.) (see Brand Philip [note 2], fig. 28; Unverfehrt [note 3], no. 21c, fig. 57; and Noordbrabants Museum [note 2], no. 97).
5. After Hieronymus Bosch, *The Conjurer,* Muze'on Yiśra'el, Jerusalem (identical to fig. 12-3). Private collection, Paris; Galerie D. Heinemann, Munich, 1928; Oliver O. and Marianne Ostier, New York, by 1973; Muze'on Yiśra'el, Jerusalem (see Unverfehrt [note 3], no. 21e, fig. 59; and Noordbrabants Museum [note 2], no. 35, repro.).

For additional works by Bosch in the Philadelphia Museum of Art, see John G. Johnson Collection inv. nos. 1321, 1275 (attributed to), 1276 (attributed to), cat. nos. 352 (follower of), 353 (follower of), 386 (follower of), inv. nos. 353 (follower of), 2055 (follower of), cat. no. 354 (copy after), inv. no. 77 (copy after).

Probably the son of the artist of the same name (c. 1550–1623 or later), Daniel Bretschneider the Younger became a citizen of Dresden on October 11, 1623, and was buried there on January 7, 1658. Little else is known of his life.

Bretschneider specialized in miniature history paintings of battles, genre scenes of peasant kermisses, and portraits. A painting of Orpheus charming the animals entered the archduke of Saxony's *Kunstkammer* by 1640. A major effort was a painting of the family tree of the Saxon dukes of Widukind through Johann Georg II, which was completed in the year of Bretschneider's death. The artist's works are rare, with most of the known examples preserved in the Staatliche Kunstsammlungen and the Historisches Museum, Dresden.

LITERATURE: Ernst Sigismund in Thieme-Becker 1907–50, vol. 4 (1910), p. 592.

FIG. 13-1 Daniel Bretschneider the Younger, *Portrait of Johann Georg I,* oil on panel, 5⅞ x 3¾" (15.2 x 9.8 cm.), Historisches Museum, Dresden, no. H407.

13 DANIEL BRETSCHNEIDER
THE YOUNGER

FIG. 13-2 Unknown artist, *Portrait of Johann Georg I*, panel, 5½ x 3½" (14 x 9 cm.), Staatliche Kunstsammlungen, Dresden, no. H18.

FIG. 13-3 Unknown artist, *Portrait of Johann Georg I*, tempera or gouache on panel, 5½ x 3½" (14.1 x 9 cm.), Staatliche Kunstsammlungen, Dresden, no. H19.

PORTRAIT OF JOHANN GEORG I, c. 1647
Oil on panel, 7⅛ x 4⅛" (18.1 x 10.5 cm.)
Bequest of Carl Otto Kretzschmar von Kienbusch. 1977-167-1032

Portrayed full length, the subject is Johann Georg I (1585–1656), elector of Saxony. The elector appears as an old man dressed in a hunting costume, standing with his mastiff at his side. His coat is green with gold embroidery. At his waist he wears an elaborately decorated hunting garniture and sword. In his right hand he holds a walking stick; on his boots are spurs. His plumed hat rests on a table at the right. The elector appears in a room decorated with a checkered tile floor and a draped column on the left. Beneath the portrait is a view of Dresden.

The Historisches Museum, Dresden, owns a similar portrait of the elector by Bretschneider (fig. 13-1), with the same view of Dresden; there the sitter wears a different hunting costume, places his hand on his hip, and is attended by a different dog. Two other portraits of the elector by unknown masters in the Staatliche Kunstsammlungen, Dresden, adopt the same pose as in the painting held by the Historisches Museum, as well as the general setting of the Philadelphia picture; but the costume is changed and the view of Dresden omitted (figs. 13-2 and 13-3).[1] Still another portrait of the elector as Nimrod, painted by Bretschneider in 1647 as the title page for the elector's personal, hand-illuminated hunting chronicle, depicts the subject in a costume and with hunting equipment that are similar, though not identical, to those in the Philadelphia painting.[2] Erna von Watzdorf has noted that the gold and green costume worn by the elector on Bretschneider's title page survived to the twentieth century, as did similar turquoise hunting garnitures in the Historisches Museum.[3] Even the collar worn by the dog in the illustration and in the Philadelphia painting is similar to collars preserved in Dresden.

The Philadelphia painting probably dates from about the same time as the title page, or slightly later. Though closely related in design, format, and style, the several portraits of the elector that are on panel are probably not a series but, as is often the case with royal portraiture, probably repeat a successful portrait formula, perhaps first codified in the title-page portrait.

NOTES
1. J. F. Haywood of Sotheby's drew attention to these related works in a letter of October 1966, when he sold the painting to Kienbusch. Philadelphia Museum of Art, Kienbusch Archives.
2. See Erna von Watzdorf, "Kursächsische Jagdwaffen von Gabriel Gipfel in der Dresdner Rüstkammer," *Zeitschrift für historische Waffenkunde*, n.s., vol. 5 [o.s., vol. 14], no. 1 (1935–36), fig. 5.
3. Ibid., pp. 4–14.

PROVENANCE: J. F. Hayward, director, Sotheby's, London, October 1966; Carl Otto Kretzschmar von Kienbusch.

LITERATURE: Howard L. Blackmore, *Hunting Weapons* (London, 1971), p. 60.

CONDITION: The vertically grained support has a slightly convex warp along the lower edge. Old losses in the paint film appear in the table cover on the right and in the left of the cityscape. A more recent loss appears at the upper left. Abrasion is apparent throughout, and the paint film has become very thin. The varnish layer is moderately discolored.

Born in Brussels in 1564, Pieter Brueghel the Younger was the eldest son of the famous Flemish painter of the same name, Pieter Bruegel (c. 1525/30–1569), and Mayken Coecke, daughter of the painter Pieter Coecke van Aelst (q.v.). The couple's other son, Jan (1568–1625, known as "Velvet"), also became a painter. Unlike Pieter the Elder and "Velvet" Brueghel, Pieter the Younger is rarely mentioned in early literature. Karel van Mander stated in 1603–4 in *Het Schilder-Boeck* that he studied with Gillis van Coninxloo (1544–1607) and that he painted portraits "from life"; however, in the author's appendix he corrected himself, saying that he had been misinformed about Brueghel's portraits and that, instead, Brueghel was "adroit at copying and imitating his father's works" ("hy veel zijns Vaders dinghen seer aerdich copieert en nadoet"), an assessment borne out by the surviving works. Although it is possible that Pieter the Younger's teacher was a little-known painter of this name who was a relative on Brueghel's mother's side, it is more likely that he was trained by the celebrated Antwerp landscapist, although nothing of Coninxloo's manner is detectable in his style. Brueghel joined the Antwerp guild in 1585. Three years later he married Elisabeth Goddelet; the couple had seven children. Their son Pieter III (b. 1589) studied with his father and also became a painter. Among Brueghel's many students were Frans Snyders (q.v.) and the portraitist and genre painter Gonzales Coques (1614–1684). Pieter the Younger evidently remained in Antwerp all his life, figuring in municipal documents in 1597, 1599, 1600, 1601, 1612, 1616, and 1626. The registers of the Guild of Saint Luke indicate that he died in 1637 or 1638.

Although much of Pieter the Younger's work is dependent upon his father's art, he also invented his own compositions, asserting an independent personality in his taste for anecdote and vivid colors. Despite his nickname "Hell Brueghel" ("de helsche Brueghel"), the artist painted relatively few infernal or incendiary subjects, preferring genre and religious themes. The two artists whose art is most commonly confused with that of Pieter the Younger are Pieter Balten (1525–1598) and Marten van Cleve (c. 1560–1604). Brueghel's portrait was engraved by Anthony van Dyck (1599–1641) for the latter's *Iconographie* series.

LITERATURE: Van Mander 1603–4, fol. 234; F. J. van den Branden, *Geschiedenis der Antwerpsche Schilderschool* (Antwerp, 1883), pp. 400–441; Musées Royaux des Beaux-Arts de Belgique, Brussels, *Le Siècle de Bruegel,* September 27–November 24, 1963, pp. 74–76; Georges Marlier, *Pierre Brueghel le Jeune* (Brussels, 1969); Jacqueline Folie, "Pierre Brueghel le Jeune," in Palais des Beaux-Arts, Brussels, *Bruegel: Une Dynastie de peintres,* September 18–November 18, 1980, pp. 137–64.

For additional works by Pieter Brueghel the Younger in the Philadelphia Museum of Art, see John G. Johnson Collection cat. nos. 421, 422, 423, 1176, inv. no. 2519 (imitator of).

14 PIETER BRUEGHEL THE YOUNGER

THE ADORATION OF THE MAGI, 1595?
Signed lower left: *P. BRUEGHEL*
Oil on canvas, 48⅝ x 63⅜″ (123.5 x 161 cm.)
Gift of Mrs. Bloomfield H. Moore. 83-73

In an open-sided stable, the three kings kneel before the holy family. At the center sits Mary with the Christ child on her lap; behind stands Joseph with hat in hand. Around the structure crowd soldiers and peasants and members of the wise men's entourage, some bearing gifts. Behind are pack animals, and, in the walled city beyond, an elephant. The winter season is indicated by the bare trees and ice-covered river in the right distance.

 This work is one of many copies (see Copies and Versions) of a composition invented by Pieter Bruegel the Elder (c. 1525/30–1569); the original is generally believed to be the version preserved in the Musée Royal des Beaux-Arts, Brussels (fig. 14-1).[1] Its design was probably inspired by the central panel of Hieronymus Bosch's triptych *The Adoration of the Magi,* 1516, in the Prado, Madrid (height 54″ [138 cm.], no. 2048). The Brussels version is tempera on unprepared linen (a technique known as *tuechlein*) and is in a problematic state owing to moisture damage;[2] nonetheless, it is generally regarded as an authentic early work of 1555–57.[3] Only Charles de

FIG. 14-1 Pieter Bruegel the Elder, *Adoration of the Magi*, 1555–57, tempera on linen, 48¹³⁄₁₆ x 66½" (124 x 169 cm.), Musée Royal des Beaux-Arts, Brussels, inv. no. 3929.

FIG. 14-2 Pieter Brueghel the Younger, *Adoration of the Magi*, 1595, pen on paper, Damiron Collection, Lyons.

Tolnay and Edouard Michel doubted the Brussels work; the latter believed that it, too, is a copy.[4] Max Friedländer noted that the crowded composition with high horizon line and "the arrangement reminiscent of tapestry [was appropriate to the medium since] painted fabric was popular as a less expensive substitute for precious pictorial weavings, whose stylistic conventions they tended to follow."[5] Fritz Grossmann also alluded to these practices, noting that Pieter Coecke's wife, Mayken Verhulst (c. 1520–1600), used the technique, which was much favored in her native Malines. The connection with tapestries acquires an additional dimension in the context of Grossmann's suggestion that another possible source for Brueghel's painting is one of the series of tapestries on the Life of Christ now in the Vatican, woven in Brussels between 1520 and 1531 from cartoons created by the School of Raphael.[6] Aspects of both the general design and individual figure motifs recall the Raphael tapestry.

Philadelphia's version was attributed to Bruegel the Elder until 1965, when the attribution was changed to the son in the *Check List of Paintings in the Philadelphia Museum of Art*. Georges Marlier listed sixteen copies of the Brussels painting. He addressed the various earlier attributions to Pieter Brueghel the Younger and concluded that the Philadelphia version alone and a related pen drawing in the Damiron Collection in Lyons (fig. 14-2) were autograph works by the artist.[7] The date 1595 on the drawing, in Marlier's opinion, appears authentic and could, through the work's stylistic connection with the Philadelphia version, provide a date for the painting. Another copy of the Brussels original is attributed to Pieter Balten (see Copies and Versions, no. 4), while a series of smaller variants on the design, mostly on copper, have long been attributed to Jan "Velvet" Brueghel I (see Copies and Versions, nos. 16–21).[8]

NOTES
1. Koninklijke Musea voor Schone Kunsten van België, *Inventariscatalogus van de oude Schilderkunst* (Brussels, 1984), p. 39, inv. no. 3929, repro. Acquired in November 1909, lot 10, from the Edouard Fétis sale, Brussels. For the literature on the painting, see René van Bastelaer and Georges Hulin de Loo, *Peter Bruegel l'Ancien: Son Oeuvre et son temps* (Brussels, 1907), pp. 297–98; Edouard Michel, *Bruegel* (Paris, 1931), p. 37; Gustave Glück, *Bruegels Gemälde* (Vienna, 1932), p. 36; Max J. Friedländer, *Pieter Bruegel* (Berlin, 1921), p. 92; Max J. Friedländer, *Early Netherlandish Painting*, vol. 14, *Pieter Bruegel*, translated by Heinz Norden (Leiden, 1937; reprint Leiden, 1976), pp. 20, 42, no. 2, pl. 2; Charles de Tolnay, *Pierre Bruegel l'Ancien* (Brussels, 1935), p. 94, no. 145; Gotthard Jedlicka, *Pieter Bruegel: Der Maler in seiner Zeit* (Erlenbach-Zurich, 1938), p. 520; Leo van Puyvelde, *La Peinture flamande au siècle de Bosch et Breughel* (Paris, 1962); Fritz Grossmann, *Bruegel: The Paintings* (London, 1955), p. 190, repro. no. 4; Musées Royaux des Beaux-Arts de Belgique, Brussels, *Le Siècle de Bruegel*, September 27–November 24, 1963, no. 53, repro. no. 202; Robert Hughes and Piero Bianconi, *The Complete Paintings of Bruegel* (London, 1969), p. 87, no. 7; Palais des Beaux-Arts, Brussels,

Bruegel: Une Dynastie de peintres, September 18–November 18, 1980, p. 49, repro. In 1563 Bruegel the Elder executed a second *Adoration of the Magi* (43¾ x 32¾" [111 x 83.5 cm.], National Gallery, London, no. 3556) but with an upright format that concentrates on and monumentalizes the central protagonists. In still another work of 1567 (Reinhart Collection, Winterthur), the Magi theme is integrated into a wintry village setting.
2. For a technical analysis of the work, see Albert Philippot, Nicole Goetghebeur, and Regine Guislain-Wittermann, "L'Adoration des Mages de Bruegel," *Institut Royal du Patrimoine Artistique Bulletin, Brussels*, vol. 11 (1969), pp. 5–33. Another work, *The Gift of Saint Martin* (36½ x 28¾" [92.5 x 73 cm.], Kunsthistorisches Museum, Vienna, no. 2691), whose attribution to Bruegel the Elder is sometimes questioned, is also tempera on canvas but survives only in a fragmentary state.
3. Jedlicka (see note 1), p. 520, suggests 1562–63.
4. De Tolnay (see note 1), p. 94; Michel (see note 1), p. 37.
5. Friedländer in 1976 (see note 1), p. 20.
6. Fritz Grossmann, "Breugels Verhältnis zu Raffael und zur Raffael-Nachfolge," *Festschrift Kurt Badt* (Berlin, 1961), p. 139.

7. Georges Marlier, *Pierre Brueghel le Jeune* (Brussels, 1969), p. 320.

8. On Jan Brueghel I's variations of the design, see Klaus Ertz, *Jan Brueghel d. A. Die Gemälde* (Cologne, 1979), pp. 422–28, and Copies and Versions, nos. 16–21.

PROVENANCE: Mrs. Bloomfield H. Moore, by 1883.

LITERATURE: Arthur Edwin Bye, "An Adoration of the Magi by Pieter Brueghel," *Bulletin of the Pennsylvania Museum* (Philadelphia Museum of Art), vol. 18, no. 72 (November 1922), repro. p. 9; Arthur Edwin Bye, "An 'Adoration of the Magi' by Pieter Bruegel," *The Connoisseur*, vol. 73 (1925), pp. 9–14, repro. [as Pieter Bruegel the Elder]; PMA 1965, p. 9 [as Pieter Brueghel the Younger]; Georges Marlier, *Pierre Brueghel le Jeune* (Brussels, 1969), pp. 316–17, no. 14, repro.

CONDITION: The painting was cleaned and the fabric support relined with a wax-resin in 1962. The lining remains sound. The original tacking edges were trimmed. Some weave enhancement is visible. The paint film has marked abrasions overall, with minute paint losses over the high points of the canvas weave. These areas of abrasion are particularly noticeable in the darks. There are old losses along the upper-left edge, along the lower center edge, in the central king's robe, in the robe of the figure on the extreme lower right, in the ice at the upper right, and scattered over the stable roof. The varnish is clear.

COPIES AND VERSIONS

1. Panel, 45½ x 64⅛" (115.5 x 163 cm.), sale, M. von Nemes, Munich, November 2, 1933, lot 29, repro.; Dr. Ludwig Ostner, Nuremberg, 1951; Vittorio Duca, Milan, 1962 (photograph, Rijksbureau voor Kunsthistorische Documentatie, The Hague, no. L19402) (Georges Marlier, *Pierre Brueghel le Jeune* [Brussels, 1969], no. 12).

2. Canvas, 53⅛ x 73¾" (135 x 187 cm.), E. Huber, Strasbourg, 1934; sale, Hôtel Drouet, Paris, December 15, 1937, lot 46, repro.; Galerie Arta, Geneva, 1980 [as Pieter Brueghel the Younger] (Marlier no. 13). The design has been enlarged slightly at the right and left and individual figures and elements in the background changed.

3. Canvas, 47¼ x 66⅛" (120 x 168 cm.), Dr. C.J.K. van Aalst, Hoevelaken, Holland, on loan to Centraal Museum, Utrecht, cat. 1933, no. 263; van Aalst sale, Christie's, London, April 1, 1960, lot 15; sale, Sotheby's, London, October 19, 1977, lot 29 [as Pieter Brueghel the Younger] (Marlier no. 8).

4. Panel, 53⅛ x 66½" (135 x 169 cm.), Museum Graz, Austria; Taymans Collection, Brussels; sale, Brussels, March 1, 1957, lot 274, repro.; with Galerie Finck, 1966; sale, Christie's, London, May 20, 1966, lot. 129; sale, Christie's, London, December 2, 1983, lot 116, repro. [as Pieter Balten], (Marlier no. 4).

5. Canvas, 46½ x 68½" (118 x 174 cm.), sale, Palais des Beaux-Arts, Brussels, November 17, 1954, lot 284; sale, Palais des Beaux-Arts, Brussels, June 16, 1959, lot 423 [as Pieter Brueghel the Younger] (Marlier no. 5).

6. Canvas, 51¼ x 70" (130.2 x 178 cm.), sale, Palazzo Capponi (Sotheby's of London), Florence, October 18, 1969, lot 6, repro. [as Pieter Brueghel the Younger]; private collection, Switzerland; Shickman Gallery, New York; after 1978 with the Sarah Campbell Blaffer Foundation, Houston (see Christopher Wright, *A Golden Age of Painting* [San Antonio, Tex., 1981], p. 48) (Marlier no. 16). As in the Antwerp copy, no. 7, figures and a cottage have been added at the right and left.

7. Canvas, 56¼ x 67¾" (143 x 172 cm.), Musées Royaux des Beaux-Arts, Antwerp, no. 847 [as attributed to Pieter Brueghel the Younger] (Marlier no. 1).

8. Canvas, 46¾ x 65" (119 x 165 cm.), Prado, Madrid, no. 2470 [as Pieter Brueghel the Elder] (Marlier no. 10).

9. Medium unknown, 63 x 80¾" (160 x 205 cm.), Museo Lazaro Galdiano, Madrid, no. 11295 (photograph, Rijksbureau voor Kunsthistorische Documentatie, The Hague, neg. no. L19403) (Marlier no. 11).

10. Medium unknown, 49¼ x 65" (125 x 165 cm.), Monasterio de las Descalzas Reales, Madrid (photograph, Rijksbureau voor Kunsthistorische Documentatie, The Hague, no. L19403) (Marlier no. 9).

11. Canvas, 46½ x 71¼" (118 x 181 cm.), Landeshauptmann Grüner, Hofburg; Schloss Itter, until 1922; sale, Sotheby's, London, November 30, 1983, lot 67, repro. (Marlier no. 7).

12. Panel, dimensions unknown, Public Library, Arbroath (photograph, Witt Library, London) (Marlier no. 2).

13. Canvas, 46¼ x 64" (117.5 x 162.5 cm.), sale, Christie's, London, December 2, 1983, lot 91 [as attributed to Pieter Brueghel the Younger].

14. Medium and dimensions unknown, Ferdinandeum, Innsbruck, cat. 1928, no. 690 [as attributed to Franz Josef Textor] (Marlier no. 6).

15. Medium and dimensions unknown, Kurt Meissner, Zurich, formerly in Guy Stein Collection, Paris (Marlier no. 15).

16. Copper, 9¾ x 13¾" (25 x 35 cm.), signed and dated *BRVEGHEL 1600*, Musée Royal des Beaux-Arts, Antwerp, no. 922 [as Jan Brueghel I] (Marlier no. 3, as in "Coll. Mme Langeveld") (see Klaus Ertz, *Jan Brueghel der Altere [1568–1625]: Die Gremälde* [Cologne, 1979], cat. no. 63).

17. Copper, 13 x 18⅞" (33 x 48 cm.), signed and dated *BRVEGHEL 1598*, Kunsthistorisches Museum, Vienna, no. 617 [as Jan Brueghel I] (Ertz cat. no. 49, fig. 507).

18. Copper, 10⅜ x 13¾" (26.5 x 35.2 cm.), signed *BRVEGHEL*, The Hermitage, Leningrad, no. 3090 (Ertz cat. no. 50, fig. 508).

19. Tempera on paper, 13 x 18⅞" (32.9 x 48 cm.), signed and dated . . . *RVEGHEL 1598*, National Gallery, London, no. 3547 (Ertz cat. 48, fig. 506, as an autograph replica of no. 17 above).

20. Panel, 10¼ x 13" (26 x 33 cm.), dated 1600, sale, Sotheby's, London, November 25, 1970, lot 21 (Ertz cat. no. 64, fig. 509).

21. Copper, 10¾ x 14⅛" (27.4 x 36 cm.), Museum Mayer van den Bergh, Antwerp, no. 497 [as Jan Brueghel I] (Ertz p. 568, under cat. no. 64 [as possibly Jan Brueghel II]).

15 ATTRIBUTED TO PIETER BRUEGHEL *THE CRUCIFIXION*, 1617?
 THE YOUNGER Oil on panel, 27¼" x 48⅛" (69.2 x 122.2 cm.)
 Purchased for the W. P. Wilstach Collection. W03-1-6

At the center of a broad landscape viewed from above, Christ is crucified
before a diverse crowd on Calvary. Two of the tall crosses are already in
place, while the third is just being pulled aloft on the left. In the distance,
the remains of another victim of an earlier crucifixion can be seen before the
city of Jerusalem. The crowd of soldiers, peasants, and other onlookers is
seen mostly from the back. Beneath the central cross the mounted centurion
raises the lance with the vinegar-soaked sponge. Beneath the cross on the
right a curiously cowled figure holds up the tablets of the law to one of the
crucified thieves. In the center foreground three combatants fight over
Christ's clothes. Some onlookers seeking better views have climbed the trees
of the wooded hillside on the right, beneath which two dogs gnaw a horse's
carcass and the holy women huddle together in grief. In the distance at the
extreme left is a large domed building, most likely the holy sepulcher. The
stormy sky overhead sets the somber mood.

 First published by Axel L. Romdahl in 1905 as the work of Pieter
Bruegel the Elder (c. 1525/30–1569),[1] the painting was reassigned two years
later to Pieter Brueghel the Younger by René van Bastelaer and Georges
Hulin de Loo,[2] the attribution that the work has carried at the Philadelphia
Museum of Art since 1918. Gustav Glück believed that the composition was
invented by the son,[3] but most writers consider it to be based, at least in
part, on a lost work by his father. Several early sources mention Crucifixion
subjects by Bruegel the Elder: one, a painting dated 1559, was mentioned by
Arnoldus Buchelius [Arend van Buchell] in his *Res Pictoriae* as in the
collection of Bartholomeus Ferreris of Leiden, the man to whom Karel van

FIG. 15-1 Pieter Brueghel the Younger, *The
Crucifixion,* signed and dated 1615, oil on
panel, 39⅜ x 57⅞" (100 x 147 cm.), private
collection.

FIG. 15-2 Attributed to Pieter Brueghel the Younger, *The Crucifixion,* signed and dated 1617, oil on panel, 32¼ x 48⅜" (82 x 123 cm.), Szépmüvészeti Múzeum, Budapest, inv. no. 1038.

FIG. 15-3 Infrared reflectogram assembly of the underdrawing of the thief on the left in *The Crucifixion,* attributed to Pieter Brueghel the Younger.

FIG. 15-4 Attributed to Hieronymus Bosch, *Figure Studies,* pen on paper, private collection, Paris.

Mander dedicated part of *Het Schilder-Boeck* of 1603–4;[4] another painting of this subject was in the collection of Hendrik Bartels in 1672.[5] Thus it seems likely that the numerous copies and versions of the composition reflect a lost prototype by Bruegel the Elder.

Unlike the Philadelphia version, in which the crucified Christ appears silhouetted against the open sky, some of these variants (see Copies and Versions, nos. 1–7) adopt a loftier point of view and include an extensive rocky landscape in the background (see fig. 15-1). Hulin de Loo believed that this feature was an addition made by Pieter the Younger to his father's original design, which is best documented in the Philadelphia version. Georges Marlier, who of all the scholars dealing with this topic has discussed the various versions in the greatest detail, disputed the belief that the landscape was invented entirely by Pieter the Younger, surmising more plausibly that the son only elaborated on his father's design.[6] Rocky landscapes and the so-called *Weltlandschaften,* or world landscapes, had been an important part of Pieter the Elder's art from his earliest drawings. It is likely, therefore, that the sparer setting and lower viewpoint of *The Crucifixion* scene in Philadelphia and the closely related *Crucifixion* in Budapest, dated 1617 (fig. 15-2), constitute a later simplification or reduction of the original composition. At the same time, the quality of the execution—evident not only in the handling of the paint but also in the lively underdrawing (see fig. 15-3 for a detail of the underdrawing of the thief on the left obtained through infrared reflectography)—is equal or superior to that of most other surviving versions, lending some support to the traditional attribution to Pieter Brueghel the Younger.

Bruegel the Elder's original composition, like so much else in the painter's art, may have owed a debt to Hieronymus Bosch (c. 1450–1516). Not only the practice of subsuming the sacred protagonist in a crowd of subsidiary secular figures—as it were, drowning the image of good in a sea of evil[7]—but also individual figure motifs recall Bosch. Charles de Tolnay attributed to Bosch a drawing of four figures who appear at the lower right of the various versions of the Crucifixion (fig. 15-4).[8] He theorized accordingly that the lost Bruegel at least, in part, paraphrased a lost work by Bosch.

NOTES

1. See Axel L. Romdahl, "Pieter Brueghel der Ältere und sein Kunstschaffen," *Jahrbuch der Kunsthistorischen Sammlungen des Allerhöchsten Kaiserhauses,* vol. 25 (1905), p. 106.

2. See René van Bastelaer and Georges Hulin de Loo, *Peter Bruegel l'Ancien : Son Oeuvre et son temps* (Brussels, 1907), pp. 361–62, under cat. no. C.15.

3. See Gustav Glück in P. de Boer Gallery, Amsterdam, *De Helsche en de Fluweelen Brueghel en hun invloed op de kunst in de Nederlanden,* February 10–March 26, 1934, p. 7.

4. Buchelius recorded, "Vidi apud Fererium een crucifix van Brueghel, admodum divine pictum frequentibus admodum icunculis cum fenestris ex colore aqueo ovium albidini temperatum fenestres vero superius sive exterius erant oleo depictae albo nigro coloribus. Annus erat 1559," reprinted in *Arnoldus Buchelius, "Res Pictoriae," 1583–1639,* edited by G. J. Hoogewerff and J. Q. van Regteren Altena (The Hague, 1928), p. 78. This passage is cited both by Gustav Glück, *Das grosse Brueghel-Werk* (Vienna and Munich, 1963), p. 115, and Georges Marlier, *Pierre Brueghel le Jeune* (Brussels, 1969), p. 287.

5. "Een schilderey van de Cruyssingh Cristy. Van den ouden Breugel f. 150" [A painting of the Crucifixion of Christ. By the elder Bruegel 150 guilders], cited by Marlier (see note 4), p. 287.

6. Marlier (see note 4), p. 289; and Glück (see note 4), p. 115.

7. See Hieronymus Bosch, *The Temptation of Saint Anthony*, signed, oil on panel, triptych: central panel, 51¾ x 46⅞" (131.5 x 119 cm.), side panels, 51¼ x 20⅞" (131.5 x 53 cm.), Museu de Arte Antiga, Lisbon, inv. no. 1498; and Pieter Bruegel the Elder, *Procession to Calvary*, signed and dated 1564, oil on panel, 48¾ x 67" (124 x 170 cm.), Kunsthistorisches Museum, Vienna, inv. no. 1025.

8. See Charles de Tolnay, "Remarques sur quelques dessins de Bruegel l'Ancien et sur un dessin de Bosch récemment réapparus," *Bulletin des Musées Royaux des Beaux-Arts*, vol. 9, nos. 1–2 (March–June 1960), pp. 22–28.

PROVENANCE: Sale, René della Faille de Waerloos, Antwerp, F. Muller, Amsterdam, July 7, 1903, lot 31 [as Pieter Bruegel the Elder]; purchased for the W. P. Wilstach Collection, Philadelphia, August 6, 1903.

LITERATURE: Axel L. Romdahl, "Pieter Brueghel der Altere und sein Kunstschaffen," *Jahrbuch der Kunsthistorischen Sammlungen des Allerhöchsten Kaiserhauses*, vol. 25 (1905), p. 106 [as Pieter Bruegel the Elder]; René van Bastelaer and Georges Hulin de Loo, *Peter Bruegel l'Ancien : Son Oeuvre et son temps* (Brussels, 1907), pp. 361–62, under cat. no. C.15 [as Pieter Brueghel the Younger]; Wilstach 1910, no. 57 [as attributed to Pieter Bruegel the Elder], 1913, no. 59 [as attributed to Pieter Bruegel the Elder], 1922, no. 40 [as attributed to Pieter Brueghel the Younger]; Gustav Glück in P. de Boer Gallery, Amsterdam, *De Helsche en de Fluweelen Brueghel en hun invloed op de kunst in de Nederlanden*, February 10–March 26, 1934, p. 7; Gustav Glück, *Das grosse Brueghel-Werk* (Vienna, 1951), p. 114, no. 84 [as a composition invented by Pieter Bruegel the Elder]; Charles de Tolnay, "Remarques sur quelques dessins de Bruegel l'Ancien et sur un dessin de Bosch récemment réapparus," *Bulletin des Musées Royaux des Beaux-Arts*, vol. 9, nos. 1–2 (March–June 1960), pp. 22–28, fig. 16; Gustav Glück, *Das grosse Brueghel-Werk* (Vienna and Munich, 1963), p. 114; Piero Bianconi with an introduction by Giovanni Arpino, *L'Opera completa di Bruegel* (Milan, 1967), repro. p. 96; Andor Pigler, *Katalog der Galerie Alter Meister, Szépmüvészeti Múzeum, Budapest*, vol. 2 (Tübingen, 1968), p. 106; Piero Bianconi, with an introduction by Robert Hughes, *The Complete Paintings of Bruegel* (London, 1969), repro. p. 96; Georges Marlier, *Pierre Brueghel le Jeune* (Brussels, 1969), pp. 288–90, 292, no. 8.

CONDITION: The wooden panel support is composed of two planks with grain running horizontally, which now have split at the horizontal join. A second crack, running the full width of the panel, appears approximately 5" (12.5 cm.) from the bottom; additional cracks are at the upper right and left, running in from the edges. An old cradle was removed in 1949 and aluminum strips attached on the reverse. The back was also coated with aluminum paint. The paint film on the lower half of the panel has lifted repeatedly; cleaving paint was reattached in 1960, 1966, and 1968. Many scattered losses are retouched in this area. In thin areas the underdrawing is visible. The varnish applied in 1966 is very slightly discolored.

COPIES AND VERSIONS

1. Pieter Brueghel the Younger, *The Crucifixion*, signed and dated "P BRVEGHEL 1615," private collection (identical to fig. 15-1). Comte de Buisseret, Antwerp; Baron Coppée, Brussels. Exhibited at P. de Boer Gallery, Amsterdam, *De Helsche en de Fluweelen Brueghel en hun invloed op de kunst in de Nederlanden*, February 10–March 26, 1934, no. 24, pl. 7 [as Pieter Brueghel the Younger and erroneously as dated 1605]; Palais des Beaux-Arts, Brussels, *Bruegel: Une dynastie de peintres*, September 18–November 18, 1980, cat. no. 92, repro. (Georges Marlier, *Pierre Brueghel le Jeune* [Brussels, 1969], no. 1, fig. 167).

2. Signed "P. BRVEGHEL," oil on panel, 39⅛ x 57⅞" (100 x 147 cm.), sale, Gräfin Gatterburg et al., Zell, Hanover, May 18, 1949, lot 109 (Marlier no. 2). This painting differs only in small details from fig. 15-1.

3. Oil on panel, 59 x 75⅝" (150 x 192 cm.), Koninklijk Museum voor Schone Kunsten, Antwerp, no. 962 [as P. Brueghel II after P. Brueghel I]. Abbé E. H. Cotteleer, Antwerp; H. Petri, Antwerp; sale, Petri of Antwerp, Amsterdam, November 30, 1926, lot 49, repro.; gift of Baron G. Caroly to Koninklijk Museum voor Schone Kunsten, Antwerp, 1927 (Marlier no. 3, fig. 168).

4. Oil on panel, 35⅜ x 51⅛" (90 x 130 cm.), Eglise Saint-Nicolas-du-Chardonnet, Paris. Exhibited at Musée Galliera, Paris, *Peintures méconnues des églises de Paris: Retour d'évacuation*, 1946, cat. no. 4 (Marlier no. 4, figs. 169–71).

5. Mme J. van Gysel Collection, Brussels. See Leo van Puyvelde, *La Peinture flamande au siècle de Bosch et Breughel* (Paris, 1962), fig. 58 (Marlier no. 5).

6. Oil on panel, 31⅞ x 48" (81 x 122 cm.), sale, Christie's, London, January 29, 1954, lot 120 (Marlier no. 6).

7. Oil on panel, 33¾ x 47⅜" (86 x 120.5 cm.), sale, Dr. R. Piloty of Würzburg, Helbing, Munich, November 14, 1911, lot 669, repro. [as Pieter Bruegel the Elder].

8. Attributed to Pieter Brueghel the Younger, *The Crucifixion*, signed and dated "P. BRVEGHEL 1617," Szépmüvészeti Múzeum, Budapest (identical to fig. 15-2). Acquired in 1891 by the Szépmüvészeti Múzeum, Budapest, from T. van Meemstede Obelt, Amsterdam (Marlier no. 9, fig. 172).

9. W. von Bissing Collection, by 1910; see Hermann Nasse, in *Münchener Jahrbuch der bildende Kunst*, vol. 1 (1910), p. 114, fig. XV [as Pieter Brueghel the Younger] (Marlier no. 10).

10. Oil on panel, 46¼ x 63⅜" (117.5 x 161 cm.), Stichting Nederlands Kunstbezit, The Hague. Possibly earlier in the Vieweg collection, Brunswick (Marlier no. 11).

11. M. Michiels-Ruben, Hôtel zum König von Spanien, Aix-la-Chapelle; see René van Bastelaer and Georges Hulin de Loo, *Peter Bruegel l'Ancien: Son Oeuvre et son temps* (Brussels, 1907), pp. 361–62, under no. C. 15 (Marlier no. 12).

12. Oil on panel, 37 x 53½" (94 x 136 cm.), art market, Vienna, 1937 (Marlier no. 13).

13. Oil on panel, 39⅜ x 57⅞" (100 x 147 cm.), T. Braamkamp, Düren, 1938 (Marlier no. 14).

The record of the baptism of Hendrick van der Burch (Burgh) was entered at Naaldwijk, near Delft, on June 27, 1627. He was the son of Rochus Hendricksz. van der Burch, a candlemaker and salt merchant, and Diewertje Jochemsdr. van Vliet. One of his sisters seems to have been Jannetje van der Burch, the wife of Pieter de Hooch (q.v.). In 1642 Hendrick is first recorded as being in Delft, where his family owned a house on the Binnenwatersloot. He joined the guild in Delft in 1649 and appeared in Leiden and The Hague in 1651. The following year he signed as a witness to a document with De Hooch in Delft, and again in 1654 and 1655. By September 4, 1655, Van der Burch had moved to Leiden, where two months later he married Cornelia Cornelisdr. van Rossum. The couple had five children; their second son Rochus (b. 1658) also became a painter. Van der Burch lived on the Rapenburg in Leiden. His house was opposite the university and one of his rare signed paintings depicts a graduation procession there (c. 1656–59, oil on canvas, 28⅛ x 23¼" [71.5 x 59 cm.], Rijksmuseum, Amsterdam, no. A2720). He had left Leiden by May 1659 for Amsterdam, where he baptized a child the following year, but was mentioned again in Leiden in 1661, 1662, and 1663. In 1664 he paid dues to the Delft guild and two years later baptized his last recorded child in Leiden. His date and place of death are unknown.

A genre painter, Van der Burch painted primarily guardroom, merry company, domestic interior, and courtyard scenes. He also painted at least one group portrait and a river scene; a Susanna by Van der Burch is mentioned in an inventory of 1703. His works reveal an interest in light and spatial effects and reflect the influence of Pieter de Hooch.

LITERATURE: E. W. Moes in Thieme-Becker 1907–50, vol. 5 (1911), p. 251; C. Hofstede de Groot, "Hendrick van der Burgh, een voorganger van Pieter de Hoogh," *Oud Holland,* vol 39 (1921), pp. 121–28; W. R. Valentiner, *Pieter de Hooch: Des Meisters Gemälde in 180 Abbildungen mit einem Anhang über die Genremaler um Pieter de Hooch und die Kunst Hendrik van der Burchs* (Berlin and Leipzig, 1929), pp. xxxvii–lii; W. R. Valentiner, *Pieter de Hooch: The Master's Paintings in 180 Reproductions with an Appendix on the Genre Painters in the Manner of Pieter de Hooch and Hendrik van der Burch's Art,* translated by Alice M. Sharkey and E. Schwandt (London and New York, 1930); Fritz Lugt, "Italiaansche kunstwerken in Nederlandsche verzamelingen van vroeger tijden," *Oud Holland,* vol. 53 (1936), p. 121; Peter C. Sutton, "Hendrick van der Burch," *The Burlington Magazine,* vol. 122, no. 926 (May 1980), pp. 315–26.

16 HENDRICK VAN DER BURCH *AN OFFICER AND A STANDING WOMAN,* mid-1660s
 Oil on canvas, 22¾ x 25⅛″ (57.8 x 64 cm.)
 The William L. Elkins Collection. E24-3-51

In an orderly interior a woman stands before a man sitting at a table
holding a roemer of wine. The woman wears a fur-lined red jacket, yellow
dress, and white headdress and apron. Holding his broad-brimmed, black
hat on his lap, the man wears a yellow jerkin with an orange and gold sash,
gray trousers, red tights, and white stockings. Black and white tiles cover
the floor, and the walls are decorated with patterned and gilt leather. At the
left a mullioned window offers a glimpse of tiled rooftops. By the window
hangs a small birdcage and on the sill rests a white ceramic tankard. At the
right a spotted dog stands before an open door, which reveals a woman
sitting in a chair on a low platform doing needlework.

FIG. 16-1 Pieter de Hooch, *An Officer and a Woman Conversing*, c. 1663–65, oil on canvas, 23⅝ x 24¾" (60 x 63 cm.), Germanisches Nationalmuseum, Nuremberg, no. 406.

FIG. 16-2 Hendrick van der Burch, *A Family in an Interior*, oil on canvas, 22½ x 25" (57.2 x 63.5 cm.), E.N.F. Lloyd sale, Christie's, London, April 30, 1937, lot 107.

The picture sold as early as 1774 as a Pieter de Hooch (q.v.) and was attributed to that artist until W. R. Valentiner correctly reassigned it to Van der Burch in 1929. Van der Burch and Pieter de Hooch had personal contact in Delft in the 1650s and probably also in Amsterdam in the early 1660s. Moreover, they seem to have been related by marriage. The many points of resemblance between their styles are underscored by comparison of the painting in Philadelphia and a series of genre scenes that De Hooch painted in Amsterdam around 1663–65 depicting highly ordered interiors with gilt leather walls (for example, fig. 16-1).[1] We recognize Van der Burch's manner, however, in his steeper, more exaggerated foreshortening of space (see fig. 16-2) and the use of sparkling, somewhat disembodied highlights (note especially the reflections on the gilt leather behind the two central figures). Additional support for the assignment to Van der Burch is provided by the reappearance of the same dog in his monogrammed *Graduation Procession at Leiden University*.[2] Other details of the scene also figure elsewhere in Van der Burch's art: the cushion on the chair at the left reappears in *Drinkers before the Fireplace*,[3] as does a similar view through an open doorway and up a set of stairs to an adjacent room; the birdcage reappears in *Woman and Child at a Window*,[4] and the woman sewing by a window recalls the principal motif in Van der Burch's painting in the Bentinck-Thyssen Collection.[5] The little platform on which the sewer sits was called a *soldertien* and served to stave off the chill of the cold floor. The gilt leather wall hangings were not gilt at all but calfskin faced with tinfoil and varnished to impart a golden look.[6]

Given Van der Burch's pattern of dependency on De Hooch and other artists' styles, the present work was probably inspired by his colleagues' examples. Elegant, highly ordered interiors had appeared by c. 1660–61 in the genre scenes of Gabriel Metsu (1629–1667) and Jan Steen (q.v.), but Van der Burch doubtless learned these ideas, like his approach to courtyard spaces, from De Hooch. For example, the pattern of Van der Burch's tiled floor shows through the thinner areas of paint in the figures, especially the dog, indicating that he shared De Hooch's practice of constructing his architectural environments before inserting the figures. Microscopic examination of this picture reveals that he drew his spaces on the ground of the painting before applying paint, a technique that is also comparable to De Hooch's. The bright palette and interest in the expressive use of light and orderly space also recall De Hooch. Despite these dependencies, this painting must be reckoned among Van der Burch's best works. The painter's observation of light—a sensibility much cultivated by the Dutch, who, as we see in the present work, even placed windows inside their houses to permit light to pass from one room to another—is subtly refined and his spatial design more successful than in most of his other pictures.

Whether Van der Burch intended a commentary on this piquant little scene is unclear. The idleness and leisure of the jaunty officer chatting with the standing lady contrast with the industriousness of the woman at her needlework in the distance. Sewing, like spinning, represented a common theme of domestic virtue in Dutch genre painting.[7] Moreover, the bird in the cage at the left might recall emblems alluding to the "sweet slavery of [marital] love."[8] The dog who eyes the couple was a time-honored symbol

of fidelity. Accordingly, various motifs could stand in moral opposition to the dalliance in the foreground; in typical fashion, however, Van der Burch offered no clarification of his meaning. He had little of Nicolaes Maes's command of moralizing anecdote or Johannes Vermeer's gift for richly layered meanings.

NOTES

1. See also *A Party of Four Figures at a Table,* c. 1663–65, oil on canvas, 23 x 27" (58.4 x 68.5 cm.), The Metropolitan Museum of Art, Robert Lehman Collection, New York, no. P100; *A Party of Five Figures, with a Man Entering from a Doorway,* c. 1663–65, oil on canvas, 25⅛ x 29¼" (64 x 74.5 cm.), Museu Nacional de Arte Antiga, Lisbon, inv. no. 1620-P; and *Card Players beside a Fireplace, with an Embracing Couple and a Serving Boy,* c. 1663–65, oil on canvas, 26⅜ x 30¼" (67 x 77 cm.), Musée du Louvre, Paris, inv. no. 1373. For the foregoing, see Sutton 1980, cat. nos. 56–58, pls. 59–61.

2. *Graduation Procession at Leiden University,* c. 1656–59, oil on canvas, 28⅛ x 23¼" (71.5 x 59 cm.), Rijksmuseum, Amsterdam, no. A2720.

3. Perhaps 1660s?, oil on canvas, 30½ x 26⅛" (77.5 x 66.3 cm.), The Frick Collection, New York, acc. no. 18.1.78.

4. Oil on panel, 16⅜ x 13" (41.5 x 33 cm.), Dienst Verspreide Rijkskollekties, Amsterdam, no. NK2422, on loan to the Stedelijk Museum het Prinsenhof, Delft.

5. Oil on panel, 9⅝ x 8" (24.5 x 20.5 cm.), Bentinck-Thyssen Collection, on loan to the Kunstmuseum, Düsseldorf (see Institut Neerlandais, Paris, *Choix de la Collection Bentinck,* May 20–June 28, 1970, cat. no. 19, pl. 10; *Die Sammlung Bentinck-Thyssen* [Dusseldorf, 1970], cat. no. 11, repro.).

6. On the taste for gilt leather wall coverings, see Peter Thornton, *Seventeenth-Century Interior Decoration in England, France, and Holland* (New Haven and London, 1978), pp. 118–23, 132–33; on their construction, see H.A.B. van Soest, "Restaureren van Goudleer," *Spiegel Historiael,* vol. 10, no. 1 (January 1975), pp. 36–43.

7. See M.G.A. Schipper-van Lottum, "Een naijmantgen met een naijcussen," *Antiek,* vol. 10, no. 2 (August–September 1975), pp. 137–63.

8. See E. de Jongh, "Erotica in vogelperspectief," *Simiolus,* vol. 3, no. 1 (1968–69), pp. 49–52; and De Jongh et al. 1976, under cat. no. 50.

PROVENANCE: Sale, Amsterdam, June 21, 1774, lot 103 [as Pieter de Hooch], to Braun; sale, Jan de Groot, Amsterdam, December 10, 1804, lot 25 [as Pieter de Hooch], to Coclers;[1] possibly P. de Smeth van Alphen, Amsterdam,[2] but not in sale of 1810; William L. Elkins Collection, Philadelphia, by 1900.

NOTES TO PROVENANCE

1. This sale reference was tentatively but incorrectly listed by Hofstede de Groot 1908–27, vol. 1 (1908), no. 194 [as Pieter de Hooch], under the painting now in Nuremberg (fig. 16-1).

2. According to Elkins 1887–1900, vol. 2, no. 102.

LITERATURE: Elkins 1887–1900, vol. 2, no. 102, repro. [as Pieter de Hooch]; Clotilde Brière-Misme, "Tableaux inédits ou peu connus de Pieter de Hooch," *Gazette des Beaux-Arts,* 5th ser., vol. 16 (1927), p. 73 [as Pieter de Hooch]; W. R. Valentiner, *Pieter de Hooch. Des Meisters Gemälde in 180 Abbildungen mit einem Anhang über die Genremaler um Pieter de Hooch und die Kunst Hendrik van der Burchs* (Berlin and Leipzig, 1929), p. 293, repro. p. 234 [as Hendrick van der Burch]; W. R. Valentiner, *Pieter de Hooch: The Master's Paintings in 180 Reproductions with an Appendix on the Genre Painters in the Manner of Pieter de Hooch and Hendrik van der Burch's Art,* translated by Alice M. Sharkey and E. Schwandt (London and New York, 1930), p. 293, repro. p. 234 [as Hendrick van der Burch]; PMA 1965, p. 9 [as Hendrick van der Burch]; Sutton 1980, p. 140, under cat. no. D10; Peter C. Sutton, "Hendrick van der Burch," *The Burlington Magazine,* vol. 122, no. 926 (May 1980), pp. 323–24, n. 48, fig. 53 [as Hendrick van der Burch]; Sutton et al. 1984, p. LVII, fig. 107; Peter C. Sutton, *A Guide to Dutch Art in America* (Grand Rapids and Kampen, 1986), p. 230.

CONDITION: The canvas support is in good condition, lined with two fabrics: an earlier aqueous lining and a later wax-resin addition. The original tacking edges are missing. The paint film is secure, but exhibits a fine overall crackle pattern and slight cupping. There is some abrasion of the paint along the lower edge and in the black and brown designs and shadows. There are several old flake losses in the top right quadrant. The varnish is moderately discolored.

Baptized at Dordrecht on October 12, 1642, the artist was the eldest son of Pieter Jansz. van Calraet (c. 1615–1680), a woodcarver. Like other members of his family, he sometimes spelled his name Calraat or, occasionally, Kalraet. Houbraken stated that Abraham learned to draw from the sculptors Aemilius (Gillis?) and Samuel Huppe (both active c. 1650) of Dordrecht, and that his brother Barent (1649–1737) was a pupil of Aelbert Cuyp (1620–1691). Judging from his known paintings, Abraham also probably studied with Cuyp. He seems to have spent his entire life in Dordrecht, where he married the daughter of the painter Cornelis Bisschop (1630–1674) in 1680, and was buried on June 12, 1722.

According to Arnold Houbraken he painted figures and fruit and, like his father, was a woodcarver. In 1682, 1697, and 1702, he was described as a painter and in 1687 as a woodcutter. A small number of still-life paintings with fruit (*Peaches,* oil on panel, 17½ x 25⅜" [44.5 x 64.5 cm.], John G. Johnson Collection at the Philadelphia Museum of Art, cat. no. 628) and a group of portraits by his hand are known. By far, the largest part of his oeuvre, however, is comprised of representations of stables, riding schools, and other scenes with horses and horsemen, occasionally with views of Dordrecht. He also did a few cavalry skirmishes and scenes of livestock (*Cows in a Stable,* oil on panel, 17⅛ x 23¼" [44.8 x 59.7 cm.], John G. Johnson Collection at the Philadelphia Museum of Art, inv. no. 424). Most of his paintings are small-scale panels and are signed "A.C." Until Bredius initiated the rediscovery of the artist, virtually his entire oeuvre was assigned to Aelbert Cuyp, whose style served as the foundation for Calraet's work, which can also resemble that of Philips Wouwermans (q.v.).

LITERATURE: Houbraken 1718–21, vol. 3, pp. 181–82 [as Abraham van Kalraat]; Abraham Bredius, *Kunstchronik,* n.s., vol. 25 (1913–14), cols. 93–94; Abraham Bredius, "Das Nachlass-Inventar der Mutter von Barend und Abraham van Calraet," in Bredius 1915–22, vol. 1 (1915), pp. 307–20; Abraham Bredius, "Die stilleven-schilder Abraham (van) Calraat (1642–1722)," *Oude Kunst,* vol. 1 (1915–16), pp. 90–91; Abraham Bredius, *Oude Kunst,* vol. 1 (1915–16), pp. 186–88, 293–94, 314, 386; Abraham Bredius, "Een Calraet tentoonstelling," *Oude Kunst,* vol. 2 (1916–17), pp. 105, 109, 159; N. G. van Huffel, "Een voluit gemerkt perzikstilleven van A. van Calraet," *Oude Kunst,* vol. 2 (1916–17), p. 9; Abraham Bredius, "The Still-Life Painter, Abraham Calraet," *The Burlington Magazine,* vol. 30, no. 160 (May 1917), pp. 172–90; F. Schmidt-Degener, "Kalraet [en andere aanwinsten] in Boymans," *Oude Kunst,* vol. 4 (1918–19), pp. 285–91; Abraham Bredius, "Further Light upon the Painter Calraet (Kalraet)," *The Burlington Magazine,* vol. 35, no. 198 (September 1919), p. 120; C. Hofstede de Groot in Thieme-Becker 1907–50, vol. 19 (1926), pp. 482–84; J. G. van Gelder, "A. Calraet, niet Cuyp," *Kunsthistorische Mededeelingen,* vol. 1 (1946), pp. 7–8; Neil

MacLaren, *The National Gallery Catalogues: The Dutch School* (London, 1960), pp. 69–70; Laurens J. Bol, *Holländische Maler des 17. Jahrhunderts nahe den grossen Meistern: Landschaften und Stilleben* (Brunswick, 1969), pp. 236–37.

For additional works by Calraet in the Philadelphia Museum of Art, see John G. Johnson Collection cat. nos. 625, 628, inv. no. 424.

17 ABRAHAM PIETERSZ. VAN CALRAET

GROOM WITH THREE HORSES AND TWO DOGS
Monogrammed lower right in reddish brown: *AC*
Oil on panel, 13¼ x 21″ (33.6 x 53.3 cm.)
The William L. Elkins Collection. E24-3-3

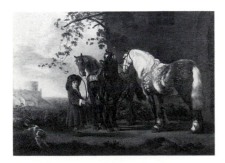

FIG. 17-1 Abraham Pietersz. van Calraet, *A Boy Holding the Bridles of Three Horses,* oil on panel, 13⅞ x 19⅞″ (35.5 x 49.5 cm.), formerly Northwick Park, Blockley.

Standing before a vine-covered stone structure, presumably a stable, a young groom in a broad-brimmed brown hat and long coat holds the reins of three horses—one black, one chestnut, and one dappled gray. Two dogs appear at the lower left. One raises its leg to urinate. As with virtually all of Calraet's paintings, this work was formerly assigned to Aelbert Cuyp (1620–1691) and had carried this attribution at least as early as 1834. J. G. van Gelder first suggested (personal communication) that the attribution be changed to Calraet, an assignment supported by comparison with the growing body of works determined to be by this master.

A second version of this work, also signed "A.C.," in the Hermitage, Leningrad, but on canvas and without the dogs on the left, is incorrectly attributed to Cuyp.[1] Still another version (fig. 17-1), showing only the smaller dog at the far left, was formerly at Northwick Park.[2] As far as can be judged from photographs, the latter appears more labored and generally inferior in execution to both the Philadelphia painting and the version in Leningrad, characteristics suggesting that it may be a copy. Whether either the Philadelphia or Leningrad version is the first or original version of the composition is unclear; nothing about the Russian picture is obviously fresher or indicative of a first conception of the subject. Both the groom and the dappled gray horse also reappear in the same poses elsewhere in Calraet's work.[3]

Similar scenes of figures with horses standing before a stable on the right and with a warmly lighted landscape vista on the left are found in *Halt at an Inn, Two Horsemen at an Inn, Two Horses,* and *A Woody River Landscape.*[4] In addition to copies after Cuyp, an unidentified picture of a worker with horses appeared in the inventory of the estate of Calraet's mother in 1701.[5]

NOTES

1. Abraham Pietersz. van Calraet, *Three Horses in Front of a Stable,* oil on canvas, 14½ x 23″ (37 x 58 cm.), The Hermitage, Leningrad, no. 1105 (see Smith 1829–42, vol. 9 [suppl.] [1842], p. 649, no. 1 [as Aelbert Cuyp]; Hofstede de Groot 1908–27, vol. 2 [1909], no. 563 [as Aelbert Cuyp]). The picture was in Leningrad at least as early as 1842. According to the 1901 Hermitage catalogue, another version of their composition, with the same dimensions but with two additional dogs, was sold with the collection of J. van der Linden van Slingeland (of Dordrecht) in Amsterdam in 1785 for 501 guilders. While such a work would have corresponded very closely to the Philadelphia painting, the only picture to appear in the Van der Linden van Slingeland sale, August 22, 1785, of comparable dimensions was lot 76, *Cavaliers Halting,* oil on panel, 13½ x 21″ (34 x 53 cm.). That painting, however, which sold to Beekman for 501 guilders, also included three cavaliers (see Hofstede de Groot 1908–27, vol. 2 [1909], no. 526 [as Aelbert Cuyp]).
2. *A Boy Holding the Bridles of Three Horses,* signed, oil on panel, 13⅞ x 19⅜″ (35.5 x 49.5 cm.), formerly Lord Northwick, Thirlestane House, Cheltenham, by 1854 (see Waagen 1854, vol. 3, p. 208; Hofstede de Groot 1908–27, vol. 2 [1909], no. 582 [as Aelbert Cuyp]). Sale, Lord Northwick, Thirlestane House, July 26, 1859, lot 235 [as Aelbert Cuyp], bought in; Northwick Park, Blockley, 1864, no. 31 [as Aelbert Cuyp]; Tancred Borenius, *A Catalogue of the Collection of Pictures at Northwick Park* (1921), no. 181 [as Aelbert Cuyp]; sale, Northwick Park, Christie's, London, February 25, 1966, lot 92, repro. [as Aelbert Cuyp, the provenance being confused with the present version].
3. Compare, for example, the groom in the painting in the Heilbronner sale, F. Muller, Amsterdam, May 31, 1949, lot 9, monogrammed, oil on panel, 14⅛ x 22⅜″ (36 x 57 cm.). Compare also the horses in *Interior of a Stall with Two Dapple-Grays,* oil on panel, 12⅜ x 15¾″ (31.4 x 40 cm.), Museum Boymans–van Beuningen, Rotterdam, inv. no. 1395.
4. *Halt at an Inn,* oil on panel, 15¼ x 23⅛″ (38.7 x 58.7 cm.), The Wallace Collection, London, no. P228; *Two Horsemen at an Inn,* oil on panel, 14 x 21″ (35.5 x 53.3 cm.), previously collection of the Earl of Dysart, Ham House, Richmond (see Hofstede de Groot 1908–27, vol. 2 [1909] no. 521 [as Aelbert Cuyp]); *Two Horses,* oil on panel, 11⅜ x 15⅞″ (29 x 40.4 cm.), Dulwich Picture Gallery, London, no. 71; *A Woody River Landscape,* oil on panel, 39¼ x 62″ (99.3 x 157.5 cm.), sale, Christie's, London, June 29, 1973, lot 92, repro. [as Aelbert Cuyp].
5. See no. 54, "Een stuck met een arbeyder met paerden," from "Das Nachlass-Inventar der Mutter von Barend und Abraham van Calraet," in Bredius 1915–22, vol. 1 (1915), p. 312.

PROVENANCE: P.J.F. Vrancken, 1834;[1] sale, P.J.F. Vrancken, Lokeren, May 15, 1838, lot 7 [as Aelbert Cuyp], to Chaplin; sale, James Stewart, London, April 20, 1839 [as Aelbert Cuyp], to Chaplin; J. Louis Miéville, London, by 1878;[2] sale, J. Louis Miéville, London, April 29, 1899, lot 62, to Agnew; Marquis de Ganay, Paris;[3] Thomas Agnew's Gallery, London; William L. Elkins Collection, Philadelphia, by 1900.

NOTES TO PROVENANCE
1. See Smith 1829–42, vol. 5 (1834), p. 344, no. 210 [as Aelbert Cuyp].
2. See Royal Academy, London, winter 1878, no. 243.
3. See Hofstede de Groot 1908–27, vol. 2 (1909), no. 560 [as Aelbert Cuyp].

EXHIBITION: Royal Academy, London, winter 1878, no. 243 [lent by J. Louis Miéville, according to exhibition sticker on the reverse].

LITERATURE: Smith 1829–42, vol. 5 (1834), p. 344, no. 210 [as Aelbert Cuyp], vol. 9 [suppl.] (1842), no. 30 [as Aelbert Cuyp]; Elkins 1887–1900, vol. 2, no. 88 [as Aelbert Cuyp], repro.; J. G. van Gelder, "A. Calraet, niet Cuyp," *Kunsthistorische Mededeelingen,* vol. 1 (1946), p. 8 n. 4; Hofstede de Groot 1908–27, vol. 2 (1909), no. 560 [as Aelbert Cuyp]; PMA 1965, p. 10 [as Abraham Pietersz. van Calraet].

CONDITION: The horizontally grained panel support is cradled and worn at the edges. Old gouges are visible in the head of the dog at the far left and the hindquarters of the horse at the right. The paint film shows scattered losses throughout, especially along the lower edge and in the foreground; there is some general abrasion, particularly noticeable in the upper-left and lower-left corners. The varnish is moderately discolored.

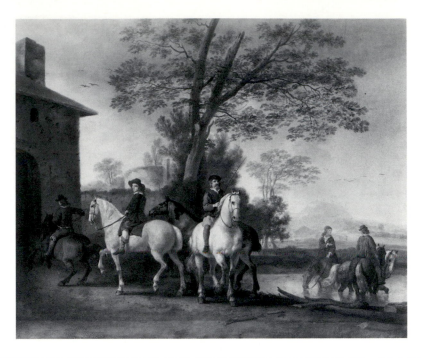

18 ATTRIBUTED TO ABRAHAM
 PIETERSZ. VAN CALRAET

HORSEMEN WATERING THEIR HORSES
Oil on panel, 24 x 29¾″ (61 x 75.5 cm.)
The William L. Elkins Collection. E24-3-74

Beside a stable at the left and beneath a central tree appear three riders on brown, beige, and white horses. One of the men leads a fourth, riderless, chestnut-colored horse. Two other riders water their mounts and another horse in a stream at the right.

 According to a Sedelmeyer Gallery catalogue[1] and to C. Hofstede de Groot,[2] the picture formerly bore Aelbert Cuyp's monogram; but no such mark is visible on the picture any longer. Hofstede de Groot first suggested that the attribution be changed to Calraet,[3] with whose work the picture has more in common than with Cuyp's, as is evident from other scenes by Calraet of riders training and watering their horses.[4] Nonetheless, weaknesses in the drawing of the figures and their mounts make the attribution unlikely.

NOTES
1. *Illustrated Catalogue of the Fifth Series of 100 Paintings by Old Masters of the Dutch, Flemish, Italian, French, and English Schools . . .* (Paris, 1899), p. 12, no. 5, repro. p. 13 [as "The Watering Place" by Aelbert Cuyp].
2. Hofstede de Groot 1908–27, vol. 2 (1909), no. 590 [as Aelbert Cuyp].
3. In Thieme-Becker 1907–50, vol. 19 (1926), p. 483.
4. Compare, for example, *White Horse in a Riding School*, oil on panel, 13¾ x 20½″ (34.9 x 52 cm.), Dulwich Picture Gallery, London, no. 65, and the picture in sale, dealer P. Brandt, Amsterdam, November 28, 1967, lot 8, repro. [erroneously as Aelbert Cuyp].

PROVENANCE: Leigh Pemberton, Torry Hill, near Sittingbourne; dealer C. Sedelmeyer, Paris, 1899; William L. Elkins Collection, Philadelphia, by 1900.

EXHIBITION: Sedelmeyer Gallery, Paris, 1899, no. 5 [as "The Watering Place" by Aelbert Cuyp].

LITERATURE: Elkins 1887–1900, vol. 2, no. 87, repro. [as Aelbert Cuyp]; Hofstede de Groot 1908–27, vol. 2 (1909), no. 590 [as Aelbert Cuyp]; Thieme-Becker 1907–50, vol. 19 (1926), p. 483; PMA 1965, p. 10 [as Abraham Pietersz. van Calraet].

CONDITION: The horizontally grained panel is cradled, planar, and in stable condition. The paint film is moderately abraded throughout; the varnish is heavily discolored.

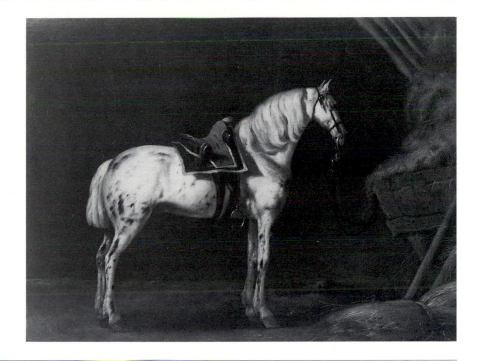

19 COPY AFTER ABRAHAM
 PIETERSZ. VAN CALRAET

WHITE HORSE IN A STABLE
Oil on panel, 12½ x 16¾″ (31.8 x 42.5 cm.)
The William L. Elkins Collection. E24-3-91

FIG. 19-1 Abraham Pietersz. van Calraet,
White Horse in a Stable, monogrammed, oil
on panel, 12 x 15¾″ (30.5 x 40 cm.), Collection
of the Trustees of Berkeley Castle, London.

A white, spotted horse wearing a red and black saddle is turned to the right in a stable.

Originally assigned to Aelbert Cuyp (1620–1691), the picture was reattributed to Calraet by C. Hofstede de Groot in 1926.[1] The work, however, appears to be a copy of a monogrammed example of this composition by Calraet (fig. 19-1). The same horse reappears in *White Horse in a Riding School,* also monogrammed "AC."[2]

NOTES
1. C. Hofstede de Groot in Thieme-Becker 1907–50, vol. 19 (1926), p. 483.
2. Oil on panel, 13¾ x 20½″ (34.9 x 52 cm.), Dulwich Picture Gallery, London, no. 65. Another version of this scene was with Newhouse Galleries, New York, in 1929.

PROVENANCE: William Prinsy, Berkeley Square, London; William L. Elkins Collection, Philadelphia, by 1900.

LITERATURE: Elkins 1887–1900, vol. 2, no. 85, repro. [as Aelbert Cuyp]; C. Hofstede de Groot in Thieme-Becker 1907–50, vol. 19 (1926), p. 483; PMA 1965, p. 10 [as Abraham Pietersz. van Calraet].

CONDITION: The panel support, formerly cradled, is now shaved. The panel has a horizontal grain, is uniformly thick, about ¼″ (0.6 cm.), and is in good condition. The paint film shows moderate abrasion; small, old losses along the edges and in the dark background have been retouched. A 1¼″ (3.2 cm.) scratch in the surface crosses the horse's nose. The varnish is mildly discolored.

LITERATURE: Boetticher (1891–1901) 1969, vol. I, p. 170; H. Hymans in Thieme-Becker 1907–50, vol. 5 (1911), p. 562.

Born in Amsterdam in 1834, Carabain studied at the academy there with Jacobus Schoemaker Doyer (1792–1867) and Valentin Bing (1812–after 1855). He moved to Brussels, where he became a citizen in 1880. Evidently he traveled extensively in Europe. His architectural paintings and landscapes depict views in Belgium, Germany (Rothenburg), France, Italy (Padua, Vicenza, Verona), and Switzerland.

20 JACQUES FRANÇOIS CARABAIN

STREET SCENE IN ZUG, SWITZERLAND, 1891
Signed lower right: *J. Carabain*
Oil on canvas, 16½ x 22½" (41.9 x 57.2 cm.)
Gift of Walter Lippincott. 23-59-5

This street scene in Zug, Switzerland, recedes to a central tower. Figures gather before a shop on the left, and a barrow and horsecart appear in the street.

On the reverse of the canvas is the inscription in English: "I declare that this picture was painted to the order/of Mr. Craig and Evans/Brussels. 6 Mai 1891./Js. Carabain."

PROVENANCE: Craig and Evans, Brussels.

LITERATURE: PMA 1965, p. 11.

CONDITION: The unlined canvas support has extensive damage (photographed prior to damage). Large punctures appear in the upper left, upper center, lower right, and smaller holes at the upper right and lower left. The canvas is dented and out of plane. The paint film has extensive losses in the punctured areas and minor losses scattered throughout. The varnish is dull and moderately discolored.

LITERATURE: Wurzbach 1906–11, vol. 1, p. 247; Thieme-Becker 1907–50, vol. 6 (1912), p. 139.

Son of the Antwerp painter of the same name (active c. 1629–1682/83), Pieter Casteels the Younger joined the guild in 1673/74. He was married to Elisabeth Bosschaert. His son, Pieter III (1684–1749), was a painter and printmaker who specialized in flower paintings.

21 STYLE OF PIETER CASTEELS II

HARBOR WITH LIGHTHOUSE
Oil on canvas, 40 x 68″ (101.6 x 172.7 cm.)
Bequest of Arthur H. Lea. F38-1-25

This view of a harbor with tall lighthouse, sailing vessels, and dock workers has been previously categorized as seventeenth-century Dutch unknown. The work bears some resemblance to the smaller compositions of decorative landscapes with towers executed on a much higher level of quality by the father of Pieter Casteels II. One may compare also the works of the Flemish painters Adriaen Frans Baudewyns (1644–1711) and Pieter Bout (1658–1719).

PROVENANCE: Arthur H. Lea.

CONDITION: The unlined canvas support is slack, out of plane, and brittle. Numerous areas of flaking, cleavage, and old and new losses appear throughout the paint film. The thick varnish layer is extremely discolored.

Pieter Coecke van Aelst (d'Alost) was born on August 14, 1502, in Aelst and died on December 6, 1550, in Brussels. Karel van Mander claimed in *Het Schilder-Boeck* that he was a pupil in Brussels of Bernard van Orley (c. 1490–1541) and that he later traveled to Rome. He returned by 1527, the year in which he became a master in the Guild of Saint Luke in Antwerp. His first wife, who had borne him two sons, died c. 1529. Two other sons of Coecke van Aelst were born to an Antonia van der Sant; Pauwels (b. c. 1530) became a painter. In 1533 Coecke traveled to Constantinople for a year to learn oriental textile designs and techniques and worked for the Sultan Suleiman I. Some of his Turkish designs were published in engravings in 1553 (*Moeurs et fachons des Turcs*) by his widow, the Mechelen-born miniature painter Mayken Verhulst (c. 1520–1600). The couple had been married around 1534; their daughter Mayken later married Coecke van Aelst's most famous pupil, Pieter Bruegel the Elder (c. 1525/30–1569). In 1537 Coecke was an officer of the Antwerp guild. In the early 1530s he designed a stained-glass window, now lost, for the St. Nicolaes Chapel of Notre Dame in Antwerp. In 1540 he was a witness to the will of the painter Joos van Cleve (c. 1485– c. 1540). He received a pension in 1541 from the municipal tapestryworks in Antwerp for his service as a designer of cartoons.

Coecke also served as court painter to both Mary of Hungary and Emperor Charles V. In 1549 he contributed to the decor set up for the triumphal entry of Prince Philip into Antwerp. He translated the architectural writings of Vitruvius Pollio and Sebastiano Serlio (published in 1539 and 1546–53) and had an extensive influence on sixteenth-century building styles in the Netherlands. Little of his activity as a sculptor and architect has been preserved. Furthermore, paintings either signed or documented as by his hand are unknown. The triptych in Lisbon, however, was already documented as his work in 1585. Other works are assigned to him with considerable probability on the basis of engravings after the works. Coecke maintained a large studio; indeed, he apparently was the overseer of a factory of artists. Thus, his is usually a generic style rather than an individual manner.

Coecke's early works reflect the influence of Bernard van Orley and the Antwerp Mannerists, especially the Master of 1518. His later works absorbed the influence of Italian Renaissance artists, above all Leonardo, Raphael, and the latter's pupils. Coecke's own documented pupils include Willem van Breda (1529), Colyn van Nieucasteel (1539), Pieter Bruegel the Elder (c. 1540), Pieter Clays (1544), and Gillis de la Heele.

LITERATURE: Van Mander 1603–4, p. 218; F.J. van den Branden, *Geschiedenis der Antwerpsche Schilderschool* (Antwerp, 1883), pp. 150–58; Eduard Plietzsch in Thieme-Becker 1907–50, vol. 7 (1912), pp. 161–63; Max J. Friedländer, "Pieter Coecke von Alost," in *Jahrbuch der königlich preussischen Kunstsammlungen,* vol. 38 (1917); Paul Wescher, "Pieter Coecke als Maler," *Belvedere,* vol. 12 (1928), pp. 27–31; Max J. Friedländer, *Early Netherlandish Painting,* vol. 12, translated by Heinz Norden (Leiden, 1937; rev. ed., Leiden, 1975), pp. 32–39; 135–36; L. van Puyvelde, *Boletin da Academia Nacional de Belas-Artes,* vol. 4 (Lisbon, 1938), p. 62; August Corbet, *Pieter Coecke van Aelst* (Antwerp, 1950); Georges Marlier, *La Renaissance flamande: Pierre Coeck d'Alost* (Brussels, 1966).

22 FOLLOWER OF PIETER COECKE VAN AELST

ALTAR OF THE PASSION, c. 1532–35
Egg tempera on panel, wings 88½ x 42″ (224.8 x 106.7 cm.), predella panels 15½ x 66″ (39.4 x 167.6 cm.)
The George Grey Barnard Collection. 45-25-117

This carved altar shrine depicts scenes from the youth and the Passion of Christ with gilded figures carved in relief or, in part, fully detached. It also includes painted wings and predella panels. With the wings closed, six painted scenes appear on the outer doors. These are, left wing, upper register: the Temptation of Christ; lower register: the Baptism of Christ and the Raising of Lazarus; right wing, upper register: Christ and the Samaritan Woman; and lower register: Christ Healing the Blind and the Transfiguration.

closed

open

With the wings open, the painted left wing reveals in the uppermost corner Christ on the Mount of Olives (fig. 22A), and in the main register Christ Betrayed and Taken Prisoner (fig. 22B) and Christ before Pilate (fig. 22C). The narrative continues on the carved altar shrine with the sculpted scene of Christ Carrying the Cross. On corbels to the upper left and upper right of this scene, small figures depict subsidiary scenes: Abraham and Isaac Carrying Wood for the Sacrifice and the Sacrifice of Isaac. The main narrative then continues on the raised central scene of the Crucifixion. Under canopies in the gothic tracery of the frame of this scene, small figure groups depict, in the upper left: the Scouts Carrying the Grapes of Canaan; lower left: the Brazen Serpent; upper right: Samson Carrying away the City Gates of Gaza; and lower right: the Israelites Dancing around the Golden Calf. To the right of the Crucifixion, the main narrative continues with the Descent from the Cross. The attending small figure groups on corbels depict, on the left, Jonah Thrown to the Whale and, on the right, Jonah Escaping from the Whale. The narrative continues on the right wing with the painted scenes in the main register of the Entombment (fig. 22D) and the Resurrection (fig. 22E), ending in the upper corner with Christ Appearing to the Virgin (fig. 22F).

FIG. 22A Christ on the
Mount of Olives.

FIG. 22F Christ Appearing
to the Virgin.

FIG. 22B Christ Betrayed
and Taken Prisoner.

FIG. 22E The Resurrection.

FIG. 22C Christ before Pilate.

FIG. 22D The Entombment.

FIG. 22G The Annunciation.

FIG. 22H The Visitation.

FIG. 22I The Massacre of
the Innocents.

FIG. 22J The Rest on the
Flight into Egypt.

FIG. 22K The Meeting of Abraham
and Melchizedek.

FIG. 22L The Last Supper.

FIG. 22M The Israelites Collecting
Manna.

FIG. 22-1 *Retable of the Passion from the Church in Oplinter, Brabant* (with the wings open), c. 1530, oak, 114 x 99¼" (290 x 252 cm.), predella 32 x 100¼" (81 x 255 cm.), Musées Royaux d'Art et d'Histoire, Brussels, inv. no. 3196.

FIG. 22-2 *Retable of the Passion from the Church in Oplinter, Brabant* (with the wings closed).

The lower register of the opened wings depicts in the painted left wing the Annunciation (fig. 22G) and the Visitation (fig. 22H). Again the story continues in the sculpted shrine with scenes of the Adoration of the Shepherds, the Circumcision, and the Adoration of the Magi. On the right wing are painted scenes of the Massacre of the Innocents (fig. 22I) and the Rest on the Flight into Egypt (fig. 22J). The predella contains three painted scenes: the Meeting of Abraham and Melchizedek (fig. 22K), the Last Supper (fig. 22L), and the Israelites Collecting Manna (fig. 22M).

The upper parts of the six carved scenes are filled with delicate gothic tracery and canopies. On the inner frames separating the central scene from the flanking ones are two small statues of prophets. Elaborate tracery decorates the curved upper outline of the shrine.

This carved retable with painted wings and predella came from the chapel of the Château de Pagny, about thirty miles south of Dijon. The altarpiece was situated in the apse behind a choirscreen, also now preserved at the Philadelphia Museum of Art (no. 30-1-84); the two works are permanently installed in their appropriate relative positions. The altarpiece was probably placed in the chapel about 1535. At that time, the Château de Pagny belonged to Philippe Chabot, admiral of France and governor of Burgundy. While the circumstances of the commission are unknown, in several places the sculptured scenes carry the mark of approval of the Antwerp guild (a hand burned into the wood with a hot iron)—for example, the area just to the right of the fainting Virgin in the central Crucifixion. Behind the left wing of the retable is a second stamp—a tower with a hand on each side—which is also the town mark but signifies final approval of the work by the governors of the Guild of Saint Luke.[1]

This altarpiece is one of several surviving examples of a type of remarkably elaborate retable produced in Antwerp and exported throughout Europe. The carved altarpieces in the series that most closely resemble the Philadelphia work in style and conception are from churches in Enghien (Montmorency), Renlies, Oplinter (figs. 22-1 and 22-2), and Opitter in Belgium; in Baume-les-Messieurs in France (Jura); and in Ringsaker, Norway (fig. 22-3).[2] As Joseph Destrée observed in 1922, the iconographic program of the carved sections of the Pagny altarpiece also closely resembles the retables then in churches in Herbais-sous-Piétrain (now Musées Royaux d'Art et d'Histoire, Brussels, inv. no. 4009), and 's Heeren Elderen, Belgium, but he noted that the quality of the carving on the Pagny shrine far excelled these lesser examples.[3] In his catalogue to the George Grey Barnard Collection, Martin Weinberger discussed the extensive and unusually complete iconographic program of the Philadelphia altarpiece.[4]

With the wings closed, the work depicts the life of Christ before the Passion starting with the Baptism. When the wings are open, the main register depicts the Passion with corresponding Old Testament prefigurations. Christ Carrying the Cross is appropriately attended by the scene of Isaac Carrying Wood (Genesis 22:6). The Crucifixion is prefigured by several smaller scenes: the Sacrifice of Isaac (Genesis 22:9), the Scouts Carrying the Grapes of Canaan (Numbers 13:23), the Brazen Serpent (Numbers 21:8), and Jonah Thrown to the Whale (Jonah 1:15).

FIG. 22-3 *Retable from the Church at Ringsaker* (with the wings closed), c. 1530–35, oak, 78¾ x 78¾ (200 x 200 cm.), Ringsaker, Norway.

Christ in Limbo is prefigured by Samson Carrying away the City Gates of Gaza (Judges 16:3). The Resurrection is symbolized by Jonah Escaping from the Whale (Jonah 2:10). The Israelites Dancing around the Golden Calf (Exodus 32:19) is unusual in this context, but as Weinberger noted, it may in fact represent the Sacrifice of the Red Heifer (Numbers 19:2), which sometimes is a symbol of the Crucifixion.[5] The lower inside register of the altarpiece relates the Mariological cycle beginning with the Annunciation and ending with the Rest on the Flight into Egypt. The predella, in traditional fashion, emphasizes the idea of the Eucharist, with the Last Supper flanked by two Old Testament prototypes.[6]

The painting in the altarpiece is unequal to the quality of the superb carving, but, nonetheless, was reasonably attributed by Weinberger and Marlier to an artist from the studio or entourage of Pieter Coecke van Aelst.[7] The treatment of the figures, facial types, drapery, foliage, architecture, as well as decorative elements all reminded Marlier of Coecke; however, he emphasized that no single individual motif or part of the general, painted compositional scheme is directly based on the master's art. This is true even in cases where Coecke treated the same subject (for example, the Annunciation, the Rest on the Flight, Christ before Pilate, the Entombment and the Resurrection). Moreover, Marlier observed a clear departure from the master's style in the treatment of the predella, where the figures' faces seemed "too feminine" for Coecke. Thus, he hypothesized that the work was probably executed without the master's direct supervision, hence by an indepenent follower instead of an artist actually working in Coecke's studio. This unknown artist he christened the Master of the Pagny Retable, also attributing to his hand the painted panels of the altarpiece in Ringsaker, Norway (fig. 22-3).[8] Like the Pagny retable, the Ringsaker shrine carries the marks (hand and castle) of the Antwerp guild. The arrival of the Reformation in Norway in 1537 offers a *terminus post quem* for the installation of the altarpiece, known to have been commissioned around this time by the rector. A date of c. 1535 for the Ringsaker altarpiece would accord well with the date c. 1530–35 first proposed for the Pagny altarpiece by Weinberger. Marlier also attributed to his Master of the Pagny Retable a large triptych that surmounts the altar of Saint Apolline in the Church of St. Pierre in Turnhout.[9] In addition, he noted stylistic and compositional resemblances between the scene depicting Christ Healing the Blind in the Philadelphia picture and a panel depicting the same subject in the Guild Church of St. Ethelburga, London.[10]

Despite these various connections, the paintings that seem closest in style and design are still those of the anonymous Oplinter retable (figs. 22-1 and 22-2), a work that until now has only been discussed in its relation to the Pagny altarpiece's sculpture.[11] The paintings of the two works are comparable in their somewhat naive but singular interpretation of the Coecke manner. Although executed in the same stylistic idiom, the Ringsaker and Turnhout retables both exhibit a surer command of composition and the human form. Whether these qualities indicate a later development in the style of the same master is unclear.

NOTES

1. See David DuBon's general study of the chapel of the Château de Pagny and discussion of the guild marks, "A Note on the Pagny Retable," *Philadelphia Museum of Art Bulletin,* vol. 56, no. 267 (autumn 1960), p. 39, fig. 3.

2. Comte Joseph de Borchgrave d'Altena has discussed these works, cataloguing and describing the major examples in his studies, "Le Retable de Herbais-sous-Piétrain," *Bulletin des Musées Royaux d'Art et d'Histoire* (Brussels), 3rd ser., vol. 14 (1942), pp. 15–24; and "Notes pour servir à l'étude des retables anversois," pts. 1, 2, *Bulletin des Musées Royaux d'Art et d'Histoire* (Brussels), 4th ser., vol. 29 (1957), pp. 2–114, vol. 30 (1958), pp. 2–54. For reproductions of the altarpieces mentioned, see part 1 of De Borchgrave d'Altena's 1957 article: figs. 17, 53, 107, 108, and pt. 2, 1958, figs. 129, 141 (with wings open).

3. Joseph Destrée, "Un Retable anversois du commencement du XVIe siècle," *Annales de l'académie royale d'archéologie de Belgique,* vol. 70 (1922), pp. 407–15; see also de Borchgrave d'Altena's article (note 2), p. 22, no. 3.

4. Martin Weinberger, *The George Grey Barnard Collection* (New York, 1941), pp. 26–27, cat. no. 117A.

5. Ibid.

6. Compare the predella in Dirck Bouts's Louvain altar of the Last Supper.

7. Weinberger (see note 4), cat. no. 117A; Georges Marlier, *La Renaissance flamande: Pierre Coeck d'Alost* (Brussels, 1966), p. 406.

8. Marlier (see note 7), p. 408, fig. 369.

9. Weinberger (see note 4); Marlier (see note 7), pp. 409–10, figs. 370–72.

10. Marlier (see note 7), p. 411, fig. 375. He also attributed to the Master of the Pagny Retable a panel painted on both sides with the Birth of the Virgin and the Infant Jesus among the Doctors, which was in the sale at the Galerie Nackers, Brussels, November 18–December 16, 1961, as "Antwerp Master c. 1530," and two wings representing the Baptism of Christ and Christ Preaching from a Boat, which were with Julius Böhler, Munich, 1926 (photograph, Rijksbureau voor Kunsthistorische Documentatie, The Hague).

11. The Parisian sculptor Robert Moreau, who worked in Antwerp, has been connected uncertainly with the Oplinter carvings because of an inscription "MOREA" on the border of one of the figure's drapery; however, the painter's name is unknown (see Ghislaine Derveaux-van Ussel, *Retables en Bois, Musées Royaux d'Art et d'Histoire* [Brussels, 1977], pp. 12–13, figs. 26–30). The style of the paintings, however, is once again closely connected with Coecke van Aelst and his studio.

PROVENANCE: Chapel, Château de Pagny, near Dijon, France; transferred in the mid-nineteenth century by the Duc d'Uzès to Château de Wideville, Seine-et-Oise; "Château de W." sale, Galerie Georges Petit, Paris, April 25, 1921, lot 35; George Grey Barnard, New York; temporarily housed at The Cloisters, New York, after 1938; purchased with the Barnard Collection, 1945.

LITERATURE: Henri Baudot, "Description de la chapelle de l'ancien château de Pagny," *Mémoires de la commission des antiquités du département de la Côte-d'Or,* vol. 1 (1838–41), p. 351; P. Foisset, "La Chapelle de Pagny," *Mémoires de la société d'histoire . . . de Beaune* (1881), p. 98; Paul Court, "Vente du retable de la chapelle du château de Pagny," *Mémoires de la commission des antiquités du département de la Côte-d'Or,* vol. 17 (1913–21), pp. 583–87; Joseph Destrée, "Un Retable anversois du commencement du XVIe siècle," *Annales de l'académie royale d'archéologie de Belgique,* vol. 70 (1922), pp. 407–15; Martin Weinberger, *The George Grey Barnard Collection* (New York, 1941), pp. 26–27, cat. no. 117A, pl. XXXIII–XXXVI; Comte Joseph de Borchgrave d'Altena, *Les Retables Brabançons, 1450–1550* (Brussels, 1942), nos. 20, 21; Comte Joseph de Borchgrave d'Altena, "Le Retable de Herbais-sous-Piétrain," *Bulletin des Musées Royaux d'Art et d'Histoire* (Brussels), 3rd ser., vol. 14, no. 1 (January–February 1942), p. 22, fig. 23; "The George Grey Barnard Collection," *Philadelphia Museum Bulletin,* vol. 40, no. 205 (March 1945), n.p.; *Art News,* vol. 44, no. 18 (January 1–14, 1946), p. 12, repro.; David Rosen, "The Preservation of Wood Sculpture: The Wax Immersion Method," *The Journal of the Walters Art Galley,* vols. 13–14 (1950–51), pp. 63–67, figs. 26–28, 29; Comte Joseph de Borchgrave d'Altena, "Notes pour servir à l'étude des retables anversois," *Bulletin des Musées Royaux d'Art et d'Histoire* (Brussels), 4th ser., vol. 30 (1958), pp. 43–45, fig. 152; David DuBon, "A Note on the Pagny Retable," *Philadelphia Museum of Art Bulletin,* vol. 56, no. 267 (autumn 1960), pp. 37–41; PMA 1965, p. 13; Georges Marlier, *La Renaissance flamande: Pierre Coeck d'Alost* (Brussels, 1966), pp. 405–11, figs. 367–68.

CONDITION: The supports for the paintings are oak panels vertically disposed in the wings and horizontally disposed in the predella. Those paintings visible with the wings closed are faced with wax and tissue. All have scattered paint loss and significant areas of discolored retouches. The varnish is slightly discolored. The Baptism of Christ has a large vertical split in the center running top to bottom. The Raising of Lazarus has a vertical split left of center along a join in the support. In the right wing, Christ Healing the Blind also has a vertical split left of center along a join. The crack extends from the bottom edge to the center of the panel. Paint loss is extensive and retouched areas are discolored.

The Transfiguration has two splits, one from top to bottom along a join to the right of center, and a 16″ (40.6 cm.) vertical split further on the right, beginning 4″ (10.1 cm.) from the bottom edge and continuing to the center of the panel, ending in the waist of the saint at right.

With the wings open, the scenes in the uppermost register depicting Christ on the Mount of Olives and Christ Appearing to the Virgin are in relatively good condition with few losses. On the main and lower registers, the retouched losses are more extensive. Christ Betrayed and Taken Prisoner reveals active cleavage and paint loss along an opened central vertical join. The left third of the panel has a large horizontal loss through the knees of Christ and the soldiers. Minor losses are retouched and discolored. In Christ before Pilate the panels have shifted at the center vertical join. To the left is another split, extending from the top edge to the dog's nose. Paint losses are more extensive in the left half of the panel. The Entombment scene is in relatively good condition, although the vertical join has shifted slightly. A split in the upper left corner extends halfway down the panel. A small split begins at the bottom left edge. The number of old inpainted losses is limited. The Resurrection panel is in fairly good condition, with the join intact except at the bottom, extending through to the green foreground. Paint losses are largely limited to the lower left. The Annunciation panel has one vertical join. Losses and old retouches are in the Virgin's costume, below the angel on the left, and along all edges. The Visitation scene has one vertical join, which has separated and has several losses. There is tented cleavage through the foreground and middleground. The lower edge has been extensively retouched. The Massacre of the Innocents has one long vertical check at the left. The center vertical join has separated and shows scattered areas of lifting paint and discolored retouches. The single vertical join in the Rest on the Flight into Egypt has opened slightly with associated paint loss. Old losses and retouches are scattered throughout the panel. Retouches are discolored along the left edge and in the vertical losses in the lower center.

On the predella, the horizontal join running the width of the panel of Abraham and Melchizedek is retouched. The losses are considerable through the central portion of the panel. In the Last Supper the central horizontal join has shifted. Retouches are concentrated in the lower third of the painting and along the join. In the Israelites Collecting Manna the central join is retouched, as are numerous scattered losses. All the numerous retouches in the altarpiece have discolored to some degree. The paint has suffered in many places from overcleaning, evident in areas of local abrasion in each of the panels. The varnish remains relatively colorless.

Cornelis Cornelisz. (known as Cornelis van Haarlem) was born in 1562, the son of well-to-do parents in Haarlem. He first studied under Pieter Pietersz. from about 1572 to 1578 in Haarlem. Later he traveled by ship to France at the age of seventeen, but upon arrival at Rouen took refuge in Antwerp because of the plague. There he was a pupil of Gillis Coignet (1538–1599) for one year. He was back in Haarlem around 1580–81 and in 1583 was commissioned to paint a local militia company banquet (*Banquet of the Civil Guard at Haarlem,* 85¾ x 165¾" [218 x 421 cm.], Frans Halsmuseum, Haarlem, no. 51). The second (posthumous) edition of Karel van Mander's *Het Schilder-Boeck,* published in 1618, states that after Van Mander returned to Haarlem in 1583, he and Hendrik Goltzius (1558–1617) and Cornelis van Haarlem set up an academy to study from life. Much speculation has been offered as to the nature of this academy, which flourished in 1588–90 and perhaps survived until about 1600; however, it may only have been a loosely organized group of artists. In 1591 Cornelis painted *The Massacre of the Innocents* for the city of Haarlem, a project that was followed by many other municipal commissions. Sometime between 1593 and 1603 Cornelis married Maritgen Arentsdr. Deyman, daughter of a burgomaster. Although the couple were childless, Cornelis had an illegitimate daughter, Maria, who married the silversmith Pieter Jansz. Begijn, and who, in turn, was the mother of the painter Cornelis Bega (1631/32–1664). From 1613 to 1619 Cornelis was regent of the Old Men's Home and from 1626 to 1629, a member of the Catholic Saint Jacob's Guild. Together with other artists he established a new set of rules for the Guild of Saint Luke of Haarlem in 1630. Cornelis lived his entire life in Haarlem, dying there on November 11, 1638.

One of the leading practitioners of late Dutch Mannerism, Cornelis van Haarlem executed history paintings and a few portraits and genre scenes. His best-known religious and mythological works exhibit agitated figures, often with attenuated proportions and unnaturally luminous color schemes. Although a sizable body of his paintings survive (about two hundred and fifty), few of his drawings are known. From 1588 to 1602 he produced twenty-two print designs. Of his numerous students, only Gerrit Pietersz. Sweelinck (b. 1566) and to a lesser extent Cornelis Jacobsz. Delff (1571–1643) and Cornelis Engelsz. (1575–before 1653) still enjoy some renown.

LITERATURE: Van der Willigen (1870), 1970, pp. 114–16; F. Wedekind, *Cornelis Cornelisz. van Haarlem* (Leipzig, 1911); E. W. Moes in Thieme-Becker 1907–50, vol. 7 (1912), p. 427; C. J. Gonnet, "Cornelis Cornelisz. van Haarlem," *Oud Holland,* vol. 40 (1922), pp. 175–81; Wolfgang Stechow, "Zum Werk des Cornelis Cornelisz. van Haarlem," *Zeitschrift für bildende Kunst,* vol. 59 (1925–26), pp. 54–56; Wolfgang Stechow, "Cornelis van Haarlem en de Hollandsche laatmaniëristische schilderkunst," *Elseviers Geillustreerd Maandschrift,* vol. 90, (1935), pp. 73–91; J. Bruyn, "Een keukenstuk voor Cornelis Cornelisz. van Haarlem," *Oud Holland,* vol. 66 (1951), pp. 45–50; Pieter van Thiel, "De Madonna die het Kind een peer geeft, door Cornelis Cornelisz. van Haarlem," in *Jaarverslag Museum Amstelkring,* 1961–62, pp. 13–17; Pieter van Thiel, "Cornelis Cornelisz. van Haarlem as a Draughtsman," *Master Drawings,* vol. 3 (1965), pp. 123–54; G. Faggin, *Il Manierismo di Haarlem, I Maestri del Colore* (Milan, 1967); Pieter van Thiel, "Late Dutch Mannerism," in Blankert et al. 1980–81, pp. 77–85.

23 CORNELIS CORNELISZ.
VAN HAARLEM

CHRIST AS THE MAN OF SORROWS, 1597
Signed and dated lower left on stone: *C. Haerlemesis Ao. 1597–*
Oil on panel, 16¾ x 12⅜" (42.5 x 31.4 cm.)
Gift of Dr. and Mrs. Richard Levy. 68-182-1

Christ is depicted as the traditional Man of Sorrows, seated on the cold stone with instruments of the Passion—the column of the flagellation at the left, the crown of thorns, the reed used in the mocking of Christ, and the cross of the Crucifixion resting on his shoulder. The Man of Sorrows is a devotional image, not a depiction of a biblical event. The suffering Christ is detached from any spatial and temporal context. He is the Christ whose suffering brings man redemption, who lives and is the Redeemer present in his eternal suffering. This is the distinction between the Man of Sorrows and the figure of Christ in other devotional images centered on the Passion (Christ Carrying the Cross, Christ on the Column, and so forth). During the late Middle Ages, the devotional link between the image of the Man of

FIG. 23-1 Cornelis Cornelisz. van Haarlem, *Christ as the Man of Sorrows*, monogrammed and possibly dated 1636?, oil on panel, 13½ x 9¼" (34 x 23.5 cm.), location unknown.

FIG. 23-2 Cornelis Cornelisz. van Haarlem, *Christ as the Man of Sorrows*, monogrammed and dated indistinctly, oil on panel, 11 x 5½" (28 x 14 cm.), Duque de Aveiro, Malaga.

FIG. 23-3 Cornelis Cornelisz. van Haarlem, *Mary Mourning at the Foot of the Column*, monogrammed and dated indistinctly, oil on panel, private collection, Brussels.

Sorrows and the spectator was stronger, more immediate, and more urgent than that of any other religious theme and thereafter remained an image associated with great piety.[1]

As noted in the *Dutch Mannerism* catalogue of the 1970 exhibition at Poughkeepsie, the calm pose of the Christ figure in this work, the smooth surfaces, and the simplified composition are characteristics of Cornelis's more relaxed style following his break around 1594 with the tortured Mannerism that he, Hendrik Goltzius (1558–1617), and Karel van Mander had so admired in the art of Bartholomeus Spranger (1546–1611).[2] The painting is similar in conception and technique to several other small-scale, single-figure paintings on panel that Cornelis executed in these years.[3] He would return to the theme of the Man of Sorrows, possibly as late as forty years afterward, in another small panel (fig. 23-1).[4] There the composition (in reverse) closely resembles that of the present painting, but the cross is exchanged for other instruments of the Passion (nails, a hammer, a scourge), while a faintly described landscape appears in the distance. Another version of the theme, monogrammed and dated indistinctly by Cornelis, is in the collection of the Duque de Aveiro, Malaga (fig. 23-2).[5] Some memory of the figure of Christ in the Philadelphia painting, especially his lower quarters, may also be reflected in the figure of Adam in Cornelis's depiction of *The Fall*, dated 1622 (oil on canvas, 34¼ x 25¼ [87 x 64 cm.], Kunsthalle, Hamburg, no. 67). It was noted in the *Dutch Mannerism* catalogue that "a later painting by Goltzius, *Christ Crowned with Thorns* of 1607 in the Centraal Museum, Utrecht [oil on canvas, 47¾ x 34¼" (121 x 87 cm.), inv. no. 2510], is similar to [the Philadelphia] work in pose, facial expression, and elements of design and reflects the impact of Cornelis's art on Goltzius after the latter began to paint in 1600."[6] Goltzius's *Christ on the Cold Stone with Angels,* of 1602 (copper, 49½ x 37½" [126 x 95.5 cm.], Museum of Art, Rhode Island School of Design, Providence, no. 61.006) also may attest to Cornelis's influence.

When the Philadelphia picture was with the dealer Feigen in 1967, Pieter van Thiel plausibly suggested in a letter that it might be the companion piece to the painting *Mary Mourning at the Foot of the Column,* monogrammed "CVH" and indistinctly dated, then in a private collection in Brussels (fig. 23-3).[7] The subjects of the two works are related, and Mary's pose, seated and turned to the viewer's left with her hands crossed and gaze turned heavenward, could be designed to complement that of *Christ as the Man of Sorrows.*

NOTES

1. Albrecht Dürer appended a verse from Benedict Chelidonius to the image of the Man of Sorrows by the title page of his *Large Passion* series (1510)—a distant antecedent of the present image—which reads, in translation: "I bear these cruel wounds for thee, O Man! And I heal thy frailty with my blood. I heal thy wounds with my wounds, with my death I expiate thy death. I am God and have become man for thee. But thou dost not thank me. With thy sins thou often tearest open my wounds. I am still lashed for thy misdeeds. Have done now. I once suffered great torment from the Jews. Now, friend, let peace be between us." A large literature exists on the Man of Sorrows theme: see especially, H. Löffler, "Ikonographie des Schmerzensmannes," diss., Berlin, 1922; Wiltrud Mersmann, *Der Schmerzensmann* (Düsseldorf, 1952); R. Berliner, "Arma Christi," in *Münchner Jahrbuch der bildenden Kunst,* vol. 6 (1955), pp. 35–116; and Gertrude Schiller, *Iconography of Christian Art,* vol. 2 (Greenwich, Conn., 1972), p. 197.

2. Vassar College Art Gallery, Poughkeepsie, New York, *Dutch Mannerism: Apogee and Epilogue,* April 15–June 7, 1970, introduction by Wolfgang Stechow, p. 10.

3. See, for example, his *Apollo,* dated 1598, panel, 13½ x 9¼" (34 x 23.5 cm.), sale, Sotheby's, London, February 12, 1962, lot 13; engraved by Jacob Matham (see F.W.H. Hollstein, *Dutch and Flemish Etchings, Engravings and Woodcuts,* vol. 11 [Amsterdam, 1949], p. 227, no. 182).

4. Sale, Sotheby's, London, March 5, 1958, lot 46, as signed and dated 1603, but according to the photograph at the Rijksbureau voor Kunsthistorische Documentatie, The Hague, it is monogrammed and dated 1636.

5. See E. Valdivieso, *Pintura Holandesa del Siglo XVII en España* (Valladolid, 1973), p. 237, pl. 63, titled "Ecce Homo."

6. Vassar College Art Gallery (see note 2), p. 32; painting titled "Ecce Homo," in Centraal Museum, Utrecht, *Catalogus der Schilderijen* (Utrecht, 1952), p. 358.

7. Philadelphia Museum of Art, accession files. See S. Bergmans, "La Problème Jan van Hemessen, monogrammiste de Brunswick," *Revue Belge d'Archéologie et d'Histoire de l'Art,* vol. 24 (1955), p. 134, fig. 1, erroneously as by Catharine van Hemessen, and incorrectly identified as "La femme du Levite de Guibha," dated "156 . ."; according to Rijksbureau voor Kunsthistorische Documentatie, The Hague, first attributed to Cornelis van Haarlem by Horst Gerson.

PROVENANCE: Probably sale, Souterwoude, April 19, 1775, lot 31; sale, Christie's, London, February 9, 1925, lot 111 (to Moore); sale, Mensing, Amsterdam, February 25, 1941, lot 22; sale, Christie's, London, April 9, 1965, lot 6; Richard Feigen Gallery, Chicago and New York, by 1967 [sticker on reverse]; Dr. and Mrs. Richard Levy, New Orleans.

EXHIBITION: Vassar College Art Gallery, Poughkeepsie, New York, *Dutch Mannerism: Apogee and Epilogue,* April 15–June 7, 1970, introduction by Wolfgang Stechow, no. 29, pl. 22.

CONDITION: The uncradled panel support is in very good condition; however, it is not beveled on the right or top edges, perhaps indicating that it was cut slightly. The grain runs vertically. The paint film shows only minor abrasion and scattered, small losses; one slightly larger loss is inpainted in the drapery covering the upper-right corner of the stone. The varnish is clear.

JAN JOOST VAN COSSIAU c. 1660–1732/34

LITERATURE: Wurzbach 1906–11, vol. 1, p. 343; Thieme-Becker 1907–50, vol. 7 (1912), p. 512; Walther Bernt, *The Netherlandish Painters of the Seventeenth Century,* translated by P. S. Falla (London, 1970), vol. 1, p. 26; Luigi Salerno, *Pittori di paesaggio del Seicento a Roma (Landscape Painters of the Seventeenth Century in Rome),* translated by Clovis Whitfield and Catherine Enggass (Rome, 1977–78), vol. 2, pp. 530, 880–81, vol. 3, pp. 1012, 1138 [as Gio. Coscio Fiamengo].

Born in Breda about 1660, Jan Joost van Cossiau painted classical landscapes with historical staffage in a style reminiscent of Gaspard Dughet (1615–1675). He may have been active in Paris (his *Country Fete,* oil on canvas, 48 x 44" [122 x 112 cm.], is in the Trianon, Versailles) and perhaps is identifiable with "Giovani Judoco de Corsican," who was a member of the Accademia dei Virtuosi al Pantheon in 1695 in Rome. In 1699 he exhibited five paintings on the feast day of Santa Maria di Loreto. Later he worked in Germany, where he was a court painter in Frankfurt, Bamberg, and Pommersfelden; at Pommersfelden he was also gallery director. Cossiau published a catalogue of the gallery at Gaybach (*Delitiae imaginum* [Bamberg, 1721]). He died in Mainz in 1732 or 1734.

24 JAN JOOST VAN COSSIAU

IMAGINARY HARBOR SCENE WITH RUINS, early eighteenth century
Oil on canvas, 12 x 20⅛″ (30.5 x 51.1 cm.)
Bequest of Robert Nebinger. 89–139

The theme of an imaginary Claudian harbor with tall columns and genrelike staffage recalls seicento ideals of classical landscape, but the decorative quality of the painting betrays its late origins. The painting is later than the *Mountain Landscape* of 1690 (Staatsgalerie, Bamberg) and the Italianate landscape pendants of 1704,[1] but perhaps not as late as the group of nine large, idealized landscapes, including a series of the times of day, dating from 1721 to 1729, preserved at the Staatsgalerie in Schloss Johannisburg, Aschaffenburg.[2]

NOTES

1. *Italianate Landscape with a Village,* signed and dated 1704, oil on canvas, 42½ x 55⅛″ (108 x 140 cm.), Herzog Anton Ulrich Museum, Brunswick, no. 405 (repro. in Luigi Salerno, *Pittori di paesaggio del Seicento a Roma* [*Landscape Painters of the Seventeenth Century in Rome*], translated by Clovis Whitfield and Catherine Enggass [Rome, 1977–78], vol. 2, p. 881, no. 164.2); and *Italianate Landscape with Pyramid,* signed and dated 1704, oil on canvas, 42½ x 55⅛″ (108 x 140 cm.), Herzog Anton Ulrich Museum, Brunswick, no. 406 (repro. in Walther Bernt, *The Netherlandish Painters of the Seventeenth Century,* translated by P. S. Falla [London, 1970], vol. 1, no. 262).

2. *Morning,* 1722, oil on canvas, 47½ x 54½″ (120.6 x 138.6 cm.); *Midday,* 1723, oil on canvas, 47½ x 54½″ (120.8 x 138.5 cm); *Afternoon,* 1728, oil on canvas, 48 x 54¾″ (121.8 x 139.1 cm.); *Evening,* 1727, oil on canvas, 47¾ x 54¾″ (121.5 x 139.4 cm.). Other idealized landscapes also in the museum's collection are *Ideal Landscape with the Stigmatization of Saint Francis,* 1721, oil on canvas, 58¾ x 38½″ (149.3 x 97.6 cm.); *Landscape with the Parable of the Wise and Foolish Virgins,* 1721, oil on canvas, 55¾ x 49¾″ (141.6 x 126.5 cm.); *Ideal Landscape with an Imaginary Town,* 1729, oil on canvas, 30½ x 43½″ (77.8 x 110.4 cm.); *Ideal Landscape with Village,* 1729, oil on canvas, 30½ x 43½″ (77.3 x 110.4 cm.); and *Wooded Landscape,* oil on canvas, 40 x 48½″ (101.8 x 123 cm.).

PROVENANCE: Robert Nebinger.

LITERATURE: PMA 1965, p. 15.

CONDITION: The canvas support is dry and slightly out of plane. Some minor abrasion to the paint film appears along the edges. The varnish is deeply discolored.

A portraitist, Dubordieu was born in Lille-Bouchard in Touraine. In 1664 he claimed to be fifty-five years old; hence he was born in 1609 or 1610. Like his fellow Frenchmen Durispy and the Rembrandt pupils Isaack de Jouderville (c. 1612–c. 1645) and Jacques de Rousseau (d. 1636), he moved at an early age to Leiden, where he was living "op 't plein voor 's Gravensteyn" when he was married in the Hooglandse Kerk on December 27, 1633, to Mary Le Febre, a woman from Rouen then living on the Breestraat. The couple had five or possibly six children. On June 5, 1636, he became a citizen of Amsterdam, but in 1637 was living again in Leiden on the Steenschuur when he baptized a child in the Walloon church. He seems to have remained in Leiden for the rest of his life. In 1639, claiming ill health, he refused to serve in the militia and was forced to pay a yearly fee instead; several later documents concern nonpayment of these costs. He requested permission in 1646 to organize an auction of paintings by "renowned" artists, and on March 18, 1648, he paid his entry fee to the guild. In 1651 he announced that he was retiring as a painter but in 1665 rejoined the guild (he was active until 1676). He reappears in documents in Leiden until 1678. His wife ran a school for young girls. In 1656 his house burned and all his possessions were lost. A document dated the following year referring to nonpayment of militia fees suggests that Dubordieu was suffering financial hardship but was indisposed to work with his hands. He had an interest in a scarlet dyeworks (*scharlakenververij*) in Amsterdam in the 1640s, which he gave up in 1649 only to build a new dyeworks in the same year with a certain David de Potter on the corner of the Paardesteeg near the Bostelbrug in Leiden. This business seems also to have fallen on hard times, and Dubordieu was forced to turn it over to one of his creditors in 1661 (archival material provided by P.J.M. de Baar of the Leiden Archives).

Dubordieu painted portraits of the professors at Leiden University. He also portrayed the Leiden burgomaster Jan Jansz. Orlers in 1640 (oil on canvas, 23⅝ x 20¼″ [60 x 51.5 cm.], Stedelijk Museum "de Lakenhal," Leiden, no. 87) and was commissioned to paint portraits of both Prince Willem II and III (destroyed in the 1929 fire in the Leiden town hall). His portraits were engraved by Suiderhof, Natalis, and Matham. His work bears some resemblance to the formal portraits of Michiel Jansz. van Miereveld (1567–1641) and Jan Anthonisz. van Ravesteyn (c. 1572–1657) but also reflects his Franco-Flemish origins.

LITERATURE: W.I.C. Rammelman Elsevier in *De Navorscher,* vol. 20 (1870), pp. 355–57; Abraham Bredius in Thieme-Becker 1907–50, vol. 10 (1914), p. 1; W. Martin, "Some Portraits by Pieter Dubordieu," *The Burlington Magazine,* vol. 41, no. 236 (1922), pp. 217–18; J. H. Kernkamp, "De Famille-portretten uit de collectie De la Court," in *Dancwerc, opstellen aangeboden aan Prof. Dr. D. Th. Enklaar ter gelegenheid van zijn vijfenzestigste verjaardag,* edited by J. B. Wolters (Groningen, 1959), pp. 290–304.

25 PIETER DUBORDIEU

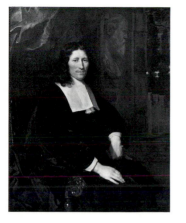

FIG. 25-1 Abraham van den Tempel, *Portrait of Pieter de la Court the Younger,* signed and dated 1667, oil on canvas, 52⅜ x 41¾″ (133 x 106 cm.), Rijksmuseum, Amsterdam, no. A2243.

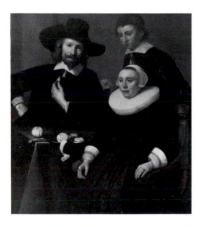

FIG. 25-2 Pieter Dubordieu, *Portrait of an Unidentified Family,* signed and dated 1637, 48 x 44½″ (122 x 113 cm.), location unknown.

PORTRAIT OF PIETER DE LA COURT, 1635
Monogrammed lower right: *P D* (ligated) *fecit;* inscribed upper left:
 AETATIS 42; dated upper right: *AN1635.*
Oil on panel, 45½ x 33⅛″ (115 x 84 cm.)
Purchased for the W. P. Wilstach Collection. W04-1-63

A man in a white millstone collar and black costume is viewed three-quarter length and turned to the right. His right hand is placed on his hip, and his left hand holds a pair of gloves. At the right on a table is a book with an hourglass on top of it.

The sitter is Pieter de la Court, who was born on May 8, 1590, in Yperen, Belgium, and died on May 6, 1657.[1] He was the son of Jacob de la Court, a farmer and innkeeper in Yperen, and Pieronne Beghin. His chief fame is as the father of the renowned political economist and writer Pieter de la Court the Younger (1618–1685; fig. 25-1), who was a central figure in Jan de Witt's regime (1653–72).[2] Fleeing religious persecution, the elder Pieter de la Court settled in Leiden by 1613 and soon prospered in the textile (*lakens;* wool, linen, silk) and grain trade. By 1630 he was one of the most prominent merchants in Leiden and lived on the prestigious Breestraat, near the town hall. He was married on April 9, 1616, to Jeanne de Planque (1591–1663), a woman also from the south—Marck near Lille. The couple had eight children. His wife's portrait (no. 26) was executed by Dubordieu as a pendant to the present work. Viewed three-quarter length and turned slightly to the viewer's left, with her right hand resting on a book and her left hand holding a glove, the wife's pose complements her husband's. The style of these works closely resembles that of other paintings by the artist from the mid-1630s, such as the family portrait of 1637 (fig. 25-2).

A second pair of bust-length portraits of De la Court and his wife (figs. 25-3 and 25-4), which, to judge from the ages of the sitters, probably originated about a decade later, also came from the same eighteenth-century collection of De la Court portraits as these. The unsigned pendants were correctly attributed to Dubordieu by J. H. Kernkamp and Albert Blankert.[3] These four works are the only known certain portraits of the sitters. Yet another painting by Dubordieu, dated 1629, has also been said to depict De la Court, but this identification is unlikely since, as C. Willemijn Fock and R.E.O. Ekkart observed, the man portrayed looks older than the sitter in the Philadelphia portrait of 1635.[4]

The present panel has the coat of arms of the De la Court family (azure, three mallets bendwise, a chief indented argent) painted on the reverse and beneath it the identification of the sitter as Pieter de la Court, husband of "Jaene la Planche." Together with its pendant, the bust-length portraits mentioned above, as well as other family portraits by Nicolaes Maes (q.v.), Abraham van den Tempel (1622/23–1672), Godfried Schalcken (1643–1706), Willem van Mieris (1662–1747), and others, it remained in the De la Court family collection for more than two and a half centuries. It was copied in a drawing in the family album of Willem Backer (1656–1731), the husband of the sitter's grandchild, Magdalena. It was also mentioned by Allard de la Court, son of the enormously wealthy textile magnate Pieter de la Court van der Voort, in an inventory of 1749.[5] Subsequently it was owned by descendants until 1904, when it was put up for sale in Amsterdam and immediately purchased for the W. P. Wilstach Collection. By 1894, however,

FIG. 25-3 Pieter Dubordieu, *Portrait of Pieter de la Court the Elder,* c. 1645–50, oil on canvas, 25⅛ x 20⅞″ (64 x 53 cm.), Backer-Stichting, Amsterdam, on loan to the Amsterdams Historisch Museum, Amsterdam, no. B2527.

FIG. 25-4 Pieter Dubordieu, *Portrait of Jeanne de Planque,* c. 1645–50, oil on canvas, 24¾ x 20⅞″ (63 x 53 cm.), Backer-Stichting, Amsterdam, on loan to the Amsterdams Historisch Museum, Amsterdam, no. B2528.

when it was exhibited in Utrecht as a work from the School of Rembrandt, the artist's name had been forgotten. Its pendant was shown in 1903 in The Hague, and C. Hofstede de Groot, writing in the German edition of the catalogue, recalled that when the present work had been exhibited nine years earlier it had borne a monogram that he had deciphered as the initials "J.R." intertwined. This conjecture resulted in the portrait's being catalogued and discussed for years as a work by the anonymous monogrammist "J.R.," whom Hofstede de Groot had independently identified as Jacques de Rousseaux (d. 1636).[6] Writing in the Wilstach Collection catalogue of 1922, Maurice W. Brockwell attributed the work to Jan Anthonisz. van Ravesteyn (c. 1572–1657), a portraitist who worked for the court in The Hague.[7] He also tentatively identified the sitter as Pieter de la Court but openly questioned the inscription on the reverse because he assumed that the sitter was the son and not the father, hence too young to have been portrayed as a grown man in 1635. Arthur Edwin Bye corrected this mistake in his critical notes published in brackets beneath Brockwell's entry in the 1922 Wilstach catalogue.[8] In 1959 J. H. Kernkamp pointed out that the interpretation of the monogram as "J.R." in the present work, and "R" in the case of its pendant, was probably a misreading of the initials "P" and "D" intertwined with "f(ecit)."[9] Although Kernkamp's basic theory was correct, it must be noted that *fecit* is fully written out in the Philadelphia portrait of De la Court.

The book next to the man, like the hourglass resting upon it, may be a traditional *vanitas* symbol of the vanity of human knowledge. Motifs such as the gloves held casually in De la Court's hand and the position of his arm placed akimbo were part of the standard repertory of poses employed by Northern Baroque portraitists to enliven their subjects. To remove one's gloves was a traditional symbol of peaceful intentions, candor, and sincerity.[10]

At some time in the past the top of the present panel was arched. The pendant, however, proves that the original format of the pair was rectangular.

NOTES

1. The date of birth, May 8, 1590, is recorded in the family genealogies, as C. Willemijn Fock and R.E.O. Ekkart have observed ("De portret-galerij van de familie de la Court," *Jaarboek van het Centraal Bureau voor Genealogie,* vol. 35 [1981], p. 188, cat. no. 1); however, a document dated September 3, 1643, preserved in the Leiden notarial archives (inv. 573, no. 78), records that De la Court was then fifty years old. This document, supported by the inscription and date on the present painting (forty-two years old in 1635), suggests that he was born in 1593.

2. See also the portrait of Pieter de la Court the Younger by Godfried Schalcken (1643–1706) of 1679, oil on panel, 16¾ x 13⅜″ (42.5 x 34 cm.), Stedelijk Museum "de Lakenhal," Leiden, no. 382. Ferdinand Bol's (1616–1680) double portrait of a *Couple in a Landscape* of 1661, oil on canvas, 68 x 82¼″ (173 x 209 cm.), Museum voor Schone Kunsten, Antwerp, no. 812, has also been identified as a marriage portrait of De la Court and his second wife Catharina van der Voort (see Jhr. F.G.L.O. van Kretschmar, "Identificatie van het dubbel portret van Ferdinand Bol in het Koninklijk Museum voor Schone Kunsten te Antwerpen," *Jaarboek, van het Koninklijk Museum voor Schone Kunsten te Antwerpen* [Antwerp, 1966], pp. 215–17, repro.); Albert Blankert, however, rejects the identification; see *Ferdinand Bol (1616–1680): Rembrandt's Pupil,* translated by Ina Rike (Doornspijk, 1982), no. 173. On Pieter de la Court the Younger and his economic theories, see T. van Tijn, "Pieter de la Court, zijn leven en zijn economische denken," *Tijdschrift voor Geschiedenis,* vol. 69 (1956), pp. 304ff.

3. J. H. Kernkamp, "De Famille-portretten uit de collectie De la Court," in *Dancwerc, opstellen aangeboden aan Prof. Dr. D. Th. Enklaar ter gelegenheid van zijn vijfenzestigste verjaardag,* edited by J. B. Wolters (Groningen, 1959), figs. 3 and 4; and Albert Blankert, *Amsterdams Historisch Museum: Schilderijen daterend van voor 1800* (Amsterdam, 1975–79), nos. 119 and 120.

4. Oil on canvas, 29⅛ x 20⅞″ (74 x 53 cm.), sale, F.J.E. van Lennep, Christie's, Laren, October 20, 1980, lot 215, repro. See C. Willemijn Fock and R.E.O. Ekkart (note 1), p. 188 n. 4.

5. No. "9 Dito ['t Portrait] van Pieter de la Court, leevensgroote, halve lijff, man van Jeanne la Planque, door Du Bordieu"; no. 10 was the pendant. G. A. Leiden, Bibliotheek Leiden, no. 75651.

6. C. Hofstede de Groot, ed., *Meisterwerke der Porträtmalerei auf der Ausstellung im Haag, 1903* (Munich, 1903), p. 31, under cat. no. 91.

7. Maurice W. Brockwell in Wilstach 1922, no. 251.

8. Arthur Edwin Bye in Wilstach 1922, no. 251.

9. Kernkamp (see note 3), p. 295.

10. On the iconography of the glove, see David R. Smith, *Masks of Wedlock: Seventeenth-Century Dutch Marriage Portraiture* (Ann Arbor, 1982), pp. 72–81.

PROVENANCE: By descent with its pendant (no. 26) to Pieter de la Court van der Voort (1664–1739), the sitter's grandson, Leiden [inventories of c. 1710, 1731, and 1739, housed at the Leiden Municipal Archives]; his daughter, Adriana Catharina de la Court (1690–1752), 1740; Allard de la Court (1688–1755) [inventory of 1749, no. 9, G.A. Leiden, Bibliotheek Leiden, no. 75651], Leiden; by descent to Dowager De la Court-Ram, Utrecht, 1894; sale, "Collection de tableaux anciens de feu M. le Dr. A. H. van der Burgh à la Haye; Galerie de portraits de la Famille—De la Court," F. Muller, Amsterdam, September 21, 1904, lot 96; purchased for the W. P. Wilstach Collection, Philadelphia, 1904.

EXHIBITIONS: Kunstliefde Museum, Utrecht, *Catalogus der tentoonstelling van oude schilderkunst te Utrecht,* August 20–October 1, 1894, no. 419 [as School of Rembrandt].

LITERATURE: C. Hofstede de Groot, ed., *Meisterwerke der Porträtmalerei auf der Ausstellung im Haag, 1903* [Munich, 1903], p. 31, under cat. no. 91 [as the pendant of Haagsche Kunstkring, The Hague, *Catalogus van de tentoonstelling van Oude Portretten,* July–September 1, 1903]; Wilstach 1906, no. 153 [as Master J.R.?], 1907, no. 162 [as Master J.R.?], 1910, no. 213 [as Master J.R.?], repro., 1913, no. 224 [as Master J.R.?], repro., 1922, no. 251 [as Jan Anthonisz. van Ravesteyn]; *A Picture Book of Dutch Painting of the XVII Century* (Philadelphia, 1931), p. 7, fig. 13 [as Jan Anthonisz. van Ravesteyn]; Horst Gerson in Thieme-Becker 1907–50, vol. 27 (1933), p. 54 [as unknown Monogrammist J.R.?]; Horst Gerson in Thieme-Becker 1907–50, vol. 29 (1935), p. 113; J. H. Kernkamp, "De Famille-portretten uit de collectie De la Court," in *Dancwerc, opstellen aangeboden aan Prof. Dr. D. Th. Enklaar ter gelegenheid van zijn vijfenzestigste verjaardag,* edited by J.B. Wolters (Groningen, 1959), pp. 290–304, fig. 1; PMA 1965, p. 19 [as Pieter Dubordieu]; Albert Blankert, *Amsterdams Historisch Museum: Schilderijen daterend van voor 1800* (Amsterdam, 1975–79), p. 86; C. Willemijn Fock and R.E.O. Ekkart, "De portret-galerij van de familie de la Court," *Jaarboek van het Centraal Bureau voor Genealogie,* vol. 35 (1981), pp. 188–89, cat. no. 1.

CONDITION: The panel support is composed of three planks running vertically with an addition at the top. The support is reinforced with horizontal aluminum strips and sealed at the back with wax. The top edge was arched at one time, and wood inserts 2¾″ (7 cm.) high were added to convert the panel to a rectangular format. The support shows evidence of insect damage; there are two vertical 6″ (15.2 cm.) cracks at the top, and the edges are abraded. The paint film has several old losses along the right edge, which have been retouched. The inserts at the top are also filled and retouched; otherwise only scattered, small losses appear throughout. The varnish is slightly discolored.

25 PIETER DUBORDIEU

PORTRAIT OF PIETER DE LA COURT, 1635
Monogrammed lower right: *P D* (ligated) *fecit;* inscribed upper left:
 AETATIS 42; dated upper right: *AN1635.*
Oil on panel, 45½ x 33⅛″ (115 x 84 cm.)
Purchased for the W. P. Wilstach Collection. W04-1-63

27 ALBERT GUSTAF ARISTIDES
EDELFELT

SHORE SCENE WITH TWO BOYS ON A LOG (THE LITTLE BOAT), 1884
Signed and dated lower right: *A. EDELFELT 1884*
Oil on canvas, 35½ x 42¼" (90.2 x 107.3 cm.)
The W. P. Wilstach Collection. W06-1-9

Two blond and barefoot boys recline on a log while playing with a toy
sailboat in the water below them. In the distance is a harbor with tall sailing
ships. The original title of this anecdotal genre scene may have been *The
Little Boat*, which was the name it carried when catalogued for John G.
Johnson in 1892, just eight years after its execution. The Johnson catalogue
for 1892 states that the work was engraved by the Parisian wood engraver
Charles Baude (b. 1853) and appeared in the Paris Salon in 1885. The theme
of boys playing, or simply lolling, at the Scandinavian shore was one of
Edelfelt's favorites. The bright daylight and limpid atmosphere of the
painting are characteristic of the artist's work.

PROVENANCE: John G. Johnson,
Philadelphia; gift of John G. Johnson to the
W. P. Wilstach Collection, Philadelphia,
October 1906.

EXHIBITION: Paris, Salon, 1885, no. 914.

LITERATURE: *Catalogue of a Collection
of Paintings Belonging to John G. Johnson*
(Philadelphia, 1892), no. 92; Wilstach 1907,
no. 109, 1908, no. 109, 1910, no. 137, 1913,
no. 141, 1922, no. 110; PMA 1965, p. 24.

CONDITION: The unlined canvas support
has two small punctures, previously repaired,
in the sky at the upper left. The paint film is
in stable condition with some traction crackle
and stretcher marks. There are two flake
losses along the upper edge and a few along
the bottom edge. Retouches are limited to
the areas of the old punctures. The varnish is
moderately discolored.

Albert Edelfelt was born in the vicinity of Borgå, Finland, on July 21, 1854. He was the son of the well-to-do, Swedish-born architect Carl Albert Edelfelt. His art studies began at the fine arts association, Helsinki. In 1873 he enrolled in the academy in Antwerp and from 1874 to 1877 studied under Jean Léon Gérôme (1824–1904) at the Ecole des Beaux-Arts, Paris. His first works were historical genre pieces, like the *Queen Blanka,* with which he made his debut at the Paris Salon in 1877. These works quickly served to establish his reputation in Scandinavia and northern Europe. Subsequently, he painted open-air scenes, often of Finnish farm life. These have less in common with Impressionist landscapes than with the works of Jules Bastien-Lepage (1848–1884). Edelfelt also painted portraits, genre scenes, religious subjects, and fantasies. He exhibited in Paris throughout the 1880s and 1890s, winning a Grand Prix at the 1889 Paris Exposition Universelle. His influence on younger Scandinavian artists was considerable. A strong advocate of Finnish national art, Edelfelt began incorporating native Finnish themes in his work by the mid-1880s. When Finland came under Russian imperial rule in 1899, Edelfelt helped to persuade officials at the Paris Exposition Universelle Centennale of 1900 to permit Finland its own pavilion separate from that of Russia. In the same year, he illustrated *Tales of Ensign Stål,* a collection of patriotic poems by the Finnish poet laureate Johan Ludvig Runeberg. In 1904 he executed murals for the University of Helsinki. Edelfelt's death, mourned throughout Finland, came at his summer villa near Borgå on August 18, 1905. An extensive monographic retrospective of his work was held in Helsinki in 1913.

LITERATURE: Boetticher (1891–1901) 1969, vol. 1, p. 268; J. Ahrenberg, *Ljus* (Stockholm, 1902); G. Strengell, *Finska mästare* (Helsinki, 1906); *Albert Edelfelt,* Små kunstböocker, no. 12 (Lund, 1911); J. J. Tikkanen in Thieme-Becker 1907–50, vol. 10 (1919), pp. 335–37; Carl Laurin, Emil Hannover, and Jen Thiis, *Scandinavian Art* (New York, 1922); Jukka Ervamaa, "Albert Edelfelt's *The View from Kankola Ridge,"* *Ateneumin Taidemuseo Museojulkaisu,* vol. 20 (1975–76), pp. 42–59; Salme Sarajas-Korte, "The Norwegian Influence in Finland in the Early 1890s," *Ateneumin Taidemuseo Museojulkaisu,* vol. 21 (1977–78), pp. 45–48; Kirk Varnedoe, *Northern Light: Realism and Symbolism in Scandinavian Painting, 1880–1910* (Brooklyn, 1982), pp. 86–91.

FIG. 26-1 Pieter Dubordieu, *Portrait of a Woman*, signed and dated 1637, oil on panel, 28 x 23¼″ (71 x 60.5 cm.), Rijksmuseum, Amsterdam, no. A4221.

The subject is posed three-quarter length and turned slightly to the viewer's left. She wears a starched white cap, a broad millstone ruff, and white lace cuffs over an embroidered black dress. Her left hand holds a pair of gloves; her right hand rests on a small prayer book lying on a table.

The subject is Jeanne de Planque, who was born in Marck near Rijssel in 1591. She died in Leiden on April 9, 1663. Jeanne was married in the Franse Kerk, Leiden, on April 9, 1616, to Pieter de la Court; her niece Pyroone Fortye served as a witness.

The portrait is the pendant to the preceding painting (no. 25). After nearly eighty years of separation, the pair were reunited in 1982, when this portrait was purchased by the Museum. Along with a pair of later bust-length portraits in the Backer-Stichting (figs. 25-3 and 25-4), these are the only known portraits of the sitters. The *Portrait of a Woman*, dated 1637 (fig. 26-1) in the Rijksmuseum, Amsterdam, has been improbably identified as Jeanne de Planque, presumably on the basis of its resemblance to the sitter in the Philadelphia painting.[1] Identification of both the Amsterdam painting and its pendant[2] with Jeanne de Planque and Pieter de la Court seems highly unlikely, however.

A drawn copy of the present work is preserved in the family album of Willem Backer (1656–1731), the husband of the sitter's grandchild, Magdalena.

NOTES
1. "Keuze uit de aanwinsten," *Bulletin van het Rijksmuseum*, vol. 20 (1972), p. 182, fig. 3 [as portrait of "Janneke des Planques" (1591–1663), wife of Pieter de la Court (1580–1657)]; Amsterdam, Rijksmuseum, no. A4221; however, in *All the Paintings of the Rijksmuseum in Amsterdam* (Amsterdam, 1976), p. 202, by Pieter van Thiel et al., it is simply identified as *Portrait of a Woman*.
2. Oil on canvas, 29⅛ x 20⅞″ (74 x 53 cm.), sale, F.J.E. van Lennep, Christie's, Laren, October 20, 1980, lot 215, repro.

PROVENANCE: By descent with its pendant (no. 25) to Pieter de la Court van der Voort (1664–1739), the sitter's grandson, Leiden [inventories of c. 1710, 1731, and 1739, housed at the Leiden Municipal Archives]; his daughter, Adriana Catharina de la Court (1690–1752), 1740; Allard de la Court (1688–1755) [inventory of 1749, no. 10, G.A. Leiden, Bibliotheek Leiden, no. 75651], Leiden; Collection "Y.Y.," London, by 1903; sale, Rutley et al., London, June 8, 1923, lot 98; Comte Guizard Collection [according to Rijksbureau voor Kunsthistorische Documentatie, The Hague]; J. M. Carger, Cumberland Court, London, 1946; dealer P. de Boer, Amsterdam; private collection, Amsterdam; purchased 1982.

EXHIBITION: Haagsche Kunstkring, The Hague, *Catalogus van de tentoonstelling van Oude Portretten*, July 1–September 1, 1903, no. 91 (catalogue by C. Hofstede de Groot).

LITERATURE: C. Hofstede de Groot, ed., *Meisterwerke der Porträtmalerei auf der Ausstellung im Haag, 1903* (Munich, 1903), p. 31, cat. no. 91, pl. 41; Horst Gerson in Thieme-Becker 1907–50, vol. 29 (1935), p. 113; J. H. Kernkamp, "De Familie-portretten uit de collectie De la Court," in *Dancwerc, opstellen aangeboden aan Prof. Dr. D. Th. Enklaar ter gelegenheid van zijn vijfenzestigste verjaardag*, edited by J. B. Wolters (Groningen, 1959), pp. 293–95, fig. 2; Albert Blankert, *Amsterdams Historisch Museum: Schilderijen daterend van voor 1800* (Amsterdam, 1975–79), p. 86; C. Willemijn Fock and R.E.O. Ekkart, "De portret-galerij van de familie de la Court," *Jaarboek van het Centraal Bureau voor Genealogie*, vol. 35 (1981), pp. 189–90, cat. no. 3, fig. 2.

CONDITION: The oak panel support is constructed of three pieces with a vertical grain. It has been thinned by about ⅛″ (3 mm.) and glued to an oak panel of about ¼″ (5 mm.) thickness. Traces of an inscription seem to be visible in an area in the upper center (corresponding to the inscribed area on the reverse of the pendant), which has been preserved in its original thickness. Some planar irregularities are evident in the support, especially along the joint left of center. The paint film has repainted passages along the joints in the support. Several inpainted scratches appear in the upper right, and small retouched losses are scattered throughout. The discolored varnish was selectively cleaned about the subject's head and face before the work was acquired in 1982.

26 PIETER DUBORDIEU *PORTRAIT OF JEANNE DE PLANQUE*, 1635
 Monogrammed lower left: *P D* (ligated); inscribed upper left:
 AETATIS 43; dated upper right: *A°1635*
 Oil on panel, 44⅞ x 32⅞″ (114 x 83.5 cm)
 Purchased: The George W. Elkins Fund. E1982-1-1

Gerbrand van den Eeckhout was born in Amsterdam on August 19, 1621, the son of a goldsmith, Jan Pietersz. van den Eeckhout, and Grietie Claes Lydeckers. According to Arnold Houbraken, he was one of the best pupils and a "great friend" of Rembrandt. The dates of this period of study have not been pinpointed, but most writers suggest the later 1630s. His earliest dated paintings are of 1640/41. Little is known of his life; he served as a tax appraiser of art works in 1659, 1669, and 1672, and seems to have been an amateur poet. In 1654 he sent a poem to the Amsterdam poet Jacob Heyblock and in 1657 composed a hymn of praise to his friend the Amsterdam landscape painter Willem Schellinks (1627–1678). Van den Eeckhout never married and evidently remained his entire life in Amsterdam, where he was buried in the Oudezijds Kapel on September 29, 1674.

Primarily a painter of history subjects, Van den Eeckhout also executed genre scenes, portraits, and *portraits historiés*. His history-painting style owes much to Rembrandt in its chiaroscuro effects, broad execution, and approach to narration. The last mentioned is also indebted to the narrative techniques of Pieter Lastman (1583–1633), Rembrandt's teacher. Van den Eeckhout's biblical paintings tend to be more Rembrandtesque than his mythological subjects. His portraits reflect Rembrandt's impact in lighting and the handling of paint but adopt the more conventional poses of Amsterdam portraiture of the period. Noteworthy among his group portraits are two large paintings of the officers of the Amsterdam coopers' and wine-rackers' guild dated 1657 and 1673 (oil on canvas, 64⅛ x 77½″ [163 x 197 cm.], National Gallery, London, no. 1459; and oil on canvas, 83⅛ x 99½″ [211.3 x 253 cm.], Dienst Verspreide Rijkskollekties, The Hague, inv. no. NK2378). Van den Eeckhout's genre scenes are more innovative. While his scenes of soldiers relaxing in interiors dating from 1651 onward owe something to the guardroom painters of the 1630s and possibly to early Gerard ter Borch (q.v.), they anticipate features of Pieter de Hooch's (q.v.) earliest works. His scenes of elegant companies on terraces and in rich halls also look ahead to a greater elegance, which Dutch genre painting adopted in the third quarter of the century. Van den Eeckhout's early landscapes of c. 1642 bear a surprising resemblance to the works of Jan Asselijn (1610/15–1652) and other Dutch Italianate landscapists, but his mature works recall the tenebrous landscapes of Rembrandt and Roeland Roghman (1627–1692). Besides painting and drawing, Van den Eeckhout was active as an etcher and designed pattern books for gold- and silversmiths.

LITERATURE: Houbraken 1718–21, vol. 1, p. 174, vol. 2, p. 100; Immerzeel 1842–43, vol. 1, p. 215; J. Immerzeel, Jr., "Eenige bijzonderheden betrekkelijk de familie van den beroemden Ned. schilder Gerbrand van den Eeckhout," *Allgemeen Nederlandsch familieblad*, vol. 1 (1883–84), nos. 104–5; A. D. de Vries, "Biografische aantekeningen betreffende voornamelijk Amsterdamsche schilders, plaatsnijders, enz. en hunne verwanten," *Oud Holland*, vol. 3 (1885), p. 141; Wurzbach 1906–11, vol. 1, pp. 481–83; R. Bangel in Thieme-Becker 1907–50, vol. 10 (1914), pp. 355–57; Neil MacLaren, *The Dutch School: National Gallery Catalogues* (London, 1960), pp. 117–19; Eduard Plietzsch, *Holländische und flämische Maler des 17. Jahrhunderts* (Leipzig, 1960), pp. 180–81; Werner Sumowski, "Gerbrand van den Eeckhout als Zeichner," *Oud Holland*, vol. 77, no. 1 (1962), pp. 11–39; Rainer Roy, "Studien zu Gerbrand van den Eeckhout," diss., Vienna, 1972; Werner Sumowski, *Drawings of the Rembrandt School*, edited and translated by Walter Strauss, vol. 3 (New York, 1980), pp. 1311–1767; Arthur K. Wheelock, Jr., in Blankert et al. 1980–81, pp. 141, 174–77; Werner Sumowski, *Gemälde der Rembrandt-Schüler*, vol. 2 (Landau, 1983), pp. 719–23; Sutton et al. 1984, pp. 200–201; Sutton et al. 1987, pp. 304–6.

28 GERBRAND VAN DEN EECKHOUT

THE CONTINENCE OF SCIPIO, 1659
Signed and dated lower center on step: *G.v. Eeckhout fe. A 1659*
Oil on canvas, 51⅝ x 66⅝″ (131.1 x 169.2 cm.)
Purchased: The George W. Elkins Fund. E1981-1-1

The subject of the painting is taken from Livy, who relates the story of Publius Cornelius Scipio Africanus, the young commander of the Roman forces in Spain.[1] In 209 B.C. Scipio surprised and captured the Celtiberian town of New Carthage (now Cartagena in the province of Murcia), the headquarters of Carthaginian power in the Iberian Peninsula. In doing so he obtained not only an excellent harbor but also a wealth of booty. Yet his kindly treatment of the Spanish hostages won many over to his side. Here

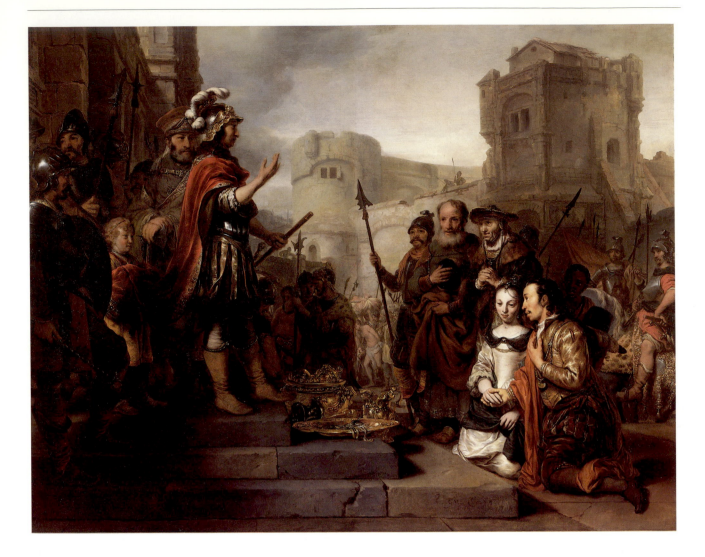

we witness the best known of his acts of clemency, in which he returned a
beautiful young captive to her fiancé, Aluccius. Scipio stands on a low flight
of stairs at the left attended by soldiers, bearded advisors, and a small boy
serving as a trainbearer. At the right the reunited couple kneel in gratitude.
Behind them stand the elderly parents of the bride attended by a servant.
On the step in the center is a pile of precious metalware, coins, and
jewelry—the ransom offered to Scipio by the parents and subsequently
returned by the general to the young couple as a wedding gift. At the
extreme right are mounted officers who supervise the procession of captives
and spoils carried off in the brightly lit center distance. The towers of the
walled city of New Carthage form the backdrop.

The subject of the Continence of Scipio enjoyed great popularity in
the North.[2] Like Petrarch and their Renaissance forebears, the Dutch saw
in the Roman hero the supreme embodiment of those virtues of continence
and liberality essential to the proper leadership of the new republic. Scipio
was admired less for his military feats than for his equanimity, magnanimity,
and justice. He also was praised by Machiavelli, among others, as the very
model of clever statecraft. Nearly all Dutch seventeenth-century art theorists

FIG. 28-1 Gerbrand van den Eeckhout, *The Continence of Scipio*, oil on canvas, 52⅜ x 66⅛" (133 x 168 cm.), Dienst Verspreide Rijkskollekties, The Hague, no. NK 2276, on loan to the Royal Dutch Embassy, Warsaw.

FIG. 28-2 Gerbrand van den Eeckhout, *The Continence of Scipio*, signed and dated 165[8], oil on canvas, 54⅜ x 67½" (138.1 x 171.5 cm.), The Toledo Museum of Art, Ohio, gift of Arthur J. Secor, no. 23.3155.

FIG. 28-3 Gerbrand van den Eeckhout, *The Continence of Scipio*, 1669, oil on canvas, 17½ x 19¾" (45 x 50 cm.), Musée des Beaux-Arts, Lille, no. P291.

alluded to Scipio and recommended episodes from his life for representation.[3] As the paradigm of exemplary leadership, the Continence of Scipio was one of the most popular subjects to be commissioned for Dutch town halls and other government buildings.[4] During the 1650s alone, three plays were performed in Amsterdam with the Continence of Scipio as the subject, one by Jurrian Bouckart and two by Jan Lemmers.[5]

Van den Eeckhout represented this popular theme four times. The earliest is probably the partially signed, undated painting owned by the Dienst Verspreide Rijkskollekties (fig. 28-1).[6] On stylistic grounds, the picture seems to date from the early 1650s. As in the Philadelphia work, it depicts Scipio on a stairway at the left, the ransom objects in the center, and the suppliants at the right, but depicts the parents kneeling and the young couple standing while devoting more attention to subsidiary figures. In a painting signed and dated 165[8] in the Toledo Museum of Art (fig. 28-2), the composition is improved by extending the stairway three-quarters across the scene and focusing attention on the main figures.[7] More clearly than in any other version, the family members at the right in the Toledo painting bear portrait features.[8] The Philadelphia painting is dated one year later and closely follows the general design of the Toledo picture, except that the young couple kneel while the parents stand, a youthful trainbearer replaces Scipio's throne, and numerous other small changes appear in the cast of supporting figures, the still-life details, and the architecture beyond. One also notes a greater refinement in the conception of the group on the right as well as a more expressive use of light and color. Particularly effective is the juxtaposition of the darkly handsome Aluccius and his luminous, pearly skinned bride. The greater elegance of this work is carried still further in a painting in Lille dated ten years later (fig. 28-3).[9] There the figures have become more attenuated, indeed rather mannered, and the composition has sacrificed some of its concentration and power. Although many similar figure motifs appear in this work, an archway replaces the open-air architecture in the distance. Unfortunately, the circumstances surrounding the commission of all four of Van den Eeckhout's versions of this theme remain unknown.

Van den Eeckhout's composition is based on a traditional design used in scenes of emperors addressing their troops, an arrangement known as an *adlocutio*. The design's ultimate classical sources are found in Roman relief sculpture, such as the scenes on Trajan's column and the arch of Constantine. These designs were used by Italian Renaissance artists, such as Raphael (1483–1520) and Giulio Romano (1499–1546) and later seventeenth-century northern artists who traveled to Rome, such as Peter Paul Rubens (q.v.)[10] and Rembrandt's teacher, Pieter Lastman (1583–1633).[11] Doubtless it was Lastman's examples that influenced the later use of these designs by Rembrandt as well as by his pupils.[12] A painting by Lastman depicting a Scipio theme is recorded in the Anthoni van Davelaer inventory, Amsterdam, December 14, 1647.[13] This lost work may well have resembled *The Continence of Scipio* dated 1643 by Nicolaes Moeyaert (1592/93–1655; fig. 28-4), an artist who was profoundly influenced by Lastman. The Moeyaert not only anticipates Van den Eeckhout's general design but also individual motifs, such as the young trainbearer and the figure with crossed hands standing behind Scipio, the soldier standing at the left, and servant at the back. Other Lastmanian motifs in the Philadelphia painting, such as

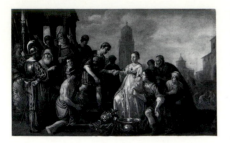

FIG. 28-4 Nicolaes Moeyaert, *The Continence of Scipio*, 1643, oil on canvas, 44 x 71¼" (112 x 181 cm.), Musée des Beaux-Arts, Caen, inv. no. 181.

the mounted soldier on the right and the burdened figures in the distance, suggest that he and Moeyaert may have shared sources in the influential Amsterdam painter's art. Whatever the course of influence, clearly all of these artists felt that the *adlocutio* composition was appropriate to stories *all'antica*. Van den Eeckhout employed variations of this design, with a standing and a kneeling figure, repeatedly in his career.[14]

Rembrandt's broad manner of the 1640s is readily recalled in the Philadelphia painting's execution, lighting effects, and warm palette. Arnold Houbraken's observation that Van den Eeckhout continued to paint in Rembrandt's style until the end of his life still seems valid today, as does his qualifying remark that "in many of his paintings [Van den Eeckhout] made the background somewhat clearer and lighter" than Rembrandt would have done.[15] A final feature of this work deserving note is the splendid still-life detail of metalware in the foreground. We recall that Van den Eeckhout's father was a goldsmith and that he himself executed designs for elaborate gold vessels. Identifiable designs (for example, a cup of 1614 by Adam van Vianen [1569–1627]) were sometimes used for the objects in Van den Eeckhout's paintings[16] (see the pictures in the Metropolitan Museum of Art, New York,[17] the Dienst Verspreide Rijkskollekties, and the Toledo Museum of Art [figs. 28-1 and 28-2]). Although no known objects are included here in the ransom treasure, works like the golden pitcher on the right are similar to existing metalware.

NOTES

1. Titus Livius, *Historiarum ab urbe condita libri*, book 26, 50; see also Polybius, *Histories*, book 10, 19.3–7; Valerius Maximus, *Factorum et dictorum memorabilium*, book 4, chap. 3. On Scipio in general, see Basil Henry Liddell Hart, *A Greater than Napoleon, Scipio Africanus* (Edinburgh and London, 1926); Howard Hayes Scullard, *Scipio Africanus in the Second Punic War* (Cambridge, 1930); Richard Mansfield Haywood, *Studies on Scipio Africanus* (Westport, Conn., 1933); Howard Hayes Scullard, *Scipio Africanus: Soldier and Politician* (Ithaca, N.Y., and London, 1970); and Aldo S. Bernardo, *Petrarch, Scipio, and the "Africa": The Birth of Humanism's Dream* (Westport, Conn., 1978).

2. In addition to the numerous examples listed by Andor Pigler, *Barockthemen: Eine Auswahl von Verzeichnissen zur Ikonographie des siebzehnten und achtzehnten Jahrhunderts*, 2nd ed. rev., vol. 2 (Budapest, 1974), pp. 427–29, see Rijksbureau voor Kunsthistorische Documentatie, *Decimal Index to the Art of the Low Countries* (The Hague, 1958–), s.v. "Scipio."

3. Inspired by Valerius Maximus, among others, whose popular *Factorum* (nine books with commentaries on memorable deeds from history) lists Scipio's act as the first under the title "de continentia," Karel van Mander (1603–4, vol. 13, nos. 17a–e) praised both Scipio and Alexander the Great for their emotional self-control and referred earlier (vol. 1, p. 22) to the related notion of Prov. 16:32 ("He that is slow to anger is better than the mighty; and he that ruleth his spirit

than he that taketh a city"). For discussion of Van Mander's own painting of the subject, see P.J.J. van Thiel and Hessel Miedema, "De grootmoedigheid van Scipio, een schilderij van Karel van Mander uit 1600," *Bulletin van het Rijksmuseum*, vol. 26 (1978), pp. 51–59. Outlining a crude hierarchy of subject matter in art ("Van de dry graden der konst"), Samuel van Hoogstraten (*Inleyding tot de hooge schoole der schilderkonst, anders de zichtbaere werelt* [Rotterdam, 1678; reprint Soest, 1969, and Ann Arbor, 1980], p. 83) cited Scipio and his triumphal return from Africa as an exemplary history-painting subject of the sort that is the highest form of art. Similarly, Gérard de Lairesse (*Het Groot Schilderboek*, 2nd ed., vol. 1 [Haarlem, 1740; reprint Soest, 1969], pp. 117–18) mentioned the Continence of Scipio as a prime example of a "moral picture," in which great deeds— *exempla virtutis* (models of virtue)—have an instructive function in revealing patterns of virtue to mankind. For discussion of Lairesse's theory of the "moral picture," see D. P. Snoep in Blankert et al. 1980–81, p. 230.

4. In 1639–40, for example, Jan Lievens (1607–1674) was commissioned by the city of Leiden to decorate the new (1635) *Vroedschapskamer*, or town council chamber, of the town hall with a *Continence of Scipio* (oil on canvas, 74 x 93¼" [188 x 237 cm.]), destroyed by fire in 1929 (see H. Schneider and R.E.O. Ekkart, *Jan Lievens: Sein Leben und Seine Werke* [Amsterdam, 1973], no. 106, with repro. of a copy, fig. 24). Dirck Hardenstein's (b. 1620) painting of the subject, dated 1653, is still in the town hall at

Deventer. Finally, when Gérard de Lairesse (q.v.) was commissioned about 1688 by the Court of Justice at The Hague to decorate a room with scenes from the actual and mythological history of ancient Rome, he turned again to "moral picture" subjects, and specifically, to the Continence of Scipio. No doubt Lairesse's choice reflected the complex political position of this court, for which both princely (in recognition of the office of the stadholder) and judicial virtues were appropriate; see D. P. Snoep, "Gérard Lairesse als plafond-en kamerschilder," *Bulletin van het Rijksmuseum*, vol. 18 (December 1970), pp. 159–220.

5. The play by Bouckart, *De Nederlaagh van Hannibal* (1653), in which the bride is named Olinda, was performed twenty-eight times between 1653 and 1663. Lemmers's *Schipio en Olinde* appeared four times in 1657 and 1658, and his *Schipio in Kartago* ten times in 1649 and 1651 (see E. Oey-de Vita and M. Geesink, *Academie en Schouwburg Amsterdams Toneelrepertoire, 1617–1665* [Amsterdam, 1983], pp. 184 and 192). Beatrijs Brenninkmeyer-de Rooÿ and Gary Schwartz brought these plays to the author's attention.

6. Rainer Roy, "Studien zu Gerbrand van den Eeckhout," diss., Vienna, 1972, p. 223, no. 87. A close variant (Roy no. 88) is in the Ten Bos Collection, Almelo.

7. Although the date has been deciphered as 1650 or 1658 (see The Toledo Museum of Art, Ohio, *European Paintings: The Toledo Museum of Art* [Toledo, 1976], pp. 57–58), both Rainer Roy ([see note 6], p. 223, no. 85) and Werner Sumowski, in a letter of November 4, 1981

(Philadelphia Museum of Art, accession files), prefer 1658. Roy also lists a variant (p. 224, no. 89) in an unknown collection. For discussion of the Toledo painting, see Blankert et al. 1980–81, pp. 174–75, repro.

8. Other Dutch artists of the period included portraits in their depictions of this theme: for example, Jan van Noordt (c. 1620–after 1676), *The Continence of Scipio,* c. 1670–75 (see Andor Pigler, *Katalog der Galerie alter Meister* [Budapest, 1968], vol. 1, p. 493), in which the artist and his wife are assumed to be portrayed. See also Rose Wishnevsky, "Studien zum 'portrait historié' in der Nederlanden," diss., Munich, 1967, pp. 95–96, under "Grossmut des Scipio."

9. François Benoit, *La Peinture au Musée de Lille,* vol. 2 (Paris, 1909), no. 113, pl. 104.

10. See, for example, *The Emblem of Christ Appearing to Constantine,* 1622, oil on panel, 18¼ x 22⅛" (46.3 x 56.2 cm.), John G. Johnson Collection at the Philadelphia Museum of Art, cat. no. 659.

11. See B.P.J. Broos, "Rembrandt and Lastman's Coriolanus: The History Piece in Seventeenth-Century Theory and Practice," *Simiolus,* vol. 8 (1975–76), pp. 199–228.

12. For example, Lastman's *Coriolanus and the Roman Matrons,* 1622, oil on panel, 31⅛ x 52⅜" (81 x 133 cm.), Trinity College, Dublin (see *Bulletin of the Philadelphia Museum of Art,* vol. 78, no. 336 [fall 1982], fig. 8); compare Rembrandt's *Historical Scene,* 16[2]6, oil on panel, 35¼ x 47⅞" (89.8 x 121 cm.), Stedelijk Museum "de Lakenhal," Leiden, no. 814, and his reed pen drawing of *The Continence of Scipio,* 7½ x 7¼" (193 x 184 mm.), Museum Boymans–van Beuningen, Rotterdam, inv. no. R32 (see Otto Benesch, *The Drawings of Rembrandt: A Critical and Chronological Catalogue,* vol. 5 [London and New York, 1957], no. 1034; *Bulletin of the Philadelphia Museum of Art,* vol. 78, no. 336 [fall 1982], fig. 9). A lost drawing by Rembrandt of the Continence of Scipio theme is known through several copies: one, pen and wash over traces of lead pencil, 7⅞ x 12¾" (203 x 324 mm.), Cabinet des Dessins, Musée du Louvre,

Paris, gen. inv. III, no. 1293 (see Benesch, *The Drawings of Rembrandt: A Critical and Chronological Catalogue,* vol. 4 [London and New York, 1955], no. C43); another, pen and sepia with wash, 6⅛ x 12⅛" (171 x 308 mm.), Kupferstichkabinett, Museum Dahlem, Berlin (see Elfried Bock and Jakob Rosenberg, *Die niederländischen Meister: Beschreibende Verzeichnis sämtlicher Zeichnungen* [Frankfurt, 1931], no. 3109); and a third, pen and sepia with light wash, 7¾ x 11⅜" (199 x 289 mm.), Wallraf-Richartz-Museum, Cologne, inv. no. Z1789 (see Hella Robels, *Niederländische Zeichnungen vom 15. bis 19. Jahrhundert im Wallraf-Richartz-Museum Köln* [Cologne, 1983], no. 222).

13. See Kurt Freise, *Pieter Lastman: Sein Leben und seine Kunst* (Leipzig, 1911), no. 113.

14. For example, *The Meeting of Abraham and Melchizedek,* dated 1648, oil on canvas, 61¾ x 79⅞" (157 x 203 cm.), Mänttä, Gösta Serlachius-Museum, no. 381; *Alexander and the Wife of Darius,* c. 1662–64, oil on canvas, 81⅞ x 94" (207 x 239 cm.), Alte Pinakothek, Munich, no. 1798; *Anne Presenting Samuel to Eli,* c. 1665, oil on canvas, 46 x 56¼" (117 x 143 cm.), Musée du Louvre, Paris, inv. no. 1267; *Christ and the Adulterous Woman,* c. 1664, oil on canvas, 25⅞ x 32¼" (66 x 82 cm.), Rijksmuseum, Amsterdam, no. A106; and *Pharaoh Returns Sarah to Abraham,* dated 1667, oil on canvas, 21⅛ x 24½" (55 x 62.5 cm.), formerly A. Tooth Gallery, London.

15. Houbraken 1718–21, vol. 2, p. 79; "Alleenlyk heeft hy in velen van zyne Konststukken den agtergrond wat klaarder of helderder gehouden" (author's translation).

16. See T. M. Duyvené de Wit-Klinkhamer, "Een vermaarde zilveren beker," *Nederlands Kunsthistorisch Jaarboek,* vol. 17 (1966), pp. 79–103.

17. *Isaac Blessing Jacob,* 1642, oil on canvas, 39⅝ x 50½" (100.6 x 128.2 cm.), no. 25.110.16.

PROVENANCE: Possibly Half Collection, Wassenaar, 1752;[1] Thomas Jefferson Bryan (c. 1800–1870), New York; Cooper Union; deeded to the New-York Historical Society, 1867; dealer H. Shickman, New York.

NOTE TO PROVENANCE

1. Jean Baptiste Descamps mentions a picture "chez M. Half-Wassenaar, la Continence de Scipion" (Descamps 1753–64, vol. 2, p. 330). It has not been possible, however, to identify this work securely with any of the artist's known versions of the subject.

LITERATURE: Possibly Descamps 1753–64, vol. 2, p. 330; New-York Historical Society, *Catalogue of the Gallery of Art of the New-York Historical Society* (New York, 1915), p. 71, no. B-115; Sydney P. Noe, "Two Paintings by Pupils of Rembrandt in the New York Historical Society," *The New York Historical Society Quarterly Bulletin,* vol. 11, no. 2 (July 1927), pp. 35–40, repro.; Rainer Roy, "Studien zu Gerbrand van den Eeckhout," diss., Vienna, 1972, p. 223, no. 86; Arthur K. Wheelock, Jr., in Blankert et al. 1980–81, p. 174 [as dated 1669]; Peter C. Sutton, "*The Continence of Scipio* by Gerbrandt van den Eeckhout (1621–1674)," *Bulletin of the Philadelphia Museum of Art,* vol. 78, no. 336 (fall 1982), pp. 3–15; Werner Sumowski, *Gemälde der Rembrandt-Schüler,* vol. 2 (Landau, 1983), no. 430, repro.

CONDITION: The canvas support is stable. At an unknown but recent date before its purchase by the Museum the painting was relined with an aqueous adhesive and two fabrics without fully relaxing the paint film. The tacking edges are missing. At present the paint film is in good condition with only scattered flake losses and retouchings around the edges and in two areas in the sky, although much of the surface is quite irregular, owing to the slight misalignment or overlap of paint flakes. The surface is slightly abraded, as is evident in the heads and shoulders of the main figures, and some of the deepest darks are quite thin. A number of small damages, in the sky and background in particular, have been inpainted, as have strips along all four edges. Prior to the painting's entering the collection, the varnish was selectively removed or thinned and new films of varnish applied; because the lights were cleaned selectively and the darks not at all, the varnish layer is uneven. The varnish remains colorless.

Brother of the sculptor Erdmann Encke (1843–1896) and the photographer Ernst Encke, Fedor was born in Berlin on November 13, 1851. He began his studies there in the academy in 1869, and in 1872 trained with Karl Gussow (b. 1843) and Theodore Hagen (1842–1919) in Weimar. In 1879 Encke was living in New York City in the house of Edward Stieglitz, the subject of one of his portraits (no. 29). Among famous Americans whom he later portrayed were Theodore Roosevelt and J. P. Morgan. In Paris in 1879–83 he worked temporarily with Mihály Munkácsy (1849–1909) and exhibited in Salons in 1880–82. Encke made his home in Berlin in his later life, while making frequent trips to America, where he exhibited regularly until 1913. The date of his death is unknown. In addition to numerous portraits, Encke painted a few genre scenes.

LITERATURE: Boetticher (1891–1901) 1969, vol. 1, pp. 281–82; Thieme-Becker 1907–50, vol. 10 (1913–14), pp. 509–10.

29 FEDOR ENCKE

PORTRAIT OF EDWARD STIEGLITZ, 1879
Signed and dated lower left: *Fedor Encke. 1879. New York.*
Oil on canvas, 41 x 25″ (104 x 63.5 cm.)
Gift of Mrs. William Howard Schubart. 68-45-1

Viewed three-quarter length and in lost profile turned to the viewer's left, the subject stands with folded arms holding a smoking cigar. The sitter is Edward Stieglitz, father of the famous photographer Alfred Stieglitz (1864–1946). Edward was born in Hannoversch-Münden, Germany, and grew up on a farm. In the year following the calamities of 1848 he traveled to the United States where, for lack of work, he first became an apprentice in the making of mathematical instruments. After serving briefly as a lieutenant in the Union army during the Civil War, he became a partner in a woolen business, which soon prospered. In 1862 he married Hedwig Werner. The couple settled in Hoboken, New Jersey, where Alfred (the first of six children) was born on January 1, 1864. In 1871 Edward's increasing wealth enabled the family to move to 14 East Sixtieth Street in New York, where they received and entertained artists and writers. Among these was the painter of the present portrait, who doubtless was living with the family at the time he painted the picture.[1] Encke also portrayed the mother and sister of Alfred Stieglitz (nos. 30, 31) as well as the photographer himself.[2] In 1881 Edward retired from business and took the entire family to Europe, where Alfred made some of his earliest experiments in photography with Ernst Encke, the painter's brother, in Berlin. Edward and Hedwig Stieglitz returned to New York in 1886 and in their later life divided their time between the city and a summer house on Lake George. Edward died in 1909.

From published recollections of Edward Stieglitz's personality, we would conclude that the image of the proud and strong-willed figure Encke portrayed here accurately captured his subject. Paul Rosenfeld described him as "always well-groomed and very much the cavalier . . . with his proud carriage, his fine head and luxuriant mustaches."[3] Alfred Stieglitz later often complained of his father's penchant for worrying over financial matters but concluded that "even while rebelling against my father and finding him vain, impatient and impossible to speak to, I admired him. Both he and my mother were extremely kind and sentimental at heart."[4]

NOTES
1. Dorothy Norman, *Alfred Stieglitz: An American Seer* (New York, 1960), pp. 19, 25.
2. Ibid., fig. 11.
3. Paul Rosenfeld, "The Boy in the Dark Room," in *America and Alfred Stieglitz,* edited by Waldo Frank, Lewis Mumford, Dorothy Norman, et al. (New York, 1934), p. 60.
4. See Norman (note 1), p. 16.

PROVENANCE: Mrs. William Howard Schubart.

CONDITION: The canvas support is lined with an aqueous adhesive. The tacking edges are missing. Small flake losses appear in a line along the lower edge of the upper stretcher member. The paint film shows minor abrasion and overall fine crackle pattern but is otherwise intact. The varnish is slightly discolored. The frame appears to be original.

30 FEDOR ENCKE

PORTRAIT OF HEDWIG STIEGLITZ, 1881–86
Signed and inscribed lower right: *Fedor Encke Berlin*
Oil on canvas, 24 x 19½″ (61 x 49.5 cm.)
Gift of Mrs. William Howard Schubart. 68-45-2

Seated in a chair, turned to the observer's right and viewed half length, the
sitter is the mother of Alfred Stieglitz and the wife of Edward Stieglitz.
Like her husband, Hedwig Werner was born in Germany; she moved to the
United States at the age of eight. She came from an intellectual, literary
family that included several rabbis. Paul Rosenfeld remembered her as
"cultured, soft, hospitable, generous."[1]

While the previous portrait of Edward Stieglitz (no. 29) was painted
in New York, this picture, according to the inscription, must have been
executed while the Stieglitz family was in Europe, from 1881 to 1886.

NOTE
1. Paul Rosenfeld, "The Boy in the Dark
Room," in *America and Alfred Stieglitz,*
edited by Waldo Frank, Lewis Mumford,
Dorothy Norman, et al. (New York, 1934),
p. 61.

PROVENANCE: Mrs. William Howard
Schubart.

CONDITION: In 1968, the canvas support was
lined with wax-resin adhesive, an old tear was
repaired, and numerous small losses were
inpainted. The paint film is generally abraded.
The varnish is uneven but clear.

31 FEDOR ENCKE

PORTRAIT OF FLORA STIEGLITZ
Signed lower right: *Fedor Encke*
Oil on canvas, 23¼ x 19¼" (59 x 49 cm.)
Gift of Mrs. Sue Davidson Lowe. 68-69-53

Viewed bust length and turned to the observer's left, the sitter is the sister
of the photographer Alfred Stieglitz (see nos. 29, 30).

PROVENANCE: Mrs. Sue Davidson Lowe.

CONDITION: The canvas support was lined
with wax resin adhesive and the painting was
cleaned in 1968. At that time a tear and dent
in the support were repaired and the varnish
layer replaced. Some general abrasion appears
in the paint film. The varnish is colorless.

Vincent Willem van Gogh was born in 1853 in the south of Holland, the eldest son of the Reverend Theodorus van Gogh (1822–1885) and Anna Cornelia Carbentus (1819–1907). Four years later Vincent's brother Theo (Theodorus), with whom he remained close all his life, was born. After attending the village school in Zundert and a boarding school in Zevenbergen, Van Gogh entered the new grammar school in Tilburg in 1866 and remained there until March 1868. One year later he became an apprentice at Goupil & Company, art dealers, in The Hague. In May 1873 he transferred to Goupil's London branch and in May 1875 to their Paris branch. On April 1, 1876, Van Gogh was dismissed by the firm. He traveled to England, where he worked as a teacher and later also as an assistant preacher in Ramsgate and Isleworth. In 1877 he returned to Holland, where he worked in a bookshop in Dordrecht for several months before moving to Amsterdam in May to prepare for study at the theological seminary. He abandoned this study in July and enrolled in a three-month course for evangelists in Brussels. From 1878 to 1880 he worked as an evangelist in Borinage. In 1880 he decided to become an artist and moved to Brussels. From April 1881 to December he lived with his parents in Etten, where he fell in love with his cousin Kee Vos. In 1882–83 he was living in The Hague where his model, Sien Hoornik, became his mistress. From September to December 1883 he worked in Drenthe. In 1882–85 he returned again to south Holland, living first with his parents and then alone, in Nuenen. In 1884 he had an affair with Margot Begemann. On March 26, 1885, his father died suddenly. He moved to Antwerp in November and worked in the Royal Academy of Fine Arts for six weeks in 1886. Departing for Paris at the end of February he lived with his brother Theo until 1888. For several months he worked at Fernand Cormon's studio. During these years he met several other artists, including Emile Bernard (1868–1941), Paul Signac (1863–1935), and Paul Gauguin (1848–1903). In February 1888 he moved to Arles and two months later he set up his own studio. Gauguin joined him in October but they soon quarreled and Vincent was interned in the hospital at Arles. In May 1889 Van Gogh placed himself in the mental asylum in Saint-Rémy. In May 1890 he moved to Auvers-sur-Oise and in July committed suicide at the age of thirty-seven. Theo died the following January.

A painter, draftsman, and printmaker, Van Gogh is the most famous Dutch artist of the nineteenth century and one of the greatest innovators of the Post-Impressionist period. In his early years he painted landscapes and figure studies in a dark manner derived from the earlier Barbizon and Hague School artists. After moving to Paris in 1886, his palette became much lighter, his colors bolder, and his touch progressively broader. Although he sold scarcely any paintings in his own lifetime and had no students, his art had a lasting influence and many imitators. Van Gogh's extensive correspondence with his brother offers many personal comments on his art.

LITERATURE: J. B. van Gogh-Bonger, ed., *Brieven aan zijn broeder,* 3 vols. (Amsterdam, 1914); Julius Meier-Graefe, *Vincent van Gogh,* 2 vols. (London, 1922); J.-B. de la Faille, *L'Oeuvre de Vincent van Gogh: Catalogue raisonné,* 4 vols. (Paris and Brussels, 1928); Stedelijk Museum, Amsterdam, *Vincent van Gogh en zijn tijdgenooten,* 1930; W. Scherjon, *Catalogue des tableaux par Vincent van Gogh décrits dans ses lettres. Périodes: St. Rémy et Auvers sur Oise* (Utrecht, 1932); Museum of Modern Art, New York, *Vincent van Gogh,* 1935–36 (catalogue by Alfred H. Barr); Walter Pach, *Vincent van Gogh, 1853–1890* (New York, 1936); M. Florisoone, *Van Gogh* (Paris, 1937); Walther Vanbeselaere, *De hollandsche periode (1880–1885) in het werk van Vincent van Gogh* (Amsterdam and Antwerp, 1937); J.-B. de la Faille, *Vincent van Gogh* (Paris, 1939); Ludwig Goldscheider and Wilhelm Uhde, *Vincent van Gogh* (New York, 1941); Werner Weisbach, *Vincent van Gogh: Kunst und Schicksal,* 2 vols. (Basel, 1949–51); Meyer Schapiro, *Vincent van Gogh* (New York, 1951); Jean Leymarie, *Van Gogh* (Paris, 1951); Carl Nordenfalk, *The Life and Work of Van Gogh* (New York, 1953); Réné Huyghe, *Van Gogh,* translated by Helen C. Slonim (New York, 1958); Marc Edo Tralbaut, *Van Gogh: Eine Bildbiographie* (Munich, 1958); *The Complete Letters of Vincent van Gogh,* 2nd ed., 3 vols., translated by Johanna van Gogh-Bonger and C. de Drood (Greenwich, Conn., 1959); Raymond Cogniat, *Van Gogh* (New York, 1959); Marc Edo Tralbaut, *Van Goghiana* (Antwerp, 1963–70); Marc Edo Tralbaut, *Vincent van Gogh* (New York, 1969); De la Faille 1970; Mark W. Roskill, *Van Gogh, Gauguin, and the Impressionist Circle* (Greenwich, Conn., 1970); Mark W. Roskill, *Van Gogh, Gauguin, and French Painting of the 1880s: A Catalogue Raisonné of Key Works* (Ann Arbor, 1970); Paolo Lecaldano, *L'Opera pittorica completa di van Gogh,* 2 vols. (Milan, 1971); Pierre Leprohon, *Vincent van Gogh* (Cannes, 1972); Jan Hulsker, *Van Gogh door van Gogh: De brieven als commentaar op zijn werk* (Amsterdam, 1973); Bogomila M. Welsh-Ovcharov, *Van Gogh in Perspective* (Englewood Cliffs, N.J., 1974); Bogomila M. Welsh-Ovcharov, *Vincent van Gogh: His Paris Period, 1886–1888* (Utrecht and The Hague, 1976); Jan Hulsker, *Van Gogh en zijn weg* (Amsterdam, 1977); C. M. Zemel, *The Formation of a Legend: Van Gogh Criticism, 1890–1920* (Ann Arbor, 1977); Griselda Pollock and Fred Orton, *Vincent van Gogh: Artist of His Time* (Oxford, 1978); John Rewald, *Post-Impressionism from Van Gogh to Gauguin,* 3rd ed. (New York, 1978); Jan Hulsker, *The Complete Van Gogh: Paintings, Drawings, Sketches* (Oxford and New York, 1980); Rijksmuseum Vincent van Gogh, Amsterdam, *Vincent van Gogh in zijn Hollandse jaren: Kijk en land door Van Gogh en zijn tijdgenoten 1870/1890,* 1980–81; The Metropolitan Museum of Art, New York, *Van Gogh in Arles,* October 18–December 30, 1984 (catalogue by Ronald Pickvance); Roland Dorn, "Decoration: Van Goghs Werkreihe für das Gelbe Haus in Arles," diss., Mainz, 1986; The Metropolitan Museum of Art, New York, *Van Gogh in Saint-Rémy and Auvers,* November 25, 1986–March 22, 1987; Walter Feilchenfeldt, *Vincent van Gogh & Paul Cassirer, Berlin: The Reception of Van Gogh in Germany from 1901 to 1914* (Zwolle, 1988).

For an additional work in the Philadelphia Museum of Art, see John G. Johnson Collection inv. no. 2322 (imitator of).

32 VINCENT VAN GOGH

STILL LIFE WITH A BOUQUET OF DAISIES, 1886
Oil on paper mounted on panel, 16⅞ x 22½ (42.8 x 57.1 cm.)
Bequest of Charlotte Dorrance Wright. 1978-1-33

In a gray-green beer mug decorated with dark green bands and cartouches
is a large bouquet. Comprising mainly small white and yellow daisies, the
bouquet inclines to the left. A single yellow chrysanthemum provides a
strong color accent among the green leaves and blue flowers on the left.

In 1928 J.-B. de la Faille characterized this as a work from 1885 when Van
Gogh was still in Nuenen, but in 1937 Walther Vanbeselaere transferred it
and many other flower studies to the Paris period, a change that has gained
general acceptance. Owing to the blooms—daisies and chrysanthemums—
the work is thought to have been executed in the later summer or early fall
of 1886. Van Gogh seems to have begun concentrating on flower still lifes
soon after his Fernand Cormon period in Paris, that is May or June 1886.[1]
Late in July 1886, Van Gogh's brother Theo wrote to his mother describing
his brother's life in Paris and noted, "He is mainly painting flowers—with
the object to put a more lively colour into his next pictures.... He also has
acquaintances who give him a collection of flowers every week which may
serve him as models."[2] Van Gogh himself commented on his motivations in
the flower paintings in an undated (c. August–October 1886) letter to his

friend Levens, "And now for what regards what I myself have been doing, I have lacked money for paying models else I had entirely given myself to figure painting. But I have made a series of color studies in painting, simply flowers, red poppies, blue corn flowers and myosotys, white and rose roses, yellow chrysanthemums—seeking oppositions of blue with orange, red and green, yellow and violet, seeking *les tons rompus et neutres* to harmonize brutal extremes. Trying to render intense colour and not a grey harmony."[3]

NOTES

1. J.-B. de la Faille, *L'Oeuvre de Vincent van Gogh: Catalogue raisonné* (Paris and Brussels, 1928), vol. 2, no. 197; Walther Vanbeselaere, *De hollandsche period (1880–1885) in het werk van Vincent van Gogh* (Amsterdam and Antwerp, 1937), p. 416. See De la Faille 1970, pp. 110ff.; Jan Hulsker, *The Complete Van Gogh: Paintings, Drawings, Sketches* (Oxford and New York, 1980), pp. 234ff. Compare especially De la Faille nos. F217 (location unknown), F249 (Rijksmuseum Kröller-Muller, Otterlo, inv. no. 1106-41), F250 (Städtische Kunsthalle, Mannheim, cat. no. 59), and F282 (Museum Boymans–van Beuningen, Rotterdam, St 92).

2. In Jan Hulsker, "What Theo Really Thought of Vincent," *Vincent: Bulletin of the Rijksmuseum Vincent Van Gogh,* vol. 3 (1974), pp. 8–9.

3. *The Complete Letters of Vincent van Gogh,* 2nd ed., translated by Johanna van Gogh-Bonger and C. de Drood (Greenwich, Conn., 1959), no. 459a (written in English).

PROVENANCE: Oldenzeel Art Gallery, Rotterdam; J.G.L. Nolst Trénité, Rotterdam, acquired 1903; Van Wisselingh Art Gallery, Amsterdam; sale, Sotheby's, London, December 3, 1958, lot 154; E.L. Catz, Curaçao, 1960; Lefevre Art Gallery, London, 1962; private collection, England; Wildenstein and Company, London, 1966; Mr. and Mrs. William Coxe Wright, St. Davids, Pennsylvania, by 1970.

EXHIBITIONS: Oldenzeel Art Gallery, Rotterdam, January 1903; Oldenzeel Art Gallery, Rotterdam, February 1906; Rotterdamsche Kunstkring, Rotterdam, *Het hollandsche stilleven in den loop der tijden,* September 11–October 10, 1909, no. 29; Museum Boymans–van Beuningen, Rotterdam, *Catalogus van de Kersttentoonstelling,* December 23, 1927–January 16, 1928, no. 31; E. J. van Wisselingh and Company, Amsterdam, *Vincent van Gogh: Quelques oeuvres de l'époque 1881–1886, provenant de collections particulières néerlandaises,* February 20–March 17, 1956, no. 31; The Hallsborough Gallery, London, *Flower and Still Life Paintings of Four Centuries,* May 2–June 17, 1960, no. 13; Lefevre Gallery, London, *XIX and XX Century French Paintings,* February–March 1962, no. 5; Philadelphia Museum of Art, *The Charlotte Dorrance Wright Collection,* December 15, 1978–January 21, 1979, no. 37.

LITERATURE: *Moderne Kunstwerken,* vol. 1 (1903), p. 4, no. 29; *De Kroniek,* January 3, 1903, pp. 19–20; *De Kroniek,* February 7, 1903, pp. 45–46; J.-B. de la Faille, *L'Oeuvre de Vincent van Gogh: Catalogue raisonné* (Paris and Brussels, 1928), vol. 2, no. 197, pl. LIII [as painted in Nuenen]; Walther Vanbeselaere, *De hollandsche periode (1880–1885) in het werk van Vincent van Gogh* (Amsterdam and Antwerp, 1937), p. 416 [as painted in Paris]; J.-B. de la Faille, *Vincent van Gogh* (Paris, 1939), p. 170, no. 210 [as painted in Nuenen, 1885]; L. Frohlich-Bume, "Londoner Ausstellungen," *Weltkunst,* vol. 30, no. 10 (May 15, 1960), p. 30, repro.; *Illustrated London News,* May 28, 1960, p. 935, repro.; "Flower and Still Life Paintings of Four Centuries at the Hallsborough Gallery," *The Connoisseur,* vol. 145, no. 586 (May 1960), p. 258, repro; *Illustrated London News,* February 17, 1962, repro.; De la Faille 1970, p. 180, no. F197, repro. [as painted in Paris, autumn 1886]; Paolo Lecaldano, *Tout l'oeuvre de Van Gogh: 1881–1888,* vol. 1 (Paris, 1971), pp. 110–11, no. 316, repro. [as painted in Paris, autumn 1886]; Jacques Lassaigne, *Van Gogh* (London, 1972), p. 75, fig. 1 [as painted in Paris, autumn 1886]; Jan Hulsker, *The Complete Van Gogh: Paintings, Drawings, Sketches* (Oxford and New York, 1980), p. 254, no. 1167, repro [as painted in Paris, summer–fall, 1886].

CONDITION: The painting was executed on primed linen fabric, which may have been mounted on a wooden panel, as is suggested by small chips of wood projecting from beneath the original fabric at the edges. The painting, which has no tacking edges, is now lined with a linen fabric and wax-resin adhesive. A third, unattached fabric conceals the painting's reverse. There are extensive losses of ground and paint film in the upper-right quadrant, lower center, and in a horizontal swath across the center of the painting. The original support is intact beneath these losses. Textured fills have been applied in excess of actual loss and the painting substantially repainted in at least two campaigns of restoration. A fabric weave impression is present in some areas of original paint, apparently due to rolling or stacking of the partially dry painting with other works. The synthetic resin varnish is extremely thick and hazy.

33 VINCENT VAN GOGH

MME AUGUSTINE ROULIN AND HER BABY, MARCELLE, 1888 or 1889
Oil on canvas, 36¼ x 28¾" (92 x 73 cm.)
Bequest of Lisa Norris Elkins. 50-92-22

Viewed to the knees and turned in three-quarter profile to the viewer's left, Mme Roulin is dressed in green and seated in a reddish brown chair. She holds her baby on her lap. The infant is dressed in white with a white cap. The background is lemon yellow.

In late November or before about December 4, 1888, Vincent wrote to his brother Theo from Arles: "I have made portraits *of a whole family,* that of the postman whose head I had done previously—the man, his wife, the baby, the little boy, and the son of sixteen, all characters and very French, though the first has the look of a Russian. Size 15 canvases. You know how I feel . . . in my element. . . . I hope to get on with this and to be able to get more careful posing, paid for by portraits. And if I manage to do this *whole family* better still, at least I shall have done something to my liking and something individual."[1] Van Gogh had probably begun painting the *Portrait of the Postman Joseph Roulin* in Arles in August 1888.[2] The present work depicts Joseph's wife, Augustine-Alix Pellicot Roulin (born in Lambesc, October 9, 1851, died April 5, 1930), and her baby, born on July 31, 1888.[3] The child was a girl named Marcelle[4] and was the subject of single-figure portraits by Van Gogh on three other occasions.[5] At the time of the baby's birth, Van Gogh wrote to his sister Wilhelmina in August: "If I can get the mother and father to allow me to do a picture of it, I am going to paint a baby in a cradle one of these days. The father has refused to have it baptized—he is an ardent revolutionary—and when the family grumbled, possibly on account of the christening feast, he told them that the christening feast would take place nonetheless, and that he would baptize the child himself."[6] Although Van Gogh did not paint the baby as soon as he intended, Mme Roulin and her baby appear in a work closely related to the Philadelphia painting in the Lehman Collection at the Metropolitan Museum of Art in New York (fig. 33-1);[7] Mme Roulin[8] and her sons Armand[9] and Camille were also depicted separately by Van Gogh on several occasions. Paul Gauguin (1848–1903) depicted Mme Roulin on his visit to Arles in 1888 in a painting now in the Saint Louis Art Museum[10] that closely resembles Van Gogh's portrait of her in Winterthur (fig. 33-2).

The precise sequence of Van Gogh's portraits is difficult to ascertain. The letter about Van Gogh's desire to paint a whole family suggests that work on the series was carried out before and after November/December 1888, the date usually assigned to the present work. However, Mark Roskill has argued that the Museum's painting and the three other paintings of the baby were painted "early in 1889, after van Gogh's breakdown,"[11] Mme Roulin had remained in Arles with her children when her husband left for Marseille in January, but moved to her mother's home in the country soon thereafter.[12] In Roskill's view the Lehman Collection picture is the first version and the Museum's the variant "because of [the latter's] greater stabilization of the composition . . . and the greater stiffness in the way shapes are defined."[13] Ronald Pickvance also persuasively argued that the Lehman Collection picture is the first version, noting its "abrupt elisions of form, discontinuous outlines, and anatomical distortions" as evidence of the difficulties of posing and portraying a young baby.[14] He also observed that the Lehman picture is executed on a "size 15 canvas," suggesting that it

FIG. 33-1 Vincent van Gogh, *Mme Roulin and Her Baby,* 1888, oil on canvas, 25½ x 20" (65 x 51 cm.), The Metropolitan Museum of Art, New York, Robert Lehman Collection, no. 1975.1.231.

FIG. 33-2 Vincent van Gogh, *Mme Roulin,* oil on canvas, 21¼ x 25½" (54 x 65 cm.), Collection of Dr. Oskar Reinhart, Winterthur, Switzerland.

was one of the six portraits from the Roulin family series that had been completed by about December 4, 1888.[15] Pickvance dated the larger Philadelphia portrait to "later in December" 1888.[16]

Although this variant probably predates the more elaborate portrait of Mme Roulin known as *La Berceuse* and existing in five versions (see fig. 35-5), work on which is known to have begun by January 22 or 23, 1889,[17] it could have been executed early in 1889. Van Gogh made replicas of the portrait of the Roulin baby as payment to the sitters, a practice that may explain the existence of the variant of the portrait of Mme Roulin and Marcelle.

NOTES

1. *The Complete Letters of Vincent van Gogh*, 2nd ed., translated by Johanna van Gogh-Bonger and C. de Drood (Greenwich, Conn., 1959), no. 560; see Jan Hulsker, *The Complete Van Gogh: Paintings, Drawings, Sketches* (Oxford and New York, 1980), p. 378.

2. Oil on canvas, 32 x 25¾" (81.3 x 65.4 cm.), Museum of Fine Arts, Boston, no. 11.35.1982. De la Faille 1970, no. F432; compare also the other versions: nos. F433, F434, F435, F436, F439, and drawing nos. F1458, F149, and SD1723.

3. See *Complete Letters* (note 1 and hereafter), nos. 518, B14.

4. See *Complete Letters*, no. 573, in which he refers to "la petite" and his letter to Gauguin of the same period (see J. Rotonchamp, *Paul Gauguin* [Paris, 1906], pp. 57ff.), where she is called "la petite Marcelle." See also C. Coquiat, *Vincent van Gogh* (Paris, 1923), p. 179.

5. National Gallery of Art, Washington, D.C., inv. no. 1695 (De la Faille 1970, no. F440); Rijksmuseum Vincent van Gogh, Amsterdam (De la Faille 1970, no. F441); and Louis Franck, Gstaad, Switzerland (De la Faille 1970, no. F441a).

6. *Complete Letters*, no. W6.

7. De la Faille 1970, no. F491.

8. Compare De la Faille 1970, nos. F503, F504 (*La Berceuse*), F505, F506, F507, F508, and F592.

9. Museum Folkwang, Essen, and Museum Boymans–van Beuningen, Rotterdam, respectively. De la Faille 1970, nos. F492 and F493.

10. Oil on canvas, 19¼ x 24½ (48.9 x 62.2 cm.), no. 5:59.

11. Mark W. Roskill, *Van Gogh, Gauguin, and French Painting of the 1880s: A Catalogue Raisonné of Key Works* (Ann Arbor, 1970), p. 80.

12. See *Complete Letters*, nos. 571 and 578.

13. Roskill (see note 10), p. 80.

14. Ronald Pickvance in The Metropolitan Museum of Art, New York, *Van Gogh in Arles*, October 18–December 13, 1984, p. 228, cat. no. 136.

15. Ibid., p. 223; *Complete Letters*, no. 560.

16. Pickvance (see note 14), p. 228.

17. See *Complete Letters*, nos. 573 and 571a. For the five versions of *La Berceuse*, see De la Faille 1970, nos. 504–8.

PROVENANCE: E. Bernard, Paris; Ambroise Vollard, Paris; A. Schuffenecker, Clamart, 1908; F. Meyer-Fierz, Zurich, by 1924; sale, Meyer-Fierz, F. Muller and Company, Amsterdam, July 13, 1926, no. X; Thannhauser Art Gallery, Munich; Reid and Lefevre Art Gallery, London; M. Knoedler and Company, New York, by 1943, until 1946; William L. Elkins Collection, Philadelphia.

EXHIBITIONS: Société des Artistes Indépendants, Paris, *Vincent van Gogh exposition rétrospective*, March 24–April 30, 1905, no. 38; Kunsthalle, Mannheim, *Internationale Kunstausstellung*, May–October 1907, no. 1080; Galerie E. Druet, *Vincent van Gogh*, January 6–18, 1908, no. 28; Vienna, *Internationale Kunstschau*, 1909, no. 3; Paul Cassirer, Berlin, *III. Ausstellung*, October–November 1910 (not in catalogue); Kunsthalle, Basel, *Vincent van Gogh*, March 27–April 21, 1924, no. 36; Kunsthaus, Zurich, *Vincent van Gogh*, July 3–August 10, 1924, no. 42; Thannhauser Art Gallery, Munich, Lucerne, and Berlin, *Erste Sonderausstellung in Berlin*, January 9–mid-February 1927; The Detroit Institute of Arts, *The Age of Impressionism and Objective Realism*, May 3–June 2, 1940, no. 49; Worcester Museum of Art, *The Art of the Third Republic: French Painting, 1870–1940*, February 22–March 16, 1941, no. 16; Wildenstein and Company, New York, *The Art and Life of Vincent van Gogh: Loan Exhibition in Aid of American and Dutch War Relief*, October 6–November 7, 1943, p. 78, no. 37; Art Gallery, Toronto, *Loan Exhibition of Great Paintings*, 1944, no. 23; University of Rochester Memorial Art Gallery, New York, *Old Masters of Modern Art*, 1944; Philadelphia Museum of Art, *Masterpieces of Philadelphia Private Collections*, May 1947, p. 73, no. 30; M. Knoedler and Company, New York, *Vincent van Gogh: 14 Masterpieces*, March 30–April 17, 1948, no. 8; Auckland City Art Gallery, New Zealand, *Van Gogh in Auckland*, August 19–October 5, 1975, no. 7.

LITERATURE: Elizabeth Du Quesne van Gogh, *Personal Recollections of Vincent van Gogh*, translated by Katherine S. Dreier (Boston and New York, 1913), p. 38, repro.; *Wissen und Leben*, vol. 17, no. 1 (October 1, 1923), p. 70, repro.; Julius Meier-Graefe,

Vincent van Gogh, vol. 2 (London, 1926), pl. 70; Florent Fels, *Vincent van Gogh* (Paris, 1928), p. 91, repro.; J.-B. de la Faille, *L'Oeuvre de Vincent van Gogh: Catalogue raisonné* (Paris and Brussels, 1928), vol. 1, p. 140, no. 490; Julius Meier-Graefe, *Vincent van Gogh* (New York, 1933), pl. 40; W. Scherjon and W. J. de Gruyter, *Vincent van Gogh's Great Period: Arles, St. Rémy, and Auvers sur Oise* (Amsterdam, 1937), p. 156, no. 129, repro.; J.-B. de la Faille, *Vincent van Gogh* (Paris, 1939), p. 369, no. 520, repro.; "Masterpieces of Philadelphia Private Collections," *The Philadelphia Museum of Art Bulletin*, vol. 42, no. 214 (May 1947), no. 30; Henry Clifford, "The Lisa Norris Elkins Collection: Paintings and Sculpture," *Philadelphia Museum of Art Bulletin*, vol. 46, no. 228 (winter 1951), p. 28, repro. (on cover); The Metropolitan Museum of Art, New York, *Masterpieces in the Philadelphia Museum of Art*, 1952, p. 11, repro.; *Philadelphia Museum of Art Bulletin*, vol. 57, no. 270 (summer 1961), p. 110, repro.; PMA 1965, p. 78; De la Faille 1970, p. 220, no. F490, repro.; Mark W. Roskill, *Van Gogh, Gauguin, and French Painting of the 1880s: A Catalogue Raisonné of Key Works* (Ann Arbor, 1970), pp. 80–81; Jan Hulsker, *The Complete Van Gogh: Paintings, Drawings, Sketches* (Oxford and New York, 1980), p. 378, no. 1637, repro.; The Metropolitan Museum of Art, New York, *Van Gogh in Arles*, October 18–December 30, 1984, pp. 223, 228, fig. 66 (catalogue by Ronald Pickvance); Walter Feilchenfeldt, *Vincent van Gogh & Paul Cassirer, Berlin: The Reception of Van Gogh in Germany from 1901 to 1914* (Zwolle, 1988), repro. p. 99.

CONDITION: The canvas support was lined with an aqueous adhesive. The tacking edges are missing. In 1967 cleaving paint was set down. In 1973 the painting was cleaned and inpainted. Losses exist in the thicker paint of the baby's clothing, along the left and top edges, and in the right center foreground in Mme Roulin's dress. The varnish remains colorless.

34 VINCENT VAN GOGH

PORTRAIT OF CAMILLE ROULIN?
Oil on canvas, 17 x 13¾" (43.2 x 35 cm.)
Gift of Mrs. Rodolphe Meyer de Schauensee. 73-129-1

The sitter, viewed bust length, wearing a blue cap and green coat against a
bright yellow field, has been assumed to be the younger son, Camille,[1] of
the postman Joseph Roulin, one of Van Gogh's close friends in Arles.
A slightly smaller version is in the Rijksmuseum Vincent van Gogh,
Amsterdam (fig. 34-1).[2] It has been argued, however, by the authors of
the catalogue of the Museu de Arte, São Paulo, and by Mark Roskill that
the so-called "Portrait of a Schoolboy" in São Paulo (fig. 34-2) may be the

FIG. 34-1 Vincent van Gogh, *Camille Roulin?*, oil on canvas, 14¾ x 12¾" (37.5 x 32.5 cm.), Rijksmuseum Vincent van Gogh, Amsterdam, inv. no. Lf538.

FIG. 34-2 Vincent van Gogh, *Portrait of a Schoolboy (Probably Camille Roulin)* , oil on canvas, 25¼ x 21¼" (63.5 x 54 cm.), Museu de Arte, São Paulo.

portrait of Camille from the Roulin family series.[3] The size of that canvas better accords with a "size 15 canvas" Van Gogh mentioned in a letter to his brother Theo describing his portraits of the postman's family.[4] Moreover, the work was called "The Postman's Child" at least as early as 1922.[5] This theory, however, has been rejected by the editors of the newest edition of De la Faille, who state that "while the style [of the São Paulo picture] is close to the portraits executed at Arles, the passage from letter 622 [Saint-Rémy, January 4, 1890: "Just now I have done a little portrait of one of the servants here, which he wanted to send to his mother"] makes it more probable that this painting was executed at Saint Rémy."[6] Ronald Pickvance accepted the São Paulo picture as the portrait from the Roulin family series, but did not mention the smaller bust-length pictures.[7] The authors of the exhibition of Van Gogh's works held in Japan in 1985–86 assumed that all three pictures depicted Camille, comparing their similar absent-minded or dreaming expressions.[8]

Camille was eleven years old when these portraits were executed, having been born in Lambesc on July 10, 1877. He became a clerk in the Service des Messageries Maritimes and died on June 4, 1922.

NOTES

1. See Priou, *Arts,* August 31–September 6, 1955, p. 6.
2. De la Faille 1970, no. F538 [as painted in Arles, November 1888]; W. Scherjon and W. J. de Gruyter, *Vincent van Gogh's Great Period: Arles, St. Rémy, and Auvers sur Oise* (Amsterdam, 1937), no. 133.
3. Museu de Arte, São Paulo, cat. 1963, no. 112; Mark W. Roskill, *Van Gogh, Gauguin, and the Impressionist Circle* (Greenwich, Conn., 1970), p. 79.
4. *The Complete Letters of Vincent van Gogh,* 2nd ed., translated by Johanna van Gogh-Bonger and C. de Drood (Greenwich, Conn., 1959), no. 560.
5. See Roskill (note 3), p. 79; *L'Amour de l'Art,* vol. 3 (1922), p. 204, vol. 5 (1924), p. 394. The identification of the São Paulo picture with Camille's portrait is supported by the authors of the exhibition catalogue for the Arts Council of Great Britain, Haywood Gallery, London, *Paintings and Drawings from the Vincent van Gogh Foundation in Amsterdam,* 1968–69, p. 94, under cat. no. 139.
6. *Complete Letters* (note 4), no. 622; De la Faille 1970, p. 262, no. F665; Jan Hulsker, *The Complete Van Gogh: Paintings, Drawings, Sketches* (Oxford and New York, 1980), pp. 430, 432, no. 1879 [as "Boy with Uniform Cap"].

7. Ronald Pickvance in The Metropolitan Museum of Art, New York, *Van Gogh in Arles,* October 18–December 30, 1984, cat. no. 135.
8. The National Museum of Western Art, Tokyo, *Vincent van Gogh Exhibition,* October 12–December 8, 1985, Nagoya City Museum, December 19, 1985–February 2, 1986, p. 221, under cat. no. 78.

PROVENANCE: Joseph Roulin, Marseille; Ambroise Vollard, Paris; Amédée Schuffenecker, Paris; J. Meier-Graefe, Berlin; sold in May 1905 to Paul Cassirer, who sold it back to Meier-Graefe in October 1909, who sold it to Cassirer again in October 1912; Paul Cassirer Gallery, Berlin; sold by Cassirer to dealer Georg Caspari, Munich, April 5, 1916; Thannhauser Art Gallery, Lucerne; A. Lewisohn, New York; Marius de Zayas, New York, by 1921; M. de Zayas sale, Anderson Gallery, New York, March 23–24, 1923, lot 85; J. K. Thannhauser Gallery, New York; Joseph Stransky, New York, by 1934; Wildenstein and Company, New York; Valentine Gallery, New York; Mr. and Mrs. Roldolphe Meyer de Schauensee, Devon, Pennsylvania, April 1940.

EXHIBITIONS: Galerie Bernheim-Jeune, Paris, *Vincent van Gogh,* March 15–31, 1901, no. 41; Paul Cassirer, Hamburg, *I. Ausstellung,* September–October 1905, no. 52, Ernst Arnold, Dresden, November 1905, and Paul Cassirer, Berlin, December 1905; H. O. Miethke, Vienna, *Vincent van Gogh,* January 1906, no. 40; Paul Cassirer, Berlin, *Vincent van Gogh,* May–June 1914, no. 100; The Metropolitan Museum of Art, New York, *Loan Exhibition of Impressionist and Post-Impressionist Paintings,* May 3– September 15, 1921, no. 123; Paul Cassirer Gallery, Berlin, *Vincent van Gogh,* January 15– March 1, 1928, no. 55; on loan to Worcester Museum of Art, 1932–35; Museum of Modern Art, New York, *Vincent van Gogh,* December 1935–January 1936, no. 42, also shown at The Art Institute of Chicago, Museum of Fine Arts, Boston, The Cleveland Museum of Art, The Detroit Institute of Arts, The Nelson Gallery and Atkins Museum, Kansas City, The Minneapolis Institute of Art, and the M. H. de Jongh Memorial Museum, San Francisco; Wildenstein and Company, London, *"Collections of a Collector": Modern French Paintings from Ingres to Matisse (The Collection of the Late Josef Stransky),* July 1936, no. 21; Wildenstein and Company, New York, *The Child through Four Centuries,* March 1–28, 1945, no. 42; Philadelphia Museum of Art, *Masterpieces of Philadelphia Private Collections,* May 1947, no. 29; Delaware Art Museum, Wilmington, *French Painting, 1847–1947,* 1948, no. 46; City Art Museum of Saint Louis, *Vincent van Gogh,* also shown at The Toledo Museum of Art, and Philadelphia Museum of Art, 1953–54; Wildenstein and Company, New York, *Van Gogh,* March 24–April 30, 1955, no. 40; The Solomon R. Guggenheim Museum, New York, *Van Gogh and Expressionism,* 1964, no. 20; Philadelphia Museum of Art, *Gifts to Mark a Century: An Exhibition Celebrating the Centennial of the Philadelphia Museum of Art,* February 18–March 20, 1977, no. 162.

LITERATURE: *The Arts,* vol. 3, no. 3 (March 1923), p. 227, repro.; J.-B. de la Faille, *L'Oeuvre de Vincent van Gogh: Catalogue raisonné* (Paris and Brussels, 1928), vol. 1, p. 153, vol. 2, pl. 147, no. 537, repro.; W. Scherjon and W. J. de Gruyter, *Vincent van Gogh's Great Period: Arles, St. Rémy and Auvers sur Oise* (Amsterdam, 1937), p. 157, no. 134, repro.; J.-B. de la Faille, *Vincent van Gogh* (Paris, 1939), p. 382, no. 544, repro. [as painted in November 1888]; Edward Alden Jewell, *French Impressionists and Their Contemporaries Represented in American Collections* (New York, 1944), pl. 156; *Philadelphia Museum of Art Bulletin,* vol. 42, no. 214 (May 1947), pp. 73ff.; Joachim Beer, "Van Gogh: Diagnosis of a Tragedy," *Art News Annual,* vol. 19, pt. 2 (November 1949), p. 87, repro.; Raymond Cogniat, *French Painting at the Time of the Impressionists* (Paris, 1951), p. 110, repro.; *An Art News Picture Book* (New York, 1953), p. 45, repro.; De la Faille 1970, p. 230, no. F537, repro. [as painted in Arles, November 1888]; Jan Hulsker, *The Complete Van Gogh: Paintings, Drawings, Sketches* (Oxford and New York, 1980), p. 378, no. 1644, repro.; Walter Feilchenfeldt, *Vincent van Gogh & Paul Cassirer, Berlin: The Reception of Van Gogh in Germany from 1901 to 1914* (Zwolle, 1988), pp. 16, 100, 103, repro.

CONDITION: The canvas support has been wax-lined with a fine fabric and is in sound condition. The tacking edges were removed. The paint film reveals old losses at the lower and right edges and to the left of the crown of the sitter's cap. All losses have old retouches, which have discolored. The varnish is discolored and residues of dark brown varnish remain in the interstices of the brush marking.

35 VINCENT VAN GOGH

SUNFLOWERS, 1889
Signed on the left of the vase in red: *Vincent*
Oil on canvas, 36¼ x 28⅞" (92 x 73.3 cm.)
Mr. and Mrs. Carroll S. Tyson, Jr., Collection. 63-116-19

Twelve sunflowers are arranged in a yellow and mauve vase outlined in red on a yellow ocher table with a bright turquoise background. Van Gogh's sunflowers, of which he made seven versions, are probably his single most famous series of paintings. Although he had painted sunflowers in Paris late in the summer of 1887,[1] the series for which he is renowned was begun in Arles in the following summer. About August 18, 1888, Van Gogh wrote to Emile Bernard: "I am thinking of decorating my studio with half a dozen pictures of 'Sunflowers,' a decoration in which the raw or broken chrome yellows will blaze forth on various backgrounds—blue, from the palest malachite green to *royal blue,* framed in thin strips of wood painted with orange lead. Effects like those of stained-glass windows in a Gothic church."[2] Several days later he wrote to Theo:

> I am hard at it, painting with the enthusiasm of a Marseillais eating bouillabaisse, which won't surprise you when you know that what I'm at is the painting of some big sunflowers.
>
> I have three canvases going—1st, three huge flowers in a green vase, with a light background, a size 15 canvas;[3] 2nd, three flowers, one gone to seed, having lost its petals, and one a bud against a royal-blue background, size 25 canvas;[4] 3rd, twelve flowers and buds in a yellow vase (size 30 canvas). The last one is therefore light on light, and I hope it will be the best.[5] Probably I shall not stop at that. Now that I hope to live with Gauguin in a studio of our own, I want to make decorations for the studio. Nothing but big flowers. Next door to your shop, in the restaurant, you know there is a lovely decoration of flowers; I always remember the big sunflowers in the window there.
>
> If I carry out this idea there will be a dozen panels. So the whole thing will be a symphony in blue and yellow. I am working at it every morning from sunrise on, for the flowers fade so soon, and the thing is to do the whole in one rush.[6]

The following day he again wrote to Theo, informing him, "I am now on the fourth picture of sunflowers. This fourth one is a bunch of 14 flowers, against a yellow background,[7] like a still life of quinces and lemons that I did some time ago...."[8] Van Gogh's initial idea to decorate his studio with the sunflowers seems to have given way to the thought to decorate the guestroom in the Yellow House, which he first occupied in September 1888. On September 9 and 16, he wrote to his sister Wilhelmina: "In this very little room [the room that would become Paul Gauguin's when he came] I want to put, in the Japanese manner, at least six very large canvases, particularly the enormous bouquets of sunflowers."[9] This plan was thwarted when the flowers ended. On September 29 he wrote to Theo, "I wanted to do some more sunflowers too, but they were already gone."[10] By October he evidently had reduced his plan to the use of only two versions in Gauguin's room (see letter no. 552, where two *Sunflowers,* are listed as set aside for the decoration of the house). Gauguin had acquired two of the Paris sunflower series earlier and seems

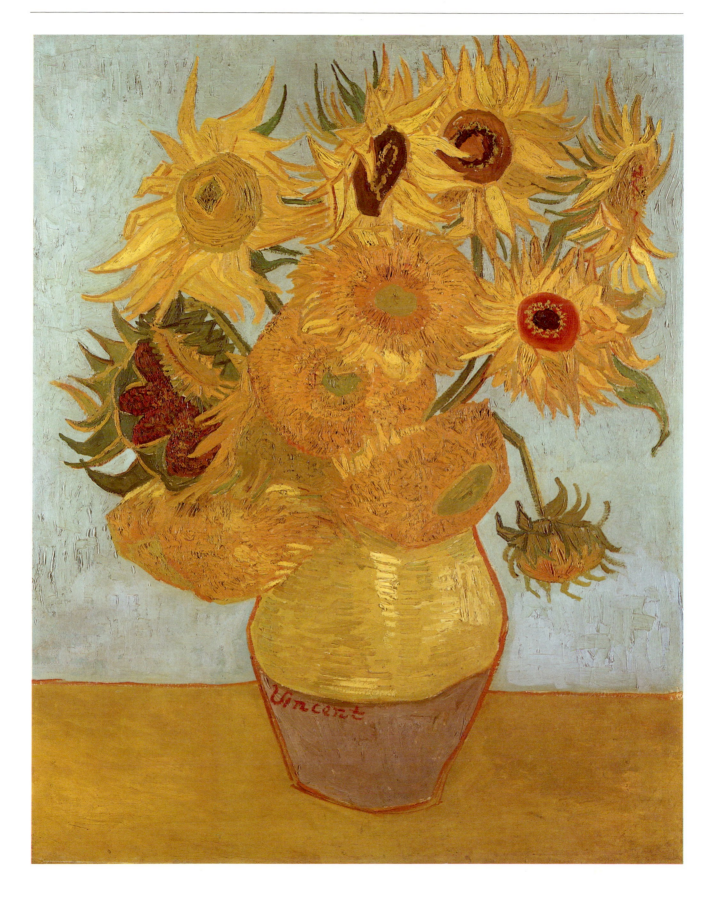

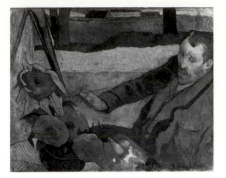

FIG. 35-1 Paul Gauguin, *Portrait of Vincent van Gogh Painting Sunflowers*, 1888, oil on canvas, 28¼ x 36¼" (73 x 91 cm.), Rijksmuseum Vincent van Gogh, Amsterdam, no. B3499.

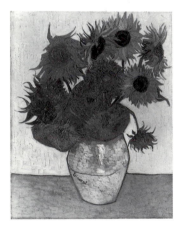

FIG. 35-2 Vincent van Gogh, *Sunflowers,* oil on canvas, 35⅞ x 28" (91 x 71 cm.), Neue Pinakothek, Bayerische Staatsgemäldesammlungen, Munich, no. 8672.

upon his arrival in Arles to have admired these paintings ("ça . . . c'est . . . la fleur"; see letter no. 573). By December 14, 1888, Gauguin had painted his famous *Portrait of Vincent van Gogh Painting Sunflowers* (fig. 35-1), a fanciful composition since the season for sunflowers had passed and Van Gogh did not work on his sunflowers when Gauguin was in Arles. After the portrait was finished, Van Gogh is alleged to have said to Gauguin, "It is certainly I, but it is I gone mad";[11] the famous incident during which Van Gogh cut off part of his ear followed on December 23.

To the original group of four or possibly five paintings of sunflowers executed in 1888, Van Gogh added two replicas in January 1889. He wrote to Theo on January 28 after his breakdown: "During your visit I think you must have noticed the two size 30 canvases of sunflowers in Gauguin's room. I have just put the finishing touches to copies, absolutely identical replicas of them [*absolument equivalentes et pareilles*],"[12] and on January 30, "When Roulin came I had just finished the duplicate of my sunflowers."[13] In all probability, the present work, as W. Sherjon and W. J. de Gruyter (1937) implied, and the editors of J.-B. de la Faille (1970), Mark Roskill (1970), Jan Hulsker (1980), and Roland Dorn (1986) have stated, is the replica Van Gogh made of the painting now in Munich (fig. 35-2). These two paintings are the only two in the series that depict twelve sunflowers and are virtually identical in design and dimensions. The greater freedom of execution in the Munich version would support its identification as the earlier of the two. Roskill also observed that when Van Gogh wrote to Wilhelmina in September or early October 1888, he noted that his sunflower painting with twelve blooms (the third, mentioned in previously quoted letter no. 526) had a "blue-green" background, which, Roskill noted, better applies to the Munich than the Philadelphia picture, whose background is a paler turquoise.[14] Beyond the argument of color, the author also noted that the form of the signature in the Philadelphia painting and in a version in the Rijksmuseum Vincent van Gogh, Amsterdam (fig. 35-4)[15] suggests that these are the two replicas. The Amsterdam painting is a virtually identical but, like the present work, slightly stiffer repetition of the painting in the Tate Gallery, London (oil on canvas, 36½ x 28¾" [92 x 73 cm.], no. 3863). The letters in its signature, like those in the Philadelphia picture, are more widely spaced and individually formed in a fashion different from that of the other five versions.[16] According to Roskill, "Van Gogh's signature changed in exactly this sense between September 1888 and the beginning of 1889."[17]

There seemingly were two reasons to recreate the sunflowers of the previous August. The first was an apparent request from Gauguin, by then back in Paris, to have one of the sunflower paintings as a gift or in exchange for some of his works. In a letter to Theo from January 17, Van Gogh initially turned him down: "I think it rather strange that he [Gauguin] claims a picture of sunflowers from me. . . . But for the moment . . . I am definitely keeping my sunflowers."[18] By January 22, however, he had relented, offering to make a replica for Gauguin of either of the two sunflower pictures that he was then proposing to exhibit at Goupil's in Paris: "I should very much like to give Gauguin real pleasure. So if he wants one of the two canvases, all right, I will do one of them over again, whichever he likes."[19] However, in the letter of January 28 (no. 574) mentioning the replicas of the sunflowers, Van Gogh also mentioned making two copies of *La Berceuse* (fig. 35-5),[20] thus expressing renewed interest in a larger decorative scheme. He stated: "I picture to myself these

canvases between those of the sunflowers, which would thus form lamp brackets or candelabra beside them, the same size, and so the whole would be made up of 7 or 9 canvases." Thus his conception again changed. He now thought of the third and fourth versions and their replicas as linked with the versions of *La Berceuse*. Having sent the pictures to Theo in Paris at the end of April, he wrote in May 1889: "You must realize that if you arrange them this way, say 'La Berceuse' in the middle and the two canvases of the sunflowers to the right and left, it makes a sort of triptych. And then the yellow and orange tones of the head will gain in brilliance by the proximity of the yellow wings."[21] He drew a little sketch (fig. 35-3) in the letter to illustrate this point; compare the composite reconstruction (figs. 35-4, 35-5, and 35-6). The versions Van Gogh sent to his brother were at least two in number,[22] and probably, as Roskill noted, consisted of the two replicas (the present work and the painting in Amsterdam). Theo

FIG. 35-3 Vincent van Gogh, sketch of *The Berceuse* flanked by *Sunflowers,* in a letter to his brother Theo of May 25, 1889.

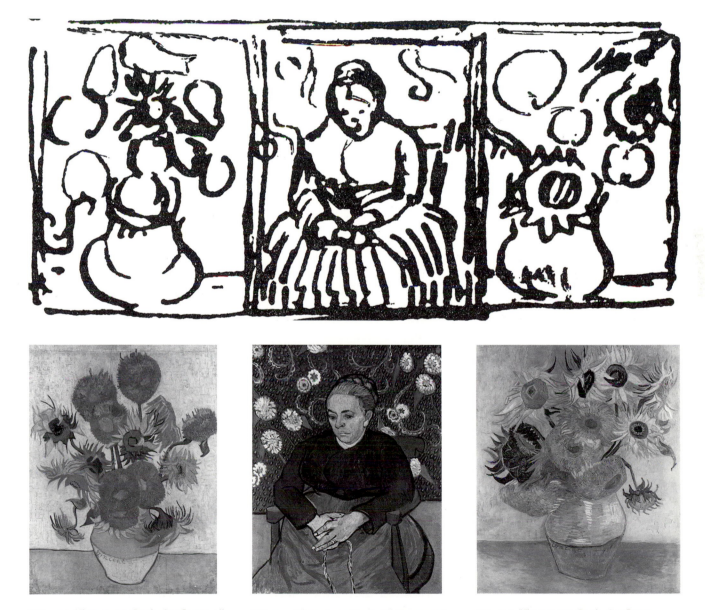

FIG. 35-4 Vincent van Gogh, *Sunflowers,* oil on canvas, 37½ x 28¾" (95 x 73 cm.), Rijksmuseum Vincent van Gogh, Amsterdam, no. F458.

FIG. 35-5 Vincent van Gogh, *La Berceuse,* oil on canvas, 35¾ x 28¼" (91 x 71.5 cm.), Stedelijk Museum, Amsterdam, inv. no. A965.

FIG. 35-6 Vincent van Gogh, *Sunflowers,* oil on canvas, 36¼ x 28⅞" (92 x 73.3 cm.), Philadelphia Museum of Art, no. 63-116-19.

definitely owned the Amsterdam picture, whereas the present work may have been exhibited by the dealer Tanguy, in December 1889, in Paris.[23] Van Gogh never abandoned the idea of giving Gauguin a sunflower painting as part of an exchange; as late as February 1890 he wrote to Theo: "Give him [Gauguin] my kindest regards, and, if he likes, he can take the copies of the 'Sunflowers' and the copy of 'La Berceuse' in exchange for something of his that you would like."[24] However, there is no evidence that Gauguin ever received the paintings.

In a letter to Wilhelmina written from Saint-Rémy in the middle of February 1890, Van Gogh noted that his sunflowers "may symbolize gratitude."[25] On February 11 he also wrote to the critic Albert Aurier, who had written an article on his work in *Mercure de France* (January 1890), "Suppose that the two pictures of sunflowers, which are now at the *Vingtistes'* exhibition [the versions now in London and Munich], have certain qualities of color, and that they also express the idea symbolizing 'gratitude.'"[26] Since the sixteenth century the sunflower has been associated with love (both sacred and profane) because of its heliotropic behavior; the sunflower follows the sun just as the true believer follows Christ or the lover, his sweetheart. In addition, it also has symbolized fidelity, as in the sense of the faithful subject who follows his leader or of art that follows nature. The latter connotation explains why the sunflower often has symbolized the art of painting (for example, Anthony van Dyck's famous *Self-Portrait with a Sunflower* in the collection of the duke of Westminster).[27] Citing the hanging of the sunflowers in Gauguin's room, Konrad Hoffmann has suggested that the flower's connotations of art and love may have been associated by Van Gogh with the concept of artistic friendship, which, recalling the triptych plan, was further compounded with religious or spiritual (albeit somewhat vague) associations, as in the notion of man's gratitude for God's beneficence.[28] Roskill rightly cautioned, however, that Van Gogh referred to his sunflowers as symbols of gratitude only in a "strictly private sense," since his letter to Aurier goes on to say that these meanings do not in themselves differentiate these canvases from those of other flower painters, such as Ernest Quost (1844–1931) and Georges Jeannin (1841–1925). Thus he distinguished between the private and public meanings of the work of art, and in the latter regard saw his sunflowers as wholly in line with late Romantic flower painting.[29]

According to Roland Dorn's thesis, the provenances of the Philadelphia and Yasuda Kasai paintings have been confused; the former picture, he argues, was the work that was lent by Emile Schuffenecker to the famous exhibition of Van Gogh's works at Bernheim-Jeune in 1901, since its palette accords better with the description of number five ("Tournesols sur fond vert très pâle" [Sunflowers on a very pale green background]) than number six (Tournesols sur fond jaune" [Sunflowers on a yellow background]), lent by Comte A. de la Rochefoucauld.[30] However, Walter Feilchenfelt has noted that in the copy of the exhibition catalogue annotated by Julien Leclercq and dedicated to Johanna van Gogh (now preserved in the library of the Rijksmuseum Vincent van Gogh, Amsterdam), *jaune* has been crossed out and *veronese* written in, thus suggesting that Dorn was mistaken.[31] Feilchenfeldt adds further that the Philadelphia painting is the only one of the sunflower paintings that cannot be traced to the Van Gogh family, but it may be identical with the "Soleils dans un pot," which the records of the

dealer Ambroise Vollard indicate he bought for a high price from a Félix Roux on October 23, 1895, and sold on December 21 of the following year to Comte de la Rochefoucault.[32]

NOTES

1. See De la Faille 1970, nos. F375 (The Metropolitan Museum of Art, New York), F376 (H. R. Hahnloser, Bern), F377 (Rijksmuseum Vincent van Gogh, Amsterdam), and F452 (Rijksmuseum Kröller-Müller, Otterlo).

2. *The Complete Letters of Vincent van Gogh,* 2nd ed., translated by Johanna van Gogh-Bonger and C. de Drood (Greenwich, Conn., 1959), no. B15.

3. This doubtless is the painting in a private collection, United States (De la Faille 1970, no. F453; canvas, 28¾ x 22¾″ [73 x 58 cm.]).

4. Formerly Koyata Yamamoto Collection, Ashiya, Japan; destroyed World War II (De la Faille 1970, no. F459; panel, 38½ x 27⅛″ [98 x 69 cm.]).

5. According to W. Scherjon and W. J. de Gruyter (*Vincent van Gogh's Great Period: Arles, St. Rémy, and Auvers sur Oise* [Amsterdam 1937], no. 75), De la Faille (1970, no. F456), Mark W. Roskill (*Van Gogh, Gauguin, and French Painting of the 1880s: A Catalogue Raisonné of Key Works* [Ann Arbor, 1970], p. 41), and Jan Hulsker (*The Complete Van Gogh: Paintings, Drawings, Sketches* [Oxford and New York, 1980], no. 354), this is the version now in the Neue Pinakothek, Bayerische Staatsgemäldesammlungen (cat. 1981, pp. 113–14, no. 8672); canvas, 35⅞ x 28⅜″ (91 x 72 cm.).

6. *Complete Letters* (see note 2 and hereafter), c. August 23, 1888, no. 526.

7. Tate Gallery, London, cat. 1959, no. 3863 (De la Faille 1970, no. F454).

8. *Complete Letters,* c. August 24, 1888, no. 527. In letter no. 534 to Theo he also wrote of this room, "You will see these great pictures of the sunflowers, 12 or 14 to the bunch, crammed into this tiny boudoir with its pretty bed and everything else dainty. It will not be commonplace."

9. *Complete Letters,* no. W7.

10. *Complete Letters,* no. 543.

11. Paul Gauguin, *Avant et après, avec les vingt-sept dessins du manuscrit original* (Paris, 1923), p. 13.

12. *Complete Letters,* no. 574.

13. *Complete Letters,* no. 575.

14. Roskill (see note 5), p. 42; *Complete Letters,* no. W8.

15. Vincent van Gogh Foundation, inv. no. F458 (De la Faille 1970, no. F458).

16. The seventh painting in the series is the *Still Life with Fourteen Sunflowers,* oil on canvas, 39⅜ x 30″ (100 x 76 cm.), formerly in the Helen Chester Beatty Collection, sale, Christie's, London, March 30, 1987, lot 43, to the Yasuda Fire and Marine Insurance Company for the Yasuda Kasai Museum, Tokyo. Although it has the same number of blooms as the London (De la Faille 1970, no. F454) and Amsterdam (no. F458) pictures, it is unsigned and somewhat larger. De la Faille (1970) and Scherjon and De Gruyter (see note 5) identify it as another replica, but Roskill (see note 5, p. 44) believes it is a fifth version executed in August 1888. Roland Dorn (see Beatty sale, Christie's, London, March 30, 1987, p. 20), on the other hand, noted that it was painted on a rough, coarse canvas similar to that of the Philadelphia version, and thus may have been painted in January 1889. He supports this theory with the reference in Van Gogh's letter of January 28 (*Complete Letters,* no. 574), suggesting that he envisioned still a third triptych—"the whole would be composed of seven or nine canvases." Dorn also hypothesized that the Yasuda Kasai painting might have been executed for Gauguin.

17. Roskill (see note 5), p. 44.

18. *Complete Letters,* no. 571.

19. De la Faille 1970, nos. F454 and F456; *Complete Letters,* no. 573.

20. See De la Faille 1970, nos. F504–8.

21. *Complete Letters,* no. 592.

22. See *Complete Letters,* nos. 592, T12, and 614.

23. "The sunflowers were on show at Tangui's [*sic*] this week"; *Complete Letters,* dated December 22, 1889, no. T22.

24. *Complete Letters,* no. 626.

25. *Complete Letters,* no. W20.

26. *Complete Letters,* no. 626a.

27. On the traditional symbolism of the sunflower, see Mario Praz, *Studies in Seventeenth Century Imagery* (Rome, 1964); G. de Taverent, *Attributs et symbols dans l'art profane, 1450–1600,* vol. 2 (Ghent, 1959), pp. 385ff.; and J. Bruyn Hzn. and J. A. Emmens, "De zonnebloem als embleem in een schilderijlijst," *Bulletin van het Rijksmuseum,* vol. 4 (1956), pp. 3–9.

28. Konrad Hoffmann, "Zu van Goghs Sonnenblumenbildern," *Zeitschrift für Kunstgeschichte,* vol. 31, no. 1 (1968), pp. 27–48.

29. See Roskill (note 5), p. 46.

30. Dorn ("Decoration: Van Goghs Werkreine für das Gelbe Haus in Arles," diss., Mainz, 1986); see Helen Chester Beatty Collection sale, Christie's, London, March 30, 1987, p. 28.

31. Letter to author, September 11, 1989, Philadelphia Museum of Art, accession files.

32. Ibid. A copy of the Philadelphia painting is in the collection of J. N. Jacobson, Belport, New York, oil on canvas, 29 x 23″ (73.7 x 58.4 cm.).

PROVENANCE: Possibly Félix Roux, who sold it to the dealer Ambroise Vollard, Paris, October 23, 1895, who in turn sold it to Comte de la Rochefoucault, December 21, 1896; Paul Rosenberg Art Gallery, Paris, who sold it to Carroll S. Tyson, Jr., Chestnut Hill, Pennsylvania, 1928.

EXHIBITIONS: Possibly Maison Tanguy, Paris, December 1889; Galerie Bernheim Jeune, Paris, *Vincent van Gogh,* March 15–31, 1901, no. 6; Museum of Modern Art, New York, *Vincent Van Gogh,* December 1935–January 1936, no. 31, also exhibited at The Art Institute of Chicago, Museum of Fine Arts, Boston, The Cleveland Museum of Art, The Detroit Institute of Arts, The William Rockhill Nelson Gallery of Art, Kansas City, The Minneapolis Institute of Arts, Philadelphia Museum of Art, and M. H. de Young Memorial Art Museum, San Francisco (catalogue by Alfred H. Barr); Wildenstein and Company, New York, *The Art and Life of Vincent van Gogh: Loan Exhibition in Aid of American and Dutch War Relief,* October 6–November 7, 1943, no. 28; Philadelphia Museum of Art, *Masterpieces of Philadelphia Private Collections,* May 1947, no. 28; Wildenstein and Company, New York, *The Magic of Flowers in Paintings,* April 15–May 3, 1954, no. 27; Philadelphia Museum of Art, *A World of Flowers,* May 9–June 2, 1963.

LITERATURE: J.-B. de la Faille, *Vincent van Gogh* (Paris, 1928), no. 455, repro. [as painted in Arles, August 1888]; Victor Doiteau and E. Leroy, *La Folie de van Gogh* (Paris, 1928), p. 93, repro.; W. Scherjon and W. J. de Gruyter, *Vincent van Gogh's Great Period; Arles, St. Rémy and Auvers sur Oise* (Amsterdam, 1937), p. 105, no. 78, repro.; J.-B. de la Faille, *Vincent van Gogh* (Paris, 1939), p. 336, no. 469, repro. [as painted in Arles, August 1888]; Edward Alden Jewell, *Vincent van Gogh* (New York, 1946), p. 49, repro.; "Masterpieces of Philadelphia Private Collections," *The Philadelphia Museum of Art Bulletin,* vol. 42, no. 214 (May 1947), no. 28; R. Alley, *Tate Gallery Catalogue: Foreign Paintings, Drawings, and Sculpture* (London, 1959), p. 270; John Rewald, "The Collection of Carroll S. Tyson, Jr., Philadelphia, U.S.A.,"

Philadelphia Museum of Art Bulletin, vol. 59, no. 280 (winter 1964), pp. 59–62, repro. p. 79; Fritz Neugass, "A Windfall for the Philadelphia Museum of Art," *Art Voices,* vol. 3, no. 2 (February 1964), p. 20, repro.; Mark W. Roskill, letter to *Times Literary Supplement,* December 10, 1964 [as 1889]; L. Pierard, *Vincent van Gogh* (Paris, n.d.), no. 25, repro.; PMA 1965, p. 28 [as 1888]; Parker Tyler, *Van Gogh* (New York, 1968), no. 41; The Arts Council of Great Britain, Hayward Gallery, London, *Vincent van Gogh,* October 23, 1968–January 12, 1969, p. 91, under cat. no. 132; Mark W. Roskill, *Van Gogh, Gauguin, and French Painting of the 1880s: A Catalogue Raisonné of Key Works* (Ann Arbor, 1970), pp. 41–47; De la Faille 1970, no. F455 [as painted in Arles, January 1889]; Philadelphia Museum of Art, *Treasures of the Philadelphia Museum of Art and the John G. Johnson Collection* (Philadelphia, 1973), p. 81, repro. [as 1888]; Jan Hulsker, *The Complete Van Gogh: Paintings, Drawings, Sketches* (Oxford and New York, 1980), p. 385, no. 1668, repro.; Roland Dorn, "Decoration: Van Goghs Werkreihe für das Gelbe Haus in Arles," diss., Mainz, 1986; Christie's, London, *Van Gogh's Sunflowers: The Property of the Late Mrs. Helen Chester Beatty,* March 30, 1987, pp. 19, 20, 24, 28, fig. 7; Ann Hoenigswald, "Vincent van Gogh: His Frames, and the Presentation of His Paintings," *The Burlington Magazine,* vol. 130, no. 1022 (May 1988), pp. 367–72.

CONDITION: The canvas was lined with an aqueous adhesive sometime after 1928. A third linen canvas was loosely stretched behind the lining canvas. In 1967 the surface was treated for cleavage and flaking of the paint film. An irregular crackle pattern is present in the turquoise background; one crack extends into the golden foreground to the left of the vase. The paint film is very fragile and shows several small losses along the left and upper edges, through the impasto of the flowers, and in the golden foreground. Areas of cleavage and flaking were consolidated in the lowest flower at the right in 1960 and again in 1967, as well as at the base of the vase and the blossom directly above it. Old retouches in the background do not match the original tones. The painting appears unvarnished. The surface is uneven, varying from matte to a soft sheen, depending on the richness of the paint mixtures. Grime has become imbedded in the fragile and somewhat porous surface.

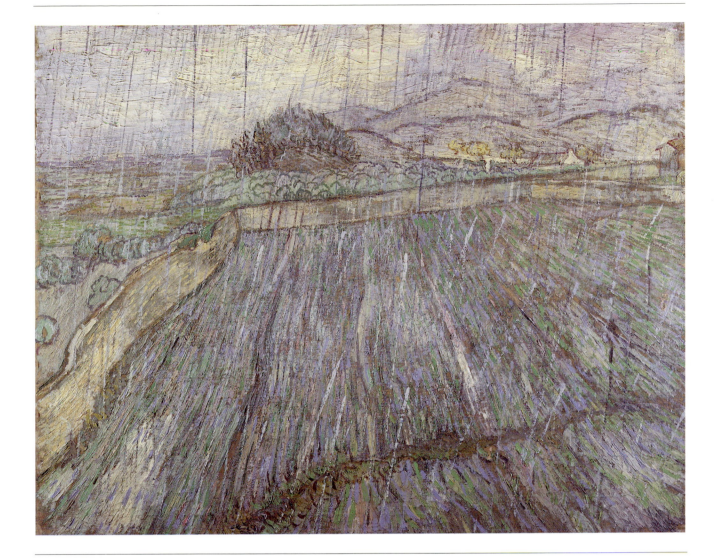

36 VINCENT VAN GOGH

RAIN, 1889
Oil on canvas, 29¼ x 36⅛" (74.3 x 93.1 cm.)
The Henry P. McIlhenny Collection in memory of Frances P.
 McIlhenny. 1986-26-36

A driving rainstorm obscures the enclosed wheat field visible from the
artist's window at the asylum of Saint-Paul-de-Mausole, Saint-Rémy.
Extending in a broken diagonal from the lower left to a juncture in the
upper-left middle distance and continuing across the scene to the upper
right, the wall occludes the rapid retreat of the furrows of the field. An
entrenched footpath in the foreground creates a second meandering
diagonal that echoes the first. The high horizon of distant plains, trees,
and, on the right, mountains, is also angled and ascends to more than
four-fifths of the height of the canvas, engulfing the viewer in landscape.
Counterbalancing these forms are the slashing lines of the rain, seemingly
deflected and whitened by the wind as they race across the striated impasto
of the field. The subdued palette comprises shades of gray, light olive green,
taupe, and lavender. Despite a glimpse of rooftops at the upper right, no
human figures appear.

FIG. 36-1 Vincent van Gogh, *The Enclosed Wheat Field,* black chalk, brown ink, heightened with white and black chalk on paper, 18¾ x 22″ (47.5 x 56 cm.), Rijksmuseum Kröller-Müller, Otterlo, inv. no. 1517-70.

FIG. 36-2 Vincent van Gogh, *Wheat Field at Sunrise,* oil on canvas, 28¾ x 36¼″ (73 x 92 cm.), sale, Sotheby's, New York, April 24, 1985, lot 19.

Van Gogh was admitted as a voluntary patient to Saint-Paul-de-Mausole on May 8, 1889. He described his room as well as the view from its window in a letter to his brother Theo, dated May 25, 1889: "Through the iron-barred window I see a squarefield of wheat in an enclosure, a perspective like Van Goyen [q.v.], above which I see the morning sun rising in all its glory."[1] Although Van Gogh was not confined to the asylum, the window provided his chief view of the outside world when he was feeling the effects of his illness. From June 1889 to the spring of 1890 he drew and painted a series of views from his window, reflecting the changes of seasons, hour, climate, and his mood. He painted the young wheat, the harvest in full bloom, as well as the reaper with sheaves and haystacks. At least eleven canvases and numerous drawings depict the enclosed wheat field.[2] Van Gogh apparently made drawings both preparatory to his wheat-field pictures and after them, as a letter to Theo of June 25, 1889, proves.[3]

One of the most finished sheets is in the Rijksmuseum Kröller-Müller (fig. 36-1).[4] With the exception of Philadelphia's picture and a nocturnal scene with the rising moon,[5] all of the paintings of the wheat field depict the scene in sunlight, whether at sunrise, noonday, or sunset. The *Wheat Field at Sunrise* that recently appeared in the Florence J. Gould sale in New York (fig. 36-2) is mentioned in a letter written to Theo in November 1889 and must have been painted in the same month as *Rain.*[6] In a letter datable to after October 25 and before November 17, 1889, Van Gogh referred to the Philadelphia painting: "I have a rain effect going."[7]

Van Gogh had remarked on the beauty of the rain in a letter written seven years earlier from The Hague: "How beautiful it is outside when everything is wet from the rain—before— in— and after the rain. I oughtn't to let a single shower pass."[8] While in Paris he had treated the theme of rain with works like *Cemetery in the Rain* (fig. 36-3), which emphasize the gloomy aspect of a downpour.[9] Van Gogh's solution to the challenge of capturing rain effects with rapid, diagonal slashes of pen or paint brush undoubtedly reflects his interest in Japanese prints. In the Lowlands he first cultivated this interest as early as December 1885.[10] Since Holland was the only country that traded with Japan during its isolation from 1639 to its reopening in 1854, it offered an unrivaled treasury of Japanese art, but Van Gogh became seriously interested only after moving to Paris in March 1886, where Japonisme had been in fashion at least since the late 1860s. In 1977 the authors of the catalogue of the Allentown exhibition of the McIlhenny Collection correctly noted the debts to the Japanese in the Philadelphia painting, pointing out that Van Gogh had made copies of *ukiyo-e* prints, including in 1887 Hiroshige's *Bridge in the Rain* (fig. 36-4).[11] In letters to Theo and the painters Emile Bernard (1868–1941) and Paul Gauguin (1848–1903), Van Gogh expressed his notion that the South of France was "the equivalent of Japan,"[12] that "the Japanese of France [were] the impressionists."[13] Even his dream of forming a fellowship of artists in the South of France was linked in his mind with a Japanese "sort of fraternal community."[14] But, in truth, Van Gogh's notions of Japan were probably superficial, formed more by such novels as Pierre Loti's *Madam Chrysanthème* (1887) than any true acquaintance with the history of the Japanese artistic community or culture.[15]

FIG. 36-3 Vincent van Gogh, *Cemetery in the Rain,* ink and colored chalk, heightened with white on paper, 14¼ x 19″ (36.5 x 48 cm.), Rijksmuseum Kröller-Müller, Otterlo, inv. no. 1121-43.

Two drawings executed following the Philadelphia painting by Van Gogh in March–April 1890 couple the theme of rain in the same enclosed wheat field with the figure of his beloved sower.[16] A still later painting in the National Museum of Wales, Cardiff, again takes up the theme of rain in a landscape, albeit no longer a view from the asylum.[17]

Living in relative isolation in Saint-Rémy, Van Gogh thought longingly of the northern landscape, made copies or variations of the works of artists who had influenced him earlier in his career (Millet, Daumier, Rembrandt, and Delacroix), and began to abandon the brilliant primary colors of his Arles period for more subdued color harmonies. In the last regard, *Rain* is typical of Van Gogh's palette during his Saint-Rémy period. Van Gogh requested in a letter that Theo refrain from looking at this picture and others of this period until he had had it stretched and placed in a white frame, which the artist insisted was essential to its coloristic effect.[18]

Exploring the expressive possibilities of a series of pictures of the same subject under different temporal and seasonal conditions, Van Gogh shared contemporary interests with Claude Monet (1840–1926), who embarked in 1889 on an exploration of serialized imagery (the Creuse Valley, poplars, haystacks, Rouen Cathedral, and other themes). However, Monet's landscapes invariably are images of the open countryside, while Van Gogh's views of an enclosed field are always records of confinement, depictions of the view through the unseen bars of the asylum window. Rare in southern France, the rain in the Philadelphia picture increases the sense of being shut in. No doubt these qualities contributed to the feeling that the wheat-field paintings are "disturbing pictures . . . the lines of the tilled field . . . abruptly stopped by the wall. . . . The cool tonalities, along with the conflicting patterns of line seen from a high viewpoint, make it impossible for us to enter Van Gogh's field. Just as [Van Gogh] was confined and alone at St. Rémy, we remain outside his wheat field to contemplate its disturbing and forbidding images."[19]

FIG. 36-4 Vincent van Gogh after Hiroshige, *Bridge in the Rain,* 1887, oil on canvas, 28¾ x 21¼″ (73 x 54 cm.), Rijksmuseum Vincent van Gogh, Amsterdam, no. F372.

NOTES

1. *The Complete Letters of Vincent van Gogh,* 2nd ed., translated by Johanna van Gogh-Bonger and C. de Drood (Greenwich, Conn., 1959), no. 592.

2. See De la Faille 1970, nos. 611, 617, 618, 619, 641, 718, 720, 722, 735, 737, 1546, 1547, 1550, 1551, 1552, 1556, 1557, 1558, 1559, 1560, 1561, SD 1728.

3. "I am sending you a dozen drawings today, all from canvases I am working on. . . . The latest one I've started is the 'Wheat Field.'" *Complete Letters* (see note 1 and hereafter), no. 597.

4. De la Faille 1970, no. 617; Jan Hulsker, *The Complete Van Gogh: Paintings, Drawings, Sketches* (Oxford and New York, 1980), pp. 404–5, no. 1753.

5. Oil on canvas, 28¾ x 36¼″ (72 x 92 cm.), Rijksmuseum Kröller-Müller, Otterlo, inv. no. 310-12 (see De la Faille 1970, no. 735; and Hulsker [see note 4], p. 406, no. 1761).

6. In letter no. 614 (*Complete Letters*), Van Gogh lists the works he would like to send to the exhibition at the association of the XX in Brussels, including "number 6. Wheat Field at Sunrise, on which I am working at the moment."

7. "J'ai un effet de pluie en train." *Complete Letters,* no. 613.

8. *Complete Letters,* August 1882, no. 227.

9. De la Faille 1970, no. 1399a; Hulsker (see note 4), p. 225, no. 1032.

10. See *Complete Letters,* no. 437, written to Theo from Antwerp, "My studio is not bad, especially as I have pinned a lot of little Japanese prints on the wall, which amuse me very much."

11. This print is from the series *One Hundred Famous Views of Edo,* 1856–58, by Hiroshige. See Allentown Art Museum, *French Masterpieces of the 19th Century from the Henry P. McIlhenny Collection,* May 1–September 18, 1977, p. 80. On Van Gogh and Japonisme,

see F. Orton, "Vincent's Interest in Japanese Prints," *Vincent,* vol. 1, no. 3 (1971), pp. 2–12; Rijksmuseum Vincent van Gogh, Amsterdam, *Japanese Prints Collected by Vincent Van Gogh,* 1978; Johannes van der Wolk, "Vincent van Gogh and Japan," *Japonisme in Art: An International Symposium* (Tokyo, 1980); Tsukasa Kōdera, " Japan as Primitivistic Utopia: Van Gogh's *Japonisme* Portraits," *Simiolus,* vol. 14, nos. 3/4 (1984), pp. 189–208; Akiko Mabuchi, "Van Gogh and Japan," in The National Museum of Western Art, Tokyo, *Vincent van Gogh Exhibition,* October 12–December 8, 1985, Nagoya City Museum, December 19, 1985–February 2, 1986, pp. 169–77.

12. See *Complete Letters,* nos. 500, 463, B2, and B22.

13. *Complete Letters,* no. 511.

14. *Complete Letters,* no. B18.

15. See *Complete Letters,* no. 555.

16. Pencil and black chalk, 9½ x 12⅛" (23.5 x 31.5 cm.), Museum Folkwang, Essen, no. 437; and black chalk, 9½ x 11" (24 x 27.5 cm.), Rijksmuseum Vincent van Gogh, Amsterdam, inv. no. F155 (De la Faille 1970, no. 1550; Hulsker [see note 4], p. 436, nos. 1897 and 1898).

17. Oil on canvas, 19⅛ x 39⅜" (50 x 100 cm.), National Museum of Wales, Cardiff, no. 812 (De la Faille 1970, no. 811; Hulsker [see note 4], p. 476, no. 2096).

18. *Complete Letters,* no. 621.

19. See Allentown Art Museum (note 11), p. 80.

PROVENANCE: Johanna van Gogh, who sold it to Hugo von Tschudi, Berlin, April 1903; Angela von Tschudi, Munich, who placed it on extended loan to Neue Staatsgalerie, Munich; Paul Rosenberg and Company, Paris and New York, by 1932; acquired by Henry P. McIlhenny, Philadelphia, 1949.

EXHIBITIONS: Paul Cassirer, Berlin, December 1901, no. 17 (no catalogue); Munich, *Secession,* February–March 1903, no. 231; Municipal Museum, Amsterdam, July–August 1905, no. 209a; Kunstverein, Bremen, *Internationale Kunstausstellung,* February–April 1906, no. 89; Paul Rosenberg and Company, Paris, *Monet à Van Gogh,* 1932, no. 55; Palais des Beaux-Arts, Brussels, *L'Impressionisme,* June 15–September 29, 1935, no. 102; Museum of Modern Art, New York, *Vincent van Gogh,* December 1935–January 1936, no. 52, also shown at Philadelphia Museum of Art, January 11–February 10, 1936; International Exhibition, Paris, *Van Gogh,* June–October 1937, p. 17, no. 43; Buenos Aires, *Pintura Francesca,* 1939–1940, also shown in Rio de Janeiro and Montevideo, no. 70; M. H. de Young Memorial Museum, San Francisco, *The Painting of France since the French Revolution,* December 1940–January, 1941, p. 21, no. 53, p. 87; Los Angeles County Museum, *From Cézanne to Picasso,* January–March 1941, no. 58; The Art Institute of Chicago, *Masterpieces of French Art,* April 10–May 20, 1941, p. 26, no. 78, pl. XLI; Paul Rosenberg and Company, New York, *Masterpieces by Van Gogh,* January 15–31, 1942, p. 24, no. 8; The Cleveland Museum of Art, *Works by Vincent van Gogh,* November 3–December 12, 1948, pp. 21–20, no. 28, pl. XXVII; Philadelphia Museum of Art, "The Henry P. McIlhenny Collection," May 15–September 11, 1949; Philadelphia Museum of Art, *Masterpieces from Philadelphia Private Collections,* May 20–September 15, 1950, no. 99; The California Palace of the Legion of Honor, San Francisco, *The Henry P. McIlhenny Collection: Paintings, Drawings, and Sculpture,* June 15–July 31, 1962, no. 24; The Solomon R. Guggenheim Museum, New York, *Van Gogh and Expressionism,* July–September 1964; Allentown Art Museum, *French Masterpieces of the 19th Century from the Henry P. McIlhenny Collection,* May 1–September 18, 1977, p. 80; High Museum of Art, Atlanta, *The Henry P. McIlhenny Collection: Nineteenth-Century French and English Masterpieces,* May 25–September 30, 1984, no. 32; The Metropolitan Museum of Art, New York, *Van Gogh in Saint-Rémy and Auvers,* November 25, 1986–March 22, 1987, p. 139, no. 29, p. 140; Philadelphia Museum of Art, *The Henry P. McIlhenny Collection,* November 22, 1987–January 17, 1988, pp. 110, 112, 113.

LITERATURE: Andries Bonger, "Catalogue des oeuvres de Vincent van Gogh" [inventory made in 1891 following Theo van Gogh's death], no. 171, "Versant de colline (effet de pluie)"; Louis Piérard, *La Vie tragique de Vincent van Gogh* (Paris, 1924), pl. 44; J.-B. de la Faille, *L'Oeuvre de Vincent van Gogh* (Paris and Brussels, 1928), vol. 1, p. 184, no. 650, vol. 2, pl. CLXXXII; Florent Fels, *Vincent van Gogh* (Paris, 1928), repro. p. 137; Michel Florisoone, *Van Gogh* (Paris, 1937), p. 53; Alice M. Goudy, "Four Collectors in Philadelphia," *Art News,* vol. 49, no. 4 (summer 1950), p. 31, repro.; John Rewald, *Post-Impressionism: From Van Gogh to Gauguin* (New York, 1956), p. 356, repro. p. 357; John Canaday, *Mainstreams of Modern Art* (New York, 1959), p. 374, repro. p. 377, no. 451; De la Faille 1970, p. 258, repro. p. 259, no. F650; The National Museum of Western Art, Tokyo, *Vincent van Gogh Exhibition,* October 12–December 8, 1985, Nagoya City Museum, December 19, 1985–February 2, 1986, p. 230, under cat. no. 83; Jan Hulsker, *The Complete Van Gogh: Paintings, Drawings, Sketches* (Oxford and New York, 1980), p. 421, repro. p. 424, no. 1839; Ann Hoenigswald, "Vincent van Gogh: His Frames, and the Presentation of His Paintings," *The Burlington Magazine,* vol. 130, no. 1022 (May 1988), pp. 367–72; Walter Feilchenfeldt, *Vincent van Gogh & Paul Cassirer, Berlin: The Reception of Van Gogh in Germany from 1901 to 1914* (Zwolle, 1988), pp. 15, 16, 110, repro.

CONDITION: The support is unprimed plain-weave fabric of medium weight. The painting is unlined but has been mounted over a second canvas. Although the paint has cracked and cupped in thickly applied areas, the impasto and brushwork are well preserved. The unprimed fabric, left exposed as a unifying tone in broad passages of broken brushwork, has darkened from a pale buff color to a medium brown, due to the grime and the discolored varnish that covers the painting. The darkening of the fabric has thrown a great proportion of the brushwork into stark contrast with the fabric tone, and it is clear that the painting originally had a softer, paler aspect, particularly in the lower three-fourths.

Jan Josephsz. van Goyen, the son of a shoemaker, was born in Leiden on January 13, 1596. According to J. J. Orlers, from 1606 onward he was a pupil in Leiden successively of Coenraet Adriaansz. van Schilperoort (c. 1577–1635/36), Isaac Claesz. Swanenburgh (c. 1538–1614), and Jan Adriansz. de Man (active early seventeenth century), and the glass painter Hendrick Klock, and later worked for two years under Willem Gerritsz. at Hoorn. Orlers further claimed that Van Goyen returned to Leiden, traveled in France for a year, and subsequently returned to Haarlem, where he was a pupil of Esaias van de Velde (c. 1590–1630). He married Annetje Willemsdr. van Raelst at Leiden in 1618, was living there also the following year, and in 1625 bought a house on the St. Peterskerkstraat, which he sold in 1629 to Jan Porcellis (c. 1584–1632), the marine painter. He is mentioned regularly in documents in Leiden from 1627 to 1632. Van Goyen probably moved in the summer of 1632 to The Hague, where he became a citizen two years later. Sometime in 1634 he was painting in Haarlem at the house of Isaack van Ruysdael (1599–1677), brother of Salomon van Ruysdael (q.v.). In 1635 he bought a house in The Hague on the Veerkade and the following year built the house on the Dunne Bierkade in which the animal painter Paulus Potter (q.v.) lived from 1649 to 1652. Van Goyen was regularly mentioned in The Hague as living in his house on the Wagenstraat. He was named *hoofdman* (leader) of The Hague guild in 1638 and 1640. In 1649 his daughter Maria married the still-life painter Jacques de Claeuw (active c. 1642–d. 1676), and his other daughter Margarethe married Jan Steen (q.v.). In 1651 he painted a panoramic view of The Hague for the city's town hall. Throughout his life Van Goyen had speculated, with little success, in various businesses, including houses and tulips. He died at The Hague on April 27, 1656, and was buried in the Grote Kerk.

One of the greatest and most prolific (more than one thousand drawings and twelve hundred paintings bear his name) seventeenth-century Dutch landscapists, Van Goyen closely resembled his teacher Esaias van de Velde in his early works prior to 1626. Thereafter he developed a new tonal manner with three other gifted Haarlem painters, Pieter Molijn (1595–1661), Salomon van Ruysdael, and Jan Porcellis. He made many drawings in the countryside around The Hague, Leiden, Haarlem, and Amsterdam, and on trips to the southern Netherlands, Gelderland, and the area around Kleve. Nicolaes Berchem (1620–1683) was his student but reflected little or nothing of his style.

LITERATURE: J. J. Orlers, *Beschrijvinge der Stadt Leyden* (Leiden, 1641), p. 373; Van Hoogstraten (1678) 1980, p. 273; Houbraken 1718–21, vol. 1, pp. 166, 170, vol. 2, pp. 111, 135, vol. 3, p. 13; Weyerman 1729–69, vol. 1, pp. 393–96; Descamps 1753–64, vol. 1, pp. 419–22; R. van Eynden and Adriaan van der Willigen, *Geschiedenis der vaderlandsche schilderkunst sedert de helft van de XVIII eeuw*, 4 vols. (Haarlem, 1816–40), vol. 1, p. 378; Immerzeel 1842–43, vol. 1, p. 290; Kramm 1857–64, vol. 2, pp. 596–97; Carel Vosmaer, "Jan Josephsz. van Goyen," *Kunstkronijk*, vol. 15 (1874), pp. 49–53; Carel Vosmaer, "Johen Josefszoon van Goyen," *Zeitschrift für bildende Kunst*, vol. 9 (1874), pp. 12–20; Paul Mantz, "Jan van Goyen," *Gazette des Beaux-Arts*, 17th year, vol. 12 (1875), pp. 138–51, 298–311; Abraham Bredius, "Jan Josephszoon van Goyen: nieuwe bijdragen tot zijne biographie," *Oud Holland*, vol. 14 (1896), pp. 113–25; Hofstede de Groot 1907–1928, vol. 8 (1923), pp. 3–350; Abraham Bredius, "Varia," *Oud Holland*, vol. 34 (1916), pp. 158–65; Abraham Bredius, "Heeft Van Goyen te Haarlem gewoond?" *Oud Holland*, vol. 37 (1919), pp. 125–27; Stedelijk Museum, Amsterdam, *Jan van Goyen* (Amsterdam, 1903); C. Hofstede de Groot, "Jan van Goyen and His Followers," *The Burlington Magazine*, vol. 42, no. 238 (1923), pp. 4–27; Hans Volhard, "Die Grundtypen der Landschaftsbilder Jan van Goyens und ihre Entwicklung," diss., Halle-Wittenberg University, 1927; Henri van

de Waal, *Jan van Goyen* (Amsterdam, 1941); Hans Ulrich Beck, "Jan van Goyens Handzeichnungen als Vorzeichnungen," *Oud Holland*, vol. 72 (1957), pp. 241–50; Neil MacLaren, *The National Gallery Catalogues: The Dutch School* (London, 1960), pp. 134–40; Stedelijk Museum "de Lakenhal," Leiden, *Jan van Goyen*, June 4–July 27, 1960; A. Dobrzycka, *Jan van Goyen* (Poznan, 1966); Hans Ulrich Beck, *Jan van Goyen, 1596–1656*, 2 vols. (Amsterdam, 1972–73); Laurens J. Bol, *Die Holländische marinemalerei des 17. Jahrhunderts* (Brunswick, 1973), pp. 119–32; I. Q. van Regteren Altena, *Oud Holland*, vol. 88 (1974), pp. 242–44; Alan Jacobs Gallery, London, *Jan van Goyen, 1596–1656: Poet of Dutch Landscape*, April 20–May 25, 1977; Mauritshuis, The Hague, *Hollandse Schilderkunst: Landschappen 17de eeuw* (The Hague, 1980), pp. 31–38, Gallery Gebr. Douwes, Amsterdam, *Esaias van de Velde, schilder, 1590/91–1630; Jan van Goyen, tekenaar, 1596–1656*, 1981 (catalogue by Evert J. M. Douwes); Waterman Gallery, Amsterdam, *Jan van Goyen, 1596–1656: Conquest of Space*, 1981 (catalogue by Hans Ulrich Beck, M. C. Wurfhain, and W. L. van de Watering); Bob Haak, *The Golden Age: Dutch Painters of the Seventeenth Century* (New York, 1984), pp. 224, 243–45, 269, 336–37; Sutton et al. 1987, pp. 317–32; Rijksmuseum, Amsterdam, *Land and Water: Dutch Drawings from the 17th Century in the Rijksmuseum Print Room*, 1987, pp. 21–26 (catalogue by Marijn Schapelhouman and Peter Schatborn); Frits Duparc, *Landscape in Perspective: Drawings by Rembrandt and His Contemporaries* (Cambridge, Mass., 1988), pp. 112–21.

For additional works by Van Goyen in the Philadelphia Museum of Art, see John G. Johnson Collection cat. nos. 462, 463, 464, 469 (imitator of), 505 (imitator of).

37 JAN VAN GOYEN

PEASANTS RESTING BEFORE AN INN, early 1640s
Oil on canvas, 48 x 53¾" (122 x 136.5 cm.)
The William L. Elkins Collection. E24-3-30

In the center foreground of a landscape, two peasants are seated on the ground by a roadside conversing with a man who stands before them with a boy and a dog. On the left two men with a dog are seated before a small building near a large tree. In the middle distance is a gabled building identified as a rural inn by its signboard hung over the entryway with a bust-length portrait of a man. Numerous travelers assemble in the road before this stopping place. The far right offers a view to a distant prospect. The entire scene is painted in a restrained palette of browns, grays, greens, and yellows.

The theme of a landscape with peasants and travelers resting before an inn was much favored by Van Goyen and his contemporaries, such as Salomon van Ruysdael (q.v; see no. 99). Often the same inn reappears in Van Goyen's works with only slight alterations and repeated staffage motifs; for example, the carriage group feeding its horses in the middle distance of this picture reappears in a painting of 1631 in Stockholm.[1] The original design for the Museum's painting was probably conceived in a drawing now in the Statens Museum voor Kunst in Copenhagen (fig. 37-1).[2] The drawing corresponds closely to the Museum's picture but omits the group of peasants in the foreground and adds another low building on the left and a well on the right. A very similar design also appears in a

FIG. 37-1 Jan van Goyen, *Peasants Resting before an Inn,* chalk on paper, 4¼ x 6¼" (10.9 x 16 cm.), Statens Museum voor Kunst, Copenhagen, inv. no. 7316.

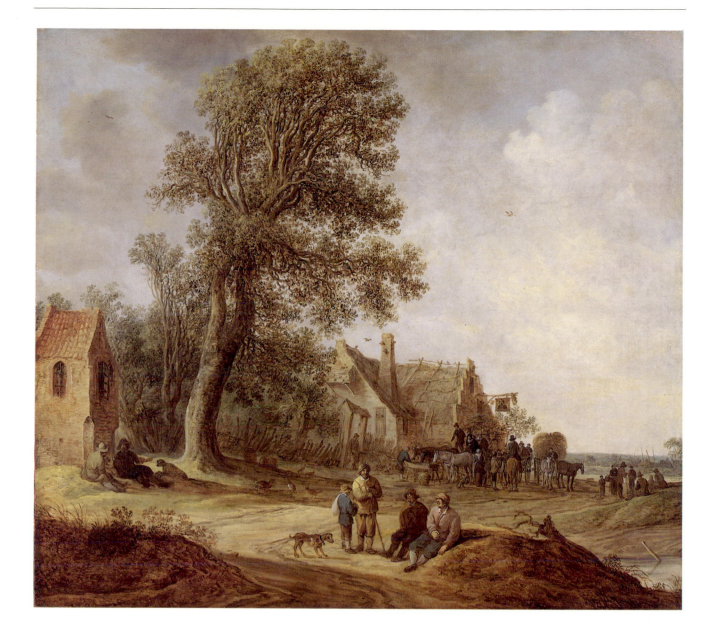

FIG. 37-2 Jan van Goyen, *Peasants Resting before Two Inns,* c. 1635, oil on panel, 11 x 14¾″ (27.5 x 37.5 cm.), Schoeller Collection, Burg Gretesch.

smaller painting on panel in the Schoeller Collection in Burg Gretesch near Osnabrück (fig. 37-2).[3] There the viewpoint on the left is closer to that of the Museum's picture, but it has two taller oak trees, and a second inn appears to the right of the well on the far right. Although the present work is not dated, it is related stylistically to other large-scale and relatively broadly painted works from the early 1640s, such as the Rijksmuseum's well-known *Landscape with Two Oaks,* dated 1641.[4] Beck dated the painting in the Schoeller Collection to around 1635. Thus, it may precede the drawing in Copenhagen, which Beck dated to around 1640, and probably predates the Museum's painting. Wolfgang Stechow offered the suggestion that the nearly square format of this painting, which results in a somewhat lopsided composition, might indicate that the canvas was cut, presumably

FIG. 37-3 Jan van Goyen, *Street in De Bilt, near Utrecht*, 1623, oil on panel, 15½ x 27″ (39 x 69 cm.), Herzog Anton Ulrich Museum, Brunswick, no. 339.

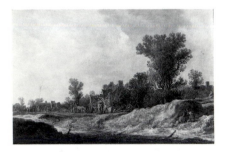

FIG. 37-4 Jan van Goyen, *Village Road with Travelers*, c. 1632, Staatliche Kunsthalle, Karlsruhe.

FIG. 37-5 Detail of *Village Road with Travelers* (fig. 37-4).

along the right edge.[5] The original design may, therefore, have been more like that of the Schoeller Collection's painting. Although less likely on compositional grounds, the design conceivably once extended farther to the left and resembled the original drawing more.

Beck noted that the small building on the far left is based on the tiny Petronella Chapel in the village of De Bilt near Utrecht.[6] A devotional chapel with an image of the Madonna, this stone structure stood until about 1774 on the site of what is now the Royal Dutch Meteorological Institute. This was one of Van Goyen's favorite architectural motifs. It appears in two early pictures, a painting reminiscent of works by Esaias van de Velde (c. 1590–1630) and dated 1623 in the Herzog Anton Ulrich Museum in Brunswick (fig. 37-3), which depicts a scene with soldiers in the streets of De Bilt, and a painting dated 1632 (formerly with the dealer Duits in London in 1929), which transports the chapel to a roadside in an imaginary hilly landscape.[7] The chapel also figures in the distance of an undated dune landscape by Van Goyen of about 1632 in Karlsruhe (fig. 37-4), where it is flanked by two roadside taverns and appears as a large walled shrine with two worshipers kneeling in prayer before it (fig. 37-5). Comparisons of Van Goyen's various depictions of the chapel prove that he took liberties both with its architecture and site.

In a discussion of symbolism in Dutch landscape paintings, Hans Joachim Raupp has interpreted Van Goyen's introduction of details like the Petronella Chapel as moralizing messages in his landscapes.[8] The travelers in the Karlsruhe painting—wayfarers on life's journey or the "pilgrimage of life"—are presented with a dilemma: whether to care in their moment of rest for the body or the soul—whether to visit the tavern or the shrine. Raupp argued that the image of the couple kneeling in prayer before the chapel would have appeared to Dutch Calvinists as idolatry, although for a Catholic like Van Goyen it was an exemplary act of devotion. Implicit in Raupp's theory is the notion that the tavern and chapel function in moral opposition in the Philadelphia painting. However, it must be pointed out that other Protestant artists like Herman Saftleven (1609–1685) also depicted the picturesque Petronella Chapel repeatedly without any apparent symbolic intent.[9] Abraham Rademaker (1675–1735) produced an engraving of the chapel (fig. 37-6), which is probably based on Saftleven's drawing.

FIG. 37-6 Abraham Rademaker, *Petronella Chapel, De Bilt,* engraving.

NOTES

1. Signed and dated, oil on panel, 15¼ x 19¼″ (39 x 49 cm.), Nationalmuseum, Stockholm, cat. no. 2171; repro. in Hans Ulrich Beck, *Jan van Goyen, 1596–1656,* 2 vols. (Amsterdam, 1972–73), vol. 2, p. 450, no. 1000.

2. See Beck (note 1), vol. 1, p. 222, no. 692, repro.

3. According to Beck (see note 1), vol. 2, p. 464, no. 1036, repro., falsely signed and dated 164[8]. See also Van Goyen's closely related black chalk drawing, probably dating from the 1630s, 5½ x 7¾″ (14 x 19.6 cm.), in the Staatliche Kunstsammlungen, Kassel, inv. no. 11811.

4. Oil on canvas, 33½ x 41″ (85 x 104.5 cm.), Rijksmuseum, Amsterdam, no. A990; see Beck (note 1), vol. 2, p. 499, no. 1144, repro.

5. See comment dated January 20, 1955, in Philadelphia Museum of Art, accession files.

6. See Beck (note 1), vol. 2, p. 469, no. 1052. On the Petronella Chapel, see P. H. Damsté, "De St. Petronillakapel aan de Bilt," *Jaarboekje van Oud-Utrecht* (1957), pp. 72–88.

7. See Beck (note 1), vol. 2, p. 108, no. 220, repro.; and *Horse-drawn Wagon,* 1632, oil on panel, 15½ x 21″ (39.3 x 53.2 cm.); see Beck (note 1), vol. 2, p. 108, no. 221, repro. The chapel also appears in Van Goyen's drawings in Copenhagen (fig. 37-1), Kassel (see note 3), the Topografische Atlas, Rijksarchief, Utrecht, no. 678 (black chalk, 3½ x 5¹³⁄₁₆″ [8.8 x 14.8 cm.]), and a private collection, Bieleveld, in c. 1955 (black chalk, 4⅜ x 7½″ [11.1 x 19.3 cm.]); information kindly provided by Jan van der Heijden (letter to Lawrence Nichols, June 9, 1989, Philadelphia Museum of Art, accession files).

8. Hans Joachim Raupp, "Zur Bedeutung von Thema und Symbol für die holländische Landschaftsmalerei des 17. Jahrhunderts," *Jahrbuch der Staatlichen Kunstsammlungen in Baden-Wurtemburg,* vol. 17 (1980), pp. 85–110, especially pp. 102–4.

9. *Petronella Chapel, De Bilt,* black chalk and brown wash, 4¼ x 6″ (10.7 x 15.3 cm.), Rijksprentenkabinet, Amsterdam, no. A4356. See Wolfgang Schulz, *Herman Saftleven (1609–1685)* (Berlin and New York, 1982), cat. nos. 368, 369, 437, and 519.

PROVENANCE: Dealer Colnaghi, London, 1897; dealer Charles Sedelmeyer, Paris, 1897; William L. Elkins Collection, Philadelphia, by 1900.

EXHIBITION: Charles Sedelmeyer Gallery, Paris, *Illustrated Catalogue of the Fourth Hundred Paintings by Old Masters,* 1897, no. 8.

LITERATURE: Elkins 1887–1900, vol. 2, no. 95, repro.; Hofstede de Groot 1907–28, vol. 8 (1923), p. 97, no. 364; Elkins 1924, no. 30; PMA 1965, p. 28; Hans Ulrich Beck, *Jan van Goyen, 1596–1656,* 2 vols. (Amsterdam, 1972–73), vol. 2, p. 469, no. 1052, repro.; Hans Joachim Raupp, "Zur Bedeutung von Thema und Symbol für die holländische Landschafts-malerei des 17. Jahrhunderts," *Jahrbuch der Staatlichen Kunstsammlungen in Baden-Wurtemburg,* vol. 17 (1980), p. 109 n. 94.

CONDITION: Before treatment in 1966 the original tacking edges were removed and the canvas was enlarged by ¾″ (1.9 cm.) on all sides.[1] These later additions were eliminated when the old lining fabric was removed, and the original canvas was relined with wax resin. Discolored varnish and retouches were removed. The painting was retouched and revarnished. Areas of retouches include a previously repaired puncture in the area where the group of figures stands before the inn, a series of old losses located in the area of the sky 5 to 10″ (12.7 to 25.4 cm.) above the horizon on the right, the upper-right corner, and the right and left edges. The paint film reveals only moderate abrasion. The varnish is even and remains colorless.

NOTE TO CONDITION:

1. The measurements have been recorded variously in the past: 47 x 54″ (119 x 137 cm.) (Charles Sedelmeyer Gallery, Paris, *Illustrated Catalogue of the Fourth Hundred Paintings by old Masters* [Paris, 1897], no. 8); 45 x 56″ (114 x 142 cm.) (Elkins 1887–1900, vol. 2, no. 95); 45½ x 46½″ (115.6 x 118 cm.) (Hofstede de Groot 1907–28, vol. 8 [1923], p. 97); and 49⅛ x 55⅝″ (124.8 x 141.3 cm.) (PMA 1965, p. 28).

LITERATURE: Van der Willigen (1870) 1970, p. 37; Abraham Bredius, "Het Schilders-register van Jan Sysmus, stads-doctor van Amsterdam," *Oud Holland*, vol. 8 (1890), p. 13; Wurzbach 1906–11, vol. 1, p. 667, vol. 3, p. 100; Abraham Bredius, "De schilder Gerrit van Hees," *Oud Holland*, vol. 31 (1913), pp. 67–70; Thieme-Becker 1907–50, vol. 16 (1923), p. 235; Plietzsch 1960, p. 102; Laurens J. Bol, *Holländische Maler des 17. Jahrhunderts nahe den grossen Meistern: Landschaften und Stilleben* (Brunswick, 1969), pp. 209–10, 213.

Little is known of the life of Gerrit van Hees. The date 1650 on *View of a Village* (oil on panel, 30 x 42″ [76 x 106.5 cm.], Frans Halsmuseum, Haarlem, no. 159) shows that he was active by then. He is mentioned by Vincent Laurensz. van der Vinne (1629–1702) in his list of artists and in Haarlem documents of 1660 and 1663. He made a will on September 23, 1670, and was buried in Haarlem on October 6 of the same year.

A landscapist, Van Hees painted in the styles of Jacob van Ruisdael, Meindert Hobbema (qq.v.), and Isaack van Ostade (1621–1649). His works have also been wrongly assigned to Cornelis Decker (d. 1678), Guillam Dubois (c. 1610–1680), and Gillis Rombouts (1630–1678).

38 GERRIT VAN HEES

TRAVELERS RESTING BY AN INN IN A LANDSCAPE
Signed and dated (falsely) lower right on road: *I ostade.f./1653*
Oil on canvas, 39⅞ x 50″ (101.3 x 127 cm.)
The William L. Elkins Collection. E24-3-35

FIG. 38-1 Gerrit van Hees, *Inn by a Wooded Road,* signed, oil on canvas, 42⅛ x 59⅞" (107 x 152 cm.), Musée des Beaux-Arts, Rennes, inv. no. 794.1.2.

FIG. 38-2 Gerrit van Hees, *Wooded Landscape with an Inn,* monogrammed, oil on canvas, 43⅜ x 40" (110.2 x 101.5 cm.), Musée des Beaux-Arts, Lille, inv. no. 254.

FIG. 38-3 Currently attributed to Gerrit van Hees, *Wooded Landscape with Travelers,* oil on panel, 19¼ x 26⅜" (49 x 67 cm.), sale, Vienna, March 20, 1911, lot 134.

A group of travelers have stopped before a wayside inn in a forest with tall trees. The inn is the point of convergence for two narrow dirt roads proceeding from the lower-left and right corners and a single road traveled by a carriage continuing out of sight to the right. On the flat horizon to the right are the outlines of distant villages. In the patch of light before the inn several riders feed their horses. Silhouetted by this light are a seated woman and three male figures in the foreground. Additional figures appear before the shadowed doorway of the inn.

Although the design and conception of the picture bear resemblance to landscapes with inns by Isaack van Ostade (1621–1649),[1] J. G. van Gelder was correct in stating in 1954 that the work is not by the master.[2] The trees and figures are too crude, the colors too muddy, the tonal contrasts overly pronounced, and the execution excessively labored for the master. The signature in the lower right is surely forged, since the date 1653 accompanying it postdates Isaack's death. Gillis Rombouts (1630–1678) has been suggested, privately, as an alternative attribution, but the resemblance to his art is only superficial; the undulating trunks and branches of Rombouts's trees bear some resemblance, but his vision of nature is more dramatic and tormented.[3] Closer in style is the milder art of Gerrit van Hees, whose few signed works include relatively large-scale paintings of cottages beside sandy roads in the woods (figs. 38-1 and 38-2).[4] The treatment of the foliage and light as well as the Van Ostade-like figures in the Philadelphia painting are consistent with Van Hees's manner.[5] In addition to this new attribution, several other landscapes with inns and travelers that until now have been wrongly assigned to Isaack van Ostade can also be tentatively reattributed to Van Hees (see fig. 38-3).[6]

NOTES

1. See, for example, *Inn in the Dunes,* signed and dated 1640 or 1646, oil on canvas, 42 x 59¼" (107 x 150.5 cm.), Museum Boymans–van Beuningen, Rotterdam (*Catalogus schilderijen tot 1800* [Rotterdam, 1962], no. 1638).
2. Philadelphia Museum of Art, accession files.
3. Compare, for example, Gillis Rombouts's *Wooded Landscape,* signed, oil on canvas, 29 x 25" (74 x 63.5 cm.), Rijksmuseum, Amsterdam, no. A753.
4. See, respectively, *Peintures de la Collection Robien, Musée de Rennes* (Rennes, 1972), introduction by François Bergot, cat. no. 35, pl. XIV; and Musée des Beaux-Arts de Lille, *Grands noms, grandes figures du Musée de Lille: II Donation d'Antoine Brasseur* (Lille, 1981), introduction by Hervé Oursel, cat. no. 44. Compare also the signed paintings *View of a Village,* dated 1650, oil on panel, 30 x 42" (76 x 106.5 cm.), Frans Halsmuseum, Haarlem, no. 159; and *The Plank Fence,* 22 x 31½" (56 x 79.5 cm.), Akademie der bildenden Künste, Vienna, inv. no. 893.
5. The figures in the Rennes painting (fig. 38-1) were once attributed to Isaack, as, evidently, were those in a painting by Van Hees in The Hermitage, Leningrad, no. 830; see Musée des Beaux-Arts de Lille, *Tresors des musées du Nord de la France, I. Peinture hollandaise,* October 27–December 31, 1972, Musée d'Arras, January 7–March 5, 1973, and Musée de Dunkerque, March 15–April 30, 1973, p. 62, but not listed in The Hermitage's 1958 catalogue.
6. Such as *Roadside Inn,* oil on panel, 42½ x 53½" (108 x 135.9 cm.), formerly Ralph Vivian, London. See also *Landscape with Cottages,* 42 x 54" (107 x 137 cm.), Ashmolean Museum, Oxford, cat. no. A1064; and *Landscape with an Inn,* oil on canvas, 39 x 58⅛" (99 x 149 cm.), sale, W. H. de Monchy et al., Rotterdam, October 29, 1969, lot 75, repro.

PROVENANCE: William L. Elkins Collection, Philadelphia, by 1900.

LITERATURE: Elkins 1887–1900, vol. 2, no. 115, repro. [as Isaack van Ostade and hereafter]; Elkins 1924, no. 35; Hofstede de Groot 1908–27, vol. 3 (1910), no. 36; PMA 1965, p. 51.

CONDITION: The canvas support is slack and has an old aqueous lining. The tacking edges are missing. The paint film exhibits considerable abrasion, especially at the edges. Losses are scattered throughout. The varnish is deeply discolored, with darker varnish residues in the interstices of the paint film.

Baptized in Amsterdam on February 2, 1642, Lodewyck (probably named for his grandfather Lodewyck Lowys) van der Helst was the son of the famous Amsterdam portraitist Bartholomeus van der Helst (1613–1670). His portrait as a child, in the museum at Rijssen, was painted by Bartholomeus. After his father's death in 1670, he lived in a house on the Herengracht owned by his mother, Anna Du Pire, and, in 1671, had an inventory compiled of his possessions. In 1681 litigation settled a dispute between Van der Helst and his brother-in-law concerning his late mother's estate. Another lawsuit took an unexpected turn: in 1676 Van der Helst painted a picture of a naked Venus, which a woman named Gertruid de Haes (b. 1653) believed depicted her in a degrading fashion. The dispute was amicably resolved when Lodewyck proposed to Gertruid. The marriage took place in January 1677, and a son was born in 1680. In 1682 Lodewyck fell ill and appealed for assistance to the city authorities, who ruled that twelve paintings he had done in 1681 would be sold at public auction to pay his debts. By 1684 he had died or had left Amsterdam.

Arnold Houbraken informs us that Lodewyck was Bartholomeus van der Helst's follower; no doubt he also was his father's pupil. He evidently completed some of his father's works in Bartholomeus's last years. His own portraits employ many of the same formulas, but exhibit stiffer poses and a colder, more mechanical technique. In Houbraken's words, although he "followed in his father's laudable footsteps, he lagged too far behind to be compared with him" ("en zyn Vader op het loffelyke spoor wel na stapte, maar te veer agter gebleven is om aan hem te gedenken").

LITERATURE: Houbraken 1718–21, vol. 2, pp. 9–10; G. H. Veth, "Aelbert Cuyp, Jacob Gerritsz. Cuyp, en Benjamin Cuyp," *Oud Holland,* vol. 2 (1884), p. 239; Bredius 1915–22, vol. 2 (1916), pp. 406, 417; Jan Jacob de Gelder, *Bartholomeus van der Helst* (Rotterdam, 1921), pp. 17, 21, 23, 29, 97, 146–48; Jan Jacob de Gelder in Thieme-Becker 1907–50, vol. 16 (1923), pp. 357–58.

39 LODEWYCK VAN DER HELST

PORTRAIT OF A GENTLEMAN AND A LADY SEATED OUTDOORS, c. 1670
Oil on canvas, 62½ x 46½" (159 x 118 cm.)
Purchased for the W. P. Wilstach Collection. W04-1-60

A stout couple is seated before two tree trunks. The man wears a red velvet coat with a black sash and has a white feathered beret in his lap. With his right hand he holds a walking stick and with his left his wife's hand. She wears a white satin dress, a pink underdress, and pearls. Between the man's legs is a small dog. At the upper left the barrel of his rifle is seen resting against the tree.

Although the portrait was acquired and has always been catalogued and exhibited at the Museum as a work by Bartholomeus van der Helst (1613–1670), the attribution was rejected as early as 1921 by Jan Jacob de Gelder.[1] Bartholomeus often depicted couples and family groups in gardenlike settings,[2] but his poses are more gracefully animated and his technique more fluent and assured. Clearly this painting is by an artist in Bartholomeus van der Helst's circle in Amsterdam who used the master's portrait formulas. In 1980 William H. Wilson attributed the piece to Bartholomeus's son Lodewyck,[3] an assignment first proposed by the present author. The attribution is supported by comparison with Lodewyck's signed works, which reveal a comparably rather thin modeling technique and similar draftsmanship; compare, especially, *Family of Samuel de Marez.*[4] Lodewyck's particular treatment of textures also resembles the handling of materials in this work, such as the velvet, the satin, and the feather.[5] From

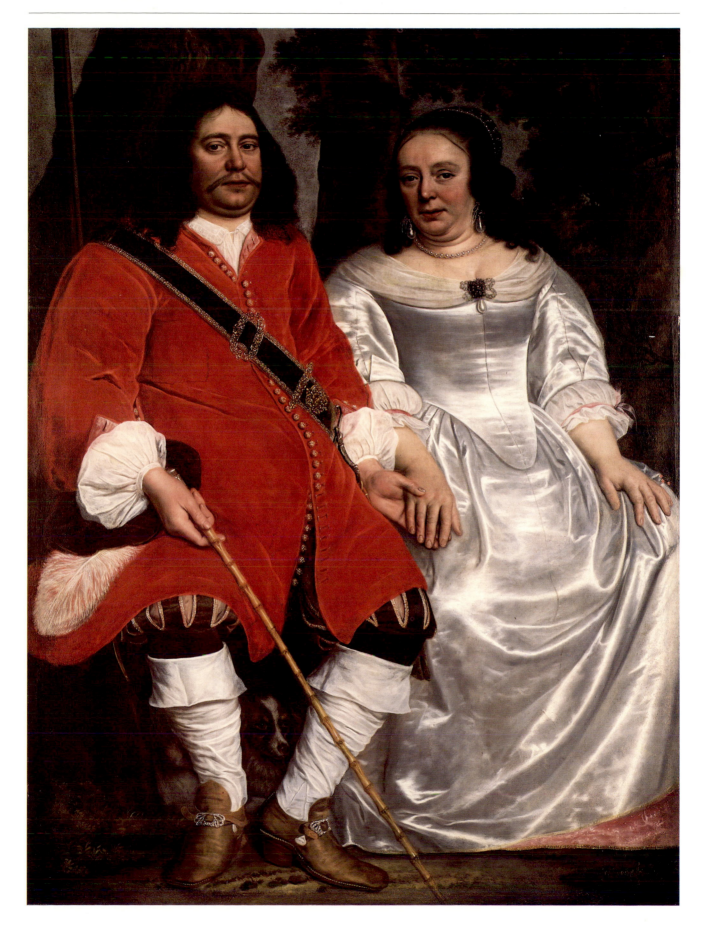

the figures' costumes, the picture can be judged to have been executed around 1670, a date that would not be inconsistent with Lodewyck's authorship.

Families and married or engaged couples were often depicted in settings suggestive of gardens or woods. Peter Paul Rubens (q.v.) and Frans Hals (1581/85–1666) were innovators in the use of this convention of portraiture in the Lowlands.[6] Gardens were one of Venus's traditional habitats, and lovers had been portrayed in gardens as early as the fifteenth century. The dog peering out between the man's legs might also be an allusion to steadfast love and loyal fidelity; however, especially in conjunction with the gun, the animal reinforces the man's role as a hunter. Hunting was closely associated with and regulated by the court and nobility in Holland.[7] Attributes of the hunt became status symbols in family portraits in the second half of the seventeenth-century.[8] Thus, while the plump and elegantly attired couple might seem ill-suited to the rigors of hunting in the wilds, the conceit of their hunting garb ensured identification with the Dutch aristocracy. This surely was also the case in *A Family Group,* 1654, an earlier double portrait by Bartholomeus van der Helst (fig. 39-1). In these years, Ferdinand Bol (1616–1680) and Govaert Flink (1615–1660) also portrayed gentlemen as hunters.

The present work is a fragment with later additions. Although the date when it was cut down cannot be pinpointed, the reduction must have occurred before 1902, when the picture was sold with measurements nearly the same as those today. One cannot specify the work's original dimensions, but it is probable that the composition once included other motifs—quite possibly the couple's children at the right, as in Bartholomeus's work (see fig. 39-1). During the seventeenth century, life-size family portraits situated outdoors were frequently conceived on a broad horizontal format;[9] the rather crowded design in the Philadelphia painting suggests that it might have been considerably larger at the right. No doubt because of their substantial size, portraits of this type unfortunately have often suffered the fate of being dismembered or cut down.[10]

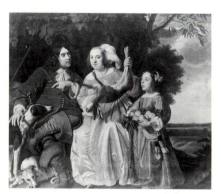

FIG. 39-1 Bartholomeus van der Helst, *A Family Group,* signed and dated 1654, oil on canvas, 66 x 77¼″ (170.8 x 198.4 cm.), The Wallace Collection, London, no. P110.

NOTES

1. Jan Jacob de Gelder, *Bartholomeus van der Helst* (Rotterdam, 1921), pp. 242–43, no. 874.
2. See, especially, *Portrait of the Reepmaker Family,* 166(9?), oil on canvas, 74¾ x 57″ (190 x 145 cm.), Musée du Louvre, Paris, no. R.F. 2129; *Portrait of Abraham de la Court and His Wife Maria de Keerssegieter,* 1654, oil on canvas, 67¾ x 57¹¹⁄₁₆″ (172 x 146.5 cm.), Museum Boymans–van Beuningen, Rotterdam, inv. no. 1296; and *Marriage Portrait in a Garden,* 1666, formerly Arensberg Collection, Brussels.
3. William H. Wilson, *Dutch Seventeenth Century: The Golden Age* (Sarasota, Fla., 1980), cat. no. 35.
4. Collection of Baron A. van Dedem, Huize Den Berg, Dalfsen (photograph Rijksbureau voor Kunsthistorische Documentatie, The Hague). Compare also the treatment of the woman to that in *Portrait of Lucia Wybrants,* dated 1666, oil on canvas, 28¹³⁄₁₆ x 24⅛″ (73.2 x 62 cm.), Szépművészeti Múzeum, Budapest, inv. no. 200; *Portrait of Adriana Jacobusdr. Hinlopen, Wife of Johannes Wijbrants,* dated

1667, 29⅛ x 24¾″ (74 x 63 cm.), Rijksmuseum, Amsterdam, no. A863; and *Portrait of an Unknown Lady,* signed, Douglas Wing School House, Iden, Rye (photograph Witt Library, London). The man may be compared with the three-quarter-length *Portrait of a Man with a Dog,* sale, Lutzen van Voorst, Berlin, February 10, 1904, lot 111, repro.
5. Compare the treatment of the objects in the signed and dated *Posthumous Portrait of Aucke Stellingwerff,* 1670, oil on canvas, 40½ x 53½″ (103 x 136 cm.), Rijksmuseum, Amsterdam, no. A148.
6. See Peter Paul Rubens's *Self-Portrait with Isabella Brant,* 1609, oil on canvas (mounted on panel), 70¹⁄₁₆ x 53¾″ (178 x 136.5 cm.), Alte Pinakothek, Munich, inv. no. 334; and Frans Hals's *Marriage Portrait of Isaac Abrahamsz. Massa and Beatrix van der Laen,* oil on canvas, 55⅛ x 65⁹⁄₁₆″ (140 x 166.5 cm.), Rijksmuseum, Amsterdam, no. A133. For discussion of this convention, see Hans Kauffmann, in *Form und Inhalt, Kunstgeschichtliche Studien, Otto Schmitt zum*

60. Geburtstag am 13 Dezember 1950 dargebracht von seinen Freunden (Stuttgart, 1950), pp. 257–74; E. de Jongh and P. J. Vinken, "Frans Hals als voortzetter van een emblematische traditie: bij het huwelijksportret van Isaac Massa en Beatrix van der Laen (Rijksmuseum, Amsterdam)," *Oud Holland,* vol. 76 (1961), pp. 117–52; Seymour Slive, *Frans Hals* (London and New York, 1970), vol. 1, pp. 59–68; David Ross Smith, "The Dutch Double and Pair Portrait: Studies in the Imagery of Marriage in the Seventeenth Century," diss., Columbia University, 1978; David Ross Smith, *Masks of Wedlock: Seventeenth-Century Dutch Marriage Portraiture* (Ann Arbor, 1982); and E. de Jongh in Frans Halsmuseum, Haarlem, *Portretten van echt en trouw,* February 15–April 13, 1986, cat. no. 20.

7. For discussions of the role of hunting in seventeenth-century Dutch society and portraiture, see Scott A. Sullivan, "Rembrandt's Self-Portrait with a Dead Bittern," *The Art Bulletin,* vol. 62, no. 2 (June 1980), pp. 236–54, an article based on the author's dissertation, "The Dutch Gamepiece," Case Western Reserve University, Cleveland, Ohio, 1978, published as *The Dutch Gamepiece* (Totowa and Montclair, N.J., 1984); H.F.K. van Nierop, *Van Ridders tot regenten. De Hollandse adel in de zestiende en de eerste helfte van de zeventiende eeuw* (n.p., 1984), p. 47; and E. de Jongh in Frans Halsmuseum (see note 6), cat. no. 63.

8. See, for example, Salomon Koninck, *Portrait of the Family of Pieter Coenen,* Rijksdienst Beeldende Kunst, The Hague; Cornelis Holsteyn, *Reynier and Adriaen Pauw and the Family Outside Westwijk,* location unknown; and Matthias Withoos, *Portrait of the Kayser Family,* 1676, Westfries Museum, Hoorn; respectively Frans Halsmuseum (see note 6), pl. 63a, 63c, 63.

9. See, for example, the family portrait by Pieter Claesz. Soutman (q.v.), *Paulus van Beresteyn and His Spouse Catherina Both van der Eem with Their Six Children and Two Servants,* c. 1630–31, oil on canvas, 65¾ x 94⅞" (167 x 241 cm.), Musée du Louvre, Paris, inv. no. R.F. 426.

10. See, for example, Frans Hals's *Family Portrait in a Landscape,* c. 1620, oil on canvas, 59½ x 64⁷⁄₁₆" (151 x 163.6 cm.), Collection of Viscount Boyne, Bridgnorth, Shropshire, on loan to the National Museum of Wales, Cardiff. Seymour Slive has convincingly argued that this work was originally united with *Portrait of Three Children with a Goat Cart,* c. 1620, oil on canvas, 59⅞ x 42⁵⁄₁₆" (152 x 107.5 cm.), Musées Royaux des Beaux-Arts de Belgique, Brussels, inv. no. 4732 (see Slive, *Frans Hals* [London and New York, 1970], vol. 1, pp. 63–66).

PROVENANCE: Sale, Christie's, London, May 3, 1902, lot 74 [as Bartholomeus van der Helst]; purchased for the W. P. Wilstach Collection, Philadelphia, August 23, 1904.

EXHIBITIONS: Allentown Museum of Art, *Seventeenth Century Painters of Haarlem,* April 2–June 13, 1965, cat. no. 41 [as Bartholomeus van der Helst]; William H. Wilson, *Dutch Seventeenth Century Portraiture: The Golden Age* (Sarasota, Fla., 1980), cat. no. 35 [as attributed to Lodewyck van der Helst].

LITERATURE: Wilstach 1906, no. 135 [as Bartholomeus van der Helst and hereafter], 1907, no. 143, 1908, no. 143, 1910, no. 189, 1913, no. 198; Jan Jacob de Gelder, *Bartholomeus van der Helst* (Rotterdam, 1921), pp. 242–43, no. 874 ["judging from photograph, not a work by Van der Helst"]; Wilstach 1922, no. 149 [as Bartholomeus van der Helst]; Philadelphia Museum of Art, *A Picture Book of Dutch Painting of the XVII Century* (Philadelphia, 1931), p. 7, fig. 14; PMA 1965, p. 32 [as Bartholomeus van der Helst]; Rishel 1974, p. 31, fig. 10 [as Bartholomeus van der Helst]; Rijksbureau voor Kunsthistorische Documentatie, The Hague, *Decimal Index of the Art of the Low Countries* (The Hague, 1958–), no. 42D3.

CONDITION: The painting is doubtless a fragment of a larger composition. A section of canvas measuring 31 by 5" (78.7 x 12.7 cm.) was inserted into the upper right, and all four edges were extended by about 1" (2.5 cm.) during an old restoration. When the picture was examined before it was treated and relined in 1968, the area above the woman's left hand and at the center right edge of the canvas suggested that the original revealed a section of sky and an architectural column. The major part of the continuation is lost, having been replaced with the later addition of a section of canvas. At present only a sprig of three tiny flowers appears inexplicably above the hand. Three branched tears are visible in the canvas in the center left and top center, and a fourth horizontal tear appears 6½" (16.5 cm.) above the lower edge in the center. The paint film shows extensive losses, now filled and retouched, in the woman's dress at the lower and center right. Pentimenti are noticeable in the man's left hand, left sleeve, and collar, as well as in the sky to the right of his head. The paint film is also moderately abraded, flattened in areas, and exhibits scattered small losses throughout. The varnish remains colorless, having been replaced in 1968.

The son of Lubbert Meyndertsz., Meyndert (or Meijndert) was baptized in Amsterdam on October 31, 1638. At an early age he adopted the surname Hobbema, which his father evidently never used. In July 1660, Jacob van Ruisdael (q.v.) claimed that Hobbema, who was then living in Amsterdam, had been his apprentice for "some years," presumably in Amsterdam. Hobbema's work, which often is based on Ruisdael's, seems to confirm this contact. In 1668 Hobbema became one of the winegaugers for the Amsterdam octroi, a post he held until the end of his life. In the same year he was married to Eeltje Pieters Vinck, then thirty years old, with Ruisdael serving as a witness. It was previously believed that Hobbema gave up painting after marrying and assuming his new job, but a handful of later works, some of high quality (for example, *The Avenue at Middelharnis*, 1689, oil on canvas, 40¾ x 55½" [103.5 x 141 cm.], National Gallery, London, no. 830) have been identified. Nevertheless, it seems clear that his activity as a painter was sharply curtailed after 1668. Hobbema died on December 7, 1709, in Amsterdam, the city where he had lived on the Rozengracht throughout his later years.

Hobbema was active as a painter and draftsman of landscapes, above all, wooded scenes in the manner of Jacob van Ruisdael. Although sometimes wrongly thought to be a dilettante, he was a highly productive painter with a large oeuvre. His earliest dated work is of 1658 (*A River Scene*, oil on panel, 18⅝ x 24¾" [47.3 x 62.8 cm.], The Detroit Institute of Arts, no. 89.38), but it is only after about 1662–64 that the influence of Ruisdael's art is observable in his work. His early paintings recall the style of Salomon van Ruysdael (q.v.) and Cornelis Vroom (c. 1591–1661). The majority of Hobbema's best works date from about 1662 to 1668 and usually are horizontal scenes of woods with houses, watermills, and sandy roads. He is distinguished from Ruisdael by his lighter, more colorful landscapes, yet in achieving this livelier view of nature he sacrificed something of his teacher's power and intensity.

LITERATURE: R. van Eynden and A. van der Willigen, *Geschiedenis der vaderlandsche schilderkunst sedert de helft van de XVIII eeuw*, 4 vols. (Haarlem, 1816–40), vol. 1, pp. 122–28, vol. 4, p. 101; Smith 1829–42, vol. 6, pp. 109–63, vol. 9, pp. 719–29; A. van der Willigen, "Iets wegens de schilderijen, door M. Hobbema," *Algemeene Konst- en letter-bode*, 1831, pp. 302–4, 361–64, 409–10, 460, 474, 1832, pp. 24–25; H. J. Héris, "Sur la vie et les ouvrages de Mindert Hobbema," *La Renaissance*, vol. 1 (1839–40), pp. 5–7; Immerzeel 1842–43, vol. 2, p. 41; H. J. Héris, *Notice raisonnée sur la vie et les ouvrages de Mindert Hobbema* (Paris, 1854); Kramm 1857–64, vol. 3, pp. 693–98; P. Scheltema, "Meindert Hobbema," *Aemstel's oudheid*, vol. 5 (1863), pp. 45–64; P. Scheltema, "De geboorteplaats van Meindert Hobbema," *Nederlandsche Kunstbode*, vol. 3 (1876), pp.

11–12; N. de Roever, "Meindert Hobbema," *Oud Holland*, vol. 1 (1883), pp. 81–85; A. D. de Vries, "Biografische aanteekeningen," *Oud Holland*, vol. 3 (1885), p. 151; E. Michel, *Hobbema et les paysagistes de son temps en Hollande* (Paris, 1890); F. Cundall, *The Landscape and Pastoral Painters of Holland* (London, 1891), pp. 39–62; Abraham Bredius, "Uit Hobbema's laatste levensjaren," *Oud Holland*, vol. 28 (1910), pp. 93–106; Abraham Bredius, "Hobbema's laatste levensjaren: een nalezing," *Oud Holland*, vol. 29 (1911), pp. 124–28, vol. 33 (1915), pp. 194ff.; Hofstede de Groot 1908–27, vol. 4 (1912), pp. 350–451; J. Rosenberg, "Hobbema," *Jahrbuch der Preussischen Kunstsammlungen*, vol. 48 (1927), pp. 139–51; H. F. Wijnman, "Het leven der Ruysdael II," *Oud Holland*, vol. 49 (1932), p. 176; Georges Broulhiet, *Meindert Hobbema* (Paris, 1938); Horst Gerson, "Een

Hobbema van 1665," *Kunsthistorische Mededelingen*, vol. 2, nos. 3–4 (1947), pp. 43–46; Wolfgang Stechow, "The Early Years of Hobbema," *The Art Quarterly*, vol. 22 (spring 1959), pp. 2–18; Wolfgang Stechow, *Dutch Landscape Painting of the Seventeenth Century* (London, 1966), pp. 76–80, 127–28; H. Hagens, "Jacob van Ruisdael, Meindert Hobbema en de identificatiezucht," *'t inschrien*, vol. 14 (1982), pp. 7–12; Bob Haak, *The Golden Age: Dutch Painters of the Seventeenth Century* (New York, 1984), pp. 465–67; Sutton et al. 1987, pp. 345–55.

For related works in the Philadelphia Museum of Art, see John G. Johnson Collection cat. nos. 571 (imitator of), 572 (imitator of), 573 (copy after).

40 MEINDERT HOBBEMA

WOODED ROAD IN A LANDSCAPE, 1662
Signed lower left: *m. hobbema · f · 166[2]*
Oil on canvas, 42⅛ x 51½" (107 x 131 cm.)
The William L. Elkins Collection. E24-3-7

A road winds away through a wood from the left center foreground. At a fork in the middle distance, a smaller road branches off to the door of a cottage on the left. Two other cottages appear farther down the main road, and a fourth is seen in the foreground at the far left. All of these structures are partly hidden among the trees. The largest and loftiest group of trees in the left center shades a peasant couple. Along the alternatively sunlit and shaded road are additional staffage figures at intervals.

The date has been read variously (see fig. 40-1). Both G. F. Waagen (in 1854) and the compilers of the Elkins Collection catalogue (in 1900) deciphered it as 1652; when exhibited in New York in 1909 it was said to read 166—, and the cataloguers suggested a date of about 1665; in 1912 C. Hofstede de Groot preferred to see 16—2 and suggested "the illegible figure most probably was a 6, and not a 5 as some have suggested"; in 1938

FIG. 40-1 Detail of the signature on Hobbema's *Wooded Road in a Landscape.*

FIG. 40-2 Meindert Hobbema, *The Old Oak,* signed and dated 1662, oil on canvas, 39¾ x 56¾" (101 x 144 cm.), National Gallery of Victoria, Melbourne, acc. no. 2252/4.

FIG. 40-3 Meindert Hobbema, *Village among Trees,* signed and dated 1665, oil on panel, 30 x 43½" (76.2 x 110.5 cm.), The Frick Collection, New York, no. 02.1.73.

FIG. 40-4 Meindert Hobbema, *Village with Trees,* signed and dated 1665, oil on canvas, 37 x 48" (94 x 122 cm.), Percy Meyer sale, Christie's, London, March 16, 1956, lot 52.

Georges Broulhiet accepted the Hudson-Fulton exhibition catalogue's reading of 1665; and, finally, in 1959 Wolfgang Stechow concurred with Hofstede de Groot's reading of 1662.[1] The date was reexamined in May 1981 in the Museum's laboratory. The third digit now appears to be a six, a reading corroborated by the fact that no dates earlier than 1658 have been discovered on Hobbema's works, and the form of the signature, with the first initial separated from the last name ("m. hobbema"), occurs only after 1660.[2] The last digit is the most heavily drawn and appears with the naked eye, microscope, and infrared photography to be a two. An old loss has been repaired just to the right of the date, and areas around the signature and date reveal some overpaint. Nonetheless, a reading of 1662 for the date seems most convincing, given that the work bears a stylistic resemblance to other pictures of this date.

Stechow, who accepted the date of 1662 without reservations, discussed the picture as a milestone in Hobbema's early career, stressing that it was one of his first compositions to reveal the pointed influence of Jacob van Ruisdael (q.v.).[3] Several other works dated 1662—*The Farm,*[4] two views of watermills,[5] and *The Old Oak* (fig. 40-2)—also attest to the fact that Ruisdael's impact was at its most pronounced during this year; the last work mentioned is actually based on an early Ruisdael etching. In the present work the Ruisdaelian elements include the design of a road running diagonally through a wood filled with enormous oaks, the lighting system that cleverly distributes patches of sunlight and backlights the tree trunks, and the color scheme of rich greens and earth hues. The heavy trees with their compact forms and the closed composition are typical of Hobbema's art of 1662; only one year later, he would adopt more open and varied designs.[6] Stechow wrote that the palette was "heavier and of a deeper brown than the pictures of 1663, [but that it] foreshadow[s] the mature style of the middle sixties in composition and numerous details."[7] Two paintings also in American collections, dated 1665, employ virtually the same design: *Village among Trees* (fig. 40-3) and *A View on a High Road,* in the National Gallery of Art in Washington, D.C.,[8] as does a painting in the collection of Percy Meyer sold in 1956 (fig. 40-4). Hobbema often repeated compositions and motifs. Although his repertory, therefore, was limited, a careful comparison of these three closely related designs proves that his variations in no way produced mechanical results; he achieved surprising variety with great economy of design.

NOTES

1. Waagen 1854, vol. 2, p. 225; Elkins 1887–1900, vol. 2, no. 101, repro.; The Metropolitan Museum of Art, New York, *Catalogue of a Loan Exhibition of Paintings by Old Dutch Masters Held at The Metropolitan Museum of Art in Connection with the Hudson-Fulton Celebration,* September 20– November 30, 1909, p. 182, no. 20, repro.; Hofstede de Groot 1908–27, vol. 4 (1912), pp. 367–68, no. 46; Georges Broulhiet, *Meindert Hobbema* (Paris, 1938), p. 402, no. 197; Wolfgang Stechow, "The Early Years of Hobbema," *The Art Quarterly,* vol. 22 (spring 1959), p. 3.
2. Stechow (see note 1), p. 18.
3. Ibid., p. 10.
4. Oil on canvas, 32¼ x 40½" (82 x 103 cm.), Musée du Louvre, Paris, no. 1526.

5. Hofstede de Groot 1908–27, vol. 4 (1912), p. 383, no. 88, p. 389, no. 108.
6. Compare the paintings dated 1663 formerly in the collection of Sir Alfred Beit, Blessington, now in the National Gallery of Ireland, Dublin (Hofstede de Groot 1908–27, vol. 4 [1912], p. 400, no. 136; Broulhiet [see note 1], no. 304); National Gallery of Art, Washington, D.C., no. 1937.1.61 (Hofstede de Groot 1908–27, vol. 4 [1912], p. 412, no. 171); and the Musées Royaux des Beaux-Arts de Belgique, Brussels, inv. no. 2616 (Hofstede de Groot 1908–27, vol. 4 [1912], pp. 396–97, no. 127).
7. Stechow (see note 1), p. 10.
8. Oil on canvas, 36¾ x 50½" (93.4 x 128.3 cm.), no. 1937.1.62.

PROVENANCE: Sir Richard Ford, London, by 1851,[1] and, according to Waagen in 1854, it was in "the possession of Mrs. Ford's family for four generations";[2] sale, London, 1871; Sir John Fowler, by 1872; sale, Sir Richard Fowler, London, May 6, 1899, lot 89, to A. Wertheimer; William L. Elkins Collection, Philadelphia, by 1900.

NOTES TO PROVENANCE
1. See British Institution, London, 1851, no. 83.
2. Waagen 1854, vol. 2, p. 225: Referring to the work as a noteworthy and "admirable" picture, Waagen cited the Ford provenance as evidence of "how early this great master was appreciated by the English." On the inside of the stretcher is the inscription "Mr. Ford, 49."

EXHIBITIONS: British Institution, London, 1851, no. 83; probably British Institution, London, 1863, no. 74 [as "Woody Landscape" lent by Clare Ford]; The Metropolitan Museum of Art, New York, *Catalogue of a Loan Exhibition of Paintings by Old Dutch Masters Held at The Metropolitan Museum of Art in Connection with the Hudson-Fulton Celebration,* September 20–November 30, 1909, p. 182, no. 50; City Art Museum, Saint Louis, *40 Masterpieces: A Loan Exhibition from American Museums,* October 6–November 10, 1947, no. 21; Philadelphia Museum of Art, *Diamond Jubilee Exhibition: Masterpieces of Painting,* November 4, 1950–February 11, 1951, no. 40, repro. [as signed and dated 1662]; Amsterdam, Boston, Philadelphia 1987–88, cat. no. 44, pl. 107.

LITERATURE: Waagen 1854, vol. 2, p. 225; Elkins 1887–1900, vol. 2, no. 101, repro.; Hofstede de Groot 1908–27, vol. 4 (1912), pp. 367–68, no. 46; Elkins 1924, no. 7; Philadelphia Museum of Art, *A Picture Book of Dutch Painting of the XVII Century* (Philadelphia, 1931), p. 5, fig. 6; Georges Broulhiet, *Meindert Hobbema* (Paris, 1938), no. 197, repro.; *The Philadelphia Museum Bulletin,* vol. 37, no. 193 (March 1942), p. 19, repro.; Wolfgang Stechow, "The Early Years of Hobbema," *The Art Quarterly,* vol. 22 (spring 1959), pp. 3, 10, fig. 8; PMA 1965, p. 33; Rishel 1974, p. 29, fig. 3; The Cleveland Museum of Art, *European Paintings of the 16th, 17th, and 18th Centuries* (Cleveland, 1982), p. 240; Peter C. Sutton, *A Guide to Dutch Art in America* (Grand Rapids and Kampen, 1986), p. 225, fig. 327.

CONDITION: The canvas support was relined in 1965, when two earlier linings were removed. The tacking edges are missing. In 1965 the old discolored varnish was removed, together with most of the previous inpainting; some repaint in the sky was retained. Old scattered losses in the paint film are visible along the lower edge, the right edge, and especially in the sky at the upper left. When examined before treatment in 1965, the area around the signature also showed some old repaint. Elements of the date were thought to have been strengthened by a later hand. A thin coat of old varnish was retained in the area of the signature and date when the picture was cleaned, inpainted, and newly varnished. This crucial area was reexamined in 1981. The stretcher is impressed with a die stamp in three places with the inscription "Fleetham/Liner," referring to the mid-nineteenth-century English conservator Francis Leedham, who won recognition in his day for his relining practices.

According to Arnold Houbraken, Melchior (Melgior) de Hondecoeter was born in Utrecht in 1636. He came from a family of painters. His grandfather was Gillis Claesz. de Hondecoeter, the landscapist, and his father and teacher was Gysbert Gillisz. de Hondecoeter (1604–1653), the landscape and bird painter. Melchior also seems to have studied with his uncle Jan Baptist Weenix (q.v.), whose impact may be detected in his still-life subjects and Italianate aspects of his art. Melchior was working at The Hague by 1659 and, in 1662, was a *hoofdman* (leader) of the painters' confraternity there. He was in Amsterdam by 1663, when he married Susanna Tradel, and evidently remained in the city until his death on April 3, 1695.

Among other details of his life, Houbraken claimed that the painter became very religious and seriously considered leaving his profession to become a preacher. Less reliable, however, is J. C. Weyerman's account of Hondecoeter's taking to drink because of his nagging wife—surely one of the author's questionable *topoi*. In addition, the reason for the artist's impoverishment at his death remains unknown.

Hondecoeter was the preeminent Dutch bird painter. Ranging in scale from cabinet-sized works to murals, his paintings always have a decorative character but reveal remarkably careful observation of all aspects of the appearance and behavior of birds. He painted live birds, still lifes of dead birds, and fanciful bird "concerts." A number of his pictures are dated 1668 and after. His early works with dead game, perhaps predating his arrival in Amsterdam in 1663, recall the art of his teacher Jan Baptist Weenix. He also painted fish still lifes in these years in the style of Abraham van Beyeren (q.v.). Around the mid-1660s, the influence of Willem van Aelst (1625/26–1686) is detected in his palette. His mature and later gamepieces attest to Flemish influences, above all to that of Frans Snyders (q.v.). Hondecoeter's large decorative works, often inventorying ornithological menageries, were frequently designed for the palatial residences of aristocratic patrons. Willem III, for example, commissioned him to paint a "portrait" (now preserved in the Mauritshuis, The Hague) of the private zoo at the royal country residence Het Loo. Hondecoeter's virtuosity won him the nineteenth-century sobriquet "the Raphael of animals."

LITERATURE: Houbraken 1718–21, vol. 3, pp. 68–74; Weyerman 1729–69, vol. 4, pp. 39–40; Abraham Bredius, "De schilders Melchior de Hondecoeter en Johan le Ducq," in Obreen (1877–90), 1976, vol. 4, pp. 75, 83, 120, 130, 131, 149, vol. 5, pp. 130, 154, 288, 297; Wurzbach 1906–11, vol. 1, pp. 704–5; Bredius 1915–22, vol. 4 (1917), pp. 1210–40; Thieme-Becker 1907–50, vol. 17 (1924), p. 433; A.P.A. Vorenkamp, *Bijdrage tot de geschiedenis van het hollandsch stilleven in de zeventiende eeuw* (Leiden, 1933), pp. 77, 87, 91; Ingvar Bergstrom, *Dutch Still-Life Painting* (New York, 1956), p. 255; Neil MacLaren, *The National Gallery Catalogues: The Dutch School* (London, 1960), pp. 176–77; Plietzsch 1960, pp. 159–63; Laurens J. Bol, *Holländische Maler des 17. Jahrhunderts nahe den grossen Meistern: Landschaften und Stilleben* (Brunswick, 1969), pp. 281, 337; Akademie der bildenden Künste, Vienna, *Melchior de Hondecoeter (1636–1695): Katalog der XVI. Sonderausstellung* (Vienna, 1968); Scott A. Sullivan, *The Dutch Gamepiece* (Totowa and Montclair, N.J., 1984), pp. 30, 54–55.

For additional works by Hondecoeter in the Philadelphia Museum of Art, see John G. Johnson Collection cat. nos. 630, 629 (follower of).

41 MELCHIOR DE HONDECOETER

STILL LIFE WITH GAME BIRDS, c. 1665–75
Oil on canvas, 31¼ x 27⅜″ (79.4 x 69.5 cm.)
Purchased for the W. P. Wilstach Collection. W02-1-18

A dead rooster and a partridge are suspended by a string above the corner of a stone table. A pile of smaller birds with black, orange, and blue markings are arranged on a green cloth to the right. Behind are a powder horn and a straw basket containing a spool of nets used to snare birds.

Although unsigned, the work has always been assumed to be by Hondecoeter. The attribution is supported by the painting's close resemblance in subject, design, and technique to his monogrammed *Dead*

FIG. 41-1 Melchior de Hondecoeter, *Dead Game Still Life with Cock,* monogrammed, oil on canvas, 34¼ x 26¾" (87 x 68 cm.), Staatliches Museum, Schwerin, inv. no. G401.

Game Still Life with Cock (fig. 41-1). The same table ledge appears, as well as a similar arrangement of a dead rooster with a pile of smaller birds at the right.[1] Details of the execution of the present work can also be compared with other aspects of Hondecoeter gamepieces, such as the treatment of the feathers in the *Still Life with Birds* in the Toledo Museum of Art[2] and the painting of the basket snares as well as the plumage in *Still Life with Dead Duck and Basket.*[3] It must be noted, however, that very similar still lifes of dead birds and hunting gear were also painted by other artists during this period, including the Delft painter Willem van Aelst (1625/26–1686), who favored the motif of the tabletop and used a similar palette; Hendrik Fromantiou (1633–1690);[4] and especially the Scottish painter Willem Gouw Ferguson (1632/33–after 1695), who was active in The Hague and Amsterdam.[5] Ferguson's themes and general style come very close to those of the Philadelphia painting, but his technique is more labored and his touch drier.

NOTES

1. Another fully signed still life, *The Dead Rooster,* is inscribed *M. d'Hondecoeter f.* Oil on canvas, 44 x 32⅝" (112 x 83 cm.), Musées Royaux des Beaux-Arts de Belgique, Brussels, inv. no. 2737. A design very like that of the Philadelphia picture appears in *Dead Cock Still Life,* oil on canvas, 39 x 31⅛" (99 x 79 cm.), Statens Museum for Kunst, Copenhagen, inv. no. 1060; this piece is currently attributed to Willem van Aelst, but was formerly (correctly?) attributed to Hondecoeter.

2. Signed, oil on canvas, 21⅞ x 18⅞" (55.5 x 47.8 cm.), no. 62.69.

3. Sale, Empress Eugénie, Christie's, London, July 1, 1927. Compare also *Dead Game Still Life,* signed and dated 1667, oil on canvas, 22½ x 21½" (57 x 54.6 cm), sale, Christie's, London, December 18, 1936, lot 71; and *Still Life with Cock,* sale, Bukowski, Stockholm, April 4, 1973, lot 156, repro.

4. See Fromantiou's *Still Life,* 1679, oil on canvas, 21⅛ x 16⅞" (53.7 x 42.8 cm.), John G. Johnson Collection at the Philadelphia Museum of Art, cat. no. 645.

5. Compare Ferguson's signed *Still Life with Birds,* oil on canvas, 26⅞ x 21⁷⁄₁₆" (68 x 54.5 cm.), Worcester Art Museum, acc. no. 1976.50; his *Still Life: Dead Game,* signed, oil on canvas, 41½ x 33¾" (105.4 x 85.8 cm.), National Gallery of Scotland, Edinburgh, no. 1029; *Still Life: Dead Game,* signed and dated 1684, oil on canvas, 26 x 21" (66 x 53.4 cm.), National Gallery of Scotland, Edinburgh, no.

970; *Still Life with Dead Sparrow Hawk, Partridge, Snipe, and Hunting Gear,* signed and dated 1663, oil on canvas, 26 x 32¹⁄₁₆" (66 x 81.5 cm.), sale, Christie's, Amsterdam, November 27, 1986, lot 21, repro.; and the bird still life, Musées des Beaux-Arts, Nîmes, cat. 1940, no. 219 [as by an unknown artist], but according to a photograph from the Rijksbureau voor Kunsthistorische Documentatie, The Hague, signed and dated indistinctly 1656(?).

PROVENANCE: Purchased for the W. P. Wilstach Collection, Philadelphia, October 15, 1902.

LITERATURE: Wilstach 1903, no. 94 [as Melchior de Hondecoeter, and hereafter], 1904, no. 130, 1906, no. 143, 1907, no. 151, 1908, no. 151, 1910, no. 197, 1913, no. 206, 1922, no. 156; PMA 1965, p. 33.

CONDITION: The canvas support is lined with an aqueous adhesive. The tacking edges are missing. The paint film shows moderate to severe abrasion throughout and an irregular crackle pattern with associated cupping. In several passages a later hand has strengthened the darks—for example, the shadows beneath the table cover at the lower left and around the rooster's head. The smaller birds piled at the right have also suffered from considerable abrasion. The varnish is very uneven and deeply discolored.

42 MELCHIOR DE HONDECOETER
AND STUDIO

THE POULTRY YARD, 1680s?
Oil on canvas, 84¼ x 110¼″ (214 x 280 cm.)
Purchased for the W. P. Wilstach Collection. W96-1-12

A variety of garden and barnyard fowl are seen in the foreground of a
formal garden with a perspectival view at the left offering a glimpse of an
Italianate villa. A large male and a female peacock are perched at the right
on some architectural fragments strewn before a taller wall with pilasters
and a lower wall with an urn filled with flowers. Before the peacocks are
chickens, ducks, and waterfowl. Some respond with alarm to a hawk that
appears in the lower-left corner holding a chick in its talons. Above this
detail a pheasant perches on a section of wall and two ducks fly overhead.

Hondecoeter painted numerous large-scale decorative paintings of
birds in richly appointed gardens with ruins, vistas, flowers, and topiary.[1]
Although the buildings in the distance can sometimes be identified, the
majority, as in the present case, are imaginary. So faithful, on the other
hand, are the markings, the display, and the calling gestures of the
individual fowl that usually the birds can be identified by name. Many birds
in Hondecoeter's pictures recur together or in different combinations in
other paintings, suggesting that the artist worked from a standard repertory

FIG. 42-1 Melchior de Hondecoeter, *Peacocks and Ducks,* signed, oil on canvas, 83 x 69½″ (210.8 x 176.5 cm.), The Wallace Collection, London, no. P64.

FIG. 42-2 Melchior de Hondecoeter, *The Poultry Yard,* signed, oil on canvas, 51⅞ x 71⅞″ (131.7 x 182.5 cm.), Hamburger Kunsthalle, Hamburg, no. 320.

of studies.[2] For example, the peacocks seen here often reappear in the same or only slightly varied poses (see fig. 42-1).[3] No fewer than twelve of the birds in the Philadelphia painting are repeated in another composition, the best version of which seems to be *The Poultry Yard* in Hamburg (fig. 42-2), which is a variation of the right two-thirds of this picture.[4] The most conspicuous omissions in the Hamburg version are the elimination of the cock on the right, the white hen on the wall, the flowers above, and the conversion of the formal garden vista to a view with mountains. Details of this work are painted more freshly than in the Philadelphia painting. Also, the individual birds seem somewhat better related to their surroundings; they do not float in space or appear to have been inserted into the scene. Yet, many of the individual birds in the present work, such as the peacocks as well as the hawk and the chicken in the lower left, are painted very masterfully. Although the Hamburg painting can make claims to being the first version, the present picture may well be an elaborated and enlarged replica, executed by the master with the aid of his studio. Some support for this assumption is provided by the fact that the painting appears to be a unique example of this larger design. Although the date of the work cannot be pinpointed, in all likelihood it was executed in the last quarter of the seventeenth century and perhaps in the 1680s.[5]

Beyond the appeal that Hondecoeter's works had for his contemporaries as unrivaled records of the beautiful plumage and appearances of rare and domesticated fowl, they also probably prompted additional associations and in some cases encoded emblematic meanings. For the Dutchman weaned upon sayings and proverbs about strutting peacocks, proud roosters, and querulous magpies, the behavior and idiosyncracies of the feathered world offered rich human parallels, some comically bellicose and others, like the marauding hawk in Philadelphia's picture, sadly predatory.

NOTES

1. Compare, for example, his paintings in the Akademie der bildenden Künste, Vienna: *Peacocks,* oil on canvas, 61 x 74¹³⁄₁₆″ (155 x 190 cm.), inv. no. 620; and *Dead Game Still Life,* oil on canvas, 49¼ x 68⁵⁄₁₆″ (125 x 173.5 cm.), inv. no. 819.

2. See, for example, *Studies of Birds,* oil on canvas, 24½ x 29⅛″ (62.3 x 74 cm.), Musée des Beaux-Arts, Lille, inv. no. P.1027 (repro. in Musée des Beaux-Arts, Lille, *Tresors des Musées du Nord de la France, III. La Peinture Flamande au temps de Rubens* [Lille, 1977], cat. no. 69). Although this work is attributed in Lille to Adriaen van Utrecht (1599–1652/53), Richard Muhlberger and Scott Sullivan, who are jointly preparing a study of Hondecoeter, consider it to be by Hondecoeter.

3. Compare also *Peacocks,* signed and dated 1683, oil on canvas, 74⅞ x 53″ (190 x 134.6 cm.), The Metropolitan Museum of Art, New York, acc. no. 27.250.1; and *Bird Concert with Peacocks,* signed and dated 1682, with dealer P. de Boer, Amsterdam, 1952 (photograph, Rijksbureau voor Kunsthistorische Documentatie, The Hague, no. L23058).

4. Other versions include *The Poultry Yard,* oil on canvas, 43¼ x 53⅛″ (110 x 135 cm.), sale, Demachy, Georges Petit, Paris, May 1912; Lord Clarendon (photograph, Witt Library, London); oil on canvas, 29⅛ x 36¼″ (74 x 92 cm.), with dealer J. Spink, London, 1931, and earlier in sale, Schoenlank, Cologne, April 1896, lot 90 [judging from photographs, possibly a copy]. These other versions all appear to be based on *The Poultry Yard* in Hamburg (fig. 42–2), which includes a flying bird at the upper left that reappears in all but the painting formerly with Spink.

5. Compare the dated works mentioned in note 3.

PROVENANCE: Purchased for the W. P. Wilstach Collection, Philadelphia, November 30, 1896.

LITERATURE: Wilstach 1897, suppl., no. 190 [as by Melchior de Hondecoeter and hereafter], 1900, no. 73, 1902, no. 81, 1903, no. 95, 1904, no. 131, 1906, no. 144, 1907, no. 152, 1908, no. 152, 1910, no. 198, 1913, no. 207, 1922, no. 155, repro.; PMA 1965, p. 33; Rishel 1974, p. 31.

CONDITION: The canvas support had been lined with an aqueous adhesive at some time before it was cleaned in 1968-69; nonetheless the canvas remains weak. The original fabric is seamed horizontally 36″ (91.5 cm.) from the lower edge. The tacking edges are missing and there are draws in the lower-left corner. Sometime before the 1968-69 treatment the paint film had been extensively abraded through cleaning in the sky and vista at the upper left as well as in the dark colors. Discolored overpaint and retouches cover areas of abrasion and numerous small tears. The varnish is colorless.

Pieter de Hooch (Hoogh) was baptized in Rotterdam on December 20, 1629, the son of a master bricklayer and a midwife. Arnold Houbraken informs us that he was a pupil of the Italianate landscapist Nicolaes Berchem (1620–1683) at the same time as his fellow Rotterdamer Jacob Ochtervelt (1634–1682). De Hooch's first known appearance in Delft was in 1652, when he signed a document with the painter Hendrick van der Burch (1627–after 1666). In 1653 he was described as a painter and servant (*dienaar*) to a linen merchant, Justus de la Grange, and an inventory of the latter's collection drawn up in 1655 lists eleven paintings by De Hooch. In 1653 De Hooch attended a baptism in Leiden, but was recorded as a resident of Rotterdam in the following year, when he was betrothed to Jannetje van der Burch of Delft, no doubt the sister of Hendrick van der Burch. De Hooch joined the Guild of Saint Luke in Delft in 1655 and made two additional payments to the guild in 1656 and 1657. The artist's earliest dated works are from 1658 and include Delft motifs. By April 1661 De Hooch had settled in Amsterdam; he may have moved there up to eleven months earlier. Except for one appearance in Delft in 1663 (presumably as a visitor), De Hooch seems to have remained in Amsterdam for the rest of his life. At some point he entered the insane asylum (Dolhuis), but the date and precipitating circumstances of his commitment are unknown. On March 24, 1684, he was buried in the St. Anthonis Kerkhof in Amsterdam.

De Hooch is remembered principally for his genre scenes of middle-class figures in orderly interiors and sunny courtyards. He first began to produce these works in Delft, while working with his famous colleague Johannes Vermeer (1632–1675). Less well known are his early guardroom scenes and the numerous later works depicting elegant Amsterdam high life.

LITERATURE: Houbraken 1718–21, vol. 2, pp. 27, 34; Smith 1829–42, vol. 4, pp. 217–42, and suppl., pp. 563–74; P. Haverkorn van Rijsewijk, "Pieter de Hooch," *Nederlandsche Kunstbode*, vol. 2 (1880), pp. 163–65; Abraham Bredius, "Iets over de Hooch," *Nederlandsche Kunstbode*, vol. 3 (1881), p. 126; Abraham Bredius, "Nog eens de Hooch," *Nederlandsche Kunstbode*, vol. 3 (1881), p. 172; Abraham Bredius, "Bijdragen tot de biographie van Pieter de Hoogh," *Oud Holland*, vol. 7 (1889), pp. 161–68; C. Hofstede de Groot, "Proeve eener kritische beschrijving van het werk van Pieter de Hooch," *Oud Holland*, vol. 10 (1892), pp. 178–91; Hofstede de Groot 1908–27, vol. 1 (1908), pp. 471–570; Arthur de Rudder, *Pieter de Hooch et son oeuvre* (Brussels and Paris, 1913); C. H. Collins Baker, *Pieter de Hooch* (London, 1925); Clotilde Brière-Misme, "Tableaux inédits ou peu connus de Pieter de Hooch," pts. 1–3, *Gazette des Beaux-Arts*, 5th ser., vol. 15 (1927), pp. 361–80, vol. 16 (1927), pp. 51–79, 258–86; W. R. Valentiner, *Klassiker der Kunst in Gesamtausgaben*, vol. 35, *Pieter de Hooch* (Berlin and Leipzig, 1929); W. R. Valentiner, *Pieter de Hooch* (London and New York, 1930); F.W.S. van Thienen, *Pieter de Hoogh* (Amsterdam [c. 1945]); Sutton 1980; Sutton et al. 1984, pp. 214–22.

For additional works by De Hooch in the Philadelphia Museum of Art, see John G. Johnson Collection cat. nos. 499, 501, 498 (follower of).

43 PIETER DE HOOCH

INTERIOR WITH FIGURES, probably 1675
Oil on canvas, 32¹⁄₁₆ x 38¾" (81.4 x 98.4 cm.)
Purchased for the W. P. Wilstach Collection. W12-1-7

In an elegant hall with a marble floor, tall windows, and classical architectural decorations, five figures engage in music, drinking, and amorous dalliance. To the left of center a woman in a silver satin dress stands with her back to the viewer and arms akimbo, receiving a toast offered her by a man in black, standing with an upraised glass. To his right a woman in bright orange red leaning against a table covered with an oriental carpet plays a lute. At the left beside a tall window a man leans down to embrace a seated woman, while a small dog springs up toward her lap. At the far right a serving boy brings a tray of fruit. Stairs rise up in the background, where a large archway flanked by pilasters is surmounted by a larger gilt-framed picture in which a reclining nude is partially visible. A chandelier hangs overhead, and a deep red curtain is draped over the shutter of the window at the left.

FIG. 43-1 Pieter de Hooch, *A Musical Conversation with Four Figures,* signed and dated 1674, oil on canvas, 38⅝ x 45¼" (98 x 115 cm.), Academy of Arts, Honolulu, no. 3798.1.

FIG. 43-2 Pieter de Hooch, *A Standing Woman with a Woman Playing a Cello,* c. 1675, oil on canvas, 26⅜ x 20⁷⁄₁₆" (67 x 52 cm.), private collection, West Germany.

The picture formerly bore a signature and date by the window at the left, which was deciphered in Sedelmeyer's Paris exhibition catalogue of 1898 (no. 71) as 1653 but was later read, probably correctly, in 1908 by C. Hofstede de Groot as 1675. In a photograph taken before the picture was cleaned in 1940, one can clearly read "P. de Hoogh/1675." Evidently this inscription was cleaned off, but it finds support not only in the form of the signature[1] but also in the style of the painting itself, which resembles other works by De Hooch from about 1675. The elegant theme, the figure types, the dark tonality, and the brilliant color scheme of silver, black, and reddish orange link the work to other dated pictures from the mid-1670s, now in Honolulu (fig. 43-1), East Berlin, and London.[2]

In the past, the work has been titled "The Minuet." Dancing had long been a popular subject of Dutch genre. Following the sixteenth-century Flemish tradition of depicting balls, Pieter Codde (1599–1678), Dirck Hals (1591–1656), Willem Duyster (1598/99–1635), and Anthonie Palamedesz. (q.v.) painted the restrained dances of the well-to-do, while Adriaen van Ostade (q.v.) and other low-life artists depicted the more bumptious dance fests of the peasant kermis and wedding celebration. It is unclear whether the central couple in the Philadelphia painting is dancing or merely toasting (note the man's raised glass), nor can the nature of the step they are performing be determined from the configuration, particularly since the minuet was introduced at the French court only around 1650. During his later years, De Hooch often depicted elegant companies playing music and socializing in spacious hallways created from his imagination—works doubtless designed to satisfy the increasingly aristocratic tastes of his Amsterdam patrons.[3]

A painting in a private collection in West Germany (fig. 43-2) depicts a standing woman viewed from the rear, similarly to the figure in the present work. According to early sales catalogues, the West German piece was once part of a larger horizontal composition in which a man was facing the woman. Unfortunately, the original canvas was cut down sometime between 1788 and 1892.[4] Another painting, now lost, seems to have resembled the Museum's *Interior with Figures* in theme and design.[5]

Infrared photographs of the Philadelphia painting reveal another figure, or perhaps a bust on a pedestal, beneath the archway at the right. Old photographs also indicate that the central woman's present headgear had been formerly overpainted in the shape of a hat.[6]

NOTES

1. Although the artist signed his name in various ways ("Pieter de Hooch," "d[e] Hoogh," or, rarely, "Hooghe"), the spelling with the "g" was most common in the 1670s and through the end of his career.

2. See *A Man with a Book, and Two Women,* 1676, oil on canvas, 25 x 29½" (63.5 x 75 cm.), Staatliche Museen, Gemäldegalerie, Berlin (East), no. B102 (Sutton 1980, no. 133, pl. 134); and *A Musical Party in a Courtyard,* 1677, oil on canvas, 32⅛ x 27" (83.5 x 68.5 cm.), National Gallery, London, no. 3047 (Sutton 1980, no. 134, pl. 137).

3. See, for example, the large *Music Party with Twelve Figures,* oil on canvas, 40½ x 52⁵⁄₁₆" (103 x 133 cm.), Wellington Museum, Apsley House, London, inv. no. 1487–1948 (Sutton 1980, no. 117, pl. 120).

4. Sutton 1980, no. 115.

5. *The Minuet,* oil on canvas, 26 x 32½" (66 x 82.5 cm.), location unknown, is described as follows by Hofstede de Groot 1908–27, vol. 1 (1908), p. 509, no. 123 (and p. 544, no. 250): "Between the pillars in the background of a large and dimly lighted hall are a lady and gentleman. Before them is a negro boy wearing a red jacket and yellow scarf, who brings a dish of oranges. A fair young gentleman, hat in hand, who stands at the back facing the spectator, and a girl in red, who waits in the right foreground with her

back to the spectator, are about to dance a minuet. Beside the couple sit a man playing a fiddle and a woman who beats time and looks at a music-book. The architecture is in a rich baroque style, with statues in niches. The sunlight falls from the left; the persons on the right are more in shadow." See Sutton 1980, no. C135.

6. See the reproduction in W. R. Valentiner, *Pieter de Hooch* (London and New York, 1930), no. 138.

PROVENANCE: Dealer Lesser, London, 1889; Sir Charles Robinson, London, 1892; dealer Sedelmeyer, Paris; Rodman Wanamaker, Philadelphia, by 1898; purchased for the W. P. Wilstach Collection, Philadelphia, 1912.

EXHIBITION: Sedelmeyer Gallery, Paris, 1898, no. 71.

LITERATURE: Abraham Bredius, "Bijdragen tot de biographie van Pieter de Hoogh," *Oud Holland,* vol. 7 (1889), p. 167, n. 2; C. Hofstede de Groot, "Proeve eener kritische beschrijving van het werk van Pieter de Hooch," *Oud Holland,* vol. 10 (1892), pp. 178–91; E. C. Siter, *Catalogue of the Rodman Wanamaker Collection* (Philadelphia, 1904), no. 22; Wurzbach 1906–11, vol. 1, p. 717 [as 1653]; Hofstede de Groot 1908–27, vol. 1 (1908), p. 531, no. 197 [as 1675]; Hans Jantzen, *Farbenwahl und Farbengebung in der holländischen Malerei des XVII. Jahrhunderts* (Parchim, 1912), p. 13; Arthur de Rudder, *Pieter de Hooch et son oeuvre* (Brussels and Paris, 1913), p. 105; Wilstach 1913, no. 209;

Clotilde Brière-Misme, "Un Pieter de Hooch inconnu au Musée de Lisbonne," *Gazette des Beaux-Arts,* 5th ser., vol. 4 (1921), p. 342; Wilstach 1922, no. 153; C. H. Collins Baker, *Pieter de Hooch* (London, 1925), pp. 3, 8 [as 1675]; Clotilde Brière-Misme, "Tableaux inédits ou peu connus de Pieter de Hooch," pt. 3, *Gazette des Beaux-Arts,* 5th ser., vol. 16 (1927), p. 276 [as 1675]; W. R. Valentiner, *Klassiker der Kunst in Gesamtausgaben,* vol. 35, *Pieter de Hooch* (Berlin and Leipzig, 1929), no. 138 [as 1675]; W. R. Valentiner, *Pieter de Hooch* (London and New York, 1930), no. 138 [as 1675]; Hans Kauffman (review of W. R. Valentiner) in *Deutsche Literaturzeitung,* April 26, 1930, col. 805; PMA 1965, p. 33; Rishel 1974, p. 31; Sutton 1980, pp. 37–38, no. 114, pl. 117 [as probably 1675].

CONDITION: The canvas support is stable and planar but slack on the stretcher. Tears at the edges were repaired and the entire canvas relined with wax-resin in 1967. The paint film is extensively abraded from cleaning. Photographs taken before the painting was cleaned in 1940 show considerable overpaint in the figures and the background. Whether the abrasion of the work occurred at the time of that cleaning or earlier is unclear; however, the signature and date that were visible in photographs taken of the picture before treatment in 1940 in all probability reflected an original inscription. Losses throughout the work (especially along the edges and in the lower right) and large areas of abrasion were inpainted in 1967. The varnish is colorless. There are small mat areas related to some of the inpainted areas.

Born in Groningen on January 27, 1824, Jozef Israëls grew up in a modest Jewish home. He first took his instruction in art at the Minerva Academy at Groningen in 1835. Later, around 1840, he was a pupil of Jan Adam Kruseman (1804–1862) in Amsterdam and attended the Royal Academy there, studying under Jan Willem Pieneman (1779–1853). In 1845 he traveled to Paris, where he studied at the Académie des Beaux-Arts (1846–47) and with François Edouard Picot (1786–1868), who was a student of Jacques-Louis David (1748–1825). During these years he made copies of works by Rembrandt, Velázquez, and Raphael at the Louvre. In 1847 he returned from France to Holland, where he began his career painting large, romantic historical subjects. He made a trip to Düsseldorf, seat of German Romantic painting, in 1850. In 1853 he was in Paris and visited Ary Scheffer (1795–1858). After a stay at Zandvoort in 1855 he abandoned history painting and devoted himself to scenes of peasants and fishermen. In 1863 he married Aleida Schaap, and the couple lived on the Prinsengracht in Amsterdam. The previous year he had traveled to London and in 1869 he visited Germany and Switzerland. Three years later he settled in The Hague where, except for trips to Italy (1877 and 1909) and Spain and North Africa (1894), he remained until his death on August 12, 1911. During his lifetime his works were exhibited in Paris and London as well as in Holland, and he enjoyed great renown.

In The Hague, Israëls was the dominant figure in the school of artists that included the brothers Jacob Hendricus Maris and Willem Maris (qq.v.), Anton Mauve (q.v.), Johannes Bosboom (1817–1891), and Hendrik Willem Mesdag (1831–1915). The group took their collective name, the Hague School, from the city.

LITERATURE: Jozef Israëls, *Spanje, een reisverhaal* (The Hague, 1899); J. de Meester, "Jozef Israël," in *Dutch Painters of the Nineteenth Century,* edited by Max Rooses, vol. 1 (London, 1899), pp. 83–99; Max Liebermann, *Jozef Israël, Kritische Studie: Mit einer Radierung und dreizehn zum Teil ganzseitigen Abbildungen* (Berlin, 1901); Jan Veth, "Modern Dutch Art: The Work of Jozef Israels," *The Studio,* vol. 26 (1902), pp. 239–51; W. Steenhoff, "Jozef Israëls," *Onze Kunst,* vol. 3 (1904), pp. 29–51; H. J. Hubert, *De etsen van Jozef Israëls* (Amsterdam, 1909); H. J. Hubert, *The Etched Work of Jozef Israëls: An Illustrated Catalogue* (Amsterdam, n.d.); Max Eisler, "J. F. Millet en J. Israëls," *Onze Kunst,* vol. 10 (1911), pp. 117–28; Max Eisler, "Modern Dutch Portrait Painting, with Special Reference to the Works of Jozef Israëls," *The Studio,* vol. 52 (1911), pp. 106–21; E. G. Halton, "Jozef Israëls, the Leader of the Modern Dutch School," *The Studio,* vol. 54 (1912), pp. 89–102; Frank Wakeley Gunsaulus, *Josef Israels: An Address Delivered at the Opening of the Exhibition of Josef Israels' Paintings, Toledo Museum of Art* (Chicago, 1912); Max Eisler, *Josef Israëls,* edited by Geoffrey Holme (London, 1924); G. Knuttel Wzn. in Thieme-Becker 1907–50, vol. 19 (1926), pp. 255–60; W. F. Douwes, "Israëls en de Hollandsche Van Gogh als figuur- en interieur-schilders," *Maandblad voor Beeldende Kunsten,* vol. 6, no. 11 (1929), pp. 342–51; Hendrik Enno van Gelder, *Jozef Israëls* (Amsterdam, [1947]); J. Knoef, "Israëls-studien I: een compositie-principe," *Oud Holland,* vol. 62 (1947), pp. 79–86; Groninger Museum voor Stad en Lande, *Herdenkingstentoonstelling Jozef Israëls, 1824–1911,* 1961–62, and Gemeentemuseum, Arnhem; Haags Gemeentemuseum, The Hague, *Meesters van de Haagse School,* June 18–August 15, 1965, pp. 42–48; Joseph de Gruyter, *De Haagse School,* 2 vols. (Rotterdam, 1968), vol. 1, pp. 46–59; Pieter A. Scheen, *Lexicon Nederlandse beeldende Kunstenaars, 1750–1880* (The Hague, 1981), pp. 242–43; The Hague, Paris, London 1983, pp. 186–99.

For additional works by Israëls in the Philadelphia Museum of Art, see John G. Johnson Collection cat. nos. 1010, 1009.

44 JOZEF ISRAËLS

THE LAST BREATH, 1872?
Signed lower right: *Jozef Israels*
Oil on canvas, 44 x 69⅜″ (112 x 176 cm.)
Gift of Ellen Harrison McMichael in memory of C. Emory McMichael.
 42-60-2

FIG. 44-1 After Jozef Israëls, *The Orphans,*
engraving.

At the left of a simple interior, a woman with a dog lying at her feet grieves over a man, no doubt her husband, who evidently has died. He is lying in an enclosed bed of the type often found in Dutch homes. To the right by a window an older woman, presumably the grandmother, comforts two small children. Behind her a candle, a coffee grinder, a bowl, and an apple rest on a small cabinet, and before her a simple meal is set out on a low table. Overhead a birdcage is suspended from the beams. At the left a clock hangs on the wall above a low table with a lantern and bowl. Beside the table stands a chair draped with fishing nets; on the seat, a Bible is open to a colored illustration.

This scene is characteristic of the type of highly emotional, melodramatic works that Israëls painted during the early years of his career in the mid-1850s and 1860s. Specifically, themes of death and dying and funeral subjects begin in his art shortly before 1860. An old inscription in English on a sticker on the back of the frame reads "J. Israels 1872/The Last Breath" and may reflect an accurate date and title. Although the date 1872 seems somewhat late, anecdotal titles of this sort are not unusual in Israëls's work.

FIG. 44-2 Jozef Israëls, *Mending the Nets,* signed, oil on canvas, 30⅞ x 47⅜" (78.4 x 120.3 cm.), Vancouver Art Gallery, no. 40.17.

FIG. 44-3 Jozef Israëls, *The Convalescent,* 1869, location unknown.

FIG. 44-4 Jozef Israëls, *Alone in the World,* signed, 1878, oil on canvas, 35½ x 15⅝" (90 x 139 cm.), Rijksmuseum, Amsterdam, inv. no. A1179.

The right-hand side of the composition (including the woman, the two children, the window, and the cabinet with candle and basin) exists in another version called *The Orphans,* known through an old wood engraving (fig. 44-1).[1] The overall design of the interior owes much to seventeenth-century Dutch paintings, such as those of Pieter de Hooch (q.v.) and his followers.[2]

Evidently the room and the composition were among the artist's favorites. He painted several variations of them—for example, *Mending the Nets* (fig. 44-2)[3] and *The Convalescent* (fig. 44-3).[4] A slightly later painting, *Alone in the World* (fig. 44-4), treats a similar theme, in which a woman is seated weeping before an enclosed bed. Certain elements of the design and motifs found in the Philadelphia painting are retained, though in reverse (such as the location of the clock, no doubt intended as a memento mori), but the grandmother with the children has been eliminated. Another painting of a mourning spouse, alternately entitled *Nothing Left* or *Alone in the World,* reverses the roles of the wife and husband, making the latter the mourner.[5]

NOTES

1. Photograph, Rijksbureau voor Kunsthistorische Documentatie, The Hague, no. L60.646.
2. Compare, for example, Pieter de Hooch's *Interior with a Mother Delousing Her Child's Hair (A Mother's Duty),* oil on canvas, 20¾ x 24" (52.5 x 61 cm.), Rijksmuseum, Amsterdam, no. C149.
3. *Mending the Nets* was formerly with dealer Backstitz, The Hague, 1938, from the F. van Gans Collection. See Vancouver Art Gallery, *Rembrandt to Van Gogh,* 1957, cat. no. 22, repro., where it is listed as from the H. S. Southam Collection, Ottawa, Ontario.
4. See Max Eisler, *Josef Israëls,* edited by Geoffrey Holme (London, 1924), pl. XIII.
5. Dated 1880 (or before), oil on canvas, 49¼ x 78¾" (125 x 200 cm.), Museum Mesdag, The Hague, no. 154; see The Hague, Paris, London 1983, p. 20, fig. 9.

PROVENANCE: Ellen Harrison McMichael.

LITERATURE: PMA 1965, p. 34; Rishel 1971, p. 23, cat. no. 2, repro.

CONDITION: The painting has an aqueous lining. The tacking edges are missing. The canvas support is brittle and has slight draws at the corners. The paint film exhibits extensive traction crackle throughout. Retouching of the most conspicuous areas of crackle is evident in the darks—for example, around the dog, in the shadow of the enclosed bed, and between the table and the woman at the right. The signature appears to be genuine but has been strengthened. The varnish is cloudy and deeply discolored.

45 JOZEF ISRAËLS

OLD FRIENDS, 1877?
Signed lower left: *Jozef Israels*
Oil on canvas, 52 x 69″ (132 x 175 cm.)
The William L. Elkins Collection. E24-3-10

In the corner of a simple room with a window on the left and a fireplace at the rear on the right, an old man sits filling his pipe. Facing him sits his dog. On top of a simple wooden table before the window rests a metal brazier holding red-hot coals, presumably to light the pipe.

Although no date appears on the work, H. E. van Gelder claimed in 1947 that it had been painted in 1877 (he also stated, wrongly, though, that it was in private hands).[1] Although it has not been possible to verify this claim, the picture certainly predates 1882, when it was shown in the Salon in Paris under the title "Dialogue silencieux."[2] The painting was the subject of an enthusiastic letter dated March 18, 1882, from Vincent van Gogh to his brother Theo, which deserves to be quoted at length:

> Israëls', "An Old Man" (if he were not a fisherman, it might be Thomas Carlyle, the author of the *French Revolution* and *Oliver Cromwell,* for he decidedly has a head characteristic of Carlyle) is sitting in a corner near the hearth, on which a small piece of peat is faintly

FIG. 45-1 Jozef Israëls, *Before the Fishing Trip,* signed and dated 1864, oil on canvas, 21 x 28″ (53 x 71 cm.), location unknown.

FIG. 45-2 Jozef Israëls, *Silent Company,* pen on paper, 11¼ x 17″ (28.5 x 43 cm.), Rijksprentenkabinet, Amsterdam, inv. no. 1955.149.

glowing in the twilight. For it is a dark little cottage where that old man sits, an old cottage with a small white-curtained window. His dog, which has grown old with him, sits beside his chair—those two old friends look at each other, they look into each other's eyes, the dog and the man. And meanwhile the old man takes his tobacco pouch out of his pocket and lights his pipe in the twilight. That is all—the twilight, the silence, the loneliness of those two old friends, the man and the dog, the understanding between those two, the meditation of the old man—what he is thinking of, I do not know, I cannot tell, but it must be a deep, long thought, something, but I do not know what; it comes rising from a past long ago—perhaps that thought gives the expression to his face, an expression melancholy, contented, submissive, something that reminds one of Longfellow's famous poem with the refrain: But the thoughts of youth are long, long thoughts.[3]

I should like to see this picture by Israëls hanging beside "Death and the Woodcutter" by Millet.[4] I certainly do not know a single picture except this Israëls which is the equal of Millet's "Death and the Woodcutter," or is worthy of being shown with it. And then I feel in my mind an irresistible longing to bring these two pictures together, so they can complete each other...one at one end, the other at the other end of a long, narrow gallery—with no other pictures in that gallery but these two....It is a famous Israëls; I could not really see anything else, I was so struck by it.[5]

Clearly, the painting's sentiment moved Van Gogh, and the work itself undoubtedly enjoyed considerable renown in its own day.[6]

The composition was one that Israëls returned to on several occasions. A smaller painting from 1864, *Before the Fishing Trip,* signed and dated by Israëls, depicts the old man and the dog in reversed positions (fig. 45-1).[7] There the old man is occupied with mending fishing nets instead of filling his pipe and appears more picturesque and less pathetically impoverished than his counterpart in the later painting in Philadelphia. Another smaller version of the Philadelphia picture, with a shutter on the window and other changes, was last seen in the collection of W. P. Montijn in Wassenaar (near The Hague) and may be a replica, or conceivably a preparatory study.[8] A related drawing preserved in the Rijksprentenkabinet, Amsterdam (fig. 45-2) may be the sketch that Israëls executed after the work for reproduction.[9] Van Gelder mentioned a watercolor of the same subject called *The Good Companions.*[10] The Rijksmuseum, Amsterdam, also owns a smaller painting with a very similar design in which a cat has been substituted for the dog depicted in the present work.[11]

NOTES

1. Hendrik Enno van Gelder, *Jozef Israëls* (Amsterdam, [1947]), p. 34.

2. Paris, Salon, 1882, no. 1388.

3. From the poem "Lost Youth," 1858, by Henry Wadsworth Longfellow.

4. Oil on canvas, 30½ x 38¾″ (77.5 x 98.5 cm.), Ny Carlsberg Glyptotek, Copenhagen, inv. no. 972.

5. *The Complete Letters of Vincent van Gogh,* 3 vols., edited by Johanna van Gogh-Bonger and C. de Drood (Greenwich, Conn., 1959), vol. I, pp. 325–26, no. 181.

6. After Anton Mauve (q.v.), it was Israëls, of all the Hague School artists, who made the greatest impression on Van Gogh; see Charles S. Moffett, "Vincent van Gogh en de Haagse School," in The Hague, Paris, London 1983, pp. 137–46.

7. L. and L. Honsdricht Collection; repro. in Max Eisler, *Josef Israëls,* edited by Geoffrey Holme (London, 1924), pl. XL [as *Mending the Nets*].

8. Signed lower left, oil on canvas, 20½ x 25¾″ (52 x 66 cm.); provenance: William Schaus, New York; Edward T. Stotesbury,

Philadelphia; sale, William J. Ralston, American Art Association, New York, March 12, 1926, lot 45, repro. [as 24 x 29"]; sale, E. H. Block (to M. Skalter), Anderson Art Galleries, New York, February 4, 1932, lot 139, repro.; sale, Charles Stewart Smith, American Art Association, New York, January 4, 1935, lot 32, repro.

9. The Witt Library, London, has an illustration of this drawing or a very similar one clipped from an unspecified nineteenth-century French publication and entitled "*Dialogue Silencieux. Croquis de Jozef Israels, d'apres son tableaux.*" Still another clipping from an uncredited English publication of approximately the same period is a lithographic reproduction of the Philadelphia painting.

10. Van Gelder (see note 1), p. 35.

11. *Interior of a Peasant Hut,* signed, oil on canvas, 23½ x 28¼" (60 x 70 cm.), Rijksmuseum, Amsterdam, no. A2921.

PROVENANCE: Dealer J. S. Forbes, London [from sticker on the reverse]; William L. Elkins Collection, Philadelphia, by 1900.

EXHIBITIONS: Paris, Salon, 1882, no. 1388; Amsterdam, International Exhibition, 1883, no. 108.

LITERATURE: *Exposition des Beaux-Arts, Salon de 1882* (Paris, 1882), pp. 105–6, repro.; *The Complete Letters of Vincent van Gogh,* 3 vols., edited by Johanna van Gogh-Bonger and C. de Drood, (Greenwich, Conn., 1959), vol. I, pp. 325–26, no. 181; W. Steenhof, *Onze Kunst,* vol. 3 (February 1904), repro.; Elkins 1887–1900, vol. I, no. 27, repro., 1924, no. 10; Max Eisler, *Josef Israels,* edited by Geoffrey Holme (London, 1924), pp. 20–21, pl. XLI [as *Comrades*]; Hendrik Enno van Gelder, *Jozef Israëls* (Amsterdam, [1947]), pp. 26, 34–35,

repro.; PMA 1965, p. 34; Rishel 1971, pp. 24–25, cat. no. 3, repro.; Charles Moffett, "Vincent van Gogh en de Haagse School," in The Hague, Paris, London 1983, p. 140, fig. 113.

CONDITION: The painting is in poor condition. The old aqueous-lined canvas support is loose and sagging on its stretcher. The tacking margins are missing. The paint film has drying cracks of wide aperture throughout, possibly resulting from the use of bitumen. The most conspicuous cracks, especially those in the figures, have been retouched extensively and are now discolored. Some cupping of paint accompanies the crackle. The varnish is deeply discolored.

46 JOZEF ISRAËLS

THE FISHERMAN'S FAMILY
Signed lower left: *Jozef Israels*
Oil on panel, 11 x 17¼" (27.9 x 43.8 cm.)
The William L. Elkins Collection. E24-3-79

FIG. 46-1 Jozef Israëls, *The Young Mother,* signed, oil on canvas, 19¼ x 29″ (49 x 74 cm.), location unknown.

In the dark interior of a simple cottage with a lighted window in the center of the back wall sits a peasant woman holding her child. Before her on a table rests her knitting and a vase of flowers. At the left is a door and to the right a second chair and a hearth.

The motif of a mother and child seated beside a lighted window was one of Israëls's favorites. A somewhat more finished and larger picture employing the same subject but with the design reversed was in the Francis Wilson sale of 1943 (fig. 46-1).[1] The Rijksmuseum owns a much larger canvas called *The Joy of Motherhood,* dated 1890, with a comparable subject and design.[2] There is also an undated painting with the same composition but upright in format.[3]

Israëls first became interested in the poverty-stricken lives of fishermen's families during his visits in 1855–56 to Katwijk and Zandvoort, two seaside villages to the north of The Hague. Later he even built in the corner of his studio a partial replica of a fisherman's dwelling where he could pose models. In addition to their sources in the art of Millet (1814–1875) and the Barbizon School, Israëls's simple domestic images have roots in seventeenth-century Dutch art. This work, for example, generally recalls designs by Rembrandt, whom Israëls greatly admired.[4]

NOTES

1. Sale, Parke-Bernet Galleries, New York, November 26, 1943, lot 43, repro.; see Max Eisler, *Josef Israëls,* edited by Geoffrey Holme (London, 1924), pl. XXX.
2. Signed, 1890, oil on canvas, 41¾ x 50¾″ (106 x 129 cm.), Rijksmuseum, Amsterdam, no. A2597.
3. Oil on canvas, 24 x 19″ (61 x 48 cm.), location unknown (photograph, Rijksbureau voor Kunsthistorische Documentatie, The Hague).
4. Compare Rembrandt's etching of *The Virgin and Child at a Window,* dated 1654 (Arthur M. Hind, *Rembrandt's Etchings,* 2 vols. [London, 1912], vol. 2, pl. 275).

PROVENANCE: William L. Elkins Collection, Philadelphia, by 1900.

LITERATURE: Elkins 1887–1900, vol. 1, no. 26, repro.; PMA 1965, p. 34.

CONDITION: The uncradled panel support with horizontal grain is planar and in stable condition. The paint film shows minimal abrasion and few losses. The varnish is cloudy, abraded by the frame rabbet, and deeply discolored.

Born in Lattrop in the province of Overijssel on June 3, 1819, Jongkind was a student in The Hague of the landscapist Andreas Schelfhout (1787–1870). He received a royal stipend to work in Paris, where he studied in the atelier of François Edouard Picot (1786–1868). There he met Jozef Israëls (q.v.) and other artists. In 1848 he first exhibited at the Salon in Paris. He traveled to Normandy in 1850 and 1851. In 1853 he returned to Holland, where he lived in and around Rotterdam until 1860. He returned to Paris in 1860 and lived there until 1870, while making excursions to various parts of France and the Lowlands virtually every year. From 1863 onward his constant companion was Mme Fesser, a Dutchwoman to whom he was introduced by the dealer Père Martin. Jongkind traveled frequently until 1878, when he settled with Mme Fesser in Côte Saint André near Grenoble, his residence until his death.

A painter and etcher of landscapes, Jongkind had contact with many outstanding artists of his day, including Eugène Isabey (1803–1886), Gustave Courbet (1819–1877), Eugène Boudin (1824–1898), Claude Monet (1840–1926), and the Barbizon School painters. He had a significant impact upon Monet and was an important precursor of Impressionism.

LITERATURE: Loys Delteil, *Le Peintre-graveur illustré (XIX^e et XX^e siècles),* vol. 1 (Paris, 1906); Etienne Moreau-Nélaton, *Jongkind, raconté par lui-meme* (Paris, 1918); Paul Signac, *Jongkind* (Paris, 1927); Claude Roger-Marx, "The Engraved Work of Jongkind," *The Print Collector's Quarterly,* vol. 15 (April 1928), pp. 111–30; Paul Colin, *J. B. Jongkind* (Paris, 1931); Claude Roger-Marx, *Jongkind* (Paris, 1932); J. B. Zwartendijk in *Rotterdams Jaarboek,* 1934; W. Hennus, *J. B. Jongkind* (Amsterdam, n.d.); Carla Gottlieb, "Observations on Johan-Barthold Jongkind as a Draughtsman," *Master Drawings,* vol. 5, no. 3 (1967), pp. 296–303; Carla Gottlieb, "Jongkind and the Salon of 1852," *The Burlington Magazine,* vol. 109, no. 773 (August 1967), pp. 458–61; Carla Gottlieb, "Johan-Barthold Jongkind and the Views of Old-Antwerp," in *Jaarboek, Koninklijk Museum voor Schone Kunsten,* 1967, pp. 277–84; Carla Gottlieb, "Johan-Barthold Jongkind à l'Exposition Générale de Bruxelles en 1854," *Bulletin, Musées Royaux des Beaux-Arts de Belgique,* 1969, pp. 149–56; Victorine Hefting, *Jongkind d'après sa correspondance* (Utrecht, 1969); Victorine Hefting, *Jongkind: Sa vie, son oeuvre, son époque* (Paris, 1975); Smith College Museum of Art, Northampton, Mass., *Jongkind and the Pre-Impressionists: Painters of the Ecole Saint-Siméon,* October 15–December 5, 1976, and Sterling and Francine Clark Art Institute, Williamstown, Mass., December 17, 1976–February 13, 1977; Pieter Scheen, *Lexicon: Nederlandse Beeldende Kunstenaars, 1750–1880* (The Hague, 1981), p. 253.

For additional works by Jongkind in the Philadelphia Museum of Art, see John G. Johnson Collection cat. nos. 1013, 1012.

47 JOHAN BARTHOLD JONGKIND *THE PORT OF HONFLEUR AT EVENING,* 1863
 Signed lower right: *Jongkind 1863*
 Oil on canvas, 16½ x 22¼" (42 x 56.5 cm.)
 The William L. Elkins Collection. E24-3-76

Three sailing ships ride at anchor on the left in the shallows of a harbor viewed against a twilit sky. In the distance at the far left and right are lighthouses and other buildings. In the lower right and farther back in the middle distance are fishermen in small boats casting wide, tent-shaped nets.

Jongkind first visited the Normandy coast in 1850, and from 1862 to 1866 spent his summers in Le Havre and Honfleur. Having abandoned a plan to travel in the region around Nevers, Jongkind wrote to his friend the painter Eugène Boudin (1824–1898) on August 13, 1863, asking him to find lodgings in Honfleur.[1] Jongkind arrived on August 25 and moved into a house at 31 rue Dupuits. While at Honfleur he painted and drew views of the town and its port, including the present work in which several boats lie anchored at low tide near the lighthouses at the mouth of the harbor. Other views of the port also dated 1863 are found in the Toledo Museum of Art[2] and a private collection;[3] the latter employs a similar composition. Many other paintings, drawings, and etchings from these years include the lighthouses and employ nearly the same point of view from the jetty at Honfleur, although most are scenes at high tide.[4] The present work remained in the artist's possession until his death, when it figured in the posthumous sale of his estate.

NOTES

1. Victorine Hefting, *Jongkind d'après sa correspondance* (Utrecht, 1969), p. 138, letter no. 187.
2. Signed and dated, oil on canvas, 13⅛ x 18¼" (33.3 x 46.3 cm.), no. 50.71; Victorine Hefting, *Jongkind: Sa vie, son oeuvre, son époque* (Paris, 1975), no. 271.
3. Signed and dated, oil on canvas, 13 x 18⅛" (33 x 46 cm.); Hefting (see note 2), no. 270.
4. See Hefting (note 2), nos. 275, 282, 295, 296, 315, 318, 319, 341, 343, 346, 352, 354, 365, 368, 384, and 386.

PROVENANCE: Sale, Jongkind, December 7–8, 1891, lot 7; William L. Elkins Collection, Philadelphia, by 1900.

LITERATURE: Elkins 1887–1900, vol. 1, no. 29, repro.; PMA 1965, p. 36; Victorine Hefting, *Jongkind: Sa vie, son oeuvre, son époque* (Paris, 1975), no. 269, repro.

CONDITION: The painting has an aqueous lining. Several old losses in the paint film in the sky at the upper left and center right have been retouched in pink paint that does not match the original colors. The varnish is dull and moderately discolored.

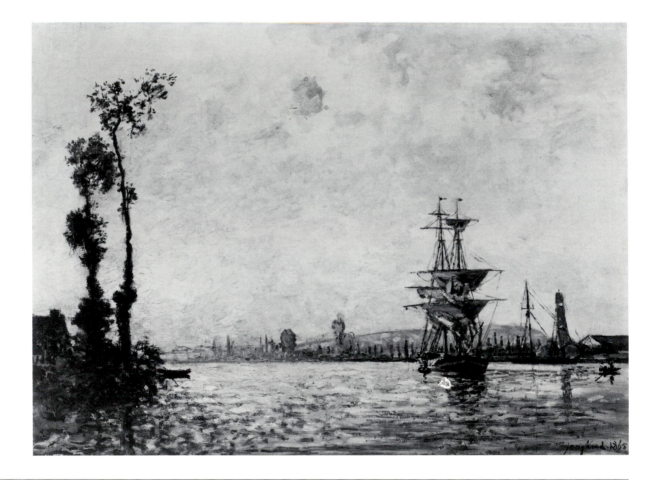

48 JOHAN BARTHOLD JONGKIND

THE SEINE NEAR ROUEN, 1865
Signed and dated lower right: *Jongkind 1865*
Oil on canvas, 20 x 28¾" (50.8 x 73 cm.)
Gift of Lucie Washington Mitcheson in memory of Robert Stockton Johnston Mitcheson. 38-22-8

FIG. 48-1 Copy after Johan Barthold Jongkind, *Sunset on the Scheldt,* signed and dated 1865, oil on canvas, 21¼ x 28¾" (54 x 73 cm.), The Metropolitan Museum of Art, New York, no. 06.1284, Gift of George A. Hearn, 1906.

In a river scene two very tall trees, a house, and a rowboat on the bank form a repoussoir on the left. On the right are two large sailing vessels, one with its sails partially raised. The far shore recedes diagonally from right to left and is studded with a row of poplars and other trees. In the distance appears a low, dome-shaped mountain.

Jongkind dated several views of the Seine near Rouen in 1865,[1] and in December of the previous year he inscribed a watercolor of a similar scene to his friend and patron Théophile Bascle, a Bordeaux collector.[2] The present work exists in at least one other version (fig. 48-1) now in the Metropolitan Museum of Art, New York, which may be identical with Hefting's number 334, listed as being in a private collection.[3] The Philadelphia painting is considerably fresher than the painting in New York; since Jongkind almost always changed elements when he executed versions, it is likely that the New York painting is a copy.

NOTES

1. Signed and dated, oil on canvas, 9½ x 12½" (24 x 32 cm.), private collection (see Victorine Hefting, *Jongkind: Sa vie, son oeuvre, son époque* [Paris, 1975], no. 335); and another, signed and dated, oil on canvas, 16 x 21½" (40.5 x 54.5 cm.), private collection (Hefting no. 336).
2. Signed and dated, watercolor on paper, 8¼ x 15" (21 x 38 cm.), private collection; Hefting (note 1), no. 305. Inscribed: "Navire de Rouen à monsieur Bascle par son ami Jongkind, Paris 31 déc. 1864."
3. Oil on canvas, dimensions given as 21¼ x 26¾" (54 x 68 cm.); Hefting (see note 1), repro. p. 164, no. 334.

PROVENANCE: Robert Stockton Johnston Mitcheson.

LITERATURE: PMA 1965, p. 36.

CONDITION: The painting is lined with fabric and wax-resin adhesive. The tacking edges are missing. The original canvas is beginning to separate from its lining. Some paint loss is evident in two gouges along the upper-left edge and in other minor damages. A network of age crackle with some associated cupping occurs throughout. Traction crackle is evident in the looser brushstrokes of the sky near the trees. The varnish is discolored and uneven.

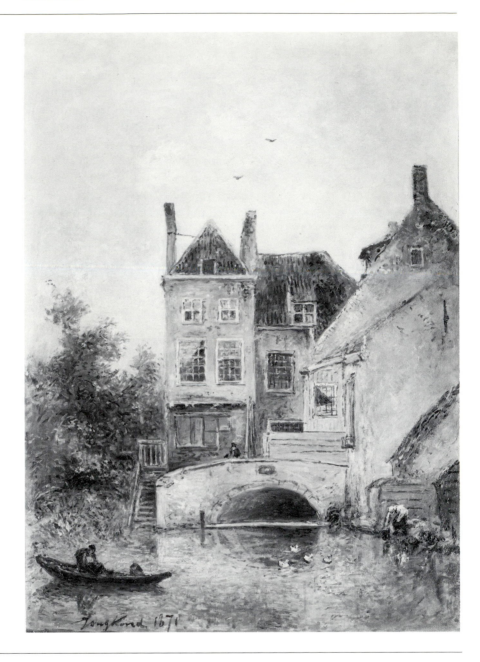

49 JOHAN BARTHOLD JONGKIND

THE ARTIST'S HOUSE IN MAASSLUIS, 1871
Signed and dated lower left: *Jongkind 1871*
Oil on canvas, 18¼ x 13½″ (46.4 x 34.3 cm.)
The William L. Elkins Collection. E24-3-84

Two tall, brightly colored houses with steeply pitched, tiled roofs are seen along the bank of a canal. A figure appears in a narrow boat at the left, and a woman draws water at the right. In the center are ducks.

The location of the scene is identified by an inscription branded into the stretcher: "Etude avec maisons à Maassluis, Holland." Thirty-two years prior to this painting, when his widowed mother was probably living in the house seen on the left, Jongkind executed a watercolor (fig. 49-1) of virtually the same scene.[1] In addition to small architectural changes made on the far right in the painting, he added a man in a boat on the left, a man in a top hat on the bridge, and a woman and ducks on the right. Jongkind

FIG. 49-1 Johan Barthold Jongkind, *View of Houses in Maassluis,* signed and dated 1839, watercolor on paper, 14 x 11½″ (35.5 x 29 cm.), private collection, The Netherlands.

subsequently inherited this house. The artist's scenes of Holland evidently were popular in the year in which he dated this painting. Complaining of the noisy fighting during the Paris Commune, in a letter to Jules Fesser dated July 12, 1871, Jongkind wrote, "I have been able to sell my paintings, and I'm being asked for others, above all views of Holland."[2] Jongkind often referred to earlier watercolors for inspiration. He wrote of this working method to the Belgian artist Eugène Smits (1826–1912) in 1856: "I made watercolors [from nature] and from them I have made my paintings."[3] In all likelihood he turned to his earlier works in 1871 to satisfy the new demand for Dutch views. However, Jongkind is known to have dated works long after they were painted, thus presenting problems of dating.

The Paris collector Charles de Bériot, who first owned this work, began to collect the artist's paintings in 1874.

NOTES

1. Signed, dated, and inscribed: "Maasluis Hollande Jongkind 1839" (see Victorine Hefting, *Jongkind: Sa vie, son oeuvre, son époque* [Paris, 1975], repro. p. 61, no. 2).
2. Author's translation from Hefting (note 1), p. 368.
3. Quoted by Charles Cunningham in Smith College Museum of Art, Northampton, Mass., *Jongkind and Pre-Impressionists: Painters of the Ecole Saint-Siméon,* October 15–December 5, 1976, and Sterling and Francine Clark Art Institute, Williamstown, Mass., December 17, 1976–February 13, 1977, p. 45.

PROVENANCE: Charles de Bériot, Paris; William L. Elkins Collection, Philadelphia, by 1900.

EXHIBITIONS: Galerie Durand-Ruel, Paris, 1899, no. 104; Smith College Museum of Art, Northampton, Mass., *Jongkind and Pre-Impressionists: Painters of the Ecole Saint-Siméon,* October 15–December 5, 1976, and Sterling and Francine Clark Art Institute, Williamstown, Mass., December 17, 1976–February 13, 1977, no. 14.

LITERATURE: Elkins 1887–1900, vol. 1, no. 28, repro.; PMA 1965, p. 36; Victorine Hefting, *Jongkind: Sa vie, son oeuvre, son époque* (Paris, 1975), no. 554.

CONDITION: The canvas support was lined with a fiberglass fabric and wax resin. In 1977 a second layer of fiberglass fabric was attached with wax resin for additional support. Inpainting covers small paint losses in the sky at the upper left and right; otherwise, the paint is in good condition. The varnish remains colorless, having been applied in 1977.

50 ATTRIBUTED TO *NOCTURNAL LANDSCAPE WITH DRAWBRIDGE*
 JOHAN BARTHOLD JONGKIND Signed (falsely?) lower right: *Jongkind*
 Oil on canvas, 18¹⁄₁₆ x 21¾″ (45.9 x 55.2 cm.)
 Gift of Lucie Washington Mitcheson in memory of Robert Stockton
 Johnston Mitcheson. 38-22-7

In a nocturnal scene illuminated by moonlight, a canal curves back from
the lower left to the right center, where an open drawbridge appears
silhouetted against the sky. On the bank at the right are trees, a footpath,
and figures with a fisherman. On the far side of the canal are a barge and a
smaller boat with figures. Behind them on the shore is a group of houses
nestled among the trees.

 Although Jongkind often painted drawbridges and executed several
nocturnal scenes in the late 1850s,[1] weaknesses in the form and execution
of this painting raise doubts about its attribution. Among the artists who
painted in Jongkind's style, Stanislas Lépine (1835–1892) produced nocturnes
that bear some resemblance to this work.[2]

NOTES
1. Compare the following paintings dated 1857: oil on canvas, 16¾ x 21¾″ (42.5 x 55 cm.), Rijksmuseum, Amsterdam, no. A2300 (see Victorine Hefting, *Jongkind: Sa vie, son oeuvre, son époque* [Paris, 1975], no. 163); oil on canvas, 8¾ x 13″ (22 x 32.8 cm.), private collection (Hefting no. 162); oil on canvas, 16½ x 22″ (42 x 56 cm.), Petit Palais, Paris (Hefting no. 168); and, dated 1858, oil on canvas, 16½ x 22″ (42 x 56 cm.), private collection (Hefting no. 184).
2. Compare *Moonlit River,* signed S. Lépine, oil on canvas, 9½ x 12⅞″ (24.1 x 32.7 cm.), Sterling and Francine Clark Art Institute, Williamstown, Mass., inv. no. 789.

PROVENANCE: Purchased by Dr. Robert Stockton Johnston Mitcheson from the Howard Young Galleries.

LITERATURE: John Canaday, *Mainstreams of Modern Art* (New York, 1959), p. 223, repro.; PMA 1965, p. 36.

CONDITION: The unlined fabric support is brittle and slack on its stretcher. The craquelure reveals prominent stress cracks, including stretcher bar creases, with associated cupping. The varnish is moderately discolored and the surface gloss is uneven.

51 COPY AFTER JACOB JORDAENS

THE INFANT JUPITER FED BY THE GOAT AMALTHEA
Oil on canvas, 38¾ x 46″ (98.4 x 116.8 cm.)
The Bloomfield Moore Collection. 89-79

FIG. 51-1 Jacob Jordaens, *The Infant Jupiter Fed by the Goat Amalthea*, black chalk, pen, and brown wash, heightened with white, 14½ x 18⅛″ (37 x 46 cm.), The Hermitage, Leningrad, inv. no. 4200.

The infant Jupiter lies on his back drinking from the udder of the goat Amalthea. A seated nymph holds the goat around the neck and a satyr lifts up the animal's hind legs to aid the god in drinking. Behind in the center another satyr plays a tambourine. On the right a young woman holding a brass milk jug leans cross-legged and with head in hand against a tree. At the left another goat appears and in the lower left-hand corner are a ceramic pitcher, a bowl, and a large gourd.

This work is a copy of a lost original by Jacob Jordaens (1593–1678) known through an original drawing in the Hermitage, Leningrad (fig. 51-1),[1] and a painted studio replica in the museum in Kichinev, USSR[2] (formerly in the collection of Prince Rupert of Bavaria),[3] as well as a fourth version whose present location is unknown.[4] The lost original shared motifs with other paintings and prints by Jordaens of this subject.[5] For example, the infant god lying on his back beneath the goat reappears in a similar pose in the engraving of 1652 attributed to Jordaens, and the girl on the right reappears in one of the two versions of this theme in Kassel (fig. 51-2).[6]

Clearly one of Jordaens's favorite themes, the subject of the infant Jupiter fed by Amalthea could be interpreted morally; on a print by Schelte à Bolswert after Jordaens (which closely resembles the painted version of the theme in the Louvre; fig. 51-3) there appears the warning inscription, "Is

it to be wondered at that Jupiter yields to the power of love and strays into forbidden beds? Here he is being reared on goat's milk among satyrs: he has imbibed the goat's [lascivious] nature and is led by it."[7]

FIG. 51-2 Jacob Jordaens, *Jupiter and Amalthea*, 1640, oil on canvas, 86¼ x 117" (219 x 297 cm.), Kassel Gemäldegalerie, no. 103.

FIG. 51-3 Jacob Jordaens, *Jupiter and Amalthea*, oil on canvas, 58 x 80" (147 x 203 cm.), Musée du Louvre, Paris, no. 1405.

FIG. 51-4 Jacob Jordaens, *The Education of Jupiter* (fragment), oil on canvas, 52 x 27½" (132.2 x 69.7 cm.), Ackland Art Museum, The University of North Carolina, Chapel Hill, no. 79.13.1.

NOTES

1. R.-A. d'Hulst (in *Jordaens Drawings,* translated by P. S. Falla [Belgium, 1974], vol. 1, no. A139, vol. 3, no. 152, repro.) agreed with Leo van Puyvelde (in *Jordaens* (Paris and Brussels, 1953), pp. 110, 181) that it was a modello for a lost painting; however, Michael Jaffe (in The National Gallery of Canada, Ottawa, *Jacob Jordaens, 1593–1678,* November 29, 1968–January 5, 1969, p. 193, no. 209) considered it a "*modellotto,* with numerous *pentimenti,* for an engraving which was not executed."

2. Oil on canvas, 34¾ x 48" (88 x 122 cm.), inv. no. 340, formerly in the museum at Lódz, Poland (inv. no. 1491) and later removed by the Germans in 1944–45; see Van Puyvelde (note 1), p. 110. This painting, according to D'Hulst (see note 1), p. 231, contains an additional satyr on the right in intimate conversation with the woman holding the jug.

3. Photograph Witt Library, London, without further information.

4. See Andor Pigler, *Barockthemen,* vol. 3 (Budapest, 1974), pl. 212, incorrectly as in the museum in Antwerp (Erik Vandamme of the Koninklijk Museum voor Schone Kunsten assures that his institution never owned this work). This version eliminates the girl with the milk can, adds a satyr on the right, includes more landscape, and apparently has a slightly arched top.

5. For paintings, see Kassel Gemäldegalerie, *Amtliches Verzeichnis der Gemälde, Cassel Gemäldegalerie* (Berlin, 1929), no. 103 (fig. 51-2) and no. 104 (1640, oil on canvas, 58 x 68" [147 x 173 cm.], which, according to R.-A. d'Hulst, *Jacob Jordaens* [London, 1982], p. 335 n. 47, is merely a copy of a lost work of which only the fragment of the infant Jupiter survives: fig. 51-4; see also Arnauld Brejon de Lavergnée, Jacques Foucart, and Nicole Reynaud, *Catalogue sommaire illustré des peintures du Musée du Louvre: Ecoles flamande et hollandaise* (Paris, 1979), p. 77, no. 1405, repro. (fig. 51-3); see D'Hulst (in *Jacob Jordaens*), p. 155, who believes that this is the earliest version, dating from about 1630–35. For prints see F.W.H. Hollstein, *Dutch and Flemish Etchings, Engravings, and Woodcuts,* vol. 9 (Amsterdam, 1949), pp. 225, 227, no. 5 [as Jordaens? signed and dated 1652] and no. 8 [as S. à Bolswert, after Jordaens], and also Jaffe (see note 1), pp. 402, 408, repro. nos. 288, 300. For discussion of Jordaens's treatment of these themes, see Van Puyvelde (note 1), pp. 109–11.

6. Hollstein (see note 5), no. 5; Kassel Gemäldegalerie (see note 5), no. 103.

7. Translated by D'Hulst (see note 5), p. 155. The Latin text reads: "Quid mirum natura Jovis si cedat Amori / Et vaga per thalamos ambulet illicitos. / Ecce inter Satyros nutritur lacte caprino, / Naturam capreae suxerat et sequitur."

PROVENANCE: Possibly sale, Amsterdam, September 10, 1798 [as Jacob Jordaens: "Jupiter and Amalthea, with several nymphs and satyrs," canvas, 38 x 48" (96.5 x 121.9 cm.)]; The Bloomfield Moore Collection.

LITERATURE: Possibly Max Rooses, *Jordaens: His Life and Work,* translated by Elisabeth C. Broers (London, 1908), p. 259 (reference to the otherwise unidentified painting in the 1798 sale mentioned above).

CONDITION: The painting is lined with an aqueous adhesive. The lining canvas comprises two pieces of linen, seamed vertically left of center. There is a 3" (7.6 cm.) square patch on the lining fabric, which relates to a dent seen from the front. The stretcher's vertical cross member is broken in the center and mended with wire. The paint film shows numerous scattered losses, extensive cupping, and some active flaking, especially in the darks. Discolored retouches are found in the figures and in the various old losses throughout. The varnish is very dull, discolored, and abraded by the frame at the edges.

LITERATURE: Thieme-Becker 1907–50, vol. 19 (1926), p. 590; Pieter Scheen, *Lexicon Nederlandse beeldende kunstenaars* (The Hague, 1981), p. 261.

Born in 1831 in The Hague, Johan was the brother and student of the genre painter Herman Frederik Carel ten Kate (1822–1891) and the father of the painter Johannes Marinus ten Kate (1859–1896). He studied at the art academy in The Hague and visited Paris before settling in Amsterdam, where he remained from 1857 to 1871. During the 1880s he lived in England and took study trips to the East Indies and the Dutch colonies. He died in Paris in 1910. Besides landscapes, J.M.H. ten Kate painted genre scenes of children and family and maritime life.

52 JOHAN MARI HENRI TEN KATE

MOTHER AND TWO CHILDREN WITH GEESE, c. 1870–75
Signed lower right: *M Ten Kate*
Oil on canvas, 15½ x 21½" (39.4 x 54.6 cm.)
Gift of Walter Lippincott. 23-59-8

A woman seated on a rustic bench before a cottage holds a child, while an older boy leans over a fence. A goose with her goslings stands at the figures' feet, and the gander is to the left. The picture was given to the Museum with the title "The Two Mothers," either an original title or a latter-day sobriquet. Wrongly attributed to the artist's son in the 1965 *Check List of Paintings,* the picture closely resembles the numerous sentimental genre scenes executed by J.M.H. ten Kate.[1] Dating his works is problematic; however, the present picture seems to have been created about 1870–75.

NOTE
1. For examples, see Pieter Scheen, *Lexicon Nederlandse beeldende kunstenaars* (The Hague, 1981), figs. 301–3.

PROVENANCE: Walter Lippincott, Philadelphia.

LITERATURE: PMA 1965, p. 67 [as Johannes Marinus ten Kate].

CONDITION: The unlined canvas is slack, with corner draws and bulges. The paint film is intact. The surface coating is abraded at the edges from contact with the frame rabbet and is only slightly discolored.

53 CIRCLE OF THOMAS DE KEYSER

PORTRAIT OF A WOMAN, c. 1635
Oil on panel, octagonal, 14½ x 12½″ (36.8 x 31.8 cm.)
Bequest of John D. McIlhenny. 43-40-41

Viewed three-quarter length and holding a lace handkerchief, the sitter wears a subdued black and white costume with a millstone ruff and an embroidered stomacher. Such attire was fashionable in Holland, especially in Haarlem, around 1635.[1]

 C. Hofstede de Groot seems to have been the first to assign the painting to Thomas de Keyser (1596/97–1667),[2] the name under which it has always appeared while in Philadelphia. The picture is not mentioned in Rudolf Oldenbourg's 1911 monograph on the artist,[3] but it is catalogued among the rejected works by Ann Adams.[4] De Keyser painted small-scale portraits early in his career but reserved the three-quarter-length composition with the figure standing beside a table almost exclusively for life-size portraits.[5] Moreover, his technique is rarely as broad as that witnessed here.

 The style and portrait formula of the work are comparable to those of other painters of small-scale portraits who were active in the Amsterdam and Haarlem area in these years, above all Pieter Codde (1599–1678), Hendrick Gerritsz. Pot (before 1585–1657), and Willem Duyster (1598/99–1635).[6] A firm attribution, however, is not possible given the present state of research. Thus the work is assigned to that circle of portraitists, of whom De Keyser is the most renowned, who were active in Amsterdam and Haarlem around 1625–40.

NOTES

1. Ann Adams in a letter of January 19, 1982 (Philadelphia Museum of Art, accession files), compared the collar and cap to those worn by the women in Johannes Cornelisz. Verspronck's portraits of 1636 and 1637 (see R.E.O. Ekkart in Frans Halsmuseum, Haarlem, *Johannes Cornelisz. Verspronck,* September 15–November 25, 1979, nos. 7 and 13). See also Ann Adams, "The Paintings of Thomas de Keyser (1596/97–1667): A Study of Portraiture in 17th Century Amsterdam," 4 vols., diss., Harvard University, Cambridge, Mass., 1985, vol. 3, no. R-69, where she states, "The painting probably dates from 1635."

2. Letter of authentication dated August 1913 (see Philadelphia Museum of Art, accession files).

3. Rudolf Oldenbourg, *Thomas de Keysers Tätigkeit als Maler* (Leipzig, 1911).

4. Adams (see note 1), no. R-69.

5. See De Keyser's *Portrait of Anna Hunthume,* dated 1637, Dienst Verspreide Rijkskollekties, The Hague, no. NK2083 (on loan to the Stedelijk Museum, Gouda) and *Portrait of a Woman* in the Musée Massey, Tarbes (see Musée du Petit Palais, Paris, *Le Siècle de Rembrandt,* November 17, 1970–February 15, 1971, no. 124, repro.); compare also the De Keyser portrait in the Oppenheim sale, Rudolph Lepke Gallery, Berlin, October 27, 1914, lot 23, repro. Adams, in her 1982 letter (see note 1), noted that full-length compositions or those without a table are more typical of De Keyser. She further asserted that the *Portrait of Petronella Witsen* in the Six Collection, Amsterdam, which invites comparison with the Philadelphia painting because of its small scale (13¾ x 10¼" [35 x 26 cm.], eight-sided panel), is incorrectly attributed to De Keyser.

6. Adams (1982 letter, see note 1) compared the treatment of the sitter in the Philadelphia painting to the seated woman in Willem Duyster's signed *Wedding Feast,* oil on panel, 30 x 42" (76 x 106.5 cm.), Rijksmuseum, Amsterdam, no. C514. Another work with a technique not unlike that of the Philadelphia portrait is the unattributed *Portrait of a Girl,* oil on panel, 17 x 13¾" (43 x 35 cm.), The Metropolitan Museum of Art, New York, no. 1971.186. Compare also the small oval *Portrait of a Woman,* copper, 5¾ x 5" (14.5 x 12.5 cm.) of 1629 in the Rijksmuseum, Amsterdam, no. A1792, formerly assigned to Pieter Codde and now tentatively attributed to Willem Duyster.

PROVENANCE: Mannheim sale, Georges Petit, Paris, March 14, 1913, lot 8 [as Dutch seventeenth century]; purchased from dealers Boehler and Steinmeyer, New York, by John D. McIlhenny, Philadelphia, 1914.

LITERATURE: *The Pennsylvania Museum Bulletin* (Philadelphia Museum of Art), vol. 21, no. 100 (February 1926), p. 91 [as Thomas de Keyser]; *The Philadelphia Museum Bulletin* (Philadelphia Museum of Art), vol. 39, no. 200 (January 1944), pp. 54, 59, repro. p. 56 [as Thomas de Keyser, 1625]; PMA 1965, p. 37 [as Thomas de Keyser]; Ann Adams, "The Paintings of Thomas de Keyser (1596/97–1667): A Study of Portraiture in 17th Century Amsterdam," 4 vols., diss., Harvard University, Cambridge, Mass., 1985, vol. 3, no. R-69.

CONDITION: The uncradled, vertically grained panel support is in good condition. Two small checks run vertically along the right side. Some abrasion is apparent in the relatively thin paint film. A large area to the left of the sitter's head is retouched. Small losses associated with the grain of the panel in the sitter's face and ruff exhibit discolored inpainting. The darker passages show traction crackle. The varnish is moderately discolored.

LITERATURE: Willigen (1870) 1970, pp. 195–97; Wurzbach 1906–11, vol. 1, p. 301; C. Hofstede de Groot in Thieme-Becker 1907–50, vol. 21 (1927), pp. 45–46; Laurens J. Bol, *Holländische Maler des 17. Jahrhunderts nahe den grossen Meistern: Landschaften und Stilleben* (Brunswick, 1969), pp. 176, 186, 287.

Born in Wesel to a Haarlem family around 1607, Knijff first appears in Haarlem records in 1639. The following year he was a member of the Reformed Church and joined the Guild of Saint Luke. He had a student, Pieter Joosten, in Haarlem in 1642. In 1644, 1646, 1647, 1653, and 1679 he held picture auctions and in 1648 sold what evidently was a dubious work by Adriaen Brouwer (1605/6–1638). After the death of his first wife, Gerritge Jans van Houten, widow of Jac. Bas, he married Lydia Leenaertsdr. of Delft, who was buried in Haarlem in 1679. In 1650 he received thirty-five guilders for two paintings that he had delivered to the Old Men's Home in Haarlem. In 1663 he was living on the Groote Houtstraat and was again mentioned in Haarlem in 1668. In view of the numerous references to the artist in Haarlem, it is unlikely, though possible, that he was identical with the painter of this name who was a member of the Middelburg painters' guild in 1652 and 1653. In 1675 Knijff was portrayed as one of the governors of the Guild of Saint Luke in Haarlem in a group portrait by Jan de Bray (oil on canvas, 51¼ x 72½" [130 x 184 cm.], Rijksmuseum, Amsterdam, no. A58). He was still alive in Bergen op Zoom at the age of eighty-six when, in 1693, his son Leendert (1650–1721), a still-life painter, visited him from London. Wouter's sons Willem and Jacob were also painters.

In a list of Haarlem painters assembled by Vincent Laurensz. van de Vinne (1629–1702), the compiler wrote beside Knijff's name "als van Goyen, bijzonder eveneens" ("like Van Goyen, whose work his resembles very much"). The majority of Knijff's landscapes do indeed resemble the "tonal" paintings of Jan van Goyen and Salomon van Ruysdael (qq.v.), but at times also show similarities with works by Jacob van Ruisdael (q.v.) and the young Aelbert Cuyp (1620–1691).

54 WOUTER KNIJFF

RIVER SCENE WITH A BARGE AND A LIMEKILN, 1640s
Possible remnants of a signature or monogram, lower left on the piling
Oil on canvas, 29⅞ x 41½" (75.9 x 105.4 cm.)
Purchased for the W. P. Wilstach Collection. W02-1-20

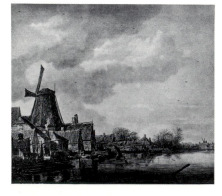

FIG. 54-1 Wouter Knijff, *Canal Scene*, signed and dated 1644, oil on canvas, 37 x 41¼" (94 x 105 cm.), formerly Museum der bildenden Künste, Leipzig, no. 507 (lost World War II).

At the center of the scene, a large barge with sails raised and flying the Dutch flag floats on a river receding from left to right. On the shore are wooden buildings, trees, and, at the left, a limekiln made of brick. Two additional barges are moored at the right. The sky is gray and overcast.

The picture was attributed to Jacob van Ruisdael (q.v.) until Horst Gerson reassigned it to Wouter Knijff in his 1934 review of the books on Ruisdael by Kurt Simon and Jakob Rosenberg.[1] The coarse, painterly treatment of the buildings recalls early works by Ruisdael, such as his *View of Egmond aan Zee*[2] and certain paintings by other Ruisdael followers such as Jan van Kessel (1640/41–1680), but the painting is still closer to works by Knijff from the 1640s. The latter's *Canal Scene* of 1644 (fig. 54-1)[3] employs virtually the same technique in the houses and the trees and a similar diagonally receding composition.[4] The resemblance to the design of the canal scene would be even greater were it not for the fact that the Philadelphia painting was probably cut at the right and possibly also at the top. Doubtless the river and far shore continued to recede, enhancing the spatial effect.

NOTES

1. Kurt Erich Simon, *Jacob van Ruisdael: Eine Darstellung seiner Entwicklung* (Berlin, 1930); Jakob Rosenberg, *Jacob van Ruisdael* (Berlin, 1928); Horst Gerson, "The Development of Ruisdael," *The Burlington Magazine,* vol. 65, no. 376 (July 1934), p. 79.

2. Monogrammed and dated painting of 1646, oil on canvas, 37¾ x 52″ (96 x 132 cm.), A. F. Philips Collection, Eindhoven.

3. Repro. in Walther Bernt, *Die Niederländischen Maler des 17. Jahrhunderts,* vol. 2 (Munich, 1948), no. 455.

4. Compare also Knijff's signed river and canal landscapes: *Ramparts Beside a River,* dated 1643, oil on panel, 15½ x 23¾″ (39.5 x 60 cm.), Frans Halsmuseum, Haarlem (see Laurens J. Bol, *Holländische Maler des 17. Jahrhunderts nahe den grossen Meistern: Landschaften und Stilleben* [Brunswick, 1969], fig. 179); *Canal with Boat and Windmill,* monogrammed and dated 1647, oil on panel, 19⁹⁄₁₆ x 25³⁄₁₆″ (49 x 64 cm.), sale, Dorotheum, Vienna, September 23, 1987, lots 420 and 421 *(Canal with Walled Tower,* oil on panel, 18⅛ x 24⁷⁄₁₆″ [46 x 62 cm.]), repros.; sale, Lempertz, Cologne, November 20, 1975, lots 109 (oil on panel, 12¾ x 16¾″ [32.5 x 42.5 cm.]) and 110 (oil on panel, 15¾ x 19¾″ [38.5 x 50 cm.]), repros.; and sale, Christie's, New York, January 9, 1981, lot 159, repro.

PROVENANCE: Purchased for the W. P. Wilstach Collection, Philadelphia, October 15, 1902.

LITERATURE: Wilstach 1903, no. 158 [as Jacob van Ruisdael and hereafter], 1904, no. 215, 1906, no. 238, 1907, no. 251, 1908, no. 251, 1910, no. 348; Hofstede de Groot 1908–27, vol. 4 (1912), no. 194 [as Jacob van Ruisdael]; Wilstach 1913, no. 363 [as Jacob van Ruisdael], 1922, no. 271 [as Jacob van Ruisdael and signed with monogram]; Jakob Rosenberg, *Jacob van Ruisdael* (Berlin, 1928), p. 79, no. 118 [as Jacob van Ruisdael but not seen by author]; Horst Gerson, "The Development of Ruisdael," *The Burlington Magazine,* vol. 65, no. 376 (July 1934), p. 79 [as Wouter Knijff]; PMA 1965, p. 60 [as Jacob van Ruisdael].

CONDITION: The fabric support is slack in its stretcher and brittle. It is probable that the painting survives only as a fragment. Retouched losses in the paint film clearly indicate that a vertical stretcher member once appeared well to the right of the center of the canvas (13⅜″ [34 cm.] from the right edge). Furthermore, the scalloping in the weave of the canvas along the left edge is not repeated at the right. This evidence suggests that the work almost certainly was cut at the right, perhaps by as much as 13″ (33 cm.). Given the proportions of Knijff's other river scenes (see fig. 54-1), it also seems possible that the picture was cut at the top. No original tacking edges remain. The paint film is extensively abraded in the sky, the kiln, and the central barge and its shadow. Old losses appear throughout. Fine cupping and flake losses occur in the darks. Fills and patches of discolored repaint are visible in the sky, the boat's sail, the rooftop behind, and along the stretcher mark at the lower right. Markings on a piling at the lower left may indicate remnants of a signature or monogram, which is no longer decipherable. The varnish is dull and moderately discolored.

LITERATURE: Thieme-Becker 1907–50, vol. 21 (1927), p. 129; Pieter Scheen, *Lexicon Nederlandse beeldende kunstenaars* (The Hague, 1981), p. 278.

A member of a well-known family of landscape and marine painters, Willem Koekkoek was the son and pupil of Hermanus Koekkoek (1815–1882), the nephew of the highly regarded landscapist Barend Cornelis Koekkoek (1803–1862), and the grandson of Johannes Hermanus Koekkoek (1778–1851). He was active in Amsterdam and visited London in 1888. His works were exhibited in Vienna and Munich, as well as in Holland. Active primarily as a landscapist, he also executed cityscapes and architectural views that often resemble the works of Cornelis Springer (1817–1891).

55 WILLEM KOEKKOEK

STREET SCENE
Signed lower right: *W. Koekkoek*
Oil on canvas, 23¾ x 17¾" (60.3 x 45 cm.)
Gift of Walter Lippincott. 23-59-12

FIG. 55-1 Willem Koekkoek, *Cityscape with a Canal,* signed, oil on canvas, 21 x 26¾" (53 x 68 cm.), sale, Sotheby Parke Bernet, London, June 13, 1973, lot 142.

A narrow paved street with brick buildings in a Dutch town stretches diagonally from left to right. In the distance a church spire rises above buildings on a second street running perpendicularly to the first. Various staffage figures and animals populate the roadway, including a boy with a dog, a girl holding a broom, a man with a barrow, and, before a house dated 1604 on the facade, a man doffing his hat to a woman.

Willem Koekkoek painted numerous street scenes, following in the tradition of seventeenth-century Dutch cityscapists such as Job Berckheyde (1630–1693), his brother Gerrit Adriaensz. Berckheyde (1638–1698), and Jan van der Heyden (1637–1712), and their late eighteenth- and nineteenth-century descendants such as Wouter van Troostwijk (1782–1810), Bart van Hove (1790–1880), Cornelis Springer (1817–1891), and Jan Wiessenbruch (1822–1880). Among Koekkoek's works are actual views in Amsterdam, Breda, Enkhuizen, Haarlem, Hoorn, Leiden, Oudewater, Rotterdam, and Woudrichem. A large number of his cityscapes, however, are imaginary views. The present picture was given to the Museum and catalogued in 1965 as a "Street Scene in Utrecht," but this identification is surely wrong, since no such church spire has ever existed in that city. The rather blunt, segmented tower bears some resemblance to the church towers in the villages of Houten or Brielle,[1] but like two of his other pictures that seem to include variations on this structure (for example, fig. 55-1),[2] the view is almost certainly a product of the artist's imagination. The ultimate source for Koekkoek's design may be Gerrit Adriaensz. Berckheyde's scenes of the actual streets in Haarlem, but Koekkoek's seventeenth-century forerunners also mixed fact and fiction in their town views.[3]

NOTES

1. The Topographical Department at the Rijksbureau voor Kunsthistorische Documentatie, The Hague, provided these observations.
2. See also Koekkoek's street scene in sale, Mak van Waay, Amsterdam, June 5, 1973, lot 150, repro. (signed, oil on canvas, 23½ x 17" [59.5 x 43.5 cm.]).
3. On the Dutch nineteenth-century revival of their seventeenth-century predecessors generally, see Frans Halsmuseum, Haarlem, *Op zoek naar de Gouden eeuw: Nederlandse schilderkunst, 1800–1850,* September 20–November 30, 1986.

PROVENANCE: Walter Lippincott, Philadelphia.

LITERATURE: PMA 1965, p. 38.

CONDITION: The painting is in fair condition, lined with an aqueous adhesive. The corners are buckling. The bottom edge has stress cracks and one old flake loss, which has been retouched without fill. There are several prominent cracks in the sky that have discolored retouches. The paint film is generally in a good state; however, the edges have suffered from cracking and minor abrasions. The picture was surface cleaned and revarnished in 1968. The varnish is slightly discolored.

Born in Erding on January 29, 1852, Kraus attended the academy in Munich. Principally a painter of humorous genre scenes of life in the cloisters in the style of Eduard Grützner (1846–1878), he also executed country scenes and still lifes. His works were popularized by postcard reproductions. Kraus is not to be confused with the nineteenth-century German sculptor of the same name (b. 1868).

LITERATURE: Thieme-Becker 1907–50, vol. 21 (1927), p. 444.

56 AUGUST KRAUS

TIRED OUT
Signed lower left in script: *August Kraus*
Oil on canvas, 20¾ x 18″ (52.7 x 45.7 cm.)
Gift of Walter Lippincott. 23-59-2

In a wood-paneled interior with a mullioned window, a bearded monk has fallen asleep in an armchair while reading a large Bible. Typical of Kraus's scenes of monastic life, this mild and slightly comical picture has little of the satirical bite that characterizes the fiercely anticlerical tradition of some nineteenth-century genre scenes, in which monks are depicted as lazy and libidinous. As with many other works by Kraus, it is close to Eduard Grützner's sentimental images of fat friars, where, however, sleep is usually brought on by strong drink.

PROVENANCE: Walter Lippincott, Philadelphia.

LITERATURE: PMA 1965, p. 38.

CONDITION: The fabric support is wax-resin lined. The heavy craquelure of the paint film is accompanied by extensive cupping. Minor paint losses are scattered throughout. The varnish layer is moderately discolored.

Born to a family of artists in Liège, Gérard de Lairesse was the son and pupil of Renier de Lairesse (c. 1597–1667). From 1655 onward he studied with Bertholet Flémalle (1614–1675), whose large and dramatically conceived history paintings influenced his early works. Early in his career Lairesse received commissions from the Jesuits and other ecclesiastical authorities in Liège and Aachen and from the elector of Brandenburg. Following a love affair involving a broken marriage contract, Lairesse was forced to leave Liège in 1664. He traveled to 's Hertogenbosch and Utrecht, arriving in Amsterdam by April 1665. There he worked for the art dealer and in-law of Rembrandt, Gerard van Uylenburgh, and soon won important patrons. In 1667 he acquired official citizenship in Amsterdam.

Known in intellectual and literary circles, Lairesse played an important role in the society "Nil Volentibus Arduum" ("Nothing is difficult for those who try") formed in 1669. From 1676 onward the society met regularly in Lairesse's house. An accomplished etcher, Lairesse provided illustrations and title pages for publications by the society's members. He also executed drawings for the famous anatomy book by Govert Bibloo published in Amsterdam in 1685. As a painter, he was most highly regarded for his large-scale decorative works. Probably the first Dutch artist to cover wooden ceilings with painted canvas, Lairesse painted the earliest surviving example (now preserved in the Peace Palace, The Hague) for the new house of the Amsterdam burgomaster in 1672. In 1675 he also painted ceiling decorations for the Leprozenhuis in Amsterdam (oil on canvas, now on loan to the Rijksmuseum, Amsterdam, no. C 382). Between 1675 and 1683, Lairesse painted a series of five grisailles (oil on canvas, now in the Rijksmuseum, Amsterdam, nos. A4174–78) for the entrance hall of the house Messina on Amsterdam's Herengracht, then owned by the Mennonite textile magnate and collector Philips de Flines. Moving to The Hague in 1684, Lairesse became a member of "Pictura" and was commissioned by the States General in about 1688 to paint seven large murals with subjects from mythology and ancient Roman history for the chambers of the Court of Justice in The Hague. Arnold Houbraken mentioned a painted room in the house of Philips's nephew, Jacob de Flines, in which Johannes Glauber (1646–1726) painted the landscape and Lairesse the figures. (These paintings, dating soon after 1684, are now preserved in Beeckesteijn, a manor house near Velzen.) On December 9, 1678, and at some later date, Lairesse was paid for painted decorations for the stadholder's country house Soestdijk. Six paintings from Soestdijk are known today. In 1686 Lairesse was paid for decorating organ doors (burned in 1722) for the Westerkerk in Amsterdam; and he is known to have designed stage sets, a candelabrum for the theater, and decorations for a coach. After 1690 problems with his eyesight prohibited major commissions, and he soon went totally blind. Thereafter Lairesse concentrated on lectures, which he later gathered and published with the help of his sons in the form of the treatise *Groot Schilderboeck* (Amsterdam, 1707), a codification of late seventeenth-century Dutch classicist art theory. Though his publications thus formed the basis of classical art theory in the Netherlands, Lairesse had no atelier or formal school. However, his sons Jan (b. 1674?) and Abraham (1666–1726/27) studied under him, and among Lairesse's pupils were Jacob van der Does the Younger (1623–1673), Ottmar Elliger the Younger

(1666–1735), Theodor Lubieniecki (1660/61–1724), Jan Hoogzaat (1654–1730), Philips Tidemann (1657–1705), Bonaventura van Overbeek (c. 1660–1706), and Jan van Mieris (1660–1690).

LITERATURE: Houbraken 1718–21, vol. 1 (1718), p. 284, vol. 2 (1721), pp. 106, 218, 328, 334, 368; Weyerman 1729–69, vol. 2, p. 405; Descamps 1753–64, vol. 3, pp. 253ff.; Immerzeel 1842–43, vol. 2, p. 150; Kramm 1857–64, vol. 3, pp. 932–35; Obreen (1877–90) 1976, vol. 2, p. 149, vol. 4, pp. 156, 222, 108; Louis Abry, *Les Hommes illustres de la nation liègeoise,* edited by H. Helbig and S. Bormans (Liège, 1867); Gustaf Upmark, "Ein Besuch in Holland 1687, aus den Reiseschilderungen des schwedischen Architecten Nicodemus Tessin," *Oud Holland,* vol. 18 (1900), pp. 117–28; Jules Helbig, *La Peinture au pays de Liège et sur les bords de la Meuse* (Liège, 1903), pp. 295ff.; Wurzbach 1906–11, vol. 2, pp. 6–8; Joachim von Sandrart, *Academie der Bau-, Bild- und Mahlerey-Künste von 1675,* edited by A. R. Peltzer (Munich, 1925), pp. 351, 364–66; M. D. Henkel in Thieme-Becker 1907–50, vol. 22 (1928), pp. 233–37; J.J.M. Timmers, *Gérard Lairesse* (Amsterdam and Paris, 1942); D. P. Snoep, "Gérard Lairesse als Plafond- en Kammerschilder," *Bulletin van het Rijksmuseum,* vol. 18 (1970), pp. 159–220; J. Hendrick, *La Peinture liègeoise du* XVIIe siècle (Gembloux, 1973); D. P. Snoep, *Praal en propaganda. Triumfalia in de Noordelijke Nederlanden in de 16de en 17de eeuw* (Alphen aan de Rijn, 1975); Musée de l'Art Wallon, Liège, *Le Siècle de Louis XIV au pays de Liège (1580–1723),* September–November 1975, pp. 99–104; D. P. Snoep, "Classicism and History Painting in the Late Seventeenth Century," in Blankert et al. 1980–81, pp. 237–44.

57 GÉRARD DE LAIRESSE

BACCHUS AND ARIADNE
Faintly signed lower left: *G. Lairesse*
Oil on canvas, 27 x 20″ (68.5 x 51 cm.)
Gift of Mrs. Edgar P. Richardson. 1986-83-1

Seated on a canopied bed, Ariadne looks heavenward as Bacchus throws her starred crown aloft. To the right a winged amor holds a thyrsus, Bacchus's symbol, and in the background Bacchus's entourage of revelers dance and carouse. The carved form of a sphinx supports Ariadne's bed in the lower left and a casket of pearls and other jewelry appears at the lower right.

This small canvas was executed by Lairesse either as a modello or more likely as a reduction of his large mural of the same subject (fig. 57-1) for the stadholder's country manor Soestdijk.[1] Lairesse received two payments for undescribed paintings for Soestdijk on December 9, 1678 (1,800 guilders) and a later unspecified date (500 guilders); six paintings, including the *Bacchus and Ariadne* now preserved in the Mauritshuis, appeared in the Soestdijk inventory of 1699–1712. In the inventory the painting was described as a "chimneypiece" from the "cabinet" ("Het cabinet. #28. Een stuk schilderij voor de schoorsteen"), where it hung with an overdoor also by Lairesse depicting Venus, Adonis, and Cupid, which was sold in 1828.[2] In support of the possibility that the smaller work may have been preparatory to the large mural, Philadelphia's canvas differs in several aspects of the composition, chief among them the extension of the design at the top of the mural to provide more space for Ariadne's crown to fly heavenward. But the painting's high degree of finish suggests that it was a later, though surely autograph, replica.

FIG. 57-1 Gérard de Lairesse, *Bacchus and Ariadne,* oil on canvas, 68⅞ x 36⅛″ (175 x 93 cm.), Mauritshuis, The Hague, no. 83.

FIG. 57-2 Gérard de Lairesse, *Bacchanal,* oil on canvas, 51¼ x 61¾" (130 x 157 cm.), Gemäldegalerie Alte Meister, Staatliche Kunstsammlungen, Kassel, no. GK462.

FIG. 57-3 Gérard de Lairesse, *Bacchus and Ariadne,* oil on canvas, 46½ x 56¼" (118 x 143 cm.), Herzog Anton Ulrich Museum, Brunswick, no. 1099.

Ovid recounted the story of Bacchus and Ariadne three times in his *Metamorphoses, Ars Amatoria,* and *Fasti.*[3] Bacchus encounters Ariadne for the first time after she has been deserted by Theseus on the isle of Naxos and falls in love with her, but soon abandons her to conquer India. Returning in triumph he discovers Ariadne declaiming against the faithlessness of both her loves and wishing for her death: "He put his arms about her, with kisses dried her tears, and 'Let us fare together,' quoth he, 'to heaven's height. As thou hast shared my bed, so shalt thou share my name'" (*Fasti,* book III, lines 509–11). "That she might shine among the deathless stars, he sent the crown she wore up to the skies. Through the thin air it flew; and as it flew its gems changed to gleaming fires [while] still keeping the appearance of a crown" (*Metamorphoses,* book VIII, lines 177–81). The jewels of Ariadne's diadem thus were transformed into the constellation known as Corona (the "Crossian Crown"). In the *Ars Amatoria,* Ovid also described in detail Bacchus's entourage, but Lairesse omitted such details as the god's chariot drawn by tigers. Unlike Titian in painting Bacchus and Ariadne,[4] he need not have consulted Ovid's specific text, since the pictorial tradition had often depicted Bacchus attended by satyrs and nymphs of the type seen here.

While the Bacchus and Ariadne theme was commonly depicted by history painters elsewhere in Europe (Titian, the Carracci, Jacob Jordaens, and many others), the subject was only rarely treated by earlier Dutch artists.[5] As Sluijter observed, Moyses van Wtenbrouck (c. 1590–1648) executed a print and Cornelis van Poelenburg (c. 1586–1667) painted the subject of the meeting of Bacchus and Ariadne on the seacoast; but Lairesse apparently was the first Dutch painter to depict Bacchus throwing aloft the crown.[6] A later ceiling decoration by Gerard Hoet (1648–1733) for the Kasteel de Slangenburg, Doetinchem, addresses the subject, and Willem van Mieris (1662–1747), Cornelis Mebeecq (1661/62–1690), and Pieter van der Werff (1665–1722) also painted the theme of Bacchus and Ariadne.[7] Lairesse painted other images of Bacchus, notably the *Bacchanal* in Kassel (fig. 57-2), where the drunken god stands amidst a scene of dionysian excess,[8] and also executed several prints of bacchanals including the *Large Bacchanal* of about 1675 praised by Sandrart.[9] However he returned to the subject of Bacchus and Ariadne only two other times, in a later painting preserved in Brunswick (fig. 57-3) in which Ariadne gestures toward the seacoast, the site of her abandonment, and Bacchus points to the ring of stars now hovering above her throne, and in a chalk drawing in which the lovers are both seated in a landscape.[10]

Karel van Mander explained the story of Bacchus and Ariadne morally, as an admonition against excessive drinking and temptation; he specifically interpreted the incident of the transformation of the crown "of the dishonorable life," which he noted was originally made by Venus's husband Vulcan for his spouse, into heavenly stars as a symbol of redemption.[11]

NOTES

1. Presently in the Mauritshuis (see Mauritshuis, The Hague, *The Royal Cabinet of Painting: Illustrated General Catalogue* [The Hague, 1977], p. 136, no. 83, repro.), the painting descended from the stadholder's collection to the original Nationale Konst-Gallery opened in the Huis ten Bosch, The Hague, in 1800. See E. W. Moes and Eduard van Biema, *De Nationale Konst-Gallery en het Koninklijk Museum* (Amsterdam, 1909), pp. 18, 20; and P.J.J. van Thiel, "De inrichting van de Nationale Konst-Gallery in het openingsjaar 1800," *Oud Holland,* vol. 95, no. 4 (1981), p. 176, no. 201, repro.

2. See S.W.A. Droessaers and T. H. Lunsingh Scheurleer, *Inventarissen van de inboedels in de verblijven van de Oranjes,* 3 vols. (The Hague, 1974–76), vol. 1, p. 622. According to the inventory, the other works by Lairesse appeared in "her Majesty's bedroom (Slaapkamer)," and included a five-part ceiling decoration depicting Diana and her companions (oil on canvas, 315 x 236¼" [800 x 600 cm.], no. A1233), a chimneypiece of *Selene and Endymion* (oil on canvas, 69⅛ x 46⅝" [177 x 118.5 cm.], no. A4210), and two overdoors, *Odysseus and Calypso* (oil on canvas, 49¼ x 37" [125 x 94 cm.], no. A211), and *Mercury Ordering Calypso to Release Odysseus* (oil on canvas, 52 x 37¾" [132 x 96 cm.], no. A212): all in the Rijksmuseum, Amsterdam.

3. *Metamorphoses* (book VIII, lines 176–82); *Ars Amatoria* (book I, lines 529–62), and *Fasti* (book III, lines 507–26). *Catullus* (*Carmina,* book LXIV, lines 50–206) also recounts the tale of Bacchus and Ariadne but does not mention the crown. For discussion of Ovid's texts see G. H. Thompson, "The Literary Sources of Titian's *Bacchus and Ariadne,*" *The Classical Journal,* vol. 51 (1956), pp. 259ff.

4. *Bacchus and Ariadne,* signed, oil on canvas, 69 x 75" (175 x 190 cm.), National Gallery, London, no. 35. For a discussion of Titian's pioneering picture, see Erwin Panofsky, *The Wrightsman Lectures,* no. 2, *Problems in Titian: Mostly Iconographic* (New York, 1969), pp. 139–44.

5. See A. Pigler, *Barockthemen,* 2 vols. (Budapest, 1974), vol. 2, pp. 46–51; and Rijksbureau voor Kunsthistorische Documentatie, The Hague, *Decimal Index of the Art of the Low Countries* (The Hague, 1958–), s.v. "Ariadne." Barent Graat's *Bacchus Crowning Ariadne* (oil on canvas, 44 x 46½" [112 x 118 cm.], Musée d'Art et d'Histoire, Geneva; repro. in Kunstmuseum, Basel, *Im Lichte Hollands,* June 14–September 27, 1987, p. 48) is undated and may postdate the Lairesse.

6. Eric Jan Sluijter, "De 'heydensche fabulen' in de noordnederlandse schilderkunst, circa 1590–1670," diss., Rijksuniversiteit, Leiden, 1986, pp. 80, 144, 420–21.

7. Sluijter (see note 6), p. 144 n. 3. The three works are Van Mieris, dated 1704, oil on panel, 23⅜ x 29¾" (59.5 x 75.5 cm.), Gemäldegalerie, Dresden, no. 1772; Mebeecq, sale, Combé, Stuttgart, April 27, 1966, lot 316 [incorrectly as Lairesse]; and Van der Werff, signed and dated 1712, oil on panel, 14⅝ x 11¼" (37.1 x 28.6 cm.), Fitzwilliam Museum, Cambridge, no. 376.

8. See Jürgen M. Lehmann, "Kasseler Bacchanale," *Festschrift für Gerhard Kleiner zu seiner fünfundsechzigsten Geburtstag* (Tübingen, 1976), p. 218, pl. 452.

9. Joachim von Sandrart, *Academie der Bau-, Bild-, und Mahlerey-Künste von 1675,* edited by A. R. Peltzer (Munich, 1925), p. 351; see J.J.M. Timmers, *Gérard Lairesse* (Amsterdam and Paris, 1942), nos. 33–36, repros.

10. Red and black chalk on paper, 8¹¹⁄₁₆ x 9⅜" (220 x 238 mm.), sale, Mak van Waay, Amsterdam, October 29, 1979, lot 289.

11. Karel van Mander, "Wtlegghingh op den Metamorphosis Publij Ovidij Nasonis," in *Het Schilder-Boeck* (Haarlem, 1603–4; reprint, Utrecht, 1969), pt. 2, fols. 71–72.

PROVENANCE: Sale, Wierman, Amsterdam, August 18, 1762, lot 5; Countess van Lynden, who lent it to the Mauritshuis, The Hague, 1901–3; sale, Mme la Duchesse F. Melzi d'Eril de Lodi, Brussels, Galerie LeRoy frères, 1920, lot 461; with dealer J. Nijstad, Lochem, by 1946; purchased from Nijstad by Mr. and Mrs. Edgar P. Richardson, Philadelphia, July 23, 1955.

NOTE TO PROVENANCE

1. The references in the provenance to the Wierman sale of 1762 and the Melzi d'Eril de Lodi sale of 1920 were provided by Alain Roy of the Institut d'histoire de l'art et d'arts plastique, Strasbourg, who is preparing a study of Lairesse.

LITERATURE: Gerard Hoet and Pieter Terwesten, *Catalogus of naamlyst van schilderyen,* 3 vols. (The Hague, 1752–70), vol. 3, p. 253.

CONDITION: The painting, which has a medium-coarse, plain-weave linen support, has been lined with a coarse plain-weave canvas and a wax-resin adhesive. The original dimensions of the painting appear not to have been significantly altered, although parts of the tacking margins have been lost. The paint and ground layers are slightly cupped but are well attached to the support. A discolored natural resin varnish is present. Retouching is minor and is mainly confined to the edges of the painting.

58 STYLE OF JAN WILLEMSZ. LAPP

PASTORAL LANDSCAPE
Oil on panel, 9¾ x 8¼" (24.8 x 20.9 cm.)
Gift of Mrs. Hampton L. Carson. 29-136-148

NOTES

1. Verbal communication. See *Italian Landscape,* oil on canvas, 23¼ x 26¾" (58.9 x 68.2 cm.), Mauritshuis, The Hague, inv. no. 84.

2. See, especially, two paintings in the Mauritshuis, The Hague: oil on copper, 6¼ x 4¾" (16 x 12 cm.), inv. no. 273, and oil on copper, 6¼ x 4¾" (16 x 12 cm.), inv. no. 274.

PROVENANCE: Mrs. Hampton L. Carson.

CONDITION: The uncradled, vertically grained panel support is in good condition. Strips 1" (2.5 cm.) wide are glued to the reverse across the upper and lower edges. The paint film has pronounced traction crackle, especially in the dark areas where lower paint layers are exposed. There is some surface abrasion. The varnish is deeply discolored. A clipping adhered to the reverse, probably from an early nineteenth-century English sale catalogue, reads "Landscape by Berghem."

A rosy twilight landscape in the Italian Campagna is bracketed by a tall tree on the left and a four-sided tower and smaller house on a hill at the right. In the foreground sits a shepherd in a blue shirt with his staff and a dog. At the right are a cow, two sheep, and a goat. In the middle distance a woman viewed from behind sits astride a horse.

The painting was sold as a Nicolaes Berchem (1620–1683) and has been attributed to "Claes Berchem" since entering the Museum. Although features of the upright design vaguely recall some of Berchem's early compositions, and the staffage figures (particularly the woman on horseback) are probably based on his paintings, the technique and the entire conception of the painting are too crude to support an attribution to the artist. An assignment to Jan Willemsz. Lapp (c. 1600–after 1663) was first tentatively suggested by W. van de Watering and finds some support from comparison with Lapp's rare signed works[1] and paintings that have been attributed to him in which the handling of the trees, the rather disjointed staffage figures, and the weak execution generally offer similarities.[2]

On the reverse of the panel, the panelmaker's incised mark "S" is clearly visible.

A still-life painter, Lelienbergh joined the guild in The Hague in 1646. In 1649 he married Agnieta Abrahams van der Hennis, daughter of a Hague art dealer. He was a member of the local militia in 1654 and two years later was one of the founders of the painters' confraternity. In 1657 he acquired a house and in 1666 was employed at Slot Moerspeuy. His latest known painting (Kurpfälzisches Museum, Heidelberg) is dated 1676.

Lelienbergh's early works are simple, small-scale compositions of dead game birds. His palette in these paintings (see especially those in the museums in Amsterdam and Rotterdam) is dominated by monochrome hues, with light gray and tan prevailing. In his later years he painted more decorative hunting still lifes in the manner of Jan Baptist Weenix (q.v.), which sometimes include live animals (examples in Dresden, Leipzig, Schwerin, and Prague), and a few domestic interiors with still-life elements (formerly with dealer Leger, London). Dr. Hans Wetzlar's Collection, Amsterdam, contained a picture of a live bittern by Lelienbergh.

LITERATURE: Thieme-Becker 1907–50, vol. 23 (1929), p. 8; Ingvar Bergström, *Dutch Still-Life Painting in the Seventeenth Century,* translated by Christina Hedström and Gerald Taylor (London, 1956), p. 250; Laurens J. Bol, *Holländische Maler des 17. Jahrhunderts nahe den grossen Meistern: Landschaften und Stilleben* (Brunswick, 1969), p. 286; Scott A. Sullivan, *The Dutch Gamepiece* (Totowa and Montclair, N.J., 1984).

59 CORNELIS LELIENBERGH

STILL LIFE OF DEAD BIRDS, 1654
Signed lower left: *C. Lelienbergh f./1654*
Oil on panel, 19½ x 16¼" (49.5 x 41.3 cm.)
Purchased for the W. P. Wilstach Collection. W02-1-19

Before a gray stone wall a dead white bird with brownish neck feathers hangs upside down from a nail by a string attached to its left talon. At the right in a partially visible niche is a pile of five other birds, three with brownish-tan plumage, one with a yellow breast, and one with a red breast. The light falls from the upper left, illuminating hairline cracks in the wall, casting part of the niche in darkness, and throwing a diagonal shadow across the lower-left corner. Silvery tonalities prevail in the light-colored palette.

This composition, with a dead bird suspended from a nail in a light-colored wall with a niche at the right, was reemployed by Lelienbergh in a larger painting dated five years later in the Rijksmuseum, Amsterdam (fig. 59-1). In that more grandly conceived work, the bird is a black rooster, and a dead rabbit replaces the pile of smaller birds in the niche. The Rijksmuseum also owns a pair of still lifes with dead birds on plinths painted by Lelienbergh in 1655, which employ a technique very similar to that of the Philadelphia painting.[1] An undated painting of game birds in a niche by Lelienbergh in the Seattle Art Museum (fig. 59-2) also offers points of resemblance in style and design.

The fine execution coupled with the light-colored wall and the shallow composition enhances the immediacy of the objects. In his study of the Dutch gamepiece Scott Sullivan concluded that trompe l'oeil still lifes of this type first appeared around mid-century in the art of Jan Baptist Weenix and Melchior de Hondecoeter (qq.v.).[2] The illusionistic impulse was at its height in Dutch art, and particularly in South Holland, in these years. The present painting has also been compared with the famous *Goldfinch* (fig. 59-3) by Carel Fabritius (1622–1654),[3] which probably was painted as a trompe l'oeil in Delft in the same year in which this work was presumably painted nearby in The Hague. Despite these similarities, Lelienbergh employed a more delicate, less painterly technique and a cooler, more muted palette than Fabritius.

FIG. 59-1 Cornelis Lelienbergh, *Dead Game,* signed and dated 1659, oil on canvas, 36⅞ x 33″ (93.5 x 84 cm.), Rijksmuseum, Amsterdam, no. A1710.

FIG. 59-2 Cornelis Lelienbergh, *Game Birds in a Niche,* oil on panel, 18⅞ x 14⅝″ (47.9 x 37.2 cm.), Seattle Art Museum, Margaret E. Fuller Purchase Fund, no. 66.74.

FIG. 59-3 Carel Fabritius, *Goldfinch,* 1654, signed and dated, oil on panel, 13³⁄₁₆ x 8¹⁵⁄₁₆″ (33.5 x 22.8 cm.), Mauritshuis, The Hague, no. 605.

NOTES

1. Oil on panel, 18½ x 14¾″ (47 x 37.5 cm.), signed and dated "Cl. f. 1655," nos. A1455 and A1454. *The Still Life with Dead Partridge before a Niche,* attributed to Lelienbergh when with the dealer Cramer in The Hague in 1974 (unsigned, oil on canvas, 18 x 13¾″ [46 x 35 cm.]), seems starker in execution and was earlier assigned to William Gouw Ferguson (1632/33–after 1695). The unsigned *White Cock* (oil on canvas, 58 x 35¾″ [114 x 91 cm.]), attributed to Lelienbergh, in the Musée des Beaux-Arts, Ghent, no. 1914-DC, also creates a different impression owing to its very dark background. Another painting by Lelienbergh of hanging game birds is in the collection of William Purdy, Burlingame, California.
2. See Scott A. Sullivan, *The Dutch Gamepiece* (Totowa and Montclair, N.J., 1984), pp. 68–69. See, especially, Weenix's *Dead Partridges,* signed, oil on canvas, 19¹⁵⁄₁₆ x 17⅛″ (50.6 x 43.5 cm.), Mauritshuis, The Hague, inv. no. 940 (Sullivan, fig. 138).
3. Joseph Rishel was the first to privately make this comparison. It is also discussed by Christopher Brown in *Carel Fabritius* (London and Ithaca, 1981), pp. 47–48, and by Ben Broos in *Meesterwerken in het Mauritshuis* (The Hague, 1987), p. 137.

PROVENANCE: Purchased for the W. P. Wilstach Collection, Philadelphia, October 15, 1902.

LITERATURE: Wilstach 1903, no. 108, 1904, no. 145, 1906, no. 164, 1907, no. 173, 1908, no. 173, 1910, no. 233, 1913, no. 244, 1922, no. 179, repro.; Thieme-Becker 1907–50, vol. 23 (1929), p. 8; Philadelphia Museum of Art, *A Picture Book of Dutch Painting of the XVII Century* (Philadelphia, 1931), p. 7, fig. 11; PMA 1965, p. 40; Rishel 1974, p. 31, fig. 9; Christopher Brown, *Carel Fabritius* (London and Ithaca, 1981), pp. 47–48, fig. 37; Scott A. Sullivan, *The Dutch Gamepiece* (Totowa and Montclair, N.J., 1984), p. 69, fig. 140; Ben Broos, *Meesterwerken in het Mauritshuis* (The Hague, 1987), p. 137, fig. 2.

CONDITION: The uncradled panel is composed of two pieces of wood, joined vertically, left of center. The right panel, as seen from the front, is vertically grained. The left portion has a large knot near the bottom that diverts the grain direction almost 90 degrees. At the left edge there are two splits along the grain around the knot in the panel. There is another jagged crack running vertically from the upper-right corner. The paint film is thin and shows little abrasion. A small loss running vertically has been inpainted 6″ (15.2 cm.) from the top along the right edge. The varnish is uneven and slightly discolored.

Born in Schrobenhausen, Von Lenbach first trained to follow in his father's footsteps as a building contractor, entering the trade school in Landstraat in 1847 and the polytechnic school in Augsburg in 1852, while working in the interim in his father's business. In 1850 he began his artistic training under the sculptor Anselm Sickinger (1807–1873) in Munich. Later he spent several months studying with the animal painter Johann Baptist Hofner (1832–1913) in Schrobenhausen, as well as the artist Albert Gräfle (1807–1889) in Munich, and he passed the winter months of 1857 in the atelier of Karl Theodore von Piloty (1826–1886) in Munich. He was also, however, an autodidact who made copies of old masters (including Titian, Van Dyck, Rubens, Rembrandt, Velázquez, Murillo). In 1858–59 he traveled to Rome with Von Piloty. On the latter's recommendation he moved in 1860 to Weimar with Arnold Böcklin (1827–1901) and Reinhold Begas (1831–1911), but returned to Munich two years later. In 1863 he rented a studio in Rome with Böcklin and Ludwig von Hagn (1819–1898). In 1867 he traveled to Madrid, where he made more copies. The following year he was back in Munich. After 1871 he moved often between Munich, Vienna, and Berlin, in 1873–74. In 1875–76 he visited Egypt. In 1878 he met Chancellor Bismarck, whose portrait he painted repeatedly and who became a close friend. During the years from 1882 to 1887 he spent the winters in Rome, where he was impressed by works in the Palazzo Borghese. In collaboration with the architect Gabriel von Seidl, he designed and built the famous Villa Lenbach in Munich between 1883 and 1889.

One of the most admired, socially elevated, and prolific portraitists of his day, Von Lenbach in his youth also made landscapes, figure sketches, and paintings of shepherd boys. His early manner was relatively tight but became much freer. He often employed photographs as artistic aids, especially for portraits. After about 1880 Von Lenbach's production of portraits increased dramatically. A large selection of his work is preserved in the Städtische Galerie in the Lenbachhaus, Munich.

LITERATURE: Boetticher (1891–1901) 1969, vol. 1, pp. 868–73; Wilhelm Wyl, "Franz von Lenbachs Erzählungen aus seinem Leben," in *Deutsche Revue,* March, April, and June 1897; Adolf Rosenberg, *Lenbach* (Bielefeld and Leipzig, 1898); Eduard Schulte, *Lenbach-Ausstellung* (Berlin, 1898); Wilhelm Wyl, *Franz von Lenbach: Gespräche und Erinnerungen* (Stuttgart and Leipzig, 1904); Leipziger Kunstverein, Museum der bildenden Künste, Leipzig, *Franz von Lenbach,* 1904; Kunstausstellungsgebäude, Munich, *Dem Andenken Franz von Lenbachs,* June–October 1905; E. Hanfstaengl in Thieme-Becker 1907–50, vol. 23 (1929), pp. 43–45; Georg August Reischl, *Lenbach und seine Heimat* (Schrobenhausen, 1954); Sonja Mehl, "Franz von Lenbach (1836–1904): Leben und Werk," diss., Munich, 1972; Siegfried Wichmann, *Franz von Lenbach und seine Zeit* (Cologne, 1973); Sonja Mehl, *Franz von Lenbach in der Städtischen Galerie im Lenbachhaus München* (Munich, 1980); Hamburger Kunsthalle, Hamburg, *Dreimal Deutschland: Lenbach, Liebermann, Kollwitz,* October 23, 1981–February 28, 1982.

60 FRANZ VON LENBACH *PORTRAIT OF THE WIDOW MARION KNAPP, NÉE GRAHAM,*
 LATER BARONESS BATEMAN, C. 1903
 Oil on construction board, oval, 27 x 25⅜" (68.6 x 64.5 cm.)
 Gift of Mrs. Henry Clifford. 75-79-3

 The sitter is viewed in profile, bust length, and turned to the viewer's left.
 She wears her hair up and is dressed in a low-cut, white gown.
 Marion Alice Knapp was the daughter of James Jeffrey Graham of
 New York and the widow of Henry Cabot Knapp. In 1904 she married
 William Spencer (b. 1856), the third baron Bateman, who died without issue
 in November 1931, bringing the barony to extinction. Baroness Bateman

FIG. 60-1 Franz von Lenbach, *Portrait of Marion Knapp*, 1903, oil on construction board, 50½ x 33¾ (112 x 86 cm.), Städtische Galerie, Lenbachhaus, Munich, no. LI2I, Gift of Lola von Lenbach, 1925.

was also the step-aunt of Henry Clifford, former curator of painting at the Philadelphia Museum of Art.

Although the painting is not signed, it bears all the characteristics of a late portrait by Von Lenbach and has an inscription of authentication on the reverse signed by the artist's wife: "I confirm that this painting/Lady Bateman/is by the hand of my husband/Franz Von Lenbach/Lola Von Lenbach."[1] The work has been linked by Sonja Mehl with several other bust-length studies of the sitter turned to the left as works variant or preparatory to a relatively finished, knee-length *Portrait of Marion Knapp*, signed and dated 1903, by Von Lenbach, now in the Städtische Galerie in the Lenbachhaus, Munich (fig. 60-1).[2] The variants listed by Mehl are as follows: a view of the sitter from the back turned in profile to the left,[3] the present work, in which the sitter is turned farther into lost profile,[4] a preparatory study for the present work,[5] a view of the sitter in three-quarter profile to the left,[6] a preparatory study for the last mentioned,[7] and finally, a knee-length variant of the sitter wearing different clothes and a large hat.[8] Additional representations of the sitter turned in profile to the right will be published in the forthcoming volume of Mehl's study.

Since two of the works in this group are dated 1903, one might presume that the entire series was executed around this time, an assumption that finds support in the late style of the present and related works. To accept this dating requires that the traditional identification of the sitter as "Lady Bateman" be changed to Marion Knapp, the sitter's name prior to her marriage to Baron Bateman in the year of Von Lenbach's death, 1904. However, one also might speculate whether Lola von Lenbach's inscription on the back indicates that the work postdated Marion's second marriage, possibly serving as a wedding portrait, and remained in the artist's studio after his death, when it was authenticated by his widow.

The tondo shape of the portrait was a format that Von Lenbach often used for portraits. The sketchy, diaphanous treatment (underdrawing is clearly visible through the paint film) is more characteristic of the artist's later work.

NOTES

1. "Ich bestatige das dieses Bild/Lady Bateman/Von der Hand meines manes/Franz von Lenbach/ist./Lola von Lenbach."

2. Sonja Mehl, *Franz von Lenbach in der Städtischen Galerie im Lenbachhaus München* (Munich, 1980), p. 163, no. 326, repro.

3. Oil on construction board, 27½ x 26½" (70.5 x 67 cm.), sale, Leo Spik, Berlin, May 1964.

4. Although Mehl wrongly stated that the picture is in a private collection, Locarno, her reference to the Galerie Heinemann archive number (photograph no. 8476) matches a sticker on the reverse of the present work. Another sticker reads "Kunstsalon/Keller & Reiner/Berlin W/nr. 11401/Lady Bateman."

5. Oil on construction board, 45¾ x 34¾" (116 x 88 cm.), from the Von Lenbach estate, now in a private collection, Starnberg and Cologne.

6. Galerie Heinemann archive, no. 19060, private collection, Locarno.

7. Pastel on construction board, 31½ x 26" (80 x 66 cm.), from the Von Lenbach estate, now in a private collection, Starnberg and Cologne.

8. Galerie Heinemann archive, no. 15931, private collection, Locarno.

PROVENANCE: Presumably by descent from Baroness Bateman to Mr. and Mrs. Henry Clifford.

LITERATURE: Sonja Mehl, *Franz von Lenbach in der Städtischen Galerie im Lenbachhaus, München* (Munich, 1980), p. 163, under no. 326.

CONDITION: The multi-ply cardboard support is slightly warped and worn at the edges but is generally in good condition. The thin paint layer is stable and well preserved. The varnish is uneven and moderately discolored.

LITERATURE: Friedrich von Uechtritz, *Blicke in das Düsseldorfer Kunst- und Kunstlerleben,* vol. 1 (Düsseldorf, 1839), pp. 377ff.; Boetticher (1891–1901) 1969, vol. 1, pp. 880–90; Thieme-Becker 1907–50, vol. 23 (1929), p. 129; Wolfgang Hütt, *Die Düsseldorfer Malerschule 1819–1869* (Leipzig, 1964); Irene Markowitz and Rolf Andree, *Die Düsseldorfer Malerschule* (Düsseldorf, 1977); Vera Leuschner, "Der Landschafts- und Historienmaler Carl Friedrich Lessing," in Kunstmuseum, Düsseldorf, *Die Düsseldorfer Malerschule,* May 13–July 8, 1979, and Mathildenhöhe, Darmstadt, July 22– September 9, 1979, pp. 86–97.

The great-nephew of Gotthold Ephraim Lessing (1729–1781), Karl Friedrich was born in Breslau on February 15, 1808. After studying briefly in Berlin to become an architect, he turned to landscape painting and studied under Wilhelm von Schadow-Godenhaus (1789–1862), to whom he was introduced by his close friend the painter Carl Ferdinand Sohn (1805–1867). In 1826 he followed Von Schadow-Godenhaus to Düsseldorf. His fresco *The Battle of Iconium* for Schloss Heltorf was painted in 1829 and 1830. Between 1833 and 1843 he attended classes at the Düsseldorf academy and soon earned a considerable reputation. In 1858 he was called to Karlsruhe, where he became gallery director; he died on June 5, 1880.

Initially devoting himself to pure landscape paintings done from drawings made in the countryside around Düsseldorf, Lessing painted his first history paintings under the influence of Von Schadow-Godenhaus. He is credited with being the inventor of historicized landscape painting. His favored themes included events from the lives of Johannes Hus and Martin Luther. Although never a member of the faculty, Lessing had a lasting influence on students at the Düsseldorf academy.

61 KARL FRIEDRICH LESSING

THE ROBBER AND HIS CHILD, 1832
Inscribed lower center in script: *C.F.L. 1832*
Oil on canvas, 16¾ x 19½" (42.5 x 49.5 cm.)
The W. P. Wilstach Collection. W93-1-65

FIG. 61-1 Karl Friedrich Lessing, *Robbers in the Mountains,* 1827–28, oil on canvas, 19⅝ x 15⅝" (50 x 39.7 cm.), Städelsches Kunstinstitut, Frankfurt, no. 1700.

On the edge of a rocky mountain overlooking a river valley, a man in a loose-fitting blouse, cap, and knee-high boots sits, head in hand, staring down into an abyss. On his shoulder rests a rifle and at his side sleeps his young child.

The subject is the robber and his child, a theme that was popular in both literature and art in Germany in the late eighteenth and early nineteenth centuries. This robber was not an unscrupulous thief but the noble robber who was forced into a life of crime either out of need or as a victim of social injustice. The noble robber first appeared in *Sturm und Drang* literature; Friedrich Schiller's seminal *Die Räuber* was first performed in 1781. Through popularization in subsequent literature the characteristics of the figure of the well-intentioned but independent-minded Karl Moor, the hero of *Die Räuber,* became confused with the behavior of real thieves of the period and the noble robber was trivialized. The robber novels of Christian Heinrich Spiess, Karl Gottlob Cramer, Christian August Vulpius, Heinrich Zschokke, and others enjoyed great popular success. The most romantic noble robber figured in Vulpius's *Rinaldo Rinaldini, der Rauberhauptmann, eine romantische Geschichte unseres Jahrhunderts* (1797) and, as Ute Ricke-Immel has observed, probably inspired early representations of the noble robber by Léopold Roberts (1794–1835).[1] The latter's *Sleeping Robber Watched by a Young Girl* and *Robber on a Precipice* were exhibited at the Berlin academy in 1824 and 1826, respectively, and together with the literary sources may have inspired the many depictions of robbers that soon followed. Lessing treated the robber theme as early as 1827–28 (fig. 61-1).[2] Whether he knew specific works like Vulpius's novel is unclear; however, he surely was aware of the general popularity of robber

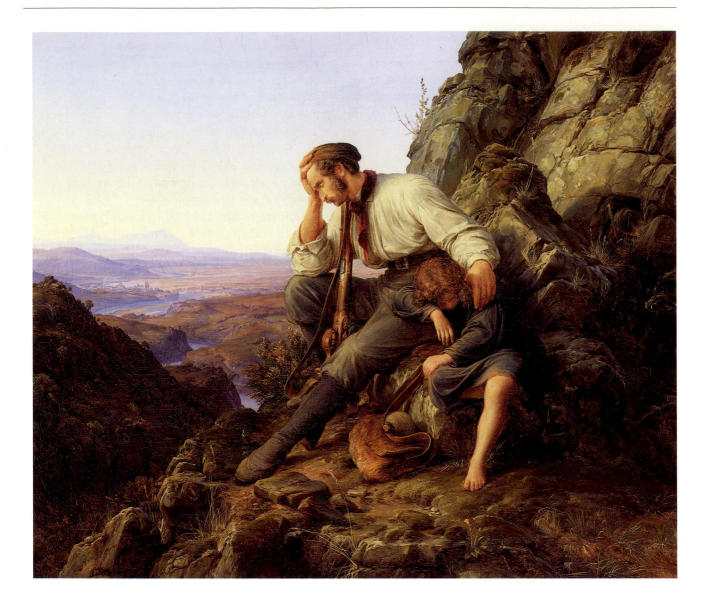

themes in romantic literature. Friedrich von Uechtritz stated that soon after his move to the Rhineland, Lessing obtained books on robber bands of the late eighteenth century and the life and fate of the folk hero Schinderhannes.[3]

 Painted as a gift for his artist friend Carl Ferdinand Sohn (1805–1867), the picture employs the general theme of man in isolation, a theme beloved by painters of the Düsseldorf School around 1830.[4] As Rolf Andree noted in the Düsseldorf exhibition catalogue of 1979, Lessing's *Trauernde Königspaar* and the *Robber* by Ferdinand Theodor Hildebrandt (1804–1874) (fig. 61-2) are early examples of these thematic concerns.[5] Hildebrandt's *Robber* also shows formal as well as thematic parallels with the Philadelphia Lessing. The latter's composition, with two seated and embracing figures, one watchful, the other asleep, and with both silhouetted on a side of a hill,

FIG. 61-2 Ferdinand Theodor Hildebrandt, *The Robber*, 1829, oil on canvas, 44⅞ x 39″ (114 x 99 cm.), Staatliche Museen, Berlin (East), no. 11796.

is anticipated by the design of Lessing's drawing *Walter and Hildegrund in Flight Resting on a Mountain,* dated 1831.[6]

Friedrich von Boetticher noted that Lessing executed a replica of the Philadelphia painting for the collector Fränkel in Berlin; this may be identical with the version that appeared in the Weinmüller sale in Munich in 1973.[7] Boetticher listed several reproductive prints after the Philadelphia version: a woodcut by Karol Raczyński (active 1820–44); a lithograph by Richebois and Desmaisons; and another lithograph by Jakob Becker (1810–1872).

NOTES

1. See Ute Ricke-Immel, "Die Düsseldorfer Genremalerei," in Kunstmuseum, Düsseldorf, *Die Düsseldorfer Malerschule,* May 13–July 8, 1979, Mathildenhöhe, Darmstadt, July 22–September 9, 1979, p. 151 n. 21.

2. See Matthias Lehmann and Vera Leuschner, "Das Morgenbachtal in der Malerei des 19. Jahrhunderts," in *Kunst in Hessen und am Mittelrhein,* vol. 7 (1977), p. 44 n. 34. Drawing studies for the mountain (known as the Doppelkopffelsens) provide a *terminus a quo* for the painting's date.

3. Friedrich von Uechtritz, *Blicke in das Düsseldorfer Kunst- und Künstlerleben,* vol. 1 (Düsseldorf, 1839), p. 378. Although the specific titles are unknown, some of the following are likely: J. W. Becker, *Die aktenmässige Geschichte der Räuberbanden an den beiden Ufern des Rheins,* 2 vols. (Cologne, 1804); A.G.F. von Rebmann, *Damian Hessel und seine Raubgenossen: Nachrichten* (Mainz, 1810); J. W. Spitz, *Geschichte der Mosel- und Hunsrückräuberbande,* vol. 2 (Cologne, 1820); "Schinderhannes, der Räuberhauptmann der Mosel- und Birkenfelder Räuberbande" and "Schinderhannes," in *Galerie der Verbrecher,* vol. 1 (Sonderhausen, 1820), pp. 1–69.

4. See Boetticher (1891–1901) 1969, vol. 1, p. 881, no. 8. Sohn, it may be noted, painted Lessing's portrait the following year, 1833 (Staatsbibliothek, Berlin [East]; repro. Kunstmuseum, Düsseldorf [see note 1], p. 86).

5. 1830, oil on canvas, 81 x 74½″ (206 x 189 cm.), The Hermitage, Leningrad, no. 4778. See Kunstmuseum, Düsseldorf (note 1), under cat. no. 156. Compare also Hildebrandt's gaier image of domestic life, *The Soldier and His Child,* 1832, oil on canvas, 41¼ x 36½″ (105 x 93 cm.), Kunstmuseum, Düsseldorf, no. 229.

6. Pencil and watercolor on paper, 13¾ x 13¹⁄₁₆″ (35 x 33.1 cm.), Cincinnati Art Museum, no. 1882.50; repro. Kunstmuseum, Düsseldorf (see note 1), fig. 51. See Cincinnati Art Museum, *Drawings by Carl Friedrich Lessing, 1808–1880* (Cincinnati, 1972), p. 9.

7. March 14, 1973, lot 1668 (pl. 149). As oil on canvas, 29¼ x 34¾″ (74 x 88 cm.), and with references to Boetticher (1891–1901) 1969, vol. 1, p. 881, nos. 8 and 9.

PROVENANCE: Carl Ferdinand Sohn, Düsseldorf; The W. P. Wilstach Collection, Philadelphia, by 1886.

EXHIBITIONS: Kunstmuseum, Düsseldorf, *Die Düsseldorfer Malerschule,* May 13–July 8, 1979, Mathildenhöhe, Darmstadt, July 22–September 9, 1979, pp. 151, 163 n. 21, p. 390, no. 156.

LITERATURE: Wilstach 1886, no. 52, 1893, no. 57, 1900, no. 84; Boetticher (1891–1901), 1969, vol. 1, p. 881, no. 8; Thieme-Becker 1907–50, vol. 23 (1929), p. 129; PMA 1965, p. 41; Matthias Lehmann and Vera Leuschner, "Das Morgenbachtal in der Malerei des 19. Jahrhunderts," in *Kunst in Hessen und am Mittelrhein,* vol. 7 (1977), pp. 44–45.

CONDITION: The canvas support was relined with wax-resin in 1979. The tacking edges are missing. Despite efforts at that time to relax the paint film, some slight residual cupping along crackle lines is still evident. The painting was cleaned in 1965 and 1979. The darks in the lower right have been abraded and old losses are filled and inpainted in the upper-left corner. The varnish is colorless.

Born on May 24, 1816, in Schwäbisch-Gmünd, Leutze moved as a child with his family to Philadelphia, where he first studied with the portraitist John Rubens Smith (1775–1849). To continue his studies he traveled in 1841 to Düsseldorf, where he studied briefly with Karl Friedrich Lessing (q.v.) but soon established himself as an independent master. In 1842 he departed on a trip that took him to Munich, Venice, and Rome; in 1845 he returned to Düsseldorf, where he executed his most famous work, *Washington Crossing the Delaware* (1851, oil on canvas, 12½ x 21¼′ [3.8 x 6.5 m.], The Metropolitan Museum of Art, New York, no. 97.34; 1970 copy by Robert B. Williams, Washington Crossing Historic Park, Pennsylvania). In 1848 he helped found the artists' society "Malkasten" and in 1856, the "Deutsche Kunstgenossenschaft." In 1851 he visited America, then returned to Düsseldorf for six years. He moved to America, permanently in 1859, the year he was commissioned to execute mural decorations on the theme of the history of the Union for the United States Capitol, Washington, D.C. (*Westward the Course of Empire Takes Its Way,* 1862, mural, 20 x 30′ [6.1 x 9.1 m.]). Apart from a visit to Düsseldorf in 1863, he resided for the remainder of his life in Philadelphia and taught at the Pennsylvania Academy of the Fine Arts there. Leutze died in Washington, D.C., on July 18, 1868.

A painter and draftsman of historical subjects and portraits, Leutze executed both cabinet-sized works and large-scale murals with subjects from American and British history.

LITERATURE: Charles G. Leland, "E. G. Leutze," *Sartain's Union Magazine,* vol. 9 (November 1851), pp. 420–21; Rudolf Wiegmann, *Die königliche Kunst-akademie zu Düsseldorf* (Düsseldorf, 1856); Henry T. Tuckerman, *Book of the Artists: American Artist Life,* 2 vols. (New York, 1867; reprint, New York, 1967); Moritz Blanckarts, *Düsseldorfer Künstler: Nekrologe aus den letzten zehn Jahren* (Stuttgart, 1877), pp. 18–29; Boetticher (1891–1901) 1969, vol. 1, pp. 894–95; Bernd Lasch, "Emanuel Leutze als Bildnis Maler," *Pemplefort: Sammlung Kleinen Düsseldorfer Kunstschriften,* no. 19 (Düsseldorf, 1926); Thieme-Becker 1907–50, vol. 23 (1929), p. 148; Wolfgang Hütt, *Die Düsseldorfer Malerschule 1819–1869* (Leipzig, 1964); Ernst Scheyer, "Leutze und Lessing: Düsseldorf und Amerika," *Aurora/Eichendorff Almanach,* vol. 26 (1966), pp. 93–100; Justin G. Turner, "Emanuel Leutze's Mural 'Westward the Course of Empire Takes Its Way,'" *Manuscripts,* vol. 18, no. 2 (September 1966), pp. 1–16; Irene Markowitz, *Kunstmuseum Düsseldorf, Die Düsseldorfer Malerschule* (Düsseldorf, 1969), pp. 210–12; National Collection of Fine Arts, Smithsonian Institution, Washington, D.C., *Emanuel Leutze, 1816–1868: Freedom Is the Only King,* January 16–March 14, 1976 (catalogue by Barbara S. Groseclose); University Art Museum, University of California, Berkeley, *American Portraits and History Painting by Emanuel Leutze,* April 20–May 20, 1976; Kunstmuseum, Düsseldorf, *Die Düsseldorfer Malerschule,* May 13–July 8, 1979, Mathildenhöhe, Darmstadt, July 22– September 9, 1979, pp. 399–402; Natalie Spassky et al., *American Paintings in the Metropolitan Museum of Art,* vol. 2 (New York, 1985), pp. 13–26.

62 EMANUEL LEUTZE

OLIVER CROMWELL AND HIS DAUGHTER, 1843
Signed and dated lower left: *E. Leutz, Düss f. 1843.*
Oil on canvas, 29⅛ x 24½" (74 x 62.2 cm.)
The W. P. Wilstach Collection. W93-1-67

At the left sits Oliver Cromwell's daughter, Lady Elizabeth Claypoole, with
a blanket over her lap and propped up by a large striped pillow. She points
with her left hand at her father who sits with his head in hand in an
attitude of intense reflection. Cromwell wears a steel gorget, velvet jerkin,
and tall boots. His plumed hat rests on the floor with his walking stick at
the right. Between the two figures on a table is a still life of glassware and a

ceramic pitcher. In the shadowed background is a portrait of a man with long hair wearing armor and holding a scepter. Reminiscent of regents' portraits, it may represent King Charles I, whom Cromwell had beheaded in 1649.

When first exhibited in 1844 at the Pennsylvania Academy of the Fine Arts, Philadelphia, the picture was entitled "Cromwell Remonstrated with by His Daughter." Friedrich von Boetticher described the painting as "Cromwell at the sickbed of his dying daughter, of royalist sentiment, who execrates her father."[1] The subject appears to refer to the legend that Lady Elizabeth Claypoole pleaded the case of political prisoners even as she lay on her deathbed. Royalist writers represented her in her last moments as upbraiding her father over the blood he had shed. A newspaper account of September 16, 1658, claimed that Lady Claypoole "did on her deathbed beseech his highness to take away the high court of justice."[2] The Protector is depicted in grief and torment watching the demise of his favorite daughter, whose death on August 6, 1658, would precede his own, on September 3, 1658, by only four weeks.

The painting was the first of a series of paintings that Leutze executed dealing with Cromwellian themes.[3] Given the revolutionary temper of the age, nineteenth-century writers and political theorists were fascinated with Cromwell, who was viewed as a forerunner of both George Washington and Napoleon. The story of Cromwell naturally raised pertinent questions about usurpation versus rightful rule. The French were particularly intrigued by it, as shown by the writings of the historian François Guizot, *Histoire de la révolution d'Angleterre* (1826–27), François René Chateaubriand's *Quatre Stuarts* (1828), and Victor Hugo's drama *Cromwell* (1827). Paul Delaroche (1797–1856) painted his famous *Cromwell at the Coffin of Charles I* in 1831.[4] While this image of regicide deliberately evoked parallels between France of 1793 and England of 1649, specific political motivations seem less likely in Leutze's work. As Barbara Groseclose wrote, "In Leutze's *oeuvre,* the variety of Cromwellian images seems less apposite unless considered within the broadest context of the nineteenth-century preoccupation with revolution...."[5] Groseclose has characterized the work as combining Düsseldorfian naturalism with an effort to humanize history painting with a "genrelike" approach, admiring "the very personal and unpretentious expression, the quietly convincing intimacy between father and daughter." One hesitates to support, however, her contention that an "ambivalence" in the technique of the picture "predicted Leutze's break with the Düsseldorf Academy."[6] Despite the criticisms of several authors—Henry Tuckerman complained that the daughter had the arm of a washerwoman[7]—the execution of the work, even allowing for its damage by past overcleaning, is not as inconsistent or unskilled as has been suggested. It compares favorably with such contemporary works as *The Iconoclast (The Puritan and His Daughter)* of 1847 (fig. 62-1), a painting of comparable size, style, and figure type.[8]

FIG. 62-1 Emmanuel Leutze, *The Iconoclast (The Puritan and His Daughter),* 1847, oil on canvas, 38 x 32″ (96.5 x 81.3 cm.), Noah Cutler, Philadelphia, in 1975.

NOTES

1. "Cromwell am Krankenbett seiner sterbenden Tochter, die königlich gesinnt, ihrem Vater flucht" (Boetticher [1891–1901] 1969, vol. 1. p. 895).

2. See *The Dictionary of National Biography* (Oxford, 1917; reprint Oxford, 1960), vol. 4, p. 468.

3. See *A Cromwellian Guarding Captive Cavaliers,* location unknown (see National Collection of Fine Arts, Smithsonian Institution, Washington, D.C., *Emanuel Leutze, 1816–1868: Freedom is the Only King,* January 16–March 14, 1976 [catalogue by Barbara S. Groseclose], no. 39); *Cromwell and Milton,* 1854, Corcoran Gallery of Art, Washington, D.C. (Groseclose, no. 65, fig. 33); *Cromwell and Milton,* Städtisches Museum, Schwäbish-Gmünd im Prediger (Groseclose, no. 66, fig. 66); *Oliver Cromwell,* 1867, Rinhart Galleries, Litchfield, Connecticut, 1975 (Groseclose, no. 114, fig. 114; compare Groseclose, no. 115, "Rummaging"); and *Cromwell Discovering the Letter of Charles I at the Blue Boar Inn, Holborn,* James R. Leutze, Chapel Hill, North Carolina (Groseclose, no. 125, fig. 125).

4. See Norman D. Ziff, *Paul Delaroche: A Study in Nineteenth-Century French History Painting* (New York, 1977), pp. 106ff., fig. 45.

5. Groseclose (see note 2), p. 100, under cat. no. 114.

6. Ibid., p. 20.

7. Henry T. Tuckerman, *Book of Artists: American Artist Life* (New York, 1867), p. 342.

8. Groseclose (see note 3), no. 38; a smaller (18½ x 14½ [36 x 43 cm.]) version, signed and dated 1850, was the property of R.H.C. Morgan in sale, Sotheby's, London, February 23, 1977, lot 265.

PROVENANCE: John Towne, 1844 and 1846 (the collection was sold in 1852); sale, John Wolfe, New York, December 22–23, 1863 (to W. P. Wilstach); The W. P. Wilstach Collection, Philadelphia, 1863.

EXHIBITIONS: Artist's Fund Society, The Pennsylvania Academy of the Fine Arts, Philadelphia, 1844, no. 45; National Academy of Design Exhibition Record, 1846, no. 188; National Collection of Fine Arts, Smithsonian Institution, Washington, D.C., *Emanuel Leutze, 1816–1868: Freedom Is the Only King,* January 16–March 14, 1976, p. 74, no. 29 (catalogue by Barbara S. Groseclose); University Art Museum, University of California, Berkeley, *American Portraits and History Painting by Emanuel Leutze,* April 20–May 20, 1976, pp. 20–23, 47, no. 29, fig. 8.

LITERATURE: Rudolf Wiegmann, *Die Königliche Kunst-akademie zu Düsseldorf* (Düsseldorf, 1856); Henry T. Tuckerman, *Book of Artists: American Artist Life* (New York, 1867; reprint New York, 1967), pp. 335, 342, 343; Moritz Blanckarts, *Düsseldorfer Künstler: Nekrologe aus den letzten zehn Jahren* (Stuttgart, 1877), p. 21; Wilstach 1886, no. 62; *Cyclopedia of Painters and Paintings,* edited by John D. Champlin, vol. 3 (New York, 1887), p. 72; Boetticher (1891–1901) 1969, vol. 1, p. 895, no. 4 [incorrectly dated 1642]; Wilstach 1893, no. 59, 1900, no. 86, 1902, no. 95, 1903, no. 111, 1904, no. 148, 1906, no. 167, 1907, no. 176, 1908, no. 176, 1910, no. 240, 1913, no. 251, 1922, no. 184; Thieme-Becker 1907–50, vol. 23 (1929), p. 148; Wolfgang Hütt, *Die Düsseldorfer Malerschule 1819–1869* (Leipzig, 1964), p. 175; PMA 1965, p. 41.

CONDITION: The canvas had been lined with an aqueous adhesive. The original tacking edges are missing. The paint film had been overcleaned before it was treated in October 1968. At the time of the 1968 treatment the old discolored varnish and discolored passages of inpainting were removed. At present the paint film has some cupping in the background and abrasion in the figures and shadowed passages. Retouches are visible in the figure of Cromwell (for example, in the modeling of his breeches and right glove) and scattered throughout the figure of his daughter (in her forehead, hands, and arms). Additional losses are visible at the right, center edge, at the left edge, and in the background. The portrait in the background has been slightly strengthened, as have several shadows beneath Cromwell's boot and the daughter's dress. The varnish is colorless.

PRINT AFTER
Engraved by Fritz Dinger.

LITERATURE: Paul Mantz, "Artistes Contemporains: M. Henri Leys," *Gazette des Beaux-Arts*, 8th yr., vol. 20 (1866), pp. 297–347; E. Fétis in *Annuaire de l'Académie Royale de Belgique* (Brussels, 1872); M. Sulzberger in *Revue de Belgique* (Brussels, 1884); H. Hymans, "Leys et De Braekeleer," *L'Art flamand et hollandais* (Antwerp, 1906); Pol de Mont, *De Schilderkunst in België van 1830 tot 1921* (The Hague, 1921); Gustave Vanzype, *Maîtres d'hier* (Brussels, 1923); Thieme-Becker 1907–50, vol. 23 (1929), pp. 174–75; Gustave Vanzype, *Henri Leys* (Brussels, 1934); Gustave Vanzype, *Leys et son école* (Brussels, 1949); J. F. Buyck, "Henri Leys," in *Openbaar Kunstbezit in Vlaanderen*, vol. 4, no. 13 (1966); Koninklijk Museum voor Schone Kunsten, Antwerp, *Schilderkunst in België ten tijde van Henri Leys (1815–1869)*, September 28–November 16, 1969; Koninklijk Museum voor Schone Kunsten, Antwerp, *Catalogus schilderijen: 19de en 20ste eeuw* (Antwerp, 1979), pp. 260–66.

For an additional work by Leys in the Philadelphia Museum of Art, see John G. Johnson Collection cat. no. 1020.

Born in Antwerp, Hendrik (Henri) Leys was a pupil at the academy under Mattheus van Bree (1733–1839) and later under his brother-in-law, Ferdinand de Braekleer the Elder (1792–1883). At first he painted in the style of Gustaf Wappers (1803–1874), addressing subjects taken from the time of the Spanish occupation of the southern Netherlands in the sixteenth and seventeenth centuries. He soon turned to middle-class domestic genre themes, country feasts and market scenes, as well as more romantically conceived subjects, and ambushes and battles. In 1835 he traveled to Paris, where he visited Eugène Delacroix's studio. His concept of historical genre, however, comes closer to that of Paul Delaroche (1797–1856).

Eschewing the animation and emotion of Romantic art, Leys favored more static, orderly compositions, often on a long horizontal format, and with meticulous, almost archaeological detail sought to reconstruct a medieval world, then still to be found in the older section of his native Antwerp. While his paintings reflect the age's love of sentiment and anecdote, he was most admired for what was perceived by his contemporaries as historical accuracy. Reviewing the Exposition Universelle of 1855, Théophile Gautier wrote of Leys, "He's a sixteenth-century painter who arrived two hundred years too late; that's all" ("C'est un peintre de seizième siècle venu deux cents ans plus tard; voilà tout"). This concern with fidelity to the past extended to style as well as content; Leys studied early Netherlandish and German art, the latter on a trip to Germany in 1850, as well as seventeenth-century Dutch and Flemish painting. In 1855 his international renown was secured by a gold medal at the Salon in Paris, where he exhibited three works whose studious archaism was much admired. In the same year he also executed murals for the dining room of his own house, later known as the Hôtel-Leys, in Antwerp. In the 1860s he received royal commissions and executed a cycle of murals on civil freedom for the Antwerp town hall (1863–69). In acknowledgment of his achievements, he was given the title of baron in 1862. Leys was also active as an etcher and lithographer. His followers included numerous Belgian and many German artists, as well as the English painter Sir Lawrence Alma-Tadema (1836–1912) and the French artist James Tissot (1836–1902).

63 HENDRIK JAN AUGUST LEYS

FAUST AND MARGUERITE, 1856
Signed and dated lower left on the wall: *H. Leys f. 1856*
Oil on panel, 40 x 69¾" (101.6 x 177.2 cm.)
The William L. Elkins Collection. E24-3-83

This painting depicts a scene from Goethe's *Faust* (1808, part 1, lines 2605–77), in which Faust first spies the chaste Marguerite and demands that Mephistopheles secure her love for him ("Hör, du musst mir die Dirne schaffen!" line 2619). Faust is seen standing with Mephistopheles on the far side of a wall with a cast-iron screen on the left. His separation from the central scene lends his espial a furtiveness matching his desire. The beautiful Marguerite emerges from church, where she has just been to confession.

FIG. 63-1 The passageway beneath the Vleeshuis, Antwerp, photograph, Stadsarchief, Antwerp.

The demonic Mephistopheles has overheard her confession and later assures Faust and the reader that she is utterly innocent. Marguerite conforms to Goethe's description of her person and character—a girl more than fourteen years old of modest or lower social standing—with red lips, glowing cheeks, and downcast eyes ("Wie sie die Augen niederschlägt," line 2615).

The elderly woman on her arm is not mentioned in the text but may be her confidante Martha or her mother, who tragically will die together with Marguerite's brother and child as a consequence of Faust's passion. Marguerite's own tragic end comes in prison. The detail of almsgiving to a blind beggar to the right of the church doorway is also unmentioned in Goethe's text but he may prefigure Faust's own final blindness. All of the other figures in the scene wear medieval costume. The architecture is also medieval in style, confected from a fanciful combination of actual buildings in Antwerp. On the left of the painting the passage beneath the Vleeshuis (Butchers' Hall) in Antwerp has been transformed into the entrance to the chapel (compare fig. 63-1), while the chapel on the right is freely based on the St. Nicolas chapel in Longue Rue Neuve.[1] On the second pier from the right an inscription in Dutch indicates that a public notary and his wife are buried there; however, no such tomb is known in Antwerp.[2]

Goethe's *Faust* was one of the most popular and influential books of the nineteenth century. It was repeatedly adapted for the opera and the popular stage and proved to be endlessly fascinating for artists.[3] As often as not, Marguerite was the center of interest in the French versions of the story, her piety and peasant origins usually made a caricature.[4] Some of the greatest Romantic artists addressed subjects from *Faust*. Eugène Delacroix

FIG. 63-2 Hendrik Jan August Leys, *Walk Outside the Walls,* oil on panel, 27¼ x 41½" (69.2 x 104.8 cm.), formerly in the Royal Collections, Brussels.

FIG. 63-3 Hendrik Jan August Leys, *Marguerite,* 1860, oil on panel, 10¼ x 8" (26 x 20.5 cm.), location unknown.

(1798–1863), for example, had been inspired by an operatic version of Goethe's tale to make a series of seventeen lithographic illustrations as early as 1825. Ary Scheffer (1795–1858) also was fascinated by *Faust,* making a specialty of themes involving Marguerite. He exhibited his *Faust in His Study* (no. 2613) and *Marguerite Spinning* (no. 2614) at the Salon of 1831.[5]

Although he could scarcely have escaped exposure to *Faust* through its many popular manifestations, Leys's artistic interest in the tale may have been inspired by Delacroix, whose studio he visited repeatedly in Paris and who returned a visit to Leys's own studio in Antwerp on August 11, 1850.[6] It must have been shortly thereafter that Leys made his trip to Germany, which increased his admiration for German artists (see, for example, *Albrecht Dürer's Visit to Antwerp in 1520,* dated 1855, oil on panel, 35½ x 63" [90 x 160 cm.], Koninklijk Museum voor Schone Kunsten, Antwerp, no. 2198) as well as German themes (*Luther at Wittenberg,* location unknown) and literature. His *Walk Outside the Walls* of 1854, which was part of the Belgian royal collections (fig. 63-2) depicts Faust and Wagner sitting outside the town gates watching people return from their Easter celebration. It was exhibited at the Paris Salon in 1855 (no. 362) with an extensive quotation from *Faust* in the catalogue extolling spring's regeneration and the resurrection of the spirit. Leys painted yet another scene from *Faust* in 1860, depicting the single figure of *Marguerite* (fig. 63-3)[7] in Martha's walled garden holding the flowers that she will pluck in an attempt to divine Faust's love.

In selecting the specific moment depicted in the Philadelphia painting, Leys focused on a turning point in Faust's tale. In the immediately preceding scene, Mephistopheles had sought to win Faust over in the witches' kitchen by appealing to his physical desire, conjuring up a female image vaguely identified as Helen of Troy. Faust's personality changes for the first time in his scene with Marguerite. Gone are his higher spiritual and scholarly aspirations, replaced by coarse language and crude passion. The embodiment of unaffected simplicity, honest folkways, and devotion, Marguerite will be ruined by Faust's newly transformed self.

Leys's "archaeological" approach to painting arose from the same spirit as pre-Raphaelitism in England; indeed, he was often called the Belgian pre-Raphaelite. He was more restrained in his sentiment, however, and more deliberately archaizing in technique (such as his use of panel supports and a painstaking execution) and in his approach to design. His practice, for example, of composing on a long horizontal format with many of the figures appearing in profile parallel to the picture plane recalls medieval compositional techniques, as witnessed in the mural on the building in this painting.

The Philadelphia picture was much admired in the nineteenth century not only by other artists but also by collectors and connoisseurs. James Tissot's *Meeting of Faust and Marguerite,* dated 1860 (fig. 63-4), exhibited with two other paintings illustrating Faust in the Paris Salon the following year,[8] and later preserved in the Musée National du Luxembourg, Paris, was undoubtedly inspired by Leys's painting.[9] It depicts the moment immediately preceding the one illustrated in the Philadelphia picture, when Faust unsuccessfully offers Marguerite his arm ("Mein schönes Fräulein, darf ich wagen,/Meinen Arm und Geleit Ihr an zu tragen?" lines 2605–6). Tissot, in fact, was criticized as a *pasticheur* for his borrowings from Leys.

FIG. 63-4 James Tissot, *The Meeting of Faust and Marguerite,* dated 1860, oil on panel, 30¾ x 47¼″ (78.1 x 120.3 cm.), Musée National du Luxembourg, Paris, cat. no. 484.

Théophile Gautier wrote in his review of the Salon of 1861, "'Thief! Corrupt thief!' cries out M. Leys before M. Tissot's painting; 'He has taken my individuality, my skin, as a robber in the night carries off a garment left on a chair'").[10] In *The Art Treasures of America,* published in 1880, Edward Strahan wrote enthusiastically about Leys's Philadelphia picture, then in the well-known collection of August Belmont in New York: "His wizard-like power of throwing himself into the spirit of the middle age, so that Matsys's [*sic*] portraits seem to be alive again, was never exerted with more illusive effect; while the lighting and *ordonnance* of the scene—the modeling, about midway between the shadow-drowned style of his earlier period, and the hard stain-glass manner of his close—the masterly grasp of the whole composition, antique as a missal, actual as a photograph—these qualities combine to give the weirdest charm that is possibly attainable from the archaic style of painting."[11]

NOTES

1. I am very grateful to Dr. J. van den Nieuwenhuizen, archivist of the City of Antwerp, for identifying these sources (letter, May 14, 1985, Philadelphia Museum of Art, accession files).

2. The visible part of the inscription reads: "D.O.M/Hier light/begraeven/JAN VAN DER/SPIET/in syn leven/notaris pub/en syn vrouw/die leef ob...." Beneath the coat of arms behind the central couple is a Latin inscription "IOHAN·EX COM AB."

3. On the operatic adaptations and settings of *Faust,* see Wallace Brockway and Herbert Weinstock, *The World of Opera* (New York, 1966), p. 259; and Félix Clement and Pierre Larousse, *Dictionnaire lyrique ou histoire des operas* (Paris, n.d.), p. 275. On *Faust* and the popular theater, see Marian Hannah Winter, *Le Théatre du merveilleux* (Paris, 1962), p. 150. For a discussion of *Faust* in France and French artists' treatments of the Faust and Marguerite theme, see Michael Wentworth, *James Tissot* (Oxford, 1984), pp. 22–24.

4. For the French conception of Marguerite, see Paul de Saint-Victor, "Les Femmes de Goethe: La Marguerite et la Frédérique," *L'Artiste,* vol. 9 (January 1870), pp. 5–19.

5. Both 65 x 49¼″ (165 x 125 cm.).

6. See Delacroix's *Journal 1822–1863* (Paris, 1980), p. 263. Delacroix also wrote admiringly of Leys's work following the latter's success at the 1855 Paris Salon in his journal entry for June 17, 1855.

7. Sale, Kums, Antwerp, May 17–18, 1898, lot 30, repro. The painting was recorded as sold to the museum in Ghent but it was not in that institution's 1930 catalogue.

8. Salon, no. 2972. The other paintings are *Faust and Marguerite in the Garden* (Salon, no. 2970), oil on panel, 28¾ x 35½″ (64.8 x 90.2 cm.), David E. Rust, Washington D.C., and *Marguerite in Her Study* (Salon, no. 2971), location unknown.

9. Wentworth (see note 4), p. 28, evidently was unaware of the Philadelphia painting and wrongly suggested that the *Walk Outside the Walls* (fig. 63-2) was the source for the Tissot. Tissot painted seven *Faust* pictures in all (see Wentworth pls. 1, 2, 4–8).

10. Quoted by Wentworth (see note 4), p. 27; see Théophile Gautier, *Abécédaire du Salon de 1861* (Paris, 1861), p. 338 ("'Au voleur! au vouleur!' pourrait crier M. Leys devant le peinture de M. Tissot; 'Il m'a pris mon individualité, ma peau, comme un larron de nuit emporte un vêtement laissé sur une chaise'").

11. Edward Strahan, *The Art Treasures of America,* vol. 1 (Philadelphia, 1880), p. 109.

PROVENANCE: Acquired from the artist by the Duc de Brabant; August Belmont, New York, by 1880; William L. Elkins Collection, Philadelphia, by 1900.

EXHIBITION: Cercle Artistique d'Anvers, Antwerp, 1856.

LITERATURE: Paul Mantz, "Artistes contemporains: M. Henri Leys," *Gazette des Beaux-Arts,* 8th yr., vol. 20 (1866), p. 308; Edward Strahan, *The Art Treasures of America,* vol. 1 (Philadelphia, 1880), p. 109, repro.; Elkins 1887–1900, vol. 1, no. 32, repro.; PMA 1965, p. 41; C. Franklin Sayre, "Sir Lawrence Alma-Tadema's *A Roman Amateur,*" *Yale University Art Gallery Bulletin,* vol. 34, no. 2 (June 1973), p. 15, fig. 5.

CONDITION: The panel support is composed of three horizontal planks with horizontal grain and is cradled. The paint film reveals drying crackle in the darks, minor wrinkling, and old inpainted losses along the edges. Brushmarking that is inconsistent with the present design suggests significant artist's changes in the painting's composition. The varnish was removed and cleaving paint set down in 1967. The new varnish layer is colorless.

LITERATURE: Jan Jansz. Orlers, *Beschrijvinge der Stadt Leyden* (Leiden, 1641), p. 375; Dmitri Rovinski, *L'Oeuvre gravé des élèves de Rembrandt* (St. Petersburg, 1894); Arthur Mayger Hind, "The Woodcut Portraits of Jan Lievens and Dirk de Bray," *The Imprint*, vol. 1 (1913), p. 233; Hans Schneider, *Jan Lievens: Sein Leben und seine Werke* (Haarlem, 1932; 2nd ed., Amsterdam, 1973); Kurt Bauch, "Rembrandt und Lievens," *Wallraf-Richartz-Jahrbuch*, vol. 2 (1939), pp. 239–68; H. van de Waal, "De Hollandsche houtsneden der zeventiende eeuw, II, Werner van den Valckert en Jan Lievens," *Halcyon*, vol. 1 (1940), nos. 3–4; F.W.H. Hollstein, *Dutch and Flemish Etchings, Engravings and Woodcuts, ca. 1450–1700*, vol. 11 (Amsterdam, 1955), pp. 5–78; J. Michalkowa, "Les Tableaux de Jan Lievens dans les collections polonaises," *Biuletyn Historii Sztuki*, vol. 18 (1956), pp. 392–401; Kurt Bauch, "Zum Werk des Jan Lievens (I)," *Pantheon*, vol. 25, no. 3 (May–June 1967), pp. 160–70; Kurt Bauch, "Zum Werk des Jan Lievens (II)," *Pantheon*, vol. 25, no. 4 (July–August 1967), pp. 259–69; Herzog Anton Ulrich Museum, Brunswick, *Jan Lievens: Ein Maler im Schatten Rembrandts*, September 6–November 11, 1979; Christopher Brown, review of the preceding catalogue in *The Burlington Magazine*, vol. 121, no. 920 (November 1979), pp. 744–46; Werner Sumowski, *Gemälde der Rembrandt-Schüler*, vol. 3 (Landau and Pfalz, 1983), pp. 1764–1950.

For additional works by Lievens in the Philadelphia Museum of Art, see John G. Johnson Collection cat. nos. 487, 473 (copy after).

Jan Lievens(z) was the son of Lieven Hendricx, an embroiderer from Ghent, and Machtelt Jansdr. van Nortsant. According to Jan Jansz. Orlers, he was born on October 24, 1607, in Leiden, where he later became a student of Joris van Schooten (1587–1651). At about the age of ten he began a two-year period of study with Pieter Lastman (1583–1633) in Amsterdam, and subsequently returned to Leiden to work on his own. He is recorded in Leiden in 1624, 1626, and 1629; in 1626 and 1627 he painted the portrait of Constantijn Huygens, the stadholder's secretary. From about 1625 to 1631 he seems to have worked very closely with the young Rembrandt. This probably was not a student-teacher relationship (Rembrandt was only one year older) but an association between colleagues. Orlers noted that Lievens traveled in 1631 to England, where he remained for the three years. The trip is confirmed by references to portraits that he painted of Charles I and members of the royal family. He had certainly returned to Antwerp by 1635, when he entered the guild there. A document of 1636 indicates that he was acquainted with Adriaen Brouwer (1605/6–1638), and Jan Davidsz. de Heem (1606–1683/84) in Antwerp. He seems to have remained in the city until 1638, when he married Susanna de Nole, daughter of the architect Andries Colyns de Nole. The following year he was back in Leiden, and in 1639 and 1640 painted a picture for the city's town hall. In December 1640 he acquired citizenship in Antwerp and baptized sons there in 1642 and 1644. By March 1644 he was in Amsterdam, apparently living with the painter Jan Miense Molenaer (c. 1610–1668), and is recorded as being there until June 1653. In 1648 he was married, for a second time, to twenty-year-old Cornelia de Bray, daughter of the Haarlem painter Salomon de Bray (1597–1664). In 1650 he worked on the decorations for the Huis ten Bosch near The Hague and seems to have lived in that city intermittently between 1654 and 1658. A letter dated 1654 describes Lievens as painter to the dukes of Brandenburg; another letter written in September 1655 notes that he had left a house in Berlin. He was a founder in 1656 of "Pictura," the painter's confraternity in The Hague, and in the same year painted a large composition for the new Amsterdam town hall. In 1661 he paid dues to "Pictura" although he had again begun living in Amsterdam and seems to have remained there until 1669. In 1661 he was commissioned to produce another painting for the Amsterdam town hall and four years later contributed decorations for the provincial assembly chamber in The Hague; in 1666, 1669, and 1670 he painted works for the Rijnlandshuis in Leiden. He was living in The Hague in 1670 and 1671, but was back in Amsterdam the following year; he died there on June 4, 1674, and was buried in Nieuwe Kerk.

A painter of history subjects, portraits, genre scenes, and landscapes, Lievens was close in style to Rembrandt in his early years, but altered his manner under the influence of Rubens (q.v.) and Anthony van Dyck (1599–1641) at Antwerp. He also was in contact with the Haarlem classicists. In his later years he enjoyed many important public and royal commissions. He also made many drawings and etchings, as well as a few woodcuts.

64 ATTRIBUTED TO JAN LIEVENS

PORTRAIT OF A MAN IN A TURBAN, c. 1629
Oil on canvas, 35½ x 25⅜″ (90.2 x 64.5 cm.)
Gift of the Reverend Theodore Pitcairn. 61-195-1

Viewed half-length and turned to the viewer's left, a man with a beard and
a small, wispy mustache is dressed in a turban of green cloth and gilt
embroidery, a dark, embroidered robe and a gold chain, and an enveloping
mantle. The figure's prominent gaze is directed not so much at the viewer
as off into space.

 The work was first published in 1899 in the exhibition catalogue of
Sedelmeyer's gallery in Paris as Rembrandt's portrait of his father.[1] Wilhelm

FIG. 64-1 Rembrandt van Rijn, *An Oriental,* 1630, etching, 4 x 4¼″ (102 x 108 mm.).

FIG. 64-2 Jan Lievens, *An Old Man in Oriental Costume,* signed, c. 1629, oil on canvas, 53¼ x 39½″ (135 x 100.5 cm.), Bildergalerie, Sanssouci, Potsdam, no. GK1884.

von Bode and C. Hofstede de Groot accepted the painting in their comprehensive study of the master's oeuvre in 1906, entitling it "Rembrandt's Father with an Oriental Head-Cloth" and dating it to his Leiden years, or about 1629.[2] In 1909 W. R. Valentiner also accepted the work but correctly rejected the identification of the model as the painter's father, of whom no certain portrait or likeness is known to exist.[3] In his catalogue raisonné of 1916, Hofstede de Groot restated his earlier opinion but titled the work "An Oriental" and claimed that it was signed.[4] No signature is now visible on the work and none was ever observed by any other writer. D. S. Meldrum (in 1923), Abraham Bredius (in 1936), and Kurt Bauch (in 1966) also accepted the painting as by Rembrandt.[5] Bauch dated the painting around 1630–31 and compared it to the *Man in a Beret* of 1629 in the James D. Warburg Collection.[6] In his revised 1969 edition of Bredius's study of 1935, Horst Gerson identified it as "A painting from the Leyden circle of Rembrandt, but not strong enough to be attributed to the master himself."[7] Most recently, Josua Bruyn and the team of the Rembrandt Research Project concluded in 1982 that the painting was not by Rembrandt or his "immediate circle" but "presents some general resemblances to Jan Lievens' work of around 1630, and might, if it is not of a later date, be connected with this artist's production."[8]

The etchings (see fig. 64-1) and paintings of "Orientals" by Rembrandt to which this should be compared all date from his Leiden and earliest Amsterdam years (c. 1629–33).[9] While the designs of these works often are quite similar, the technique of the paintings differs from that of the present picture, in which the paint was applied relatively thinly and evenly overall with only a few isolated areas of impasto such as the gold chain and the turban. As noted by the Rembrandt team, the Philadelphia painting is characterized by a fine, even craquelure. However, there is no physical or stylistic evidence to indicate later (eighteenth century) origins, as sometimes has been privately speculated; indeed, the authors of the *Corpus of Rembrandt Paintings* concluded that the paint film was likely to be "of considerable age, possibly even around 1630."[10]

During his last years in Leiden, Rembrandt worked closely with Jan Lievens. While it is often difficult to distinguish the two young artists' hands,[11] several works by Lievens reveal points of resemblance with the present work not only in execution but also in the conception and pose of the figure. *An Old Man in Oriental Costume* (fig. 64-2) in the Bildergalerie at Sanssouci in Potsdam,[12] for example, stares out of the picture in the same way, employs a similar pyramidal composition, and, though adopting a lighter overall tonality, is executed in a comparable technique, which varies relatively slick and broad passages of paint. Lievens's bust-length studies of men in historical costume, such as the painting in Warsaw,[13] also invite comparison, as do the figures with deep sunken eyes in his etchings (see fig. 64-3).[14] Constantijn Huygens mentioned the Sanssouci painting in 1630 in his autobiography,[15] providing a *terminus ad quem* for its origin. Thus it probably dates from around 1629. If by Lievens, the Philadelphia painting would also date from this period. Lievens had been mentioned as a possible author of the work on several occasions by visiting specialists prior to the published reference to this idea in 1982, although the Museum's files do not specify who first proposed the attribution.

FIG. 64-3 Jan Lievens, *Man in Historical Costume*, etching, 3½ x 2¾″ (89 x 72 mm.).

By the time Rembrandt and Lievens painted these works, the depiction of Orientals constituted a long tradition in European art.[16] The two artists' interest may have been piqued at this particular time by the fact that a Dutch embassy had been sent to Persia in 1623 to negotiate trade relations. In 1626 and 1627 great excitement attended the return visit paid by a Persian delegation.[17] Following the opening of these channels Dutch painters were active at the Persian court. Lievens's painting in Potsdam is an accurate portrayal of Persian dress;[18] however, he also depicted Orientals whose outfits were only approximations of actual native costume.[19] The present work appears to be an admixture of Persian and Turkish elements. The articles themselves are plausibly rendered; for example, the crossed-over undergarment worn beneath an overgarment (or *jama*) in a contrasting color and pattern and the multicolored turban appear on figures in seventeenth-century Persian oil paintings,[20] but the tight winding of the turban cloth at a period when Persian turbans were exaggeratedly large argues against the subject being Persian.[21] Thus, like the majority of Rembrandt's works of this type, the painting is probably designed to evoke the exotic aura of a historical personage with studio props rather than to give an authentic account of a foreigner's appearance.

NOTES

1. Sedelmeyer Gallery, Paris, *Illustrated Catalogue of the Fifth Series of 100 Paintings by Old Masters* (Paris, 1899), pp. 46–47, no. 38, repro. [as "Portrait of Rembrandt's Father"].
2. Wilhelm von Bode and Cornelis Hofstede de Groot, *The Complete Work of Rembrandt,* vol. 8 (Paris, 1906), p. 48, no. 543, repro.
3. W. R. Valentiner, *Rembrandt: Des Meisters Gemälde in 643 Abbildungen,* 3rd ed. (Stuttgart and Leipzig, 1909), p. 551, repro. p. 47. A Rembrandt drawing of an old bearded man in the Ashmolean Museum, Oxford, may represent Rembrandt's father, but the inscription "Harmen Gerrits/van Rijn" is by a later hand. Moreover, the sitter bears no resemblance to the model in the Philadelphia painting.
4. Hofstede de Groot 1908–27, vol. 6 (1916), no. 345.
5. D. S. Meldrum, *Rembrandt's Paintings* (New York, 1923), pl. XLIV, repro.; Abraham Bredius, *The Paintings of Rembrandt* (Vienna and London, 1936), no. 133, repro.; Kurt Bauch, *Rembrandt Gemälde* (Berlin, 1966), p. 9, no. 133, repro.
6. Since Bauch's writing the painting was acquired by The Fogg Art Museum, Cambridge, Massachusetts, and retitled *Portrait of His Father* (oil on canvas, 8 x 6¾″ [20 x 17 cm.], acc. no. 1969.57). The attribution to Rembrandt was questioned by Josua Bruyn, B. Haak, S. H. Levie, P.J.J. van Thiel, and E. van de Wetering in *A Corpus of Rembrandt Paintings,* Stichting Foundation Rembrandt Research Project, translated by D. Cook-Radmore, vol. 1 of 2, *1625–1631* (The Hague, Boston, and London, 1982), p. 611.

7. Abraham Bredius, *Rembrandt: The Complete Edition of Paintings,* revised by Horst Gerson (London, 1969), p. 558, no. 133, repro. p. 122.
8. Bruyn et al. (see note 6), p. 575.
9. Compare the etching of 1630 (fig. 64-1); Helle Gersaint, Glomey Gersaint, and P. Yver Gersaint, *Catalogue Raisonné de toutes les Estampes de Rembrandt,* revised and edited by Adam Bartsch (Vienna, 1797), p. 266, no. 321, and the paintings of figures in turbans and headdresses: *A Young Man in a Turban,* 1631, oil on panel, 25 x 19¾″ (63.5 x 50 cm.), Windsor Castle (Bredius [see note 5] no. 142); *The Noble Slav,* 1632, oil on canvas, 59 x 43″ (150.3 x 109 cm.), The Metropolitan Museum of Art, New York, acc. no. 20.155.2 (Bredius no. 169 [as "A Man in Fanciful Costume"]); *A Man in Oriental Costume,* 1633, oil on panel, 34 x 25¼″ (86 x 64 cm.), Alte Pinakothek, Munich, inv. no. 421 (Bredius no. 178); *A Turk,* c. 1630/35, oil on canvas, 38¾ x 29″ (98 x 74 cm.), The National Gallery of Art, Washington, D.C., acc. no. 1940.1.13 (Bredius no. 180 [as "A Man in Oriental Costume"]); and *Rembrandt's Mother,* before 1633, oil on panel, 23 x 17¾″ (58.5 x 45 cm.), Collection of Her Majesty Queen Elizabeth II, Windsor Castle (Bredius no. 70).
10. Bruyn et al. (see note 6), p. 575.
11. On the relationship of the two artists, see Kurt Bauch, "Rembrandt und Lievens," *Wallraf-Richartz-Jahrbuch,* vol. 11 (1939), pp. 239–68; J. G. van Gelder, "Rembrandt's vroegste ontwikkeling," *Mededelingen der Koninklijke Akademie van Wetenschappen,* vol. 16, no. 5 (1953), pp. 282–90; Jan Biatostocki, "Lievens und Rembrandt," in

Herzog Anton Ulrich Museum, Brunswick, *Jan Lievens: Ein Maler im Schatten Rembrandts,* September 6–November 11, 1979, pp. 13–20.

12. Gotz Eckardt, *Die Gemälde in der Bildergalerie von Sanssouci* (Potsdam, 1980), pp. 47–48, no. 70; H. Schneider, *Jan Lievens: Sein Leben und seine Werke* (Haarlem, 1932), 2nd ed., with R.E.O. Ekkart (Amsterdam, 1973), p. 130, no. 152; repro. Herzog Anton Ulrich Museum, Brunswick (see note 11 above), p. 16.

13. *An Old Man,* signed "L," oil on panel, 28 x 21¼″ (71 x 54 cm.), Muzeum Narodowe w Warzawie, inv. no. 212295; repro. Herzog Anton Ulrich Museum, Brunswick (see note 11), p. 95.

14. Gersaint et al. (see note 9), pp. 26–28, no. 27 [as "Portrait of a Man from the Left"]; Dmitri Rovinski, *L' Oeuvre gravé des élèves de Rembrandt* (St. Petersburg, 1894), no. 362; Schneider and Ekkart (see note 12), p. 273.

15. Constantijn Huygens referred to it as a "Dux Turcicus"; see J. A. Worp, "Constantijn Huygens over de schilders van zijn tijd," *Oud Holland,* vol. 9 (1891), p. 128; Herzog Anton Ulrich Museum, Brunswick (see note 11), pp. 33, 96, 240.

16. On the tradition see the two-part article by Hermann Goetz, "Oriental Types and Scenes in Renaissance and Baroque Painting," *The Burlington Magazine,* vol. 73, no. 425 (August 1938), pp. 50–62; and "Oriental Types and Scenes in Renaissance and Baroque Painting: II," *The Burlington Magazine,* vol. 73, no. 426 (September 1938), pp. 105–15; Alexandrine N. St. Clair, *The Image of the Turk in Europe* (New York, 1973); and Leonard J. Slatkes, *Rembrandt and Persia* (New York, 1983).

17. See Schneider and Ekkart (note 12), p. 302; Goetz (note 16 above), pp. 111–12.

18. Goetz (note 16), p. 112.

19. According to Goetz (note 16), p. 112, Lievens's *Moses Trampling on Pharaoh's Crown* (oil on canvas, 45 x 69″ [114 x 175 cm.], Musée des Beaux Arts, Lille, 1893 catalogue, no. 1056 [as by Bonifazio Veronese]) includes costumes that only approximate Turkish types.

20. Eleanor Sims in a letter of November 15, 1984 (Philadelphia Museum of Art, accession files), compares the costume to that of the figure in the painting reproduced as pl. 138 in Hermann Goetz's "Five Seventeenth-Century Persian Oil Paintings," in P. & D. Colnaghi, London, *Persian and Mughal Art* (London, 1976), pp. 221–48.

21. Compare Goetz (see note 20), pls. 46ii, 46xii, and 55iii. Sims in her 1984 letter suggests that the original usage of the turban cloth in the Philadelphia painting may have been a sash.

PROVENANCE: Donovan Collection, England; T. Humphrey Ward, London;[1] dealer T. Agnew & Sons, London; dealer C. Sedelmeyer, Paris, 1899; Mme F. May, Brussels, by 1906,[2] until after 1916;[3] the Reverend Theodore Pitcairn, Bryn Athyn, Pennsylvania.

NOTES TO PROVENANCE:
1. Sedelmeyer Gallery, Paris, *Illustrated Catalogue of the Fifth Series of 100 Paintings by Old Masters* (Paris, 1899), pp. 46–47, no. 38.
2. Hofstede de Groot 1908–27, vol. 6 (1916), no. 345.
3. *The Pennsylvania Museum Bulletin* (Philadelphia Museum of Art), vol. 24, no. 126 (March 1929), repro. p. 2.

EXHIBITIONS: Stedelijk Museum "de Lakenhal," Leiden, *Schilderijen en Teekeningen van Rembrandt en Schilderijen van andere Leidsche Meesters der zeventiende eeuw,* 1906, no. 34; Brussels Museum, 1916 [on loan from Mme May]; Philadelphia Museum of Art, 1929 [on loan from Reverend Pitcairn].

LITERATURE: Wilhelm von Bode and C. Hofstede de Groot, *The Complete Work of Rembrandt,* vol. 8 (Paris, 1906), no. 543, repro. [as c. 1629]; W. R. Valentiner, *Rembrandt: Des Meisters Gemälde in 643 Abbildungen,* 3rd ed. (Stuttgart and Leipzig, 1909), p. 551, repro. p. 47 [as c. 1629]; Hofstede de Groot 1908–27, vol. 6 (1916), no. 345 [as Rembrandt, signed, c. 1629]; D. S. Meldrum, *Rembrandt's Paintings, with an Essay on His Life and Work* (London and New York, 1923), pl. XLIV; *The Pennsylvania Museum Bulletin* (Philadelphia Museum of Art), vol. 24, no. 126 (March 1929), repro. p. 2; Abraham Bredius, *Rembrandt: The Complete Edition of the Paintings* (Vienna and London, 1935), 3rd ed., revised by Horst Gerson (London and New York, 1969), no. 133, repro.; "Accessions of American and Canadian Museums, January–March, 1962," *The Art Quarterly,* vol. 25, no. 2 (summer 1962), p. 176 [as Rembrandt]; Kurt Bauch, *Rembrandt: Gemälde* (Berlin, 1966), no. 133, pl. 133 [as c. 1630–31]; PMA 1965, p. 56 [as Rembrandt, c. 1629]; Josua Bruyn, B. Haak, S. H. Levie, P.J.J. van Thiel, and E. van de Wetering, *A Corpus of Rembrandt Paintings,* Stichting Foundation Rembrandt Research Project, translated by D. Cook-Radmore, vol. 1 of 2, *1625–1631* (The Hague, Boston, and London, 1982), pp. 572–75, no. C21, repros.

CONDITION: The painting has an aqueous lining. The original tacking edges are missing. The paint film has minor abrasion in the face and scattered minor losses. One large loss about 1½″ (3.8 cm.) in diameter has been filled and retouched. The loss is on the lower right side and is readily visible in the x-radiograph. Three areas of cleavage were secured in April 1970. The heavy varnish layer, to which a fresh coat was added at the time of treatment in 1970, is discolored.

Baptized in London on February 25, 1616, in the Dutch Reformed
Church Austin Friars, Isaac Luttichuys (or Luttichhuijs, Lutighuis)
was the son of Bernard Luttichuys and the brother of the still-life painter
Simon Luttichuys (1610–1662). At an unknown but probably early date, he
moved to Amsterdam, where it is presumed he and his brother studied. In
1643 he married Elisabeth Adolfs Winck in Amsterdam and the couple had
at least one child. Elisabeth died in 1645 and two years later Isaac was
married to Sara Gribert; they had two more children (one in 1648, and
another in 1650). In 1662 Luttichuys testified in Amsterdam on behalf of a
young woman from the wealthy Lestevenon family (members of which he
had portrayed on other occasions), whom he had portrayed with her French
lover, Gabriel Lalonde, in a pair of pendants. Evidently the Frenchman
absconded with the paintings after the woman had paid for them. In the
ensuing scandal, which terminated the love affair, Isaac testified to the
young woman's honor. In 1662 Luttichuys signed as a witness to a
document with the painter Philips Koninck (1619–1688). Nonpayment of
back rent totaling the not insignificant sum of 793 guilders and owed to
Laurens Dubbeldeworst resulted in actions taken against Luttichuys in 1668,
which required an inventory of his property and a small painting collection.
On March 6, 1673, Isaac was buried in the Westerkerk in Amsterdam.

A lost drawing of the mother of the poet P. C. Hooft was dated 1638
and is Luttichuys's earliest known work. A *Head of a Laughing Boy*
(formerly in the Pelzer Collection, Cologne) is dated 164– and suggests that
he began his career working in a Rembrandtesque manner reminiscent of
that of Samuel van Hoogstraten (1627–1678). In the early 1640s he also
painted full-length outdoor portraits of well-to-do burghers. Following
general trends in Amsterdam, his portraiture style shed its Rembrandtesque
chiaroscuro around 1650 for a clearer, cooler light and a technique closer to
that of Bartholomeus van der Helst (1613–1670). In addition to portraits,
Isaac seems to have painted an occasional still life.

LITERATURE: Adrius Bredius,
Künstler-Inventare, vol. 4 (The Hague, 1917),
pp. 1288–1308; W. R. Valentiner, "Isaac
Luttichuys: A Little-Known Dutch Portrait
Painter," *The Art Quarterly,* vol. 1 (1938),
pp. 150–79.

65 ISAAC LUTTICHUYS

PORTRAIT OF A YOUNG LADY HOLDING AN ORANGE, c. 1645–50?
Oil on copper, oval, 4½ x 3¼" (11.4 x 8.3 cm.)
Purchased: Director's Discretionary Fund. 68-97-1

A young woman is portrayed turned to the viewer's left holding an orange
in her left hand. Standing before a pillar, she wears a red dress covered with
a blue shawl that she holds up daintily with her right hand. She has
adorned herself with four pearl strings on her left wrist, a string of pearls
around her neck, a pair of pearl earrings, and pearl decorations at the
shoulders of her dress.

The picture was acquired as a work by Jan Mijtens (1614–1670), which,
according to an "old family story," depicted a princess of Orange.
Comparisons with Mijtens's portraits reveals some similarities but hardly
confirms the attribution. The woman's pose and costume are derived from
Anthony van Dyck's *Portrait of Frances Cranfield, Countess of Dorset* at Knole,[1]
which inspired the design of many portraits in these years.[2] Willem L. van
de Watering first observed in a letter of March 1980 the present work's close
resemblance in conception, design, and accessories to portraits by Isaac
Luttichuys, which employ the Van Dyckian formula; the Philadelphia
painting may be compared with a painting of 1657 in Mainz (fig. 65-1) as
well as a second undated *Portrait of a Woman Holding a Rose* by Luttichuys,
formerly with Galerie Hoogsteder, The Hague, and now in the Ringling
Museum, Sarasota (fig. 65-2).[3] Further, the large column in the background
(absent from the Van Dyck) reappears in Luttichuys's *Portrait of a Woman,*

FIG. 65-1 Isaac Luttichuys, *Portrait of a Lady with a Rose,* signed and dated 1657, oil on canvas, 39 x 31⅞" (99 x 81 cm.), Mittel-rheinisches Landesmuseum, Mainz, inv. no. 809.

FIG. 65-2 Isaac Luttichuys, *Portrait of a Lady with a Rose,* c. 1660, oil on canvas, 37¼ x 30½" (95 x 77 cm.), The John and Mable Ringling Museum of Art, Sarasota, Florida, no. SN 262.

which was in the sale of W. F. van Heukelom et al., Frederik Muller, Amsterdam, June 15, 1937.[4] The luminous technique of the portrait is also quite close to the style of Luttichuys; however, the tiny scale, indeed, almost miniature format, renders these similarities less evident in reproductions. We know that Luttichuys was born in London. If he retained contact with England, it might, in part, explain his familiarity with Van Dyckian motifs and interest in miniature portraiture, although the present work is not, properly speaking, a miniature. One hastens to add, moreover, that he could have just as readily learned these techniques in Holland, where small-scale portraits had long been produced. His style has more in common with the Haarlem and Amsterdam circle of portraitists than with the Leiden "fijnschilders."

While a firm identification for the sitter evades us, the tradition of identifying her as one of the princesses of Orange finds some, albeit tenuous, support through comparisons with known portraits of Maria Henriette Stuart (1631–1660), princess royal of England and princess of Orange, daughter of Charles I and Henrietta Maria, and wife of Willem II; see especially Van Dyck's portraits of the young princess, both as a child and a child bride in 1641.[5] All of Van Dyck's images depict a very young girl who even in 1641 appears at least several years younger than the teenaged sitter in the Philadelphia painting. Maria left England with her mother in 1642 and in February 1644 assumed her official conjugal role in Holland, where she is recorded as having given audiences, received ambassadors, and fulfilled all functions of state with a poise and decorum remarkable for her years.[6] If the sitter is Maria Henriette, the picture would seem to date from c. 1645–50, a period of origin not inconsistent with Luttichuys's authorship. In Van der Helst's later portrait of Maria dated 1652, she holds an orange as an allusion to the House of Orange. This attribute, however, need not be the sign of royalty; while it could signify political sympathy or association with the Orangists, it also was a costly fruit in the North, hence an appropriate attribute for wealthy sitters. This was a period in which orangeries, especially in France, were just becoming popular. Moreover, since antiquity the orange and orange blossoms had been symbols of chastity and love; thus they figured prominently as attributes in Dutch marriage and family portraits.[7] Another candidate for the identification of the portrait is Maria, princess of Orange (1642–1688), the youngest daughter of Stadholder Frederik Hendrik, who married Lodewijk Hendrik Maurits, count Palatine von Simmern in 1666.[8] In that case the portrait would date from the late 1650s.

Although the pearls worn prominently by the sitter may function only as adornment, they might have a variety of additional meanings and perhaps allude to some virtue of hers, such as purity or chastity.[9]

NOTES

1. See Gustav Glück, *Van Dyck: Des Meisters Gemälde* (Stuttgart and Berlin, 1931), p. 469 (oil on canvas, 76 x 53¼″ [193 x 135 cm.]); and Eric Larsen, *L'opera completa di Van Dyck,* vol. 2 (Milan, 1980), no. 874; the pose also figures in Van Dyck's *Portrait of Anne, Countess of Morton,* oil on canvas, 41 x 31″ (104 x 79 cm.), Althorp Park (see Glück, p. 495).

2. Compare, for example, Samuel Cooper's miniature *Portrait of Lady Margaret Lely,* dated 1648, Fitzwilliam Museum, Cambridge, no. 3787 (repro. National Portrait Gallery, London, *Samuel Cooper and His Contemporaries* [London, 1974], p. 17); Adriaen Hanneman's *Portrait of Louisa Hollandina, Princess Palatine,* dated 1655, oil on canvas, 41 x 35½″ (104 x 90 cm.), Marienburg Castle, Hanover (repro. O. ter Kuile, *Adriaen Hanneman, 1604–1671: A Portrait Painter in The Hague* [Amsterdam, 1976], pl. 79). Also compare Peter Lely's *Portrait of the Countess of Essex,* c. 1655, oil on canvas, 49 x 39½″ (124.5 x 100.3 cm.), collection of the Duke of Northumberland, and *Portrait of the Capel Sisters,* c. 1654, oil on canvas, 51¼ x 67″ (130.2 x 170.2 cm.), The Metropolitan Museum of Art, New York, acc. no. 39.65.3.

3. See The John and Mable Ringling Museum of Art, Sarasota, Fla., *Dutch Seventeenth Century Portraiture: The Golden Age,* December 4, 1980–February 8, 1981, fig. 40 (catalogue by William A. Wilson), where it is identified by Willem L. van de Watering as the companion to the *Portrait of a Man with a Spear* of 1663, pl. 39.

4. Oil on canvas, 43¼ x 33¾″ (110 x 86 cm.), lot 53 [incorrectly as B. van der Helst]. See W. R. Valentiner, "Isaac Luttichuys: A Little-Known Dutch Portrait Painter," *The Art Quarterly,* vol. 1 (1938), p. 179, fig. 24 [as Isaac Luttichuys]. Luttichuys favored the arrangement of the female figure viewed half- to three-quarter length, turned to the left, and placed before a column; compare, for example, the picture in the collection of the dukes of Osuna, Madrid (repro. E. Valdivieso, *Pintura Holandesa del Siglo XVII en España* [Valladolid, 1973], fig. 271).

5. See Glück (note 1), pp. 371, 375, 379, 385, 504, and 505. The last two mentioned, respectively, in the collection of the Governor Alvan T. Fuller, Boston (oil on canvas, 57 x 41¼″ [145 x 105 cm.]), and the Rijksmuseum, Amsterdam, oil on canvas, 71¾ x 56″ [182.5 x 142 cm.], no. A102) are the marriage portraits. Maria Henriette was also portrayed by Peter Lely (Earl of Crawford Collection), Adriaen Hanneman (oil on canvas, 51½ x 47½″ [130.5 x 120.8 cm.], Mauritshuis, The Hague, no. 429); see Ter Kuile (note 2), pls. 57–60 for several reproductions of his portraits, and Bartholomeus van der Helst (1652, oil on canvas, 78½ x 67″ [199.5 x 170 cm.], Rijksmuseum, Amsterdam, no. A142).

6. See *The Dictionary of National Biography,* vol. 12 (Oxford, 1960), pp. 1285–89.

7. See Frans Halsmuseum, Haarlem, *Portretten van echt en trouw. Huwelijk en gezin in de Nederlandse Kunst van de zeventiende eeuw,* February 15–April 13, 1986, cat. nos. 38, 39, and 56 (catalogue by E. de Jongh et al.).

8. See Johannes Mijtens's older *Portrait of Maria, Princess of Orange (1642–88),* oil on canvas, 59 x 73″ (150 x 185.5 cm.), Mauritshuis, The Hague, no. 114.

9. See E. de Jongh, "Pearls of Virtue and Pearls of Vice," *Simiolus,* vol. 8, no. 2 (1975–76), pp. 69–97.

PROVENANCE: Jonkheer Repelaer, Paris; dealer S. Nystad, The Hague.

CONDITION: The oval copper panel is in good, stable condition. Some abrasion is evident in the paint film and several tiny old losses have been inpainted, specifically along the lower edge. The uppermost varnish remains generally colorless but is uneven; older varnish residues remain in the darker areas.

Born the son of a merchant in Dordrecht in January 1634, Maes was said by Arnold Houbraken to have learned drawing from a common or mediocre master ("een gemeen Meester") and painting from Rembrandt. The latter period of tuition probably occurred in Amsterdam around 1650 and was certainly concluded by late 1653, when Maes returned to his native Dordrecht. He was betrothed to Adriana Brouwers, widow of the preacher Arnoldus de Gelder, on December 28, 1653, in Dordrecht and married there on January 31, 1654. In 1658 he bought a house on the Steechoversloot and in 1665 purchased a garden. Maes seems to have remained in his hometown until 1673, when he settled permanently in Amsterdam. According to Houbraken he journeyed to Antwerp to see paintings by Peter Paul Rubens (q.v.), Anthony van Dyck (1599–1641), and others, and visited artists, including Jacob Jordaens (1593–1678). The date for this trip is usually placed in the early to mid-1660s. Maes was buried in Amsterdam on December 24, 1693.

Maes's earliest works have religious subjects and exhibit a strong Rembrandtesque style. Subsequently, he executed genre scenes, often of domestic themes, old women praying, and street peddlers, the last mentioned recalling the art of his fellow Rembrandt pupil, Jan Victors (1619/20–c. 1676). By 1654 he had begun the small-scale domestic interiors for which he is best remembered. These anticipate works by the Delft painters such as Pieter de Hooch (q.v.) and Johannes Vermeer (1632–1675). Maes continued to paint genre paintings only through 1659, after which he apparently specialized in elegant portraits until his death. His portraits were influenced by Flemish art, especially that of Van Dyck. According to Houbraken these works were in great demand, and several hundred have survived.

LITERATURE: Houbraken 1718–21, vol. 1, pp. 131, 317, vol. 2, pp. 273–77; Smith 1829–42, vol. 4, pp. 243–49; G. H. Veth, "Aanteekeningen omtrent eenige Dordrechtsche schilders: 18. Nicolaes Maes," *Oud Holland*, vol. 8 (1890), p. 127; Wurzbach 1906–11, vol. 2, pp. 89–91; Hofstede de Groot 1908–27, vol. 6 (1916), pp. 473–605; H. Wichmann in Thieme-Becker 1907–50, vol. 23 (1929), pp. 546–47; Abraham Bredius, "Bijdragen tot een biografie van Nicolaes Maes," *Oud Holland*, vol. 41 (1923–24), pp. 207–14; W. R. Valentiner, *Nicolaes Maes* (Berlin and Leipzig, 1924); The Art Institute of Chicago, *Rembrandt after Three Hundred Years,* October 25–December 7, 1969, The Minneapolis Institute of Arts, December 22, 1969–February 1, 1970, and The Detroit Institute of Arts, February 24–April 5, 1970, pp. 81–85; Werner Sumowski, *Gemälde der Rembrandt-Schüler,* vol. 3 (Landau and Pfalz, 1983), pp. 1951–2174; Sutton et al. 1984, pp. 239–43; William W. Robinson, "The *Eavesdropper* and Related Paintings by Nicolaes Maes," in *Holländische Genremalerei im 17. Jahrhundert, Jahrbuch Preussischer Kulturbesitz* (Berlin, 1987), pp. 283–313; Jeroen Giltaij, *The Drawings by Rembrandt and His School in the Museum Boymans–van Beuningen* (Rotterdam, 1988), pp. 220–41; William W. Robinson, "The Early Works of Nicolaes Maes," Harvard University, in preparation.

For an additional work by Maes in the Philadelphia Museum of Art, see John G. Johnson Collection cat. no. 485 (or Cornelis Bisschop).

66 NICOLAES MAES

WOMAN PLUCKING A DUCK, c. 1655–56
Signed lower right: *N. MAES* (first three letters of last name ligated)
Oil on canvas, 23½ x 26″ (59.7 x 66 cm).
Gift of Mrs. Gordon A. Hardwick and Mrs. W. Newbold Ely
 in memory of Mr. and Mrs. Roland L. Taylor. 44-9-4

In a simple domestic interior a woman plucks a duck. Wearing a red jacket, black vest, and white cap, she is seated by an open window with an earthenware tankard on the sill. Strewn about the brick-red tiled floor before her are various kitchen utensils—a colander, a cooking pot, a painted majolica plate with Chinese decorations (but probably of Dutch manufacture), a wooden spoon, and an overturned marketing basket with apples—as well as a second duck eyed hungrily by a cat. In the shadows to the right, ceramic wares hang from the wall or are atop a small storage chest. A musket and a game bag, no doubt those used in the recent duck hunt, rest against the wall. In the center distance an archway leads to a small hallway and beyond to a glimpse of an adjoining room where a map hangs on the wall and a white earthenware jug and wineglass are on a table.

This painting is one of a group of more than fifteen paintings by Maes that feature a housewife or maidservant engaged in everyday activities, such as preparing food, doing needlework, or attending to children. The domestic intimacy as well as the warm colors and strong lighting of these works seems to reflect the legacy of Rembrandt, with whom Maes studied. The Philadelphia painting also attests to Maes's interest in perspective (note the orthogonals of the tiles and the *doorkijkje,* or view, to an adjoining room) and considerable talent in the expressive use of space. The order and the stillness of the room perfectly complement the woman's concentration in preparing the meal. Orderly middle-class interiors with views into secondary spaces were much favored in the 1650s by artists from South Holland, principally Dordrecht, Rotterdam, and Delft. Maes never achieved the naturalism and spatial clarity of artists like Pieter de Hooch (q.v.) and Johannes Vermeer (1632–1675). His floors always seem precariously steep and the areas of difficult spatial transition, like the threshold to the other room in this work, invariably are disguised in shadow. Nonetheless, he was an important precursor of the Delft painters.

The only element of Maes's scene that threatens to disrupt the quiet is the cat. On several occasions Maes depicted cats on the verge of, or succeeding in, stealing food from the table or kitchen. In a painting called *The Idle Servant* (fig. 66-1), the cat has stolen a fish from a plate while the serving woman, as her smiling companion points out, has fallen asleep. There can be little doubt that the detail of the cat in that painting constitutes an admonition against idleness, but the predatory aspect in *Woman Plucking a Duck* may have other meanings. The wine pitcher and glass in the far room suggest a second presence, perhaps that of the hunter who owns the gun and game bag. The ducks shot by the hunter could be associated with physical love; *vogelen,* literally "to bird," also meant to engage in sexual intercourse.[1] The authors of the 1969 Chicago exhibition catalogue concluded that the picture contains an extensive program of sexual symbolism, involving not only the duck but also the cat (symbol of lust, sensual pleasure, and the female libido), the gun, and the vessels, which collectively allude to and warn against lust and seduction.[2] Unlike

FIG. 66-1 Nicolaes Maes, *The Idle Servant,* 1655, oil on canvas, 27½ x 20¹⁵⁄₁₆″ (70 x 53.3 cm.), National Gallery, London, inv. no. 207.

FIG. 66-2 Follower of Nicolaes Maes, *Woman Plucking a Duck with a Man,* oil on canvas, 26¾ x 33⅞″ (68 x 86 cm.), private collection, California.

that of the anecdotal picture of *The Idle Servant*, however, the tone of this
quiet little painting is not explicitly didactic or cautionary. The subtlety of
Maes's approach to narration is clarified by comparing this work with those
of later imitators. In a painting by a Maes follower in a private collection in
California, the male presence is introduced literally; a man leans in at the
open window as a woman plucks a duck (fig. 66-2).[3] And, as William
Robinson has observed, a painting by Reinier Covyn (1635/36–after 1667)
depicts a hunter raising his glass and embracing the maidservant as she
plucks a duck (fig. 66-3).[4] The central theme of the Philadelphia painting
would seem to deal generally with those ideals of domesticity that served to
inspire so many scenes of Dutch home life around mid-century. Yet it may
also convey a veiled erotic message and an admonition, functioning as
footnotes to the popular theme of bourgeois tranquility.

FIG. 66-3 Reinier Covyn, *Hunter and Maidservant* (with a false Maes signature), oil on panel, 28½ x 23" (72.5 x 58.5 cm.), sale, Christie's, New York, January 9, 1981, lot 161.

C. Hofstede de Groot compared the work to *The Old Woman Spinning*[5] and, incorrectly, suggested that it might be identical with a painting that is now in the Hermitage in Leningrad.[6] Bode wrote expressively of the painting's subtle effects of light and atmosphere but underestimated Maes's capacity for invention in stressing his dependence on Rembrandt in these features. W. R. Valentiner dated the painting 1657, finding it close in style to *The Eavesdropper*[7] of 1657 and arguing that the tonalities are clearer and the contours more pronounced in these paintings than in Maes's works of 1655 and 1656. Robinson, however, has argued that the slightly earlier date is preferable, comparing the work to two other paintings dated 1655—*Woman Scraping Parsnips*[8] and *The Idle Servant* (fig. 66-1)—likening "the painting's restricted palette and soft, pervasive shadows" to the "dark tonalities of pictures he produced in 1655."[9]

NOTES

1. See E. de Jongh, "Erotica in vogelperspectief: De dubbelzinnigheid van een reeks 17de eeuwse genrevoorstellingen," *Simiolus*, vol. 3, no. 1 (1968–69), pp. 22–31, 33, 47, 72.
2. See The Art Institute of Chicago, *Rembrandt after Three Hundred Years,* October 25–December 7, 1969, The Minneapolis Institute of Arts, December 22, 1969–February 1, 1970, and The Detroit Institute of Arts, February 24–April 5, 1970, pp. 84–85, cat. no. 88, where the painting is entitled "Allegory: A Girl Plucking a Duck." On Maes's several paintings depicting or alluding to idle or lascivious maidservants, see William W. Robinson, "The *Eavesdropper* and Related Paintings by Nicolaes Maes," in *Holländische Genremalerei im 17. Jahrhundert, Jahrbuch Preussischer Kulturbesitz* (Berlin, 1987), pp. 283–313.
3. Werner Sumowski, *Gemälde der Rembrandt-Schüler,* vol. 3 (Landau and Pfalz, 1983), no. 1350 [as Nicolaes Maes].
4. Sutton et al. 1984, p. 240 n. 4.
5. c. 1655, oil on panel, 16⅜ x 13¼" (41.5 x 33.5 cm.), Rijksmuseum, Amsterdam, no. A246.
6. See Hofstede de Groot 1908–27, vol. 6 (1916), no. 28; Smith 1829–42, suppl. (1842), no. 5.
7. Oil on canvas, 36⅜ x 48" (92.5 x 122 cm.), Dienst Verspreide Rijkskollekties, The Hague, inv. no. NK 3045, on loan to the Dortdrechts Museum, inv. no. DM/953/135.
8. Oil on panel, 14 x 11¾" (35.6 x 29.8 cm.), National Gallery, London, no. 159.
9. William Robinson in Sutton et al. 1984, p. 240; Sumowski (see note 3 above), vol. 3, no. 1351, supports the date of "around 1655."

PROVENANCE: Sale, Comte de Turenne, Paris, May 17, 1852, lot 44, to dealer Nieuwenhuys; sale, Adrian Hope, Christie's, London, June 30, 1894, lot 39, to dealer Sedelmeyer, Paris; Jules Porgès, Paris; A. de Ridder, Schönberg near Cronberg, 1910; F. Kleinberger, Paris and New York; sale, A. de Ridder, Paris, June 2, 1924, lot 38; dealer D. A. Hoogendijk, Amsterdam, by 1928; dealer J. Duveen, New York; Mrs. Gordon A. Hardwick.

EXHIBITIONS: Baltimore Museum of Art [from label on reverse; date unknown]; The Art Institute of Chicago, *Rembrandt after Three Hundred Years,* October 25–December 7, 1969, The Minneapolis Institute of Arts, December 22, 1969–February 1, 1970, and The Detroit Institute of Arts, February 24–April 5, 1970, pp. 84–85, cat. no. 88.

LITERATURE: W. Roberts, *Memorials of Christie's* (London, 1897), p. 237; Charles Sedelmeyer, Paris, *Illustrated Catalogue of 300 Paintings by Old Masters of the Dutch, Flemish, Italian, French, and English Schools* (Paris, 1898), no. 81; Wurzbach 1906–11, vol. 2, p. 90; Wilhelm von Bode, *Die Gemäldegalerie des Herr A. de Ridder in seiner Villa zu Schönberg bei Cronberg im Taunus* (Berlin, 1910), p. 32; Wilhelm von Bode, *The Collection of Pictures of the Late Herr A. de Ridder,* translated by Harry Virgin (Berlin, 1913), p. 33; Hofstede de Groot 1908–27, vol. 6 (1916), no. 28 [incorrectly as Smith 1829–42, suppl. (1842), no. 5]; W. R. Valentiner, *Nicolaes Maes* (Berlin and Leipzig, 1924), pp. 48–49, pl. 43; *Elsevier's Geïllustreerd Maandschrift,* April 1929; C. H. de Jonge, *Oud Nederlandsche majolica en Delftsch aardewerk: Een ontwikkelings geschiedenis van omstreeks 1550–1800* (Amsterdam, 1947), p. 70, fig. 42; PMA 1965, p. 42; Rishel 1974, p. 31; Werner Sumowski, *Gemälde der Rembrandt-Schüler,* vol. 3 (Landau and Pfalz, 1983), no. 1351, repro.; Sutton et al. 1984, p. 240, cat. no. 65, pl. 97, repro.; Peter C. Sutton, *Dutch Art in America* (Grand Rapids and Kampen, 1986), p. 230, fig. 337.

CONDITION: The painting was relined with wax-resin adhesive and cleaned in 1983. The tacking edges are missing. Generally the paint film is in good condition with only minor abrasion, scattered minor losses and extensive loss around the edges. The varnish is colorless.

The elder brother of Matthijs (1839–1917) and Willem Maris (q.v.), Jacob Maris was born in The Hague on August 25, 1837. He was a pupil in 1849 of Johann Anthonie Balthasar Stroebel (1821–1905) and in 1853 of Hubertus (Huib) van Hove (1814–1865) at the academy in The Hague. From 1853 to 1856 he lived in Antwerp, where he enrolled in the academy; he was a pupil of Nicaise de Keyser (1813–1887) and became a friend of Lawrence Alma-Tadema (1836–1912). Royal patronage enabled Jacob and Matthijs to visit Oosterbeek and Wolfheze from 1859 to 1860 and Germany, Switzerland, and France in 1861. In 1863 he was an assistant to the marine painter Louis Meijer (1809–1866) in The Hague. During his early years in The Hague, Jacob shared a studio first with Jan Swijser (1835–1912), then with Ferdinand Sierich (1839–1905), and after 1858 with his brother Matthijs. Jacob's early paintings from these years generally are small genre and figure subjects, mostly domestic and farm themes, in a smooth, slick style. From 1865 to 1871 he was in Paris, where he studied under Ernest Hébert (1817–1908), producing studies of Italian peasant types like those of Hébert. In these same years he was also influenced by the Barbizon painters and turned increasingly to landscape. In 1867 he married Catharina Hendrika Horn, who, like the couple's children, often appears in his paintings. In 1871 Jacob returned to The Hague, where he lived, working in a studio on the Noordwest Binnensingel, until his death on a visit to Karlsbad in 1899.

Jacob Maris's art shows a gradual development from the prevailing genre style of his youth to a broad and powerfully independent approach to landscape. He became a leader of the so-called Hague School of painting. In his mature and later years, when he painted mostly landscapes, cityscapes, beach scenes, and marines, he was esteemed as the greatest Dutch painter of his age. Though influential for many later artists, he had only one true pupil, Willem de Zwart (1862–1931).

LITERATURE: Adèle J. Godoy, *Jacob Maris* (Amsterdam, 1890); P. Zilcken, *Elsevier's Geïllustreerd Maandschrift,* vol. 18 (1899), pp. 193–97; P. Zilcken, "The Late Jacob Maris," *The Studio,* vol. 18 (1900), pp. 231–40; P. Zilcken, "Jacob Maris," *Gazette des Beaux-Arts,* 3rd ser., vol. 23 (1900), pp. 147–55; Georges Riat, "Artistes contemporains: Robert Mols—P. J. C. Gabriel," *Gazette des Beaux-Arts,* 3rd ser., vol. 31 (1904), pp. 158–66; Jan Veth in *Portretstudies en silhouetten* (Amsterdam, n.d.), pp. 123–75, 205–7; Jan Veth, "Jacob Maris," *Kunst und Künstler,* vol. 9, no. 1 (1911), pp. 15–26; Max Eisler, "De collectie Drucker in het Rijksmuseum: Jacob en Willem Maris," *Elsevier's Geïllustreerd Maandschrift,* vol. 23 (1913), pp. 321–35; Albert Plasschaert, *Jacob Maris, een overzicht* (Arnhem, 1920); J. Knoef, "Fransche invloeden op Jacob Maris," *Oud Holland,* vol. 61 (1946), pp. 204–12; Haags Gemeentemuseum, The Hague, *Meesters van de Haagse School,* June 18–August 15, 1965, pp. 49–57; Willem Josiah de Gruyter, *De Haagse School,* vol. 2 (Rotterdam, 1969), pp. 16–20; Pieter A. Scheen, *Lexicon Nederlandse beeldende kunstenaars 1750–1880* (The Hague, 1981), p. 333; Ronald de Leeuw, John Sillevis, and John Dumas, eds., *The Hague School: Dutch Masters of the 19th Century* (London, 1983), pp. 201–15.

For additional works by Jacob Maris in the Philadelphia Museum of Art, see John G. Johnson Collection cat. nos. 1032, 1030, 1029.

67 JACOB HENDRICUS MARIS

VIEW OF THE SCHREIERSTOREN IN AMSTERDAM, 1882
Signed lower left in script: *J. Maris*
Oil on canvas, 32 x 58½" (81.3 x 148.5 cm.)
The William L. Elkins Collection. E24-3-11

The Amsterdam skyline is viewed panoramically beneath a bright but
overcast sky. Jacob Maris executed many views of Amsterdam and especially
favored vistas along the Amstel River. This picture freely depicts the
northern section of the city near the harbor with a view on the left of the
steepled building known as the Schreierstoren and the bridge over the
Gelderse Kade, and, in the distance on the right, the dome of the Lutheran
church. Both the Schreierstoren and the Lutheran church survive today.
However, as the authors of the catalogue of the Hague School exhibition
of 1983 observed, Jacob often took topographic liberties with this site,
including, for example, either one (as in the Philadelphia picture) or two
drawbridges.[1]

 A small painting of 1872 already included many of the elements of this
composition.[2] Several other paintings by Maris depict very similar views,[3]
and the Rijksprentenkabinet in Amsterdam owns a watercolor of 1875 from
the Völeker sale, Amsterdam, 1939, showing a variant of the same vista.
The latter may be the drawing that was exhibited at the Hollandsche
Tekenmaatschappij in 1882 and that was mentioned by Vincent van Gogh
(q.v.) in a letter dated before August 15, 1882, and described as "a very large
'Town View,' as vigorous as Vermeer of Delft."[4] Joseph J. Rishel theorized
that this unidentified drawing could have been a study for the Museum's
painting; the latter, however, was only one of many versions of this design
that Maris executed in the 1880s.[5] According to William L. Elkins's registry,

it was painted in 1882 for J. S. Forbes; James Staats Forbes's London collection was renowned for its Hague School paintings.[6]

Van Gogh's observation that the drawing resembled Vermeer's art also holds true for this picture. Maris doubtless had in mind paintings like the seventeenth-century master's famous *View of Delft* when he executed this work.[7] The art of Johannes Vermeer (1632–1675) had then only recently been the subject of renewed interest as a result of the writings in 1866 of E. J. T. Thoré-Bürger. Other earlier Dutch masters that may have influenced Maris's paintings of cityscapes and river views include the seventeenth-century landscapists Salomon van Ruysdael, Jan van Goyen (qq.v.), and Esaias van de Velde (c. 1590–1630), and Maris's immediate nineteenth-century predecessor, Andreas Schelfhout (1787–1870). Despite these precedents, Maris's broadly executed painting is clearly a product of its own time, the era that gave rise to Impressionism, and may be compared with works by his fellow Dutchman Johan Barthold Jongkind (q.v.).

NOTES

1. Ronald de Leeuw, John Sillevis, and John Dumas, eds., *The Hague School: Dutch Masters of the 19th Century* (London, 1983), p. 213, under cat. no. 62; see also note 3 below.

2. De Leeuw et al. (see note 1), as formerly with M. Knoedler & Co., New York.

3. See *The Schreierstoren on the Buitenkant, Amsterdam,* signed, oil on canvas, 32⅝ x 43¹¹/₁₆" (83 x 111 cm.), Rijksmuseum, Amsterdam, no. A2702; *The Schreierstoren and the Bridge over the Gelderse Kade,* signed, oil on canvas, 9⅝ x 14⅜" (24.5 x 36.5 cm.), Rijksmuseum, Amsterdam, no. A2466; *The Schreierstoren in Amsterdam,* signed, oil on canvas, 10⅝ x 13¾" (27 x 35 cm.), Rijksmuseum, Amsterdam, no. A2467; *Schreierstoren, Amsterdam,* oil on canvas, 31½ x 58¼" (80 x 148 cm.), Gemeentemuseum, The Hague, inv. no. 13-X-1947; *Schreierstoren in Amsterdam,* signed, oil on canvas, 31½ x 57⅞" (80 x 147 cm.), H. S. Southam Collection, Ottawa; *A Dutch Town,* oil on canvas, 20¼ x 26" (51.4 x 66 cm.), Coats sale, Christie's, London, April 12, 1935, lot 60, and later in sale, Christie's, London, July 6, 1973, lot 240, pl. 56; *Prins Hendrikkade with the Schreierstoren in Amsterdam,* signed, oil on canvas, 31⅛ x 57½" (79 x 146 cm.), sale, W.J.R. Dreesman, Frederik Muller & Co., Amsterdam, March 22–25, 1960, lot 81, repro. (repro. in *Verzameling Amsterdam—W. J. R. Dreesmann* [Amsterdam, 1951], vol. 2, p. 411, vol. 3, p. 764); and *View of Amsterdam,* oil on canvas, 31⅞ x 57⅞" (81 x 147 cm.) (repro. in *Collection Cottier Catalogue* [Paris, 1892], p. 72). Also compare a view of the Schreierstoren from the other side, *On the Amstel,* oil on canvas, 36¼ x 49⅛"

(92 x 125 cm.), National Gallery of Scotland, Edinburgh, acc. no. 1049; and further, a painting that takes topographic liberties with the site, adding, among other elements, a second drawbridge: *Amsterdam,* oil on canvas, 32 x 57½" (81.3 x 146 cm.), The Burrell Collection, Glasgow Art Gallery and Museum (see De Leeuw et al. [note 1], p. 19, fig. 8).

4. *The Complete Letters of Vincent van Gogh,* 2nd ed., vol. 3, translated by Johanna van Gogh-Bonger and C. de Drood (Greenwich, Conn., 1959), p. 327, no. R11.

5. Rishel 1971, p. 26.

6. See Charles Dumas, "Haagse Schoolverzameld," in De Leeuw et al. (see note 1), pp. 125–26.

7. Oil on canvas, 38¾ x 46¼" (98.5 x 117.5 cm.), Mauritshuis, The Hague, no. 92.

PROVENANCE: According to the 1898 "Inventory of Paintings: Wm. L. Elkins," painted in 1882 for J. S. Forbes, afterwards in the collection of George James, both of London; William L. Elkins Collection, Philadelphia, by 1898.

LITERATURE: Elkins 1924, no. 11; PMA 1965, p. 43; Rishel 1971, pp. 21–22, 26, cat. no. 4, repro.

CONDITION: The canvas was relined with a wax-resin adhesive in 1975. The support is somewhat slack and bulges through the center. The paint film reveals stress cracks, stretcher creases, and slight cupping. The upper edges of the painting and several cracks in the sky have been retouched. The varnish generally is colorless but due to selective cleaning some residues of older varnish remain over the darker areas of paint.

68 JACOB HENDRICUS MARIS *FISHING BOAT WITH HORSE ON THE BEACH AT SCHEVENINGEN,* c.1880–90
Signed lower right in script: *J. Maris*
Oil on canvas, 50 x 37⅝″ (127 x 95.6 cm.)
The William L. Elkins Collection. E24-3-12

A fishing vessel is being drawn up onto the shallow beach by a horse,
sketchily drawn. In the distance several other sailing vessels appear on the
horizon, and at the lower right there lies a drum or possibly a fishing
basket.

 The Hague School artists often depicted scenes of the beach nearby at
Scheveningen. Jacob Maris, Anton Mauve (q.v.), Hendrik Willem Mesdag

FIG. 68-1 Jacob Maris, *Fishing Boat at Scheveningen,* signed and dated 1878, oil on canvas, 48¹³⁄₁₆ x 41¹⁄₁₆″ (124 x 105 cm.), Haags Gemeentemuseum, The Hague, no. H6M.

(1831–1915), and Jan Hendrik Weissenbruch (1824–1903) all depicted the boats that landed there,[1] but Maris gave the theme its most classic form. He seems to have been especially attracted by the flat-bottomed herring-fishing vessels known as *bomschuiten* that had to be drawn up onto the beach by horses. Maris painted a series of scenes like the present one in the late 1870s; compare, for example, both the theme and the design of a smaller panel dated 1876[2] and the large *Fishing Boat at Scheveningen* dated 1878 (fig. 68-1). The latter work has been characterized as the epitome of the Hague School's gray period.[3] Its purchase by the municipal museum in The Hague in 1884 marked the advent of official approval of Maris's art; by the 1890s the artist had become immensely popular and was hard-pressed to satisfy the demand for repetitions of his works. The present painting may well be one of those later variations.

After suffering earlier in the century from an embargo, which was lifted in 1871, herring fishing in the Netherlands regained some of its prosperity, but only the fleet in Scheveningen remained faithful to the traditional bluff-bowed fishing boat.[4] This link with the past may, in part, explain the appeal of the subject; commenting on a painting by Mauve of horses drawing up a fishing boat to the dunes, Vincent van Gogh (q.v.) likened it to a "good sermon on resignation."[5]

NOTES

1. See, for example, Anton Mauve's *Fishing Boat on the Beach at Scheveningen,* 1876, oil on canvas, 30⅞ x 44½″ (78.5 x 113 cm.), Dordrechts Museum, Dordrecht, inv. no. DM/950/411 (Ronald de Leeuw, John Sillevis, and John Dumas, eds., *The Hague School: Dutch Masters of the 19th Century* [London, 1983], p. 236, cat. no. 90, repro.). Vincent van Gogh commented admiringly on a painting by Mauve of this subject; see *The Complete Letters of Vincent van Gogh,* 2nd ed., vol. 1, translated by Johanna van Gogh-Bonger and C. de Drood (Greenwich, Conn., 1959), p. 326, no. 181.

2. Oil on panel, 17⁵⁄₁₆ x 11⅛″ (44 x 29.5 cm.), sale, A. Neuhuys, Amsterdam, 1936, lot 62.

3. See Willem Josiah de Gruyter, *De Haagse School,* vol. 2 (Rotterdam, 1969), fig. 25; and De Leeuw et al. (see note 1), cat. no. 56, repro. Virtually the same composition also appears in an undated picture, oil on canvas, 38³⁄₁₆ x 31⅛″ (97 x 79 cm.), photograph, Rijksbureau voor Kunsthistorische Documentatie, The Hague, no. 23400, that was in the collection of A.A.J. van Winden,

Voorburg, as of 1964; and in *Bluff-bowed Fishing Boat on the Beach at Scheveningen,* undated, oil on canvas, 39¹⁵⁄₁₆ x 35¼″ (101.5 x 89.5 cm.), Rijksmuseum, Amsterdam, no. A2810.

4. De Leeuw et al. (see note 1), p. 209.

5. Ibid., p. 90; *Complete Letters* (see note 1) letter no. 181.

PROVENANCE: William L. Elkins Collection, Philadelphia, before 1900.

LITERATURE: Elkins 1887–1900, vol. 1, no. 34, repro., 1924, no. 12; PMA 1965, p. 43; Rishel 1971, p. 26, no. 5, repro.

CONDITION: The unlined canvas support is dry and slack. The thick paint film shows prominent mechanical crackle throughout, especially in the sky; some traction crackle appears in the water around the boat. A deep crack runs horizontally 2 to 5″ (5 to 13 cm.) from the bottom edge, corresponding to a buckle in the fabric support. The varnish is deeply discolored.

Born in The Hague on February 18, 1844, Wenzel Maris (called Willem) was first taught drawing by his older brothers, Jacob Hendricus (q.v.) and Matthijs (1839–1917), and later studied at the Akademie van beeldende Kunsten in The Hague. He was a pupil of Johann Anthonie Balthasar Stroebel (1821–1905) and sought advice from the animal painter Pieter Stortenbeker (1828–1898), but never imitated the latter's style. In 1862 he met Anton Mauve (q.v.) in Oosterbeek and the two remained lifelong friends. In his early years he made life sketches of cows and copied works by Paulus Potter (q.v.) in the Mauritshuis in The Hague. He traveled with Bernard Blommers (1845–1914) to the Rhineland in 1865, to Paris for Jacob's wedding in 1867, and to Norway in 1871. In the absence of many dated paintings, these travels assist in the dating of his works. Willem married Maria Jacoba Visser in 1872. Their son Simon Willem (1873–1935) became a figure- and portrait-painter. In 1876, together with Mauve and Hendrik Willem Mesdag (1831–1915), Willem was a founder of the Hollandsche Tekenmaatschappij (Dutch Drawing Society) in The Hague. In 1890 he married a second time. Except for occasional brief visits to Belgium, he spent all of his mature life in and around The Hague and died there on October 10, 1910.

Like his brother Jacob, Willem was a landscapist, but having come under the influence of Anton Mauve at an early date, he preferred animal motifs and especially favored images of cows in meadows and marshes. He also painted ducks, willows, canals, and windmills, but rarely humans, who figure almost exclusively in his early works. George Hendrik Breitner (1857–1923) was his pupil.

LITERATURE: G. H. Marius, "Willem Maris," *Elsevier's Geïllustreerd Maandschrift,* vol. 2 (1891), pp. 109–22; H. de Boer, *Willem Maris* (The Hague and Zurich, 1905); Max Eisler, "Willem Maris," *Elsevier's Geïllustreerd Maandschrift,* vol. 14 (1911), pp. 81–90; Max Eisler, "De collectie Drucker in het Rijksmuseum: Jacob en Willem Maris," *Elsevier's Geïllustreerd Maandschrift,* vol. 23 (1913), pp. 321–35; Albertine de Haas, "Willem Maris," *Kunst en Kunstleven,* vol. 1 (1911), pp. 355–60; Max Eisler in Thieme-Becker 1907–50, vol. 24 (1930), p. 115; Haags Gemeentemuseum, The Hague, *Meesters van de Haagse School,* June 18–August 15, 1965, pp. 69–72; Willem Josiah de Gruyter, *De Haagse School,* vol. 2 (Rotterdam, 1969), pp. 49–60; Pieter A. Scheen, *Lexicon Nederlandse beeldende kunstenaars 1750–1880* (The Hague, 1981), p. 334; Ronald de Leeuw, John Sillevis, and Charles Dumas, eds., *The Hague School: Dutch Masters of the 19th Century* (London, 1983), pp. 227–31.

For an additional work by Willem Maris in the Philadelphia Museum of Art, see John G. Johnson Collection cat. no. 1031.

69 WILLEM MARIS

COWS IN A MARSH, c. 1890–1900
Oil on canvas, 31⅜ x 57½″ (79.6 x 146 cm.)
The George W. Elkins Collection E24-4-20

Three cows graze in a marsh, their backs just touching the flat panoramic horizon. A limpid atmosphere infuses the scene.

Although unsigned, this picture is typical of Willem Maris's work.[1] Since dated works are rare in his oeuvre, it is difficult to pinpoint the date of this painting. It appears to be a later work, probably after 1890 and perhaps as late as 1900. Over the course of Willem's career, his style became broader and his colors richer and more saturated. His late works have more in common with the French Impressionists than do the works of other Hague School painters. He is quoted as having said that he painted cows "for the sake of the sun," namely as objects to catch the light.[2] These works, among all the products of the Hague School, have been characterized as the purest expression of the "l'art pour l'art" aesthetic.[3]

NOTES
1. Compare, for example, the design and the technique of *Cows,* oil on canvas, 15¾ x 20⅞″ (40 x 53 cm.), Rijksmuseum, Amsterdam, no. A2429; *Cows at a Pond,* oil on canvas, 34¹⁄₁₆ x 50″ (86.5 x 127 cm.), Rijksmuseum, Amsterdam, no. A3107; and *Summertime,* oil on canvas, 34¹⁄₁₆ x 50″ (86.5 x 127 cm.), Rijksmuseum, Amsterdam, no. A2930.
2. See Willem Josiah de Gruyter, *De Haagse School,* vol. 2 (Rotterdam, 1969), pp. 55, 60.
3. Ronald de Leeuw, John Sillevis, and Charles Dumas, eds., *The Hague School: Dutch Masters of the 19th Century* (London, 1983), p. 231.

PROVENANCE: George W. Elkins Collection, Philadelphia.

LITERATURE: Elkins 1925, no. 27; *The Pennsylvania Museum Bulletin* (Philadelphia Museum of Art), vol. 31, no. 168 (November 1935), p. 13; Rishel 1971, pp. 20–21, cat. no. 6, repro.; PMA 1965, p. 43.

CONDITION: The canvas is dry, brittle, and slack. The painting is lined with an aqueous adhesive. Although there are a few small scattered losses, the paint is generally in good condition. A vertical crackle pattern in the sky is associated with slight cupping. Some minor traction crackle occurs in the foreground. A loss in the right rear of the black cow at left is retouched. The varnish is uneven and moderately discolored. Residues of varnish are caught in the interstices of the brushstrokes.

70 WILLEM MARIS

COWS IN A MARSH, c. 1897
Signed lower right: *Willem Maris*
Oil on canvas, 25½ x 29½″ (64.8 x 75 cm.)
Gift of Mrs. Jay Besson Rudolphy. 1978-118-1

Nine cows graze in a marsh with trees on the right and several birds hover in the background under a low, overcast sky. Another typical example of Willem Maris's numerous images of cows in a landscape, this painting, like *Cows in a Marsh* (no. 69), reveals the broad shimmering stroke of the artist's later years.[1] In characteristic fashion, the animals have been placed *contre-jour* with the light glinting on their backs; the sketchy brushwork creates the impression of a warm, moist atmosphere.

NOTES
1. Compare *Summer,* signed, oil on canvas, 53¾ x 64¾″ (136.5 x 164.5 cm.), Rijksmuseum Van Bilderbeek-Lamaison, Dordrecht (see Ronald de Leeuw, John Sillevis, and Charles Dumas, eds., *The Hague School: Dutch Masters of the 19th Century* [London, 1983], p. 231, cat. no. 84, repro.), which is datable to 1897 or slightly earlier.

PROVENANCE: Mrs. Jay Besson Rudolphy.

CONDITION: The unlined canvas support is slack. The painting was cleaned in 1973. The paint film is stable. The varnish shows slight discoloration.

Born in Zaandam on September 18, 1838, Mauve came from the large family of a Mennonite preacher. He spent his youth in Haarlem, where he was a student until 1857 of the animal painter Pieter Frederik van Os (1808–1892). The following year he studied with Wouterus Verschuur (1812–1874) and P. J. C. Gabriël (1828–1903). In the late 1850s he worked with Gabriël in Oosterbeek, where he first met Johannes Warnardus (1811–1890) and Gerard Bilders (1838–1865) and developed his own manner. He settled in Amsterdam in 1865 and in The Hague in 1872. He was married two years later to Ariëtte Sophia Jeannette Carbentus, the cousin of Vincent van Gogh (q.v.). Van Gogh studied briefly with Mauve, and his early development shows the latter's influence. By the time Mauve had settled in The Hague, he had begun executing delicate watercolors, two of which are owned by the Philadelphia Museum of Art (*Milking Time,* no. 38-22-2, and *Old Coach in Snow,* no. E24-4-22). In 1876 with Willem Maris (q.v.) and Hendrik Willem Mesdag (1831–1915) he helped found the Hollandsche Tekenmaatschappij (Dutch Drawing Society) in The Hague; he also served as secretary of the Pulchri Studio there for several years. After 1878 Mauve spent the summers in Laren, settling there permanently after 1885. The Laren School, not as well known as the Hague School, enjoyed considerable renown with American and British collectors. In addition to the elderly Jozef Israëls (q.v.) and Johannes Albert Neuhuys (1844–1914), its members included Arina Hugenholtz (1848–1934), François Pieter Meulen (1843–1927), and Anton's son, Rudolf Mauve (1876–1962), all three of whom reflect the elder Mauve's style. Mauve died on February 5, 1888, in Arnhem.

Primarily a landscape painter, Mauve is best known for his paintings of sheep and cows attended by herdsmen in watery marshes and dunes. His touch is liquid but succinct, his palette restricted but enlivened with a diffuse, silvery light.

LITERATURE: A. C. Löfftelt, "Anton Mauve," *The Art Journal,* n.s., April 1894, pp. 101–6; A. C. Löfftelt, "Anton Mauve," *Elsevier's Geïllustreerd Maandschrift,* vol. 9 (1895), pp. 577–604; Raym Bouyer, *Anton Mauve: Sa vie, son oeuvre* (Paris, 1898); W. Steenhoff, "Anton Mauve en zijn tijd," *Onze Kunst,* vol. 13 (1908), pp. 12–20, 58–65; Frank Rutter, "A Consideration of the Work of Anton Mauve," *The Studio,* vol. 42 (1908), pp. 3–16; K. Sheffler, "Zeichnungen von Anton Mauve," *Kunst und Künstler,* vol. 11 (1913), pp. 383–84; Erich Hancke, "Anton Mauve," *Kunst und Künstler,* vol. 13 (1915), pp. 356–68; Thieme-Becker 1907–50, vol. 24 (1930), p. 286; H. P. Baard, *Anton Mauve* (Amsterdam, 1946); Haags Gemeentemuseum, The Hague, *Meesters van de Haagse School,* June 18–August 15, 1965, pp. 73–83; Willem Josiah de Gruyter, *De Haagse School,* vol. 2 (Rotterdam, 1969), pp. 61–72; Pieter A. Scheen, *Lexicon Nederlandse beeldende kunstenaars, 1750–1880* ('s Gravenhage, 1981), pp. 338–39, figs. 527–41; Ronald de Leeuw, John Sillevis, and John Dumas, eds., *The Hague School: Dutch Masters of the 19th Century* (London, 1983), pp. 233–55.

For additional works by Mauve in the Philadelphia Museum of Art, see John G. Johnson Collection cat. nos. 1036, 1037.

71 ANTON MAUVE

THE RETURN OF THE FLOCK AT LAREN, c. 1886–87?
Signed lower right in script: *A. Mauve*
Oil on canvas, 39⁷⁄₁₆ x 63½" (100.2 x 161.3 cm.)
The George W. Elkins Collection. E24-4-21

A flock of sheep, illuminated *contre-jour* by the setting sun, follows a shepherd up a gradual incline away from the viewer. Three trees appear on the broad horizon.

According to the 1906 sale catalogue of the actor Joseph Jefferson, this picture was given a place of honor and received a medal when shown in Room 10 at the Paris Salon in 1887. The compiler of the catalogue further stated that the cattle painter William H. Howe (1846–1929) was present at the artist's home in Laren when this composition was originally conceived in 1886, and that he was given the first sketch by Mauve's widow after the artist's death. The latter story may be inaccurate, since Mauve executed designs (inspired by the French artists Jean François Millet, Constant Troyon, and Charles François Daubigny) similar to this one at least in the early 1880s. Moreover, he had described a similar scene that he had witnessed in the fields near Oosterbeek in a letter to Willem Maris (q.v.) dated May 3, 1864: "Towards sunset I ventured out on to the heath. You can understand how it looked there. Kind, moving; kind and bold—grand. Near Oosterbeek that same shepherd came along again with his sheep; the tinkling and tapping noise they made still murmurs in my ears like the most beautiful of Beethoven's music; I watched them slowly crossing the ridges of the heath again, until they finally disappeared from view—Silence." [1]

FIG. 71-1 Anton Mauve, *Changing Pasture,* c. 1882, signed, oil on canvas, 33 x 49½" (84 x 126 cm.), Taft Museum, Cincinnati, acc. no. 1931.457.

Nonetheless, the Philadelphia painting undoubtedly depicts pasturage at Laren in the Gooi, where Mauve sought bucolic peace from the increasing urbanization of The Hague.

The Taft Museum in Cincinnati owns an undated work (fig. 71-1) also depicting sunlit sheep proceeding away from the viewer and up a road in the center of a landscape with a high horizon line; the painting has been dated as early as 1882.[2] Compare also similar works in New York, Detroit, Toledo, Montreal, Amsterdam, and elsewhere.[3]

NOTES

1. Cited in Ronald de Leeuw, John Sillevis, and John Dumas, eds., *The Hague School: Dutch Masters of the 19th Century* (London, 1983), p. 250, under cat. no. 100. The letter is preserved at the Rijksbureau voor Kunsthistorische Documentatie, The Hague.
2. See Haags Gemeentemuseum, The Hague, *Meesters van De Haagse School,* June 12–August 15, 1965, cat. no. 91.
3. *The Return to the Fold,* signed, oil on canvas, 19¾ x 33⅞" (50.2 x 86 cm.), The Metropolitan Museum of Art, New York, acc. no. 14.40.816; *Twilight,* signed, oil on canvas, 25⅝ x 17⅞" (65.7 x 45.4 cm.), The Metropolitan Museum of Art, New York, acc. no. 14.40.812; *Going to Pasture,* oil on canvas, 21⅛ x 29¾" (54.9 x 75.6 cm.), The Detroit Institute of Arts, 73.60 (repro. in *Gazette des Beaux-Arts,* 6th ser., vol. 83, no. 126 [February 1974], p. 138, fig. 447); *Sheep on the Dunes,* signed, oil on canvas, 36½ x 75" (92.5 x 189 cm.), Toledo Museum of Art, Ohio, acc. no. 25.52; *Return of the Flock,* signed, oil on canvas, 19½ x 31½" (49.5 x 80 cm.), Musée des Beaux-Arts, Montreal, no. 576; *On the Heath in Laren,* signed, oil on canvas, 30¼ x 41" (77 x 104 cm.), Rijksmuseum, Amsterdam, no. A2430; *Homeward Bound,* signed, oil on canvas (mounted on panel), 21¼ x 36¼" (54 x 92 cm.), sale, Sotheby Parke Bernet, New York, October 15, 1976, lot 57, repro. (from the estate of Helen G. Clarke).

PROVENANCE: Sale, Dr. Gerardus H. Wynkoop, Orgies and Co., New York, March 13, 1890; Joseph Jefferson sale, American Art Association, New York, April 27, 1906, lot 67; dealer Scott and Fowles, New York; George W. Elkins Collection, Philadelphia.

EXHIBITIONS: Paris, Salon, 1887, no. 1636 [as "Moutons dans la bruyère"]; Haags Gemeentemuseum, The Hague, *De Haagse School: Hollandse Meesters van de 19de eeuw,* August 5–October 31, 1983, Grand Palais, Paris, January 15–March 28, 1983, and the Royal Academy of Arts, London, April 16–July 10, 1983, cat. no. 100.

LITERATURE: Elkins 1925, no. 29; *The Pennsylvania Museum Bulletin* (Philadelphia Museum of Art), vol. 31, no. 168 (November 1935), p. 13; PMA 1965, p. 45; Rishel 1971, p. 27, cat. no. 10, repro.

CONDITION: The painting was lined with wax resin and the old varnish partially removed in 1969. The painting is currently planar. The paint film shows prominent age and traction crackle in the central sky. The outlines of several of the sheep have been retouched, presumably to clarify and strengthen the forms; also a small lamb above the straggler at the lower right has been completely overpainted, an artist's change that is now camouflaged with retouches. The right side of the sky is also retouched. The varnish is even and very slightly discolored. Darker residues remain in the interstices of the paint.

72 ANTON MAUVE

MILKING TIME, late 1870s or 1880s
Signed lower right: *A. Mauve f.*
Oil on canvas, 40 x 26″ (101.6 x 66 cm.)
The William L. Elkins Collection. E24-3-13

Four cows stand in the corner of a field with a foreshortened rail fence on the right beside tall trees. A milkmaid dressed in red and dark blue milks one of the cows; to the left stands her milk bucket.

A very similar composition depicting the corner of the same pasture exists in a watercolor by Mauve (fig. 72-1), formerly with Scott and Fowles in New York and exhibited earlier at the French Gallery, London, in 1910. Mauve often used the device of the foreshortened fence to enhance the sense of spatial recession in his pictures of cows; compare, for example, *The Milking Yard.*[1] One of Mauve's numerous tranquil scenes of farm life, this work probably dates from his mature or later career, the late 1870s or 1880s.

FIG. 72-1 Anton Mauve, *Milking Time,* wash on paper, The French Gallery, London, in 1910.

NOTE
1. Oil on canvas, 67⁷⁄₁₆ x 45¼″ (171 x 115 cm.), Rijksmuseum, Amsterdam, no. A1888.

PROVENANCE: William L. Elkins Collection, Philadelphia, by 1900.

LITERATURE: Elkins 1887–1900, vol. 1, no. 36, repro.; Elkins 1924, no. 13; PMA 1965, p. 45; Rishel 1971, p. 27, cat. no. 8, repro.

CONDITION: The unlined canvas is brittle and slack on the stretcher. Traction crackle is located in the darks at the center and along the lower right edge. Some cupping is apparent in the milk bucket. The varnish is moderately discolored and dulled by surface grime.

Baptized on January 11, 1632, in the church of St. Nicolaes in Brussels, Adam van der Meulen was apprenticed to the battle painter Pieter Snayers (1592–1666) at the age of fourteen. In 1651 he joined the painters' guild. His earliest dated painting is of 1653. In 1664 he moved to Paris and entered the service of Louis XIV of France, where he worked both as a painter and tapestry designer. In 1667 he obtained free lodgings at the Gobelins tapestry works, and on May 15, 1673, he joined the Royal Academy of Painting. Together with the artists Charles Le Brun (1619–1690) and André Le Nostre (1613–1700), Van der Meulen, who often traveled with the French army, accompanied the king at the siege of Cambrai in 1677. In 1679 he married Catherine de Lobri, who died the following year; in January 1681 he married Marie de By, Le Brun's niece, who bore him two sons and a daughter. In 1683 he was named *conseiller* and three years later *premier conseiller* at the Royal Academy. Van der Meulen was buried in the church of St. Hippolyte in Paris on October 16, 1690.

Van der Meulen was the personal history painter of the French king, recording his sieges and victories. He played an important role in the introduction into France of the Netherlandish tradition of battle painting and militia genre scenes. Van der Meulen was also a skilled landscape painter and draftsman. He had a large workshop of assistants, and many of his works were engraved. Among the artists whom he influenced were François Desportes (1661–1743), François Le Moine (1688–1737), and Antoine Watteau (1684–1721). His memoirs provide important information about his oeuvre and the journeys he undertook with the French army ("Mémoire de tout ce que François vander Meulen a peint et dessigné pour le service de sa Majesté depuis le 1ᵉ Avril 1664," National Archives, Paris).

LITERATURE: Joachim von Sandrart, *Teutsche Academie* (Nuremberg, 1675), p. 373; Florent LeComte, *Cabinet des singularitez d'architecture, peintre, sculpture, et de graveure* (Paris, 1699–1700); Dezalier d'Argenville, *Abrégé de la vie des plus fameux peintres,* 4 vols. (Paris, 1762), vol. 2, pp. 402–47; Edouard Fétis, *Les Artistes belges à l'étranger* (Brussels, 1865), vol. 2, pp. 104–35; Edouard Gerspach, "Les Desseins de van der Meulen aux Gobelins," *Gazette des Beaux-Arts,* 34th year, 4th ser., vol. 8 (1892), pp. 138–44; Wurzbach 1906–11, vol. 2 (1911), pp. 152–53; Gaston Brière, "Van der Meulen, Collaborateur de Le Brun," *Bulletin de la Société de l'Histoire de l'Art français,* 1930, pp. 150–55; Thieme-Becker 1907–50, vol. 24 (1930), pp. 450–51; Charles Mauricheau-Beaupré, "Un Peintre de Louis XIV aux armées, Van der Meulen," *Jardin des Arts,* vol. 37 (November 1967); Inga Morris, "Adam Franz van der Meulen (1632–1690)," diss., Westfälischen Willhelms-Universität, Münster, 1970.

73 ADAM FRANS VAN DER MEULEN
AND STUDIO

THE PASSAGE OF THE RHINE ON JUNE 12, 1672
Oil on canvas, 20 x 76½″ (50.8 x 194.3 cm.)
Gift of James H. Hyde. 48-27-1

This painting depicts a famous episode in the Dutch and French war of
1672–79. A prolonged drought in the summer of 1672 produced a low water
level that enabled the French army to cross the Rhine at Wesel on June 12;
later, to effect the separation of William of Orange from his base at Arnhem,
the operation was again carried out in the reverse direction. The French
army, numbering ninety thousand men, was under the joint command of
Louis XIV, Marshal Turenne, and the Prince de Condé. Astride a white
horse, King Louis XIV points with his baton to the opposite shore, where
the fort of Tolhuis is seen in the center distance. The 1836 catalogue of
Château d'Eu offers a full, if somewhat chauvinistic, account of the
engagement depicted,[1] noting that the cuirassiers, under the command of
the Comte de Revel and led by the Comte de Guiche, were the first to
throw themselves into the river. Three squadrons of Dutch cavalry, in an
unsuccessful attempt to repel the advance, waded into the Rhine and were
nearly swept away. As soon as the French were across, the Prince de Condé
and the Duc d'Enghien led an attack on the fort and defeated a large
contingent of Dutch infantry, killing five hundred and taking four thousand
prisoners.

 This work is one of several variants and versions of the subject, of
which the smaller painting in the Louvre (fig. 73-1) undoubtedly is the
primary version.[2] As Van der Meulen explained in his memoirs, that
painting was part of a trilogy, which originally included two other canvases
depicting the king in command of his marching army and engineers
constructing a pontoon bridge (a version of which is in the Musée des
Beaux-Arts, Caen).[3] Other versions, variants, and copies of the present
composition are preserved in the museums in Caen,[4] Dijon,[5] Versailles,[6]
Arras,[7] and at least one private collection.[8] The Philadelphia version's
composition corresponds fairly closely to the design of the Louvre's
painting but is broader in format (32⅞″ [83.3 cm.] longer in its horizontal
dimension), adding motifs to the left (a pair of horsemen and a tree) and
right sides (a tree and additional figures on the far bank), and altering or
eliminating many small details, such as the dappling of Louis's horse. The
largest of the various versions of this design, the Philadelphia painting is of
special interest because it was probably painted for Louis XIV's niece, the
Duchesse de Montpensier, who had a room decorated in her country villa

FIG. 73-1 Adam Frans van der Meulen,
The Passage of the Rhine, oil on canvas,
19¾ x 43¹¹⁄₁₆″ (50 x 111 cm.), Musée du Louvre,
Paris, inv. no. 2039.

at Choisy with paintings illustrating the king's military victories.[9] This painting has sometimes been said to be the version in the Louvre;[10] however, on the reverse of the Philadelphia painting are not only the stamps of the royal collection and those of Louis Philippe and the Château d'Eu but also the mark and initials of the Montpensier Collection, thus certifying the identification.[11] Although the Montpensier memoirs state that the paintings for Choisy were by Van der Meulen, it seems likely that the Philadelphia painting is, at least in part, the work of assistants.[12] Van der Meulen had a large atelier that produced many copies of his works; the inventory of the artist's estate lists no fewer than sixty-three copies of his works.[13]

NOTES

1. *Indicateur de la galerie des portraits, tableaux, et bustes qui composent la collection du roi, au Château d'Eu* (Paris, 1836), pt. 2, p. 273, no. 5.

2. See Louis Demonts, *Catalogue des peintures*, vol. 3, *Ecoles flamande, hollandaise, allemande, et anglaise, Musée National du Louvre* (Paris, 1922), p. 10, no. 2039; and *Catalogue sommaire illustré des peintures du musée du Louvre et du musée d'Orsay: IV, École française*, vol. 2 (Paris, 1986), p. 260, inv. no. 1490; Inga Morris, "Adam Franz van der Meulen (1632–1690)," diss., Westfälischen Willhelms-Universität, Münster, 1970, cat. no. 47. The Musée du Louvre's painting was engraved by C. Simoneau and P. Laurent.

3. *Preparatory Study for "Crossing the Rhine,"* oil on canvas, 31½ x 59″ (80 x 150 cm.), no. 78; see "Mémoire de tout ce que François vander Meulen a peint et dessigné pour le service de sa Majesté depuis le Iᵉ Avril 1664," National Archives, Paris, O.1934 (repro. in Morris [see note 2], p. 32, entire document pp. 29–37).

4. Oil on canvas, 31½ x 59″ (80 x 150 cm.), Musée des Beaux-Arts, Caen, no. 79, from the collection of Louis XIV.

5. Oil on canvas, 26¾ x 42½″ (68 x 108 cm.), Musée de Dijon, no. 153.

6. In addition to a copy by Jean Baptiste (Martin des Batailles) (oil on canvas, 23⅝ x 28¼″ [60 x 72 cm.], no. 2146), the Musée National du Château de Versailles, owns a tapestry cartoon of the design attributed to Louis Testelin, after Le Brun and Van der Meulen, no. 126 (as cited in Demonts [see note 2], p. 10).

7. See Morris (note 2), under cat. no. 47.

8. According to a letter from Michel Florisoone of the Muséée du Louvre (August 25, 1948, Philadelphia Museum of Art, accession files), a replica or copy was in the collection of Jacques Seligmann.

9. *Mémoires de Mademoiselle de Montpensier, fille de M. Gaston d'Orléans, frère de Louis XIV Roi de France*, 6 vols. (Paris, 1728), vol. 6, p. 317; see also Jean Vatout, *Catalogue historique des tableaux appartenues à S.A.S. Mgr. de Duc d'Orléans* (Paris, 1823), vol. 1, p. v.

10. See, for example, Demonts (note 2), p. 10, no. 2039; and Morris (note 2), no. 47; however, the reference was omitted from the work's provenance in *Catalogue sommaire* (see note 2), p. 260, inv. no. 1490.

11. A stenciled inscription reads "Passage du Rhine en 1672, par l'Armée Française sous les ordres de Louis XIV. Peint par van der Meulen." The stamp of the Château d'Eu is a crown above the letters "EU"; the stamp of the royal collection is a crown surmounting "Le Roy" in ligated script. According to the introduction to the 1836 catalogue of Château d'Eu (see note 1), the initials "C.M.," which appear on the reverse of the painting, refer to "Collection Montpensier." Furthermore, according to Vatout (see note 9), p. xiv, all works coming from the Montpensier Collection and preserved at Château d'Eu were stamped with an "S" and an "E." On the reverse is the mark "S.IIE." and on the front in the lower left, "S.5.E."

12. See note 9. The work carried no attribution whatsoever in the *Indicateur* (see note 1) and was only "attributed to" Van der Meulen in the sale, Duc de Vendôme, Galerie Georges Petit, Paris, December 4, 1931, lot 78.

13. See Morris (note 2), pp. 23–24.

PROVENANCE: Anne Marie Louise d'Orleans, Duchesse de Montpensier, called "La Grande Mademoiselle," who hung it with other scenes of Louis XIV's victories in a room in her Château Choisy, near Paris; subsequently moved to the Château d'Eu, the ancestral home of the Ducs de Guise and Lorraine, which was also owned by the Duchesse de Montpensier, and later passed with its contents to the king of France, and then on to Louis Philippe, cat. 1836, pt. 2, no. 5; Duc de Vendôme, Paris; sale, Duc de Vendôme, Galerie Georges Petit, Paris, December 4, 1931, lot 78 [as attributed to Frans van der Meulen]; James H. Hyde, New York.

LITERATURE: Jean Vatout, *Chateau d'Eu*, vol. 5 (Paris, 1836), p. 503, no. 5; *Indicateur de la galerie des portraits, tableaux, et bustes qui composent la collection du roi, au Château d'Eu* (Paris, 1836), pt. 2, p. 273, no. 5; PMA 1965, p. 45.

CONDITION: The canvas support has an aqueous lining that enlarges the work by approximately 1½″ (3.8 cm.) along the lower edge. As a consequence, the lower edge of the original canvas is overpainted. The paint film overall is in good condition with only scattered minor losses. The varnish layer is dull and moderately discolored.

Born in Antwerp on October 17, 1603, Frans de Momper was the son of the landscape painter Jan de Momper, the brother of Philip de Momper II (d. 1675), and the nephew of the well-known painter Joos de Momper II (1564–1635). In 1629 he became a master in the Antwerp guild and married Catherina Beucker, who died in 1646. Emigrating to the northern Netherlands, he was first active in The Hague, where his works were auctioned by the Guild of Saint Luke on April 10, 1647. In the same year, he was recorded in Haarlem and the following year joined the guild there. In 1648 he also appeared in Amsterdam and the following year, when he remarried, was registered as an artist from Antwerp. De Momper returned to Antwerp in August 1650 and died there in 1660. On October 6, 1662, Philip de Momper II, acting as guardian for the children and heirs of Frans de Momper, authorized a boatman to demand from a Dirck Ulbrecht in Hamburg the restitution of all the paintings that Frans de Momper had consigned to him for sale.

A painter of winter scenes, mountainous landscapes, and views of villages, Frans de Momper first worked in the Flemish landscape manner of his uncle; in the Netherlands, however, he developed a more intimate, tonal style, influenced by Jan van Goyen (q.v.) and Hercules Seghers (1589/90–between 1633 and 1638).

LITERATURE: Van der Willigen (1870) 1970; Theodor von Frimmel, "Zu Frans de Momper," *Blätter für Gemäldekunde,* vol. 1 (1905), pp. 64–66; C. Hofstede de Groot, "Inedita IX: François de Momper," *Oude Kunst,* vol. 1 (1915–16), pp. 213ff.; Wurzbach 1906–11, vol. 1, p. 180; Abraham Bredius, "Het juiste sterf-datum van Jan van Goyen," *Oud Holland,* vol. 34 (1916), pp. 158–59; C. Hofstede de Groot, "Jan van Goyen and His Followers," *The Burlington Magazine,* vol. 42, no. 238 (1923), pp. 4–27; Rolph Grosse, *Die holländische Landschaftskunst, 1600–1650* (Berlin and Leipzig, 1925), pp. 30, 86; Thieme-Becker 1907–50, vol. 25 (1931), pp. 51–52; Abraham Bredius, "Archiefsprokkelingen," *Oud Holland,* vol. 56 (1939), pp. 47-48; Arthur Laes, "Paysages de Josse et Frans de Momper," *Bulletin des Musées Royaux des Beaux-Arts* (Brussels), vol. 1 (1952), pp. 57–67; Wolfgang Stechow, *Dutch Landscape Painting of the Seventeenth Century* (London, 1966), p. 134; J. G. van Gelder, "Huiswaarts kerend landvolk," *Openbaar kunstbezit,* vol. 7 (1963), pp. 27a–b; Laurens J. Bol, *Holländische Maler des 17. Jahrhunderts nahe den grossen Meistern: Landschaften und Stilleben* (Brunswick, 1969), pp. 182–83; Bob Haak, *The Golden Age: Dutch Painters of the Seventeenth Century* (New York, 1984), p. 339; Klaus Ertz, *Josse de Momper der Jüngere: Die Gemälde* (Freren, 1986), pp. 278–95; Sutton et al. 1987, pp. 376–78.

For an additional work by Frans de Momper in the Philadelphia Museum of Art, see John G. Johnson Collection cat. no. 655.

74 FRANS DE MOMPER

VALLEY WITH MOUNTAINS, c. 1640
Signed lower center: *f Momper*
Oil on panel, 14¾ x 24⅞" (37.5 x 63.2 cm.)
The Henry P. McIlhenny Collection in memory of Frances P.
 McIlhenny. 1986-26-276

Above a wide valley in an imaginary landscape, towering, craggy mountains
soar. In the darkened foreground a rider and a traveler on foot descend into
the valley. A blasted, limbless tree on the left balances the thrust of the
church spires and mountains on the right. In the middle distance sailing
vessels ply a broad lake and on the shore is the suggestion of a city with tall
buildings and a port.

 Frans de Momper's mountain views descend from the sixteenth-century
Flemish tradition of "world landscapes" (*Weltlandschaften*) invented by
Joachim Patinir (c. 1485–1524) and perfected by Pieter Bruegel the Elder
(c. 1525/30–1569). Frans's uncle Joos de Momper II (1564–1635) helped
perpetuate this tradition, with its elevated viewpoint, dramatic scenery, and
encyclopedic account of the terrain, and, in turn, passed it along to his
nephew.[1] In this painting not only the subject but also the treatment of the
great mountains, the lake, and such details as the denuded tree recall Joos's
art. However, Frans transformed the latter's most mannered and decorative
aspects into a vision that is at once more dramatic and visionary. The scene
is still a fantasy but the landscape motifs are less stylized; the palette—
though still composed of the Mannerists' triad of brown, green, and
blue—is tempered by a new tonal harmony. These developments probably
not only reflect Frans de Momper's acquaintance with Jan van Goyen's

FIG. 74-1 Here attributed to Frans de
Momper, *Mountain Landscape,* oil on panel,
15¾ x 22" (40 x 56 cm.), H. J. Reinink
Collection, The Hague.

FIG. 74-2 Frans de Momper, *River Valley with Mountains,* signed, oil on panel, 16½ x 25³⁄₁₆″ (42 x 64 cm.), Kunstmuseum, Düsseldorf, inv. no. 214.

FIG. 74-3 Frans de Momper, *Mountain Landscape,* signed, oil on panel, 20½ x 28″ (52 x 71 cm.), Museum für Kunst und Kulturgeschichte, Dortmund, inv. no. C6169.

"tonal" landscapes of c. 1630 and later, but also the influence of the visionary art of Hercules Seghers (1589/90–between 1633 and 1638).[2] In addition to the works reassigned by Wolfgang Stechow from Seghers's oeuvre to that of Frans de Momper, there is a mountain landscape formerly in the H. J. Reinink Collection, The Hague (fig. 74-1), that employs a similar design and the same staffage as the Philadelphia painting and is tentatively reattributed to Frans de Momper by the present author.[3] None of Frans de Momper's mountain scenes are dated and few are signed,[4] but the certain works in the museums in Düsseldorf and Dortmund (figs. 74-2 and 74-3) are similar in conception and technique to this picture.

NOTES

1. On the Bruegel revival in Dutch landscape, see Teréz Gerszi, "Bruegels Nachwirkung auf die niederländischen Landschaftsmaler um 1600," *Oud Holland,* vol. 90 (1976), pp. 201–29. On Joos de Momper II's quotations from Bruegel's mountain scenery, see Teréz Gerszi, "Joos de Momper und die Bruegel-Tradition," in Nationalmuseum, Stockholm, *Netherlandish Mannerism,* 1985, p. 159; see also Klaus Ertz, *Josse de Momper der Jüngere: Die Gemälde* (Freren, 1986), p. 281.
2. Wolfgang Stechow, *Dutch Landscape Painting of the Seventeenth Century* (London, 1966), p. 211 n. 15.
3. Sutton et al. 1987, p. 377.
4. See Ertz (note 1), pp. 278–88, figs. 321–29, 332, 333a, 334–39, which include Ertz's attributions to the artist as well as certain works.

PROVENANCE: Henry P. McIlhenny Collection, Philadelphia.

EXHIBITIONS: Museum of Fine Arts, Boston, "Masterpieces from the Henry P. McIlhenny Collection," 1986 (no catalogue); Philadelphia Museum of Art, "The Henry P. McIlhenny Collection," November 22, 1987–January 17, 1988 (no catalogue); Amsterdam, Boston, Philadelphia 1987–88, cat. no. 57, pl. 41.

LITERATURE: Wolfgang Stechow, *Dutch Landscape Painting of the Seventeenth Century* (London, 1966), p. 134, fig. 268.

CONDITION: The support is an oak panel comprising two quarter-sawn pieces whose grain runs horizontally. The panel is unthinned, its reverse exhibits vertical sawmarks; it is chamfered along all four edges and coated with a thick layer of reddish-brown paint. The panel remains flat and stable. The ground is a thin cream-colored layer; wood grain is visible through the ground in thinly painted passages. The paint is well preserved with few very small losses and only minor abrasion of thin layers along ridges of wood grain and some brushmarks, due to cleaning. The synthetic varnish is thin, even, and nearly colorless, and covers residues of an earlier natural resin film toward the bottom edge.

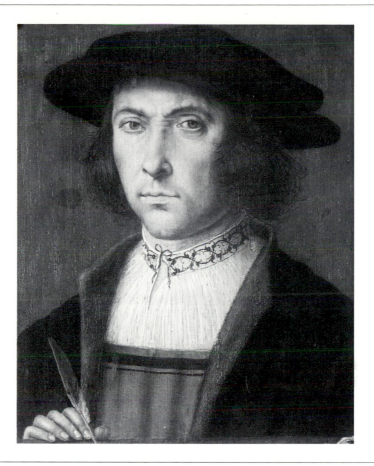

75 FOLLOWER OF JAN MOSTAERT

PORTRAIT OF A MAN, c. 1520–30
Oil on panel, 9 x 7⅜" (22.9 x 18.7 cm.)
Bequest of John D. McIlhenny. 43-40-42

The sitter is viewed bust length wearing a wide black beret, white tunic with embroidered collar, a red jerkin, and a black fur-lined coat. His right hand, holding a quill pen, rests on a thin, painted ledge at the lower edge.

An old label on the reverse attributed the work simply to the "Ecole hollandaise [Dutch School], no. 13276." While in the John D. McIlhenny Collection the painting was assigned to Cornelis Engelbrechtsz (1468–1533). Upon its receipt by the Museum, the painting was attributed to Jan Mostaert (c. 1475–1555/56), under whose name the picture has since been catalogued. In 1944 Henri Marceau compared the painting to Mostaert's *Portrait of Joost van Bronkhorst* in the Petit Palais, Paris, and the *Portrait of a Man* in Worcester, Massachusetts.[1] Allowing for the serious condition problems of the latter painting and the different format of both works (half-length portraits before landscapes), these two paintings bear some resemblance to the Philadelphia picture both in conception (the rigidly formal pose and the intent gaze, the long face and nose with the diminutive pointed chin, the slender stiffly moving fingers) and in the treatment of surfaces and materials. Mostaert's portraits of male sitters in West Berlin, Brussels, London, and Gheel also offer points of comparison.[2] The greater simplicity of Philadelphia's painting and the more cursory technique, however, suggest that it is the work of a follower or someone painting in

Mostaert's style. The costume of the sitter would suggest a date of about 1520 to 1530. James Snyder (privately) supports the view that it is the work of a "follower, c. 1520–30,... [and] definitely... North-Netherlandish."[3] The motif of the hand on the ledge holding the quill pen, a traditional attribute of scholarship, was an illusionistic device designed to enhance the immediacy of the image by drawing attention to the threshold of the pictorial space.

NOTES

1. Henri Marceau, "Paintings [from the John D. McIlhenny Collection]," *The Philadelphia Museum Bulletin* (Philadelphia Museum of Art), vol. 39, no. 200 (January 1944), p. 54. Oil on panel, 17⅛ x 11¼" (43.5 x 28.7 cm.), Petit Palais, Paris, no. 625 (see Max J. Friedländer, *Early Netherlandish Painting,* vol. 10 [rev. ed., Leiden and Brussels, 1973], no. 26, pl. 18); and oil on panel, 17½ x 12⅛" (44.7 x 30.8 cm.), Worcester Art Museum, acc. no. 1921.182 (Friedländer no. 33, pl. 21).
2. *Portrait of a Man,* c. 1520, oil on panel, 16½ x 11½" (42 x 29 cm.), Gemäldegalerie, Staatliche Museen Preussischer Kulturbesitz, Berlin (West), no. 591 (Friedländer [see note 1] no. 34, pl. 21); *Portrait of the Knight Abel van de Coulster,* oil on panel, 35¼ x 22" (89.5 x 56 cm.), Musées Royaux des Beaux-Arts de Belgique, Brussels, inv. no. 2935 (Friedländer no. 35, pl. 22); *Portrait of a Moor,* oil on panel, 12½ x 8¾" (32 x 22 cm.), Sir T. D. Barlow Collection, London (Friedländer no. 30, pl. 20); and *Portrait of Hendrik van Merode,* oil on panel, 10⅛ x 6¾" (27 x 17 cm.), Church of St. Dymphna, Gheel (Friedländer no. 154, pl. 118).
3. James Snyder to the author, August 17, 1984, Philadelphia Museum of Art, accession files.

PROVENANCE: John D. McIlhenny Collection, Philadelphia.

EXHIBITION: Memorial Hall, Philadelphia, *John D. McIlhenny Memorial Exhibition,* March 2–April 10, 1926.

LITERATURE: Arthur Edwin Bye, "Paintings," *The Pennsylvania Museum Bulletin* (Philadelphia Museum of Art), vol. 21, no. 100 (February 1926), pp. 89–92, repro. on cover [as Cornelis Engelbrechtsz]; Henri Marceau, "Paintings [from the John D. McIlhenny Collection]," *The Philadelphia Museum Bulletin* (Philadelphia Museum of Art), vol. 39, no. 200 (January 1944), p. 54 [as Jan Mostaert]; PMA 1965, p. 50 [as Jan Mostaert].

CONDITION: The panel support has a vertical grain and is stable. The paint is slightly abraded throughout. There are several vertical losses with discolored retouches in the upper-left corner, in two places along the brim of the hat, to the right of the collar, in three places on the upper part of the jerkin and fur lapel, and at the center of the lower edge. An overall fine vertical crackle pattern in the paint film is associated with the direction of the wood grain of the panel. The varnish is uneven and deeply discolored.

For an additional work by Mostaert in the Philadelphia Museum of Art, see John G. Johnson Collection cat. no. 411.

76 STYLE OF ISAAC DE MOUCHERON

CLASSICAL LANDSCAPE
Oil on canvas, 38½ x 52″ (97.8 x 132.1 cm.)
Bequest of Arthur H. Lea. F38-1-28

The parklike landscape includes architecture amidst tall poplars and other trees. A terraced hillside with balustrades and sculpture rises on the left before a central vista. A large sculpted fountain appears on the right. In the center is a hunting party with riders and dogs, and, to the right, a peacock.

In its ruined condition and with an obscuring mask of rice paper covering its surface, the painting cannot be properly assessed at this time. However, the traditional attribution to Isaac de Moucheron (1667–1744) is here provisionally downgraded to the style of that artist.

CONDITION: The canvas is loose and brittle; and the tacking edges are missing. The paint film is in ruinous condition. A protective covering of wax and facing paper presently obscures the surface.

Aert van der Neer was probably born in 1603 or 1604 in Amsterdam; on May 12, 1642, he was recorded as being about thirty-eight years old and on October 20, 1651, about forty-eight years old. According to Arnold Houbraken, Van der Neer lived in Arkel near Gorinchem and was the father of Eglon Hendrick van der Neer (1634?–1703). Houbraken also stated that he was a steward in the service of a family at Gorinchem. Among the leading artists in Gorinchem in Van der Neer's youth were Jochem (1601/2–1659) and Raphael Govertsz. Camphuysen (c. 1597/98–1657). Documents and stylistic similarities suggest that the latter was Van der Neer's teacher; in 1642 Raphael Camphuysen was a witness at the baptism of Van der Neer's daughter Cornelia in Amsterdam. Van der Neer and his wife, Elisabeth Goverts, had moved to Amsterdam about 1632. His son, the accomplished genre painter Eglon Hendrick was born there; Johannes, a lesser-known artist who imitated his father, was born in 1637/38 (d. 1665); Pieter was born March 4, 1640; Cornelia, December 28, 1642; another Pieter, July 5, 1648; and Alida, July 7, 1650.

Twice in 1659, Aert van der Neer was mentioned as a citizen of Amsterdam working as an innkeeper at "de Graeff van Hollant" on the Kalverstraat. Aert and his son Johannes were both taverners in Amsterdam. On January 25, 1662, he again appeared in a list of innkeepers. On December 12 of the same year he went bankrupt, and an inventory of his belongings was drawn up. His paintings were appraised at relatively low values, mostly five guilders and less. At the end of his life he lived in impoverished conditions. His address was given as the Kerkstraat near the Leidsegracht when he died in Amsterdam on November 9, 1677.

The artist's earliest dated painting is a genre scene of 1632 (Národní Galerie, Prague); his earliest landscape is of 1633 (*Landscape with Farm*, oil on panel, 12³⁄₁₆ x 19⁵⁄₁₆″ [31 x 49 cm.], location unknown). A painter of winter scenes and moonlit and twilight landscapes, Van der Neer developed into one of the most important landscapists of his time. His early landscapes are influenced by the Camphuysen brothers, and the winter landscapes show an interest in Hendrik Avercamp (1585–1634) and Esaias van de Velde (c. 1590–1630).

LITERATURE: Houbraken 1718–21, vol. 3, p. 172; Abraham Bredius, "Aernout (Aert) van der Neer," *Oud Holland*, vol. 18 (1900), pp. 69–82; Abraham Bredius, "Nog iets over Aernout (Aert) van der Neer," *Oud Holland*, vol. 28 (1910), pp. 56–57; Hofstede de Groot 1908–27, vol. 7 (1923), pp. 359–523; Hans Kauffmann, "Die Farbenkunst des Aert van der Neer," *Festschrift für Adolph Goldschmidt zum 60. Geburtstag* (Leipzig, 1923); Thieme-Becker 1907–50, vol. 25 (1931), pp. 374–75; Willem Martin, *De Hollandsche schilderkunst in de zeventiende eeuw* (Amsterdam, 1935–36), vol. 2, pp. 283–88; Wolfgang Stechow, *Dutch Landscape Painting of the Seventeenth Century* (London, 1966), pp. 96–98, 176–82; Fredo Bachmann, *Die Landschaften des Aert van der Neer* (Neustadt, 1966); Fredo Bachmann, "Die Brüder Rafael und Jochem Camphuysen und ihr Verhältnis zu Aert van der Neer," *Oud Holland*, vol. 85, no. 4 (1970), pp. 243–50; Fredo Bachmann, *Aert van der Neer als Zeichner* (Neustadt, 1972); Fredo Bachmann, *Aert van der Neer, 1603/4–1677* (Bremen, 1982); Manja Zeldenrust, "Aert van der Neers 'Rivier landschap bij maanlicht opgehelderd,'" *Bulletin van het Rijksmuseum* (Amsterdam), vol. 31 (1983), pp. 99–104; Bob Haak, *The Golden Age: Dutch Painters of the Seventeenth Century* (New York, 1984), pp. 304–5; Sutton et al. 1987, pp. 381–87.

For additional works by Van der Neer in the Philadelphia Museum of Art, see John G. Johnson Collection cat. nos. 553 (attributed to), 555 (imitator of), inv. no. 2862 (imitator of), cat. no. 554 (copy after).

77 AERT VAN DER NEER

RIVER LANDSCAPE AT TWILIGHT, late 1640s or early 1650s
Signed lower left: *AVDM* (ligated)
Oil on panel, 7¼ x 11¼" (18.4 x 28.6 cm.)
The William L. Elkins Collection. E24-3-52

FIG. 77-1 Aert van der Neer, *River View in
Moonlight,* monogrammed, oil on panel,
17⅝ x 24¾" (44.8 x 63 cm.), Mauritshuis,
The Hague, inv. no. 913.

A river, reminiscent of the Amstel outside Amsterdam, recedes to a central
vanishing point beneath a rose- and yellow-colored twilight sky. In the
foreground are fishing nets, and at the right two fishermen. A church spire
and a windmill appear at the left, and two tiny cows are in the middle
distance. Two churches, one with a large square tower and a second with a
pointed steeple, appear on the horizon.

The measurements of the panel were incorrectly recorded in the
1887–1900 Elkins Collection catalogue as 23½ by 32¾ inches (59.5 x 83 cm.), a
mistake repeated by C. Hofstede de Groot. In actuality the panel is only
one-third this size, having been conceived on a very intimate scale. Other
comparable small-scale panels by Van der Neer are found in London in the
Victoria and Albert Museum,[1] the National Gallery,[2] and the Wallace
Collection,[3] and in Frankfurt at the Städelsches Kunstinstitut.[4] Close in
design (note the reappearance of the steeple and mill on the left) is the
larger panel in the Mauritshuis, The Hague (fig. 77-1).[5] Although precise
dating is not possible, the Philadelphia work may have originated in the late
1640s or early 1650s. It probably postdates the moonlight landscape dated
1647 in a private collection in Montreal (fig. 77-2).[6]

FIG. 77-2 Aert van der Neer, *River View in Moonlight,* monogrammed and dated 1647, oil on panel, 25⅝ x 35″ (57.5 x 89 cm.), private collection, Montreal.

The broad view of a river receding to a central vanishing point beneath a twilight sky was one of Van der Neer's preferred designs and descends from landscape compositions favored by Netherlandish artists before and around the turn of the century. Here, as elsewhere in such scenes, the motif of fishing nets drawn horizontally across the river serves to retard the movement into space.[7] Executed with an exceptionally delicate touch, this detailed little scene gives the impression of being an actual site; as usual, however, it is undoubtedly imaginary. The commonness of scenes of sunrises and sunsets in the modern era ought not to obscure the refreshing absence of romantic sentiment in this work by one of the first specialists in this genre.

NOTES

1. *Moonlight and River Scene,* oil on panel, 13⅛ x 19½″ (33.2 x 49.5 cm.), no. D. 7; Hofstede de Groot 1908–27, vol. 7 (1923), no. 233.

2. *A River Near a Town by Moonlight,* monogrammed, oil on panel, 11¹⁵⁄₁₆ x 19¹⁄₁₆″ (30.3 x 48.4 cm.), cat. no. 239; Hofstede de Groot 1908–27, vol. 7 (1923), no. 221; *A Village by a River in Moonlight,* oil on panel, 7¾ x 11⅛″ (19.7 x 28.3 cm.), cat. no. 2536; Hofstede de Groot 1908–27, vol. 7 (1923), no. 222.

3. *Scene on a Canal,* oil on panel, 5½ x 9½″ (14 x 24.1 cm.), cat. no. P184 [as after Aert van der Neer]; Hofstede de Groot 1908–27, vol. 7 (1923), no. 55.

4. *Dutch Canal,* monogrammed, oil on panel, 7⅞ x 13⅜″ (20 x 34 cm.), inv. no. 508; Hofstede de Groot 1908–27, vol. 7 (1923), no. 33.

5. Hofstede de Groot 1908–27, vol. 7 (1923), no. 53 [as "A River Scene: Sunrise"].

6. Hofstede de Groot 1908–27, vol. 7 (1923), no. 431; Sutton et al. 1987, no. 59, pl. 42.

7. Compare *Moonlit Landscape with Fishing Nets,* monogrammed, oil on canvas, 24½ x 30″ (62.2 x 76.2 cm.), Neues Schloss Schleissheim und Staatsgalerie, Schleissheim, inv. no. 543; Hofstede de Groot 1908–27, vol. 7 (1923), no. 305; and *Dutch Canal* (see note 4).

CONDITION: The cradled panel is planar, horizontally grained, and generally stable. It has a tiny horizontal split in the upper-left corner. The paint film is generally in a good state, although it shows minor abrasion and tiny losses scattered throughout the sky. Some small areas of old and particularly insoluble overpaint were left in the clouds when the picture was cleaned in 1980. The varnish is clear.

78 AERT VAN DER NEER

MOONLIT LANDSCAPE WITH A BROOK AND A VILLAGE, 1650s
Oil on canvas, 25⁹/₁₆ x 32⁵/₁₆″ (65 x 82.1 cm.)
Purchased for the W. P. Wilstach Collection. W95-1-7

Past a stream receding from left to right, a village is seen through a line of tall trees on the left bank, and three staffage figures, a dog, and several fallen logs appear on the right bank. The moon is just rising in the distance.

According to the Sedelmeyer Gallery catalogue of 1895, the picture bore the artist's monogram; no mention was made of such a mark in the Febvre (1882) or Beurnonville (1883) sales catalogues, however; and no monogram is visible at this time.[1] Nonetheless, the subject and composition, with receding brook and backlit tree, are typical of the artist. Van der Neer had begun nocturnal scenes with rivers and canals by 1643[2] and perfected these themes in the later 1640s (see, for example, fig. 77-2).[3] While his nocturnes on panel often employ a very fine touch with delicate washes or touches of color (see no. 77), his larger works on canvas are often executed in the correspondingly broader manner and pastel hues of the Philadelphia painting. Owing to the paucity of dates after 1647, dating these works is

highly speculative. Noting that the costumes of some of the staffage figures in the large *Evening View with Village* in the National Gallery, London, are costumes that cannot have originated earlier than the "later 1640s," Neil MacLaren has dated London's painting to about 1650–55.[4] Again with the aid of costumes, he dated still another large canvas by Van der Neer in the National Gallery, London, the *View along a River near a Village at Evening* to the 1660s.[5] While the attire of the peasant family in the Museum's picture cannot be precisely dated, the work probably was executed before the more elegant, later London picture, but perhaps during the same period as the earlier painting. Thus a date in the 1650s is tentatively proposed.

NOTES

1. Sedelmeyer Gallery, Paris, *Illustrated Catalogue of the Second Hundred Paintings by Old Masters* (Paris, 1895), p. 32, no. 27, repro.; sale, A. Febvre, Paris, *Catalogue des tableaux anciens,* April 17, 1882, lot 76, repro.; sale, Baron E. de Beurnonville, Paris, May 21, 1883, lot 73.

2. See *Evening Landscape with Canal,* oil on panel, 28⅜ x 39¾" (72 x 101 cm.), Schloss Friedenstein, Gotha. See Fredo Bachmann, *Aert van der Neer, 1603/4–1677* (Bremen, 1982), fig. 27; Sutton et al. 1987, p. 382, fig. 1.

3. Sutton et al. 1987, under cat. no. 59.

4. Oil on canvas, 47¾ x 64" (121 x 162 cm.), no. 152. Neil MacLaren, *The National Gallery Catalogues: The Dutch School* (London, 1960), p. 261; Bachmann (see note 2; p. 62) prefers a date in the late 1640s.

5. Oil on canvas, 52½ x 66" (133 x 167 cm.), no. 732. MacLaren (see note 4), p. 732.

PROVENANCE: Sale, M. van Helsleuter (of Amsterdam), Paris, January 5, 1802, lot 123; sale, A. Febvre, Paris, April 17, 1882, lot 76; sale, Baron E. de Beurnonville, Paris, May 21, 1883, lot 73; dealer Charles Sedelmeyer, Paris, 1895, cat. no. 27; purchased for the W. P. Wilstach Collection, Philadelphia, August 23, 1895.

LITERATURE: *Catalogue de tableaux* (Paris, 1802), p. 71–72, no. 123; Hôtel Drouot, Paris, *Catalogue des tableaux anciens* (Paris, 1882), no. 76, repro.; Charles Sedelmeyer, Paris, *Illustrated Catalogue of the Second Hundred Paintings by Old Masters* (Paris, 1895), p. 32, no. 27, repro.; Wilstach 1897 suppl., no. 196, 1900, no. 104, 1903, no. 138, 1904, no. 185, 1906, no. 206, 1907, no. 217, 1908, no. 217, 1910, no. 293, 1913, no. 306; Hofstede de Groot 1908–27, vol. 7 (1923), no. 117; Wilstach 1922, no. 227; Thieme-Becker 1907–50, vol. 25 (1931), p. 374; PMA 1965, p. 50; Rishel 1974, p. 29.

CONDITION: The painting is lined with an aqueous adhesive. The supports are brittle. The tacking edges are missing. The paint film reveals moderate to severe abrasion throughout, especially at the left edge. Some cupping is apparent, particularly in the dark colors. Retouches in the trees have discolored. The varnish is dull and deeply discolored.

PRINT AFTER
Engraved by Gustave Greux.

Baptized at Haarlem on December 10, 1610, Adriaen van Ostade was the son of a weaver, Jan Hendriksz., from Eindhoven. Adriaen and his younger brother Isaack (1621–1649), who was also a painter, probably adopted the surname Ostade from the village near Eindhoven. Adriaen is first mentioned by this name in documents of 1636. A document of 1632 indicates that he was active by this date and receiving commissions from outside his hometown. He joined the Haarlem guild in 1634 and served as a *hoofdman,* or leader, in 1647 and 1661 and *deken,* or dean, in 1662. In 1636 he was a member of the militia company "Oude Schuts." He was married in Haarlem in 1638 to Machteltje Petersdr., who died four years later. He was remarried in 1657 to Anna Ingels (d. 1666), who came from a wealthy Catholic family. Ostade may have converted at the time of his marriage. Although his second marriage took place in Amsterdam, Ostade seems to have spent virtually his whole life in Haarlem, where he was buried in St. Bavo's on May 2, 1685. At his death Ostade resided on the Ridderstraat in a well-to-do neighborhood in Haarlem.

According to Arnold Houbraken, he was a pupil of Frans Hals (1581/85–1666) at the same time (around 1627) as Adriaen Brouwer (1605/6–1638). While Hals had little discernible influence on the artist, Brouwer made a clear impact on his approach to low-life genre. After about 1640 Rembrandt seems to have influenced Ostade's lighting effects. Unlike his brother and student Isaack, who died young, Adriaen had a long and productive career as a painter, draftsman, and etcher of peasant life. He also executed a few biblical paintings and several portraits. Ostade had many followers, among whom the best known is Cornelis Dusart (1660–1704). His pupils also included the genre painters Cornelis Bega (1631/32–1664) and Jan Steen (q.v.).

LITERATURE: Cornelis de Bie, *Het Gulden Cabinet van de edele vry Schilderconst* (Antwerp, 1661; reprint, Soest, 1971) p. 258; Houbraken 1718–21, vol. I, pp. 320, 347–49; Theodor Gaedertz, *Adriaen van Ostade: Sein Leben und seine Kunst* (Lübeck, 1869); Van der Willigen (1870), 1970, pp. 21–23, 29, 233–41; Arsène Houssaye, *Van Ostade: Sa vie et son oeuvre* (Paris, 1876); Wilhelm von Bode, "Adriaan van Ostade als Zeichner und Maler," *Die graphischen Künste,* vol. I (1879), pp. 37–48; C. Vosmaer, "Adriaen van Ostade," *L'Art,* vol. 22, no. 3 (1880), pp. 241–50, 265–68; Marguerite van de Wiele, *Les Frères van Ostade* (Paris, 1892); Adolf Rosenberg, *Adriaen und Isack van Ostade* (Bielefeld and Leipzig, 1900); Hofstede de Groot 1908–27, vol. 3 (1910), pp. 140–436; Dmitri Rovinski and Nicolas Tschétchouline, *L'Oeuvre gravé d'Adrien van Ostade* (St. Petersburg, 1912); Wilhelm von Bode, "Die beiden Ostade," *Zeitschrift für bildende Kunst,* vol. 27 (1916), pp. 1–10;

E. Trautscholdt, "Notes on Adriaen van Ostade," *The Burlington Magazine,* vol. 54, no. 311 (February 1929), pp. 74–80; Louis Godefroy, *L'Oeuvre gravé de Adriaen van Ostade* (Paris, 1930); Abraham Bredius, "Een en ander over Adriaen van Ostade," *Oud Holland,* vol. 56 (1939), pp. 241–46; J. G. van Gelder, *Adriaen van Ostade: 50 etsen* (Haarlem, 1941); J. Kusnetzov, *Adriaen van Ostade* (in Russian) (Leningrad, 1960); Bernhard Schnackenburg, "Die Anfänge des Bauerinterieurs bei Adriaen van Ostade," *Oud Holland,* vol. 85 (1970), pp. 158–69; Bernhard Schnackenburg, *Adriaen van Ostade, Isack van Ostade: Zeichnungen und Aquarelle,* 2 vols. (Hamburg, 1981); Sutton et al. 1984, pp. 281–89.

For additional works by Adriaen van Ostade in the Philadelphia Museum of Art, see John G. Johnson Collection cat. nos. 521, 522, inv. nos. 194a, 1258 (attributed to), cat. no. 523 (copy after).

79 ADRIAEN VAN OSTADE

PEASANTS DRINKING AND MAKING MUSIC, 1647?
Possible remnants of a signature lower right
Oil on panel, 10¾ x 14″ (27.3 x 35.6 cm.)
The William L. Elkins Collection. E24-3-72

FIG. 79-1 Adriaen van Ostade, *Tavern with Violinist and Dancers,* signed and dated 1645, oil on panel, 17⅛ x 25¾″ (43.5 x 65.5 cm.), dealer P. de Boer, Amsterdam, in 1960.

A group of five peasants make merry in an interior lighted by a window at the left. Seated on a bench with his back turned to the viewer, a man plays a fiddle as another stands to perform a crude little dance while holding a glass and jug of wine. Three peasants look on from the far side of a table in the center. At the right a child eats from a bowl, and at the left another child rummages in a cupboard. In the foreground rests a dog. Behind at the center a staircase and a hearth appear, and at the right is a covered bed.

When this picture was in the collection of Paul Methuen at Corsham House in 1829, it was described by the noted connoisseur and dealer John Smith as the pendant to a scene of fighting peasants.[1] From the description of the lost work, it appears that the two paintings were close in size and related by design and their mutual depiction of boisterous tavern life. Nonetheless, it is unclear whether the artist designed them as companion pieces or whether they were merely hung as a pair by a later owner.

FIG. 79-2 Adriaen van Ostade, *An Evening Scene in a Tavern with a Fiddler,* signed and dated 1655, oil on panel, 16⅞ x 20¾" (42.9 x 52.7 cm.), Collection of Her Majesty Queen Elizabeth II.

Like its putative pendant, the present work was said by Smith and C. Hofstede de Groot to be dated 1647; no date is now visible, nor was one evident in 1966, when the picture was cleaned. Nevertheless, a date of 1647 would not be inconsistent with the painting's style. Ostade painted numerous tavern scenes with violinists and dancers from the mid-1640s onward: for example, the painting dated 1645 with the dealer P. de Boer in 1960 (fig. 79-1)[2] and those of 1647 in Munich,[3] and of 1655 in the royal collection, Buckingham Palace (fig. 79-2).[4]

NOTES

1. Smith 1829–42, vol. 1, no. 197, suppl., no. 118; Hofstede de Groot 1908–27, vol. 3 (1910), no. 613, as dated 1647, oil on panel, 11 x 14" (27.9 x 35.5 cm.), and described as follows: "Five men and two women in a cottage. Two of the men have quarrelled over cards and are fighting. The cask serving as a table is upset. One man grasps the other by the collar and strikes him with his fist. A third man intervenes. A fourth man is held back on his seat by a woman. A man and woman come in at a door in the centre to watch the fray. A barking dog, with various accessories." For additional provenance, see that of no. 79. Present location is unknown.
2. See also the related drawing in Bernhard Schnackenburg, *Adriaen van Ostade, Isack van Ostade: Zeichnungen und Aquarelle,* 2 vols. (Hamburg, 1981), vol. 2, no. 41.
3. *Merry Peasant Company,* oil on panel, 17¹¹⁄₁₆ x 15¹⁄₁₆" (45 x 38.3 cm.), Alte Pinakothek, Munich, inv. no. 567.
4. Christopher White, *The Dutch Pictures in the Collection of Her Majesty the Queen* (Cambridge, 1982), p. 82, no. 129.

PROVENANCE: Paul Methuen, Corsham House, 1829;[1] sold by Smith with the pendant to W. D. Acraman, Bristol, 1840;[2] offered for sale with the pendant by the London dealer Woodin, 1845; sale, G. T. Braine, London, April 6, 1857, to Gritten; according to a note in Smith's personal copy of the Braine sale catalogue, Gritten later exchanged it for the companion, which had been purchased at the sale by J. E. Fordham,[3] and thus it is possibly identical with the "Interior" by Van Ostade offered in sale, J. E. Fordham, London, 1867 (bought in);[4] sale, Baron de Beurnonville, Paris, May 9, 1881, lot 401; sale, Tabourier, Paris, June 20, 1898, lot 176; William L. Elkins Collection, Philadelphia, by 1900.

NOTES TO PROVENANCE

1. Valued by dealer John Smith with its pendant at £525 for the pair (see Smith 1829–42, vol. 1, no. 196).
2. Smith 1829–42, suppl., no. 117.
3. Contrary information is given by *Art Sales,* which states the painting was bought by Jones.
4. See Hofstede de Groot 1908–27, vol. 3 (1910), no. 737d.

LITERATURE: Smith 1829–42, vol. 1, no. 196 [as dated 1647], suppl., no. 117; Elkins 1887–1900, vol. 2, no. 114, repro.; Hofstede de Groot 1908–27, vol. 3 (1910), no. 521 [as dated 1647] and possibly no. 737d; PMA 1965, p. 51; Christopher White, *The Dutch Pictures in the Collection of Her Majesty the Queen* (London, 1982), p. 82, under cat. no. 129.

CONDITION: The single-membered panel support has been enlarged on all sides with strips approximately ¼" wide (0.7 cm.) in order to secure the panel into the frame. The texture of the horizontal grain of the panel shows prominently through the paint. Residues of discolored varnish obscure the design somewhat. A selective cleaning in 1966 reduced the varnish in the area of the window and the central figures of the foreground. The paint is in good condition, although there is abrasion at the edges. At the time the varnish was removed, the signature in the shadowed area to the right of the chair at the far right was deemed to be spurious and no trace of a date could be deciphered. At present only small remnants of a signature are visible and no date can be seen. Overall, the varnish is uneven and moderately discolored.

PRINT AFTER
Engraved by Felix Augustin Milius (1843–1894) (see sale, Baron de Beurnonville, Paris, May 9, 1881, lot 401).

80 ADRIAEN VAN OSTADE

WOMAN LEANING OUT A HALF DOOR, 1660s?
Signed lower center: *A v Ostade* (first two letters ligated)
Oil on panel, 10⅛ x 8⅝″ (27 x 22 cm.)
The William L. Elkins Collection. E24-3-71

A woman in a dark-colored, fur-lined cloak with a hood worn over a red
jacket and white undergarment leans out a half door. Smiling, she folds her
arms and inclines her head to the right. Above the door is a small coping
covered with a vine; on the left, a mullioned window.

 Ostade often painted and etched peasants leaning out the upper halves
of their Dutch doors or through open cottage windows.[1] Frequently they

FIG. 80-1 Adriaen van Ostade, *Woman Leaning on a Door,* signed, oil on panel, 10¹³⁄₁₆ x 8″ (27.5 x 20.5 cm.), The Hermitage, Leningrad, no. 901.

FIG. 80-2 Adriaen van Ostade, *An Old Woman Leaning on a Half Door,* signed, oil on panel, 10⅝ x 8¼″ (27 x 21 cm.), sale, Marczell von Nemes, Paris, June 17, 1913, lot 59.

chat or make merry with their neighbors,[2] but in the present work and in related paintings in the Hermitage, Leningrad (fig. 80-1),[3] Kunsthistorisches Museum, Vienna,[4] and paintings sold in Paris (fig. 80-2), Vienna, and London,[5] an old woman is depicted alone. In the picture in Vienna the woman holds a glass and in one that sold in London in 1976, a flax spindle; in the Philadelphia picture and the Leningrad painting (and fig. 80-2) the woman merely smiles benevolently.

The use of the window or doorway as a spatial diaphragm enhancing the illusion of space was a common device employed by Dutch artists of the period, especially those from Leiden, Delft, and Dordrecht. In Ostade's work, however, he turns the opening at an angle to the picture plane, sacrificing the illusionistic effect but enhancing the natural intimacy and spontaneity of the image. His comfortable and prosperous-looking peasant woman—so different from Adriaen Brouwer's coarser types—have a genial accessibility.

Ostade seems to have executed paintings of figures at windows by the late 1640s (the pendant to fig. 80-1, *The Hurdy-Gurdy Player,* is dated 1648),[6] but the more refined technique of the Philadelphia work suggests a date in the artist's later career, or sometime during the 1660s. The picture's early provenance is uncertain, but it may have been the painting "A Woman Leaning on a Door" that was sold in 1708 as part of the estate of Cornelis Dusart (1660–1704), who was Ostade's pupil. Several works in the sale were said to be unfinished paintings by Ostade completed by Dusart, but there is no evidence of two hands in the Philadelphia painting. Dusart's admiration for Ostade's female peasant types is apparent in a painting such as the *Old Woman Drinking*, in the John G. Johnson Collection in Philadelphia.[7]

NOTES
1. See Adam von Bartsch, *Le Peintre Graveur,* vol. 1 (Vienna, 1803), pp. 353–57, nos. 7, 9–11, 14.
2. For example, *Peasants Drinking at a Window,* c. 1650, oil on panel, 11¼ x 9⅛″ (28.5 x 23.2 cm.), John G. Johnson Collection at the Philadelphia Museum of Art, cat. no. 522.
3. Hofstede de Groot 1908–27, vol. 3 (1910), no. 58 [as pendant to Hofstede de Groot no. 109]. The actual companion is probably Hofstede de Groot no. 107, *The Hurdy-Gurdy Player,* dated 1648, oil on panel, 10⅝ x 8¼″ (27 x 21 cm.), The Hermitage, Leningrad, 1958 cat. no. 899.
4. *Woman at a Window with Beer Glass,* signed, oil on panel, 10¹³⁄₁₆ x 8⅝″ (27.5 x 22 cm.), inv. no. 6449. See Hofstede de Groot 1908–27, vol. 3 (1910), no. 61.
5. Sale, Dorotheum, Vienna, July 18, 1941, lot 70 (signed, oil on panel, 11 x 8⅝″ [28 x 22 cm.]); sale, Sotheby Parke Bernet, London, December 8, 1976, lot 76, repro. (signed and said to be dated 1640 [that date, however, is almost certainly too early], oil on panel, 10¾ x 8⅝″ [27.5 x 21 cm.]).
6. See note 3 above.
7. Oil on panel, 13 x 10″ (33 x 25.4 cm.), John G. Johnson Collection at the Philadelphia Museum of Art, cat. no. 529.

PROVENANCE: Possibly sale, Cornelis Dusart, Haarlem, August 21, 1708, lot 401;[1] possibly sale, Jos. Valette and others, Amsterdam, August 26, 1807, lot 163; and sale, Amsterdam, April 22, 1809, lot 96;[2] possibly sale, Bateman, London, April 11, 1896, lot 122;[3] William L. Elkins Collection, Philadelphia, by 1900.

NOTES TO PROVENANCE
1. See Hofstede de Groot 1908–27, vol. 3 (1910), no. 60a [as "A Woman Leaning on a Door"].
2. See Hofstede de Groot 1908–27, vol. 3 (1910), no. 60b [as "An Old Woman Leaning on a Half Door. A Vine Grows on the House Wall," oil on panel, 11 x 9″ (27.9 x 22.8 cm.)].
3. See Hofstede de Groot 1908–27, vol. 3 (1910), no. 60c [as "A Peasant Woman at a Window," 10½ x 8½″ (26.6 x 21.5 cm.)].

LITERATURE: Elkins 1887–1900, vol. 2, no. 113, repro.; Hofstede de Groot 1908–27, vol. 3 (1910), no. 60 [also possibly 60a, 60b, and 60c]; PMA 1965, p. 51.

CONDITION: The uncradled panel is planar, vertically grained, and in good, stable condition. Small losses appear in the window-sill at the left, at the right, and along the lower edge. The shadows of the sleeve creases have been strengthened. The varnish is very dull, cloudy, and deeply discolored.

Born in Delft in 1601, Anthonie Palamedesz., called Stevers, was the son of a gem cutter. Shortly after his birth, his father was recorded in the service of James I of England, and his brother, the battle painter Palamedes Palamedesz. (1607–1638), may have been born in London. Anthonie's teacher is unknown, but it has been speculated that he may have studied in Delft with the court painter Michiel Jansz. van Miereveld (1567–1641) and/or Hendrick Gerritsz. Pot (before 1585–1657), who was in the city in 1620. Palamedesz. joined the guild in 1621 and was a *hoofdman,* or leader, in 1653 and 1673. In 1630 he married Anna Joosten van Hoorendijck (d. 1651), who bore him three children. He married his second wife, Aagje Woedewart, around 1660; the couple had a son the following year. In 1673 Anthonie was residing in Amsterdam, probably with his eldest son, the painter Palamedes Palamedesz. II (1633–1705), when he died. An inventory of his estate has been preserved.

Anthonie Palamedesz. is best known for his genre scenes in the manner of the Haarlem and Amsterdam painters Dirck Hals (1591–1656), Pieter Codde (1599–1678), Willem Duyster (1598/99–1635), and Pot. These usually depict elegant companies of young people and soldiers dining, gaming, or making music. He also executed portraits, landscapes, still lifes, and staffage for architectural painters. In addition to his brother and his son, both called Palamedes, he trained the Rotterdam painter Ludolf de Jongh (1616–1679). From the few known works by Jacob van Velsen (d. 1656), it appears that he was Palamedesz.'s principal follower.

LITERATURE: Dirck van Bleijswyck, *Beschryvinge der Stadt Delft* (Delft, 1667), p. 847; Houbraken 1718–21, vol. 1, p. 304, vol. 2, p. 33; Abraham Bredius, "Iets over de Palamedessen [Stevensz. or Stevaerts]," *Nederlandsche kunstbode,* vol. 2 (1880), pp. 310–11; Wilhelm Bode, *Studien zur Geschichte der holländischen Malerei* (Brunswick, 1883), pp. 126–33; *Oud Holland,* 1890, p. 308; Wurzbach 1906–11, vol. 2, pp. 297–99; Thieme-Becker 1907–50, vol. 26 (1932), p. 155; Eduard Plietzsch, *Holländische und flämische Maler des 17. Jahrhunderts* (Leipzig, 1960), p. 34; Sutton et al. 1984, pp. 292–93.

For an additional work by Palamedesz. in the Philadelphia Museum of Art, see John G. Johnson Collection inv. no. 1350.

81 ANTHONIE PALAMEDESZ. *KITCHEN STILL LIFE WITH A WOMAN, A BOY, AND A DOG*, 1640s?
Signed lower left: *A. Palamedes*
Oil on canvas, 48½ x 66″ (123 x 168 cm.)
The William L. Elkins Collection. E24-3-53

At the right of a table covered with a large still life of artichokes, fruit (apples, grapes, pears, and lemons), nuts, waterfowl, and a rabbit, stands a woman holding a basket. A young boy at her side holds up a small bird. At the left in front of the table, a spotted dog looks out at the viewer as he places his paw in a pail filled with ribs of meat.

Large kitchen still lifes were first painted by the sixteenth-century Flemish artists Pieter Aertsen (1508–1575) and Joachim Bueckelaer (c. 1530/35–1573/74) and perpetuated in the southern Netherlands by Frans Snyders (q.v.) and his circle. The tradition was kept alive in the North by a number of painters, including the Haarlem artist Floris van Schooten (active 1612–55) and the Delft painters Pieter Cornelisz. van Rijck (1568–1628?) and Cornelis Jacobsz. Delff (1571–1643). It may have been through the work of the latter two that Palamedesz. first became aware of this type of painting.[1] Among those contemporaries of Palamedesz.'s who produced kitchen pieces are the little-known Delft painter Willem van Odekercken (c. 1610–1677) and Jan Olis (c. 1610–1676), who was active in nearby Dordrecht in the

1630s.[2] However, the life-size scale and the half-length format of the Philadelphia painting and its focus on still-life elements arranged horizontally on a table more closely resemble the forms of the Flemish rather than the Dutch kitchen piece. An exceptionally large and ambitious canvas for Palamedesz., this is his only known still life.[3] Although Palamedesz. collaborated with other artists on occasion, the present work appears to be entirely by his hand.

Some Netherlandish kitchen and market scenes with still lifes embody emblematic ideas and sayings or include symbols;[4] whether the Philadelphia painting includes a symbolic dimension is unclear. Two of the live animals in this scene—the dog with the meat bucket and the pet bird held by the small boy—could be viewed in opposition, being associated, respectively, with earthly carnality and a higher spirituality, or with physical and spiritual love.[5] The dog that raids the pot or bucket was already a subject in a print of about 1558 by Frans Hogenberg illustrating forty Netherlandish proverbs[6] and figured as an emblem in Jacob Cats's *Spiegel van den ouden en nieuwen tyt* (The Hague, 1632).[7] Cats's motto quoted the proverb "An open pot, an open hole, therein a dog will soon stick its muzzle" ("Een open pot, of open kuyl. Daer in steekt licht een hont sijn muyl"), a saying that, according to Cats, alludes to the idea that anything desirable left unattended will attract a predator. Cats goes on to warn against the dangers of promiscuity, specifically that of lascivious housemaids.[8]

NOTES

1. See, for example, Van Rijck's *Large Kitchen Piece,* 1604, oil on canvas, 74⅜ x 113⅜" (189 x 288 cm.), Herzog Anton Ulrich Museum, Brunswick, no. 205.

2. See Olis's *Kitchen,* signed and dated 1645, oil on panel, 26¹⁵⁄₁₆ x 32¹⁄₁₆" (68.5 x 81.5 cm.), Rijksmuseum, Amsterdam, no. A296; *In the Kitchen,* oil on panel, 18¹³⁄₁₆ x 25⁵⁄₁₆" (47.8 x 66 cm.), Herzog Anton Ulrich Museum, Brunswick, no. 335; *With the Cook,* monogrammed, oil on panel, 11 x 10⅛" (28 x 27 cm.), Museum der bildenden Künste, Leipzig, no. 1047; *Kitchen Interior,* signed and dated 1652, oil on panel, 24½ x 27¾" (62.2 x 70.5 cm.), sale, Sotheby's, London, February 1, 1950, lot 126.

3. A *vanitas* still life signed "R. Stevers" (oil on canvas, 17¹¹⁄₁₆ x 20⁷⁄₁₆" [45 x 52 cm.], Rijksmuseum, Amsterdam, no. A2358) was assigned to Palamedesz. in the sale, Hoogendijk, Amsterdam, April 28–29, 1908, lot 279.

4. See J. A. Emmens, "'Eins aber ist nötig': Zu Inhalt und Bedeutung von Markt- und Küchen-stücken des 16. Jahrhunderts," in *Album Amicorum J. G. Van Gelder,* edited by Josua Bruyn et al. (The Hague, 1973), pp. 93–101; and Amsterdam 1976, cat. no. 77, Joachim Wttewael (1566–1638), *Greengrocer* (oil on panel, 45⅞ x 63" [116.5 x 160 cm.], Centraal Museum, Utrecht, no. 359), which illustrates a saying from the poet Jacob Cats.

5. On the symbolism of pet birds and especially the goldfinch, see Herbert Friedmann, *The Symbolic Goldfinch: Its History and Significance in European Devotional Art* (Washington, D.C., 1946); and E. de Jonge, *Zinne- en minnebeelden in de schilderkunst van de zeventiende eeuw* (Amsterdam, 1967), pp. 41–49.

6. See Walter Gibson, *Bruegel* (New York and Toronto, 1977), fig. 43.

7. p. 104, no. XXXIV.

8. For an illustration and discussion of the emblem, see William W. Robinson, "The *Eavesdropper* and Related Paintings by Nicolaes Maes," in *Holländische Genremalerei im 17. Jahrhundert, Jahrbuch Preussischer Kulturbesitz* (Berlin, 1987), p. 302, fig. 17.

PROVENANCE: William L. Elkins Collection, Philadelphia, by 1900.

LITERATURE: Elkins 1887–1900, vol. 2, no. 116, repro.; PMA 1965, p. 51.

CONDITION: The canvas support is lined with an aqueous adhesive. It is slack and shows evidence of mildew damage on the back. The tacking edges are missing. A seam is visible in the original canvas approximately 7" (17.8 cm.) from the top. The paint film has a very fine net crackle pattern overall. Weave enhancement and a slight dimpling of the surface are the results of the lining. The paint film shows old losses in the table and at the lower and right edges. The brittle varnish is scratched at the lower right, on the boy's arms, below his face, and where rubbed by the frame. The varnish is uneven and extremely discolored.

82 WORKSHOP OF
JOACHIM PATINIR

LANDSCAPE WITH JOHN THE BAPTIST PREACHING, 1516–17?
Oil on panel, 14⅜ x 20″ (36.5 x 50.8 cm.)
Gift of Mrs. Gordon A. Hardwick and Mrs. W. Newbold Ely
 in memory of Mr. and Mrs. Roland L. Taylor. 44-9-2

FIG. 82-1 Joachim Patinir, *John the
Baptist Preaching,* oil on panel, 13⅞ x 17¾″
(35.3 x 45.2 cm.), Musée Royal des Beaux-Arts
de Belgique, Brussels, no. 1041.

At the center of a rocky landscape with a mountain on the left and a broad
river valley on the right, John the Baptist preaches to a small congregation
of about a dozen listeners who have assembled beneath a tree. In the middle
distance on the right, the tiny figure of Christ is seen approaching. In the
lower right corner is a coat of arms depicting a black ox facing left on a
gold shield and a second ox in three-quarter view above the helmet. On the
banderole is the Latin expression "POST TENEBRAS SPERO LUC[EM?]"
("After darkness one expects light").

This painting is one of three versions of a composition by Joachim
Patinir (c. 1480–1524), of which the painting in Brussels is the best
(fig. 82-1).[1] While Max Friedländer considered the Philadelphia and Brussels
paintings "of equal merit," Robert Koch correctly regarded the latter as the
primary version and the former as a workshop copy. The Philadelphia
painting not only treats motifs like the foliage and rock formations in more
summary fashion but also omits details such as the tiny figures seen in the
Brussels painting of John baptizing Christ on the riverbank in the distance.

Nevertheless, the painting is of interest because it probably was executed by Patinir's immediate circle soon after the Brussels original. This is deduced from the presence of the coat of arms of Lucas Rem in the lower right. A merchant from a patrician family in Augsburg, Rem first visited Antwerp in 1508 and conducted business there between 1511 and 1518. According to his diary, his commercial dealings were so favorable in the years 1516 and 1517 that he was able to purchase "paintings, gems, [and] fabrics" in Antwerp, while the years between 1502 and 1515 permitted no such extravagances.[2] Four landscape paintings by Patinir and his circle bear the Rem coat of arms and as Koch has observed, can be presumed to have been acquired between about 1516 and 1520.[3] The only painting of this group that appears to be by Patinir's hand and that can reasonably be presumed to be specially commissioned by Rem is *The Assumption of the Virgin* in the John G. Johnson Collection at the Philadelphia Museum of Art (fig. 82-2). That work includes the Rem coat of arms with the pious motto "ISTZ GVOT SO GEBS GO[T]" (If it is good, may God give it),[4] and also, in the spandrels of the frame, a tiny grisaille figure of Saint Luke and his ox. Luke was the patron saint of Lucas Rem, whose family name was the biblical Hebrew word for wild ox (*reem*), which also explains the oxen on the coat of arms. The other two paintings by Patinir's studio that bear Rem's symbol are the *Landscape with Saint Jerome* in the Ca d'Oro, Venice, and the *Rest on the Flight* in the collection of Mrs. George Kidston, Bristol, England.[5] Yet another important purchase that Rem made in this period was an altarpiece commissioned from Quentin Massys (1464/65–1530) and now in the Alte Pinakothek in Munich.[6]

Patinir painted the subject of John the Baptist Preaching in the Wilderness on three other occasions but always as a subsidiary scene.[7] Like most Christian artists, he conceived of the wilderness not as a desert but as a forest, the Sermon in the Forest prefiguring Christ's Sermon on the Mount. Only his makeshift pulpit (compare *Mary Magdalene Preaching,* oil on panel 48⅛ x 30″ [123.2 x 76.2 cm.], John G. Johnson Collection at the Philadelphia Museum of Art, cat. no. 402) points to the rustic setting. The tiny spring and stream at the left may allude to the fountain of life and John's important role in baptism. The rabbits on the right are also traditional symbols of rebirth, renewal, and fecundity. The large tree on the left seems to be dead or dying (note its naked limbs and exposed roots at its base), while the flourishing ivy that girdles its trunk is a symbol of everlasting life and fidelity. Together the two motifs could thus refer to death and immortality—ideas appropriate to John's traditional role as the forerunner of Christ and the advocate of baptism as a form of repentance for the remission of sins and salvation.[8] Patinir's contemporary Andrea Alciati published an emblem of a vine-encircled tree with the Latin lemma "Amicitia etiam post mortem durans," to convey the idea of the imperishableness of love, love that continues after death.[9]

Discussing other similar paintings by Patinir, Reindert Falkenburg and Walter Gibson have stressed the symbolic functions of his landscapes and their relationship to his religious figural elements.[10]

FIG. 82-2 Joachim Patinir, *The Assumption of the Virgin,* oil on panel, 24½ x 23¼″ (62.2 x 59.1 cm.), John G. Johnson Collection at the Philadelphia Museum of Art, cat. no. 378.

NOTES

1. The weaker third version (oil on panel, 8 x 12″ [20 x 30 cm.]) was with the dealer Julius Böhler, Munich, in 1917; see Max J. Friedländer, *Early Netherlandish Painting,* vol. 9, pt. 2, *Joos van Cleve, Jan Provost, Joachim Patenier,* translated by Heinz Norden (Berlin, 1931; rev. ed., Leiden, 1972), pl. 220b.

2. See B. Greiff, *Tagebuch des Lucas Rem* (Augsburg, 1861), p. 31; see for discussion Robert A. Koch, *Joachim Patinir* (Princeton, N.J., 1968), pp. 9–11. A portrait medallion of Rem by Friedrich Hagenauer is reproduced in Paul Wescher, *Grosskaufleute der Renaissance* (Basel, n.d.), p. 135; an oil portrait of Rem, bearing his coat of arms and the date 1505, attributed to Leonhard Beck (q.v.), is in the Städtische Kunstsammlungen, Augsburg, oil on panel, 14 x 10″ [35.6 x 25.5 cm.], inv. no. 11960; see Städtische Kunstsammlungen, *Hans Holbein der Ältere und die Kunst der Spätgotik,* 1965, cat. no. 145, fig. 154.

3. Koch (see note 2), p. 10.

4. Koch (see note 2), pp. 10–11, assumes that the different mottoes (both the other works acquired by Rem employ the saying) do not indicate a later substitution, but in fact two different mottoes. The Latin saying, he notes parenthetically, was also the motto of Philip II of Spain.

5. Oil on panel, 11½ x 21½″ (29 x 55 cm.), Ca' d'Oro, Venice; and oil on panel, 12½ x 22″ (31.3 x 56 cm.), Bristol, England. Respectively Koch (see note 2), cat. nos. 10a and 20. Koch (pp. 11 and 20) dates the latter somewhat later, or c. 1520.

6. *The Holy Trinity* with wings depicting *Saints Sebastian and Roch,* oil on panel, center 35½ x 25″ (90 x 63.5 cm.), no. 3335, left wing 35½ x 11″ (90 x 28 cm.), no. 5380, right wing 35½ x 11″ (90 x 28 cm.), no. 719.

7. See *The Baptism of Christ,* oil on panel, 23½ x 30⅓″ (59.5 x 77 cm.), Kunsthistorisches Museum, Vienna, inv. no. 981; Koch (see note 2), no. 5; triptych with *Rest on the Flight,* and wings depicting *Saint John the Baptist and Saint Cornelius,* formerly Kaufmann Collection, Berlin, oil on panel, central panel, 28⅓ x 43⅓″ (72 x 110 cm.), right and left wings each 28⅓ x 12″ (72 x 30 cm.) (Koch no. 8); and triptych with *The Penitence of Saint Jerome,* and wings depicting *The Baptism of Christ and Saint Anthony Abbot,* oil on panel, center 32 x 47⅞″ (81.2 x 120.3 cm.); right and left wings each 32 x 14½″ (81.2 x 36.8 cm.), The Metropolitan Museum of Art, New York, no. 36.14A–C (Koch no. 14). See also the workshop triptych with *Saint Jerome,* and wings depicting *Jerome and the Lion and the Baptism of Christ,* oil on panel, possibly in Prince di Trabia Collection, Palermo (Koch no. 31).

8. Since classical times the vine-entwined tree had been a metaphor of love and friendship. For a discussion of this tradition, especially as it alludes to conjugal love, see E. de Jongh and P. J. Vinken, "Frans Hals als voortzetter van een emblematische traditie," *Oud Holland,* vol. 76 (1961), pp. 117–52. On the other hand, the vine that kills the tree came to be used as an emblematic symbol of ingratitude and false friends; see Arthur Henkel and Albrecht Schöne, *Emblemata* (Stuttgart, 1967), cols. 276–77.

9. Andrea Alciati, *Emblemata* (Paris, 1534), p. 16.

10. See Reindert Leonard Falkenburg, *Joachim Patinir: Landscape as an Image of the Pilgrimage of Life,* translated by Michael Hoyle (Amsterdam and Philadelphia, 1988), where he stresses the fact that Patinir's landscapes reinforce his religious figural themes in the same way that later medieval "Andachtsbilder" function; Walter Gibson "Patinir and Saint Jerome: The Origins and Significance of a Landscape Type," lecture delivered at the meeting of the College Art Association, Boston, February 1987.

PROVENANCE: Lucas Rem, Antwerp, c. 1516–17; possibly dealer D. A. Hoogendijk & Co., Amsterdam [sticker on the reverse]; Roland L. Taylor, Philadelphia; on loan to the Baltimore Museum of Art, 1929? [label on the reverse].

LITERATURE: Max J. Friedländer, *Early Netherlandish Painting,* vol. 9, pt. 2, *Joos van Cleve, Jan Provost, Joachim Patenier,* translated by Heinz Norden (Berlin, 1931; rev. ed., Leiden, 1972), cat. no. 220, pl. 212; *Philadelphia Museum of Art Annual Report,* no. 68 (1944), p. 16, repro.; PMA 1965, p. 52; Robert A. Koch, *Joachim Patinir* (Princeton, N.J., 1968), pp. 10, 21, 27, fig. 11; Reindert Leonard Falkenburg, *Joachim Patinir: Landscape as an Image of the Pilgrimage of Life,* translated by Michael Hoyle (Amsterdam and Philadelphia, 1988), p. 138 n. 483.

CONDITION: The panel support with a horizontal grain and center join is uncradled and in good condition. Narrow rabbets are cut into the reverse along the top and bottom edges. The paint film is abraded, especially in the sky. The upper trunk and branches of the tall tree on the left are also badly abraded; the vista at the right is largely intact. Numerous small flake losses have occurred overall. Retouches in the foreground harmonize with the original paint but retouches in the sky are darker. The old varnish was selectively removed from the sky and figures and lighter elements in the landscape leaving some discolored varnish in the darker elements. The new varnish is even and only slightly discolored.

For additional works by Patinir in the Philadelphia Museum of Art, see John G. Johnson Collection cat. nos. 378 (fig. 82-2), 377 (studio).

Baptized in Antwerp on July 23, 1614, Bonaventura Peeters was the younger brother of the painter Gillis Peeters (1612–1653), with whom he seems to have shared a studio. Bonaventura's teacher is unknown; however, his marines descend from Flemish Mannerist seascapes (Hans Savery I and others) but also reveal stylistic resemblances with the Dutch artists Jan Porcellis (c. 1584–1632), Jan van Goyen (q.v.), and even Simon de Vlieger (c. 1601–1653). He was recorded as a master of the Antwerp guild in 1634–35. In 1639 Bonaventura and Gillis received joint payment of 480 guilders for a large canvas depicting the *Siege of Callao,* which had been commissioned by the municipal authorities of Antwerp. Reportedly in poor health, Bonaventura moved at the end of his life to nearby Hoboken, where he died on July 25, 1652. In addition to his activity as a painter, Peeters was also a poet and wrote several satires attacking the Jesuits. Some writers have speculated that these writings forced his departure from Antwerp.

Besides marine paintings, Bonaventura executed landscapes, small-scale figure paintings, and etchings. His sister Catharina and brother Jan were both his pupils and worked in his manner.

LITERATURE: Cornelis de Bie, *Het Gulden Cabinet van de edele vry Schilderconst* (Antwerp, 1661; reprint, Soest, 1971), pp. 170–71; Houbraken 1718–21, vol. 2, pp. 12–13; Weyerman 1729–69, vol. 2, pp. 124–26; F. J. van den Branden, *Geschiedenis der Antwerpsche Schilderschool* (Antwerp, 1883), pp. 1046–50; Fred C. Willis, "Die niederländische Marinemalerei," diss., Halle, 1910, pp. 77–79; Wurzbach 1906–11, vol. 2, pp. 319–20; Thieme-Becker 1907–50, vol. 27 (1933), pp. 6–7; Erik Larsen, "Some Seventeenth-Century Paintings of Brazil," *Connoisseur,* vol. 175, no. 704 (October 1970), pp. 123–31; Musées Royaux des Beaux-Arts de Belgique, Brussels, *Le Siècle de Rubens,* October 15–December 12, 1965, pp. 150–52; Laurens J. Bol, *Die holländische Marinemalerei des 17. Jahrhunderts* (Brunswick, 1973), pp. 7–9; Jacques Foucart in Grand Palais, Paris, *Le Siècle de Rubens dans les collections publiques françaises,* November 17, 1977–March 13, 1978, pp. 135–36; Lawrence O. Goedde, "Convention, Realism, and the Interpretation of Dutch and Flemish Tempest Painting," *Simiolus,* vol. 16, nos. 2–3 (1986), pp. 139–49; Sabine Mertens, *Seestrum und Schiffbruch: Eine Motivgeschichtliche Studie* (Hamburg, 1987); Lawrence O. Goedde, *Tempest and Shipwreck in Dutch and Flemish Art: Convention, Rhetoric, and Interpretation* (University Park, Pa., 1989).

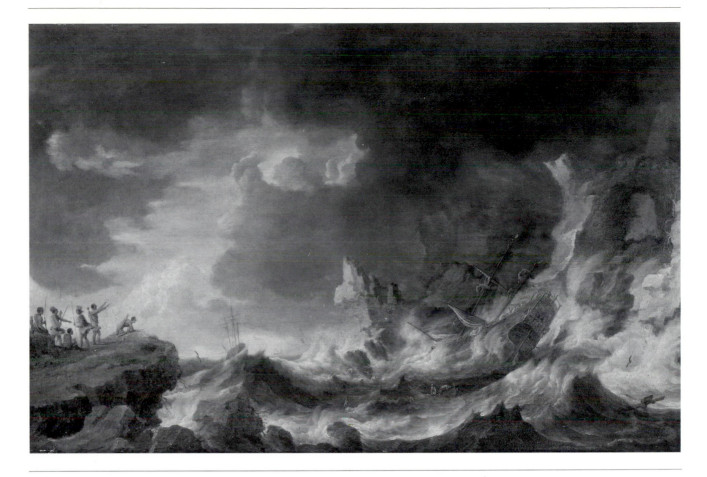

83 BONAVENTURA PEETERS

SHIPWRECK ON A ROCKY COAST, c. 1640
Signed lower left on rock: *B·P·*
Oil on panel, 17½ x 27″ (44.5 x 68.5 cm.)
Purchased: Director's Discretionary Fund. 70-2-1

As its crew abandons ship, a Dutch man-of-war founders at the right on a jagged coastline. From a large rock at the left, a group of Indians witness the calamity, gesturing excitedly. In the distance other ships are driven perilously close to the rocks.

The comments of Arnold Houbraken suggest that the tempestuous marines of Bonaventura Peeters were celebrated as the best of their kind by his contemporaries for their naturalistic rendering of the atmosphere, water, rocks, and shore.[1] But in this painting and the master's other shipwreck scenes, the fantastically conceived coastline, which in Mannerist fashion reiterates the forms of the waves, is surely a product of the artist's imagination. Following in the tradition of earlier marine painters, such as Adam Willaerts (1577–1664) and Jan Porcellis (c. 1584–1632), Peeters observed the artistic conventions of Netherlandish shipwreck scenes, namely that they never occur on the high seas, but only on coasts and then hardly ever on the sandy beaches of the Lowlands but almost exclusively on rocky foreign shores.[2] The wild animals and natives who inhabit these forbidding coasts serve only to add to the terror of being dashed on the rocks. In Peeters's shipwreck, the Indians with their feathered headdresses, spears, bows, and arrows suggest a scene in the New World.[3] Bonaventura painted other American scenes: *Dutch Men-of-War in the West Indies,* dated 1648

FIG. 83-1 Bonaventura Peeters, *Dutch Men-of-War in the West Indies,* monogrammed and dated 1648, oil on panel, 18½ x 28⅛″ (47 x 71.5 cm.), Wadsworth Atheneum, Hartford, inv. no. 1940.403.

FIG. 83-2 Bonaventura Peeters, *Shipwreck,*
22 x 28¾" (56 x 73 cm.), oil on panel,
Hessisches Landesmuseum, Darmstadt,
inv. no. GK 208.

(fig. 83-1);[4] *Dutch Vessels off the Brazilian Coast,* dated 1640 or 1646, São Paulo, Brazil;[5] *Indians on the Shore,* Rio de Janeiro;[6] *Indians on the Shore,* dated 1652?, with dealer Leegenhoek, Paris, in 1972;[7] *Dutch Ships Landing on a Stormy Brazilian Coast,* formerly with dealer Nijstad, The Hague;[8] *Landing on the Coast of South America,* Galerie Müllenmeister, Solingen;[9] and (circle of Peeters), *The Landing of Columbus in America,* Elrick Collection, Wiesbaden.[10] Two East Indian scenes were also in the possession of the dealer Forchoudt in Antwerp in 1698.[11] Nevertheless, as yet there is no proof that Bonaventura Peeters actually traveled to the New World. He might only have based these pictures on other artists' sketches and travelers' reports. Larsen believed that the latter was the case, arguing that Bonaventura's Brazilian scenes were created from sketches his brother Gillis made there in about 1637 and 1640.

Although Bonaventura painted a great many shipwrecks, often with similar designs, few have American settings. Most depict fanciful northern coastlines, sometimes treated like the mountain scenery of Joos de Momper II (1564–1635), and several suggest Scandinavian settings; see, for example, the pine trees on the shore of Darmstadt's *Shipwreck* (fig. 83-2).[12] Yet whatever the sources of the individual motifs, his marines almost always have the muted Dutch light and monochrome colors (gray, brown, yellow, and pink) of this work, supporting the belief that he never traveled widely.

NOTES
1. Arnold Houbraken, *De Groote Schouburgh,* vol. 2 (The Hague, 1753), p. 13: "Lucht, Water, Klippen, en Stranden zoo natuurlyk te schilderen, dat hy geoordeelt wierd de beste in zyn tyd."
2. See Lawrence O. Goedde, "Convention, Realism, and the Interpretation of Dutch and Flemish Tempest Painting," *Simiolus,* vol. 16, nos. 2–3 (1986), pp. 139–49, esp. p. 142.
3. Erik Larsen ("Some Seventeenth-Century Paintings of Brazil," *Connoisseur,* vol. 175, no. 704 [October 1970], p. 129), has identified Indians in Gillis Peeters's Brazilian paintings as Tapuyas, or Ge, as they are known in anthropological treatises. However, the Indians in the present work are too sketchily painted to permit identification. It is probable that, like the landscape, they are in part imaginary. For a survey of seventeenth-century European attitudes to American Indians, often feared as cannibals, see Hugh Honour, *The New Golden Land* (New York, 1975), pp. 3–27, 53–85. Concerning the Indian and the rise of the myth of the "noble savage," see A. Scaglione, "A Note on Montaigne's 'Des Cannibales' and the Humanist Tradition," in *First Images of America: The Impact of the New World on the Old* (Berkeley, 1976), vol. 1, pp. 63ff. For the images of Brazilian Indians that Albert

Eckhout painted in the 1640s for Johan Maurits of Nassau, see R. Joppien, "The Dutch Vision of Brazil; Johan Maurits and His Artists," in E. van den Boogaart, ed., *Johan Maurits van Nassau-Siegen 1604–1679* (The Hague, 1979), pp. 302ff., and The Mauritshuis, The Hague, *Zo wijd de wereld strekt,* 1979–80, pp. 121ff.
4. Wadsworth Atheneum, Hartford, *The Netherlands and the German-Speaking Countries: Fifteenth–Nineteenth Centuries* (Hartford, 1978), pp. 171–72.
5. Oil on panel, 17¾ x 25¼" (45 x 64 cm.), private collection; repro. in Larsen (see note 3), no. 6.
6. Oil on panel, 13½ x 10½" (34.3 x 26.7 cm.), private collection; repro. in Larsen (see note 3), no. 7.
7. Oil on panel, 14 x 19" (35.5 x 48 cm.); photograph, Rijksbureau voor Kunsthistorische Documentatie, The Hague.
8. Oil on panel, 18 x 28" (45.5 x 71 cm.), photograph, Dingjan, The Hague, no. 64083. This work also has the tempest-tossed seas of the Philadelphia painting.
9. Oil on panel, 21 x 31½" (53 x 80 cm.); repro. in *Apollo,* n.s. vol. 41, no. 97 (March 1970), p. lxv.
10. Oil on panel, 23 x 31½" (58 x 80 cm.).
11. See Jean Denucé, *Art-Export in the 17th Century in Antwerp, the Firm Forchoudt* (The Hague, 1931), p. 223, no. 11.

12. Compare the compositionally related shipwreck scene with European scenery in *The Tempest,* oil on panel, 9 x 15½" (23 x 39 cm.), Musées Royaux des Beaux Arts de Belgique, Brussels, inv. no. 2545. See also Peeters's *Tempest near a Scandinavian Coast,* oil on canvas (transferred from panel), 22 x 30" (56 x 76 cm.), Château-Musée, Dieppe, inv. no. 966-8-1; repro. in Grand Palais, Paris, *Le Siècle de Rubens dans les collections publiques françaises,* November 17, 1977–March 13, 1978, p. 136, with references to other related works.

PROVENANCE: Dealer Julius Böhler, Munich, before 1970.

LITERATURE: Rishel 1974, p. 29, fig. 5.

CONDITION: The uncradled panel support has a horizontal grain and a horizontal crack in the middle running its full length. Losses in the paint film located along the central crack, in the upper-right corner, the lower-left corner along the lower edge, and a scratch in the upper center are retouched. Abrasion is limited; however, it is somewhat more pronounced in areas of the sky and the figures in the left foreground. The varnish is only slightly discolored.

Nothing is known about the life of N. L. or le Peschier apart from the fact that he signed and dated paintings in a three-year period, 1659, 1660, and 1661. His *vanitas* still lifes are related in theme to paintings by artists active in Leiden; however, a thorough search (obligingly undertaken by P.J.M. de Baar in 1980) of both the municipal archives and those of the Leiden Saint Luke's Guild uncovered no trace of the painter. The appearance of French texts in several of the artist's still lifes with Leiden-School subjects (for example, figs. 84-3 and 84-5), in combination with an unusually broad style, apparently inspired the oft-repeated theory that Peschier was a Frenchman working in the North or a Dutchman working in France; however, the hypothesis has no basis in fact.

LITERATURE: Thieme-Becker 1907–50, vol. 26 (1932), p. 462; Museum Boymans–van Beuningen, Rotterdam, *Vier eeuwen Stilleven in Frankrijk,* July 10–September 20, 1954, p. 46; Poul Gammelbo, "On a Vanitas Still Life by N. L. Peschier," *Studia Muzealne,* vol. 4 (1964), pp. 74–77; Laurens J. Bol, *Holländische Maler des 17. Jahrhunderts nahe den grossen Meistern: Landschaften und Stilleben* (Brunswick, 1969), p. 380 n. 615; Walther Bernt, *The Netherlandish Painters of the Seventeenth Century,* translated by P. S. Falla, 3 vols. (London, 1970), vol. 3, p. 92; Stedelijk Museum "de Lakenhal," Leiden, *Ijdelheid der Ijdelheden: Hollandse Vanitas-voorstellingen uit de zeventiende eeuw,* June 26–August 23, 1970, p. 20; Michel Faré, *Le Grand Siècle de la nature morte en France: Le XVIIᵉ siècle* (Freiburg, 1974), pp. 158–59.

84 N. L. PESCHIER

VANITAS STILL LIFE, 1661

Signed and dated lower left: *N vs Le Peschier Fecit 1661*

Oil on canvas, 32⁵⁄₁₆ x 40¾" (82 x 103.5 cm.)

The Henry P. McIlhenny Collection in memory of Frances P. McIlhenny. 1986-26-287

On the edge of a table partially covered with a cloth is a wedge-shaped pile of objects. Along the front edge, from left to right, are leather moneybags, including one with a red-and-white checked handle, an unidentified Italian music book, and a landscape print by Jan van de Velde (c. 1593–1641) from his series "Amenissime Aliquot Regiunculae," part 2 (one of fifteen), of 1616 (fig. 84-1).[1] In the center of the composition are a metal lantern with an extinguished candle, a skull, a wooden recorder, and a celestial globe showing several constellations of the northern hemisphere, in particular Lyrae, Cygnus, and Pegasus. In the right background are a circular wooden box filled with deeds and documents, a baton(?), and a terra-cotta sculpted bust of a man. Hung on the wall at the left is a pen and gray wash drawing of the head of a peasant in the manner of Adriaen van Ostade (q.v.) or of one of his followers such as Cornelis Dusart (1660–1704), as well as a dancing master's fiddle (kit or *pochette*).[2]

This previously unpublished painting raises to five the number of vanitas still lifes signed by the unknown painter N. L. Peschier and dated to a three-year period. These works include the following: the painting of 1659 in the Victoria and Albert Museum (fig. 84-2),[3] the paintings of 1660 in the Rijksmuseum, Amsterdam (fig. 84-3),[4] and formerly in the R. Payelle Collection, Paris (fig. 84-4),[5] and the picture of 1661 in the Lugt Collection, Paris (fig. 84-5).[6] Poul Gammelbo first attempted to reassemble Peschier's still lifes; however, the *vanitas* still life in the Muzeum Narodowe, Poznan, Poland, that prompted his study and that he attributed to the artist on the

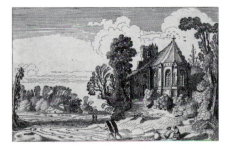

FIG. 84-1 Jan van de Velde, *Landscape with Church,* 1616, from the series "Amenissime Aliquot Regiunculae," etching.

FIG. 84-2 N. L. Peschier, *Vanitas Still Life,* signed and dated 1659, oil on canvas, 26¼ x 35″ (66.6 x 88.8 cm.), Victoria and Albert Museum, London, no. P.46-1962.

FIG. 84-3 N. L. Peschier, *Vanitas Still Life,* signed and dated 1660, oil on canvas, 22½ x 27½″ (57 x 70 cm.), Rijksmuseum, Amsterdam, no. AI686.

FIG. 84-4 N. L. Peschier, *Vanitas Still Life,* signed and dated 1660, oil on canvas, 27½ x 35″ (70 x 89 cm.), formerly R. Payelle Collection, Paris.

basis of style, is probably by another hand, perhaps that of Jacques de Claeuw (active c. 1642–d. 1676).[7] Saskia Nihom-Nijstad further expanded the oeuvre and observed that many of the same objects recur in Peschier's *vanitas* still lifes.[8] The Philadelphia painting confirms these practices, including the same skull, lantern, moneybags, celestial globe, music book, and baton, as well as prints and documents similar to those in figures 2–5. In addition to these *vanitas* still lifes, Peschier signed a breakfast piece in 1660 and two game still lifes in 1659 and 1661.[9]

The ancestry of Peschier's *vanitas* still life is clearly traced to the Leiden School. *Vanitas* imagery had appeared in early Mannerist prints and in painted form as early as a *Vanitas* of 1603 by Jacques de Gheyn II (1565–1629), but paintings of these themes gained wider popularity only in the latter half of the 1620s in the university town of Leiden.[10] Ingvar Bergström and other authors have speculated that this obsession with ideas of mortality and transience may have been related to several concerns: the resumption of hostilities in the Netherlands following the conclusion of the Twelve Year Truce in 1621; the plagues that wracked the country in 1624–25 and that in 1635 killed nearly fifteen thousand people in Leiden alone; and the strict form of Calvinism, which dominated thought and education at Leiden University, condemning all things and behavior considered worldly.[11] David Bailly (1584–probably 1657), Jan Davidsz. de Heem (1606–1683/84), Pieter Claesz. (1597/98–1660), and Pieter Potter (c. 1597–1652) all played early roles in popularizing the *vanitas* still life. Potter's painting of 1636, formerly in Berlin (fig. 84-6), already employed the wedge-shaped composition of diverse objects on a table favored by Peschier, as well as a similar repertory of objects—skull, moneybag, musical instruments, documents, even a celestial globe. Gammelbo rightly stressed the importance of the examples of the still lifes of Jacques de Claeuw for Peschier,[12] and Nihom-Nijstad saw the direct parentage for the composition and working methods of the Lugt Collection picture (fig. 84-5) in De Claeuw's *Vanitas* of 1641.[13]

In their purest form, *vanitas* still lifes were designed to make the observer contemplate the brevity of life, the frailty of man, and the vanity of all worldly things. The skull—so central to Peschier's composition in Philadelphia's picture—is, of course, the most undisguised symbol of human mortality. The lamp with an extinguished candle is also a time-honored symbol of transience. Other objects in Peschier's picture may allude more subtly to the vanity of various forms of earthly existence—the world of wealth and power (*vita practica*), as embodied in the purses, the documents, and the baton; the contemplative life (*vita contemplativa*), to which objects like the music, the sculpture, and the globe could refer; and the life of pleasure (*vita voluptaria*), which could be symbolized by the musical instruments and even possibly by the prints.[14] In recognition of their pleasurable aspect, Van de Velde's landscape print series represented in this painting was titled "Various Most Pleasant Sites" and the landscape series of 1611–12 by Claes Jansz. Visscher (1587–1652) was subtitled "Plaisante Plaetsen" ("Pleasant Places").[15] Seventeenth-century moralists perceived parallels between the fleeting nature of music and that of time. Poets such as Jan van de Veen wrote, "The fiddle or violin is alas used more in the service of vanity than in the praise and glory of God" ("De Vedel of Fiool die wert God betert, meer/Gebruyckt tot ydelheyt, als tot Godts lof en eer").[16] Musical instruments had often figured in images of the Prodigal Son squandering his inheritance; hence they could be associated with a lazy and sinful life. A

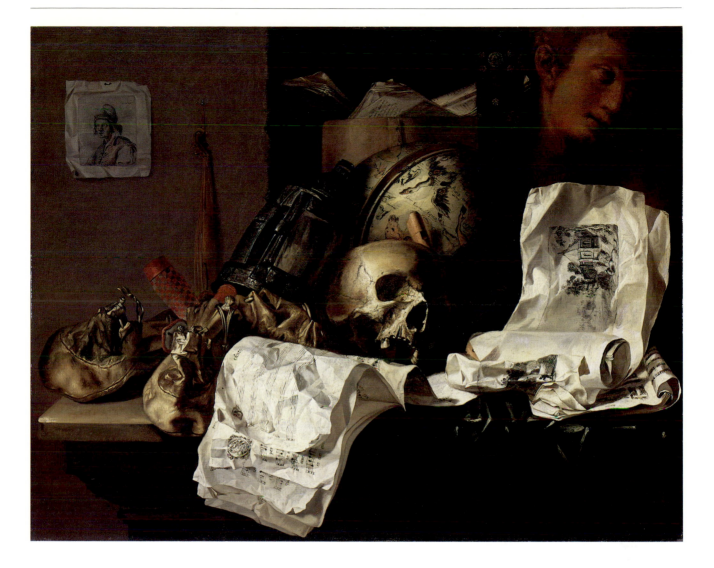

still-life display of music books and instruments was inscribed "vanitas" in the engraving of 1622 by Theodoor Matham (1605/6–1676; fig. 84-7), illustrating one specific form of vanity, namely *voluptas*. Matham's print includes in the background a merry company succumbing to earthly pleasures.[17]

 In the absence of Latin or Dutch inscriptions to think on death (such as "vanitas vanitatis et omnia vanitas," "mors omnia vincit" or "denckt op t'ent"), or similar expressions of the type that often appears in Dutch *vanitas* still lifes, it is unclear whether Peschier intended his work to be a straightforward warning against worldliness or a more subtly complex statement. Peschier's painting in London (see fig. 84-2), for example, includes promising symbols of resurrection (ears of corn) among its symbolic battery of allusions to life's brevity.[18] Precedents for the inclusion of a celestial globe in the Philadelphia painting appeared in earlier paintings by, among others, De Heem and Pieter Potter. Celestial globes also appear in conjunction with terrestrial globes not only in *vanitas* still lifes but also in Dutch emblems of this period, where the spheres of heaven and earth are contrasted.[19] In such contexts the celestial globe embodies all that is eternal and everlasting as opposed to temporal and ephemeral; thus it may

FIG. 84-5 N. L. Peschier, *Vanitas Still Life,*
signed and dated 1661, oil on canvas,
35⅛ x 40¾" (89.3 x 103.5 cm.), Collection
Frits Lugt, Institut Néerlandais, Paris,
inv. no. 7674.

FIG. 84-6 Pieter Potter, *Vanitas Still Life,*
signed and dated 1636, oil on panel, 10⅝ x 13¾"
(27 x 35 cm.), Kaiser Friedrich-Museum,
Berlin, prior to World War II.

FIG. 84-7 Theodoor Matham, *Vanitas,* 1622,
engraving.

introduce into Peschier's symbolic program a hopeful note, namely the
possibility of attaining heaven through a righteous life, or, according to an
alternative and stricter Calvinist belief, by predestination.

In attempting to retrieve the associations that *vanitas* subjects and,
indeed, all still lifes had for their contemporary Dutch viewers we must
consider the possibility, raised by both Remmet van Luttervelt and
Bergström, that these works by mid-century were as much concerned with
decorative or aesthetic concerns as with didactic or expository expression.[20]
Hessel Miedema has shown that early seventeenth-century *vanitas* still lifes,
previously thought to be pure exhortations against transitoriness, employ
vanitas allusions as only part of a larger subject, such as the theme of
studium—the study whereby *vanitas* is conquered.[21] It also seems probable
that over the course of the century the message of *vanitas* was supplemented
more and more freely, even at times carelessly, with other complementary
ideas. For example, a late *vanitas* still life by Edwaert Collier (c. 1640–after
1707)[22] depicting music books, instruments, and a globe is inscribed with
the familiar warning "memento mori" as well as the reassuring saying "Music
is the friend of pleasure and the balm of sorrow" ("Musica/Letitiae/Comes/
Medicina/Dolorum"); and several other *vanitas* paintings by Collier[23]
supplement the same admonition to think of death with the complementary
idea expressed in the inscription "Life is short, art long" ("Vita Brevis Ars
Longa"). The possibility that the attributes of the arts in Peschier's still life
might carry positive as well as negative associations enriches the painting's
meaning, but also introduces an element of ambiguity and lack of specificity
that seems to support the view that *vanitas* still lifes evolved over the course
of the century.

NOTES
1. D. Franken and J. P. van der Kellen,
L'Oeuvre de Jan van de Velde (Amsterdam,
1883), no. 284 IV.
2. Identified by Sam Quigley of the Musical
Instruments Department, Museum of Fine
Arts, Boston.
3. C. M. Kauffmann, *Catalogue of Foreign
Paintings, Victoria and Albert Museum*
(London, 1973), pp. 219–20, cat. no. 272,
repro.
4. For discussion see Stedelijk Museum "de
Lakenhal," Leiden, *Ijdelheid der Ijdelheden:
Hollandse Vanitas-voorstellingen uit de
zeventiende eeuw,* July 26–August 23, 1970,
no. 21, repro.
5. Sale, Palais Galliera, Paris, November 23,
1972, lot 47; sale, Drouot Montaigne, Paris,
June 27, 1989, lot 24, repro. See Museum
Boymans–van Beuningen, Rotterdam, *Vier
eeuwen Stilleven in Frankrijk,* July 10–
September 20, 1954, cat. no. 25, fig. 15; and
Michel Faré, *Le Grand Siècle de la nature morte
en France: Le XVII᷄ siècle* (Freiburg, 1974),
pp. 158–59, repro.
6. See Institut Néerlandais, Paris, *Refléts du
siècle d'or; Tableaux hollandais du dix-septième
siècle,* March 10–April 30, 1983, introduction
by Saskia Nihom-Nijstad, pp. 100–101,
cat. no. 61, pl. 95.

7. Poul Gammelbo, "On a Vanitas Still Life
by N. L. Peschier," *Studia Muzealne,* vol. 4
(1964), pp. 74–77.
8. See note 6.
9. Respectively, signed and dated 1660, oil on
canvas, 16½ x 21½" (41.8 x 54.5 cm.) with dealer
S. Nijstad, The Hague, in 1960 (see
Gammelbo [note 7], p. 75, no. 5, fig. 64 and
Institut Néerlandais [note 6], p. 101 n. 6);
signed and dated 1659, oil on canvas,
36¼ x 26⅜" (92 x 67 cm.), Pushkin Museum,
Moscow, inv. no. 396 (see Gammelbo, p. 75,
no. 6, and Institut Néerlandais, p. 10 n. 7);
and oil on canvas, 11¾ x 25⅝" (30 x 65 cm.)
(Faré [note 5], p. 160, repro., and Institut
Néerlandais [note 6], p. 101 n. 8).
10. Oil on panel, 32½ x 21¼" (82.6 x 54 cm.),
The Metropolitan Museum of Art, New York,
acc. no. 1974.1. On *vanitas* still lifes generally,
see Ingvar Bergström, *Dutch Still-Life Painting
in the Seventeenth Century,* translated by
Christina Hedström and Gerald Taylor
(London, 1956), pp. 154–89; and Christian
Klem, "Weltdeutung-Allegorien und
Symbole in Stilleben: Vanitas," in
Westfälisches Landesmuseum für Kunst und
Kulturgeschichte, Münster, *Stilleben in
Europa,* November 25, 1979–February 27, 1980,
Staatliche Kunsthalle, Baden-Baden, March
15–June 15, 1980, pp. 191–218.

11. Bergström (see note 10), pp. 154–58.

12. Gammelbo (see note 7), p. 74.

13. See Institut Néerlandais (note 6), p. 100. Oil on panel, 8½ x 11" (21.6 x 28 cm.), with dealer S. Nijstad, The Hague, in 1965; see Laurens J. Bol, *Holländische Maler des 17. Jahrhunderts nahe den grossen Meistern: Landschaften und Stilleben* (Brunswick, 1969), pp. 95–96, pl. 82.

14. Citing the precedent of Hadrianus Junius's commentary on the Judgment of Paris, Bergström (see note 10), p. 154 n. 2, divided still-life objects in *vanitas* paintings into these three spheres of earthly existence.

15. On landscape as *delectatio,* see David Freedberg, *Dutch Landscape Prints of the Seventeenth Century* (London, 1980), p. 36; and Sutton et al. 1987, pp. 13, 57.

16. Cited and translated by Bergström (see note 10), p. 156; Jan van der Veen, *Zinne-Beelden oft Adams Appel* (Amsterdam, 1659), riddle 32.

17. For discussion, see Pieter Fischer, *Music in Paintings of the Low Countries in the 16th and 17th Centuries* (Amsterdam, 1975), pp. 63–64.

18. On ears of corn and sprigs of laurel or ivy as resurrection symbols, see Ingvar Bergström, "Djur-och stillebenmaleri i karolinsk tid," *Konsthistorisk Tidskrift,* vol. 21 (1952), p. 80 n. 9, with reference to Rudolf Wittkower, "Death and Resurrection in a Picture by Marten de Vos," in *Miscellanea Leo van Puyvelde* (Brussels, 1949), pp. 117–23; Bergström (see note 10), pp. 154, 307 n. 4. Kauffmann (see note 3), p. 220, has identified the musical text in figure 84-2 as by Giovanni Battista Guarini (1537–1612), relating the verses to the empty eye sockets of the skull. Italian verses are also just barely visible on the partly covered page of the music book in the Philadelphia painting, but the opened pages are empty except for the word "chato" (*sic*).

19. See the still lifes by Edwaert Collier (c. 1640–after 1707), Adam Bernardt (active c. 1660 and after), and Juriaen van Streeck (1632–1687) discussed by E. de Jongh in Auckland City Art Gallery, New Zealand, *Still Life in the Age of Rembrandt,* 1982, under cat. nos. 40, 45. De Jongh (p. 201, fig. 40c) illustrates and discusses an emblem by the influential Jesuit father Adriaen Poirters (in *Het masker van de werelt afgetrocken* [Antwerp, 1646; reprint, Antwerp, 1714], pp. 56–58), which depicts figures weighing terrestrial and celestial globes to stress the greater weight and importance of the latter. On emblems, see John B. Knipping, *Iconography of the Counter Reformation in the Netherlands,* vol. 1 (Nieuwkoop and Leiden, 1974), p. 42.

20. See Remmet van Luttervelt, *Schilders van het stilleven* (Naarden, 1947), p. 53; Bergström (note 10), p. 159: "The serious meaning of the *genre* [of *vanitas* still-life painting] diminished towards the middle of the century, and the pursuit of more purely decorative effects became marked."

21. Hessel Miedema, "Over het realisme in de Nederlandse Schilderkunst van de zeventiende eeuw naar aanleiding van een tekening van Jacques de Gheyn II (1565–1632)," *Oud Holland,* vol. 89, no. 1 (1975), pp. 2–18, especially pp. 13–16.

22. Oil on canvas, 16¼ x 20½" (41 x 52.5 cm.), sale, Kunsthaus Lempertz, Cologne, November 23, 1978, lot 44, repro.

23. See, for example, the signed painting of 1692, *A Vanitas Still Life,* oil on panel, 14¼ x 11½" (36 x 29 cm.), sale, Sotheby's, London, October 12, 1983, lot 48, repro.

PROVENANCE: Purchased from Tomas Harris, Spanish Art Gallery, London, by Henry P. McIlhenny, Philadelphia, 1950.

CONDITION: The support is a medium weight, plain-weave linen fabric. The tacking edges are missing and the painting is lined with a fabric of similar construction and an aqueous adhesive. The ground is a thin, light gray oil layer. The oil paint is reasonably well preserved in light passages but extensively retouched to conceal abrasion of thinly painted darks throughout the painting. A thick, yellowed natural resin varnish is present, which has been sprayed over with a synthetic varnish.

Baptized at Enkhuizen on November 20, 1625, Paulus Potter was the son of the painter Pieter Potter (c. 1597–1652) and Aaltje Paulusdr. Bartsius, sister of the painter Willem Bartsius (b. c. 1612). The family settled in Amsterdam by 1631. According to Arnold Houbraken, Potter studied under his father. Some early works also seem to reflect the influence of Claes Cornelisz. Moeyaert (1592/93–1655). Potter's earliest dated works are of 1642. In May of that year a "P. Potter" was a student of Jacob Willemsz. de Wet (1610–1671/72) in Haarlem, but it is unknown whether this was the artist in question. By August 1646, Potter was living in Delft and joined the guild there. In 1649 he entered the guild at The Hague and was married to Adriana Balkeneynde in that city in July 1650. Potter's wife was the daughter of the city architect Claes Dirksz. Balkeneynde (d. 1664), who worked on the royal palaces and may have introduced Potter to Amalia van Solms, widow of Prince Frederick Henry, for whom the artist painted a picture now in Leningrad. He also had the patronage of Jan Maurits van Nassau. From 1649 to 1652 he lived in the house of the painter Jan van Goyen (q.v.) on the Dunne Bierkade. Houbraken claimed he was persuaded to leave The Hague for Amsterdam by Dr. Nicolaes Tulp, whose son he later portrayed. He settled by May 1, 1652, in Amsterdam, where he was living in January 1653, when he made a will. Potter was buried in the Nieuwezijdskapel on January 17, 1654. He was only twenty-nine years old at the time of death. Potter's portrait by Bartholomeus van der Helst (1613–1670), dated in the year of his death, is preserved in the Mauritshuis, The Hague (oil on canvas, 39 x 31½″ [99 x 80 cm.], no. 54).

Despite his brief life, Potter was a highly innovative and influential artist. Most of his pictures are cabinet-sized paintings of animals, usually cows, in landscapes; however, his well-known *Young Bull* (1647, oil on canvas, 92¾ x 133½″ [235.5 x 339 cm.], Mauritshuis, The Hague, no. 136) and his equestrian *Portrait of Dirck Tulp* (1653, oil on canvas, 122 x 107⅞″ [310 x 274 cm.], M.J.P. Six Collection, Amsterdam) are both life size. His paintings are related to those of Karel Dujardin (c. 1622–1678) and the two may have had a mutual influence on one another's work. In addition to paintings Potter also executed about two dozen etchings of animals.

LITERATURE: Houbraken 1718–21, vol. 2, pp. 126–29; Descamps 1753–64, vol. 2, pp. 351–56; Smith 1829–42, vol. 5, pp. 113–65, vol. 9, pp. 620–28; T. van Westrheene, *Paulus Potter: Sa vie et ses oeuvres* (The Hague, 1867); Georges Duplessis, *Eaux-fortes de Paul Potter* (Paris, 1875); Emile Michel, *Paulus Potter* (Paris, 1906); Wurzbach 1906–11, vol. 2, pp. 349–54; Hofstede de Groot 1908–27, vol. 4 (1912), pp. 582–670; Rudolf von Arps-Aubert, "Die Entwicklung des reinen Tierbildes in der Kunst des Paulus Potter," diss. University of Halle, 1923; Kurt Zoege von Manteuffel, *Paulus Potter* (Leipzig, 1924); Thieme-Becker 1907–50, vol. 27 (1933), pp. 328–33; Tancred Borenius, "Paul Potter," *The Burlington Magazine,* vol. 81, no. 472 (July 1942), pp. 290–94; Neil MacLaren, *The National Gallery Catalogues: The Dutch School* (London, 1960), pp. 298–300; Wolfgang Stechow, *Dutch Landscape Painting of the Seventeenth Century* (London, 1966); Kurt Müllenmeister, "Charme der Tieridylle: Ein Blick auf das Werk des Malers Paulus Potter," *Kunst und Antiquitäten,* vol. 4 (1980); Kurt Müllenmeister, *Meer und Land im Licht des 17. Jahrhunderts,* vol. 3 (Bremen, 1981), pp. 23–28; Amy L. Walsh, "Imagery and Style in the Paintings of Paulus Potter," diss., Columbia University, 1985; Sutton et al. 1987, pp. 416–22.

For related works in the Philadelphia Museum of Art, see John G. Johnson Collection cat. no. 618 (follower of), inv. no. 2829 (imitator of), cat. no. 619 (copy after).

85 PAULUS POTTER

FIGURES WITH HORSES BY A STABLE, 1647
Signed and dated lower left: *Paulus Potter·f 1647*
Oil on panel, 17¾ x 14¾" (45 x 37.5 cm.)
The William L. Elkins Collection. E24-3-17

FIG. 85-1 Paulus Potter, *The Farrier's Shop*,
1648, oil on panel, 19 x 18″ (48.3 x 45.7 cm.),
National Gallery of Art, Washington, D.C.,
Widener Collection, no. 1942.9.52.

On the right a man and the light gray horse that he curries are spotlighted in the doorway of a crude stable. Near the doorway a woman suckles her infant and one man assists another in mounting a brown horse. The horse wears a harness for pulling a cart or plow but no saddle. The man struggling to mount the horse has torn the seat of his trousers and seems to draw a smile from the nursing mother. At the left a pasture with cows stretches to a distant horizon. Judging from the new leaves on the tree before the stable and on the smaller one at the left, the season is spring. A rooster and three chickens appear in the lower right and a dog scratches itself before the open stable door.

When J.A. Smith (1834) saw the picture in the Hope Collection it was said to be the companion of the painting *Cattle and Sheep in a Stormy Landscape,* now in the National Gallery in London;[1] however, that work differs in design and, as MacLaren observed, has a different early history. Thus, it is unlikely that Potter designed the two as pendants. With its upright composition juxtaposing the near view of the darkly silhouetted stable and the distant, brightly lit meadow, the work's design most resembles (in reverse) that of Potter's *Farrier's Shop* (fig. 85-1), dated 1648, in the National Gallery of Art, Washington, D.C. Walsh discussed the two pictures together, noting their shared theme of the protective farmer caring for his workhorse, and related such images to seventeenth-century ideals of man's relationship to animals.[2] The system of backlighting seen in the Philadelphia painting, in which the light streams from the distance toward the viewer, is one that Potter favored in those years.[3] Additional paintings by Potter dated 1647 are found in the Mauritshuis, The Hague, the Brussels Museum, and the M.J.P. Six Collection, Amsterdam.[4]

The deft execution of this superbly preserved panel presents Potter at his best. In 1854 Waagen wrote of the picture, "In impasto, warmth, and force of colouring, the master here appears in all his excellence. Nothing can be more striking in effect than this grey horse, lighted by the sunbeam."[5] A copy, which recently sold in London, is probably identical with the picture identified by Smith as a replica of this painting.[6]

NOTES

1. Also signed and dated 1647, oil on panel, 18¼ x 14⅞" (46.3 x 37.8 cm.), no. 2583.

2. Amy L. Walsh, "Imagery and Style in the Paintings of Paulus Potter," diss., Columbia University, 1985, pp. 321ff. She also suggested (p. 269) that the nursing mother underscores the idea of the fertility of nature, especially in the spring.

3. Compare the Czernin Collection's painting of 1647, *Morning Pasturing of Cattle,* oil on panel, 15 x 19¾" (38.5 x 50 cm.), Salzburger Residenzgalerie, Vienna, no. 548. On the importance of Potter's treatment of light for Delft painting, see Sutton 1980, p. 17.

4. *The Young Bull,* oil on canvas, 92¾ x 133½" (235.5 x 339 cm.), Mauritshuis, The Hague, no. 136; *The Pig Sty,* oil on panel, 22¼ x 20¼" (56.5 x 51.5 cm.), Musées Royaux des Beaux-Arts de Belgique, Brussels (Musées Royaux des Beaux-Arts de Belgique, Brussels, *Catalogue de la Peinture Ancienne* [Brussels, 1949], p. 96, no. 357); and *Milkmaid Washing a Bucket,* oil on panel, 15 x 16½" (38 x 42 cm.), M.J.P. Six Collection, Amsterdam. Previously the Musée du Louvre's early Potter, *Two Draft Horses in Front of a Cottage,* oil on panel, 9¼ x 10" (23.5 x 25.5 cm.), inv. no. 1731, was said to be dated 1647 but is actually dated 1649; see Arnauld B. de Lavergnée, Jacques Foucart, and Nicole Reynaud, *Ecoles flamande et hollandaise* (Paris, 1979), pp. 106–7.

5. Waagen 1854, vol. 2, p. 120.

6. Signed and dated 1647, oil on panel, 20 x 17" (50.6 x 43.2 cm.); provenance: probably sale, Pieter de Klok, Amsterdam, April 22, 1744, lot 67; probably sale, Ph. van der Land, Amsterdam, May 22, 1776, lot 73, to Wubbels [in both sales as 21 x 17"]; Joseph Marsland,

Manchester (who, according to Smith 1829–42, vol. 5, pp. 153–54, no. 87, paid £315 for it), before 1834; sale, Christie's, London, June 6, 1840, lot 31, to Wise [the date incorrectly recorded as 1643]; sale, Christie's, London, April 18, 1980, lot 50, repro.

PROVENANCE: Sale, Plattenberg, Amsterdam, April 2, 1738, lot 66; Willem Lormier,[1] who sold it to J. W. Frank, June 4, 1756; H. P. Hope, London, by 1815; Philip Henry Hope, London, by 1834;[2] by descent to Henry Thomas Hope, London, by 1854; by descent to Lord Francis Pelham Clinton-Hope, Deepdene; sold to P. & D. Colnaghi and A. Wertheimer with entire collection, 1898; William L. Elkins Collection, Philadelphia, by 1899.

NOTES TO PROVENANCE

1. See Gerard Hoet, *Catalogus of naamlyst van schilderyen met derzelver pryzen* (The Hague, 1752; reprint, Soest, 1976), vol. 2, p. 435.

2. See Smith 1829–42, vol. 5, pp. 153–54, no. 87.

EXHIBITIONS: British Institution, London, *Pictures by Artists of the Flemish and Dutch Schools,* 1815, no. 137; Manchester, *Art Treasures of the United Kingdom,* 1857, no. 996; Royal Academy, London, winter 1881, no. 71; South Kensington Museum, London, *Pictures of the Dutch and Flemish Schools Lent to the South Kensington Museum by Lord Francis Pelham Clinton-Hope,* 1891–98, no. 117; Union League of Philadelphia, May 11–27, 1899, no. 31; The Metropolitan Museum of Art, New York, *Catalogue of a Loan Exhibition of Paintings by Old Dutch Masters Held at the Metropolitan Museum of Art in Connection with the Hudson-Fulton Celebration,* September–November 1909, no. 71.

LITERATURE: Gerard Hoet, *Catalogus of naamlyst van schilderyen met derzelver pryzen* (The Hague, 1752; reprint, Soest, 1976), vol. 1, p. 500, vol. 3, p. 435; Smith 1829–42, vol. 5, pp. 153–54, no. 87; Waagen 1854, vol. 2, p. 120; W. Bürgher (E.J.T. Thoré), *Trésors d'Art en Angleterre* (Paris, 1865), pp. 283–84; T. van Westrheene, *Paulus Potter: Sa vie et son oeuvres* (The Hague, 1867), p. 156–57, no. 35; South Kensington Museum, London, *A Catalogue of Pictures of the Dutch and Flemish Schools Lent to the South Kensington Museum by Lord Francis Pelham Clinton-Hope* (London, 1891), no. 31; *The Hope Collection of Pictures of the Dutch and Flemish Schools* (London, 1898), no. XVII, repro.; Elkins 1887–1900, vol. 2, no. 117, repro.; Hofstede de Groot 1908–27, vol. 4 (1912), pp. 582–670, no. 156; Elkins 1924, no. 17; Philadelphia Museum of Art, *A Picture Book of Dutch Painting of the XVII Century* (Philadelphia, 1931), p. 5; Neil MacLaren, *The National Gallery Catalogues: The Dutch School* (London, 1960), p. 300; PMA 1965, p. 55; Rishel 1974, pp. 30–31, pl. III; Amy L. Walsh, "Imagery and Style in the Paintings of Paulus Potter," diss. Columbia University, 1985, pp. 269, 321, repro. B62; Peter C. Sutton, *Dutch Art in America* (Grand Rapids and Kampen, 1986), p. 225, fig. 328.

CONDITION: The uncradled panel is in good condition with moderate convex warping across the horizontal grain. Little abrasion and only a few minor losses appear in the paint film along the lower edge. The varnish is applied unevenly and is moderately discolored.

A native of Utrecht, Van der Puyl was born on March 4, 1750. He was a student of Hendrik van Velthoven (1728–1770) for five years and began his travels abroad in 1770. He lived in France for several years, where he painted family and single-figure portraits. In 1780 he was briefly active in Leiden, where he painted professors' portraits and the burgomaster Nicolaes Hartingh. He subsequently was active in England for at least four years between 1784 and 1788; his portrait of the astronomy professor Antony Shepherd, painted in 1784 (University Library, Cambridge), is his earliest dated English work. He first exhibited at the Royal Academy in 1785, and again in 1787 and 1788, when the present work (no. 86) was shown. In London he resided at 25 Henrietta Street, Covent Garden. C. H. Balkema informs us that Van der Puyl returned to Holland in 1806 after an absence of thirty-six years; he may have been in Amsterdam as early as 1803, however, since drawings of this date representing his studio appear in the diary of Jurriaen Andriessen (1742–1819). Moreover, he was the director of the drawing academy at Utrecht from 1804 to 1806. On the other hand, his presence in Boulogne in 1805 is proved by three canvases with head studies of officers, now in the museum in Calais. In 1806 he was a member of the Painter's College as well as general director of the drawing academy in Utrecht. The following year he wrote a brief history of the drawing academy, but shortly thereafter had to escape to France when it was discovered that he had misused academy funds. He probably died in Saint-Omer.

In addition to cabinet-sized conversation pieces like the Philadelphia picture, Van der Puyl executed full-scale portraits.

LITERATURE: C. H. Balkema, *Biographie des peintres flamands et hollandais* (Ghent, 1844), pp. 255–56; William Roberts, "A Conversation Piece by L. F. G. Vander Puyl, 1787," *Art in America*, vol. 8, no. 5 (August 1920), pp. 218–23; Thieme-Becker 1907–50, vol. 27 (1933), p. 475; Centraal Museum, Utrecht, *Utrechtsche Kunst, 1800–1850*, July 15–September 13, 1942, pp. 9–10; A. Staring, "De beeldende Kunst in de 18de eeuw," *Kunstgeschiedenis der Nederlanden*, 1946, p. 618; J. Knoef, "Het dagboek van Jurriaen Andriessen," *Jaarverslag van het Koninklijk Oudheidkundig Genootschap*, 1946, p. 65; A. Staring, *De Hollanders Thuis* (The Hague, 1956), pp. 158, 164; Pieter A. Scheen, *Lexicon Nederlandse Beeldende Kunstenaars 1750–1880* (The Hague, 1981), p. 413.

86 LOUIS FRANÇOIS GÉRARD
 VAN DER PUYL

THOMAS PAYNE, HIS FAMILY, AND FRIENDS, 1787
Signed and dated lower right beside the chair: *L.F.G. van der Puyl pt/1787*
Oil on canvas, 36¼ x 48⅜″ (92.1 x 122.9 cm.)
Gift of John H. McFadden, Jr. 51-125-17

In a rectilinear interior, eighteen seated or standing figures have gathered around two tables to play cards and socialize. The sitters' identities are provided by an old (early nineteenth-century?) inscription on the reverse referring to the picture as "'Conversation' painted by Mr. Vanderpoile for 'Old Tom Payne' of The Mews Gate" and listing all but one of the figures by name. They prove to be relatives and friends of the popular and highly esteemed London bookseller Thomas Payne, Sr. (1719–1799), also known as "Honest Tom Payne," who originated the practice of printing lists of books available in his shop.[1] A favored meeting place for literary figures and bibliophiles, the bookseller's shop in Mewsgate became known as the Literary Coffeehouse and served the great private libraries of its day.[2] Payne himself is portrayed seated at the center wearing spectacles and holding a hand of cards to his chest (see fig. 86-1, no. 8). Payne oversaw the business until 1790, when he retired in favor of his son "Young Tom Payne"

FIG. 86-1 Identification of the subjects:
1. Mrs. Brande, mother of W. T. Brande
2. Louis François Gérard van der Puyl, the
painter 3. Miss Payne, elder daughter of
Payne, Sr. 4. Augustus Everard Brande, father
of W. T. Brande 5. Mr. Kramer 6. Miss
Thomas (afterwards Mrs. Lambe) 7. Mrs.
Bale 8. Thomas Payne, Sr. 9. James Payne,
second son of Payne, Sr. 10. Dr. John Burges
11. Rear Admiral James Burney 12. Mrs. Pirner
13. William Pirner 14. Miss Sarah Payne (Mrs.
James Burney) 15. Mr. Bale 16. Mrs. Kramer
17. Thomas Payne, Jr. 18. Probably Edward
Noble.

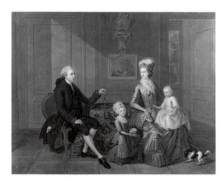

FIG. 86-2 Louis François Gérard van der
Puyl, *Portrait of a Jeweler's Family,* signed and
dated 1776, oil on copper, 22⁷⁄₁₆ x 28¾"
(57 x 73 cm.), Centraal Museum, Utrecht,
inv. no. 10242.

(1752–1831), who is seated at the far right in the present work (no. 17). The son moved the firm to Schomberg House on the south side of Pall Mall in 1806 and in 1813 took Henry Foss, his apprentice, into the business as a partner. The Philadelphia picture probably hung in the new premises of Payne and Foss until the business was dissolved in 1850.

The elder Payne's younger son, James Payne (no. 9) was also a bookseller and publisher; he died in 1809 after confinement as a prisoner of war in France;[3] Payne's elder daughter (no. 3) was a celebrated beauty in her youth; his younger daughter, Sarah (no. 14), married Rear Admiral James Burney (1750–1821; no. 11), who was the eldest son of the musician and author Dr. Charles Burney (1726–1814) and a distinguished naval officer and author of nautical history. Other members of the group include Mr. and Mrs. Bale (nos. 15, 7) about whom nothing certain is known; Augustus Everard Brande (no. 4), who, like his father, was apothecary to Queen Charlotte and author of several books, and Mrs. Brande (no. 1); Dr. John Burges (1745–1807; no. 10), a physician who had a large library and a valuable collection of *materia medica,* which he bequeathed to the College of Physicians; Mr. Kramer (no. 5), a clerk in His Majesty's German office, and his wife (no. 16), to whom he was married on the same day (July 5, 1773) and at the same place (St. George's in Hanover Square) as the other German couple in this picture, the Brandes; Mr. and Mrs. William Pirner (nos. 13, 12), who also married at St. George's, on September 4, 1774, and lived on Arlington Street, London, and Heston, Middlesex. The standing figure at the extreme right (no. 18) is the only one not identified on the reverse, but Roberts has surmised that he probably was Edward Noble, Tom Payne's chief assistant for many years and a mathematician of some renown who published a treatise on perspective. Miss Thomas (no. 6) later married Mr. Lambe, and the standing male figure at the far left (no. 2) is the artist himself.

The card game being played is the popular eighteenth-century diversion known as whist. Thomas Dibdin and William Courtney (who included an engraving of the figure of Thomas Payne from this painting in his book on whist) identified it as such,[4] and Rear Admiral James Burney's (no. 11) most popular publication was *An Essay by Way of a Lecture on the Game of Whist* (London, 1821). Furthermore, Burney's wife is generally supposed to have been the model for Sarah Battle in Charles Lamb's essay "Mrs. Battle's Opinion on Whist," published in the *London Magazine* (February 1821, pp. 161–62).

When the painting was first exhibited at the Royal Academy in 1788, it evidently was well received. In the review entitled "The Bee," the anonymous author commented that "this group of Mr. Pain and Family has great merit in the disposition; the draperies are well expressed, if we except the linens, which are too thick and woolly."[5] Described when first shown as a "conversation," the picture reflects the eighteenth-century tradition of the conversation piece, a portrait type popularized in England by William Hogarth (1697–1764), Johann Zoffany (1733–1810), and Benjamin Wilson (1721–1788). The tradition has parallels in the works of eighteenth-century Dutch artists such as Cornelis Troost (1697–1750), Jan M. Quinkhard (1688–1772), and Hendrik Pothoven (1726–1807); its roots stem from the mid-seventeenth-century Flemish and Dutch portraiture of Gonzales

FIG. 86-3 Louis François Gérard van der Puyl, *Portrait of Thomas Payne,* oil on canvas, 29 x 23″ (73.6 x 58 cm.), The New-York Historical Society, acc. no. 1883.1.

Coques (1614–1684), Gillis van Tilborgh (c. 1625–c. 1678), Gabriel Metsu (1629–1667), Pieter de Hooch (q.v.), and others.[6] Van der Puyl painted other small-scale family portraits in orderly interiors and on terraces;[7] this work, however, is the only known group portrait from his English years. Appropriately, it reveals more affinities with the English conversation piece than his other works, specifically in the effort to lend an informal air to the group by uniting them in an activity. Although often showing a pretense of engaging in some occupation (for example, the so-called *Portrait of a Jeweler's Family,* fig. 86-2), the sitters in both his earlier and later works are posed more formally and with less variety. Here the studied effect of the *tableau vivant* is replaced by a new naturalness.

In addition to the print of the single figure of Thomas Payne at cards made from the Philadelphia painting in Courtney's book on whist, a second *Portrait of Thomas Payne* by Van der Puyl, showing the sitter with his arms crossed, is in the New-York Historical Society (fig. 86-3)[8] and was engraved in 1817 for Dibdin's *Bibliographical Decameron.*[9]

NOTES

1. See *The Dictionary of National Biography,* vol. 15 (1917), pp. 567–68. Born in Brackley, Northamptonshire, in 1719, Payne married Elizabeth Taylor around 1745. The couple had "two sons and two daughters, who were described in 1775 as pretty and motherless." Payne died on February 2, 1799, and was buried beside his wife at Finchley. A poetical epitaph was written for him by William Hayley; see John Nicols, *Literary Anecdotes of the Eighteenth Century,* 9 vols. (London, 1812–15), vol. 9, p. 666.
2. Among those who frequented the shop were Clayton Cracherode, Richard Gough, Richard Porson, Frances Burney, Thomas Grenville, George Stevens, Cyril Jackson, Sir John Hawkins, Lord Spencer, Edmund Malone, and Joseph Windham. Literary references to "Honest Tom Payne's" appear in Thomas James Mathias, *Pursuits of Literature,* dialogue 2 (London, 1796), pp. 190–94; and William Beloe, *Sexagenarian, or Recollections of a Literary Life,* vol. 1 (London, 1817), chap. 32.
3. The known facts of the sitters' biographies were compiled by William Roberts in "'Thomas Payne, His Family, and Friends,' by L. F. Gerard van der Puyl, 1787," an unpublished information sheet for dealer T. Agnew & Sons, London, in 1918. It was later revised and published as "A Conversation Piece by L. F. G. Vander Puyl, 1787," *Art in America,* vol. 8, no. 5 (August 1920), pp. 218–23.
4. Thomas Frognall Dibdin, *Bibliographical Decameron; or Ten Days Pleasant Discourse upon Illuminated Manuscripts, and Subjects Connected with Early Engraving, Typography and Bibliography,* vol. 3 (London, 1817), p. 435; William Prideaux Courtney, *English Whist and English Whist Players* (London, 1894), p. 252.
5. "The Bee, or the Exhibition Exhibited in a New Light" (anonymous review of the Royal Academy exhibition), 1788.

6. On the conversation piece, see Sacheverell Sitwell, *Conversation Pieces* (London, 1936); A. Staring, *De Hollanders Thuis* (The Hague, 1956); Ralph Edwards, *Early Conversation Pictures from the Middle Ages to about 1730* (London, 1954); and Mario Praz, *Conversation Pieces* (University Park, Pa., and London, 1971).
7. See the so-called *Portrait of a Jeweler's Family* (fig. 86-2) (Centrael Museum, Utrecht, *Catalogus der Schilderijen* [Utrecht, 1952], pp. 97–98, no. 224, repro. no. 99); *Portrait of the Van Assche Family on a Terrace,* signed and dated 1776, oil on copper, 22½ x 29¼″ (57 x 74.5 cm.) (repro. in sale, "Important Old Master Paintings," Sotheby's, London, April 19, 1972, lot 2 [from the collection of Mrs. H. van Assche]); *Portrait of Nicolaes Hartingh and His Family,* signed and dated 1780, Collection of Mevrouw S. A. Verbrugge-Mees, Rotterdam (repro. in Praz [see note 6], p. 235, no. 217); and *Portrait of the De Gauville Family,* signed and dated 1811, oil on canvas, 25⁹⁄₁₆ x 20⁷⁄₁₆″ (65 x 52 cm.), Centraal Museum, Utrecht, 1952 cat. no. 226.
8. The New-York Historical Society, *Catalogue of the Gallery of Art* (New York, 1915), p. 31, no. 267. The painting was presented to the society by Mr. F. S. Ellis of London in 1883. Ellis purchased the work from John T. Payne, grandson of the subject.
9. Vol. 3 (London, 1817), p. 435.

PROVENANCE: "Honest Tom Payne's" bookstore in Mewsgate until 1806, when the firm, renamed Payne & Foss in 1813, moved to Schomberg House, where the painting probably was housed until the company dissolved in 1850; dealer Thos. Agnew & Sons, London, 1918; purchased by John H. McFadden, Philadelphia; John H. McFadden, Jr., Philadelphia.

EXHIBITION: Royal Academy, London, 1788, no. 13 [as "A Conversation"].

LITERATURE: "The Bee, or the Exhibition Exhibited in a New Light" (anonymous review of the Royal Academy exhibition), 1788; Thomas Frognall Dibdin, *Bibliographical Decameron; or Ten Days Pleasant Discourse upon Illuminated Manuscripts, and Subjects Connected with Early Engraving, Typography and Bibliography,* vol. 3 (London, 1817), p. 435; William Prideaux Courtney, *English Whist and English Whist Players* (London, 1894), p. 252; William Roberts, "A Conversation Piece by L. F. G. Vander Puyl, 1787," *Art in America,* vol. 8, no. 5 (August 1920), pp. 218–23; C. E. Mainwaring, *My Friend the Admiral: The Life, Letters, and Journals of Rear Admiral James Burney, F.R.S., The Companion of Captain Cook and Friend of Charles Lamb* (London, 1931), pp. 189–90, repro. frontispiece; A. Staring, *De Hollanders Thuis* (The Hague, 1956), pp. 45, 164, pl. XLIX; PMA 1965, p. 55.

CONDITION: The canvas support has an old, aqueous lining. The tacking edges are missing. It is dry, somewhat slack, and buckles slightly at the lower edge. The marks of the stretchers and diagonal crosspieces in the corners are evident in the craquelure. One long tear has been filled and retouched. The tear extends approximately 23″ (58.4 cm.) from top center, down through the two women in green and brown hats, continues through the six of clubs playing card and down along the right side of the chair back in the man's black coat to the level of the chair seat. The retouches and varnish do not match the original exactly. The paint film reveals some abrasion and scattered small losses. The varnish is deeply discolored.

PRINT AFTER
Engraving of figure of Thomas Payne in William Prideaux Courtney, *English Whist and English Whist Players* (London, 1894), p. 252.

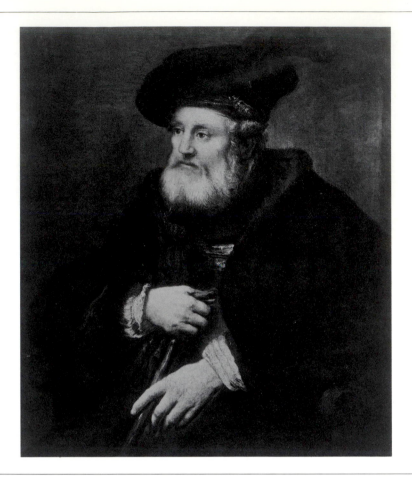

87 COPY AFTER REMBRANDT
HARMENSZ. VAN RIJN

AN OLD MAN IN FANCIFUL COSTUME HOLDING A STICK
Oil on canvas, 38¾ x 32¾" (98.4 x 83.2 cm.)
The William L. Elkins Collection. E24-3-89

An old man with a beard and wearing a feathered beret is viewed half length, seated in an armchair, and turned to the viewer's left. He holds a walking stick with both hands. This work is a copy of a painting by Rembrandt Harmensz. van Rijn (1606–1669) dated 1645, presently in the Museu Calouste Gulbenkian, Oeiras, Portugal.[1] The larger original shows somewhat more of the figure and a pilaster at the upper-right corner. C. Hofstede de Groot listed the Philadelphia picture among seven known or documented copies of the work.[2]

NOTES
1. Oil on canvas, 50⅜ x 44" (128 x 122 cm.), inv. no. 1489; see *Calouste Gulbenkian Museum Catalogue* (Lisbon, 1982), no. 967. Formerly in the Crozat Collection, Paris, and the Hermitage, Leningrad; see Abraham Bredius, *Rembrandt: The Complete Edition of the Paintings,* 3rd ed., revised by Horst Gerson (London, 1969), pp. 191–92, Br. 239.
2. Hofstede de Groot 1908–27, vol. 6 (1916), p. 229, under no. 438.

PROVENANCE: William L. Elkins Collection, Philadelphia, by 1908.

LITERATURE: Hofstede de Groot 1908–27, vol. 6 (1916), p. 229, under no. 438; PMA 1965, p. 56.

CONDITION: The canvas is lined with an aqueous adhesive. The tacking edges are missing. An old vertical tear to the right of the man's head has been mended. There are extensive drying crackle, localized areas of flaking, and scattered losses in the paint film. The varnish is deeply discolored.

For additional works related to Rembrandt in the Philadelphia Museum of Art, see John G. Johnson Collection cat. nos. 480 (attributed to), 474 (follower of), 475 (follower of), 492 (follower of), 478 (imitator of), 479 (imitator of), 476 (copy after), 477 (copy after), 481 (copy after), 483 (copy after), 482 (copy after).

LITERATURE: Boetticher (1891–1901) 1969, vol. 2, pp. 430–32; Thieme-Becker 1907–50, vol. 28 (1934), p. 325.

Born on August 15, 1827, in Nieustrelitz, Riefstahl moved at the age of sixteen to Berlin, where he studied with Wilhelm Schirmer (1802–1866). Often in Tirol in the 1860s, he visited Rome in 1869. From 1870 to 1873 he was a professor at the art school in Karlsruhe and was appointed director after another two-year sojourn in Rome. In addition to paintings of landscapes and architecture with genrelike staffage, he executed architectural drawings and engraved illustrations. His best-known paintings are Alpine scenes.

88 WILHELM LUDWIG
FRIEDRICH RIEFSTAHL

RETURN FROM THE CHRISTENING, 1865
Signed and dated lower left in red: *W. Riefstahl*[65]
Oil on canvas, 27⅝ x 43¾" (70 x 111 cm.)
The W. P. Wilstach Collection. W93-1-90

In a rocky Alpine landscape on a bright summer day a family is greeted by villagers upon their return from a christening. The father leads his young son by the hand while the mother carries her newly baptized infant. Other villagers in festive local costume attend the family. As in many of Riefstahl's works (for example, *A Wedding Procession in Tirol* and *The Burial Ceremony*),[1] the setting recalls the painter's frequent visits to Tirolean mountains. Riefstahl made a specialty of such images of folk ceremonies and processions in mountainous rural settings.

NOTE
1. Oil on canvas, 26½ x 42¾" (67.3 x 108.6 cm.), The Metropolitan Museum of Art, New York, no. 87.15.60; 1873, oil on canvas, 60 x 118" (152 x 300 cm.), Staatliche Kunsthalle, Karlsruhe, no. 574, respectively.

PROVENANCE: William P. Wilstach Collection, Philadelphia, by 1886.

LITERATURE: Wilstach 1886, no. 102, 1893, no. 80, 1900, no. 115, 1903, no. 152, 1904, no. 207, 1906, no. 229, 1907, no. 241, 1908, no. 241, 1910, no. 329, 1913, no. 343, 1922, no. 262; Thieme-Becker 1907–50, vol. 28 (1934), p. 325; PMA 1965, p. 58.

CONDITION: The painting has an aqueous lining. Its tacking edges are missing. The fabric is slack with minor bulges and cupping associated with conspicuous age crackle. Stretcher creases are prominent on all sides. The varnish is dull and moderately discolored.

Brother of the flower painter Henri Robbe (1807–1899), Louis (Lodewijk) Robbe was born at Kortrijk on November 17, 1806. He studied humanities and attended the fine arts academy there, graduating in 1820. He was a pupil of the local painter Jan Baptiste de Jonghe (1785–1844) in 1824; in 1830 he took a degree in law at the Rijksuniversiteit in Ghent. Five years later he took over his father's office and in 1840 assumed a post in the Ministry of Finance in Brussels. Despite his legal and business activities, Robbe continued to paint, first exhibiting in Ghent in 1835 and being awarded medals at Bruges in 1837, Ghent in 1838, and Brussels in 1839. In Brussels in 1854 and in Paris in 1855, he had great success with a collaborative painting entitled *La Campine,* in which he painted the animals, Charles Corneille de Groux (1825–1870) executed the figures, and Willem Roelofs (1822–1897) painted the sky. He continued to exhibit regularly, both in Belgium and abroad, throughout his life.

Robbe was an animal painter in the tradition of Eugène Joseph Verboeckhoven (1799–1881) and anticipated artists like Alfred Jacques Verwee (1838–1895) and Joseph Edouard Stevens (1819–1892). The latter was Robbe's pupil. Robbe's landscapes with farm animals are painted in bright, clear tones. The cows, sheep, and other creatures in his works invariably are executed with exacting anatomical detail. A man of some means, he patronized and supported fellow-artists like De Groux.

LITERATURE: Boetticher (1891–1901) 1969, vol. 2, pp. 445–46; E. Leclerc, *Louis Robbe* (Brussels, n.d.); *Biographie Nationale,* vol. 19 (Brussels, 1907), pp. 400–406; Georges Eekhoud, *Les Peintres animal belges* (n.p., 1911), pp. 21–24; Pol de Mont, *De Schilderkunst in België van 1830 tot 1921* (The Hague, 1921), pp. 151–52; Thieme-Becker 1907–50, vol. 28 (1934), p. 412; E. Bénézit, *Dictionnaire critique et documentaire des peintres, sculpteurs, dessinateurs et graveurs,* 3rd. ed., vol. 8 (Paris, 1976), p. 791; Koninklijk Museum voor Schone Kunsten, Antwerp, *Catalogus schilderijen 19de en 20ste eeuw* (Antwerp, 1979), p. 367.

89 LOUIS MARIE DOMINIQUE ROBBE

PASTORAL LANDSCAPE, after 1878
Signed lower left: *Robbe*
Oil on canvas, 42½ x 31½″ (108 x 80 cm.)
Gift of Mr. Hermann and Dr. Edward Krumbhaar. 21-69-2

FIG. 89-1 Louis Robbe, *Cows in a Field,* 1878, oil on canvas, 49¼ x 70½″ (125 x 179 cm.), Koninklijk Museum voor Schone Kunsten, Antwerp, no. 1121.

In a pastoral landscape, two cows, one standing and the other lying down, appear beside two sheep. At the right is an old, denuded tree trunk and a rustic fence. In the prospect at the left are additional cows.

The painting's bucolic subject and design ultimately descend from Dutch seventeenth-century works by Paulus Potter (q.v.), Adriaen van de Velde (1636–1672), Karel Dujardin (c. 1622–1678), and their followers, but claim more immediate antecedents in the art of the Belgian animal painter Eugène Joseph Verboeckhoven (1799–1881); compare, for example, the latter's *Landscape with Herdsman and Flock Near a Tree* of 1824, which includes a similar motif of the blasted tree trunk.[1] A painting by Robbe comparable to the undated Philadelphia painting in its conception, bovine theme, and exacting execution is dated 1878 (fig. 89-1), suggesting that the Philadelphia work may be a later effort by the artist. However, his touch remained tight and exact, and readily distinguished from the broader style of contemporary French animal painters such as Constant Troyon (1810–1865) and Emile Marcke de Lummen (1827–1890).

NOTE
1. 1824, oil on panel, 23¾ x 29½″ (59 x 75 cm.), Rijksmuseum, Amsterdam, no. A1150.

PROVENANCE: Mr. Hermann and Dr. Edward Krumbhaar.

LITERATURE: PMA 1965, p. 58.

CONDITION: The unlined canvas support is slack, with shallow ripples. In the sky to the left of the tree on the right are a small puncture and a dent. Stretcher creases appear in the paint film at the top and bottom and run vertically down the center. Some rubbing from the frame is evident at the edges. Little abrasion appears in the paint film. The varnish is deeply discolored.

Born in Saarbrücken on October 18, 1855, Röchling studied in Karlsruhe with Ludwig des Coudres (1820–1878) and Ernest Hildebrand (1833–1921) and at the Berlin academy with Anton von Werner (1843–1915). Collaborating with the last mentioned, he worked in 1882–83 on the panorama in Berlin commemorating the battle of Sedan (September 1, 1870) in the Franco-Prussian War. In 1885 he completed a panorama of the battle of Chattanooga for the city of Philadelphia with George Koch (b. 1857) and Eugen Bracht (1842–1921). He also executed murals for the town hall in Danzig (Gdańsk), Kreishaus Teltow, the Kaiser Wilhelm Akademie, and the museums in Celle and Falkenstein. He died in Berlin on May 6, 1920.

LITERATURE: Boetticher (1891–1901) 1969, vol. 2, pp. 453–54; Thieme-Becker 1907–50, vol. 28 (1934), p. 479.

90 CARL RÖCHLING

THE BATTLE OF FREDERICKSBURG, 1862
Signed lower right: *C RÖCHLING*
Oil on canvas, 33 x 59″ (83.8 x 149.9 cm.)
Commissioners of Fairmount Park. F29-1-1

PROVENANCE: Estate of Gen. C.H.T. Collis; Commissioners of Fairmount Park.

LITERATURE: PMA 1965, p. 58.

CONDITION: The unlined canvas support is slack. The paint film reveals prominent horizontal crackle, stretcher marks, cupping, and some small, scattered losses. Abrasion to the paint film is limited. The moderately discolored varnish is thin and the surface is dull.

The painting depicts an episode on December 13, 1862, from the battle of Fredericksburg, in the American Civil War, fought between the Union force (122,000 soldiers) under Maj. Gen. A. E. Burnside and the Confederate (79,000 soldiers) under Gen. Robert E. Lee. The specific event represented is the charge of the 114th Pennsylvania Volunteers, under the command of Collis, to the rescue of Randolph's Rhode Island battery. As with many Civil War volunteer regiments, the charging Pennsylvania soldiers wear the picturesque attire of Zouaves. Originally French infantrymen recruited from the Algerian Kabyle tribe of Zouaova, Zouaves had a widespread influence on military costume in Europe and the United States.

While the painting depicts a heroic moment for the Union forces, in the bloody engagement at Fredericksburg the army of the Potomac suffered 12,653 casualties compared with only 5,309 for the Confederates. The indecisive leadership of General Burnside in the battle prompted President Lincoln to relieve him of his command.

While the record of Rubens's baptism has not been found, he almost certainly was born on June 28, 1577, at Siegen in Germany. Rubens's father, Jan Rubens, was a lawyer and magistrate who was imprisoned at Dillenburgh for adultery with Anne of Saxony, wife of William of Orange. The letters that Rubens's mother, Maria Pypelincke, wrote to her husband during his confinement suggest that Rubens may have inherited his diplomatic and well-balanced character from her. The family moved to Cologne in 1578, and after Jan's death in 1587 Maria took her children to Antwerp, the native city of Rubens's parents. In 1589 Rubens attended the school of Rombaut Verdonck. His familiarity with Latin and knowledge of classical civilization and authors indicate sound schooling. Subsequently he acquired French, German, and Spanish (in addition to his native Dutch), and Italian—the language he preferred for correspondence. In 1590 the youthful Rubens entered the service of Countess Marguerite de Ligne-d'Arenberg. Although not listed as a pupil in the guild, he probably had three masters in Antwerp—Tobias Verhaecht (1561–1631) in 1591, Adam van Noort (1562–1641) in 1592(?), and Otto van Veen (1556–1629) in 1596(?). In 1598 he became a master in the Antwerp Guild of Saint Luke.

In 1600 Rubens departed for Italy, where he was to remain for almost eight years. Shortly after his arrival he entered the service of Vincenzo Gonzago, duke of Mantua, probably through the influence of Archduke Albert, regent of the Netherlands. He worked in Rome in 1601 and 1602. In 1603 he was sent by the duke of Mantua with gifts to the Spanish court. He traveled by way of Florence, Pisa, and Alicante. Back in Mantua in 1604 he was granted an annual pension by the duke. The following year he was in Rome. In 1606 he visited Genoa and again Rome, where he was in contact with Adam Elsheimer (1578–1610) and Paul Bril (1554–1626). He returned from Italy to Antwerp in 1608 and set up his own studio. The following year he was made a member of the Antwerp Guild of Romanists and was appointed court painter to Albert and Isabella, the governors of the Netherlands. Through the influence of Nicolaes Rockox (see no. 92), he painted an *Adoration of the Magi* for the Antwerp town hall in 1609 (oil on canvas, 136 x 192" [346 x 488 cm.], Museo del Prado, Madrid, no. 1638). On October 3 of that year he was married in Antwerp to Isabella Brant (1591–1626), who bore four children.

Over the next twelve years Rubens was active primarily in Antwerp. On January 4, 1611, he purchased a sixteenth-century house on the Wapper, which he converted to serve as his home and studio. In 1612 he traveled to Spain and became a designer to the Plantin Press, run by his friend Balthasar Moretus. In 1615 he secured the collaboration of the landscapist Lucas van Uden (1595–1672/73) and the engraver Pieter Claesz. Soutman (q.v.). An extension was completed on Rubens's house in Antwerp in 1618. In the same year he acquired from Sir Dudley Carleton, British ambassador to The Hague, a collection of antique marbles in exchange for eight paintings including the *Prometheus Bound* (no. 91). In about 1617-18 Anthony van Dyck (1599–1641) joined Rubens's studio and in 1620–21 the printmaker Lucas Vorsterman (1595–1675) executed engravings after Rubens's designs. Throughout these years Rubens received important commissions for church decorations, both in Antwerp and abroad. By the end of 1621 he had received the commission from Marie de Medici to decorate two galleries in the Luxembourg Palace, Paris. In 1622 he undertook designs for tapestries

for Louis XIII of the History of Constantine. His work on the Medici cycle required three trips to Paris. On the last, in 1625, he supervised the decorations' installation and met Georges Villiers, the duke of Buckingham and an important contact for Rubens's ongoing peace efforts for the Netherlands on behalf of the archduchess Isabella. In 1626 and 1627 he participated in peace discussions in Paris and the Netherlands and in 1628 was sent to Madrid to promote a peace plan. While there he was in contact with the famous Spanish painter Velázquez (1599–1660). Philip IV of Spain appointed him as a secretary to the privy council in the Netherlands and sent him to England to arrange an exchange of ambassadors. Rubens was successful in this effort and returned to Antwerp in 1630 with the commission from Charles I, who knighted the artist in that year, to decorate the ceiling of the Banqueting Hall at Whitehall.

Rubens married Hélène Fourment (1614–1673), the sixteen-year-old daughter of a rich tapestry dealer, at Antwerp on December 6, 1630. The couple had five children, the last born after the artist's death. He continued to act as the archduchess's political agent until 1633. The design and supervision of the decorations for the entry into Antwerp of the cardinal-infante Ferdinand in 1635 were entrusted to Rubens. In the same year he purchased the castle and fief of Steen, near Malines. In 1636 he was appointed court painter to the cardinal-infante and in autumn of that year was commissioned by Philip IV to decorate the Torre de la Parada, a royal hunting lodge near Madrid. Rubens was seriously ill in 1639 and made a will. He died in Antwerp on May 30, 1640, and was buried in the St. Jacobskerk. Works left unfinished in his studio were completed by Jacob Jordaens (1593–1678) and others.

In addition to being one of the most outstanding artists of the seventeenth century, Rubens was a scholar, a collector, and a shrewd diplomat. Renowned throughout Europe, he had a large atelier and numerous followers.

LITERATURE: Max Rooses, *L'Oeuvre de P. P. Rubens,* 5 vols. (Antwerp, 1886–92); Jacob Burckhardt, *Erinnerungen aus Rubens* (Basel, 1898; reprint, Leipzig, 1928); Rudolf Oldenbourg, *Klassiker der Kunst,* vol. 5, *P. P. Rubens: Meisters Gemälde* (Berlin and Leipzig, 1921); Gustav Glück and Franz Martin Haberditzl, *Die Handzeichnungen des Peter Paul Rubens* (Berlin, 1928); Prosper Arents, *Geschriften van en over Rubens* (Antwerp, 1940); Hans Gerhard Evers, *Peter Paul Rubens* (Munich, 1942); Prosper Arents, *Rubens-Bibliographie* (Brussels, 1943); Egbert Haverkamp-Begemann, *Olieverschetsen van Rubens* (Rotterdam, 1953–54); Ruth Saunders Magurn, trans. and ed., *The Letters of Peter Paul Rubens* (Cambridge, Mass., 1955); Julius Samuel Held, *Rubens: Selected Drawings,* 2 vols. (London, 1959); Ludwig Burchard and Roger Adolf d'Hulst, *Rubens Drawings,* 2 vols. (Brussels, 1963); Musées Royaux des Beaux-Arts de Belgique, Brussels, *Le Siècle de Rubens,* October 15–December 12, 1965, pp. 165–230; *Corpus Rubenianum Ludwig Burchard* (Brussels, 1968–); Frans Baudouin, *Rubens et son siècle* (Antwerp, 1972); Royal Museum of Fine Arts, Antwerp, *P. P. Rubens: Paintings–Oilsketches–Drawings,* June 29–September 30, 1977; Martin Warnke, *Peter Paul Rubens: Lebens und Werk* (Cologne, 1977); Julius Samuel Held, *The Oil Sketches of Peter Paul Rubens,* 2 vols. (Princeton, N.J., 1980); *Rubens and His World: Bijdragen, Opgedragen aan Prof. Dr. Ir. R.-A. d'Hulst* (Antwerp, 1985); Christopher White, *Peter Paul Rubens: Man and Artist* (New Haven and London, 1987).

For additional works by Rubens in the Philadelphia Museum of Art, see John G. Johnson Collection cat. nos. 658, 659, 663, 664, 677, 662 (attributed to), 657 (studio), 660 (follower of), 668 (imitator of), 661 (copy after), 665 (copy after), 666 (copy after), 667 (copy after).

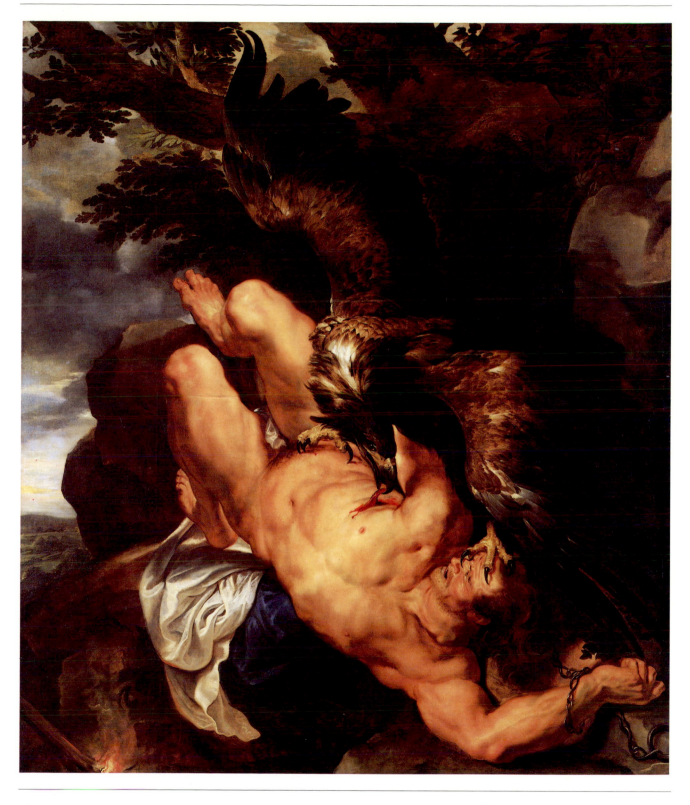

91 PETER PAUL RUBENS *PROMETHEUS BOUND*, c. 1611–12, completed by 1618
 Oil on canvas, 95½ x 82½ (243 x 210 cm.)
 Purchased for the W.P. Wilstach Collection. W50-3-1

FIG. 91-1 Rubens's description of the works offered to Sir Dudley Carleton in 1618, with the *Prometheus Bound* listed first, Public Record Office, London.

In a letter dated April 28, 1618, Rubens described the present work as part of "the flower of my stock" and identified it as "A Prometheus bound on Mount Caucasus, with an eagle which pecks his liver. Original, by my hand, and the eagle done by Snyders. 500 florins, 9 x 8 ft." (fig. 91-1).[1] Prometheus is depicted as a powerfully muscled man writhing in pain and lying foreshortened on a rock covered with blue and white drapery. His convulsed movements are restricted by a chain around his left wrist. Above him an eagle, placing one talon on his face, the other on his groin, pulls at the liver protruding from the wound on his right side. In the lower-left corner, we see the torch with the pilfered fire; above is a tree, and to the left, a glimpse of open landscape.

One of Rubens's earliest admirers, the Leiden professor and poet Dominic Baudius invited him to Holland and sought, unsuccessfully, to obtain the gift of a painting by composing laudatory verses on Rubens's art. Baudius was the first to mention *Prometheus Bound* in a Latin poem dated April 7, 1612, which described the horrific scene as follows:

> Here, with hooked beak, a monstrous vulture digs about in the liver of Prometheus, who is given no peace from his torments as ever and again the savage bird draws near his self-renewing breast and attacks it punishingly. He is not content with his inhuman sacrificial feast, but with his claws lacerates, here the agonized face, there the man's thigh. He would fly murderously on the spectators, did not his chained prey detain him. He can do no more than terrify the frightened onlookers by turning his flaming eyes from one to the other. Blood flows from the chest and every part where his claws leave their mark, and his piercing eyes dart savage flames. You might think that he moves, that his feathers tremble. Horror grips the onlookers.[2]

Baudius identifies Prometheus's attacker as a vulture (a mistake that, we shall see, is not without interest) and seeks to evoke the horrible immediacy of the image, speaking of the bird as if it were alive and imagining flames jetting from its eyes. The poem is also significant because it provides the *terminus ad quem* of April 7, 1612, for the commencement of Rubens's work on the painting. Since the picture apparently was never engraved, Baudius must have seen the original, or a very early copy, by the spring of 1612, when Rubens was thirty-five. As Julius Held observed, a date of 1611–12 for the Philadelphia painting is also supported by its resemblance in style to such works as the *Juno and Argus* (fig. 91-2), which is known to have been in existence by May 11, 1611.[3]

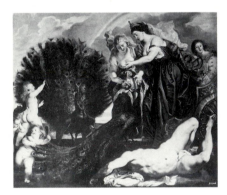

FIG. 91-2 Peter Paul Rubens, *Juno and Argus,* before May 11, 1611, oil on canvas, 98 x 116½″ (249 x 296 cm.), Wallraf Richartz Museum, Cologne, no. 1040.

Following Baudius's poem, the next reference to the work appears in the letter of 1618 quoted above, written by Rubens in Italian to Sir Dudley Carleton, the British ambassador to The Hague. This was part of a correspondence begun the previous year in which Rubens sought to exchange some of his own paintings for Carleton's collection of ancient marbles. In this letter Rubens offered twenty-four pictures (one lot, the Christ and the twelve Apostles, consisting of thirteen pieces) and noted that these included "some pictures which I have kept for my own enjoyment; some I have even repurchased for more than I had sold them to others."[4] He also added that some of the pictures were not finished but would be completed soon. It is possible, therefore, that the Philadelphia painting was in another collection before 1618, and, further, may have remained

unfinished to some degree. Patterns of cusping in the canvas (visible in x-radiographs) and the structure of the painting's ground layer and paint film indicate that the 17¼ inch (44 cm.) strip added on the left of the composition was appended only after the paint film on the two horizontal pieces of canvas had dried.[5] The enthusiasm of Baudius's poem indicates that the work probably never appeared conspicuously incomplete, but it may have once existed in a truncated form. If the strip of canvas was added only in 1618, it would explain the need for finishing and retouching. Rubens enlarged other paintings, both on canvas and panel.[6] In the Philadelphia painting the addition converts a tightly compressed composition to a more open, expansive design; indeed, it serves virtually as a textbook example of the change from Mannerist to Baroque composition.

Appended to Rubens's letter to Carleton is a list of the works offered in exchange, specifying the subjects, dimensions, values, and, most interestingly, whether and to what extent they were by his own hand or how much was done by assistants (see fig. 91-1). As we have seen, Rubens stated that the present painting was his own work except for the eagle, which was by Frans Snyders (q.v.), specialist in paintings of animals, fruits, and vegetables. Snyders and Rubens were closely associated and worked together on more than one occasion; however, the Philadelphia painting is the only documented instance of such collaboration. Arthur Popham first observed that a sheet in the British Museum is Snyders's preparatory drawing for the eagle (fig. 91-3).[7] While John Rowlands believed that Rubens delegated the responsibility for the design of this detail to his assistant, Held argued more plausibly that Rubens would never have planned such an important painting, notwithstanding the evidence of Snyders's drawing, without some definite ideas about this vital element of the design.[8] Thus Snyders's drawing is probably a working drawing made from a lost sketch by Rubens. Held suggested that the sketch might have resembled Rubens's drawing of an eagle preserved in the Musée Bonnat, Bayonne.[9]

On May 7, 1618, Carleton wrote to Rubens selecting the *Prometheus Bound* together with five other pictures, but, significantly, declined to accept any of the pictures begun by students or only retouched by the master. Rubens replied on May 12 that he valued the six "originals" at three thousand florins and added on May 20 that he had given "the finishing touch" to five of the six and "brought them to what perfection I am able, so that I hope Your Excellency may be completely satisfied." On May 23 Carleton wrote to John Chamberlain saying that he had completed the bargain with Rubens to exchange his antiquities "for a sute of tapistrie and a certaine number [the final reckoning included eight] of his pictures." On May 26, Rubens wrote to Carleton to say that his agent Lionel Wake had measured his paintings for framing (the *Prometheus Bound* is still in its original frame) and on June 1 he wrote that he had entrusted their delivery to Frans Pietersz. de Grebber (1573–1649), the Haarlem art dealer and portrait and history painter who "was astonished in seeing them all finished *con amore*."[10] Working through agents in September 1618, Carleton unsuccessfully offered this picture and several others to the king of Denmark. Here again, as in Rubens's own earlier list, the *Prometheus Bound* was the first item.[11] In 1658 the painting may have been on the market in Antwerp.[12] It next appears in an inventory of Kimbolton Castle, Huntingdonshire, the seat of the earls and dukes of Manchester, dated September 28, 1687,

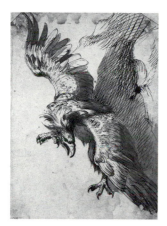

FIG. 91-3 Frans Snyders, *Study for the Eagle,* ink and wash drawing, 11⅛ x 8″ (28.1 x 20.3 cm.), British Museum, London, inv. no. 1946-7-13-176.

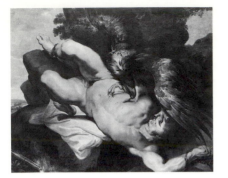

FIG. 91-4 Follower of Peter Paul Rubens, *Prometheus Bound,* oil on canvas, 74⅜ x 94½" (189 x 240 cm.), present location unknown.

FIG. 91-5 Michelangelo, *Tityus,* chalk with stumping, 7½ x 13" (19 x 32.9 cm.), Royal Library, Windsor Castle, no. RL 12771 recto.

where it is described as "In the Great Dining Room...Chimney Piece of Thometheus," without attribution. It remained in the family until 1949, when it was sold at auction.

Conceivably the painting had earlier passed from Carleton to Charles I. When Horace Walpole was to go to Huntingdonshire, George Montague wrote to him on May 25, 1763, saying that he should see the "fine Prometheus" at Kimbolton, which Montague claimed came from the collection of Charles I, although it does not appear in any of the (incomplete) royal inventories. After having seen the picture, Walpole wrote to Montague on May 30: "The *Prometheus* is a glorious picture.... It is not by Van Dyck? The Duke told me that Mr. Spence found out it was by Titian—but critics in poetry I see are none in painting....The Duke I perceive knows no more of hands than Mr. Spence."[13] The correct attribution to Rubens was restored only in 1787 by Richard Cumberland in his catalogue of pictures from the Spanish royal collection.[14] The painting was exhibited several times in the nineteenth century and was mentioned occasionally in the literature, usually with praise.[15] However, in its relative inaccessibility at Kimbolton, it was overshadowed by a second version with a horizontal format (fig. 91-4), which had been purchased by the duke of Oldenburg in 1809 and placed in the museum in Oldenburg, Germany, where it remained until it was sold early in this century.[16] Unfamiliar with Philadelphia's painting and confused by a misreading of the dimensions recorded by Rubens for the *Prometheus Bound* in 1618,[17] several authors mistakenly believed that the Oldenburg version was the picture traded to Carleton.[18] Doubts regarding this version's authenticity were expressed in the museum's catalogue, and it may only be one of numerous copies. However, Held left the possibility open that it might be an autograph, albeit less dramatic, replica executed at a later date (c. 1615), presumably with substantial help from assistants.[19] In addition to the diminished foreshortening and chiaroscuro noted by Held, other changes appear in the tree behind, the addition of a chain to Prometheus's right ankle, and the alteration of the placement of the eagle's talon from the groin to the ribs.

The myth of Prometheus inspired a great variety of moral, religious, and philosophical interpretations.[20] Hesiod, the earliest of several classical authors to record the story, informs us that Prometheus, a Titan, was punished by Zeus for stealing fire from heaven, and that he was fastened to the summit of Mount Caucasus where an eagle daily devoured his ever-regenerating liver until Hercules set him free. The fire had been taken away from man by Zeus because Prometheus had tricked him into accepting the poorest parts of animals in burnt offerings. In Aeschylus's account, Prometheus was changed from the paragon of trickery into a tragic hero who benefited man not only with fire but also with reason and wisdom. Plato interpreted the story morally, seeing the fire as creative power. In later classical literature Prometheus is a master craftsman making men from clay; the church fathers subsequently drew parallels between Prometheus and God the Creator. Prometheus also was a model of heroic endurance; for some his suffering was of the heart, for others it was the torment of reason and the intellect. In the Renaissance, Prometheus was taken as the model of the true philosopher and often depicted as a dignified, bearded man.

FIG. 91-6 Cornelis Cort after Titian, *Tityus*, 1566, engraving.

FIG. 91-7 Peter Paul Rubens, *The Death of Hippolytus*, c. 1611, oil on copper, 19½ x 27⅝" (49.5 x 70.2 cm.), Fitzwilliam Museum, Cambridge, no. PD8-1979.

It was also during this period that the Prometheus story became fused, as well as confused, with another myth, that of Tityus. Tityus was the son of Earth who assaulted Leto (Latona), the mother of Apollo and Artemis, and was killed by Zeus and punished in the underworld by having his immortal liver devoured by one or sometimes two vultures. Often interpreted as an allegory of the tortures of immoderate love, the subject was treated by Michelangelo in a famous drawing of 1532 now at Windsor Castle (fig. 91-5).[21] This drawing became one of the most admired prototypes of a body lying in agony. As Held observed, "Some of the basic ideas of Rubens' . . . Prometheus are obviously derived from Michelangelo's drawing."[22] Returning to Baudius, we can now understand why the poet mistook the eagle for a vulture: the Tityus and Prometheus myths had become virtually interchangeable. In 1549–50 Titian painted a Tityus for Queen Mary of Hungary for her palace at Binche in the Netherlands. This work was sent to Madrid in 1556; the original or a faithful replica is now in the Prado.[23] Cumberland first observed the resemblance between Titian's work and Rubens's.[24] The violent, upside-down and greatly foreshortened pose of the Prometheus recalls the disposition of the Tityus by Titian more than that of Michelangelo, where the figure lies more quietly and nearly parallel to the picture plane. Although Rubens could have seen the Titian in 1603 when he was in Spain, in all likelihood he knew it through Cornelis Cort's engraving of 1566 (fig. 91-6), which turns the image in the same direction as the Rubens and adds a torch, thus effectively converting a Tityus into a Prometheus. When Rubens joined the strip of canvas to the left of his composition, he, too, added Prometheus's attribute, which is nowhere to be found, even in x-radiographs, on the right (original) side of the work. In this way he certified Prometheus's identity.

Held has traced the Philadelphia painting's formal roots still further, likening Prometheus's pose to that of Heliodorus in Raphael's *Expulsion of Heliodorus* in the Vatican and the nude in *Rich Man in Hell* by Bernard van Orley (c. 1490–1541) in Brussels,[25] and concluding that the disposition of one leg bent, the other outstretched, was "a formula adopted traditionally for figures undergoing a painful ordeal."[26] He also stressed the precedence of the art of classical antiquity and works like the famous Laocoön statue group, which Rubens had copied in drawings only a few years earlier. In connection with the Prometheus's classical sources, Charles Dempsey has argued that it should be considered "in part as a re-creation of a work by the Alexandrian painter Euanthes which once, according to Achilles Tatius, was displayed in the Temple of Zeus at Pelusium."[27]

Within Rubens's own oeuvre the Prometheus relates to other dramatic, and often violent, early works by the master:[28] see especially the *Death of Hippolytus* of c. 1610–11, known through two painted versions (fig. 91-7).[29] The figure of Hippolytus in the lower right of this composition assumes virtually the same pose as Philadelphia's Prometheus. A black chalk drawing in the Louvre (fig. 91-8) evidently is a study for the beleaguered Hippolytus but, as Frits Lugt first pointed out, seems also to have served for the Philadelphia picture.[30] When this drawing was exhibited in 1978 the authors of the catalogue noted in addition to the sources for the pose mentioned above, the possible influence of the enchained prisoners in the fresco at the

FIG. 91-8 Peter Paul Rubens, *Reclining Male Figure,* chalk with heightening, 16⅛ x 21½" (42.3 x 54.8 cm.), Musée du Louvre, Paris, inv. no. 20.207.

Palazzo Farnese by Francesco Salviati (1510–1563),[31] which Rubens copied in a drawing now in Antwerp.[32] Following Held, they also noted the general resemblance to the conception of the ascending and descending, oblique poses of figures in the studies for the *Erection of the Cross* in Antwerp Cathedral.[33] Another Rubens drawing of a foreshortened male nude lying on his back that relates generally to this group is the master's copy of the *Murdered Abel* (Fitzwilliam Museum, Cambridge) after the painting by Michiel Coxie (1499–1592) in the Prado, Madrid.[34]

Rubens's picture made a great impact on his contemporaries, followers, and later artists. In addition to outright copies,[35] the picture inspired in varying degrees paintings and drawings of the same or closely related themes by Jacob Jordaens (1593–1678),[36] an unknown Rubens follower,[37] the Utrecht Caravaggist Dirck van Baburen (c. 1595–1624),[38] Theodore Rombouts (1597–1637),[39] Erasmus Quellin (1607–1678),[40] and many others.[41] As J. G. van Gelder noted, Rubens's first visit to Holland (now pinpointed to 1612) aroused great interest in his art; indeed, he suggested that the *Prometheus Bound* may have partly inspired Willem Buytewech's rare etching of the subject of about 1613 as well as Hendrik Goltzius's *Tityus,* also of 1613.[42] Undoubtedly, the greatest and most famous instance of a Dutchman's quotation was Rembrandt's adoption of Prometheus's pose for the figure of Samson in his *Blinding of Samson* in Frankfurt.[43] This borrowing is said to have first been observed by Ludwig Burchard,[44] but it is so conspicuous as to have hardly escaped notice.[45] Rembrandt painted the picture for the stadholder's secretary, Constantijn Huygens, who had been instrumental in obtaining important royal commissions for the artist. Huygens undoubtedly had seen the Philadelphia Museum's picture when it was at The Hague from May 1618 to 1625 or later in the collection of Sir Dudley Carleton, a personal acquaintance.[46] Given the fact that Rubens was Huygens's favorite painter, Rembrandt undoubtedly considered the dramatic *Samson* and its thinly veiled quotation as a well-suited gift for his benefactor.

NOTES

1. "Un Prometheo legato sopra il monte Caucaso con una aguila che li becca il fegato, Originale de mia mano e l'aguila fatta dal Snyders." Ruth Saunders Magurn, trans. and ed., *The Letters of Peter Paul Rubens* (Cambridge, Mass., 1955), p. 60, letter no. 28. See also W. Noël Sainsbury, *Original Unpublished Papers Illustrative of the Life of Sir Peter Paul Rubens* (London, 1859), pp. 28–29; and Max Rooses, *Correspondance de Rubens et documents épistolaires concernent sa vie et ses oeuvres,* vol. 2 (Antwerp, 1898), p. 136.

2. Dominic Baudius, *Poematum nova editio* [published 1616], p. 578: "Heic rostro adunco vultur immanis fodit/Jecur Promethei, nec datur quies malis,/Sic usque et usque rabidus ales imminet/Faecunda poenis appentens praecordia./Non est eo contentus infandae dapis/Pastu, sed ungue laniat insuper fero/Hinc ora palpitantis, hinc femur viri./Ipse involaret in necem spectantium/Ni vincla tardent; quod potest unum tamen/Flammata torquens huc et illuc lumina,/Terret timentes; pectore ebullit cruor,/Et parte ab omni qua pedes signant notam./Trucesque flammas vibrat acies luminum/Rapidae volucris; hanc moveri; hanc tu putes/Quassare pennas; horror adstantes habet." Translation from Charles Dempsey, "Euanthes Redivivus: Rubens's *Prometheus Bound,*" *Journal of the Warburg and Courtauld Institutes,* vol. 30 (1967), pp. 421. An acquaintance of Rubens's brother Philip, his father-in-law Jan Brant, as well as his teacher Otto van Veen, Baudius did not know Rubens personally but was well acquainted with his art. His poetic missive of 1612 also versified on the famous double portrait of the artist and Isabella Brant of 1609–10 (oil on canvas on panel, 70 x 53¾" [178 x 136.5 cm.], Alte Pinakothek, Munich, no. 334), the *Ganymede* of c. 1611 (oil on canvas, 80 x 80" [203 x 203 cm.], Fürst Schwarzenberg, Vienna; repro. Rudolf Oldenbourg, *P. P. Rubens* [Berlin and Leipzig, 1921], p. 39), and the *Venus and Adonis* of c. 1610 (oil on canvas, 108⅝ x 72" [276 x 183 cm.], Akademie, Düsseldorf; repro. Oldenbourg, p. 29).

3. See Wallraf Richartz Museum, Cologne, *Katalog der Niederländischen Gemälde von 1550 bis 1800,* 1967, pp. 95–98, fig. 135; and Julius S. Held, "Prometheus Bound," *The Philadelphia Museum of Art Bulletin,* vol. 59, no. 279 (autumn 1963), pp. 29–30. For the letter to Jacob de Bie of May 11, 1611, mentioning the *Juno and Argus,* see Magurn (note 1), p. 55, letter no. 22.

4. Rooses (note 1), pp. 135–36, letter no. 166, for original Italian; translation from Magurn (note 1), p. 60, letter no. 28.

5. Peter C. Sutton, "'Tutti finiti con amore': Rubens' 'Prometheus Bound,'" in *Essays in Northern European Art Presented to Egbert Haverkamp-Begemann on His Sixtieth Birthday,* edited by Anne-Marie Logan (Doornspijk, 1983), pp. 271–72, figs. 2, 3.

6. Sutton (see note 5), pp. 272–73.

7. Arthur E. Popham, "A Drawing by Frans Synders." *The Burlington Magazine,* vol. 94, no. 592 (July 1952), p. 237. See also British Museum, London, *Rubens: Drawings and Sketches,* 1977, p. 76, cat. no. 80, repro. (catalogue by John Rowlands). Arnout Balis (letter to the author, 1985, Philadelphia Museum of Art, accession files), however, believes that Snyders's drawing is a *ricordo* rather than a preparatory study by the artist.

8. British Museum (see note 7), p. 76; Held (note 3), p. 21.

9. See Held (note 3), p. 21 n. 6, fig. 3.

10. Sainsbury (note 1), pp. 31, 32, 33, 35, 38, 43; Rooses (note 1), p. 145, letter no. 147, p. 149, letter no. 148, p. 161, letter no. 170, p. 167, letter no. 172, p. 170, letter no. 174, p. 182, letter no. 179; Magurn (note 1), p. 62, letter no. 29, p. 63, letter no. 30, p. 65, letter no. 31, p. 67, letter no. 34.

11. Sainsbury (note 1), p. 45; Rooses (note 1), p. 185, letter no. 181.

12. See Michael Jaffé, "Rubens and Snijders: A Fruitful Partnership," *Apollo,* n.s., vol. 93, no. 109 (March 1971), p. 195 n. 13; the provenance Jaffé gives for the painting is identical with the "Grand Prométhée de Me Ruben's," priced at £750, which featured in *Mémoire des tableaux et de leurs prix que me. Postel marchand à Bruxelle à Perruchon* (Estienne Perruchot to Musson, November 1, 1658: Musson, Bundel 767); see Jan Denucé, *Na Peter Pauwel Rubens: Documenten uit den Kunsthandel te Antwerpen in de XVIIe eeuw van Mattijs Musson* (Antwerp, 1949), p. 178, doc. no. 220.

13. Wilmarth Sheldon Lewis and Ralph S. Brown, Jr., eds., *Horace Walpole's Correspondence with George Montague,* vol. 2 (New Haven, 1941), pp. 76, 78.

14. Richard Cumberland, *An Accurate and Descriptive Catalogue of the Several Paintings in the King of Spain's Palace in Madrid* (London, 1787), pp. 16–17.

15. Thoré-Bürger 1857, p. 188, wrote: "L'homme et l'oiseau n'ont rien de très-merveilleux"; and André Absinthe Lavice, *Revue des Musées d'Angleterre* (Paris, 1867), p. 241: "Belle couleur, bon dessin, belle horreur."

16. Augusteum Museum, Oldenburg, *Kurzes Verzeichnis der Gemälde . . . der grossherzogl. Sammlung* (Oldenburg, 1902), no. 121; Max Rooses, *L'Oeuvre de P. P. Rubens,* vol. 3 (Antwerp, 1890), no. 671, pp. 152–53. Additional sources of provenance: Jacques Goudstikker, *Catalogue de la collection Goudstikker, d'Amsterdam,* cat. 28 (1924), no. 102; after World War II, no. 1175 of the recuperated pictures from Germany; E. Proehl Collection, Amsterdam (see Frits Lugt, *Inventaire général des dessins des écoles du Nord: Ecole flamande,* vol. 2 [Paris, 1949],

p. 18); Martin Ascher, London, before 1970.

17. Sainsbury ([note 1], p. 29) read the measurements correctly as 9 by 8 feet. Rooses ([note 1], p. 136) transcribed them as 6 by 8 feet, an error that remained uncorrected until Magurn ([see note 1], p. 60). The measurement of 9 by 8 Antwerp feet is somewhat larger than the Philadelphia canvas, but as Held ([see note 3], p. 23 n. 8), indicated, this discrepancy probably reflects the fact that the measurements were only approximations; all are recorded in whole feet. Moreover, from Rubens's letter of June 1, 1618, to Carleton (Sainbury, p. 43; Rooses, p. 181, letter no. 179; Magurn, p. 67, letter no. 34): "As for the measurements, which proved somewhat less than you had expected, I did my best, taking the dimensions according to the measure current in this country."

18. See Oldenbourg (note 2), p. 79.

19. Held (see note 2), pp. 23–24.

20. For an extensive account of the myth and its history, see Olga Raggio, "The Myth of Prometheus: Its Survival and Metamorphoses Up to the Eighteenth Century," *Journal of the Warburg and Courtauld Institutes,* vol. 21 (1958), pp. 44–62; see also Held (note 2), pp. 25–27, for an encapsulated review of the theme's meanings.

21. Arthur E. Popham and J. Wilde, *The Italian Drawings of the XV and XVI Centuries in the Collection of His Majesty the King at Windsor Castle* (London, 1949), p. 429, pl. 21.

22. Held (see note 2), p. 27. Rudolf Oldenbourg, "Die Nackwirkung Italiens auf Rubens und die Gründung seiner Werkstatt," in *Jahrbuch der Kunsthistorischen Sammlungen des Allerhöchsten Kaiserhauses,* vol. 34 (1918), p. 180, seems to have been the first to connect Michelangelo's drawing with Rubens's figure, then known to the author only through the Oldenburg version (fig. 91-4).

23. *Tityus,* oil on canvas, 10 x 8½" (25.3 x 21.7 cm.), Museo del Prado, Madrid, no. 427; repro. in Harold E. Wethey, *The Mythological and Historical Paintings,* vol 3, *The Paintings of Titian* (London, 1975), pp. 156–60, no. 19A, pl. 99.

24. Richard Cumberland, *An Accurate and Descriptive Catalogue of Several Paintings in the King of Spain's Palace at Madrid* (London, 1787). Other Netherlandish artists who were influenced by Titian's *Tityus* included Cornelis Cornelisz. van Haarlem (q.v.), whose ink and chalk drawing of the subject (14⅛ x 10⁵⁄₁₆" [35.9 x 26.2 cm.]), dated 1588, is in the Graphische Sammlung Albertina, Vienna, inv. no. 81-1.

25. *Expulsion of Heliodorus,* width 295¼" (750 cm.), Stanza d'Eliodoro, Vatican; *Rich Man in Hell,* closed right wing of the triptych *The Virtue of Patience,* signed and dated 1521, oil on panel, 68½ x 31½" (174 x 80 cm.), Musées Royaux des Beaux-Arts de Belgique, Brussels, inv. no. 1822.

26. Held (see note 3), p. 28.

27. Dempsey (see note 2), p. 421.

28. *Juno and Argus* (fig. 91-2); *Judith and Holofernes* (copy after Rubens?), oil, Museum, Carpentras (see Held [note 3], p. 27, fig. 13); *Judith Killing Holofernes*, 1606–8, pen and ink wash, 8 x 6¼″ (20.5 x 16 cm.), Städelsches Kunstinstitut, Frankfurt, no. 15690 (repro. in Julius S. Held, *Rubens: Selected Drawings*, [New York, 1959], cat. no. 15, pl. 16); *Tarquinius and Lucretia*, oil on canvas, 73⅝ x 84½″ (187 x 214.5 cm.), Bildergalerie, Staatliche Schlösser und Gärten Potsdam-Sanssouci, no. 6313 (repro. in Held [note 3], p. 28, fig. 14); *Samson Captured*, 1610–11, oil on panel, 19¾ x 26⅛″ (50.4 x 66.4 cm.), The Art Institute of Chicago, no. 23.551 (repro. in Held [note 3],p. 28, fig. 15).

29. See fig. 91-7 (repro. in Fitzwilliam Museum, Cambridge, *Treasures of the Fitzwilliam Museum* [Cambridge, 1982; reprint, 1986], p. 59, no. 57; Fitzwilliam Museum, Cambridge, *Treasures from the Fitzwilliam Museum*, March 19, 1989–September 9, 1990, p. 91 [traveling exhibition]); and Peter Paul Rubens?, *The Death of Hippolytus*, oil on panel, 20 x 25⅜″ (51 x 64.5 cm.), Courtauld Institute, London, Princes Gate Collection (see *Flemish Paintings & Drawings at 56 Princes Gate London SW7* [London, 1955], pp. 32–33, no. 19, pl. XLV [as Rubens, c. 1612–13]).

30. Lugt (see note 16), no. 1029.

31. Cabinet des Dessins, Musée du Louvre, Paris, *Rubens: Ses Maîtres, ses élèves*, February 10–May 15, 1978, pp. 28–29, under no. 11; for Salviati's fresco, *Fasti Farnesiani* in Salotto dipinto, Palazzo Farnese, see Adolfo Venturi, *Storia dell'Arte Italiana*, vol. 9, pt. 6 (Milan, 1933), pp. 153–54, 185–95, figs. 107–9.

32. Ludwig Burchard and Roger Adolf d'Hulst, *Rubens Drawings* (Brussels, 1963), no. 93.

33. Held (see note 3), p. 32; Burchard and d'Hulst (see note 32), nos. 55, 56, 58.

34. Burchard and d'Hulst (see note 32), no. 33.

35. Oil on panel, 41¾ x 30″ (106 x 76 cm.), Musée des Beaux-Arts, Lille, inv. no. P.115 [as F. Wauters and then Seghers]; oil on panel, 41 x 28¾″ (104 x 73 cm.), sale, J. L. Menke (of Antwerp), Cologne, October, 27, 1890, lot 80, repro. (this, in all likelihood, is the painting of the same dimensions and support that, according to the DIAL photograph [no. 91C24.1], was assigned to Jacob Peter Gowy [active c.1632–c.1661] in sale, J. L. Menke, Brussels, June 1, 1904, lot 28); oil on panel, 36⅝ x 29⅛″ (93 x 74 cm.), private collection, Switzerland, repro. in F. Shoner, "Deux Tableaux peints par Rubens," *L'Oeil*, vol. 157 (January 1968), p. 35 [as Rubens, 1610–12] and exhibited Takashimaya Gallery, Tokyo, *Peter Paul Rubens et son entaurage*, August 8–September 17, 1985, no. 10, pl. 10 [as Rubens, c. 1612]. In addition to these copies George Scharf made

a quick sketch (preserved in his sketchbook at the National Portrait Gallery, London, no. 38110) after the painting on a visit to Kimbolton Castle on December 15, 1856, in preparation for a study he made of the collections of Charles I.

36. *Prometheus Chained*, oil on canvas, 96½ x 70″ (245 x 178 cm.), Wallraf Richartz Museum, Cologne, no. 1044. An oil study for Prometheus and the eagle is in the collection of Robert Despiegelaeres, Ghent (oil on paper, mounted on canvas, 17⅜ x 14½″ [44 x 37 cm.]).

37. *Prometheus* [as school of Rubens, c. 1630], oil on canvas, 65 x 61¾″ (165 x 157 cm.), repro. in sale, "Tableaux Anciens," Odry-Mommens, Brussels, March 11, 1929, lot 79; see also sale, Nackers, Brussels, April 20, 1966, lot 280, repro. [in both sales as "Peter Paul Rubens and F. Snijers"].

38. *Prometheus Being Chained by Vulcan*, signed and dated 1623, oil on canvas, 79½ x 72½″ (202 x 184 cm.), Rijksmuseum, Amsterdam, no. A1606.

39. *Prometheus*, signed, oil on canvas, 60⅝ x 87⅞″ (154 x 222.5 cm.), Musées Royaux des Beaux-Arts de Belgique, Brussels, inv. no. 6084; see D. Roggen, *Gentsche Bijdragen tot de Kunstgeschiedenis*, vol. 12 (1949–50), pp. 225–27, repro. An unattributed *Prometheus* related to this composition is in the St. Eloy Hospital, Utrecht (DIAL no. 91C24.1).

40. Black chalk drawing, 9½ x 7⅛″ (24 x 18 cm.), sale, Amsterdam, December 17, 1968, lot 234 (DIAL no. 91C24.1)).

41. See *Prometheus*, sepia and ink, 12⅞ x 8⅞″ (32.8 x 22.4 cm.), wrongly attributed to Rubens in sale, Hôtel Drouot, Paris, March 31, 1914, lot 107, repro. p. 25; Giovanni Battista Langetti (1625–1676) various treatments of the Prometheus theme (for example, *Prometheus Bound*, oil on canvas, 65½ x 72½″ [166.4 x 184.2 cm.], Chrysler Museum, Norfolk, repro. in *The Burlington Magazine*, vol. 110, no. 779 [February 1968], p. xvi), which, like Rombouts's work, seem to owe as much to Titian as to Rubens; and *The Hunt of Meleager and Atlanta*, Karlova Galerie, Prague, incorrectly assigned to Rubens, which includes a figure of the fallen Ankaios based on Rubens's Prometheus/Hippolytus figure.

42. See J. G. van Gelder, "Rubens in Holland in de zeventiende eeuw," *Nederlandsch Kunsthistorisch Jaarboek*, vol. 3 (1950–51), p. 125, fig. 15 (for the Buytewech) and, for the Goltzius, Frans Halsmuseum, Haarlem, cat. 1929, no. 109 (oil on canvas, 125 x 105″ [317 x 267 cm.]); however, in the latter case, Titian's *Tityus* is again probably the primary source. On the more precise dating of Rubens's first trip to Holland, see R. de Smet, "Een nauwkeurige datering van Rubens' eerste reis naar Holland in 1612," *Jaarboek van het Koninklijk Museum voor Schone Kunsten Antwerpen*, 1977, pp. 199–218.

43. Signed and dated 1636, oil on canvas, 92⅞ x 118⅞″ (236 x 302 cm.), Städelsches Kunstinstitut, no. 1383. For discussion, see Held (note 2), pp. 31–32, and E.K.J. Reznicek, "Opmerkingen bij Rembrandt," *Oud Holland*, vol. 91, nos. 1/2 (1977), pp. 88–91.

44. According to Van Gelder (see note 42), pp. 137–38.

45. See the particularly persuasive photomontage reproduced by Reznicek ([note 43], p. 90, fig. 13) of Prometheus substituted for Samson in Rembrandt's painting.

46. On the relationship between Huygens and Carleton see Van Gelder (note 42), p. 132 and Reznicek (note 43), p. 90.

PROVENANCE: Traded by Rubens to Sir Dudley Carleton, June 1, 1618; offered unsuccessfully by Carleton to the king of Denmark, September 1618; possibly passed from Carleton to King Charles I; possibly with dealer Mattij Musson, Antwerp, 1658; Charles, the fourth earl of Manchester, Kimbolton Castle, Huntingdonshire, inventory dated September 28, 1687; in the collections of the earls and dukes of Manchester until sold at auction (Knight, Frank & Rutley) at Kimbolton Castle, July 18, 1949, lot 8; acquired by dealer Martin B. Asscher, London; sold to the Philadelphia Museum of Art.

EXHIBITIONS: British Institution, London, 1850, no. 142 [lent by the duke of Manchester]; Manchester, *United Kingdom's Art Treasures*, 1857, no. 534 [lent by the duke of Manchester]; British Institution, London, 1867, no. 126 [lent by the duke of Manchester]; The Cleveland Museum of Art, *The Venetian Tradition*, 1956, no. 41, pl. XLIV; Philadelphia Museum of Art, "Philadelphia: 100 years of Acquisitions," May 3–July 3, 1983 (no catalogue).

LITERATURE: Dominic Baudius, *Poematum nova editio* [1616], p. 578; letter from Rubens to Sir Dudley Carleton, April 28, 1618, Public Record Office, London; inventory, drawn up by Willaston, of the goods and chattels at Kimbolton Castle, seat of the earls and dukes of Manchester, September 28, 1687, Public Record Office, London, Manchester Papers (6.d.15), box 3, no. 670, p. 4; letters between Horace Walpole and George Montague, May 25 and 30, 1765 (see Wilmarth Sheldon Lewis and Ralph S. Brown, eds., *Horace Walpole's Correspondence with George Montague*, vol. 2 [New Haven, 1941], pp. 76, 78); Arthur Young, *A Six-Month Tour through the North of England*, vol. 1 (London, 1770), p. 56; Richard Cumberland, *An Accurate and Descriptive Catalogue of the Several Paintings in the King of Spain's Palace in Madrid* (London, 1787), pp. 16–17; William Hookham Carpenter, *Pictorial Notices* (London, 1844), p. 142; Charles Blanc, *Les Trésors de l'art à*

Manchester (Paris, 1857), p. 156; Thoré-Bürger 1857, p. 188; W. Noël Sainsbury, *Original Unpublished Papers Illustrative of the Life of Sir Peter Paul Rubens* (London, 1859), p.29; André Absinthe Lavice, *Revue des Musées d'Angleterre* (Paris, 1867), p. 241; Max Rooses, *L'Oeuvre de P. P. Rubens,* 5 vols. (Antwerp, 1886–92), vol. 3 (1890), pp. 152–53, no. 671, vol. 5 (1892), pp. 340–41; Max Rooses, *Correspondance de Rubens et documents épistolaires concernent sa vie et ses oeuvres,* vol. 2 (Antwerp, 1898), pp. 136, 187; Rudolf Oldenbourg, *Klassiker der Kunst,* vol. 5, *P. P. Rubens: Meisters Gemälde* (Berlin and Leipzig, 1921), p. 79; Frits Lugt, *Inventaire général des dessins des écoles du Nord: Ecole flamande,* vol. 2 (Paris, 1949), p. 18; J. G. van Gelder, "Rubens in Holland in de zeventiende eeuw," *Nederlandsch Kunsthistorisch Jaarboek,* vol. 3 (1950–51), p. 127, no. 18, repro. p. 137; Helen Comstock, "The Connoisseur in America," *The Connoisseur,* vol. 127 (May 1951), pp. 116–17, repro. p. 117; "Diamond Jubilee Accessions," *The Philadelphia Museum Bulletin,* vol. 46, no. 229 (spring 1951), p. 43, repro. p. 44; Fiske Kimball, "Rubens' *Prometheus,*" *The Burlington Magazine,* vol. 94, no. 586 (January 1952), pp. 67–68, repro. p. 66; Erik Larsen, *P. P. Rubens with a Complete Catalogue of His Works in America* (Antwerp, 1952), pp. 68, 217, no. 53; Arthur E. Popham, "A Drawing of Frans Snyder," *The Burlington Magazine,* vol. 94, no. 593 (August 1952), p. 237; Leo van Puyvelde, *Rubens* (Paris and Brussels, 1952), pp. 58, 116, 204 n. 67; *Times* (London), December 28, 1952; Julius S. Held, *Peter Paul Rubens (1577–1640)* (New York, 1954), p. 7, pl. 5; Ruth Saunders Magurn, trans. and ed., *The Letters of Peter Paul Rubens* (Cambridge, Mass., 1955), p. 60, letter no. 28, p. 441, repro. opposite p. 144; Edith Greindl, *Les Peintres flamands de nature morte au XVIIe siècle* (Brussels, 1956), p. 74; Elizabeth Gilmore Holt, ed., *A Documentary History of Art,* vol. 2 (New York, 1958), p. 191; Olga Raggio, "The Myth of Prometheus: Its Survival and Metamorphoses Up to the Eighteenth Century," *Journal of the Warburg and Courtauld Institutes,* vol. 21 (1958), pp. 58,

61–62, pl. 9d; Julius S. Held, *Rubens Selected Drawings,* vol. 1 (London, 1959), p. 102, under cat. no. 21; Horst Gerson and E. H. ter Kuile, *Art and Architecture in Belgium* (Baltimore, 1960), pp. 79, 86; Julius S. Held, "Prometheus Bound," *Philadelphia Museum of Art Bulletin,* vol. 59, no. 279 (autumn 1963), pp. 17–32, fig. 1; Annamaria Kesting, "Zweimal der gefesselte Prometheus," *Museen in Köln Bulletin,* vol. 5, no. 2 (February 1966), pp. 446–48, repro.; Charles Dempsey, "Euanthes Redivivus: Rubens's *Prometheus Bound,*" *Journal of the Warburg and Courtauld Institutes,* vol. 30 (1967), pp. 420–25, pl. 55a; Horst Vey and Annamaria Kesting, *Katalog der Niederländischen Gemälde von 1550 bis 1800 im Wallraf-Richartz-Museum* (Cologne, 1967), p. 60; Wolfgang Stechow, *Rubens and the Classical Tradition* (Cambridge, Mass., 1968), pp. 40–41, fig. 26; Hella Robels, "Frans Snyders' Entwicklung als Stillebenmaler," *Wallraf-Richartz-Jahrbuch,* vol. 31 (1969), p. 54; Michael Jaffé, "Rubens and Snijders: A Fruitful Partnership," *Apollo,* n.s., vol. 93, no. 109 (March 1971), pp. 185, 195 n. 13; John Rupert Martin and Claudia Lazzaro Bruno, "Rubens's Cupid Supplicating Jupiter," in *Rubens before 1620,* edited by John Rupert Martin (Princeton, N.J., 1972), pp. 17, 19, fig. 11; Evan H. Turner, "Collectors and Acquisitions," *Apollo,* n.s., vol. 100, no. 149 (July 1974), p. 40, fig. 1; Frans Baudouin, *Peter Paul Rubens,* translated by E. Callander (New York, 1977), p. 74, fig. 38; Michael Jaffé, *Rubens and Italy* (Ithaca, 1977), p. 21; E.K.J. Reznicek, "Opmerking bij Rembrandt," *Oud Holland,* vol. 91 (1977), pp. 90–91, 105, fig. 11; John Rowlands, *Rubens: Drawings and Sketches* (London, 1977), pp. 13, 76, under cat. no. 80; Cabinet des Dessins, Musée du Louvre, Paris, *Rubens: Ses Maîtres, ses élèves,* February 10–May 15, 1978, p. 28, under cat. no. 11, repro.; Karel Braun, *Alle tot nu bekende schilderijen van Rubens,* vol. 1 (Rotterdam, 1979), p. 39, repro. p. 104, no. 112 [as c. 1610–11]; Julius S. Held, *The Oil Sketches of Peter Paul Rubens,* 2 vols. (Princeton, N.J., 1980), vol. 1, p. 334, under cat no. 245; Blankert et al. 1980–81, p. 110, under cat.

no. 14; Peter C. Sutton, " 'Tutti finiti con amore': Rubens' 'Prometheus Bound,'" in *Essays in Northern European Art Presented to Egbert Haverkamp-Begemann on His Sixtieth Birthday,* edited by Anne-Marie Logan (Doornspijk, 1983), pp. 270–75, fig. 1; Christopher White, *Peter Paul Rubens: Man and Artist* (New Haven and London, 1987), p. 134, pl. 148.

CONDITION: The fabric support consists of three pieces whose edges are turned and stitched: two horizontal pieces, each 47½" (120 cm.) high by 65" (165 cm.) wide and a narrow vertical addition 17¼" (44 cm.) wide running the full height of the painting along the left side.[1] The seams are somewhat raised and clearly apparent. The original tacking edges are missing and the painting has an aged lining adhered with an aqueous adhesive. The paint film is cupped in many areas, particularly along the vertical seam where the thickness of paint and ground layers is greatest. The painting exhibits numerous scattered tears and punctures, most quite small, with associated paint loss. The paint has been abraded in many areas; much of the retouching of abrasion and losses is readily visible. Minor pentimenti can be seen along the outline of the figure and the rocks beyond. Peaks and ridges of impasto have been somewhat flattened due to lining. The varnish is discolored to a medium yellow tone, is dull in many areas, and covers scattered residues of an older, dark brown coating. The frame is notable for being the original and is in a good state.

NOTE TO CONDITION

1. For a detailed discussion of the origin of the addition, the materials present, and the nature of Rubens's reworking of the painting, see Peter C. Sutton " 'Tutti finiti con amore': Rubens' 'Prometheus Bound,'" in *Essays in Northern European Art Presented to Egbert Haverkamp-Begemann on His Sixtieth Birthday,* edited by Anne-Marie Logan (Doornspijk, 1983), pp. 270–75.

92 PETER PAUL RUBENS

FIG. 92-1 Peter Paul Rubens, *Nicolaes Rockox,* c. 1613, oil on panel, 25½ x 22″ (65 x 56 cm.), private collection, England.

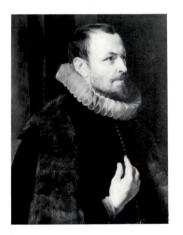

FIG. 92-2 Peter Paul Rubens, *Nicolaes Rockox,* detail of the left wing from the altarpiece *Doubting Thomas,* 1613–15, oil on panel, 57½ x 21⅛″ (146 x 55 cm.), Koninklijk Museum voor Schone Kunsten, Antwerp, no. 308.

PORTRAIT OF BURGOMASTER NICOLAES ROCKOX?, c. 1615
Oil on panel, 15⅜ x 12¼″ (39.1 x 31.1 cm.); originally octagonal panel
Gift of Mrs. Gordon A. Hardwick and Mrs. W. Newbold Ely in memory of
 Mr. and Mrs. Roland L. Taylor. 44-9-9

A man with close-cropped hair, a beard, and a mustache is turned to the viewer's left. He wears a white ruff and his black garment is sketchily painted.

While Jan Albert Goris and Julius Held assumed that the painting's assignment to Rubens was "apparently open to doubt" because it was not on view in the Museum in 1947, the attribution has never been questioned.[1] On the other hand, the identification of the sitter remains uncertain. While it had always been titled "Portrait of a Man" in earlier references, the painting was exhibited in Philadelphia in 1927–28, and published at that time by Arthur Edwin Bye as a "Portrait of Nicolas Rockox (1560–1640)."[2] Nine times the burgomaster of Antwerp and chief of the Guild of Arquebusiers, Rockox was a friend and patron of Rubens. The latter described him in 1625 as "an honest man and a connoisseur of antiquities. . . . He is rich and without children, a good administrator, and all in all a gentleman of the most blameless reputation."[3] Rubens's friendship with Rockox brought the painter a number of important public and private commissions. One of their earliest contacts was the order for a painting for the town hall that Rubens executed shortly after his return to Antwerp. This was followed by private commissions for a Crucifixion and a Samson and Delilah, the latter acquired in 1981 by the National Gallery, London.[4] Doubtless Rockox also was influential in securing for Rubens the commission in September 1611 for the famous triptych *Descent from the Cross,* painted for the chapel of the Guild of Arquebusiers in the church of Notre Dame, Antwerp, and now in the cathedral.[5] The burgomaster evidently was pleased with the results because shortly afterward he ordered a smaller triptych for himself to be hung in the Church of the Recollects over the tomb where he and his wife, Adriana Perez (d. 1619), were to be buried. The triptych, preserved in the Koninklijk Museum voor Schone Kunsten, Antwerp, was executed between 1613 and 1615 and depicts Doubting Thomas on the central panel with portraits of the donors on the wings.[6] Comparison of the present work with several other works—a rare, unfinished oil sketch by Rubens of Rockox (fig. 92-1), which could have served for his appearance in the portrait on the wing,[7] the finished portrait of Rockox (fig. 92-2), Rockox's portrait by Rubens in the *Presentation in the Temple,* which is on the right wing of the *Descent from the Cross* altarpiece, and likenesses painted by Rubens's teacher Otto van Veen (1556–1629) in 1600,[8] by Anthony van Dyck (1599–1641) in 1621 (fig. 92-3),[9] and by Thomas Willeboirts Bosschaert (1614–1654)[10]—reveals points of resemblance in the sitter's profile and hairline. While such methods are ultimately subjective, and unreliable, the identification is a plausible hypothesis.

The painting has been dated variously between about 1614 and 1618. Noting that the collar worn by the man is of an early fashion, Held questioned "whether Rubens could have done the portrait even before setting out for Italy in 1600 or immediately on returning home [1608], when Rockox was 48 years old."[11] While it is true that the present sitter appears to be about age forty or somewhat older, we should recall that Gustav Glück found it "astonishing" that Rockox had the appearance of a

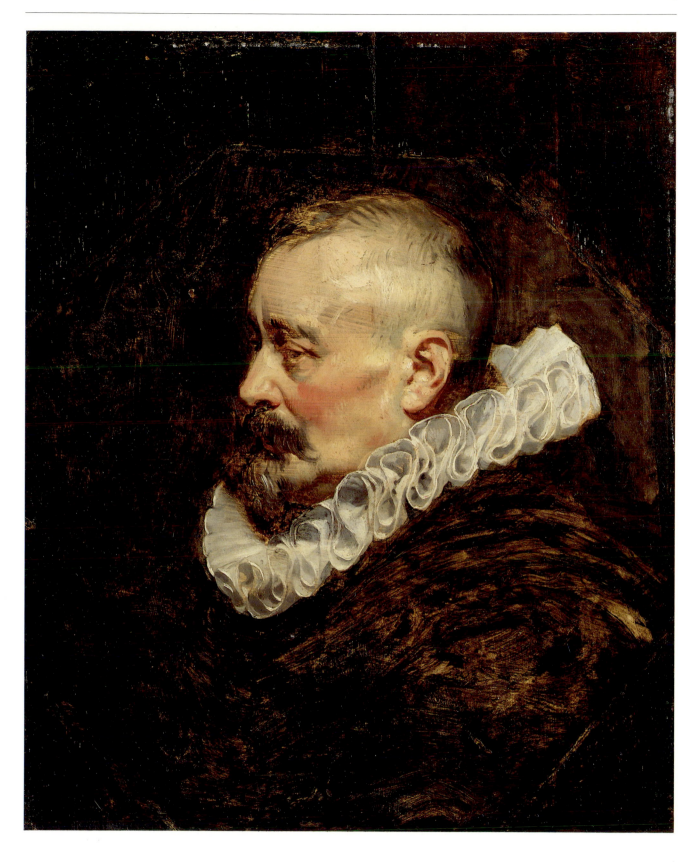

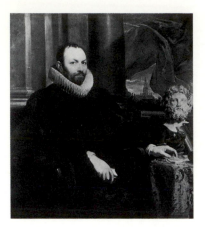

FIG. 92-3 Anthony van Dyck, *Nicolaes Rockox,* 1621, oil on canvas, 48 x 46" (122 x 117 cm.), The Hermitage, Leningrad, no. 6922.

man in his forties when Van Dyck portrayed him in 1621, at which time he would have been sixty-one.[12] Rockox also looks surprisingly young in Rubens's other portraits of him. Thus, if one accepts the sitter's identification with Rockox, the burgomaster's naturally youthful appearance may dictate a somewhat later date, of about 1615. The painting may be compared to other bust-length portraits by Rubens of men in ruffs, including the so-called *Portrait of Jan van Ghindertalen* in the museum in Berlin-Dahlem.[13] In the Berlin painting the sitter seems to sit up straighter than the gentleman in the Philadelphia picture. This probably reflects the fact that when the present panel was cut down (fig. 92-4), it was canted slightly to the viewer's left. Originally, the sitter probably had a greater air of dignity and hauteur.

FIG. 92-4 Diagram of the panel support.

NOTES

1. Jan Albert Goris and Julius S. Held, *Rubens in America* (New York, 1947), p. 48; although the painting did not appear in his work *The Oil Sketches of Peter Paul Rubens,* 2 vols. (Princeton, N.J., 1980), Held is "completely convinced of the authenticity of the work" (Held to author, March 8, 1981, Philadelphia Museum of Art, accession files).

2. Arthur Edwin Bye, "Loan Collection of Paintings from Flemish and Dutch Schools," *The Pennsylvania Museum Bulletin* (Philadelphia Museum of Art), vol. 23, no. 117 (December 1927–January 1928), p. 11.

3. Letter dated July 3, 1625, to Sieur de Palamède de Fabri Valavez; see Ruth Saunders Magurn, trans. and ed., *The Letters of Peter Paul Rubens* (Cambridge, Mass., 1955), pp. 112–13. See also Max Rooses and C. Ruelens, *Correspondance de Rubens et documents épistolaires concernant sa vie et ses oeuvres,* vol. 3 (Antwerp, 1900), p. 373, letter no. 379. On Rockox, see H. van Cuyck, "Nikolaas Rockox de Jongere, Burgemeester van Antwerpen," *Annals de l'Académie d'Archéologie de Belgique,* 3rd ser., vol. 37, no. 7 (1881), pp. 339–451; Frans Baudouin, *Nicolaas Rockox "Vriendt ende Patroon" van Peter Paul Rubens* (Antwerp, 1977); and on Rockox as an antiquary and collector, see Robert W. Scheller, *Nicolaas Rockox als Oudheidkundige, Stichting Nicolaas Rockox* (Antwerp, 1978). Ms. H. Houtman-de Smedt of Antwerp is preparing a new biography of Rockox.

4. *Samson and Delilah,* oil on panel, 72¾ x 80¼" (185 x 205 cm.), no. 6461; repro. in National Gallery, London, *The National Gallery Report: January 1980–December 1981* (London, 1982), p. 30. This painting appears in Frans Francken the Younger's *Interior of Nicolaes Rockox's 'Kunstkamer,'* oil on panel, 24½ x 38" (62.3 x 96.5 cm.), Alte Pinakothek, Bayerische Staatsgemäldesammlungen, Munich, inv. no. 858.

5. c. 1611–12, oil on panel, 165⅜ x 122" (420 x 310 cm.), wings 165⅜ x 59" (420 x 150 cm.); repro. in Rudolf Oldenbourg, *Klassiker der Kunst,* vol. 5, *P. P. Rubens: Meisters Gemälde* (Berlin and Leipzig, 1921), p. 54.

6. Oil on panel, 56¼ x 48⁷⁄₁₆" (143 x 123 cm.), wings 57½ x 21⅛" (146 x 55 cm.); in Koninklijk Museum voor Schone Kunsten, Antwerp, *Oude Meesters* (Antwerp, 1959), cat. no. 26. On the triptych, see A. Montballieu, "Bij de iconografie van Rubens' Rockox-epitafium," *Jaarboek van het Koninklijk Museum voor Schone Kunsten Antwerpen,* 1970, pp. 133–55.

7. First published by Michael Jaffé, "Rubens's Portraits of Nicolaes Rockox and Others," *Apollo,* vol. 119 (1984), pp. 274–81; see also Christopher White, *Peter Paul Rubens: Man & Artist* (New Haven and London, 1987), p. 103, fig. 116.

8. Oil on panel, 18¼ x 13¾" (46.3 x 35 cm.), Rubenshuis, Antwerp.

9. The Hermitage, Leningrad, *Catalogue of Paintings,* vol. 2 (Leningrad and Moscow, 1958), p. 52, no. 6922, fig. 45. Engraved by Lucas Vorsterman. A second version of dubious authenticity was in the collection of Mrs. Henry Barton Jacobs, Baltimore; see Gustav Glück, *Klassiker der Kunst,* vol. 13, *Van Dyke* (Stuttgart and Berlin, 1931), no. 110, repro. Compare also Van Dyck's drawing of Nicolaes Rockox at Windsor Castle, Windsor, which probably was made during his second Antwerp period (1627–32) and served as a model for a circular painted portrait in grisaille dated 1636 (6⅛" [15.2 cm.] diameter; sale, Christie's, New York, May 31, 1989, lot 123, repro.) and Paulus Pontius's engraving of 1639.

10. Oil on panel, 16½ x 12⁷⁄₁₆" (42 x 32 cm.), Koninklijk Museum voor Schone Kunsten, Antwerp, no. 711.

11. Letter of March 8, 1981 (see note 1).

12. Glück (note 9), pp. 530–31.

13. Oil on panel, 25⅜ x 19½" (64.5 x 49.5 cm.), Staatliche Museen Preussischer Kulturbesitz, Berlin (West), no. 776F. A bust-length *Portrait of a Bearded Man in a Ruff* (oil on panel, 24¼ x 19¼" [62.2 x 49 cm.]) formerly in the Cook Collection, Doughty House, Richmond, was exhibited in the New Gallery, London, 1899–1900, no. 109, as a portrait of Rockox by Rubens. Later it was catalogued in 1903 (see *Abridged Catalogue of the Pictures at Doughty House, Richmond* [London, 1903],

p. 37, no. 211) as a "Portrait of Nicolas Rockox by Rubens or more probably Van Dyck." J. O. Kronig (*A Catalogue of the Pictures at Doughty House, Richmond,* vol. 2 [London, 1914], no. 329, repro. [as Rubens]) stated that it had once been incorrectly thought to be a copy of the Philadelphia painting when the latter was in the Knaus Collection. Clearly the pictures depict two different sitters, and the former Cook Collection picture, which recently was sold as "Circle of Sir Peter Paul Rubens" (sale, "Old Master Pictures," Christie's, London, April 13, 1984, lot 37, repro.), bears far less resemblance to known portraits of Rockox.

PROVENANCE: Ludwig Knaus, Berlin, by 1883; Knaus sale, Lepke, Berlin, October 30, 1917, lot 8; Castiglione sale, F. Muller, Amsterdam, November 17–20, 1925, lot 72; dealer A. S. Drey, Munich; Roland L. Taylor, Philadelphia, by 1927.

EXHIBITIONS: Königliche Akademie der Künste, Berlin, *Die Ausstellung von Gemälden älterer Meister im Berliner Privatbesitz,* 1883, p. 53; on loan to the Pennsylvania Museum (Philadelphia Museum of Art), 1927–28.

LITERATURE: *Zeitschrift für bildende Kunst,* 1883, p. 321; Max Rooses, *Correspondance de Rubens et documents épistolaires concernent sa vie et ses oeuvres,* vol. 4 (1898), p. 242, no. 1035; Wurzbach 1906–11, vol. 2, p. 492; Adolf Rosenberg, *Klassiker der Kunst,* vol. 5, *P. P. Rubens* (Stuttgart and Leipzig, 1905), p. 126, repro. [as "Portrait of a Man," c. 1615–18]; J. O. Kronig in Herbert Cook, ed., *A Catalogue of the Paintings at Doughty House, Richmond,* vol. 2, *Dutch and Flemish Schools* (London, 1914), under no. 329; Rudolf Oldenbourg, *Klassiker der Kunst,* vol. 5, *P. P. Rubens: Meisters Gemälde* (Berlin and Leipzig, 1921), p. 81, repro. [as 1614–15]; Arthur Edwin Bye, "Loan Collection of Paintings from Flemish and Dutch Schools," *The Pennsylvania Museum Bulletin* (Philadelphia Museum of Art), vol. 23, no. 117 (December 1927–January 1928), p. 11, repro. no. 10 [as "Portrait of Nicholas Rockox," 1615]; R.A.M. Stevenson, *Rubens: Paintings and Drawings* (Oxford and New York, 1939), repro. no. 26 [as 1614–15];

Jan Albert Goris and Julius S. Held, *Rubens in America* (New York, 1947), p. 48, no. A31; Erik Larsen, *P. P. Rubens* (Antwerp, 1952), p. 216, no. 28 [as c. 1614]; PMA 1965, p. 60.

CONDITION: The oak panel support comprises a central, irregular octagonal section to which four additions have been butt joined to form an enlarged, rectangular format (see fig. 92-4). The reverse is covered with oak veneer and an oak cradle. The octagonal panel and additions are radially cut; however, the grain of the additions runs parallel to the painting's long dimension while that of the octagon is canted about 25 degrees off the vertical. The panel was examined May 15, 1981, to determine whether the central section was the original format and the additions of later origin. While all sections of the present rectangular panel appear to be old, the striated imprimatura does not extend onto the additions nor do any of the opaque background tones. Old overpainted flake losses around the edges of the octagon suggest that the paint was somewhat brittle when the surface adjacent to the additions was scraped and filled in to level the joint. The central section is not a regular octagon; no two sides are parallel and only the bottom left vertex has an interior angle of 135 degrees. It seems probable that the canting of the panel occurred at the time these changes were undertaken, indicating that the angle of the man's head originally tilted back farther to the viewer's right. The shadowed area around the head and the sketchy passages below corresponding to the man's shoulder and black garment were previously overpainted. These overpainted passages were noted as early as 1921 by Oldenbourg and, judging from the reproduction in the Knaus sale catalogue, probably predate 1917. The overpaint was removed sometime prior to treatment at the Museum in 1968, when the picture was given a surface cleaning and a fresh coat of varnish. Despite the extensive former overpaint the paint film is only moderately abraded. Old losses have been inpainted along the edges of the center panel and some overpaint remains in the shadowed background. The old, natural resin varnish is moderately discolored.

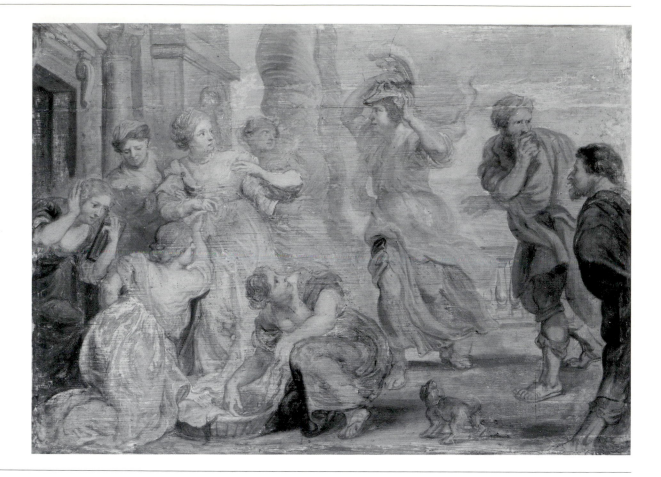

93 COPY AFTER PETER PAUL RUBENS

ACHILLES DISCOVERED AMONG THE DAUGHTERS OF LYCOMEDES
Oil on panel, 14¼ x 20¼″ (36.2 x 51.4 cm.)
Purchased for the W.P. Wilstach Collection. WO2-1-10

When the oracle informed the Greeks that Troy could not be captured
without Achilles, Ulysses was sent to look for him. Achilles had disguised
himself as a woman and hidden among the daughters of Lycomedes. To
reveal the identity of Achilles, Ulysses also adopted a disguise, that of an
itinerant peddler, and spread out a collection of his wares before the women
in Lycomedes' household. When Achilles rushed to take up the instruments
of war (described in various sources as a bow and quiver, or shield, or
sword—Rubens substituted a helmet), his identity was revealed. This is the
moment depicted in the present work.

As W. R. Valentiner first observed in 1911–12, this painting is a copy of
an oil sketch, now in the Museum Boymans–van Beuningen, Rotterdam,[1]
that Rubens executed as part of a series of designs for tapestries depicting
the life of Achilles for Charles I. A large *modello* for the scene is in the
Prado in Madrid.[2] The architectural framework that appears in these works
is omitted in the present copy. Five other copies of the Rotterdam sketch
are listed by Egbert Haverkamp-Begemann as well as etchings after the
design by Franz Ertinger of 1679 and Bernard Baron of 1724.[3] A painted
copy in the Lander Collection in Upper Hartfield, Sussex, also omits the
framing architecture.[4]

NOTES

1. W. R. Valentiner, "Gemälde des Rubens in Amerika," *Zeitschrift für bildende Kunst,* vol. 47 (1911–12), pp. 264ff. Oil on panel, 17⅞ x 24¼" (45.5 x 61.5 cm.), inv. no. 2310; repro. in Egbert Haverkamp-Begemann, *Corpus Rubenianum Ludwig Burchard,* pt. 10, "The Achilles Series" (London, 1965), pl 22.

2. Oil on panel, 42⅛ x 55⅞" (107 x 142 cm.), no. 2455; repro. in Haverkamp-Begemann (see note 1), pl. 23.

3. Haverkamp-Begemann (see note 1), pp. 108–9, under no. 3, pls. 27, 28.

4. Ibid., p. 108.

PROVENANCE: Sale, Thomas Loridon de Ghellinck, Ghent, September 3, 1821, lot 15; Abbé Gosselin, Paris; dealer Charles Sedelmeyer, Paris, by 1902; purchased for the W. P. Wilstach Collection, Philadelphia, 1902.

EXHIBITION: Sedelmeyer Gallery, Paris, *Illustrated Catalogue of the Eighth Series of 100 Paintings by Old Masters,* 1902, p. 46, no. 35.

LITERATURE: *Catalogue d'une ... collection de tableaux ... le Cabinet de Monsieur T. Loridon de Ghellinck ... à Gand* (Ghent, c. 1780), pp. 139–40, no. 403; Wilstach 1903, pp. 59–60, no. 156 [as Rubens], 1904, p. 72, no. 213, repro., 1906, no. 236, 1907, no. 249, 1908, no. 249, repro., 1910, no. 345; W. R. Valentiner, "Gemälde des Rubens in Amerika," *Zeitschrift für bildende Kunst,* vol. 47 (1911–12), pp. 264, 265, 271 [as a "school repetition"]; Wilstach 1913, no. 360; W. R. Valentiner, *The Art of the Low Countries: Studies* (Garden City, N.Y., 1914), pp. 188–89, 236, no. 28; Wilstach 1922, pp. 107–9, no. 269; Jan Albert Goris and Julius S. Held, *Rubens in America* (New York, 1947), p. 53, no. A77 [as a copy]; PMA 1965, p. 60 [attributed to Rubens]; Egbert Haverkamp-Begemann, *Corpus Rubenianum Ludwig Burchard,* pt. 10, "The Achilles Series" (London, 1965), p. 108, under no. 3a [as a copy]; Julius S. Held, *The Oil Sketches of Peter Paul Rubens,* vol. 1 of 2 (Princeton, N.J., 1980), p. 177, under cat. no. 122 [as a copy].

CONDITION: The horizontally grained cradled panel has two large cracks running the width of the panel, one in the upper quadrant and a smaller one at the lower right. The paint film is thin, revealing the horizontal brush strokes of the ground below. Extensive losses and abrasion, as well as old, discolored retouches appear throughout the paint film. The varnish is moderately discolored.

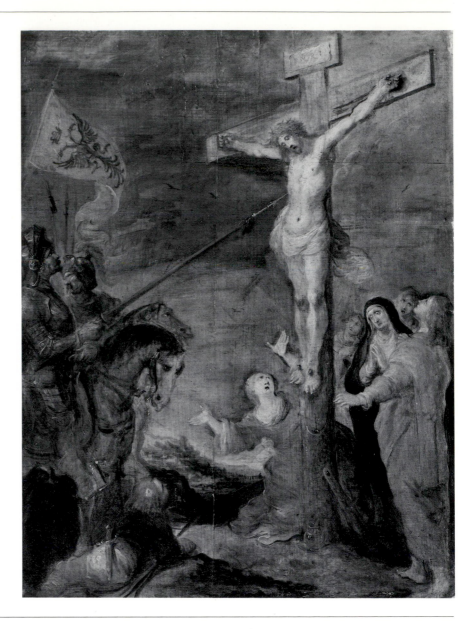

94 CIRCLE OF PETER PAUL RUBENS

CRUCIFIXION
Oil on panel, 14 x 10⅜″ (35.5 x 26.4 cm.)
John D. McIlhenny Collection. 43-40-43

The subject depicts the moment at the Crucifixion of Christ when the centurion Longinus, wearing armor and on horseback at the left, pierced the dead Christ's side with a lance (John 19:34). The wound was said to have flowed both blood and water. At the top of the cross, which is situated to the right and viewed at an angle, is the inscription "INRI" (Jesus Nazarenus Rex Judaeorum), an allusion to Pilate's reference, over the objections of the Jewish leaders, to Jesus of Nazareth as king of the Jews. At the foot of the cross kneels the Magdalen, raising her arms in a distraught gesture. Her ointment jar rests on the ground before her. Standing at the right are four additional figures, the Virgin Mary in a blue robe, John the Evangelist in red, and behind them, presumably, Mary, the mother of James, and Joseph of Arimathea. The reclining figure in the lower left, who wears a dagger on his hip and looks up at Christ, holds a

FIG. 94-1 Peter Paul Rubens, *Coup-de-lance* altarpiece, 1620, oil on panel, 168⅞ x 122⁷⁄₁₆" (429 x 311 cm.), Koninklijk Museum voor Schone Kunsten, Antwerp, no. 297.

pole or pike, perhaps identifying him as Sephaton, who extended a sponge on a pole ("reed") to the thirsting Christ (Matthew 27:48). Above the mounted soldiers on the left flies a banner with a two-headed eagle surmounted by a crown, the imperial symbol. In the central distance are the silhouette of a city, presumably Jerusalem, and a mountainous vista. The overall dark, monochromatic tonality of the work may refer to the eclipse that was said to have followed Christ's death. The only color accent, aside from the robes of the Virgin and John, is the red blood running from Christ's side.

When the sketch was acquired by John D. McIlhenny in 1912 it was said to be by Anthony van Dyck (1599–1641) and the bill of sale mentioned a preparatory drawing in the British Museum. However, none of that museum's three drawings by Van Dyck of Crucifixion scenes relates to this work.[1] Moreover, the oil sketch technique is not that of the master. The prominence of the so-called "coup-de-lance" motif recalls the (reversed) design for Van Dyck's altarpiece of the *Crucifixion* of 1629–30 in the St. Michielskerk in Ghent and related works.[2] Stronger compositional resemblances, though no direct quotations, are witnessed in Peter Paul Rubens's earlier *Coup-de-lance* altarpiece of 1620 in the Koninklijk Museum voor Schone Kunsten, Antwerp (fig. 94-1). Although Rubens's monumental work includes the two additional crosses, it probably inspired the Philadelphia sketch's general arrangement, with the mounted soldiers on the left, the mourners on the right, and the Magdalen kneeling at the center. A firmer attribution for the Philadelphia painting must await a clearer understanding of the oil sketching styles of lesser-known painters in Rubens's circle.

NOTES

1. See Arthur M. Hind, *Catalogue of Drawings by Dutch and Flemish Artists Preserved in the Department of Prints and Drawings in the British Museum,* vol. 2 (London, 1923), p. 54, nos. 4–6, pl. XXIII.
2. Gustav Glück, *Klassiker der Kunst,* vol. 13, *Van Dyke* (Stuttgart and Berlin, 1931), p. 247, repro.; Erik Larsen, *L'Opera Completa di Van Dyck,* 2 vols. (Milan, 1980), no. 653, repro. Related works are discussed by Horst Vey, "Een belangrijke toevoeging aan de verzameling van Dyck tekeningen," *Bulletin Museum Boymans–van Beuningen,* vol. 10, no. 1 (1959), pp. 2–22: an oil sketch on panel, 19½ x 16⅞" (49.5 x 43 cm.), Musée Royaux de Beaux-Arts de Belgique, Brussels, inv. no. 3014, repro. in Vey, p. 5, fig. 2; a related pen and wash drawing, 11¹⁵⁄₁₆ x 9⁹⁄₁₆" (30 x 25 cm.), Museum Boymans–van Beuningen, Rotterdam, no. MB-1958/T.23, repro. in Vey, p. 1, fig. 1; another preparatory drawing, pen and wash, 10⁷⁄₁₆ x 7¾" (27.1 x 19.6 cm.), British Museum, London, repro. in Vey, p. 18, fig. 8 (see Hind [note 1], no. 5). A second version or copy of the Brussels oil sketch was in sale, "Important Old Master Paintings," Sotheby's, London, July 9, 1975, lot 35, repro. (oil on panel, 19 x 17" [48 x 43 cm.]).

PROVENANCE: Purchased by John D. McIlhenny, Philadelphia, from F. W. Lippmann, London, July 5, 1912.

EXHIBITION: Philadelphia, Pennsylvania Museum (Philadelphia Museum of Art), 1926.

LITERATURE: *Philadelphia Museum Bulletin,* vol. 39, no. 200 (January 1944), p. 59 [as studio of Van Dyck, c. 1630]; PMA 1965, p. 60.

CONDITION: The panel support has a vertical grain. It was thinned, cradled, and has five vertical cracks from the top edge, the most severe running through the Magdalen's wrist and extending the full height of the panel. Black underdrawing is visible on the ground beneath the thin paint film. Old losses in the paint film appear along the upper and right edges, at the waist of the saint, at the lower right, and at the base of the plume of the soldier second from the left. The varnish is moderately discolored.

Jacob van Ruisdael was probably born in Haarlem in 1628 or 1629. The exact date is unknown; although a notarial act of June 9, 1661, states that he was then thirty-two, the ages of several other artists are incorrectly recorded in this document. The painter's father, Isaack Jacobsz. van Ruysdael (1599–1677), originally called "de Goyer," was a framemaker, art dealer, and painter from Naarden. Isaack and his brother Salomon van Ruysdael (q.v.) later adopted the name Ruisdael or Ruysdael, presumably because their father was from Blaricum, near the Castle Ruisdael (or Ruisschendael). On November 12, 1628, Isaack, then described as a widower, married Maycken Cornelisdr. While Jacob was probably a child of this marriage, the possibility that Isaack's first wife was Jacob's mother cannot be ruled out. In 1634 Isaack, who was not a guild member, was fined because Jan van Goyen (q.v.) had worked in his house. Landscapes only recently identified as by Isaack support the presumption that he was Jacob's first teacher. Jacob may also have studied with his uncle Salomon van Ruysdael.

Although Jacob did not become a member of the Haarlem guild until 1648, there are numerous signed and dated works of 1646. On a visit to Bentheim in Germany around 1650 Ruisdael was accompanied by the Italianate landscapist Claes Berchem (1620–1683), who, according to Arnold Houbraken, was a "great friend." The two artists probably continued to Steinfurt, the birthplace of Berchem's father. Both Steinfurt and Bentheim castles appear in Ruisdael's landscapes. Occasionally Berchem painted staffage in Jacob's landscapes.

By June 1657 Jacob had settled in Amsterdam, where he evidently lived for the rest of his life. Although his family was Mennonite, in 1657 Ruisdael was baptized in the Reformed Church in Ankeveen near Amsterdam. In 1659 Ruisdael became an Amsterdam citizen. The following year he testified that Meindert Hobbema (q.v.) lived and worked for him for several years. He was later a witness at Hobbema's marriage. Jacob made two wills in 1667 at a time when he appears to have been very ill. He was then living near the Dam. By 1670 he was living on the south side of the Dam. The artist remained a bachelor all his life and seems to have supported his father. Jacob probably died in Amsterdam and his body was sent to Haarlem, where he was buried in St. Bavo's Church on March 14, 1682. One curious feature of his biography is the possibility of a second career. Houbraken stated that Ruisdael studied medicine and performed successful surgical operations in Amsterdam. On the register of Amsterdam doctors appears the crossed-out name "Jacobus Ruijsdael" who received his medical degree in Caen on October 15, 1676. In addition, a landscape with waterfall was sold in 1720 as by a "Doctor Jacob Ruisdael."

Ruisdael is regarded today as the greatest of all Dutch landscapists, and is certainly one of the most versatile. Many of his paintings bear dates between 1646 and 1653, but only very few thereafter. The influence of Cornelis Vroom (c. 1591–1661) is particularly evident in works of 1648 and 1649. While his uncle Salomon may also have had an early impact on his landscapes, clearer is his dependence on Jan Porcellis (c. 1584–1632) and Simon de Vlieger (c. 1601–1653) in his marines. Ruisdael's mountain waterfalls and torrents were inspired by Scandinavian scenes by Allart van Everdingen (1621–1675). In addition to paintings of landscapes, winter scenes, cityscapes, and marines, he also executed thirteen etchings, all of

which date from his early career, and numerous drawings. Philips Wouwermans (q.v.), Claes Berchem, Adriaen van de Velde (1636–1672), and Johannes Lingelbach (c. 1624–1674) all painted staffage in Ruisdael's paintings. Ruisdael collaborated with Thomas de Keyser (1596/97–1667) on a large-scale landscape portrait of the family of Cornelis de Graeff, burgomaster of Amsterdam (oil on canvas, 46 x 67⁵⁄₁₆″ [117 x 171 cm.], National Gallery of Ireland, Dublin, inv. no. 287). Although Meindert Hobbema was the artist's most important pupil, he had many other followers and imitators, including his cousin Jacob Salomonsz. van Ruysdael (1629/30–1681), Cornelis Decker (d. 1678), Jan van Kessel (1641/42–1680), Adriaen Verboom (c. 1628–c. 1670), and Roelof van Vries (c. 1631–after 1681).

LITERATURE: Houbraken 1718–21, vol. 3, p. 65; Descamps 1753–64, vol. 3, pp. 9–12; Johan Wolfgang van Goethe, "Ruysdael als Dichter (1816)" in *Goethes Werke,* 7th ed., vol. 12, ed. E. Trunz (Munich, 1973); Smith 1829–42, vol. 6, pp. 1–107, vol. 9, pp. 680–718; Emile Michel, *Jacob van Ruisdael et les paysagistes de l'école de Haarlem* (Paris, 1890); Wurzbach 1906–11, vol. 2, pp. 517–22; Hofstede de Groot 1908–27, vol. 4 (1912), pp. 1–349; Georges Riat, *Jacob van Ruisdael* (Paris, 1928); Jakob Rosenberg, *Jacob van Ruisdael* (Berlin, 1928); Kurt Erich Simon, *Jacob van Ruisdael: Eine Darstellung seiner Entwicklung* (Berlin, 1930); H. F. Wijnman, "Het leven der Ruysdaels," *Oud Holland,* vol. 49 (1932), pp. 49–60, 173–81, 258–75; Horst Gerson, "The Development of Ruisdael," *The Burlington Magazine,* vol. 65, no. 377 (August 1934), pp. 76–80; Kurt Erich Simon in Thieme-Becker 1907–50, vol. 29 (1935), pp. 190–93; Wolfgang Stechow, *Dutch Landscape Painting of the Seventeenth Century,* (London, 1966), pp. 3, 4, 6–8, 10, 11, 21, 28–30, 32, 38, 39, 42–43, 45–48, 56, 59, 60, 62–64, 66, 69, 70, 72–82, 96–99, 104–9, 111, 115, 118, 121, 122, 125, 127, 128, 130, 138–41, 144–47, 182, 184–86, 189; Herman Hagels, "Die Gemälde der niederländischen Maler Jacob van Ruisdael und Nicolaas Berchem von Schloss Bentheim im Verhältnis zur Natur des Bentheimer Landes," *Jahrbuch des Heimatvereins der Grafschaft Bentheim,* 1968, pp. 41ff.; Wilfred Wiegand, "Ruisdael-Studien: Ein Versuch zur Ikonologie der Landschaftsmalerei," diss., Hamburg, 1971; R. H. Fuchs, "Over het landschap: een verslag naar aanleiding van Jacob van Ruisdael, 'Het Korenveld,'" *Tijdscrift voor Geschiedenis,* vol. 86 (1973), pp. 281–92; Iouryi Kouznetsov, "Sur le symbolisme dans les paysages de Jacob van Ruisdael," *Bulletin du Musée National de Varsovie,* vol. 14 (1973), pp. 31ff.; James D. Burke, "Ruisdael and His Haarlempjes," *M: A Quarterly Review of the Montreal Museum of Fine Arts,* vol. 6, no. 1 (summer 1974), pp. 3–11; George S. Keyes, "Les Eaux-Fortes de Ruisdael," *Nouvelles de l'Estampe,* no. 36 (November–December 1977), pp. 7–20; Hans Kauffmann, "Jacob van Ruisdael: 'Die Mühle von Wijk bei Duurstede,'" in *Festschrift für Otto von Simpson zum 6s. Geburtstag* (Frankfurt, 1977); U. D. Korn, "Ruisdael in Steinfurt," *Westfalen: Hefte für Geschichte, Kunst und Volkskunde,* vol. 56 (1978), pp. 111–14; D. Maschmayer, "Jacob Isaackszoon van Ruisdael und Meindert Hobbema malen Motive aus der Grafschaft Bentheim und ihrer Umgebung," *Jahrbuch des Heimatvereins der Grafschaft Bentheim, Das Bentheimer Land,* vol. 92 (1978), pp. 61–71; Jeroen Giltay, "De tekeningen van Jacob van Ruisdael," *Oud Holland,* vol. 94 (1980), pp. 141–86; Frits J. Duparc, Jr., *Ruisdael* (The Hague, 1981); Winfried Schmidt, "Studien zur Landschaftskunst Jacob van Ruisdaels: Frühwerke und Wanderjahre," diss., Hildesheim, 1981; Seymour Slive and H. R. Hoetink, *Jacob van Ruisdael* (New York, 1981); E. J. Walford, "Jacob van Ruisdael and the Perception of Landscape," diss., Cambridge, 1981; Sutton et al. 1987, pp. 437–65.

For additional works by Jacob van Ruisdael in the Philadelphia Museum of Art, see John G. Johnson Collection cat. nos. 563, 564, 569, 567, 570, 566 (copy after).

95 JACOB ISAACKSZ. VAN RUISDAEL

FIG. 95-1 Allart van Everdingen, *Landscape with Waterfall*, signed and dated 1647, oil on canvas, 43¹¹/₁₆ x 53⅛" (111 x 135 cm.), The Hermitage, Leningrad, inv. no. 1901.

FIG. 95-2 Jacob van Ruisdael, *Landscape with Waterfall*, signed, oil on canvas, 19⅞ x 23" (50.5 x 58.5 cm.), Salzburger Landessammlungen, Residenzgalerie, Salzburg, inv. no. 1844.

FIG. 95-3 Jacob van Ruisdael, *Landscape with Waterfall*, signed, oil on canvas, 45³/₁₆ x 58¹/₁₆" (114.8 x 147.5 cm.), The Toledo Museum of Art, Ohio, no. 30.312.

LANDSCAPE WITH WATERFALL
Signed lower left: *JvRuisdael* (first three letters ligated)
Oil on canvas, 40¾ x 56½" (103.5 x 143.5 cm.)
Purchased for the W. P. Wilstach Collection. W95-1-8

A waterfall in the center of the scene divides two rocky, tree-covered banks. A hill rises to the right with a cottage and trees at the summit. At the lower right is a fallen beech. The foreground is filled with foaming water. On the bank at the left are two silhouetted figures; three more appear in the distance at the upper right. Light fleecy clouds fill the sunset sky.

In 1842 John Smith called the painting a "superb picture."[1] It is fully signed and presents no problems of attribution. However, as with much of Ruisdael's mature and later work, its date is difficult to establish with precision. Only a handful of pictures are dated after 1653, but Ruisdael seems to have begun painting waterfalls at least by the early 1660s.[2] These works, as many writers beginning with Thoré-Bürger have observed, seem to have been inspired by northern landscapes made popular in Holland by the Alkmaar painter Allart van Everdingen (1621–1675), following his trip to Scandinavia in 1644.[3] Everdingen's earliest dated painting of a waterfall is of 1647 (fig. 95-1).[4] It already employs many of the features seen in Philadelphia's Ruisdael—the horizontal format bracketed by the twin river banks, the relatively high point of view directly in front of the subject, the jumble of boulders and logs in the immediate foreground, even the diminished human presence before nature's drama (a tiny artist sketches the scene in the Everdingen). Everdingen's waterfalls owe much to the art of his teacher, Roelandt Savery (c. 1575/76–1639);[5] and the subject's origins have been traced back to Paul Bril's paintings and prints after Pieter Bruegel the Elder's designs.[6] While the rushing water in Ruisdael's scenes may recall the undershot watermills that he witnessed on his trip to the Dutch-German border area around 1650, somewhat suprisingly, there is no proof that he ever experienced waterfalls at first hand. Indeed, Thoré-Bürger and other later writers were critical of Ruisdael's waterfalls because they are not observed from nature.[7] During the early and mid-1660s Ruisdael favored an upright format for his waterfalls, which stressed the vertical drop and crash of his torrents. Toward the end of the decade and through the 1670s, he preferred more expansive, horizontal waterfall scenes. These works on a broader format were created during the same years when Ruisdael became increasingly interested in more open spatial effects, majestic compositions, and panoramic views.[8] Examples of this later, horizontal waterfall type are in the Rijksmuseum, the Wallace Collection, the Hermitage, Galleria degli Uffizi, an English private collection, and formerly owned by Wenmon Wykeham-Musgrave of Barnsley Park, Gloucestershire.[9] Many of these works share motifs such as the central torrent, the placid pool of water visible above the falls, and the angled, fallen tree trunk in the lower corner. Particularly close to the design of the present work is a smaller painting from the Czernin Collection, now in Salzburg (fig. 95-2).[10] Although probably later in origin, the *Landscape with Waterfall* in the Toledo Museum of Art (fig. 95-3) also shares features with this painting.

Ruisdael was highly regarded by his contemporaries for his waterfalls; indeed, they even considered the subject a play on his name.[11] Arnold Houbraken characterized Ruisdael in 1721 as an artist who "painted Dutch and foreign landscape views, but especially those in which the water is seen

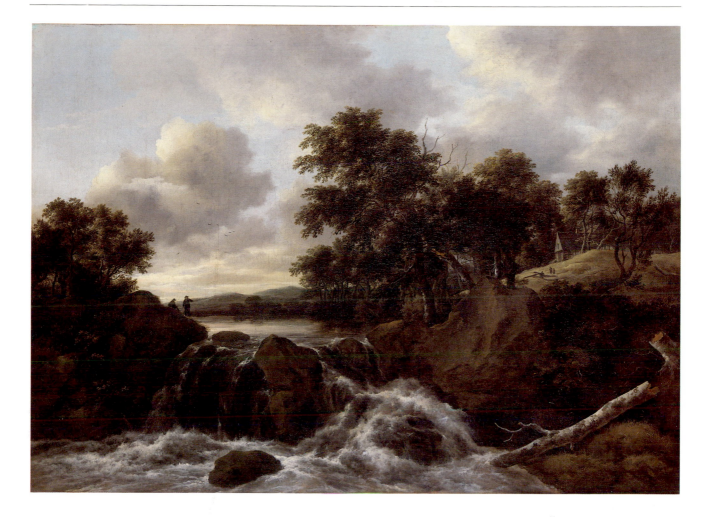

pouring down from one rock to another, and finally with great noise
(*geruis*) down through the valleys (*dalen*) or spraying out. He could depict
water splashing and foaming as it dashed upon the rocks, so naturally,
delicately and transparently that it appears to be real."[12] The Pietist poet
Jan Luyken also played on Ruisdael's name in an emblem of a waterfall
entitled "Tot verdooving" ("Until deafening"), published in 1708, which
contrasts the silence of God with earthly commotion: "Indeed, tranquility
came to this life,/which for so long now and for so many days,/inhabited
this valley of noise (*Ruis-dal*),/a place that must displease this life./Oh Valley
of noise (*Ruis-dal*), all vanity,/from the turbulent and teeming life,/that the
world gives in the realm of time,/one must flee and forsake you."[13] Wilfried
Wiegand cited this emblem along with other biblical and literary references
in interpreting Ruisdael's waterfalls as symbols of transience.[14] While such
Christian interpretations of Ruisdael's art have gained some critical
acceptance in recent years,[15] and notwithstanding such clearly allegorical
paintings as *The Jewish Cemetery*,[16] it is unclear whether and what
proportion of Ruisdael's contemporaries would have regarded his waterfalls
as symbolic.

In the past the provenance of the present painting has been confused with that of a similar but slightly smaller painting that came from the estate of Sir Hugh H. Campbell.[17] The confusion seems to stem from the fact that the Sedelmeyer Gallery in Paris mistakenly illustrated the present work in its 1895 catalogue when, in fact, they owned the Campbell picture.[18] Doubtless the mistake arose because both pictures had just sold at Christie's, the former on July 22, 1893, and the latter June 16, 1894.[19]

NOTES

1. Smith 1829–42, suppl. (1842), p. 713, no. 103.

2. *Waterfall in a Mountain Landscape,* oil on panel, 11 x 8½" (28 x 21.5 cm.), formerly in the Semenov Collection, St. Petersburg, present location unknown. See Hofstede de Groot 1908–27, vol. 4 (1912), p. 91, no. 280, where he said it was monogrammed and dated 1659. Seymour Slive in his catalogue with H. R. Hoetink, *Jacob van Ruisdael* (New York, 1981), p. 103, under cat. no. 34, tended to doubt the attribution, but cited the large group of waterfalls datable to the early 1660s.

3. See Alice I. Davies, *Allart van Everdingen* (New York, 1978); W. Bürger (Etienne Jos. Theoph. Thoré), *Les Musées de la Hollande,* 2 vols. (Paris, 1858–60), vol. 2, p. 137.

4. See Davies (note 2), p. 108, cat. no. 22, fig. 74. Compare also Everdingen's *Scandinavian Landscape with Waterfall,* undated, oil on canvas, 39 x 48" (99 x 122 cm.), sale, Sotheby's, New York, June 5, 1986, lot 49.

5. See Davies (note 2), p. 117; and Sutton et al. 1987, under cat. no. 28.

6. Joaneath Spicer, unpublished lecture, New York, 1981 (see Sutton et al. 1987, pp. 405–6, n. 15); and Ann Charlotte Steland, "Wasserfälle: Die Emanzipation eines Bildmotivs in der holländischen Malerei um 1640," *Niederdeutsche Beiträge zur Kunstgeschichte,* vol. 24 (1985), pp. 85–104.

7. Thoré-Bürger (see note 3), vol. 2, pp. 137–38.

8. See Slive's comments in Slive and Hoetink (note 2), p. 107, under cat. no. 35; and Jeroen Giltay in Sutton et al. 1987, under cat. no. 85.

9. *Waterfall,* oil on canvas, 55⅞ x 76¾" (142 x 195 cm.), Rijksmuseum, Amsterdam, no. C210 (Hofstede de Groot 1908–27, vol. 4 [1912], no. 198); *Waterfall,* oil on canvas, 40⅞ x 56¾" (104 x 144 cm.), Wallace Collection, London, no. P56 (Hofstede de Groot no. 251); *Waterfall in a Hilly Landscape,* oil on canvas, 42½ x 56⅛" (108 x 142.5 cm.), The Hermitage, Leningrad, no. 942 (Hofstede de Groot no. 276); *Waterfall with a Low Wooded Hill,* oil on canvas, 20½ x 24¼" (52.3 x 61.7 cm.), Galleria degli Uffizi, Florence, no. 8436 (Hofstede de Groot no. 221); *Waterfall with a Steep Hill and Cottages,* signed, oil on canvas, 42 x 59¼" (106.7 x 150.5 cm.), private collection, England (Hofstede de Groot

no. 252). For reproductions see Slive and Hoetink (note 2), p. 107, figs. 48, 49, 50, p. 143, cat. no. 50, p. 106, cat. no. 35; and sale, Sotheby's, London, April 3, 1985, lot 64, repro.

10. Hofstede de Groot 1908–27, vol. 41 (1912), no. 293.

11. See Slive and Hoetink (note 2), p. 22, and Jeroen Giltay in Sutton et al. 1987, p. 451.

12. Houbraken 1718–21, vol. 3, pp. 65–66.

13. Jan Luyken, *Beschouwing der Wereld* (1708). Translated in Sutton et al. 1987, p. 451.

14. Wilfried Wiegand, "Ruisdael-Studien: Ein Versuch zur Ikonologie der Landschaftsmalerei," diss., Hamburg, 1971, pp. 87–98.

15. See, for example, E. J. Walford, "Jacob van Ruisdael and the Perception of Landscape," diss., Cambridge, 1981, and Josua Bruyn, "Toward a Scriptural Reading of Seventeenth-Century Dutch Landscape Painting," in Sutton et al. 1987, pp. 84–101, especially p. 99.

16. Two versions: oil on canvas, 56 x 74½" (142 x 189 cm.), The Detroit Institute of Arts, no. 26-3, and Staatliche Kunstsammlungen, Dresden, no. 1502.

17. See Hofstede de Groot 1908–27, vol. 4 (1912), no. 367: "A wooded landscape with a river in front. On the left bank lies a fallen beech, whose withered branches fill almost half the picture. Intermingled with these are the branches of a fallen oak, one end of which lies in the water. The bank is covered with tall trees and bushes. On the other side a steep road, lined with trees, leads up the slope from the stream till lost to view. A man and a woman walk up the road. Near them four sheep graze. Sky slightly overcast, with a little sunshine. . . . Canvas, 40½ inches by 51 inches." In an aside Hofstede de Groot stated that this painting is "Possibly identical with 418 or 643c." From the collection of the marquis of Conyngham, Ireland; Campbell sale, Christie's, London, June 16, 1894. The picture was catalogued by Waagen (1854, suppl. [1857], pp. 441–42) as being at Marchmount House, and was exhibited at the Royal Academy in 1877 (no. 199, as "Forest scene, 40 x 51 in.").

18. Sedelmeyer Gallery, Paris, *Illustrated Catalogue of the Second Hundred of Paintings by Old Masters* (Paris, 1895), no. 35. The photograph clearly illustrates the present

work, but the description, the measurements, and the provenance are those of the Campbell painting: "In the foreground masses of rocks, through which a wide brook flows in gentle cascades; silvery beach and oak lie fallen along the rocky bank on the left; lofty trees fill up the background; in the distance are a man and a woman with some sheep. Signed on the left: J.V. RUISDAEL. Canvas, 40½ in. by 50 in. From the Collection of Sir Hugh Hume Campbell, Bart. Exhibited at the Royal Academy, London, 1877."

19. See William Roberts, *Memorials of Christie's,* vol. 2 (London, 1897), pp. 223, 234.

PROVENANCE: Sale, Sir Simon Clarke, Bart., London, May 8, 1840 (to dealer Nieuwenhuys); sold by Nieuwenhuys to the earl of Onslow, 1842; Rt. Hon. Arthur George, earl of Onslow (d. 1870); sale, the late Rt. Hon. Arthur George, earl of Onslow, Christie's, London, July 22, 1893 [as "A View in Guelder Land"]; possibly Sedelmeyer Gallery, Paris, 1895, but according to Wilstach 1922, purchased March 11, 1895, from the collection of the earl of Onslow.

EXHIBITION: Possibly Sedelmeyer Gallery, Paris, 1895.

LITERATURE: Smith 1829–42, suppl. (1842), p. 713, no. 103; Sedelmeyer Gallery, Paris, *Illustrated Catalogue of the Second Hundred of Paintings by Old Masters* (Paris, 1895), no. 35; Wilstach 1897 suppl., no. 200; William Roberts, *Memorials of Christie's,* vol. 2 (London, 1897), p. 223; Wilstach 1900, no. 119, 1902, no. 138, 1903, no. 157, 1904, no. 214, 1906, no. 237, 1907, no. 250, 1908, no. 250, 1910, no. 347, 1913, no. 362; Hofstede de Groot 1908–27, vol. 4 (1914), p. 92, no. 283, and p. 119, no. 366 [descriptions reversed]; Wilstach 1922, no. 272, repro.; Jakob Rosenberg, *Jacob van Ruisdael* (Berlin, 1928), p. 87, no. 239; PMA 1965, p. 60; Rishel 1974, p. 29.

CONDITION: The canvas support is lined with an aqueous adhesive. The tacking edges are missing. The paint film is in good condition except for a few tiny losses and several slightly abraded areas in the sky. The varnish is moderately discolored.

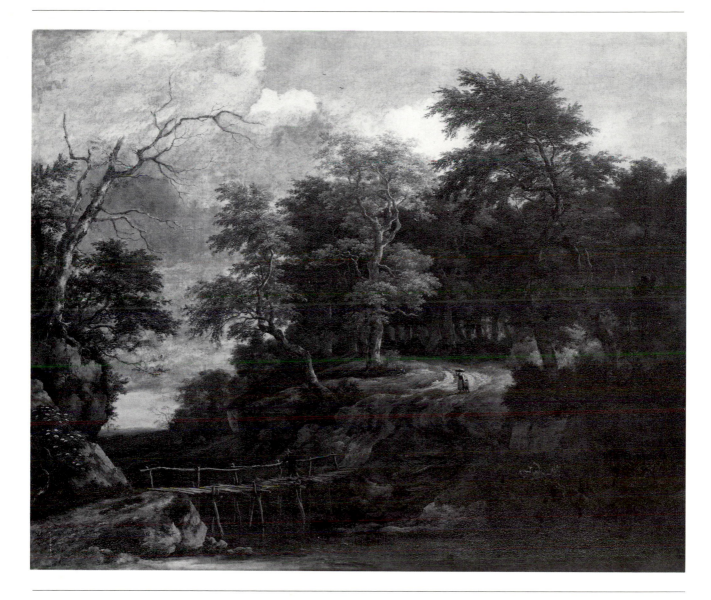

96 JACOB ISAACKSZ. VAN RUISDAEL

FOREST LANDSCAPE WITH A WOODEN BRIDGE, after 1670
Remnants of a monogram lower left
Oil on canvas, 41⅛ x 50⅜″ (104.5 x 128 cm.)
The William L. Elkins Collection. E24-3-77

FIG. 96-1 Jacob Isaacksz. van Ruisdael, *Landscape with Bridge, Cattle, and Figures,* monogrammed, oil on canvas, 37⅞ x 51¹/₁₆″ (95.6 x 129.7 cm.), Sterling and Francine Clark Art Institute, Williamstown, Mass., inv. no. 29.

A road winding down out of a dense wood on the right is connected to a rocky hill on the left by a rustic bridge in the left center of the picture. A man with a walking stick is crossing the bridge, and a woman carrying a bundle on her head and holding a small boy by the hand is seen farther up the road on the right. At the left a dead tree is silhouetted against the sky.

Ruisdael employed similar horizontal landscape compositions divided by a stream and connected by the central motif of a bridge in paintings in the Sterling and Francine Clark Art Institute, Williamstown (fig. 96-1), the Akademie der bildenden Künste, Vienna (fig. 96-2), and the Musées Royaux des Beaux-Arts de Belgique, Brussels.[1] As in the present picture, the Williamstown and Brussels paintings include a partly dead tree silhouetted against the sky on the left. In the Akademie's catalogue it was noted that their painting is probably a late work. The treatment of the slender trees in

FIG. 96-2 Jacob Isaacksz. van Ruisdael, *Landscape with Bridge,* signed, oil on canvas, 26⅛ x 32½" (67 x 82.5 cm.), Gemäldegalerie, Akademie der bildenden Künste, Vienna, inv. no. 889.

the present painting and the relative openness of its design also suggest origins in Ruisdael's late career, after 1670. The motif of the woman and child reappears in another landscape by Ruisdael in the collection of the earl of Crawford and Balcarres.[2] The landscapist Roeland Roghman (1627–1692) also made a specialty of the bridge motif (first popularized in Mannerist landscape prints) and employed the general design seen here.[3]

When the picture was cleaned and relined in 1965–66, much of the prominent monogram (already noted in the 1892 sale catalogue) proved to be a retouching but the remains of an earlier monogram beneath it may be autograph. Despite the claims of the 1965 Museum *Check List of Paintings,* no trace of the date 1658 was found during treatment in 1965–66 nor is one presently visible. Moreover, such a date would certainly be too early for a work in this style.

NOTES
1. *Landscape with River,* signed, oil on canvas, 53⅛ x 70½" (135 x 179 cm.), Brussels, inv. no. 1177.
2. *A Woodland Scene,* monogrammed, oil on canvas, 19½ x 25" (48.7 x 62.5 cm.) (Hofstede de Groot 1907–28, vol. 4 [1912], p. 154, no. 489; and Jakob Rosenberg, *Jacob van Ruisdael* [Berlin, 1928], p. 93, no. 337).
3. See Koninklijk Kabinet van Schilderijen, Mauritshuis, The Hague, *Terugzien in verwondering,* February 19–March 9, 1982, cat. no. 71.

PROVENANCE: Sale, H. Th. Höch, Munich, September 19, 1892, lot 183; Robert von Mendelssohn, Berlin; dealer Charles Sedelmeyer, Paris, 1897; sale Sedelmeyer, Lepke, Berlin, November 16, 1897, lot 42; William L. Elkins Collection, Philadelphia, by 1900.

EXHIBITION: Sedelmeyer Gallery, Paris, *Illustrated Catalogue of the Fourth Series of 100 Paintings by Old Masters,* 1897, p. 44, no. 36.

LITERATURE: Elkins 1887–1900, vol. 2, no. 123; Hofstede de Groot 1908–27, vol. 4 (1912), p. 161, no. 514; Jakob Rosenberg, *Jacob van Ruisdael* (Berlin, 1928), p. 95, no. 374; PMA 1965, p. 60 [incorrectly dated 1658].

CONDITION: The painting had previously been transferred when two old relinings were removed and a new linen canvas was attached to the paint film with wax-resin adhesive during treatment in 1965–66. The paint film has suffered extensive losses and abrasion throughout. The old fills and retouchings in the light areas were removed and replaced in 1965–66, but less extensive cleaning was undertaken in the darks because it was deemed that large areas, especially in the lower right center, were entirely lost. The monogram in the lower left dissolved like a retouching, but there were remains of an earlier monogram below. The retouchings applied in 1965–66 are extensive in both the lights and the darks. Many forms that have become thin through abrasion have been strengthened, for example, the tree at the left. The varnish is slightly discolored.

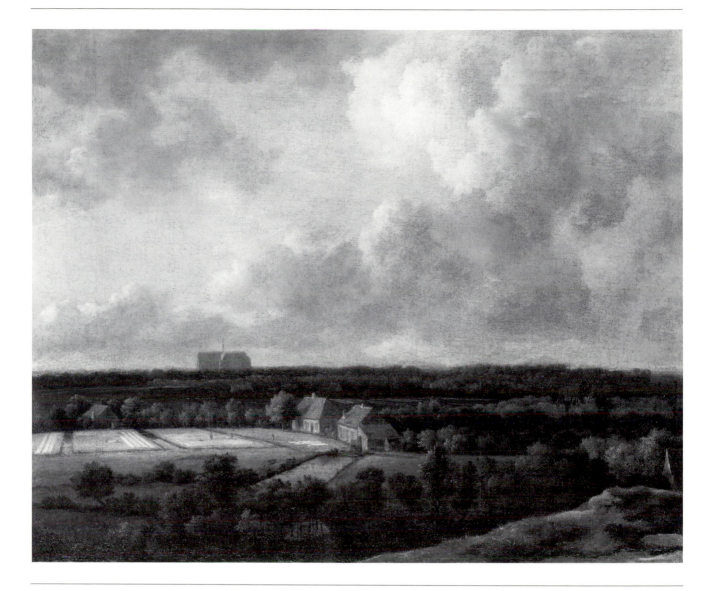

97 JACOB ISAACKSZ. VAN RUISDAEL

BLEACHING FIELDS TO THE NORTH-NORTHEAST OF HAARLEM, c. 1670–75
Illegible remnants of a signature lower right
Oil on canvas, 17¼ x 21⅛" (43.8 x 53.7 cm.)
The William L. Elkins Collection. E24-3-90

A panoramic view of Haarlem from the north with cottages, canals, and bleaching fields shows unrolled bolts of cloth spread out in fields in the foreground. The tower of St. Bavo's Church appears prominently on the horizon.

One of the foremost practitioners of the panoramic landscape, which was one of the greatest achievements of Dutch landscapists, Ruisdael painted numerous views of his native Haarlem. While he had already begun painting panoramas early in his career,[1] most of his broad views of Haarlem (none are dated) are assumed to date from about 1670–75. A reference to "een Haerlempje van Ruysdael" (a little view of Haarlem by Ruysdael) in an estate assessed in Amsterdam in 1669 establishes a *terminus ad quem* for the commencement of his work on the series.[2] Subsequently, "Haarlempje" has become the popular name used for the panoramic views of the city by Ruisdael and such artists as Jan Vermeer II of Haarlem (q.v.), Jan van Kessel (1641/42–1680), and Guillam Dubois (c. 1610–1680).

FIG. 97-1 Jacob van Ruisdael, *View of Haarlem*, signed, oil on canvas, 23½ x 30⅛" (59.7 x 77.8 cm.), Timken Art Gallery, San Diego, cat. no. 28.

In the past, the present painting has been identified as "The Bleaching Grounds of Overveen, with Haarlem in the Distance."[3] The village of Overveen lies about two and a half kilometers almost due west of Haarlem. A view of the city from this point would present the west facade of St. Bavo's, while the present work shows the north transept. In a systematic study of Ruisdael's "Haarlempjes," James Burke has sought to determine their various points of view by examining the orientation of the principal buildings (primarily St. Bavo's) on Haarlem's skyline.[4] He has concluded that these views are never exact representations of specific total prospects and that the viewing place is rarely an actual spot on the landscape. The most common viewpoints appear to have been from the north-northwest, the northwest,[5] and the west.[6] The extensive abrasion in the present work has obliterated nearly all of Haarlem's major landmarks, but like a very similar painting in the Timken Art Gallery, San Diego (fig. 97-1), it seems to depict the city from the north-northeast. The San Diego picture not only depicts a similar group of cottages in the foreground but also includes the spires of St. Jan's Kerk and St. Anne (Nieuwe) Kerk, respectively to the left and right of St. Bavo's, which have been rubbed away in the Philadelphia painting. The mound or rise in the foreground of both of these pictures, however, is probably wholly imaginary. Ruisdael often used the device of an imaginary elevated point of view to enhance the sense of the expanse and majesty of the countryside.[7]

The bleaching grounds in the present work and many of Ruisdael's other views of Haarlem were common in the vicinity of the city in his day. Bleaching linen manufactured at home and abroad was one of Haarlem's major industries. After being treated with the spring water that emerged from the foot of the dunes near Haarlem, the cloth was spread out in fields to be bleached by the sun.

NOTES

1. See the *View of Naarden, the Muiderberg and the Zuiderzee*, signed and dated 1647, oil on panel, 13¾ x 14¼" (35 x 36 cm.), Thyssen-Bornemisza Collection, Castagnola (repro. in Gertrude Borghero, *Thyssen-Bornemisza Collection: Catalogue of the Exhibited Works of Art* [Castagnola, 1981], p. 274, no. 269).
2. Bredius 1915–22, vol. 2 (1916), p. 425.
3. Hofstede de Groot 1908–27, vol. 4 (1912), pp. 28–29, no. 78; Jakob Rosenberg, *Jacob van Ruisdael* (Berlin, 1928), p. 76, no. 65; PMA 1965, p. 60.
4. James D. Burke, "Ruisdael and His Haarlempjes," *M: A Quarterly Review of the Montreal Museum of Fine Arts*, vol. 6, no. 1 (summer 1974), pp. 3–11.
5. *View of Haarlem from the Dunes*, signed, oil on canvas, 21⅞ x 24⅜" (55.5 x 62 cm.), Mauritshuis, The Hague, no. 155; *Bleaching at Haarlem*, oil on canvas, 24½ x 21¼" (62.2 x 55.2 cm.), Kunsthaus Ruzicka-Stiftung, Zurich, inv. no. R. 32; *View of Haarlem from the Northwest*, signed, oil on canvas, 17 x 15" (43 x 38 cm.), Rijksmuseum, Amsterdam, no. A351; *Oak Forest by a Lake*, signed, oil on canvas, 44⅞ x 55½" (114 x 141 cm.), Gemäldegalerie, Staatliche Museen,

Preussischer Kulturbesitz, Berlin, no. 885G; and *The Bleaching Grounds near Haarlem*, signed, oil on canvas, 21¾ x 26½" (55.2 x 67.3 cm.), The Montreal Museum of Fine Arts, no. 920. See Rosenberg (note 3), nos. 48, 44, 38, 39, and 58. For additional examples, see Burke (note 4), pp. 3–11, especially table of p. 12.
6. See Rosenberg (note 3), nos. 41 and 47.
7. See, for example, the Mauritshuis and Ruzicka-Stiftung paintings (note 5 above), as well as *The View of Haarlem*, collection of the earl of Wemyss and March, Gosford House, East Lothian, Scotland (Rosenberg [note 3], no. 46; Burke [note 4], p. 10, fig. 6).

PROVENANCE: Cardinal Fesch, Rome;[1] William L. Elkins Collection, Philadelphia, by 1900.

NOTE TO PROVENANCE

1. According to Elkins 1887–1900, no. 122, and Hofstede de Groot 1908–27, vol 4 (1912), no. 78, this work was part of the collection of Cardinal Fesch, uncle of Napoleon. The work, however, did not appear among the several Ruisdaels listed in the Galerie de Feu S. E. le Cardinal Fesch, *Catalogue raisonné des tableaux de cette galerie . . .*, March 17–April, 1845, nor in the sale catalogues of La Galerie

de Feu S. E. le Cardinal Fesch, Paris, April 17, 1843, and March 25–26, 1844.

LITERATURE: Elkins 1887–1900, vol. 2, no. 122; Hofstede de Groot 1908–27, vol. 4 (1912), pp. 28–29, no. 78; Jakob Rosenberg, *Jacob van Ruisdael* (Berlin, 1928), p. 76, no. 65; PMA 1965, p. 60; Rishel 1974, p. 29; James D. Burke, "Ruisdael and His Haarlempjes," *M: A Quarterly Review of the Montreal Museum of Fine Arts*, vol. 6, no. 1 (summer 1974), p. 11 n. 12.

CONDITION: The painting is supported with two layers of fabric: an old glue lining with the tacking edges removed and a more recent wax lining applied during the treatment undertaken from December 1965 to March 1966. The original tacking edges are missing. The paint film is considerably abraded. The paint film has suffered significant losses and considerable abrasion throughout. The sky is especially abraded. When the painting was cleaned and the old retouches were removed, the signature in the lower right corner, "Ruisdael f . . . ," proved to be largely the work of a restorer and was removed, but remnants of black lettering underneath were older, less soluble, and deemed to be possibly genuine. The varnish layer is colorless.

98 JACOB ISAACKSZ. VAN RUISDAEL

BOATS IN A STORMY SEA, after 1670
Signed lower right with a (false?) monogram
Oil on canvas, 30 x 41¼″ (76.2 x 105 cm.)
The William L. Elkins Collection. E24-3-56

Sailboats on heavy seas appear off a low coastline. Shadowed and storm-tossed waves fill the foreground. In the middle distance, silhouetted against lighted passages beyond, are two boats—one proceeding to the left with a luffing sail; the other to the right, heeling over in the stiff wind as it makes its way towards the viewer. Beyond on the right are two brightly lit sailboats under full sail. On the left, a sliver of coastline offers a glimpse of towers, windmills, and a tall beacon.

Although the monogram in the lower right has certainly been strengthened and may be entirely falsified, the attribution of the present work has been supported by Ruisdael specialists and is acceptable. Ruisdael painted a series of marines with stormy skies, choppy seas, and glimpses of shoreline on the horizon. None of the artist's approximately thirty surviving seascapes is dated, and little agreement has emerged as to their chronology. Although Jakob Rosenberg dated some marines to the 1640s, Wolfgang Stechow claimed that none predated 1660.[1] More recently, Seymour Slive has tended to agree with Rosenberg, dating works to the late 1640s and early 1650s, stressing their connection with the tradition of Jan Porcellis

FIG. 98-1 Jacob Isaacksz. van Ruisdael, *Storm Clouds over the Sea,* oil on panel, 19¼ x 25⅝" (49 x 65 cm.), Nationalmuseum, Stockholm, inv. no. NM 4033.

FIG. 98-2 Jacob Isaacksz. van Ruisdael, *Vessels in a Stormy Sea,* oil on canvas, 14 x 17½" (35.5 x 44.5 cm.), Rijksdienst Beeldende Kunst, The Hague, no. N.K. 3274.

(c. 1584–1632) and Simon de Vlieger (c. 1601–1653).[2] Porcellis's principal contribution to seascape painting was to shift emphasis from the ships to nature—the heavy seas, the overcast skies, and the moist atmosphere. Ruisdael embraced this approach, which he may have learned by way of Porcellis's follower De Vlieger.

Stechow was probably correct in dating the present work to Ruisdael's late career, after 1670.[3] With its broad expanse of water, tall sky, darkened foreground, and accented boats in the middle distance and beyond, the design of the work is encountered in two smaller paintings, *Storm Clouds over the Sea* (fig. 98-1)[4] and *Vessels in a Stormy Sea* (fig. 98-2),[5] which Slive has dated, probably correctly, to Ruisdael's earlier career.[6] While the boats in the latter painting are in similar positions—one coming about and the other heeling over, the greater scale and drama as well as the broader execution of the present work point to a later date. As Stechow observed, the boats are more massive, the clouds more threatening, and the impastoed waves bigger than in either of the rough sea paintings in Worcester and Boston, *A View of the IJ on a Stormy Day* or *Rough Sea,* which are usually dated, respectively, from the early to mid-1660s and from the mid-1660s to c. 1670.[7] In 1981 Slive concurred privately with the late dating of the Philadelphia painting.

As in his landscapes, Ruisdael seems occasionally to have reemployed motifs in his marines. The boat at the right reappears in virtually the same position in *A View on the Dutch Coast,* for example.[8] While the location of some of the artist's marines can be identified by landmarks on the shore, as with *A View of the IJ on a Stormy Day,* a precise locale has never been suggested for the present work. Nonetheless, the distant coastline resembles one in a marine that figured in the D. W. Sale, Paris, December 12, 1953, lot 3.[9] Thus, despite their moving and highly specific account of the forces of nature and man's dramatic struggle to control his vessels at sea, Ruisdael's tempestuous marines cleave to the conventions of Dutch seascape painting not only in their choice of subjects—usually gathering storms off the native coast—but also in their variation of established compositions and motifs.[10]

NOTES
1. See Jakob Rosenberg, *Jacob van Ruisdael* (Berlin, 1928), pp. 15, 40; Wolfgang Stechow, *Dutch Landscape Painting of the Seventeenth Century* (London, 1966), p. 122.
2. Seymour Slive and H. R. Hoetink, *Jacob van Ruisdael* (New York, 1981), p. 49.
3. Stechow (see note 1), p. 122.
4. Rosenberg (see note 1), no. 600.
5. See Hofstede de Groot 1908–27, vol. 4 (1912), no. 952; Rosenberg (note 1), no. 587.
6. See Slive and Hoetink (note 2), pp. 48–49, cat. no. 11, repro., and fig. 20, respectively dated "in the late 1640s or early 1650s" and "a bit earlier."
7. *View of the IJ on a Stormy Day,* signed, oil on canvas, 25⅞ x 32⁹⁄₁₆" (65.8 x 82.7 cm.), Worcester Art Museum, no. 1940.52 (Hofstede de Groot 1908–27, vol. 4 [1912], no. 959; Rosenberg [note 1] no. 594; Stechow [see note 1] p. 122, as dated in the mid-1660s; Slive and Hoetink [see note 2], no. 32, as early 1660s); *Rough Sea,* signed, oil on canvas, 42⅛ x 49½" (107 x 125.7 cm.), Museum of Fine Arts, Boston, no. 57.4 (Hofstede de Groot

1908–27, vol. 4 [1912], no. 957 [as c. 1660]; Rosenberg [note 1] no. 591 [as c. 1670]; Stechow [note 1] p. 122 [as "not much before 1670"]; Slive and Hoetink [note 2], cat. no. 48 [as c. 1670]).
8. Oil on canvas, 18⅞ x 23⅝" (48 x 60 cm.), sale, Sotheby's, London, July 22, 1937, lot 86, repro.; Hofstede de Groot 1908–27, vol. 4 (1912), no. 971.
9. *A Stormy Sea,* signed, oil on panel, 18⅛ x 24" (46 x 61 cm.); Hofstede de Groot 1908–27, vol. 4 (1912), no. 965, and Rosenberg (see note 1), no. 601.
10. On the conventionality of Dutch marine painting generally, see Lawrence O. Goedde, "The Interpretation of Dutch and Flemish Tempest Painting," *Simiolus,* vol. 16, nos. 2/3 (1986), pp. 139–49.; and Lawrence O. Goedde, *Tempest and Shipwreck in Dutch and Flemish Art: Convention, Rhetoric, and Interpretation* (University Park, Pa., 1989).

PROVENANCE: Thomas Agnew & Sons, London [from sticker on frame]; William L. Elkins Collection, Philadelphia, by 1900.

LITERATURE: Elkins 1887–1900, vol. 2, no. 124; Hofstede de Groot 1908–27, vol. 4 (1912), no. 963; Jakob Rosenberg *Jacob van Ruisdael* (Berlin, 1928), p. 109, no. 599; Wolfgang Stechow, *Dutch Landscape Painting of the Seventeenth Century* (London, 1966), p. 122, pl. 248; PMA 1965, p. 60; Rishel 1974, p. 29, fig. 4.

CONDITION: The wax-resin-lined fabric support was weak, brittle, and had a small tear in the upper left when it was lined in 1973. The tacking margins show some evidence of the continuation of the design, suggesting that the original dimensions of the picture were slightly larger. Large areas of the sky and boats are very thin. A *repentir* in the boat silhouetted at the right indicates that it was painted over the clouds behind. The sky and edges show numerous retouches. Features of the boats have been strengthened. The varnish is uneven and slightly yellowed.

Salomon Jacobsz. van Ruysdael was born in Naarden in Gooiland. He was originally called Salomon de Gooyer or Goyer (that is, Salomon from Gooiland) but he and his brother Isaack (1599–1677), who was also an artist, adopted the name Ruysdael, probably from Castle Ruisdael (or Ruisschendael), near their father's hometown. Salomon also spelled his name Ruijsdael and occasionally Ruysdael, but never Ruisdael like his more famous nephew Jacob Isaacksz. van Ruisdael (q.v.). In 1623 Salomon entered the painters' guild in Haarlem (as Salomon de Gooyer), was named a deacon in 1648, and was still active in the guild in 1669. His earliest known dated painting is of 1626, and he was praised as a landscapist as early as 1628 by the chronicler of Haarlem, Samuel van Ampzing (*Beschrijvinge ende Lof der Stad Haarlem* [Haarlem, 1628]). He was called a merchant in 1651 and dealt in blue dye for bleacheries. His wife, Maycken Willems Buysse, was buried in St. Bavo's Church in Haarlem on December 25, 1660. Salomon was a Mennonite and in 1669 was a member of the "Vereenigde Vlaamsche, Hoogduitsche en Friesche Gemeente" when he was living on the Kleyne Houtstraat. As a Mennonite he could not bear arms but contributed to Haarlem's civic guard. Although Salomon seems to have lived and worked in Haarlem his entire life, he probably made several trips in the Netherlands; he made views of Leiden, Utrecht, Amersfoort, Arnhem, Alkmaar, Rhenen, Dordrecht, and Nijmegen, among other places. The artist was buried in St. Bavo's Church in Haarlem on November 3, 1670.

Although his teacher is unknown, his earliest works of about 1626–29 recall the art of Esaias van de Velde (c. 1590–1630), who was working in Haarlem from 1609 to 1618. In addition to Van de Velde's influence, his early works reveal many parallels with Jan van Goyen's work. Together with Pieter de Molijn (1595–1661), Salomon van Ruysdael and Jan van Goyen (q.v.) were the leading "tonal" landscapists of their generation and seem to have influenced one another. Together they laid the foundation for the great "classical" period of Dutch landscape painting that followed. Besides landscapes and numerous river- and seascapes of a calm but never stormy type, he also painted a few still lifes in his later years. Besides being the uncle of Jacob Isaacksz. van Ruisdael, Salomon was the father of Jacob Salomonsz. van Ruysdael (1629/30–1681), also a painter.

LITERATURE: Houbraken 1718–21, vol. 2, p. 124, vol. 3, p. 66; Descamps 1753–64, vol. 3, p. 11; Wurzbach 1906–11, vol. 2, pp. 524–25; H. F. Wijnman, "Het leven der Ruysdaels," *Oud Holland*, vol. 49 (1932), pp. 49–60, 173–81, 258–75; K. E. Simon in Thieme-Becker 1907–50, vol. 29 (1935), pp. 189–90; Kunsthandel J. Goudstikker, Amsterdam, *Salomon van Ruysdael*, 1936; Wolfgang Stechow, *Salomon van Ruysdael: Eine Einführung in seine Kunst mit kritischem Katalog der Gemälde* (Berlin, 1938; 2nd ed., rev. and enl., Berlin, 1975); Wolfgang Stechow and Annet Hoogendoorn, "Het vroegst bekende werk van Salomon van Ruysdael," *Kunsthistorische Mededeelingen*, vol. 2 (1947), pp. 36–39; J. Niemeyer, "Het topografisch element in enkele riviergezichten van Salomon van Ruysdael

nader beschouwd," *Oud Holland*, vol. 74 (1959), pp. 51–56; H.J.J. Schotens, "Salomon van Ruysdael in de contreien van Holland's landengte," *Oud Holland*, vol. 77 (1962), pp. 1–10; Wolfgang Stechow, *Dutch Landscape Painting of the Seventeenth Century* (London, 1966), pp. 23–28, 38–43, 54–62, 90–91, 103, 113–16; Laurens J. Bol, *Die holländische Marinemalerei des 17. Jahrhunderts* (Brunswick, 1973), pp. 148–56; Mauritshuis, The Hague, *Hollandse schilderkunst: Landschappen 17de eeuw* (The Hague, 1980), pp. 94–99; Sutton et al. 1987, pp. 466–75.

For additional works by Salomon van Ruysdael in the Philadelphia Museum of Art, see John G. Johnson Collection cat. nos. 467, 466, 468.

99 SALOMON VAN RUYSDAEL

LANDSCAPE WITH CATTLE AND AN INN, 1661
Signed lower left: *S. Ruysdael 1661*
Oil on panel, 30 x 43⅛″ (76.2 x 109.5 cm.)
The William L. Elkins Collection. E24-3-55

A road leads from the distant horizon on the right to the foreground where
it fills the full width of the picture. Alongside pools in the road left by a
recent storm, drovers lead a herd of cattle, three pigs, and a goat. On the
loamy rise of the roadside at the left several tall trees are silhouetted against
the sky. In the distance at the right, travelers in carts and carriages have
stopped at an inn.

This important, later work by Ruysdael was praised by Wolfgang
Stechow in 1939 for its "remarkable beauty and stateliness, and . . . careful
finish."[1] He characterized it as a late adaptation of the painting type
represented by *A Country Road* of 1648 in the Metropolitan Museum of Art
in New York (fig. 99-1).[2] In that similar composition, tall trees also appear
at the left and a road traveled by herdsmen and their cattle spreads out, or
more precisely divides, in the foreground. The theme of the halt before the
inn was one of Ruysdael's favorites; paintings with this subject range in
date from 1635 to 1667.[3] In the present work, the monumental design, the
renewed use of bright local color, and the large trees, exhibiting what
Stechow characterized as "granular foliage," are typical of Ruysdael's later

FIG. 99-1 Salomon van Ruysdael, *A Country Road,* signed and dated 1648, oil on canvas, 38⅞ x 52⅞" (98.7 x 134.3 cm.), The Metropolitan Museum of Art, New York, no. 06.1201.

FIG. 99-2 Salomon van Ruysdael, *Landscape with an Inn,* signed and dated 1657, oil on canvas, 44⅛ x 59⁹⁄₁₆" (112 x 150 cm.), Ashmolean Museum, Oxford, no. A1065.

FIG. 99-3 Salomon van Ruysdael, *Landscape with an Inn,* signed and dated 1663, oil on panel, 21¹⁄₁₆ x 25" (53.5 x 63.5 cm.), private collection, Berlin.

phase. Although the date was deciphered as 1663 when the picture was exhibited by Sedelmeyer in 1896, it clearly reads 1661. Other comparable landscapes by Ruysdael from this and a slightly earlier period, showing drovers on a wooded road sweeping back to an inn or other buildings, are found in Oxford (fig. 99-2),[4] a German private collection (dated 1659),[5] formerly the Lilienfeld Collection, New York (probably dated 1663),[6] and formerly with Agnew's, London.[7] Especially close in design to the Philadelphia painting is a smaller panel dated 1663 (fig. 99-3), which was with the dealer Cramer in The Hague in 1972 and now is in a Berlin private collection.[8] Even individual motifs such as the white cow recur, proving that, while Ruysdael worked from a stock of studies (though no drawings by his hand have been discovered) and varied an established repertory of designs, his results are never mechanical but always fresh. The painstaking execution and the paint film's good state of preservation in the Philadelphia painting illustrate well Ruysdael's refined later technique.

NOTES

1. Wolfgang Stechow, "Salomon van Ruysdael's Paintings in America," *Art Quarterly,* vol. 2 (1939), p. 260.
2. Wolfgang Stechow, *Salomon van Ruysdael: Eine Einführung in seine Kunst mit kritischem Katalog der Gemälde,* 2nd ed., rev. and enl. (Berlin, 1975), p. 98, no. 196. Compare also *The Inn,* 1645, oil on panel, 27½ x 36¼" (70 x 92 cm.), collection of H. E. ter Kuile, Entschede, The Netherlands (Stechow, p. 91, no. 153, pl. 29).
3. See Stechow (note 2), pp. 89–93, nos. 145–65; and Sutton et al. 1987, under cat. nos. 91 and 92.
4. See Stechow (note 2), p. 92, no. 156, pl. 42.
5. Oil on panel, 24 x 31⅞"(61 x 81 cm.); see Stechow (note 2), p. 92, no. 157.
6. Oil on canvas, 31½ x 41¼" (80 x 105 cm.); see Stechow (note 2), p. 93, no. 165, pl. 68.
7. c. 1660, oil on canvas, 33½ x 39¾" (85 x 101 cm.); see Stechow (note 2), p. 94, no. 174.
8. Repro. in Jan Kelch with Ingeborg Becker, *Holländische Malerei aus Berliner Privatbesitz* (Berlin, 1984), no. 59.

PROVENANCE: Sedelmeyer Gallery, Paris, 1896; acquired for the William L. Elkins Collection, Philadelphia, 1898.

EXHIBITION: Sedelmeyer Gallery, Paris, *Illustrated Catalogue of the 3rd Series of 100 Paintings by Old Masters,* 1896, no. 40.

LITERATURE: Elkins 1887–1900, vol. 2, no. 125, repro.; Wolfgang Stechow, "Salomon van Ruysdael's Paintings in America," *Art Quarterly,* vol. 2 (1939), p. 260; PMA 1965, p. 60; Rishel 1974, p. 29, fig. 1; Wolfgang Stechow, *Salomon van Ruysdael: Eine Einführung in seine Kunst mit kritischem Katalog der Gemälde,* 2nd. ed., rev. and enl. (Berlin, 1975), p. 98; no. 160.

CONDITION: The horizontally grained panel was cradled and a ½" (1.3 cm.) strip added at the bottom edge. Sometime before the picture was examined and treated in 1966, the open joins between the three panel members were reglued, planed flat, and extensively retouched. During the treatment in 1966 the old, discolored overpaint was removed and scattered losses as well as two lesser horizontal cracks at the upper left were inpainted. Little abrasion is visible. The varnish was replaced at the time of treatment and remains colorless.

Born about 1440, Ludwig was the son of the goldsmith Caspar Schongauer the Elder and the younger brother of the more famous artist Martin Schongauer (c. 1435–1491). The family came from Schongau, moved to Augsburg, and settled in Colmar by 1445. Active in Ulm by 1472, Ludwig acquired citizenship in that city in 1479 but became a citizen of Augsburg in 1486, when he applied for permission to take on several students. In 1491 he returned to Colmar, where he died in 1494.

Four engravings are signed with Ludwig's initials, and he was active as a woodcut designer. Only recently have paintings been assigned to his hand.

LITERATURE: Hans Rott, *Quellen und Forschungen zur südwestdeutsche und schweizerischen Kunstgeschichte im XV. und XVI. Jahrhundert*, vol. 2, *Alt-Schwaben und die Reichsstädte* (Stuttgart, 1934), pp. 19, 23; Max Lehrs, *Geschichte und kritischer Katalog des deutschen, niederländischen, und französischen Kupferstichs im XV. Jahrhundert*, vol. 6 (Vienna, 1927; reprint, Nendeln, Lichtenstein, 1969), pp. 55–63; Alfred Stange, "Ludwig Schongauer, Maler, Reisser und Kupferstecher," *Das Münster,* vol. 7 (1954), pp. 82–93; Alfred Stange, *Deutsche Malerei der Gotik*, vol. 8 (Munich and Berlin, 1957; reprint, Nendeln, Lichtenstein, 1969), pp. 17–20; Bruno Bushart, "Studien zur altschwäbischen Malerei" [review of Alfred Stange, *Deutsche Malerei der Gotik*], *Zeitschrift für Kunstgeschichte,* vol. 22 (1959), pp. 139–43.

100 ATTRIBUTED TO
LUDWIG SCHONGAUER

FIG. 100-1 Attributed to Ludwig Schongauer, *The Annunciation,* oil on panel, 19¼ x 11¹³/₁₆″ (49 x 30 cm.), F. Sarre Collection.

THE NATIVITY, c. 1480–90
Oil on panel, 18¼ x 11¼″ (46.4 x 28.6 cm.)
The John D. McIlhenny Collection. 43-40-44

In the middle of this scene of the Nativity, the Madonna kneels before the newborn Christ child, who rests on a pile of straw on the floor near two adoring angels. At the left stands Joseph holding a candle. The Annunciation to the shepherds is depicted in the distance at the upper left; in the foreground two shepherds look in at the window and doorway while a third ventures inside to kneel in reverence. The stable is conceived as a semienclosed romanesque-style structure covered with vines on the outside and housing, in addition to the main figures, a cow and a donkey.

When the picture was acquired by John D. McIlhenny from the dealers Boehler and Steinmeyer in 1913, it was believed to be a work by Bartholomäus Zeitblom (c. 1455/60–1518/22), the influential Ulm painter, who was active around 1500. This attribution and date, later supported by Charles Kuhn,[1] were said on the bill of sale to have been recommended by W. R. Valentiner. While no argument for the attribution was recorded, it probably stemmed from the work's superficial resemblance in design to Zeitblom's *Nativity* scene in Bingen, a similarity that suggests shared sources rather than a common hand.[2] Friedrich Winkler in 1956 rejected the attribution to Zeitblom, preferring to attribute it to an anonymous Swabian painter of the last third of the fifteenth century.[3] He also correctly associated the work with a scene of the *Annunciation,* then in the collection

of the Islamic scholar F. Sarre (fig. 100-1) and a *Circumcision* owned by the
Louvre (fig. 100-2). As Winkler concluded, these three works are almost
certainly by the same hand and probably formed parts of a lost altarpiece
devoted to the life of Mary. The smaller size of the Philadelphia panel
results from its having been cut down on all sides, a dismemberment first
noted by Henri Marceau in 1944.[4] One can easily imagine that the present
work originally was about three centimeters (1³⁄₁₆″) taller and two to four
centimeters (³⁄₄–1⁹⁄₁₆″) wider. The charmingly naive conception and style of
these three panels suggested to Winkler an earlier date (c. 1480) than had

FIG. 100-2 Attributed to Ludwig Schongauer, *The Circumcision*, oil on panel, 19⅛ x 12¾" (49.8 x 32.3 cm.), Musée du Louvre, Paris, inv. no. R.F. 1943–44.

FIG. 100-3 Martin Schongauer, *The Nativity*, engraving, 10⅛ x 6⅛" (258 x 170 mm.).

FIG. 100-4 Attributed to Ludwig Schongauer, *The Visitation*, oil on panel, 16⅛ x 12¹⁄₁₆" (41 x 31 cm.), Hessisches Landesmuseum, Darmstadt, inv. no. 15A.

previously been proposed for any of the works. He also correctly observed a stylistic resemblance to the engravings and paintings of Martin Schongauer (c. 1435–1491).

In his review of Alfred Stange's book, Bruno Bushart took up this point, offering specific comparisons to Martin's *Nativity* in the Städelsches Kunstinstitut in Frankfurt and his famous *Nativity* engraving (fig. 100-3).[5] The figure of Mary, the heads of the ass and the cow, and the shepherds receiving the Annunciation in the distance—all paraphrase details of the print. To the parts from the lost altarpiece already mentioned, Bushart also added two panels in the Hessisches Landesmuseum in Darmstadt—*The Visitation* (fig. 100-4) and *The Adoration of the Magi* (fig. 100-5).[6] These works are of nearly identical dimensions and employ the same simplified technique. While Stange was the first to connect the Louvre panel (fig. 100-2) with the artist's name, Bushart was the first to assign the entire group to Ludwig Schongauer, Martin's brother. Efforts to reconstruct Ludwig's painted oeuvre began only in 1954 when Stange attributed to his hand *The Circumcision* and four wings from an altar that originally stood in the Wengen Cloister in Ulm.[7] The practice of attributing paintings on the basis of formal connections with prints is problematic; in this case, however, it is reasonable to assume that the influences from Martin Schongauer's art, which are so very evident in his brother's prints, would also manifest themselves in the latter's paintings. More recently, in 1970, Stange qualified the attribution, assigning it to Ludwig's workshop,[8] a change that implies finer distinctions than are permissible given the present understanding of the master's work.

NOTES
1. Charles L. Kuhn, *A Catalogue of German Paintings of the Middle Ages and Renaissance in American Collections* (Cambridge, Mass., 1936), no. 246.
2. See Alfred Stange, *Deutsche Malerei der Gotik,* vol. 8 (Munich and Berlin, 1957; reprint, Nendeln, Lichtenstein, 1969), pl. 45.
3. Friedrich Winkler, "A Suabian Painter of about 1480," translated by Liselotte Moser, *The Art Quarterly,* vol. 19, no. 3 (autumn 1956), p. 256.
4. Henri Marceau, "The McIlhenny Collection: Inaugural Exhibition," *The Philadelphia Museum Bulletin,* vol. 39, no. 200 (January 1944), p. 54.
5. Oil on panel, 15 x 11¾" (38.1 x 29.7 cm.), inv. no. SG444. See Bruno Bushart, "Studien zur altschwäbischen Malerei," *Zeitschrift für Kunstgeschichte,* vol. 22 (1959), p. 139.
6. E. Buchner first observed the connection with the Darmstadt panel verbally in 1958, according to Rathaus, Augsburg, *Hans Holbein der Ältere und die Kunst des Spätgotik,* 1965, p. 128. *The Adoration of the Magi,* it should be noted, has been cut down at the top and on the right.
7. See Alfred Stange, "Ludwig Schongauer, Maler, Reisser und Kupferstecher," *Das Münster,* vol. 7 (1954), pp. 82–93.
8. See Alfred Stange, *Kritisches Verzeichnis der deutschen Tafelbilder vor Dürer,* vol. 2 (Munich, 1970), p. 131.

PROVENANCE: The Reverend L. Douglas, Scotland; sale, dealers Boehler and Steinmeyer, New York, to John D. McIlhenny, Philadelphia, January 9, 1913.

EXHIBITIONS: Pennsylvania Museum (Philadelphia Museum of Art), *John D. McIlhenny Memorial Exhibition,* March–April 1926; The Germanic Museum, Harvard University Art Museums, Cambridge, Massachusetts, *Catalogue of the Germanic Museum Exhibition of German Paintings of the Fifteenth and Sixteenth Centuries Lent from American Collections,* June 5–September 30, 1936, no. 28 [as Bartholomäus Zeitblom, c. 1500].

LITERATURE: Arthur Edwin Bye, "The McIlhenny Bequest and Exhibition," *The Pennsylvania Museum Bulletin* (Philadelphia Museum of Art), vol. 21, no. 100 (February 1926), p. 91, Charles L. Kuhn, *A Catalogue of German Paintings of the Middle Ages and Renaissance in American Collections* (Cambridge, Mass., 1936), no. 246, pl. LXVIII [as probably Bartholomäus Zeitblom, c. 1500]; Henri Marceau, "The McIlhenny Collection: Inaugural Exhibition," *The Philadelphia Museum Bulletin,* vol. 39, no. 200 (January 1944), pp. 54, 59, repro. [as Bartholomäus Zeitblom]; Friedrich Winkler, "A Suabian Painter of about 1480," translated by Liselotte Moser, *The Art Quarterly,*

FIG. 100-5 Attributed to Ludwig Schongauer, *The Adoration of the Magi,* oil on panel, 16½ x 11¹³⁄₁₆″ (42 x 30 cm.), Hessisches Landesmuseum, Darmstadt, inv. no. 15B.

vol. 19, no. 3 (autumn 1956), p. 256, fig. 2 [as the Ulm Master, under the influence of Martin Schongauer, c. 1480]; Bruno Bushart, "Studien zur altschwäbischen Malerei" [review of Alfred Stange, *Deutsche Malerei der Gotik*], *Zeitschrift für Kunstgeschichte,* vol. 22 (1959), p. 139 [as attributed to Ludwig Schongauer]; Rathaus, Augsburg, *Hans Holbein der Ältere und die Kunst des Spätgotik,* 1965, pp. 127–28; Alfred Stange, *Kritisches Verzeichnis der deutschen Tafelbilder vor Dürer,* vol. 2 (Munich, 1970), p. 131, no. 606b [as the workshop of Ludwig Schongauer].

CONDITION: The panel support has been cradled, but is not in plane and reveals considerable buckling at old breaks. The painting was probably transferred from panel onto fabric and then mounted onto a four-membered ¼″ (0.6 cm.) thick softwood panel with a cradle, given that the orientation of the finer network of cracks in the paint film is vertical (indicating a vertically oriented wood grain in the original panel), whereas in the present mount the grain is horizontal. The painting has certainly been cut down on the left and at the bottom edge. A ¼″ (0.6 cm.) wide red stripe is painted down the right edge.

Three horizontal cracks relating to joins run the full width of the panel: at the height of the forehead of the man in the arched doorway, at the height of Joseph's shoulders, and through Joseph's knees and the Virgin's waist. These cracks have been inpainted, and a large loss in the lower left has been filled. Between the lower two of these three cracks, a regular fine horizontal striped imprint remains visible, possibly from the transfer operation. The paint film generally shows minor abrasion and is further disrupted by less prominent horizontal cracks and an uneven surface across the bottom, in the green background, and in the brown pillar in the upper left. Other scattered retouches—as in Joseph's robes, in the wall behind, and elsewhere—are extensive, but do not match the original colors. The varnish is dull, uneven, and slightly discolored.

Born in Frankfurt, Schreyer came from a prominent and wealthy family. A student of Jakob Becker (1810–1872), the artist traveled widely before settling in 1862 in Paris, where he won medals in 1864, 1865, and 1867. He followed a regiment in the Crimean War in 1855. He also visited Algiers, and other eastern regions (Turkey, Walachia, and southern Russia), as well as all the principal countries of western Europe. A popular and critical success in his own time (see especially the Salon reviews of his work by Théophile Gautier), Schreyer won a medal in Brussels in 1863, the Cross of the Order of Léopold in 1864, and another medal in Vienna in 1873. In 1862 he was made painter to the court of the grand duke of Mecklenburg-Schwerin. He did not return to Germany, however, until the outbreak of the Franco-Prussian War in 1870.

His paintings are mostly of horses and battle scenes. He specialized in two exotic themes: Russian or east European rural views, especially snow scenes, and pictures of Bedouin horsemen. His palette and technique were inspired by Eugène Delacroix (1798–1863) but were less assured than that master's. Schreyer's paintings were much sought after by American nineteenth-century collectors, which explains their extensive representation in museums in the U.S.

LITERATURE: Boetticher (1891–1901) 1969, vol. 2, pp. 653–54; Thieme-Becker 1907–50, vol. 30 (1936), p. 286; Paine Art Center and Arboretum, Oshkosh, Wisconsin, *Adolf Schreyer,* June 8–July 30, 1972; Philippe Jullian, *The Orientalists: European Painters of Eastern Scenes,* translated by Helga Harrison and Dinah Harrison (Oxford, 1977), p. 72; Edward W. Said, *Orientalism* (New York, 1978); Michelle Verrier, *The Orientalists* (New York, 1979); Donald A. Rosenthal, *Orientalism: The Near East in French Painting 1800–1880* (New York, 1982), pp. 126–28; Royal Academy of Arts, London, and National Gallery of Art, Washington, D.C., *The Orientalists: Delacroix to Matisse. The Allure of North Africa and the Near East,* 1984, p. 204.

101 ADOLF SCHREYER

WALACHIAN POST HOUSE, 1867
Signed lower right in script: *Ad Schreyer/Paris 1867*
Oil on canvas, 38¼ x 62″ (97.2 x 157.5 cm.)
The William L. Elkins Collection. E24-3-20

On a snowy, windswept road in a forest, a traveler has stopped his crude, horsedrawn sleigh before a rustic post house. Followed by his dog, he crosses the threshold at the right as smoke emerges from the darkened interior. In addition to the three horses hitched to the traveler's wicker-covered sleigh, a fourth, wearing a saddle, is tied to the foremost post of the thatched porch sheltering the horses.

Schreyer painted this scene in Paris in 1867 but doubtless worked from recollections of his travels in Walachia in eastern Europe that he had undertaken following his journey with the Crimean campaign in 1855. The painting adopts virtually the same design as Schreyer's so-called *Searching for Smugglers* (fig. 101-1), another work painted in Paris about this time. In that painting, however, the visitor is an armed gendarme who beats on the door of what apparently is a hideout. Compare also Schreyer's *Horsedrawn Sleigh before a Hut.*[1]

FIG. 101-1 Adolf Schreyer, *Searching for Smugglers,* signed, oil on canvas, 35⅛ x 45½″ (89.3 x 115.6 cm.), Kunsthalle, Hamburg, no. 1871.

NOTE
1. Sale, Lempertz, Cologne, June 11–14, 1958, lot 399, repro.

PROVENANCE: Sale, American Art Association, New York; William L. Elkins Collection, Philadelphia, by 1900.

LITERATURE: Elkins 1897–1900, vol. 1, no. 47, repro., 1924, no. 20; Thieme-Becker 1907–50, vol. 30 (1936), p. 286; PMA 1965, p. 62.

CONDITION: The canvas support is slack and has corner draws. The paint film has scattered losses and extensive retouching. Areas of cleavage were relaxed, flaking paint reattached, and losses inpainted in 1974. The varnish is deeply discolored.

102 ADOLF SCHREYER

ARAB HORSEMEN
Signed lower left in script: *Ad. Schreyer*
Oil on canvas, 35¼ x 45⅞″ (89.5 x 116.5 cm.)
Gift of Walter Lippincott. 23-59-1

Two Arabs holding guns and riding horses have stopped to confer in the center foreground at a pool of water. At the left beneath a rocky bluff other horsemen have assembled, seemingly awaiting word from the leaders in the foreground. In the distance at the right appears the skyline of a city.

Like Schreyer's many other romantic scenes of "Oriental" horsemen, this work owes much to earlier paintings by Alexandre Gabriel Decamps (1803–1860), Eugène Delacroix (1798–1863), and, above all, Eugène Fromentin (1820–1876).

PROVENANCE: Walter Lippincott.

EXHIBITION: The Free Library, Philadelphia, 1954.

LITERATURE: PMA 1965, p. 62.

CONDITION: The unlined canvas support is slack and has corner draws. The paint film exhibits mechanical and traction crackle across the central portion of the painting, and in the distant landscape at the left. The paint film is abraded in the blue sky. Retouches are scattered through the foreground. A very thick, deeply discolored varnish obscures the painting, particularly in the sky.

103 ADOLF SCHREYER

ARAB HORSEMEN, c. 1887–90
Signed lower right in script: *Ad. Schreyer*
Oil on canvas, 25¼ x 34″ (64.1 x 86.4 cm.)
Bequest of Chester Waters Larner. 1977-258-1

A troop of Arab horsemen led by one man on a black horse and one on a white steed have stopped at the edge of a ford. The lead horseman looks back at his followers, who stretch back diagonally into the distance.

While treating a subject similar to that of the preceding picture, this painting probably postdates that work and appears to be a product of the artist's late career, about 1887–90.

PROVENANCE: Brought from Europe to New York by dealer Howard Young, c. 1920; sold to William Carnill, Rydal, Pennsylvania; sale, Samuel T. Freeman & Co., Philadelphia, May 21, 1940, lot 318 [as "The Arab Patrol"], to Chester W. Larner; bequest of Chester W. Larner following life interest of Norma H. Fauzon.

CONDITION: The canvas support is lined with an aqueous adhesive. The tacking edges are missing. The paint film exhibits an overall crackle pattern with very slight cupping. There is a stretcher crease associated with the vertical cross member. The central figure's head is slightly abraded. The varnish was selectively removed at some time before the work was acquired in 1977. The paint film has a very resinous quality. The brush marking and impasto are somewhat flattened. Retouches are limited. Light blue repaint appears chalky. The varnish is glossy and moderately discolored.

104 REPLICA OR COPY OF
DANIEL SEGHERS

GARLAND OF FLOWERS WITH CARTOUCHE OF THE MADONNA AND CHILD
Oil on canvas, 40 x 29″ (101.6 x 73.6 cm.)
Purchased for the W. P. Wilstach Collection. W04-1-54

A grisaille cartouche, designed to imitate masonry and depicting within the
ornamental stone border the Madonna and standing Christ child holding an
orb, is decorated with a garland of flowers. Suspended by ivy vines dropped
from either side of the top of the cartouche, the blossoms include tulips,
roses, carnations, jonquils, nasturtiums, poppies, and other flowers. The top
of the cartouche is decorated with orange blossoms.

 This is probably a replica or copy of a slightly smaller and fresher
painting, which was exhibited at the Philadelphia Museum of Art in 1963 by
Mr. and Mrs. John Goelet (fig. 104-1).[1] Judging only from photographs,
that unsigned work's traditional attribution to Daniel Seghers (1590–1661)

FIG. 104-1 Daniel Seghers, *Madonna and Child in Garland,* oil on canvas, 38 x 27½" (96.5 x 69.5 cm.), Mr. and Mrs. John Goelet Collection.

warrants provisional support, but it must be noted that the works of Seghers's students, such as Jan Philips van Thielen (1618–c. 1667) and followers, can closely approximate his style.[2]

Together with his teacher, Jan Brueghel I (1568–1625), the Jesuit painter Daniel Seghers is generally considered to be the greatest of Flemish flower painters. Seghers entered the noviate of the Society of Jesus in 1614 as coadjutor, but only took his vows in Brussels in 1625. Seghers remained a lay brother, but never became a priest. Most frequently his works take the form of garlands painted around a central religious scene that usually was painted by other artists, including Cornelis Schut (1597–1655), Erasmus Quellin (1607–1678), Simon de Vos (1603–1676), Abraham van Diepenbeeck (1596–1675), Thomas Willeboirts Bosschaert (1614–1654), Gerard Seghers (1591–1651), Peter Paul Rubens (q.v.), Hendrick van Balen (1575–1632), and Antonie Goubau (1616–1698). This collaborative practice was documented in each case by the artist himself in a checklist that he compiled—evidently in roughly chronological order—of all his garland and flower pieces.[3] The artist who painted the central subject in the original or prime version has not been identified, but the figure types, especially the Christ child who eyes the viewer so pointedly, resemble those of Cornelis Schut. Of the thirty-six garlands with "Maria beeldeken" (little Mary figures) listed in Seghers's inventory, no less than half were executed by Schut.[4] It is also possible, though less likely on stylistic grounds, that the cartouche was executed by Erasmus Quellin. The entry "a cartouche . . . with a Mary figure in white and black by Sr Quelinus" also figured in Seghers's inventory, a unique case in which Seghers specified a work as a grisaille.[5] Other garlands by Seghers with half-length grisaille images of the Madonna and child are found in the Pushkin Museum in Moscow and the Gemäldegalerie Alte Meister, Staatliche Kunstsammlungen in Dresden;[6] the artist often included additional saints in such scenes.[7]

NOTES
1. Repro. in Philadelphia Museum of Art, *A World of Flowers,* May 2–June 9, 1963, p. III.
2. On Van Thielen, see Marie-Louise Hairs, *Les Peintres flamands de fleurs au XVIIe siècle* (Paris and Brussels, 1955), pp. 107–10; Marie-Louise Hairs, "Garpard Thielens, peintre flamand du XVIIe siècle," *Revue Belge d'Archéologie et d'Histoire de l'Art,* vol. 28 (1959), pp. 37–42.
3. Published by Walter Couvreur, "Daniël Seghers' inventaris van door hem geschilderde bloemstukken," *Gentsche bijdragen tot de kunstgeschidenis,* vol. 20 (1967), pp. 87–157. For Seghers, see Houbraken 1718–21, vol. 1, pp. 140–41; J. F. Kieckens, *Daniel Seghers de la compagnie de Jésus, peintre de fleurs: Sa vie et ses oeuvres* (Ghent, 1845); Wurzbach 1906–11, vol. 2, pp. 613–14; Thieme-Becker 1907–50, vol. 30 (1936), p. 443; Marie-Louise Hairs, *Les Peintres flamands de fleurs au XVIIe siècle* (Paris and Brussels, 1955), pp. 51–86, 233–40; Marie-Louise Hairs, "Collaboration dans les tableaux de fleurs flamands," *Revue Belge d'Archéologie et d'Histoire de l'Art,* vol. 26

(1957), pp. 150, 152–62; Marie-Louise Hairs in Musées Royaux des Beaux-Arts de Belgique, Brussels, *Le Siècle de Rubens,* October 15–December 12, 1965, pp. 238–41; Hans Vlieghe, "Grisailles van Erasmus Quellin in bloemstukken van Daniel Seghers: Een rechtzetting," *Musées Royaux des Beaux-Arts de Belgique Bulletin,* vol. 16 (1967), pp. 295–301; Walther Bernt, *The Netherlandish Painters of the Seventeenth Century,* translated by P. S. Falla, vol. 3 (London, 1970), p. 106; Hervé Oursel, in *Peinture flamande au temps de Rubens, trésors des Musées du Nord de la France* (Lille, Calais, and Arras, 1977), pp. 119–20; Jacques Foucart in Galeries Nationales d'Exposition du Grand Palais, Paris, *Le Siècle de Rubens dans les collections publique françaises,* November 17, 1977–March 13, 1978, pp. 212–15.
4. See Couvreur (note 3), pp. 87–157. The painter evidently designated the Madonna and child theme as a Mary subject since no separate listings for the theme appear.
5. "Een cartel . . . met een maria beeldeken van wit en swart van Sr Quelinus." See Couvreur (note 3), p. 112, no. 134.

6. Pushkin Museum, Moscow, no. 1931; and signed, oil on canvas, 33⅜ x 25⅜" (85.5 x 64.5 cm.), Gemäldegalerie Alte Meister, Dresden, no. 1206.
7. See, for example, *Flowers Encircling a Relief,* signed "Daniel Seghers, Soctis, Jesu," oil on canvas, 37⅞ x 21½" (96.2 x 69.9 cm.), Dulwich Picture Gallery, London, cat. no. 322.

PROVENANCE: Purchased for the W. P. Wilstach Collection, Philadelphia, June 14, 1904.

LITERATURE: Wilstach 1904, no. 228, 1906, no. 251, 1907, no. 265, 1908, no. 265, 1910, no. 375, 1913, no. 390, 1922, no. 288; PMA 1965, p. 62; Rishel 1974, p. 31.

CONDITION: The painting has an aged, aqueous lining. A large, old T-shaped tear in the upper left quadrant was repaired. The paint film has minor abrasion, several old losses, and a fine network of age crackle. The varnish is uneven but relatively clear.

105 CIRCLE OF MICHEL SITTOW

NATIVITY, C. 1510
Oil on panel, 48⅞ x 27⅝″ (124.1 x 70.2 cm.)
Purchased for the W. P. Wilstach Collection. W02-1-13

In the foreground of a nocturnal scene of the Nativity the slender, slightly
attenuated Madonna and four angels kneel around the manger, their faces
reflecting the miraculous illumination of the Christ child. Behind the Virgin
stands Joseph holding a candle, and at her side a donkey and a cow are
lying in the darkness. In the distance one of the shepherds looks in at the
window in the brick wall of the stable. Before a column projecting in front
of this wall, a group of partially overpainted angels descends from the upper
right and hovers over the scene.

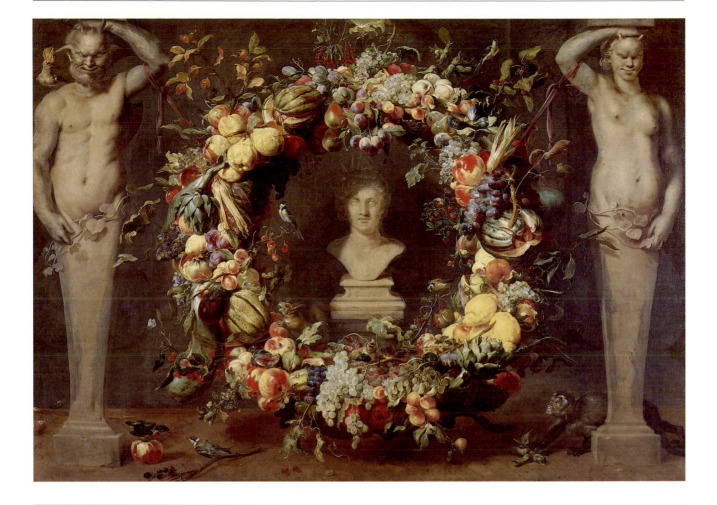

106 FRANS SNYDERS

STILL LIFE WITH TERMS AND A BUST OF CERES, C. 1630
Signed lower right: *F. Snÿders · fecit*
Oil on canvas, 67⅜ x 95″ (171 x 241 cm.)
Purchased for the W. P. Wilstach Collection. W99-1-4

A large, circular garland of diverse fruits and vegetables from different seasons and regions is suspended between two terms in the forms of a male and female satyr. The fruit includes figs, apples, lemons, pears, plums, green and purple grapes, melons, cherries, peaches, apricots, oranges, quinces, pomegranates, currants, raspberries, and strawberries; among the vegetables are corn, artichokes, eggplant, squash, and marrow squash; the animals and insects include a monkey, a squirrel, five smaller birds and a crested woodpecker, a butterfly, and a beetle. In the center of the garland is a bust of Ceres, goddess of agriculture, with wheat stalks in her hair. It rests upon a pedestal inscribed with her name. The colorful garland's contrast with the architectural setting creates a *trompe l'oeil* effect.

In the 1908 catalogue of the Brussels museum, E. Verlant first noted the work's resemblance in subject and design to a smaller (not larger, as Verlant stated), virtually identical painting by Snyders (fig. 106-1) also representing a garland supported by partially visible terminus figures.[1] Hella Robels and Paul Huvenne drew attention to yet another version by Snyders in the collection of Lord Spencer, Althorp House.[2] The three versions differ

FIG. 106-1 Frans Snyders, *Garland with Bust of Ceres,* oil on canvas, 65¾ x 70" (167 x 178 cm.), Musée Royaux des Beaux-Arts de Belgique, Brussels, inv. no. 3375.

FIG. 106-2 Frans Snyders, *Fruit Garland with Mater Dolorosa,* signed and dated 1630, oil on canvas, 73¾ x 56¼" (187.5 x 143 cm.), Kolveniershof, Antwerp.

in the arrangements of the fruit, suggesting that they all are variations by Snyders's own hand, but in the Brussels and Althorp paintings only the innermost arms and bases of the two terms appear. It has not been established whether the smaller dimensions and cropped appearance of the other versions indicate that they were cut down. The order and relationship of these versions are difficult to ascertain; however, Robels proposed approximate dates based, in part, on the poses of the animals.[3] The Althorp version, she believes, is the first since it includes terms and a bust that differ from those in the other two versions, a squirrel in a pose not found in Snyders's works before the 1620s, as well as an ape, which is encountered in paintings from the 1630s and 1640s.[4] The Philadelphia and the Brussels versions are closer in style and details, employing the fluid brushwork and brilliant colors Snyders developed during the 1630s. Robels noted that the squirrel that appears in both of these works at the center of the garland to the left of Ceres reappears in other works from the 1630s and 1640s.[5] Thus, she concluded that, while all three versions probably date from the 1630s, the Brussels and Philadelphia versions follow the Althorp painting. She leaves open the possibility that the architectural setting in the Philadelphia painting, which is painted in a thinner technique than the garland, may be by another hand; however, there appears to be no compelling reason to believe that the work is a collaborative effort. Moreover, the date 1630 that appeared on a recently rediscovered fruit-garland painting by Snyders (fig. 106-2) when it was cleaned in 1984 supports a similar dating for the Philadelphia painting.[6]

The original situation and function of the painting are unknown; its subject, design, and substantial scale suggest that it may have been commissioned as a decoration for a banquet hall. Susan Koslow first advanced the plausible theory that the Philadelphia painting was designed as a *devant de cheminée,* or fire screen.[7] Often fireplaces were dressed in summer with seasonal plants and flowers or with screens, usually made of canvas or panel.[8] The composition of this painting, with the large terms depicted several feet in front of a gray stone wall and serving as implicit supports for an unseen horizontal architectural member just above the painted image, is consistent with fireplace designs. If the painting were installed near the floor in a large hearth, the sculpted columns would seem to support the cornice of the shelf of the fireplace. That the bust of Ceres is placed on a stone pedestal before an arched niche flanked by shallow volutes also corresponds to the architecture of fireplaces of the period.

As the goddess not only of agriculture but also of summer, Ceres is an appropriate deity to decorate a fire screen. The ever-fertile satyrs holding up the sumptuous garland also could allude, through their association with Bacchus, to the food and drink found in a banquet hall. Gérard de Lairesse (q.v.) specifically mentioned Ceres and Bacchus as desirable themes for fireplace decorations and fire screens.[9] Whether the fauns in the painting coupled with the monkey (a notoriously lascivious creature) have a specifically erotic meaning is unclear. A favored subject of Peter Paul Rubens (q.v.) and his circle was the illustration of the famous quotation from the Latin comedist Terence, "Sine Cerere et Baccho friget Venus" ("Without Ceres and Bacchus, Venus grows cold").

Important precedents both formally and iconographically for Snyders's fruit-garland pictures were a series of collaborative paintings begun by Rubens and Jan Brueghel I (1568–1625) by about 1616 depicting the Madonna with the Christ child in the center of a flower garland.[10] In his study of these paintings, David Freedberg cited their relationship to Pliny's tale of Pausias and Glycera; Rubens and the still-life painter Osias Beert (c. 1580–1623/24) commemorated the subject in a painting of Glycera, who supposedly invented flower garlands, and Pausias, who sought to rival her by copying the garlands in paint, thus illustrating the superiority of art over nature.[11] Citing extensively from Counter-Reformation literature, Freedberg demonstrated how the decorative garlands reinforce and complement the devotional function of the central religious images. Paul Huvenne developed this idea, particularly in relationship to Synders's paintings of fruit garlands, publishing for the first time the *Fruit Garland with Mater Dolorosa* (fig. 106-2) and interpreting the Philadelphia painting as a symbol of fruitfulness or fertility.[12] Freedberg noted Rubens's surprising willingness to transfer the fruit symbolism of a pagan goddess to the Virgin, the Christian ideal of maternity and fertility, when the painter replaced the figure of Ceres in the center of the fruit-garland painting in Leningrad (fig. 106-3) with an image of the Virgin in the engraving after this composition by Cornelis Galle dedicated to Nicolas Rockox (on Rockox, see no. 92, by Rubens).[13] The Leningrad painting of about 1612 (fig. 106-3) was surely another important inspiration for Synders's garlands of fruit and vegetables surrounding Ceres. And like Rubens, Synders felt at liberty to bestow the same elastically symbolic fruit garlands on profane as well as religious images, since an apparently autograph variant of the Antwerp fruit garland (fig. 106-2) replaces the image of the Mater Dolorosa with a bas-relief of three putti carrying gardening tools.[14]

In addition to garlands, Synders also painted festoons of fruit and vegetables. A painting of about 1615–17 in Munich, which may have been an overdoor, includes putti by Rubens carrying a festoon by Snyders.[15] A superficial resemblance to Marie de Medici in the bust of Ceres in the Philadelphia painting has been noted privately by several observers, but there is no reliable foundation for the identification.

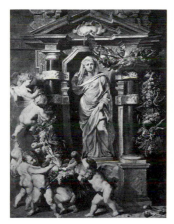

FIG. 106-3 Peter Paul Rubens, *Statue of Ceres,* c. 1612, oil on panel, 35⅞ x 25¾" (90.5 x 65.5 cm.), The Hermitage, Leningrad, no. 504.

NOTES

1. A. J. Wauters, *Catalogue historique et descriptif des tableaux anciens du Musée de Bruxelles* (Brussels, 1908), p. 175, no. 436. The bust of Ceres in the Brussels painting was formerly overpainted with a Sèvres vase.
2. Robels (verbally in 1979) and Paul Huvenne, "Een Vruchtenkrans van Frans Snijders herontdekt," *Rubens and His World* (Antwerp, 1985), pp. 193–94. Signed "F. Snyders. fecit," oil on canvas, 65 x 84" (165 x 203 cm.). For the version in Northampton, see K. J. Garlick, "A Catalogue of Pictures at Althorp," *The Walpole Society,* vol. 45 (1974–76), p. 79, no. 612. The painting was mentioned by A. Lavice, *Revue des musées d'Angleterre* (Paris, 1869), p. 268.

3. Letter, November 16, 1981, Philadelphia Museum of Art, accession files.
4. Compare the squirrel in *Fruit and Vegetables,* oil on panel, 31 x 41½" (79 x 108 cm.), Musée du Louvre, Paris, inv. no. 1850; *A Breakfast,* oil on canvas, 37⅞ x 21⅛" (91 x 55 cm.), National Gallery of Ireland, Dublin, no. 811; and *Fruit and Vegetables with Ape, Squirrel, and Parrot,* oil on panel, 34⅝ x 46" (88 x 117 cm.), Staatsgalerie, Stuttgart, inv. no. L168; and the ape in *Ape and Parrot,* oil on canvas, 31 x 41" (79 x 104 cm.), Musée du Louvre, Paris, no. MI.982; and *Still Life with an Ape,* oil on canvas, 67 x 93¾" (170 x 238 cm.), Gemäldegalerie Alte Meister, Staatliche Kunstsammlungen, Dresden, no. 1193. Although the painting's style is later, the monkey in the Philadelphia picture had

already appeared in Snyder's early works of about 1613; see Hella Robels, "Frans Snyders Entwicklung als Stillebenmaler," *Wallraf-Richartz-Jahrbuch,* vol. 31 (1969), fig. 42; the painting is now in the Palace of the Legion of Honor, San Francisco.

5. Collection Fürsten van Liechtenstein, Vaduz, inv. no. 770; and *Still Life with Fruit, Game Bag, and Vegetables,* c. 1620, oil on canvas, 36¼ x 53½" (92 x 136 cm.), Gemäldegalerie, Staatliche Museen Preussischer Kulturbesitz, Berlin (West), no. 4/65.

6. See Huvenne (note 2), pp. 193–200.

7. Letter, May 1, 1983, Philadelphia Museum of Art, accession files.

8. See Peter Thornton, *Seventeenth-Century Interior Decoration in England, France, and Holland* (New Haven and London, 1978), p. 263.

9. Gérard de Lairesse, *Groot Schilderboeck* (Amsterdam, 1707; reprint, Soest, 1969), vol. 2, p. 174.

10. See especially *Madonna in a Garland of Flowers,* c. 1616, oil on panel, 72⅞ x 82½" (185 x 209.8 cm.), Alte Pinakothek, Bayerische Staatsgemäldesammlungen, Munich, no. 331; oil on panel, 31 x 25½" (79 x 65 cm.), Madrid, Prado, inv. no. 1418; and oil on panel 32⅞ x 25½" (83.5 x 65 cm.), Paris, Musée du Louvre, inv. no. 1764.

11. Oil on canvas, 80 x 76½" (203.2 x 194.3 cm.), Ringling Museum of Art, Sarasota, no. 219. David Freedberg, "The Origins of the Rise of Flemish Madonnas in Flower Garlands: Decoration and Devotion," *Münchner Jahrbuch der bildenden Kunst,* vol. 32 (1981), pp. 115–50.

12. Huvenne (see note 2) pp. 193–200.

13. Freedberg (see note 11), p. 132, fig. 17. The print is inscribed "How well, O Virgin Mother, standing as a tree in a cultivated garden, you may bring forth the eternal abundance and wealth. This is the meaning of the grapes and ripe apples which pious love has painted on the sterile panel. O blessed Tree . . . whoever tasted the fruits lives again. The tree of life alone produces lifegiving abundance." And on the cartouche is a quotation from the Book of Sirach, "I brought forth fruit like the vine."

14. Oil on canvas, 80¾ x 57½" (205 x 146 cm.), sale, Christie's, London, July 7, 1972, lot 48; repro. Huvenne (note 2), fig. 3.

15. Oil on canvas, 47¼ x 80¼" (120 x 203.8 cm.), Bayerische Staatsgemäldesammlungen, Alte Pinakothek, Munich, no. 330. For discussion, see National Gallery of Art, Washington, D.C., *Masterworks from Munich: Sixteenth- to Eighteenth-Century Paintings from the Alte Pinakothek,* 1988, cat. no. 24. On Snyders's collaboration with Rubens, see no. 91.

PROVENANCE: Purchased for the W. P. Wilstach Collection, Philadelphia, December 1899.

LITERATURE: Wilstach 1900, no. 132, 1902, no. 149, 1903, no. 169, 1904, no. 237, 1906, no. 260, 1907, no. 274, 1908, no. 274; E. Verlant in A. J. Wauters, *Catalogue historique et descriptif des tableaux anciens du Musée de Bruxelles* (Brussels, 1908), p. 1975, no. 436; Wilstach 1910, no. 384, 1913, no. 399, 1922, no. 294; Thieme-Becker 1907–50, vol. 31 (1937), p. 190; Rogers Bordley, *A Frans Snyders Inventory* (New York, 1945), p. 16; Reginald Howard Wilenski, *Flemish Painters 1430–1830,* 2 vols. (New York, 1960), vol. 1, pp. 256, 279, 287, vol. 2, pl. 554; PMA 1965, p. 63; Rishel 1974, p. 31; Edith Greindl, *Les Peintres flamands de nature morte au XVIIe siècle* (Sterrebeek, 1983), p. 379, no. 245; Paul Huvenne, "Een Vruchtenkrans van Frans Snijders herontdekt," in *Rubens and His World* (Antwerp, 1985), p. 193, fig. 2.

CONDITION: The canvas is lined with an aqueous adhesive and is in fair condition. The tacking edges are missing. The paint film shows old losses at the edges, along a vertical seam in the center, and scattered throughout (for example, in the pedestal of the term on the left, to the left of the bust, and in all four corners). There is an area of discolored retouches in the background to the left of the bust. It is 1½" (3.8 cm.) in diameter and corresponds to an L-shaped tear in the support.

Born in Haarlem, Soutman, according to Cornelis de Bie, was a pupil of Peter Paul Rubens (q.v.). In 1619–20 he became an Antwerp citizen and in the following years made engravings after Rubens's designs. In 1624 he entered the service in Poland and in 1628 was described as the court painter to the king of Poland. Returning to Haarlem by the latest in 1628, he became a member of the fraternity of the "Schoonenvaerders" and two years later was married. In 1633 he was named an official in the Haarlem guild. During these years he painted portraits and history paintings that contributed to the rise of an indigenous classicist style of painting in Haarlem. Well respected in his day, in 1648 he was awarded the commission to paint *The Triumph of Frederick Henry* in the Oranjezaal in the Huis ten Bosch.

LITERATURE: Cornelis de Bie, *Het Gulden Cabinet van de edel vry schilderconst* (Antwerp, 1661; reprint, Soest, 1971), p. 154; Philippe-Félix Rombouts and Théodore van Lerius, *Les Liggeren et autres archives historiques de la gilde anversoise de Saint-Luc, sous la devise 'Wt Ionsten Versaemt'* (Antwerp and The Hague, 1864–76), vol. 1, p. 558; Wurzbach 1906–11, vol. 2, pp. 643–44; A. Bredius and M. D. Henkel in Thieme-Becker 1907–50, vol. 31 (1937), p. 313; J. G. van Gelder, "De Schilders van de Oranjezaal," *Nederlandsch Kunsthistorish Jaarboek*, vol. 1 (1948–49), p. 134; Marie-Louise Hairs, *Dans le Sillage de Rubens: Les Peintres d'histoire anversois au XVIIe siècle* (Liège, 1977), pp. 56–57.

107 ATTRIBUTED TO
 PIETER CLAESZ. SOUTMAN

JUDITH WITH THE HEAD OF HOLOFERNES
Oil on canvas, 46⅝ x 39⅜″ (118 x 100 cm.)
Gift of Mrs. George H. Frazier. 36-26-1

Viewed to the knees and in three-quarter profile, Judith stands at the center of the picture holding a sword in her right hand while dropping the head of Holofernes into a bag held by her maid at the right. While the elderly maid wears a simple white headdress and a fur-lined coat, her mistress is arrayed in a white gown, mantle, and pearls. Turning her head to the viewer, Judith fixes us with her gaze.

The subject of the painting derives from the Apocryphal Old Testament Book of Judith (13:1–12), which relates how Nebuchadnezzar, king of Assyria, sent his general, Holofernes, to conquer the Israelites. After Holofernes' armies had besieged the town of Bethulia for forty days, its citizens, dying from thirst, resolved to surrender unless relief was found in five days. Judith, a beautiful well-to-do widow from the tribe of Simeon, upbraided the city fathers for their decision, arguing that if Bethulia fell the whole of Judea would follow. Devising a plan of deliverance, she discarded her widow's weeds, attired herself richly and set out with her maid toward the enemy camp. Inventing stories to deceive the sentries, she gained access to the general's tent, where she promised Holofernes victory over not only Bethulia but all Israelites. Beguiled by her beauty, the general believed her stories and allowed her to pass freely through his military lines, ostensibly to pray in the open. After refusing to dine with Holofernes for three days, Judith accepted his invitation to a banquet with his retinue. Overcome with passion, Holofernes invited her to stay the night. No sooner had he fallen into a drunken slumber than Judith took his sword and cut off his head. With the help of her maid, she placed it in their food bag. Passing through the lines unhindered, she returned to Bethulia and publicly displayed the

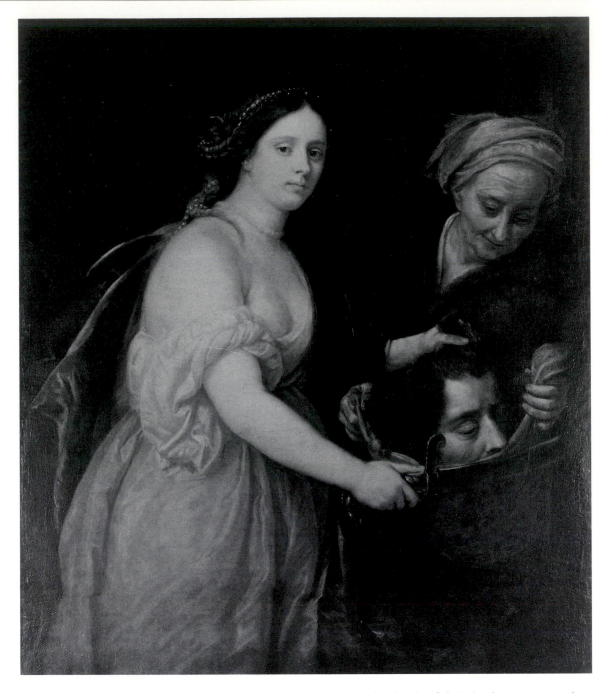

head to the rejoicing citizenry. With the death of their leader, consternation spread through the Assyrian camp and the siege was lifted.

Like Esther and Jael, Judith had long been extolled as one of the Old Testament heroes who helped to liberate her people. By the seventeenth century she was regarded as a prefiguration of the Virgin Mary and a symbol of purity, humility, and above all chastity ("It was my face that tricked him to his destruction, and yet he committed no act of sin with me, to defile me and shame me," Judith 13:16), while Holofernes exemplified pride and lust. In Dutch literature Judith was a popular figure exemplifying high moral principles and the chaste life.[1] While the Book of Judith, as part of the Apocrypha, was excluded from the Dutch state Bible, it was canonical in the Catholic southern Netherlands. Thus Judith was depicted more often by Flemish than Dutch painters.[2]

FIG. 107-1 Peter Paul Rubens, *Judith with the Head of Holofernes*, c. 1620, oil on panel, 47¼ x 43¾" (120 x 111 cm.), Herzog Anton Ulrich Museum, Brunswick, no. 87.

FIG. 107-2 Peter Paul Rubens, *Judith with the Head of Holofernes*, c. 1625, oil on canvas, 44½ x 35" (113 x 89 cm.), Palazzo Vecchio, Florence.

FIG. 107-3 Pieter Claesz. Soutman, *Samson and Delilah*, 1642, oil on canvas, 60¾ x 54¼" (154 x 137 cm.), City Art Gallery, York, no. 15.

The prominent pearls that adorn Judith's braided headdress and neck in this work could allude to her paradoxical role as an honorable seductress; pearls had a wide variety of associations, from Faith and Chastity to the "satanic" pearls worn by whores and the allegorical figure of *Vrouw Wereld* (Dame World), the personification of all earthly desires.[3]

This painting's old attribution to Jacob Jordaens (1593–1678) was first proposed by Henri Marceau, former director of the Museum. The technique is incompatible with that of Jordaens, but the work's design descends from prototypes developed by his teacher, Peter Paul Rubens (q.v.). Rubens painted several versions of the Judith and Holofernes theme, depicting successive episodes of the story: the actual murder in all its gruesome drama;[4] Judith displaying or handing the head to her maidservant (fig. 107-1);[5] and, finally, placing the head in the sack (fig. 107-2).[6] In developing his monumental three-quarter-length design Rubens may have been influenced by Venetian art, specifically works like Paolo Veronese's *Judith with the Head of Holofernes*.[7] The Philadelphia painting is closest in conception to Rubens's painting in Florence (fig. 107-2), but it turns Judith's figure in profile and reverses the position of the maid. The style of the work has most in common with the art of the relatively little-known Pieter Claesz. Soutman, one of Rubens's various followers. The latter's *Samson and Delilah* (fig. 107-3), dated 1642, in the City Art Gallery, York, offers points of comparison in the figure and facial types as well as the handling of drapery. However, the York painting's greater polish and surface detail suggest that the attribution of the Philadelphia painting to him remain tentative.

NOTES
1. See Ann Marie Musschoot, *Het Judith-thema in de Nederlandse letterkunde* (Ghent, 1972). On the celebration of Judith as an archetype of chastity, see also E. Wind, "Donatello's Judith: A Symbol of 'Sanctimonia,'" *Journal of the Warburg Institute*, vol. 1 (1937–38), pp. 62–63; J.J.M. Timmers, *Symboliek en iconographie der Christelijke Kunst* (Roermond, 1947), nos. 410, 1001, 1022, 1259; Hans Martin von Erffa, "Judith-Virtus Virtutum-Maria," *Mitteilungen des Kunsthistorischen Institutes in Florenz*, vol. 14 (1969–70), pp. 460–65; E. de Jongh, "Pearls of Virtue and Pearls of Vice," *Simiolus*, vol. 8, no. 2 (1975–76), p. 92.
2. See Andor Pigler, *Barockthemen*, 2nd ed., vol. 1 (Budapest, 1974), p. 196.
3. See De Jongh (note 1), pp. 69–97.
4. See the painting of c. 1609 attributed to Rubens formerly in the Van der Arend Collection, Brussels (oil on canvas, 59⅞ x 42⅛" [152 x 107 cm.]; repro. in Rudolf Oldenbourg, *Klassiker der Kunst*, vol. 5, *P. P. Rubens* [Berlin and Leipzig, 1921], p. 30); the related engraving by Cornelis Galle (20½ x 14¾" [52.1 x 37.6 cm.], in Wallraf Richartz Museum, Cologne, *Peter Paul Rubens, 1577–1640*, cat. no. 2, *Maler mit dem Grabstichel: Rubens und die Druckgraphik*, October 15–December 15, 1977, p. 3, fig. 1); and the painting in the museum in Carpentras (repro. in *Philadelphia Museum of Art Bulletin*, vol. 59, no. 279 [autumn 1963], p. 27, fig. 13).
5. Related to the Brunswick painting is an unpublished *Judith with the Head of Holofernes*, attributed to Rubens, oil on canvas, 35⅞ x 28⅞" (91 x 73.5 cm.), with Harry Marlot, Mainz, in 1980.
6. See also the lost Rubens composition known through an engraving by Alexander Voet II (b.c. 1637).
7. c. 1570–79, oil on canvas, 43¾ x 39½" (111 x 100.5 cm.), Kunsthistorisches Museum, Vienna, inv. no. 34.

PROVENANCE: Mrs. George H. Frazier.

LITERATURE: PMA 1965, p. 36 [attributed to Jacob Jordaens].

CONDITION: The canvas support is brittle and slack with an aqueous lining. The tacking edges are missing. A large puncture and loss were repaired to the left of the old woman's head. Scratches appear in the old woman's right eye and scattered in the background. Extending horizontally, about 7–8" (18–20 cm.) from the bottom edge is a line of retouched loss. Repaint has discolored in Judith's garment, along the edges, and in scattered losses throughout. Retouched additions are flaking along the edges. The varnish is deeply discolored.

Born in Brussels in 1609, Spierincks (Spierinck, Spirinck, Spieringh, Spirench; called Carlo Fillippo in Italian documents) came to Rome in 1624, and was recorded from 1634 to 1636 as living in the same house on the Via Vittoria as the sculptor François Duquesnoy (1579–1643), with whom Nicolas Poussin (1594–1665) also lived for a time. Spierincks was a member and administrator of the fraternity of Saint Maria in Campo Santo. He was a pupil of Paul Bril (1554–1626), a member of the Academy of Saint Luke, and died in 1639 at the age of thirty. The only contemporary records of his work note that he made an engraving in the *Galleria Giustiniani* (Rome, c. 1632) and was commissioned to execute paintings for the sacristy of St. Maria dell'Anima, a project left unfinished at his death and now lost. Two of his paintings appeared in inventories of Flemish merchants living in Rome, a *Bacchanal with Putti* owned by Filips Baldescot in 1641 and a *Saint Norbertus* in the possession of Peter Visscher in 1643.

Spierincks's early date of death suggests that he was the first artist to derive his personal style from Poussin's famous bacchanals of the early 1630s.

LITERATURE: Wurzbach 1907–11, vol. 2, p. 647; Godefridus Joannes Hoogewerff, *Nederlandsche Schilders in Italie in de XVIe eeuw* (Utrecht, 1912), p. 250; Godefridus Joannes Hoogewerff, *De Nederlandsche Kunstenaars te Rome* (The Hague, 1926), pp. 99, 101; Thieme-Becker 1907–50, vol. 31 (1937), p. 374; Godefridus Joannes Hoogewerff, *De Bentvueghels* (The Hague, 1952), p. 127; Anthony Blunt, "Poussin Studies X: Karel Philips Spierincks, the First Imitator of Poussin's 'Bacchanals,'" *The Burlington Magazine,* vol. 102, no. 688 (July 1960), pp. 308–11.

108 KAREL PHILIPS SPIERINCKS

JUPITER AND CALLISTO
Oil on canvas, 53 x 70″ (135 x 178 cm.)
Mr. and Mrs. Carroll S. Tyson, Jr., Collection. 63-116-12

In the left foreground Jupiter, in the guise of the huntress Diana, embraces
the nymph Callisto. Seven putti attend the couple—one looks after Diana's
hounds, bow and quiver, another holds aloft a torch, others string their
bows or shoot arrows at the lovers, and still another pair rain flowers upon
them from above. In the distance Callisto reappears being dragged by the
hair by Juno, Jupiter's jealous wife, who can be identified by her attributes,
a chariot and peacocks. This small detail depicts Juno turning Callisto into a
she-bear and seems to follow Ovid's account of the episode fairly closely
(*Metamorphoses,* lines 446–95). Juno rages, "The form you so delight in, the
lovely form / That caught my husband's eye, I shall take from you!' / She
grabbed her [Callisto's] hair, pulled it down over her forehead, / Flung her
down to the ground, and the girl, reaching / Her arms toward her in
pleading, saw them blacken, / Grow rough with shaggy hair; her hands
curved inward, / Turned into feet, with claws . . ." (lines 477–83). The sexual
union of the god and the nymph is emphasized symbolically in the painting
by the pose of Callisto, who throws her leg across that of Jupiter / Diana.[1]

FIG. 108-1 Karel Philips Spierincks, *Nymphs, Satyrs, and Cupids,* oil on canvas, 55 x 66" (140 x 168 cm.), Collection of Her Majesty Queen Elizabeth II, Hampton Court Palace.

FIG. 108-2 Nicolas Poussin, *Lovers (Jupiter and Callisto?) with Putti in a Landscape,* wash on paper, 6 x 7⅞" (15.2 x 20 cm.), Kunstmuseum, Düsseldorf, inv. no. FP4425.

FIG. 108-3 Nicolas Poussin, *Lovers (Jupiter and Callisto?) with Putti in a Landscape,* wash on paper, 5½ x 7¾" (13.9 x 19.8 cm.), Accademia, Venice, no. 146.

In some versions of the story, Callisto is shot by Diana after having been transformed into a bear. Thus, the tiny love-arrows launched by the putti may prefigure Callisto's demise.

Although prior to Anthony Blunt's reassignment in 1966[2] the painting was always attributed to Nicolas Poussin (1594–1665), skepticism regarding the attribution had often been expressed. As early as the eighteenth century, Diderot, who must have seen the work when it belonged to his friend Holbach, had commented upon its breach of unity of time (Callisto's double appearance), a feature never found in autograph works by the master. Moreover, the flat, relatively unmodulated technique of the painting is not Poussin's. Most viewers have assumed that the work is a copy of a lost original. Blunt related it to three early references to paintings by Poussin of this subject, but stated that "it is more than doubtful if even the design is [Poussin's]."[3] He concluded that the work "shows all the characteristics of the paintings which have been ascribed to Karel Philips Spierincks." Earlier, in 1960, Blunt had assembled the tiny oeuvre of Spierincks around the painting *Nymphs, Satyrs, and Cupids* at Hampton Court (fig. 108-1), which was already assigned to Carlo Fillippo (the name Spierincks used in Italy) in an inventory of 1660.[4] The present work employs figure types and relations between the figures and the landscape like those in the Hampton Court painting and the other works that Blunt has assigned to the artist.[5] The oddly hydrocephalic putto type in the Philadelphia painting also appears in paintings by Andrea Podestà (d. before 1674), a Genoese follower of Poussin, whose authorship for the painting has been promoted.[6] Nonetheless, the attribution to Spierincks, supported by Clovis Whitfield and Konrad Oberhuber, seems most plausible.[7] In supporting Blunt's attribution to Spierincks, Oberhuber argued that the artist was more dependent upon Poussin than Blunt had allowed. As generally related compositions, three drawings were cited by Oberhuber depicting lovers with putti in landscapes he assigned to Poussin and dated around 1628: two in Düsseldorf (see fig. 108-2) and one in Venice (fig. 108-3).[8] These works show Poussin experimenting with a design not unlike that of the present work and, in Oberhuber's view, indicate that Spierincks "followed a Poussin prototype rather closely."[9] Indeed, Oberhuber now posits Spierincks's "free imitation" of a lost painting or one that Poussin never executed and likens the pose of Jupiter and Callisto in the Philadelphia composition to that of Acis and Galatea in Poussin's painting in Dublin.[10]

Another version of the painting on the London art market is doubtless a copy.[11]

NOTES

1. Concerning this pose, see Leo Steinberg, "Michelangelo's Florentine *Pietà:* The Missing Leg," *The Art Bulletin,* vol. 50 (1968), pp. 343–53.

2. See Anthony Blunt, *The Paintings of Nicolas Poussin* (London, 1966), p. 175.

3. Blunt (see note 2), p. 175, no. R83. They are as follows: sale, Count von Plattenberg und Wittem, Amsterdam, April 2, 1783, lot 17 (see Gerard Hoet, *Catalogus of Naamlyst van Schilderyen* [The Hague, 1752–70], vol. 1, p. 496 [58 x 70" (147 x 178 cm.)]); sale, Van Zwieten, The Hague, April 12, 1741, lot 13 (see Hoet, vol. 2, p. 11 [48 x 68" (122 x 173 cm.)]); and Pier Francesco Grimaldi, Genoa (see Carlo Giuseppe Ratti, *Istruzione di quanto può vedersi di più bello in Genova,* 2nd ed. [Genoa, 1780], vol. 1, p. 137).

4. Anthony Blunt, "Poussin Studies X: Karel Philips Spierincks, the First Imitator of Poussin's 'Bacchanals,'" *The Burlington Magazine,* vol. 102, no. 688 (July 1960), p. 308; the references to the early inventories were provided by Oliver Millar.

5. See the bacchanal and pastoral scenes *Drunken Silenus,* oil on canvas, 39 x 47¼" (99 x 120 cm.), Collection of Sir James Hunter-Blair; *Bacchus, Silenus, and Pan,* oil on canvas, Collection of the marquis of Northampton, Castle Ashby; and *Pastoral Scene,* oil on canvas, 30¼ x 40⅛" (77 x 102 cm.), Collection of Mrs. Lindsay Drummond. Repro. in Blunt (see note 4), figs. 20–22.

6. Verbally by Scott Schaefer in 1972. Concerning Podestà, see Anthony Blunt, "Poussin dans les Musées de Province," *La Revue des Arts,* vol. 8, no. 1 (1958), pp. 13–16; and Blunt (see note 4), p. 311.

7. Respectively, letters of March 25, 1981, and November 25, 1981, Philadelphia Museum of Art, accession files. See also Kimbell Art Museum, Fort Worth, *Poussin, the Early Years in Rome: The Origins of French Classicism,* September 24–November 27, 1988, p. 182 (catalogue by Konrad Oberhuber).

8. For the other drawing attributed to Poussin, see Kimbell Art Museum (note 7), cat. nos. D138, D139 (black chalk and wash on paper, Kunstmuseum, Düsseldorf, no. FP4447).

9. Letter, November 25, 1981 (see note 7).

10. *Acis and Galatea,* oil on canvas, 40½ x 53" (97 x 135 cm.), National Gallery of Ireland, Dublin, no. 84; repro. in Kimbell Art Museum (note 7), cat. 58, see p. 182.

11. Measurements unknown; provenance (according to M. de la Caillerie in a letter of November 8, 1964, Philadelphia Museum of Art, accession files): member of the family of La Rochefoucault de l'Angoumois; by descent to the Comte Henri de Vandière de Vitrae, who sold it in 1883 to dealer Gatti, Paris; M. Hignard, Nantes; by descent in 1913 to Comte de Lestang, Château de Boivre, near Poitiers, from whence it was acquired in 1927 by Ulysse de la Caillerie, Parthenay, Deux-Sèvres (as the original); London art market.

PROVENANCE: According to Anthony Blunt,[1] almost certainly the painting with the following provenance: F. X. Geminiani, Rome, 1752; brought to Paris, 1752;[2] sale, Holbach, Paris, March 16, 1789, lot 21;[3] sale, Donjeux, Paris, April 29, 1793, lot 31;[4] probably the painting in the Lebrun Gallery;[5] probably in the Fesch Collection; sale, Moret, Paris, April 28, 1859, lot 129[6] to Mesteil;[7] sale, Paris, April 18, 1868, to Baron Clary; sale, Paris, May 2, 1872, lot 27;[8] Baron de la Tournelle, 22 rue Marignan, Paris; Wildenstein & Co., Paris; Mr. and Mrs. Carroll S. Tyson, Jr., Philadelphia, by 1928.

NOTES TO PROVENANCE

1. Anthony Blunt, *The Paintings of Nicolas Poussin* (London, 1966), p. 175.

2. See Nicolas Guibal, *Eloge de Nicolas Poussin* (Paris, 1783), p. 54; and Henri Bouchitté, *Le Poussin, sa vie et son oeuvre, suivi d'une notice sur la vie et les ouvrages de Philippe de Champagne et de Champagne le Neveu* (Paris, 1858), p. 347; and Andreas Andresen, *Nicolaus Poussin: Verzeichniss der nach seinen Gemälden gefertigten gleichzeitigen und späteren Kupferstiche* (Leipzig, 1863), p. 83, nos. 336, 337.

3. As Poussin, 49 x 64" (124.5 x 162.6 cm.); engraved by I. Frey and J. Daullé.

4. As Poussin, and from the Holbach sale.

5. See Paul de Saint-Victor, "La Galerie Lebrun, Collection de M. George," *L'Artiste,* vol. 6, 5th ser. (1851), p. 56.

6. As Poussin; engraved by J. Daullé; from the Fesch Collection.

7. See Léon Coutil, *Nicolas Poussin,* vol. 1 (Les Andelys, 1924), p. 2.

8. As Poussin, 74¾ x 88½" (190 x 225 cm.); from the Mesteil sale.

EXHIBITION: Pennsylvania Museum (Philadelphia Museum of Art), "The New Museum of Art Inaugural Exhibition," 1928 (no catalogue).

LITERATURE: Denis Diderot, *Oeuvres Complètes,* edited by J. Assezat and M. Tourneux, 20 vols. (Paris, 1775–77), vol. 10, p. 497 [as Poussin]; Nicolas Guibal, *Eloge de Nicolas Poussin* (Paris, 1783), p. 54 [as Poussin]; Smith 1829–42, vol. 8, no. 183 [as Poussin]; Paul de Saint-Victor, "La Galerie Lebrun, Collection de M. George," *L'Artiste,* vol. 6, 5th ser. (1851), p. 56 [as Poussin]; Henri Bouchitté, *Le Poussin, sa vie et son oeuvre, suivi d'une notice sur la vie et les ouvrages de Philippe de Champagne et de Champagne le Neveu* (Paris, 1858), pp. 347–48 [as Poussin]; Andreas Andresen, *Nicolaus Poussin: Verzeichniss der nach seinen Gemälden gefertigten gleichzeitigen und späteren Kupferstiche* (Leipzig, 1863), nos. A336 (engraving by J. Daullé) and A337 (engraving by I. Frey); Otto Grautoff, *Nicolas Poussin: Sein Werk und sein Leben* (Munich and Leipzig, 1914), vol. 1, p. 131 n. 138, vol. 2, p. 100, no. 61, repro. p. 101 [as Poussin]; Léon Coutil, *Nicolas Poussin,* vol. 1 (Les Andelys, 1924), p. 2; "The New Museum of Art Inaugural Exhibition," *The Pennsylvania Museum Bulletin* (Philadelphia Museum of Art), vol. 23, no. 119 (March 1928), p. 15 [as Poussin]; Georges Wildenstein, "Catalogue des Graveurs de Poussin, par Andresen," *Gazette des Beaux-Arts,* n.s., vol. 60 (1962), p. 184, nos. A. 336, A. 337, repro. p. 168; John Rewald, "The Collection of Carroll S. Tyson, Jr., Philadelphia, U.S.A.," *Philadelphia Museum of Art Bulletin,* vol. 59, no. 280 (winter 1964), pp. 60–61, repro. p. 64 [as Poussin]; PMA 1965, p. 55 [as circle of Poussin]; Anthony Blunt, *The Paintings of Nicolas Poussin* (London, 1966), p. 175, no. R83 [as attributed to Karel Philips Spierincks]; Kimbell Art Museum, Fort Worth, *Poussin, the Early Years in Rome: The Origins of French Classicism,* September 24–November 27, 1988, p. 182 (catalogue by Konrad Oberhuber).

CONDITION: The canvas has an old aqueous lining to which a more recent wax-resin lining was added. It is stable at present. The tacking edges are missing. The paint film is slightly dimpled as a result of its aqueous lining. Some general abrasion is apparent. An inverted L-shaped tear 6" (15.2 cm.) long in the tree trunk in the lower left was repaired. Smaller losses are scattered throughout. Considerable dark residues were left in the interstices of the paint film when the picture was last cleaned. The thick varnish layer has a dull, uneven gloss and is moderately discolored.

PRINTS AFTER

1. J. Daullé, when in the collection of Baron Holbach and dedicated to General Betzky (repro. Georges Wildenstein, "Catalogue des graveurs de Poussin, par Andresen," *Gazette des Beaux-Arts,* n.s., vol. 60 [1962], p. 168).

2. I. Frey, Rome, 1752.

109 FOLLOWER OF
BARTHOLOMEUS SPRANGER

MARTYRDOM OF SAINT JOHN THE EVANGELIST, after 1573
Oil on panel, 40 x 31" (101.6 x 78.7 cm.)
Bequest of Arthur H. Lea. F38-1-35

Only partly visible on the left is the figure of Saint John the Evangelist in
the cauldron of boiling oil. Onlookers in the foreground draw back in
amazement. Through the gate at the right, no doubt the Porta Latina, is a
view of Rome.

 This painting was once entirely overpainted with a portrait of the grand
duchess of Tuscany, attributed in the Lea Collection inventory (no. 159) to
"Fiovavanti" (possibly the little-known seventeenth-century Roman painter
called Fioravante [active c. 1620–60], although he is known as a still-life
artist). In or before 1929, Pasquale Farina, the conservator to John G.
Johnson and other collectors, removed the overpainted portrait to reveal
the history painting now visible. This work is half of a picture that was
probably inspired by an altarpiece (fig. 109-1) painted by Bartholomeus
Spranger (1546–1611) in 1573 of the martyrdom of Saint John the Evangelist

FIG. 109-1 Bartholomeus Spranger, *The Martyrdom of Saint John the Evangelist,* 1573, altarpiece, San Giovanni a Porta Latina, Rome.

for the church of San Giovanni a Porta Latina, built on the site in Rome of the saint's legendary martyrdom.[1] Spranger's original remains *in situ.* Saint John is reported to have been brought by the emperor Domitian to Rome for persecution. There his head was shaved as a token of infamy and he was tossed into a cauldron of boiling oil before the gate of the city known as the Porta Latina. Miraculously he experienced no pain, emerged unscathed, and subsequently lived to an advanced age in Ephesus. In memory of the miracle, the early Christian church in Rome was devoted to him and May 6 is celebrated as the anniversary of his martyrdom.[2]

NOTES

1. Spranger was born in Antwerp in 1546 and studied successively with three landscapists: Jan Mandyn (1500–c. 1560), Gillis Mostaert (1534–1598), and Cornelis van Dalem (active c. 1545–56). He also copied engravings by Frans Floris (1516/20–1570) and Parmigianino (1503–1540). In 1565 he journeyed to Paris, Lyons, and Milan; the following year he was in Parma and Rome, where he worked in the circle of Federico Zuccaro (c. 1540/43–1609). In 1575 he worked at the court of Maximilian II and, after the latter's death, for his successor, the great art patron Rudolf II, at Prague. Spranger worked in Prague for the remainder of his life, dying there in 1611. His influence on western European art was pervasive by way of prints made after his works; the Haarlem Mannerists Hendrik Goltzius (1558–1617), Cornelis van Haarlem (q.v.), and Karel van Mander (1548–1606) were all strongly influenced by his art after about 1585. See A. Niederstein in Thieme-Becker 1907–50, vol. 31 (1937), pp. 403–6; Konrad Oberhuber, "Die Stilistische Entwicklung im Werk Bartholomäus Spranger," diss., Vienna, 1958; Thomas Da Costa Kaufmann, *The School of Prague: Painting at the Court of Rudolf II* (Chicago, 1988); Kunsthistorisches Museum, Vienna, *Prag um 1600,* 1988.

2. See also Jacobus de Voragine, *The Golden Legend,* translated and adapted by Granger Ryan and Helmut Ripperger (reprint, New York, 1969), pp. 276–77.

PROVENANCE: Isaac Lea Collection, inv. no. 159 [as the "Portrait of the Grand Duchess of Tuscany" by "Fiovavanti"]; Arthur H. Lea.

LITERATURE: Pasquale Farina, *To the Collectors of Paintings by Old Masters: The Misleading Golden Glow* (Philadelphia, 1929), n.p.; PMA 1965, p. 35 [as unknown seventeenth-century Italian artist].

CONDITION: The vertically grained support is a fragment of the original, which probably extended to the left a distance roughly equal to its present horizontal dimension. The panel and the two horizontal dovetailed cleats on the back are slightly bowed and insect-damaged. Several cracks and checks in the panel appear at the top and bottom. The paint film has old scattered losses and scratches throughout, especially along the lower and right edges. The varnish layer is deeply discolored.

Steen was born in Leiden, the son of a brewer. His date of birth has not been pinpointed, but in 1646, when he matriculated at Leiden University, he was recorded as being twenty years old; hence, he must have been born in 1625 or 1626. His training as an artist probably did not begin until after his stay at the university. Arnold Houbraken claimed that he was a pupil of the landscapist Jan van Goyen (q.v.), whose daughter he married. J. C. Weyerman further claimed that he studied successively with Nicolaes Knüpfer (c. 1603–1655) at Utrecht, Adriaen van Ostade (q.v.) at Haarlem and last, Jan van Goyen at The Hague. Steen is recorded in Leiden between 1644 and 1646. In March 1648 he became a member of the newly founded Saint Luke's Guild in Leiden, indicating that in the relatively brief period of two years' time he had become an independent master. By September 1649 he was living in The Hague and was married there to Margarethe van Goyen. Although he was still living in The Hague in July 1654, in April 1653 he had paid dues to the Leiden guild. His father leased a brewery for him at Delft from 1654 to 1657, and he painted a Delft scene in 1655; but there is no proof that he ever resided or remained long in that city. From 1656 to 1660 he was living in a small house in Warmond several miles from Leiden. By 1661 he had settled in Haarlem, where he entered the guild in the same year and is recorded until 1670, when he inherited a house in Leiden. Until the end of his life he evidently remained in Leiden, where he obtained permission to open an inn in 1672 and served as *hoofdman,* or leader, of the guild in 1671, 1672, and 1673 and dean in 1674. He was buried in Leiden on February 3, 1679.

Steen is best known for his humorous genre scenes, but he also painted religious, mythological, and historical subjects. His works reveal a knowledge of contemporary literature and the theater. Although recent efforts have reduced the size of his accepted oeuvre, he must have been an exceptionally prolific artist.

LITERATURE: Houbraken 1718–21, vol. 1, p. 374, vol. 2, p. 245, vol. 3, pp. 7, 12–30; J. C. Weyerman, *De levens beschryvingen der nederlandsche konstschilders,* vol. 2 (The Hague, 1729), p. 348; Tobias van Westrheene, *Jan Steen: Etude sur l'art en Hollande* (Haarlem, 1856); Van der Willigen (1870) 1970, pp. 38, 267–70; Obreen (1877–90) 1976, vol. 5, pp. 182–83, 207, 250; Hofstede de Groot 1908–27, vol. 1 (1908), pp 1–252; Wurzbach 1906–11, vol. 2, pp. 655–58; J.B.F. van Gils, "Jan Steen en de rederijkers," *Oud Holland,* vol. 52 (1935), pp. 130–33; Willem Martin, "Jan Steen as a Landscape Painter," *The Burlington Magazine,* vol. 67, no. 392 (November 1935), pp. 211–12; Dowdeswell & Dowdeswell, London, *Jan Steen,* 1909; C. J. H[olmes], "Notes on the Chronology of Jan Steen," *The Burlington Magazine,* vol. 15, no. 76 (July 1909), pp. 243–44; Abraham Bredius, *Jan Steen* (Amsterdam, 1927); E. Trautscholdt in Thieme-Becker 1907–50,

vol. 31 (1937), pp. 509–15; Albert Heppner, "The Popular Theatre of the Rederijkers in the Work of Jan Steen and His Contemporaries," *Journal of the Warburg and Courtauld Institutes,* vol. 3 (1939–40), pp. 22–48; S. J. Gudlaugsson, *De Komedianten bij Jan Steen en zijn tijdgenoten* (The Hague, 1945); S. J. Gudlaugsson, *The Comedians in the Work of Jan Steen and His Contemporaries,* translated by James Brockway and Patricia Wadle (Soest, 1975); Horst Gerson, "Landschappen van Jan Steen," *Kunsthistorische mededelingen van het Rijksbureau voor Kunsthistorische Documentatie,* vol. 3, no. 4 (1948), pp. 50–56; Willem Martin, *Jan Steen* (Amsterdam, 1954); C. H. de Jonge, *Jan Steen* (Amsterdam, 1939); Cornelis Wilhemus de Groot, *Jan Steen: Beeld en woord* (Utrecht, 1952); P.N.H. Domela Niewenhuis, *Jan Steen: Catalogus van de tentoonstelling* (The Hague, 1958–59); Lyckle de Vries, *Jan Steen: De schilderende*

Uilenspiegel (Weert, 1976); Baruch D. Kirschenbaum, *The Religious and Historical Paintings of Jan Steen* (New York, 1977); Lyckle de Vries, "Jan Steen 'de kluchtschilder,'" diss., Groningen, 1977; Karel Braun, *Alle tot nu toe bekende schilderijen van Jan Steen* (Rotterdam, 1980); Peter C. Sutton and Marigene H. Butler, "Jan Steen: Comedy and Admonition," *Bulletin of the Philadelphia Museum of Art,* vol. 78, nos. 337–38 (winter 1982–spring 1983); Sutton et al. 1984, pp. 307–25; Lyckle de Vries, "Jan Steen zwischen Genre- und Historienmalerei," *Niederdeutsche Beiträge zur Kunstgeschichte,* vol. 22 (1984), pp. 118–28.

For additional works by Steen in the Philadelphia Museum of Art, see John G. Johnson Collection cat. nos. 513, 517, 509, 510, 512, 514, 520, 519, 515 (attributed to), 516 (copy after), 518 (imitator of).

110 JAN STEEN

THE FORTUNE-TELLER, c. 1648–52
Signed lower center on end of log: *J Steen* (first two letters ligated)
Oil on canvas, 39⅝ x 36¼″ (100.6 x 92.1 cm.)
Purchased for the W. P. Wilstach Collection. W02-1-21

FIG. 110-1 Jan Steen, *Landscape with Fortune-Teller*, c. 1650–54, signed, oil on canvas, 28¹⁵/₁₆ x 23⅝" (73.5 x 60 cm.), Rijksdienst Beeldende Kunst, The Hague, no. NK 2727, on loan to the Centraal Museum, Utrecht.

In the left foreground a gullible couple have their fortunes told by a gypsy woman holding an infant. Taking advantage of the distraction, a small child, no doubt the gypsy's accomplice, picks the man's pocket. Behind them is a crumbling villa, serving as a rustic tavern, shaded by a tall oak tree. In front of the tavern are various patrons, a horsecart, and a dog with a bell on its tail. At the right a milkmaid carrying a yoke with two buckets makes her way along a road that weaves through the dunes to open pasture.

Although Wolfgang Stechow considered the attribution of the painting doubtful,[1] all other writers have accepted it as an autograph early work by the master. Like many other paintings by Steen devoted largely to landscape, it is almost certainly a product of his early years in The Hague (c. 1648–54). Karel Braun's dating of 1652–54 seems slightly late because it is unlikely that this piece follows the more accomplished *Wedding Procession*, dated 1653, in the Museum Boymans–van Beuningen, Rotterdam.[2] As Lyckle de Vries has observed,[3] it also probably predates another compositionally related scene of a fortune-teller (fig. 110-1).[4] The major elements of these two designs—the large tree and crumbling building on the left, the distant prospect on the right, the focus on the figures in the lower left, and the still-life details of the foliage in the immediate foreground—are very close, but the drawing of the figures in the latter painting is improved, giving them overall a more naturalistic appearance. S. J. Gudlaugsson first noted that the motif of the elegant lady in the *Landscape with Fortune-Teller* (fig. 110-1) is adopted from a painting by Gerard ter Borch (q.v.), which he dated "around or shortly after 1650."[5] De Vries observed that, while the present work must certainly have been executed before the Rotterdam painting, it is not necessarily earlier than Steen's earliest dated works of 1651.[6]

Steen probably was first attracted to the theme of wayfarers by a tavern in a landscape through the paintings of Adriaen (q.v.) and Isaack van Ostade (1621–1649), who are presumed to have been his teachers and exerted a strong influence on his early development as a landscapist and genre painter.[7] As several authors have noted, however, the connection in this painting with Jan van Goyen's art is stronger. Willem Martin even claimed that the Philadelphia picture and another early painting were the product of collaboration between the two men;[8] he saw Van Goyen's hand in the execution of the "beautiful gnarled oak tree" in the present work and of the sky in the *Horsemarket at Valkenburg* (Catacre–de Stuers Collection, Vorden).[9] While recent writers have correctly rejected the notion that either painting was a collaborative effort,[10] De Vries noted the Philadelphia work's close resemblance to the *Landscape with Fortune-Teller* dated 1638 by Van Goyen (q.v.; fig. 110-2).[11] Both works address the same theme in upright compositions dominated by a large tree on one side and a winding country road on the other. Although De Vries felt that Martin exaggerated Van Goyen's importance for Steen, he argued persuasively that the present work documents Steen's brief but intense interest in his father-in-law's art, while the *Landscape with Fortune-Teller* (fig. 110-1) already reflects his absorption of these influences and growing independence. The painting's connection with Van Goyen, therefore, strengthens the assumption that its date falls in the period during which Steen was in The Hague, since it was there that Van Goyen was active.

FIG. 110-2 Jan van Goyen, *Landscape with Fortune-Teller,* signed and dated 1638, oil on canvas, 64^15/16 x 56^11/16" (165 x 144 cm.), Musée des Beaux-Arts, Bordeaux, inv. no. 6277.

The theme of the gypsy fortune-teller was a common subject in Baroque painting.[12] Although encountered earlier, it seems to have first been popularized by Caravaggio (1571–1610) and his followers. These origins perhaps account for the Caravaggesque motif of the gypsy seated closest to the viewer with back turned and chemise pulled off one shoulder. Gypsies were also portrayed by other Dutch and Flemish artists: Jacques de Gheyn II (1565–1629), Adriaen van de Venne (1589–1662), and "Pseudo" van de Venne, Jan Lievens (q.v.), Hendrik Avercamp (1585–1634), Arent Arentsz. [Cabel] (1586–1635), Dirck Hals (1591–1656), David Teniers (1582–1649), Jacob Duck (c. 1600–1667), Leonard Bramer (1596–1674), Jan Miense Molenaer (c. 1610–1668), the Leiden *fijnschilders,* Philips Wouwermans, Salomon van Ruysdael (qq.v.), and numerous others. Then, as now, gypsies (known as *Egyptenaren* for their presumed place of origin, or simply as "heathens") were not without an aura of romance, as conveyed by Jacob Cats's popular poem *Het Spaens Heydinnetje* (Spanish Gypsy Girl) of 1637.[13] Yet their itinerant, socially unassimilated lives made them a special problem group in seventeenth-century Holland.[14] The archives are filled with cases of gypsies and their nongypsy followers, known as *gadjos,* having been accused of vagrancy, theft, and various swindles, including palm reading and quacksalvery.[15] They preyed not only on the rich, as represented by the well-to-do couple in the present work (and fig. 110-1), but also on the poor, as depicted in Van Goyen's picture and in another early painting by Steen, *The Gypsy Woman,* which shows a crude encampment of gypsies, again beside a rustic inn, with one of their number telling the fortune of a peasant and milkmaid as two gypsy children steal the couple's eggs and milk.[16] An element of caricature appears in that work's figure types as in those of the Philadelphia painting, where the fop who listens with gaping jaw to the gypsy's recitation is a first cousin of those swaggering characters Capitano or Giangurgolo, from the *Commedia del Arte,* who appear elsewhere in Steen's art. Steen's message seems clear; regardless of one's social station, gullibility or superstition is ruinous.[17]

NOTES

1. His opinion as recorded by E. Trautscholdt in Thieme-Becker 1907–50, vol. 31 (1937), p. 511.
2. On loan from the Rijksdienst Beeldende Kunst, The Hague; signed and dated, oil on canvas, 25^3/16 x 31^7/8" (64 x 81 cm.), no. 2314 (Hofstede de Groot 1908–27, vol. 1 [1908], no. 455; Karel Braun, *Alle tot nu toe bekende schilderijen van Jan Steen* [Rotterdam, 1980], no. 56).
3. Lyckle de Vries, "Jan Steen 'de kluchtschilder,'" diss., Groningen, 1977, p. 32.
4. Hofstede de Groot 1908–27, vol. 1 (1908), no. 225. Braun (see note 2, no. B-52) wrongly attributed the painting to Gerard ter Borch (q.v.). Another painting that, to judge only from an engraving by Boulard, evidently resembled these two works in design is *Tavern Courtyard* (oil on panel, 28^5/16 x 23^5/8", (72 x 60 cm.), last seen in the de Beurnonville sale, Paris, May 9–16, 1881, lot 476; see Hofstede de Groot 1908–27, vol. 1 (1908), no. 650; and Braun (note 2), no. B-167.
5. S. J. Gudlaugsson, *Geraert ter Borch,* 2 vols. (The Hague, 1959–60), cat. no. 80.

6. De Vries to author, February 1982, Philadelphia Museum of Art, accession files. See *The Toothpuller,* signed and dated 1651, oil on canvas, 12^13/16 x 10^1/2" (32.5 x 26.7 cm.), Mauritshuis, The Hague, no. 165 (Hofstede de Groot 1908–27, vol. 1 [1908], no. 180; Braun [note 2], no. 32); and *The Death of Ananias,* signed and dated 1651, oil on panel, 17^11/16 x 14^1/8" (45 x 36 cm.), formerly H.A.G. Stenger Collection, The Hague (Hofstede de Groot 1908–27, vol. 1 [1908], no. 66; Braun [note 2], no. 33).
7. Baruch D. Kirschenbaum likens the composition (in reverse) of the present work to a painting assigned to Isaack van Ostade, *Travelers before an Inn,* oil on canvas, 42^5/16 x 60^3/16" (107.5 x 153 cm.), Kunsthistorisches Museum, Vienna, inv. no. 6235 (*The Religious and Historical Paintings of Jan Steen* [New York, 1977], fig. 24, p. 35). That work, however, may be by Isaack's follower, Gerrit van Hees (q.v.).
8. Willem Martin, "Jan Steen as a Landscape Painter," *The Burlington Magazine,* vol. 67, no. 392 (November 1935), p. 211; Willem

Martin, *Jan Steen* (Amsterdam, 1954), p. 29.

9. Oil on canvas, 43¼ x 61″ (110 x 155 cm.) (Hofstede de Groot 1908–27, vol. 1 [1908], no. 249; Braun [see note 2], no. 23).

10. See Kirschenbaum (note 7), p. 35; Lyckle de Vries, "Jan Steen 'de kluchtschilder,'" diss., Groningen, 1977, p. 31; Braun (see note 2), no. 43. The older tradition of assigning parts of the *Valkenburg* painting to Van Goyen (q.v.) was already disputed by Hofstede de Groot (Hofstede de Groot 1908–27, vol. 1 [1908], no. 249); Abraham Bredius (*Jan Steen* [Amsterdam, 1927], p. 50).

11. See Lyckle de Vries, *Jan Steen: De schilderende Uilenspiegel* (Weert, 1976), p. 29, pl. 5; Lyckle de Vries, "Jan Steen 'de kluchtschilder,'" diss., Groningen, 1977, pp. 31–32.

12. See Andor Pigler, *Barockthemen: Eine Auswahl von Verzeichnissen zur Ikonographie des siebzehnten und achtzehnten Jahrhunderts,* 2nd ed. rev., vol. 2 (Budapest, 1974), pp. 571–73; and Rijksbureau voor Kunsthistorische Documentatie, The Hague, *Decimal Index of the Art of the Low Countries* (The Hague, 1958–), no. 13E56.11.

13. See Ivan Gaskell, "Transformations of Cervantes's 'La Gitanilla' in Dutch Art," *Journal of the Warburg and Courtauld Institutes,* vol. 45 (1982), pp. 263–70.

14. On gypsies in the Netherlands, see O. van Kappen, *Geschiedenis der Zigeuners in Nederland* (Assen, 1965).

15. The pendant to Steen's early *Fortune-Teller at a Doorway* (oil on panel, 9⁷⁄₁₆ x 8⅛″ [24 x 20.7 cm.], Musée du Petit Palais, Avignon, inv. no. 929; see Hofstede de Groot 1908–27, vol. 1 [1908], no. 220; Braun [see note 2], no. 17) is the *Spectacles Salesman at a Doorway* (oil on panel, 9¹¹⁄₁₆ x 8″ [24.6 x 20.3 cm.], National Gallery, London, no. 2556; see Hofstede de Groot 1908–27, vol. 1 [1908], no. 274; Braun [see note 2], no. 16).

16. Signed, oil on canvas, 19¹¹⁄₁₆ x 25¹⁵⁄₁₆″ [50 x 66 cm.], with dealer D. Katz, Dieren, 1936 (Hofstede de Groot 1908–27, vol. 1 [1908], no. 223; Braun [see note 2], no. 44 [as 1652–54]). Braun's dating seems too late. A lost painting by Steen *Lady Talking to a Gypsy Woman* (17 x 13½″ [43 x 34 cm.]), was in the sale, D. Versteegh, Amsterdam, November 3, 1823, lot 33 (to De Lelie) (see Hofstede de Groot 1908–27, vol. 1 [1908], no. 221; Braun [see note 2], no. A-128).

17. In Cesare Ripa's *Iconologia of Uytbeeldinghe des Verstands,* translated by D. P. Pers (Amsterdam, 1644; reprint, Soest, 1971), p. 60, the personification of superstition is a gypsy fortune-teller.

PROVENANCE: Purchased for the W. P. Wilstach Collection, Philadelphia, October 5, 1902.

EXHIBITIONS: Campbell Museum, Camden, 1972, 1975–80 (no catalogue); Philadelphia Museum of Art, *Jan Steen: Comedy and Admonition,* 1982–83, no. 2.

LITERATURE: Wilstach 1903, no. 174, repro., 1904, no. 242, repro., 1906, no. 266, repro., 1907, no. 280, repro.; Hofstede de Groot 1908–27, suppl., no. 219a; Wilstach 1910, no. 394, 1913, no. 409, repro., 1922, no. 301, repro.; Willem Martin, "Jan Steen as a Landscape Painter," *The Burlington Magazine,* vol. 67, no. 392 (November 1935), p. 211; E. Trautscholdt in Thieme Becker 1907–50, vol. 31 (1937), p. 511; "New Painting Galleries," *The Philadelphia Museum Bulletin,* vol. 36, no. 187 (November 1940), repro.; Willem Martin, *Jan Steen* (Amsterdam, 1954), p. 29 n. 52; PMA 1965, p. 64; O. van Kappen, *Geschiedenis der Zigeuners in Nederland* (Assen, 1965), p. 224, repro.; Rishel 1974, p. 31; Baruch D. Kirschenbaum, *The Religious and Historical Paintings of Jan Steen* (New York, 1977), pp. 33, 35, fig. 18; Lyckle de Vries, "Jan Steen 'de kluchtschilder,'" diss., Groningen, 1977, pp. 31, 32, cat. no. 8 [as an early work]; Karel Braun, *Alle tot nu toe bekende schilderijen van Jan Steen* (Rotterdam, 1980), no. 43 [as 1652–54]; Peter C. Sutton and Marigene H. Butler, "Jan Steen: Comedy and Admonition," *Bulletin of the Philadelphia Museum of Art,* vol. 78, nos. 337–38 (winter 1982–spring 1983), pp. 12–14, 44–51, cat. no. 2, pl. 2, fig. 41.

CONDITION: The original canvas is intact, although its tacking margins have been cut by perhaps ⅛″ (0.3 cm.). In the process, the side edges were slightly skewed, while the top and bottom edges were cut more evenly. A new wax-resin lining was applied in 1981 and the painting cleaned. Overall the paint film is in good condition. Some abrasion is evident in the horsecart, the man standing beside it, and the woman's face in the foreground. Tiny pinpoint losses are scattered around the edges, in the building on the left and throughout the sky. Pentimenti appear in the branches on the right side of the tree, in the objects hung from the inn's signpost, and the collar of the man standing in the foreground. The varnish is colorless, having been replaced in 1981.

III COPY AFTER JAN STEEN

WOMAN AT A CLAVICHORD, 1661 or 1664?
Falsely signed and dated lower left: *J. Stein/16[6]1* or *16[6]4*
Oil on canvas, 25¼ x 21¾″ (64.1 x 55.2 cm.)
The William L. Elkins Collection. E24-3-37

A young man seated on a chest, evidently in rapture, gazes up at a young
woman who stands at a keyboard playing music. In the background a
young boy reaches for a lute, presumably to deliver it to the enthralled
young man in the foreground. Additional figures include a serving-woman
peeling a lemon and a young boy in a broad-brimmed hat who stares out at
the viewer. Through a doorway at the right, a man in a tall hat is seen
crossing a courtyard.

 Despite several well-executed passages, the picture is undoubtedly a
copy of a superior painting formerly in the Heugel Collection, Paris,
and last known to be in an English private collection in the late 1970s
(fig. III-1).[1] Virtually the same size but on panel, the latter work is signed
"Jan Steen" above the keyboard. The copy differs in several respects: a rose
window above the doorway and a pewter pitcher in the lower right are
deleted; the floor is wood instead of tile; and the central woman wears a

FIG. III-I Jan Steen, *Woman at a Clavichord,* signed, oil on panel, 25⁹⁄₁₆ x 21¹¹⁄₁₆″ (65 × 55 cm.), location unknown.

dark, rather than light-colored, jacket. A number of details in the Philadelphia work, such as the crude perspective of the window and the harpsichord, the more schematized folds of the figures' costumes (especially the woman's shoulder wrap), and the flat, doll-like features of the boy's face, expose the picture as an old copy. Yet the work is of interest because of the remnants of the date, which probably read 16[6]1 or 16[6]4 and may reflect a lost date on the original. Given the scarcity of dates on Steen's works, every potential aid in establishing a chronology is of value.

NOTE

1. See Tobias van Westrheene, *Jan Steen: Etude sur l'art en Hollande* (The Hague, 1856), no. 463; Hofstede de Groot 1908–27, vol. 1 (1908), no. 427; Karel Braun, *Alle tot nu toe bekende schilderijen van Jan Steen* (Rotterdam, 1980), no. 247 [as c. 1665]; P.N.H. Domela Niewenhuis, *Jan Steen: Catalogus van de tentoonstelling* (The Hague, 1958–59), pl. 26.

PROVENANCE: Purchased from M. Knoedler & Co., New York, 1900; William L. Elkins, Philadelphia.

EXHIBITIONS: Campbell Museum, Camden, 1980–81 (no catalogue); Philadelphia Museum of Art, *Jan Steen: Comedy and Admonition,* 1982–83, no. 13.

LITERATURE: PMA 1965, p. 64 [as Jan Steen]; Karel Braun, *Alle tot nu toe bekende schilderijen van Jan Steen* (Rotterdam, 1980), no. 247a [as a copy]; Peter C. Sutton and Marigene H. Butler, "Jan Steen: Comedy and Admonition," *Bulletin of the Philadelphia Museum of Art,* vol. 78, nos. 337–38 (winter 1982–spring 1983), p. 43, cat. no. 13, repro. [as a copy].

CONDITION: The canvas support has an old lining. An irregular net fracture crackle-pattern has formed overall in the paint film with associated cupping. An old flake loss about 1½″ (3.8 cm.) long, located along the bottom right edge, is varnished over. Although there is little evidence of abrasion, old discolored retouches are scattered throughout, and the varnish is dull and deeply yellowed.

Born in Brussels in 1823, Alfred was the son of Jean François Léopold, an aide to King William of the Netherlands at the battle of Waterloo and an enthusiastic art collector, who owned, among other things, sketches by Eugène Delacroix (1798–1863). Stevens's mother was the daughter of the proprietor of the Café de l'Amitié in the Place Royale, Brussels, then a leading gathering place in the city. The oldest son of this artistic family was Joseph Stevens (b. 1816) a well-regarded animal painter; the youngest son, Arthur, became an art critic, dealer, connoisseur, and artistic adviser to King Léopold. Alfred Stevens trained in Brussels (1840–44) with the David pupil François Joseph Navez (1787–1869), but departed in 1844 for Paris where, except for the years 1849 to 1852 when he returned home, he remained all his life. He is said to have studied at the Ecole des Beaux-Arts with Ingres (1780–1867) and shared a studio in Paris with his compatriot Florent Willems (1823–1905). He first exhibited at the Brussels Salon of 1851 and made his Paris debut in the Salon of 1853. Stevens's early works of these years reflect the influence of Gustav Courbet (1819–1877) and, to a lesser extent, Thomas Couture (1815–1879). Isolated works also suggest the influence of Hendrik Jan August Leys (q.v.). By 1854 and 1855, however, he had developed the type of painting that was to establish his reputation and fortune: intimately scaled images of elegant women at leisure in upper-class and bourgeois domestic settings. One of the most perceptive critics of the period, Thoré-Bürger correctly likened these works to the seventeenth-century Dutch "high life" genre scenes by Gerard ter Borch (q.v.) and Gabriel Metsu (1629–1667). Stevens moved in the rich and fashionable circles of Paris during the Second Empire, counting among his acquaintances Princess Mathilde, the vicomtesse de Pourtalès, and Princess Metternich. He received commissions from the court and official honors. At the same time he also had close ties with other artists: Courbet painted his portrait (oil on canvas, 25⅝ x 22⅝″ [65 x 57.5 cm.], Musées Royaux des Beaux-Arts de Belgique, Brussels, inv. no. 3191); Delacroix was invited to his marriage in 1858; Edouard Manet (1832–1883), Frédéric Bazille (1841–1871), and Berthe Morisot (1841–1895) were longtime friends; and Edgar Degas (1834–1917) was the godfather of his first child. Stevens died in Paris in 1906.

LITERATURE: Camille Lemonnier, "Les Artistes contemporains: Alfred Stevens," *Gazette des Beaux-Arts,* 2nd ser., vol. 17 (1878), pp. 160–74, 335–42; Boetticher (1891–1901) 1969, vol. 2, p. 835; Paul Lambotte, "Alfred Stevens," *L'Art flamand & hollandais,* vol. 7, no. 4 (April 1907), pp. 153–80; Musée Moderne, Société Royale des Beaux-Arts et l'Art Contemporain, Brussels, *L'Oeuvre de Alfred Stevens,* April–May, 1907, Musée des Beaux-Arts, Antwerp, May–June, 1907 (catalogue by Paul Lambotte); Paul Lambotte, *L'Oeuvre de Alfred Stevens* (Brussels, 1913); Philip Hale, "Alfred Stevens," *Masters in Art,* vol. 10, pt. 109 (January 1919); François Boucher, *Alfred Stevens* (Paris, 1930); Gustave Vanzype, *Les Frères Stevens* (Brussels, 1936); Thieme-Becker 1907–50, vol. 32 (1938), pp. 25–26; Peter Mitchell, *Alfred Emile Leopold Stevens, 1823–1906* (London, 1973); Palais des Beaux-Arts, Charleroi, *Rétrospective Alfred Stevens,* January 11–February 16, 1975; William A. Coles, *Alfred Stevens* (Ann Arbor, 1977).

For additional works by Stevens in the Philadelphia Museum of Art, see John G. Johnson Collection cat no. 1083, inv. nos. 2822 (follower of), 2848 (follower of).

112 ALFRED EMILE LÉOPOLD STEVENS *DEPARTING FOR THE PROMENADE*
 (WILL YOU GO OUT WITH ME, FIDO?), 1859
 Signed and dated lower right: *Alfred Stevens, 59*
 Oil on panel, 24 x 19⅞″ (61 x 50.5 cm.)
 The W. P. Wilstach Collection. W93-1-106

A woman in a full-length dress, bonnet, and paisley shawl pauses as she opens a door to go out and looks over her shoulder at a small white lapdog. The elegant interior is amply proportioned and decorated with gilt molding. A green couch appears behind and an eighteenth-century portrait of a woman hangs on the back wall.

Dated 1859, this painting was executed at a time when Stevens's reputation was first solidified and his income rising; 1857 marked his first big sale to the Berlin collector Ravené. This increasing success enabled him to marry in 1858 and move into more elegant quarters. William Coles suggested that the new surroundings may have inspired the luxurious domestic setting in the Philadelphia painting.[1] The woman's rich costume also denotes her status. According to Shane Davis the cashmere shawl

FIG. 112-1 Alfred Stevens, *The Letter of Announcement,* signed, c. 1862, oil on canvas, 39½ x 27⅛″ (100 x 69 cm.), private collection, Brussels.

FIG. 112-2 Claude Monet, *Camille,* signed and dated 1866, oil on canvas, 90 x 59″ (231 x 151 cm.), Kunsthalle, Bremen, inv. no. 298–1906/1.

returned to fashion in 1856 and this painting must have been one of Stevens's earliest uses of what became a trademark in his works.[2] Coles quoted François Monod on the beauty of Stevens's cashmeres, "unfolded like fairy plumages, with a background of vermilion, white, sulfur, azure, orange, plum, or emerald colors, with their subtle medallion border of decorated feathers."[3] In a slightly later and larger painting entitled *The Letter of Announcement* (fig. 112-1), a woman in a shawl stands in the corner of a similar room (among other changes in the furnishings, the portrait is replaced by an allegory of painting) with the lapdog just visible in an open doorway. In that work the model is less conventionally beautiful, her troubled expression suggesting the receipt of disturbing news. In the earlier Philadelphia painting the pretty model is well suited to the anecdotal narrative and its lighthearted, piquant subject. However, as Geneviève Lacambre observed, the coy title "Will you go out with me, Fido?" traditionally given to the work is probably a later American invention; it first appears in the handwritten inventory from 1870 of the collection of Mrs. Wilstach, preserved in the Philadelphia Museum of Art archives.[4]

Within their self-imposed limitations, Stevens's images of the modish, fashion-plate world of highborn women were not only accomplished but also influential. His favored formula of posing a single, standing female figure, viewed in lost profile and richly attired, was probably descended ultimately from Gerard ter Borch (q.v.) and had an impact in the 1860s, as Lacambre noted, on both James Abbott McNeill Whistler (1834–1903) and Edouard Manet (1832–1883). In the figure, one may find a relationship with the work of the young Claude Monet (1840–1926; see fig. 112-2).[5] In connection with the Philadelphia painting, Lacambre quoted a comment by Camille Lemonnier, one of Stevens's earliest biographers, that a good picture by Stevens is like "a rare perfume concentrated within a scent bottle."[6]

NOTES
1. William A. Coles, *Alfred Stevens* (Ann Arbor, 1977), p. 9.
2. Ibid. The cashmere shawl figures, for example, in *A Visit* of 1857 (see Paul Lambotte, "Alfred Stevens," *L'Art Flamand & Hollandais,* vol. 7, no. 4 [April 1907], repro. p. 160), *The Visit* (formerly the Cardon and Boitte collections; see Lambotte, repro. p. 158), and, in an early appearance, in *The Pawnbroker's Shop* of 1854 (Rhode Island School of Design, Providence).
3. Coles (see note 1), p. 9; and François Monod, *Un Peintre des femmes du Second Empire, Alfred Stevens* (Evreux, 1909), p. 15.
4. See Philadelphia Museum of Art, *The Second Empire, 1852–1870: Art in France under Napoleon III,* October 1–November 26, 1978, the Detroit Institute of Arts, January 15–March 18, 1979, and Grand Palais, Paris, *L'Art en France sous le Second Empire,* May 11–August 13, 1979, p. 354, cat. no. VI-105.
5. See Philadelphia Museum of Art (note 4), p. 354, cat. no. VI-105.
6. "On dirait d'un parfum rare concentré dans les parois d'un flacon." From Camille Lemonnier, "Les Artistes contemporains: Alfred Stevens," *Gazette des Beaux-Arts,* 2nd ser., vol. 17 (1878), p. 170. See Philadelphia Museum of Art (note 4), p. 354, cat. no. VI-105.

PROVENANCE: W. P. Wilstach, Philadelphia, by 1870; Anna H. Wilstach, until 1893; bequest to the Philadelphia Museum of Art, 1893.

EXHIBITIONS: Mt. Holyoke College, South Hadley, Massachusetts, "Linear Art of the 19th Century," 1966 (no catalogue); The University of Michigan Museum of Art, Ann Arbor, *Alfred Stevens,* September 10–October 16, 1977, Walters Art Gallery, Baltimore, November 20, 1977–January 1, 1978, and Musée des Beaux-Arts, Montreal, February 2–March 19, 1978, p. 9, no. 4, p. 8; Philadelphia Museum of Art, *The Second Empire, 1852–1870: Art in France under Napoleon III,* October 1–November 26, 1978, the Detroit Institute of Arts, January 15–March 18, 1979, and Grand Palais, Paris, May 11–August 13, 1979, p. 354, no. VI-105; Philadelphia Museum of Art, "100 Years of Acquisitions," May 7–July 3, 1983 (no catalogue).

LITERATURE: Edward Strahan, ed., *The Art Treasures of America,* vol. 3 (Philadelphia, 1879), p. 34; Wilstach 1900, no. 136, 1902, no. 153, 1903, no. 175, 1904, no. 243, 1906, no. 267, 1907, no. 281, 1908, no. 281, 1910, no. 395, 1913, no. 410, 1922, no. 302, repro.; PMA 1965, p. 65.

CONDITION: The panel support with a vertical grain is in good, stable condition. The paint film is thin in places, especially where the underdrawing of the architecture is visible through the couch and the floor. There are losses along the edges and at the bottom right corner. Localized traction crackle is found in the area of the wall to the left of the door. The painting was partially cleaned in 1965 and again in 1966. The varnish is colorless.

113 FOLLOWER OF DAVID TENIERS II

TWO PEASANTS IN A NICHE
Oil on canvas, 22½ x 16" (57.2 x 40.5 cm.)
Bequest of Arthur H. Lea. F38-1-22

Two peasants appear in a niche. One in a feathered hat smokes a clay pipe and holds a jug in his left hand. The second peasant stands on the right behind the first. On the ledge before him are two additional vessels.

Previously assigned to Jan Steen (q.v.), this work has more in common with Flemish low-life genre. The work's broad touch calls to mind the work of artists such as Joos van Craesbeeck (c. 1606–1654/61) who were active in Antwerp during and after the period of David Teniers II (1610–1690), but its crude execution, obscured by abrasion and overpaint, defies attribution.[1]

NOTE
1. For David Teniers II, see Franz Joseph Peter van den Branden, *Gescheidenis der Antwerpsche Schilderschool* (Antwerp, 1883), pp. 981–1008; Adolf Rosenberg, *Teniers der Jüngere,* 2nd ed. (Bielefeld and Leipzig, 1901); Roger Peyre, *David Teniers* (Paris, 1910); L. Bouquet, *David Teniers* (Paris, 1924); George Eekhoud, *Teniers* (Brussels, 1926); K. Zoege von Manteuffel in Thieme-Becker 1907–50, vol. 32 (1938), pp. 527–29; S. Speth-Holterhoff, *Les Peintres flamands de cabinet d'amateurs au XVIIe siècle* (Brussels, 1957), pp. 127–60; Francine Claire Legrand, *Les Peintres flamands de genre au XVIIe siècle* (Brussels and Paris, 1963), pp. 127–29; Jane P. Davidson, *David Teniers the Younger* (Boulder, 1979); Noortman & Brod, New York, *Adriaen Brouwer, David Teniers the Younger,* October 7–30, 1982, and Maastricht, November 19–December 11, 1982 (catalogue by Margret Klinge).

PROVENANCE: Arthur H. Lea.

LITERATURE: Karel Braun, *Alle tot nu toe bekende schilderijen van Jan Steen* (Rotterdam, 1980), p. 174, no. B-185, repro. [as not by Jan Steen].

CONDITION: The canvas support is dry and brittle. Extensive overpaint, especially in the architecture of the niche, covers the paint film. Old losses are evident along the lower edge and general abrasion appears throughout. The varnish is dull and deeply discolored.

For additional works by Teniers II in the Philadelphia Museum of Art, see John G. Johnson Collection cat. nos. 689, 693, 694, 695, 696, 697, 690 (attributed to), 691 (attributed to), 692 (attributed to), inv. no. 162 (imitator of), cat. nos. 532 (copy after), 682 (copy after).

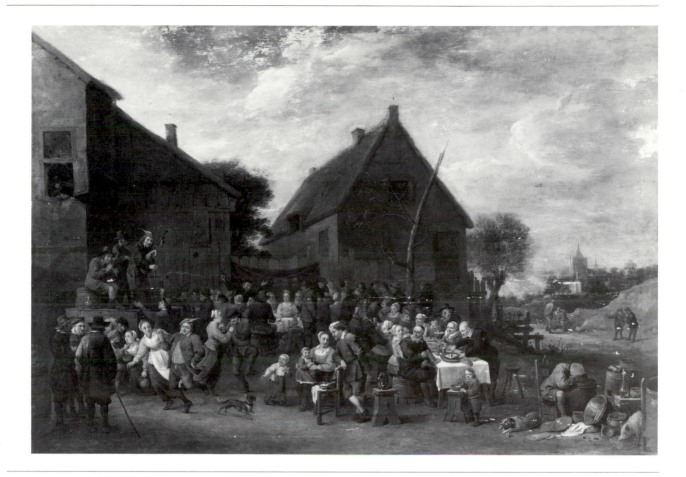

114 COPY AFTER DAVID TENIERS II

A WEDDING FEAST
Falsely signed lower right: · *D TENIERS F* ·
Oil on panel, 31⅜ x 44⅝″ (80 x 113 cm.)
The William L. Elkins Collection. E24-3-38

A large crowd has assembled to celebrate a wedding. At the left are musicians and dancers and in the center are two long tables surrounded by celebrants. The bride is seen on the far side of the table closest to the two large buildings in the middle ground. At the right a man sleeps on a barrel amid utensils; beyond is a landscape with a church tower.

 This work is one of several copies of an original painting by David Teniers II (1610–1690) dated 1650 in the Hermitage, Leningrad.[1]

NOTE
1. Oil on canvas, 32¼ x 42½″ (82 x 108 cm.), no. 1719. Other copies: oil on canvas, 29⅞ x 42⅛″ (76 x 107 cm.), Collection J. L. Groenemans, St. Laurens, in 1950, formerly with dealer Smit, Rotterdam; oil on panel, 11 x 14⅛″ (28 x 36 cm.), sale, Niesewand, London, June 9, 1886, and sale, A. de Ridder, Paris, June 2, 1924, lot 76; signed, oil on panel, 38½ x 40½″ (98 x 103 cm.), sale, Princes Salm-Salm et al., Bonn, December 20, 1888, lot 74; monogram lower left, oil on canvas, 32⅝ x 48⅜″ (83 x 123 cm.), sale, J. Stillwell,

Anderson Galleries, New York, December 1, 1937, lot 227, repro.; with dealer J. R. Bier, Haarlem, in 1966 (photograph, Rijksbureau voor Kunsthistorische Documentatie, The Hague, no. 24319).

PROVENANCE: Sale, M.A.M. Nicolaeff, Paris, February 10, 1890, lot 20; Woortman-Holland Collection; William L. Elkins Collection, Philadelphia, by 1900.

LITERATURE: Elkins 1887–1900, vol. 2, no. 127, repro.; Elkins 1924, no. 38.

CONDITION: The panel support is cradled, has a horizontal grain, and one horizontal crack beginning at the right edge in the sky. The paint film reveals extensive losses and abrasion in the sky. There are losses and tented cleavage throughout the background. The varnish layer has been partially removed, leaving the paint film of the sky exposed. The remaining varnish is moderately discolored.

Born in Oslo on October 20, 1847, Thaulow was the nephew of the Norwegian painter and art dealer Henrik Arnoldus Thaulow (1722–1799). He studied at the academies in Copenhagen (1870–72) and Karlsruhe (1873–74) before traveling to Paris, where the Exposition Universelle of 1878 made a strong impression on him. With Christian Krohg (1852–1925) and Erik Theodor Werenskiold (1855–1938), he was one of the leaders of the Norwegian naturalism movement that was waged against the local artist's association. In September 1883 he founded an "Open Air Academy" in Modum. After initial successes with open-air painting, he turned increasingly to studio work. Thaulow excelled in views of canals and rivers. He specialized in impressionistic images of rain, snow, storms, and night scenes. Claude Monet (1840–1926) had an influence on his work. He also was in contact with the French painters Emile Auguste Carolus-Duran (1838–1917), Jean Charles Cazin (1841–1901), and Leon Augustin Lhermitte (1844–1925). He exhibited often and widely, in Paris (1889, 1898, and 1900), London (1892), Venice (1894), Vienna (1894), Pittsburgh (1894, 1897), and Munich (1901). A portrait of Thaulow and his family by Jacques Emile Blanche (1861–1942) was in the Musée Luxembourg, Paris (70⅞ x 78¾" [180 x 200 cm.], cat. no. 40). Active as a writer as well as an artist, Thaulow published newspaper articles on art. Selections of his writings and sketches were published in book form by his wife, Alexandra Thaulow, with the title *I Kamp og fest* (Kristiania, 1908). A personal friend of Monet, he arranged for the French artist to visit Norway in 1895, where they painted winter landscapes together. Deeply influenced by the Impressionists, Thaulow nonetheless managed to fashion his own style. He died in Holland after suffering many years with diabetes. Early admired by American nineteenth-century collectors (Thaulow visited the Philadelphia Centennial Exposition in 1876), Thaulow's art is represented in several museums in this country (Boston, Chicago, Pittsburgh, Saint Louis, Worcester, and others). Thaulow's portrait by J. W. Alexander was formerly in the Philadelphia Museum of Art as part of the W. P. Wilstach Collection but was sold in 1954.

LITERATURE: Andreas Aubert, *Die Norwegische Malerei im XIX Jahrhundert, 1840 bis 1900* (Leipzig, 1910); Thieme-Becker 1907–50, vol. 32 (1938), pp. 583–84; Henning Alsvik, Leif Østby, and Reidar Revold, *Norges billedkunst i det nittoende og tyrvende århundre,* 2 vols. (Oslo, 1951–53); Jan Askeland, *A Survey of Norwegian Painting* (Oslo, 1971); Stiftelsen Modums Blaafarvevaerk, Modum, *Frits Thaulow in the 1880s,* July 28–October 1, 1979 (catalogue by Vidar Poulsson); Hirschl and Adler Galleries, New York, *Frits Thaulow,* October 11–November 16, 1985 (catalogue by Vidar Poulsson).

For additional works by Thaulow in the Philadelphia Museum of Art, see John G. Johnson Collection cat. nos. 1091, 1092.

115 FRITS THAULOW

THE RIVER ARQUES AT ANCOURT—EVENING, 1895
Signed and dated lower right: *Frits Thaulow '95.*
Oil on canvas, 34¼ x 25½" (87 x 64.8 cm.)
The William L. Elkins Collection. E24-3-93

A stream with snow-covered banks curves back and under a stone bridge
foreshortened on the left. In the central distance is a stone stairway leading
down to the water and up to several houses with snow-covered roofs. A
tiny figure carrying a yoke with two buckets appears in the street on the far
side of the bridge.

Although usually unidentified or assumed to be a depiction of a
Norwegian scene,[1] the site in this work is probably a bend in the river
Arques at Ancourt near Dieppe, France, where Thaulow was living in 1895
when he dated this work. This we conclude not simply from the fact that
from about 1892 onward Thaulow painted almost exclusively French

scenery, but also from the record of the work's having been exhibited at the Carnegie Art Galleries (forerunner of the Carnegie Institute) in Pittsburgh in 1897. Of his three works exhibited, only number 219, "The Arques at Ancourt—Evening," fits the description of this scene of a wintry river with lengthening shadows.[2] According to the catalogue, the work was awarded a medal of the second class, the only work of Thaulow's trio to be so honored. Another scene of the river Arques dated 1895 but depicting the swollen waters in March was exhibited at Hirschl and Adler Galleries in New York in 1985.[3]

NOTES

1. See Thieme-Becker 1907–50, vol. 32 (1938), p. 583 [as "Norwegian Sun"].

2. Carnegie Art Galleries, Pittsburgh, *Second Annual Exhibition*, November 4, 1897–January 1, 1898. The other two works were: *Banks of the Cauche, Morning in May,* no. 218, and *An Old Street of the Convent, Dieppe,* no. 220.

3. Signed and dated, oil on canvas, 24¾ x 35¼″ (63 x 89.7 cm.); see Hirshl and Adler Galleries, New York, *Frits Thaulow,* October 11–November 16, 1985, cat. no. 15, repro. Compare also the design of the river scene *Winter in France,* signed, also probably painted in 1895, pastel on paper mounted on canvas, 22¾ x 23⅝″ (73 x 60 cm.); see Hirshl and Adler Galleries, New York, *Frits Thaulow,* cat. no. 14, repro. (with a discussion of other versions of the composition).

PROVENANCE: William L. Elkins Collection, Philadelphia, by 1900.

EXHIBITION: Carnegie Art Galleries, Pittsburgh, *Second Annual Exhibition,* November 4, 1897–January 1, 1898, probably no. 219.

LITERATURE: Elkins 1887–1900, vol. 1, no. 50, repro. [as "Landscape"]; Thieme-Becker 1907–50, vol. 32 (1938), p. 583 [as "Norweg. (ische) Sonne"]; PMA 1965, p. 67 [as "Landscape"].

CONDITION: The unlined canvas is very slack with corner draws. The relatively thin paint film is in good, stable condition. The varnish is moderately discolored.

116 STYLE OF GASPAR PEETER
VERBRUGGHEN II

DECORATIVE FLOWER PIECE, c. 1700–1720
Oil on canvas, 58⅜ x 76½″ (148.3 x 194.3 cm.)
Gift of Mrs. Chester Dale. 50-121-1

At the center is a large urn with a flower arrangement. Flowers also appear
in the foreground in a metal pail and are strewn about the ground. A
stairway at the right leads back to a fountain.

 Formerly attributed simply to an unknown Dutch seventeenth-century
artist, this series of four decorative panels reveals points of resemblance with
the work of Gaspar Peeter Verbrugghen II (1664–1730).[1] Son of the flower
painter of the same name (1635–1681), Verbrugghen specialized in decorative
flower pieces. The quality of execution of these pieces, however, is too weak
and crude for the artist.

NOTE
1. Frans Jozef van den Branden, *Geschiedenis
der Antwerpsche Schilderschool* (Antwerp, 1883),
p. 1139; Wurzbach 1906–11, vol. 2, p. 763;
Thieme-Becker 1907–50, vol. 34 (1940),
p. 228.

PROVENANCE: Mrs. Chester Dale.

LITERATURE: PMA 1965, p. 21 [as Dutch,
unknown, seventeenth century].

117 STYLE OF GASPAR PEETER
 VERBRUGGHEN II

DECORATIVE FLOWER PIECE, c. 1700–1720
Oil on canvas, 58⅜ x 76½″ (148.3 x 194.3 cm.)
Gift of Mrs. Chester Dale. 50-121-2

A vase of flowers rests on a decorative stone pedestal in a garden.
Architectural fragments litter the ground, and at the left a statue of a
reclining nude surmounts a fountain.

118　STYLE OF GASPAR PEETER
VERBRUGGHEN II

DECORATIVE FLOWER PIECE, c. 1700–1720
Oil on canvas, 58⅜ x 76½″ (148.3 x 194.3 cm.)
Gift of Mrs. Chester Dale. 50-121-3

A bouquet in an urn adorns a fountain in the shape of a griffin. A
medallion bust-length portrait in stone relief of a man wearing a laurel
wreath lies on the ground in the lower right. At the rear left a gate opens to
a distant prospect with mountains and forests.

119 STYLE OF GASPAR PEETER
VERBRUGGHEN II

DECORATIVE FLOWER PIECE, c. 1700–1720
Oil on canvas, 58⅜ x 76½″ (148.3 x 194.3 cm.)
Gift of Mrs. Chester Dale. 50-121-4

Flowers fill a vase on a pedestal and spill over a stone pot lying overturned
on the ground. At the left is a fountain in the shape of a woman's head; at
the right, a distant prospect.

CONDITION: All four canvas supports are
slack and out of plane. A puncture appears in
the lower left of no. 116. The paint film has
numerous old and new losses and extensive
cupping. Some active flaking is apparent. The
varnish is extremely discolored.

Jan (Johannes) Vermeer (Van der Meer) was a member of a family of Dutch painters. He was baptized on October 22, 1628, in Haarlem and buried there in St. Bavo's Church on August 25, 1691. He was the eldest son of Hester Candele and Jan Vermeer I (1600/1601–1670), a Haarlem art dealer and brandy and tobacco merchant, who, according to Abraham Bredius and C. Hofstede de Groot, was also a landscape painter. Jan II was the brother of the painter Isaack Vermeer and the father of Jan Vermeer III (1656–1705), a landscape and animal painter, and Barent Vermeer (1659–after 1690), a still-life painter. In 1638 Jan II was apprenticed to Jacob Willemsz. de Wet (1610–1671/72), and in 1654 he entered the Haarlem guild. He was married in the same year in Haarlem to Aeltje Bosvelt. Mentioned as a painter in Haarlem in 1663, 1665, 1669, and 1673, he also was active as an art appraiser of Haarlem estates in 1678, 1681, and 1682. The last archival reference to him is in 1689.

A landscapist, Jan II often painted the dunes in the vicinity of his native Haarlem. He probably was influenced by his contemporaries Jacob van Ruisdael (q.v.) and Guillam du Bois (1623/25–1680), as well as by Philips Koninck (1619–1688). Confused in the last century with his famous namesake, Johannes Vermeer of Delft (1632–1675), he also should not be mistaken for the Utrecht portrait and figure painter of the same name (c. 1640–after 1692) nor for his own son Jan III. Moreover his oeuvre has been obscured by wrongful attributions of similar works by Jan van Kessel (1641/42–1680), Jan Koninck (active 1693), Adriaen Verboom (c. 1628–c. 1670), and Dionijs Verburgh (c. 1650–1715/22).

LITERATURE: Bredius 1915–22, vol. 6 (1919), pp. 2223–31; Eduard Trautscholdt in Thieme-Becker 1907–50, vol. 34 (1940), pp. 261–64; Plietzsch 1960, pp. 101–2; Wolfgang Stechow, *Dutch Landscape Painting in the Seventeenth Century* (London, 1966), pp. 48–49; Laurens J. Bol, *Holländische Maler des 17. Jahrhunderts nahe den grossen Meistern: Landschaften und Stilleben* (Brunswick, 1969), pp. 217–19; Kurt J. Müllenmeister, *Meer und Land im Licht des 17. Jahrhunderts,* vol. 3 (Bremen, 1981), p. 87.

120 JAN VERMEER II (VAN HAARLEM)

VIEW OF THE DUNES NEAR HAARLEM, 1667 or 1677
Signed lower left: *J V Meer* (first three letters ligated); dated: *16*[6 or 7?]*7*
Oil on panel, 23½ x 32⅛″ (59.8 x 82.9 cm.)
The William L. Elkins Collection. E24-3-95

A panoramic view across the dunes of Overveen, near Haarlem, depicts the
tower of St. Bavo's Church with several other spires in Haarlem on the left,
and sailboats at the right. A traveler dressed in blue and red and holding a
walking stick appears on the sandy road in the foreground. At the right are
some beach flowers and in the left middle distance the roofs of several
low-lying cottages. The composition unfortunately has been imbalanced by
later additions enlarging the stretch of water on the right, adding bigger
boats, and probably overpainting at least one building: a multi-storied villa
that appears on the right in other paintings of nearly the same view (see
figs. 120-1 and 120-2).

 At least as early as the 1900 William L. Elkins Collection catalogue the
picture was titled "Moonlight," but when the discolored varnish was
removed in 1968–69, it was revealed to be a daylight scene. At the time of
treatment the signature and a date of 1684 were present; however, a recent
microscopic examination of this date indicates that it originally was 16[?]7.
The artist's other works suggest that the third digit was most likely a six or
a seven. Wolfgang Stechow observed that Jan II's dated works range from

FIG. 120-1 Jan Vermeer II (van Haarlem),
View of Haarlem, signed, oil on panel, 16¼ x
30¾″ (42.5 x 78 cm.), Wallraf Richartz
Museum, Cologne, inv. no. 2367.

FIG. 120-2 Attributed to Jan van Kessel, *View of Haarlem*, oil on canvas, 30½ x 39¾" (77.5 x 101 cm.), Szépművészeti Múzeum, Budapest, inv. no. 4260.

1648 to 1676.[1] The few panoramas that he painted seem to date from the 1660s and 1670s. Two reliably dated works are the *Dunes near Haarlem* of 1675 in the Louvre,[2] and the *View of Noordwijk* of 1676 in Rotterdam (fig. 120-3). Jan II's panoramas can resemble those of Philips Koninck (1619–1688) but the Philadelphia painting and others come closer to Jacob van Ruisdael's panoramic compositions in their arrangement of the city on the horizon, detailed treatment of the dunes and foliage, and placement of the foreground figures. Despite these similarities Jan Vermeer II of Haarlem never attained Ruisdael's power or drama; he remained tied to a simpler, more matter-of-fact approach to naturalism.

The single work that most resembles Philadelphia's painting is Jan II's *View of Haarlem* (fig. 120-1), which employs virtually the same site and point of view.[3] Stechow dated that painting to the 1660s. It appears fresher than Philadelphia's painting, which is much abused, and may predate it. Almost the same view also appears in an unsigned painting in Budapest attributed to Jan van Kessel (1641/42–1680; fig. 120-2).[4] Doubtless the popularity of this specific view stems from Ruisdael's "Haarlempjes," or views of Haarlem.[5]

FIG. 120-3 Jan Vermeer II (van Haarlem), *View of Noordwijk*, signed and dated 1676, oil on canvas, 34⅞ x 60⅛" (88.5 x 154 cm.), Museum Boymans–van Beuningen, Rotterdam, inv. no. 1502.

NOTES

1. Wolfgang Stechow, *Dutch Landscape Painting of the Seventeenth Century* (London, 1966), p. 48; see *Landscape on the Edge of the Dunes,* signed and dated 1648, oil on panel, 20½ x 26¾" (52 x 68 cm.), Mauritshuis, The Hague, no. 724.
2. Oil on canvas, 31½ x 39¾" (80 x 101 cm.), Musée du Louvre, Paris, no. 2862; repro. in Arnauld Brejon de Lavergnée, Jacques Foucart, and Nicole Reynaud, *Catalogue sommaire illustré des peintures du Musée du Louvre, no. 1, Écoles flamande et hollandaise* (Paris, 1979), p. 87.
3. See Horst Vey and Annamaria Kesting, *Katalog der niederländischen Gemälde von 1550 bis 1800 im Wallraf-Richartz-Museum und im öffentlichen Besitz des Stadt Köln* (Cologne, 1967), pp. 67–70, pl. 93; compare also *View in the Outskirts of Haarlem,* oil on panel, 18⅞ x 25⅜" (48 x 64.5 cm.), Alte Pinakothek, Bayerische Staatsgemäldesammlungen, Munich, no. 9562 (repro. in Stechow [note 1], pl. 84); *Distant View of Haarlem,* 19 x 27⅕" (48.3 x 69.9 cm.), The New-York Historical Society (*Catalogue of the Gallery of Art* [New York, 1915], p. 77, no. B-167 [as Jacob van Ruisdael]); and *Dutch Landscape,* 13¼ x 15" (33.5 x 38 cm.), Frans Halsmuseum, Haarlem, no. 257 [as Jacob van Ruisdael].
4. See A. Pigler, *Katalog der Galerie Alter Meister* (Tübingen, 1968), vol. 1, pp. 350–51, vol. 2, pl. 287.
5. See no. 97. Compare examples in the Rijksmuseum, Amsterdam (no. A351), the Mauritshuis, The Hague (no. 155), and the Gemäldegalerie, Staatliche Museen Preussischer Kulturbesitz, Berlin (West) (no. 885C) (see James D. Burke, "Ruisdael and His Haarlempjes," *M: A Quarterly Review of the Montreal Museum of Fine Arts,* vol. 4 [summer 1974], pp. 3–11), and Stiftung Ruzicka, Kunsthaus, Zurich (no. R32) (see Mauritshuis, The Hague, *Jacob van Ruisdael,* October 1, 1981–January 3, 1982, and Fogg Art Museum, Cambridge, Mass., January 18, 1982–April 11, 1982, pp. 130–33).

PROVENANCE: William L. Elkins Collection, Philadelphia, by 1900.

LITERATURE: Elkins 1887–1900, vol. 2, no. 107, repro. [as Jan van der Meer of Haarlem, "Moonlight"]; Eduard Trautscholdt in Thieme-Becker 1907–50, vol. 34 (1940), p. 264; Rishel 1974, p. 29, fig. 6 [as dated 1684 or 1689?].

CONDITION: The uncradled panel has a horizontal grain and comprises two planks joined at the center. The panel is well preserved but is warped and worn at the corners. The paint film is extensively abraded and overpainted, especially in the sky and at the horizon line. The shoreline at the right has been altered. The paint is also severely abraded. The foliage, steeple, and towers at the left horizon are also abraded and retouched. Losses at the lower edge were filled and retouched. Pentimenti appear in the center right foreground, indicating that the artist had included two more figures among the dunes, but later painted them out. The date is also altered: the number "84" was evidently painted over the last two digits of the remnants of 16[6 or 7]7. The varnish is uneven and moderately discolored. Colorless synthetic varnishes were applied overall in 1968–69.

LITERATURE: Jantzen (1910) 1979, pp. 101ff.;
Wurzbach 1906–11, vol. 2, p. 804; W.
Gramberg in Thieme-Becker 1907–50, vol. 34
(1940), pp. 463–64; Walter A. Liedtke,
"Hendrick van Vliet and the Delft School,"
The Toledo Museum of Art Museum News, vol.
21, no. 2 (1979), pp. 40–52; Walter A. Liedtke,
*Architectural Painting in Delft: Gerard
Houckgeest, Hendrick van Vliet, Emanuel de
Witte* (Doornspijk, 1982), pp. 57–68.

Born in Delft, Hendrick Cornelisz. van Vliet was said to have been twenty-one years old when he joined the guild in Delft in 1632. According to the Delft chronicler Dirck van Bleyswijck (*Beschryvinge der Stadt Delft* [Delft, 1667], p. 852), he was a student of his uncle, the history and portrait painter Willem Willemsz. van de Vliet (c. 1584–1642); later he studied portraiture under Michiel Jansz. van Miereveld (1567–1641). Van Bleyswijck praised Van Vliet's grasp of perspective, foreshortening, and illusionistic effects, as well as the naturalness of his coloring. After twenty years of activity as a portraitist, he became an architectural painter. His last dated painting, of the interior of the cathedral at Utrecht (oil on canvas, 41¾ x 50¾" [106 x 129 cm.], Centraal Museum, Utrecht, no. 1346), was done in 1672. He died in Delft in 1675.

Van Vliet's earliest architectural paintings are dated 1652. These works are clearly dependent upon Gerard Houckgeest (c. 1600–1661) and Emanuel de Witte (c. 1617–1692), two painters who invented a new, more naturalistic architectural style of painting in Delft around 1650. Van Vliet specialized in views of the interiors of the Oude Kerk and the Nieuwe Kerk in Delft, churches that held local interest because they enshrined the tombs of two of Holland's greatest heroes—Admiral Piet Hein and William the Silent.

121 HENDRICK CORNELISZ. VAN VLIET

VIEW OF THE OUDE KERK, DELFT, 1659
Signed and dated on the foreground column base: *H. van Vliet / 1659*
Oil on canvas, 31¾ x 26⅝" (81 x 67.6 cm.)
Purchased for the W. P. Wilstach Collection. W02-1-15

FIG. 121-1 Hendrick Cornelisz. van Vliet, *View of the Oude Kerk, Delft,* signed and dated 1654, oil on panel, 29⅛ x 23⅝" (74 x 60 cm.), Rijksmuseum, Amsterdam, no. A455.

Incorrectly identified in the past as being a view of the Nieuwe Kerk in Delft and wrongly described in the 1922 Wilstach Collection catalogue as portraying the tomb of William the Silent, the scene was correctly identified by James Welu in 1979 as depicting the interior of the Oude Kerk in Delft.[1] One of Van Vliet's favorite architectural subjects, the Oude Kerk is here represented from a viewpoint in the choir looking obliquely into the *vrouwenkoor,* or choir for female voices, and the north transept. The same view can be found in a painting dated five years earlier in the Rijksmuseum, Amsterdam (fig. 121-1), as well as in a scene in the Manchester City Art Gallery (fig. 121-2) that is virtually identical to the Philadelphia painting and possibly a copy of it.[2] The composition of both of these related works, unlike that of the Philadelphia painting, includes a darkened arch at the top, a motif Van Vliet often employed to enhance the sense of spatial recession. The same view also appears without the arch in a picture in the Staatliche Kunstsammlungen in Kassel.[3] The Mauritshuis in The Hague and the Staatliche Kunsthalle in Karlsruhe (dated 1662) own similar scenes; but both are viewed from a point deeper in the choir than is employed in the Philadelphia work.[4] As Walter Liedtke observed, the view from the choir seems first to have been treated by Emanuel de Witte (c. 1617–1692) around 1651–52 (fig. 121-3).[5]

Although we can usually identify the viewpoint of Van Vliet's paintings of the Oude Kerk,[6] he often took liberties with the architecture. In this work, as in most of Van Vliet's views of the structure, the verticality of the architecture is exaggerated to enhance the sense of a lofty and elevated

space. The artist also freely rearranged objects within the space. As Welu observed, the sculptural relief on the foremost column is a monument dated 1644 to an important Delft official, Johan van Lodensteyn, and his wife Maria van Bleyswyck.[7] This monument hangs where it was originally installed, on the south side of the middle pillar of the choir area, and seems to be depicted in its actual situation in the Philadelphia painting and in the pictures in Amsterdam, Manchester, Kassel, and The Hague.[8] In the painting of the Oude Kerk exhibited in Worcester in 1979, however, as Welu observed, this monument and other objects in the church have been moved from their original locations.[9] Just as Van Vliet freely redesigned architecture and repositioned objects, he often rearranged the same staffage.

FIG. 121-2 Copy or replica of Hendrick Cornelisz. van Vliet?, *View of the Oude Kerk, Delft,* oil on canvas, 30⁵⁄₁₆ x 27⅛″ (77 x 69 cm.), Manchester City Art Gallery, no. 1953.207.

FIG. 121-3 Emanuel de Witte, *View of the Oude Kerk, Delft,* c. 1651–52, oil on panel, 17¼ x 15⅜″ (45 x 39 cm.), formerly Van Duyn Collection, Rotterdam.

FIG. 121-4 The monument of Johan van Lodensteyn and Maria van Bleyswyck, 1644, in the Oude Kerk, Delft.

The three kneeling figures who seem to be reading an inscription on a tombstone at the left reappear in the paintings in the Mauritshuis and in Manchester (fig. 121-2). The latter work also repeats the motif of the gravedigger who appears at the right in the Philadelphia picture. Together with the diamond-shaped memorial tablets on the columns and the putti and the skull on the Van Lodensteyn relief, this staffage group could allude, of course, to the brevity of life;[10] gravediggers in Dutch paintings of church interiors had become so common, however, that their memento mori associations are unlikely to have constituted a central meaning of Van Vliet's work.

NOTES

1. James A. Welu to author, personal communication, 1978; and James A. Welu, *17th Century Dutch Painting: Raising the Curtain on New England Private Collections* (Worcester, Mass., 1979), pp. 117–19, no. 34.
2. Although the picture is very possibly a copy, small changes that appear in the work—the addition of a dog in the foreground, different figures in the central distance, and a new coat of arms on the blazon at the top of the central column, for example—may indicate an autograph replica. See Manchester City Art Gallery, *Concise Catalogue of Foreign Paintings* (Manchester, 1980), p. 108 [as after Hendrick Cornelisz. van der Vliet].
3. *Interior of the Oude Kerk in Delft,* oil on canvas, 20¹⁄₁₆ x 18½″ (51 x 47 cm.), inv. no. 428.
4. *View of the Oude Kerk in Delft,* signed, oil on canvas, 30½ x 26⅞″ (77.5 x 68.2 cm.), Mauritshuis, The Hague, no. 203; *Interior of the Oude Kerk in Delft,* signed and dated 1662, oil on canvas, 21¹¹⁄₁₆ x 18⁵⁄₁₆″ (55.1 x 46.5 cm.), Staatliche Kunsthalle, Karlsruhe, inv. no. 2453.
5. Walter A. Liedtke, *Architectural Painting in Delft: Gerard Houckgeest, Hendrick van Vliet, Emanuel de Witte* (Doornspijk, 1982), p. 83 and fig. 77.
6. For example, *The Oude Kerk in Delft,* signed and dated 1671, oil on panel, 20½ x 16⅝″ (52 x 42.2 cm.), Akademie der bildenden Künste, Vienna, inv. no. 716; *The Oude Kerk in Delft,* oil on panel, 15¹⁵⁄₁₆ x 10¹⁄₁₆″ (40.5 x 25.6 cm.), Alte Pinakothek, Munich, no. W.A.F. 1161; *Interior of a Church,* oil on panel, 13⅞ x 12″ (35.3 x 30.5 cm.), Szépművészeti Múzeum, Budapest, inv. no. 405 [as Jacob van der Ulft]; and *Oude Kerk, Delft,* oil on panel, 18⅛ x 17⁷⁄₁₆″ (47.3 x 44.3 cm.), private collection (see Welu [note 1], no. 34)—all depict the Oude Kerk from the south aisle facing the north transept.
7. Discussed and reproduced in Welu (see note 1), pp. 117–19, fig. 34b.

8. See E. A. van Beresteyn, *Grafmonumenten en grafzerken in de Oude Kerk te Delft* (Assen, 1938), p. 20, no. 6. An eighteenth-century engraving shows the missing coat of arms that formerly appeared on the top of the monument; see P. Timareten, *Verzameling van gedenkstukken in Nederland,* vol. 1 (The Hague, 1775), p. 130, no. 5.
9. See Welu (note 1), pp. 116–19, no. 34.
10. See Welu (note 1), pp. 117–19. For the *vanitas* symbolism of this motif, see Horst W. Janson, "The Putto with the Death's Head," *The Art Bulletin,* vol. 19, no. 3 (September 1937), pp. 423–49.

PROVENANCE: Purchased for the W. P. Wilstach Collection, Philadelphia, October 15, 1902.

EXHIBITIONS: Campbell Museum, Camden, 1973, and 1979–80 (no catalogues).

LITERATURE: Wilstach 1903, no. 195, 1904, no. 281, 1906, no. 305, 1907, no. 316, 1908, no. 316, 1910, no. 441, 1913, no. 458, 1922, no. 334; PMA 1965, p. 69; Jantzen (1910) 1979, no. 581; James A. Welu, *17th Century Dutch Painting: Raising the Curtain on New England Private Collections* (Worcester, Mass., 1979), p. 119 n. 6; Walter A. Liedtke, *Architectural Painting in Delft: Gerard Houckgeest, Hendrick van Vliet, Emanuel de Witte* (Doornspijk, 1982), p. 107, no. 75.

CONDITION: The canvas support, relined with an aqueous lining, is dry; there are minor horizontal bulges scattered across the painting. The paint film is generally in good condition; but numerous old flake losses are evident around the edges, as well as a few small losses in the lower half of the painting. Although some of the scattered old losses have been retouched, many remain untouched, showing the canvas support beneath. The paint film exhibits a fine net crackle overall, with slight cupping and incipient cleavage in the lower-right quadrant. Some abrasion is noticeable in the darks. The varnish is moderately discolored, and the gloss uneven.

In a document dated April 29, 1604, De Vos was said to be twenty years old; hence he was born in 1584 or 1585. The brother of Paul de Vos (q.v.), the animal painter, and the brother-in-law of Frans Synders (q.v.), he was a pupil of David Remeeus (1559–1626) in Antwerp from 1599 to 1604 and later became a master in the guild in 1608. It is likely that De Vos took a study trip during the four years following his apprenticeship, since he applied in 1604 for a passport solely to see countries and to learn his profession ("alleenelyck omme de landen te besiene ende zyn ambacht te leerene"); still, no proof exists for such travels. In 1616 he became a citizen of Antwerp, in 1619 a deacon of the guild, and in 1620–21 served as a high deacon. Evidently also active as an art dealer, De Vos was listed in documents in 1616 and 1623 as "marchand de peintures" and appeared several times in this capacity at the Saint-Germain fair in Paris. On May 27, 1617, he married Suzanne Cock, who bore six children between 1618 and 1632. In 1635 he worked on the decorations of the city of Antwerp for the entry of cardinal-infante Ferdinand, executing under the direction of Peter Paul Rubens (q.v.) and in collaboration with Jacob Jordaens (1593–1678) the paintings for the triumphal arches. He also collaborated with Rubens on the decorations for the Torre de la Parada. His will of 1648 indicates that he was well-to-do. He died in Antwerp on May 9, 1651.

Principally remembered as a portraitist to the patrician families of Antwerp, De Vos was also active as a genre and history painter. His documented pupils include Simon de Vos (1603–1676) in 1615 and Willem Eversdyck (d. 1671) in 1633.

LITERATURE: Max Rooses, *Geschiedenis der Antwerpsche Schilderschool* (Ghent, 1880), pp. 531–39; Frans Jozef van den Branden, *Geschiedenis der Antwerpsche Schilderschool* (Antwerp, 1883), pp. 639–48; Wurzbach 1906–11, vol. 2, pp. 818–19; Jozef Muls, *Cornelis de Vos: Schilder van Hulst* (Antwerp, 1932), Edith Greindl, "Les Portraits de Corneille de Vos," *Jaarboek van het Koninklijk Museum voor Schone Kunsten van België*, vol. 2 (1939), pp. 131–72; Edith Greindl in Thieme-Becker 1907–50, vol. 34 (1940), pp. 550–52; Edith Greindl, *Corneille de Vos: Portraitiste flamand (1584–1651)* (Brussels, 1944); Leo van Puyvelde, *La Peinture flamande à Rome* (Brussels, 1950), pp. 198–200; Plietzsch 1960, pp. 195–98, pls. 359–67; Edith Greindl, "Corneille de Vos," in Musées Royaux des Beaux-Arts de Belgique, Brussels, *Le Siècle de Rubens,* October 15–December 12, 1965, pp. 277–82; Jacques Foucart, "Cornelis de Vos," in Grand Palais, Paris, *Le Siècle de Rubens dans les collections publiques françaises,* November 17, 1977–March 13, 1978, pp. 249–53.

For an additional work by Cornelis de Vos in the Philadelphia Museum of Art, see John G. Johnson Collection cat. no. 671.

122 CORNELIS DE VOS

PORTRAIT OF ANTHONY REYNIERS AND HIS FAMILY, 1631
Signed and dated lower left on chair: *C. DE VOS. F. A°1631*
Oil on canvas, 67 x 96½" (170.1 x 245 cm.)
Purchased for the W. P. Wilstach Collection. W02-1-22

On the left side of the full-length family portrait sits the father dressed in black and wearing a white collar. Before him stands a small boy dressed in brown and holding a broad-brimmed hat; behind him an older boy sits at a table covered with a carpet and holds an open book. On the right side sits the mother dressed in black with a white millstone collar; she is holding an infant on her lap. An older girl wearing olive-green and red silks, seated at the extreme right, offers the child fruit. Before the right-hand group stands

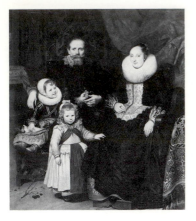

FIG. 122-1 Cornelis de Vos, *Portrait of the Artist and His Family*, signed and dated 1621, oil on canvas, 74 x 63¾" (188 x 162 cm.), Musées Royaux des Beaux-Arts de Belgique, Brussels, inv. no. 2246.

FIG. 122-2 Cornelis de Vos, *Portrait of an Unknown Family*, signed and dated 1631, oil on canvas, 65 x 92½" (165 x 235 cm.), Koninklijk Museum voor Schone Kunsten, Antwerp, no. 841.

FIG. 122-3 Cornelis de Vos, *Portrait of an Unknown Family*, oil on canvas, 56¼ x 80¾" (144 x 205 cm.), Museum voor Schone Kunsten, Ghent, inv. on. 1959A.

a little girl holding a bread roll. The wall is covered with gilded and green-colored leather wall covering and a horizontal half-length portrait of an elderly man and woman, doubtless an image of the grandparents.

The family is identified by the address on a folded letter lying upon the table, which reads "A Snr Anthoni/ Reiniersen Coopman / tot Antwerpen" (To Mr. Anthoni Reiniersen, merchant in Antwerp). De Vos used this traditional device for identifying sitters on several occasions.[1] According to an inscription on his tomb in Antwerp cathedral, Anthony Reyniers was the son of Adam Reyniers (d. 1586), "Old almoner of this city," and Magdalena del Becq (d. 1585).[2] The record of his birth has not come to light, but in the registry of his marriage he was recorded as having been born in the cathedral parish.[3] When his father made a will in 1582, Anthony was said to be underage;[4] hence he would have been at least forty-nine years old in 1631, when this picture was painted. Anthony was married to Maria Levitter (Lewieters, Lewiter, or Le Wieter; d. 1669) in St. Walburgis Church. While little is known of Reyniers, his activity as one of Antwerp's merchants is confirmed in a document of 1626.[5] Baptismal records for ten of the couple's children have survived (at St. Walburgis): Adam, October 28, 1621; Antonio (who must have died soon thereafter), January 16, 1623; Antonius, April 18, 1627; (at Onze Lieve Vrouwe Kerk, North): Clara, January 27, 1629; Catharina, April 31, 1630; Johannes Baptista, July 23, 1631; Dominicus, December 28, 1632; Marie Isabella, April 9, 1634; Bartholomeus, August 17, 1635; and Sara, January 3, 1637. Several of these children can be identified in the Philadelphia painting. The eldest boy at the left is probably ten-year-old Adam; the smaller boy is four-year-old Antonius; the infant on her mother's lap doubtless is one-year-old Catharina; and the young girl holding the roll is probably Clara, who was then nearly three years old. The identity of the eldest girl remains unknown.

This work shows De Vos at the height of his powers as a portraitist. The sitters clearly wished to be depicted amidst signs of their material success—expensive clothing, costly leather wall covering of the type made in Mechelen, and an Oriental carpet. The last-mentioned was identified by John Mills as of the coupled-column or Ladik variety.[6] In addition to the many conspicuous attributes of wealth and prestige, the family is successfully united as a group yet psychologically individualized. De Vos's commitment to faithful likenesses is evident in the suggestion that Maria Levitter had a stigmatism. Evidently this detail disturbed a later restorer, since her left pupil was formerly overpainted.[7] The overpaint on Maria's eye was removed at some time before 1968, when the picture was rephotographed and cleaned.

After about 1620 De Vos painted several family portraits that sought to unify the sitters within an elegant, domestic ambiance while retaining an air of dignified formality. One of the earliest is the artist's full-length portrait of his own family dated 1621 (fig. 122-1). With its horizontal design, the Philadelphia painting most resembles the *Portrait of an Unknown Family*, dated 1631 but of lesser quality, in the museum of Antwerp (fig. 122-2).[8] The composition also resembles that of another *Portrait of an Unknown Family*, formerly owned by Baron Gendebien, Brussels, and now in the museum in Ghent, which also depicts the sitters in attitudes of studied informality but in a three-quarter-length format (fig. 122-3).[9] Compare also De Vos's three-quarter-length family portraits on terraces, in Cologne and

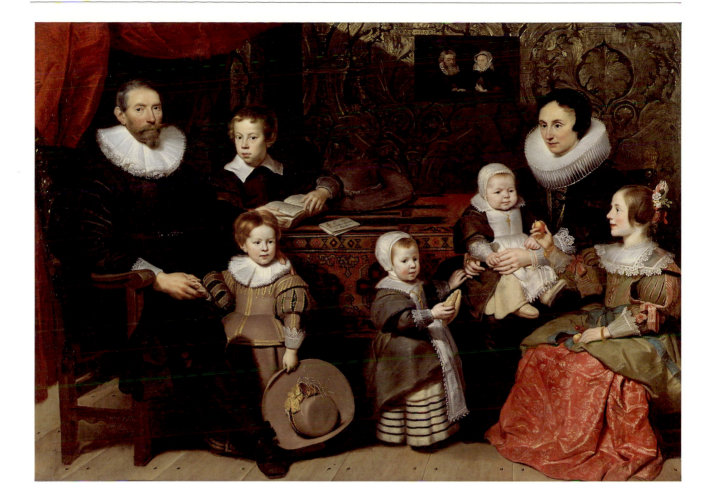

Munich.[10] Edith Greindl correctly rejected two theories advanced in the 1922 Wilstach Collection catalogue: that the painting now in Ghent depicts the same family as the Philadelphia painting, and that the Philadelphia picture descends from a portrait type invented by Marten de Vos (q.v.).[11] While the latter painted comparable family portraits,[12] the portrait type has earlier Flemish (for example, Frans Floris) as well as Italian sources.

NOTES

1. See, for example, *The Portrait of Jan Roose,* oil on canvas, 42⅞ x 33¹³/₁₆″ (109 x 86 cm.), Musées Royaux des Beaux-Arts de Belgique, Brussels, inv. no. 3650; and the *Portrait of Joris Vekemans,* oil on panel, 48⁹/₁₆ x 33¹³/₁₆″ (123.3 x 86 cm.), Museum Mayer van den Bergh, Antwerp, no. 10.

2. See *Inscriptions funéraires et monumentals de la Provence d'Anvers—Arrondissement d'Anvers,* vol. 1 (Antwerp, 1856), p. 130.

3. I am grateful to F. Melis of the Municipal Archives of Antwerp for information regarding Reyniers and his family.

4. Antwerp Archives, collection 18, fol. 253, June 5, 1595; public notary, no. 1482, March 11, 1594.

5. Antwerp Archives, no. SR 577, fol. 371.

6. John Mills to author, personal communication, 1980. Sarah B. Sherrill has discussed a carpet with a similar design that appears in a still life of 1664 by Nicolaes van Gelder in the Rijksmuseum, Amsterdam; see *Antiques,* vol. 109, no. 1 (January 1976), p. 163, pl. XIX. See also May H. Beattie, "Coupled-Column Prayer Rugs," *Oriental Art,* vol. 14, no. 4 (winter 1968), pp. 251–57, fig. 24.

7. Compare the reproduction in Edith Greindl, *Corneille de Vos: Portraitiste flamand (1584–1651)* (Brussels, 1944), pl. 76.

8. Until 1930 the canvas was divided in two pieces; see Jozef Muls, "Een restauratie in het Antwerpsch Museum," *De Kunst der Nederlanden,* vol. 1 (1930), pp. 34–35, repro.

9. See Edith Greindl, "Corneille de Vos," in Musées Royaux des Beaux-Arts de Belgique, Brussels, *Le Siècle de Rubens,* October 15–December 12, 1965, p. 282.

10. Dated 1626, oil on canvas, 63¼ x 72¾" (160.5 x 184.5 cm.), Wallraf Richartz Museum, Cologne, inv. no. 1033; and *The Hutten Family,* oil on panel, 55⅛ x 77¼" (140 x 196 cm.), Alte Pinakothek, Munich, inv. no. 383.

11. See Greindl (note 7), p. 34.

12. See, for example, his *Portrait of the Anselme Family,* dated 1577, oil on panel, 40½ x 65⅝" (103 x 166 cm.), Musées Royaux des Beaux-Arts de Belgique, Brussels, inv. no. 3689.

PROVENANCE: Purchased for the W. P. Wilstach Collection, Philadelphia, November 6, 1902.

LITERATURE: Wilstach 1903, no. 201, 1904, no. 287, 1906, no. 311, 1907, no. 322, 1908,

no. 322, 1910, no. 447, repro., 1913, no. 464, repro.; Rudolf Oldenbourg, *Die flämische Malerei des XVII. Jahrhunderts: Handbücher der Königlichen Museen zu Berlin* (Berlin, 1918), p. 79; Wilstach 1922, no. 340, repro.; Jozef Muls, *Cornelis de Vos: Schilder van Hulst* (Antwerp, 1932), pp. 31, 79; Edith Greindl, "Einige besondere Wesenszüge der Bildnisse des Cornelis de Vos," *Pantheon,* vol. 23 (April 1939), p. 114; Edith Greindl, "Les Portraits de Corneille de Vos," *Jaarboek van het Koninklijk Museum voor Schone Kunsten van België,* vol. 2 (1939), pp. 142, 143, 166, fig. 8; Edith Greindl in Thieme-Becker 1907–50, vol. 34 (1940), p. 552; Edith Greindl, *Corneille de Vos: Portraitiste flamand (1584–1651)* (Brussels, 1944), pp. 120–21, pl. 76; R. H. Wilenski, *Flemish Painters 1430–1830* (London, 1960), vol. 1, pp. 233, 247, 248, 251, 272, 274, 275, 282, 295, 297, 303, 331, vol. 2, pl. 600; PMA 1965, p. 69; E. de Jongh, *Portretten van echt en trouw: Huwelijk en gezin in de Nederlandse kunst van de zeventiende eeuw door* (Haarlem, 1986), p. 208, fig. 44b.

CONDITION: The original canvas is composed of two parts, with the seam running horizontally at the level of the cushion on the man's chair. The canvas has an older aqueous-adhesive lining. The tacking edges are missing. In 1968 the painting was cleaned and areas of loose and cleaving paint, primarily in the upper-left corner and right one-fifth of the canvas, were resecured. Small old losses were inpainted at this time along the seam, in the curtain at the upper left, in the gilt leather at the upper right, and in several scattered areas in the floor. A diagonal scratch in the lower left running through the right chair leg was repaired and inpainted in 1976. Except for minor abrasion and impressed impasto, the paint appears generally in very good condition. The varnish shows only slight discoloration.

123 FOLLOWER OF CORNELIS DE VOS

HEAD OF A WOMAN IN A RUFF

Oil on paper mounted on canvas, 16 x 13½" (40.6 x 34.3 cm.)
Gift of Peter D. Krumbhaar. 71-151-1

Acquired as the work of an unknown Flemish artist, this bust-length portrait was reassigned to a follower of Cornelis de Vos at the suggestion of H. Pauwels.[1] Although details like the eyes and mouth show some refinement, the overall execution is crude.

NOTE

1. Pauwels to Peter D. Krumbhaar, April 26, 1971, Philadelphia Museum of Art, accession files.

PROVENANCE: Purchased by Edward B. Krumbhaar in Naples, April 6, 1911; by descent to Peter D. Krumbhaar, Philadelphia.

CONDITION: The painting's support is paper with a white ground. It is mounted onto two fabrics, each with aqueous adhesive. The first fabric mount was trimmed to its current size, possibly cropping some of the paper support. There are four poorly mended tears, one under the sitter's nose and three in the ruff. The paper is locally distorted where it has detached from its mount. There is little loss or retouching. The varnish is hazy in patches and deeply discolored.

Born in Antwerp in 1532, Marten de Vos was the best pupil of Frans Floris (1516/20–1570). The latter encouraged him to visit Italy, where he studied with Jacopo Tintoretto (1518–1594). Upon his return to Antwerp in 1558 he joined the Guild of Saint Luke. In 1572 he helped found the confraternity of Romanists, which included other artists who had traveled to Italy. After Floris's death, De Vos became the foremost painter in Antwerp. As well regarded as his paintings in the monumental, late sixteenth-century manner were his drawings, which were collected not only by leading connoisseurs but also by other artists. De Vos died in Antwerp on December 4, 1603.

LITERATURE: F. J. van den Branden, *Geschiedenis van de Antwerpsche Schilderschool* (Antwerp, 1883), pp. 216–58; G. J. Hoogewerff, *Nederlandsche Schilders in Italië* (Utrecht, 1912), pp. 114–18; Wurzbach 1906–11, vol. 2, pp. 821–22; Max Rooses, *Art in Flanders* (New York, 1914), pp. 179–81; J. Denucé, *De Konstkamers van Antwerpen in* *de 16e en 17e eeuwen* (Antwerp, 1932), pp. 287, 291, 337; K. Zoege von Manteuffel in Thieme-Becker 1907–50, vol. 34 (1940), pp. 555–56; S. Speth-Holterhoff in Musées Royaux des Beaux-Arts de Belgique, Brussels, *Le Siècle de Bruegel: La Peinture en Belgique au XVIe siècle,* September 27–November 24, 1963, pp. 164–66, 200–201.

124 COPY AFTER MARTEN DE VOS, POSSIBLY BY DANIEL DE VOS

SPRING FROM THE SERIES "THE FOUR SEASONS"
Oil on canvas, 45¼ x 57¾" (115 x 146.7 cm.)
John W. Pepper Bequest. 35-10-98

The Four Seasons had been depicted as personifications since classical times, but toward the end of the sixteenth century it became increasingly common to depict them as mythological figures set before landscapes with activities appropriate to the respective times of the year.[1] Both Fra Francesco Colonna's *Hypnerotomachia Poliphili,* which was printed in Venice in 1499, and C. Ripa's *Iconologia,* which first appeared in Rome in 1593, cited the gods depicted in this series as appropriate to their seasons. Marten de Vos, who probably owed something to Maerten van Heemskerck (1498–1574) in both the theme and design of the print series, which was engraved by Adriaen Collaert (c. 1560–1618; fig. 124-1), also designed a second print series, engraved and published by Crispijn de Passe the Elder (1564–1637) that employs personifications with less traditional attributes of the Four Seasons.[2]

As copies of prints, the Philadelphia paintings cannot with certainty be attributed to any individual hand; their simple, schematic manner, however, resembles other works by Daniel de Vos (1568–1605), the first son of Marten de Vos, who is known to have made copies of his father's works.[3]

In *Spring* Venus is seated on a pedestal before a landscape with tiny figures engaged in various springtime activities (milking, courtship, planting, hunting, fishing). She is identified by her garland and her bouquet of flowers, by the pair of doves perched on her knee, and by the presence of Cupid, whom she restrains. Floating in the sky overhead are the zodiac symbols of Aries, Taurus, and Gemini.

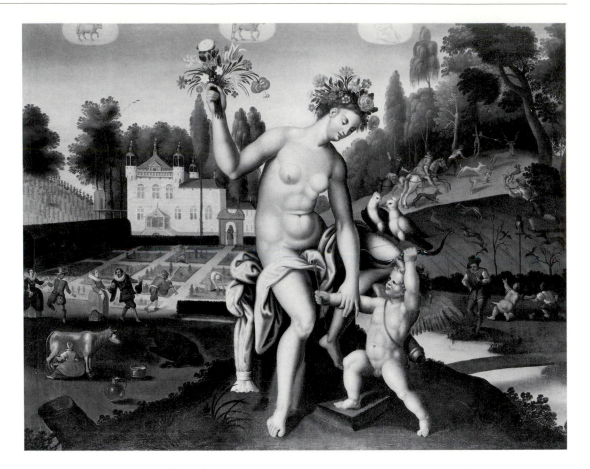

The print from which this work is copied is entitled "Ver Veneri S." and inscribed with the verses: "When the fields, rejuvenated in the spring, laugh with fresh green grass, and the pleasure gardens nourish the eyes with colored buds, the gracious Venus is worshiped; every kind of living creature perceives Venus: charming as she is, she loves to be served in a seductive season."[4]

NOTES

1. On the sixteenth-century iconography and representations of the Four Seasons, see Ilja M. Veldman, "Seasons, Planets and Temperaments in the Work of Maarten van Heemskerck: Cosmo-astrological Allegory in Sixteenth-Century Netherlandish Prints," *Simiolus*, vol. 11, nos. 3–4 (1980), pp. 149–63.
2. See F.W.H. Hollstein, *Dutch and Flemish Etchings, Engravings, and Woodcuts, ca. 1450–1700*, vol. 15 (Amsterdam, n.d.), p. 199, nos. 560–63; and Veldman [note 1], figs. 19–22.
3. Compare for example, *Saint Eustache* and *Saint Arsène*, both oil on canvas, 57½ x 75³⁄₁₆" (146 x 191 cm.), sale, Sotheby's, Monte Carlo, December 8, 1984, lot 309, repros.
4. "Cum viridi rident vernantes gramine campi, / Et pictis pascunt horti oculos oculis; / Alma Venus colitur; Venerem genus omne animantum / Sentit: amat blando tempore blanda coli" (translated by Annawies van den Hoek).

PROVENANCE: John W. Pepper.

LITERATURE: PMA 1965, p. 26 [as unknown Flemish artist].

CONDITION: The fabric support has a wax-resin lining. The tacking edges are missing. Scattered abrasion occurs overall. The paint film exhibits slight cupping. Paint is lost on the edges, in the lower-right corner, and scattered throughout. Retouches no longer match the original paint. The varnish is slightly discolored.

FIG. 124-1 Adriaen Collaert after Marten de Vos, *Ver Veneri S.*, engraving, 7¾ x 8½" (197 x 217 mm.), The Witt Library, London.

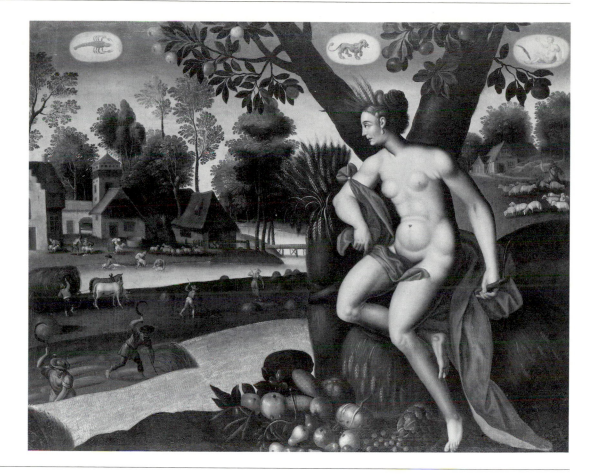

125 COPY AFTER MARTEN DE VOS,
POSSIBLY BY DANIEL DE VOS

SUMMER FROM THE SERIES "THE FOUR SEASONS"
Oil on canvas, 46¼ x 58″ (117.5 x 147.3 cm.)
John W. Pepper Bequest. 35-10-96

Ceres is seated in the foreground on a pile of wheat beneath an orange tree. The goddess of agriculture is identified by the sheaves of wheat in her hair, her sickle, and the summer fruits and vegetables at her feet. In the landscape beyond, small figures harvest wheat and herd and shear sheep. Overhead are the zodiac symbols of Cancer, Leo, and Virgo. The original print (fig. 125-1) is titled "Aestas Cereri S." and inscribed: "When the sun rests on the rough backs of the heat-bringing lion, and descends slowly into the laps of the virgins, blond Ceres balances the heat with an abundance of crops: steady toil ensures rewards from the gods." [1]

FIG. 125-1 Adriaen Collaert after Marten de Vos, *Aestas Cereri S.,* engraving, 7³⁄₁₆ x 8½″ (183 x 215 mm.), The Witt Library, London.

NOTE
1. "Aestiferi cum Sol premit aspera terga Leonis, / Virginis & sensim labitur in gremium; / Flava Ceres gravidis compensat messibus aestus: / Constans a Superis praemia Sudor habet" (translated by Annawies van den Hoek).

PROVENANCE: John W. Pepper.

LITERATURE: PMA 1965, p. 26 [as unknown Flemish artist].

CONDITION: The fabric support has a wax-resin lining. The tacking edges are missing. The surface is abraded. Losses are located along the edges, in the lower-right corner and scattered throughout. The retouches no longer match the original paint. There is a fine net crackle pattern overall with associated cupping. The varnish is slightly discolored.

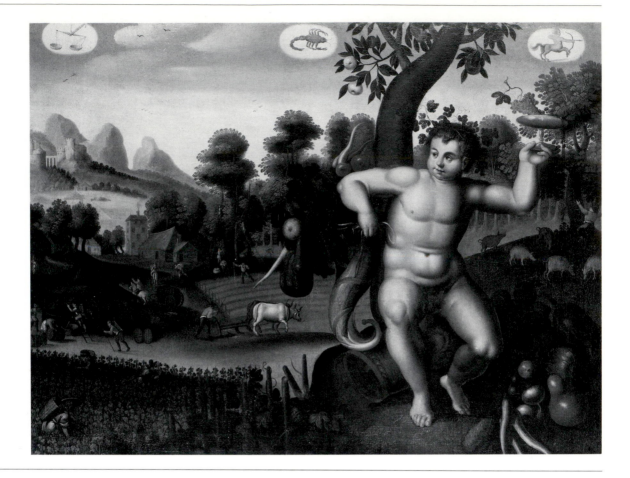

126 COPY AFTER MARTEN DE VOS,
 POSSIBLY BY DANIEL DE VOS

AUTUMN FROM THE SERIES "THE FOUR SEASONS"
Oil on canvas, 43⅜ x 58⅛" (110.2 x 147.6 cm.)
John W. Pepper Bequest. 35-10-97

Bacchus is seated in the foreground in a basket, which presumably is a
container for a jug of wine. The god is identified by his crown of
grapevines, the overflowing glass of wine that he holds aloft, the cornucopia
at the left, and the fall fruits and vegetables at his feet. In the landscape
beyond, workers harvest the vineyards, press wine, plow, and sow the
winter crop; and on the right, a swineherd knocks apples from a tree to
feed his pigs. Overhead are the zodiac symbols of Libra, Scorpio, and
Sagittarius. The original print (fig. 126-1) is entitled "Autumnus Baccho S."
and inscribed: "The third variable season of the year moves up; a rustic
throng recognizes that new gods have arrived; of first importance the
irresponsible and indiscrete Bacchus with his light-hearted face; he is a
youth, indeed, he makes old men young."[1]

FIG. 126-1 Adriaen Collaert after Marten de
Vos, *Autumnus Baccho S.*, engraving, 7⅜ x 8⅝"
(188 x 219 mm.), The Witt Library, London.

NOTE
1. "Tertia succedit anni variabilis aetas; /
Sentit adesse novos rustica turba deos; /
Inprimis hilari juvenantem fronte Lyaeum; /
Est juvenis, juvenes quin facit ille senes"
(translated by Annawies van den Hoek).

PROVENANCE: John W. Pepper.

LITERATURE: PMA 1965, p. 26 [as unknown
Flemish artist].

CONDITION: The fabric support has a
wax-resin lining. The tacking edges were
trimmed. The paint film is moderately
abraded. There are losses and discolored
retouches at the upper edge and along a
vertical scratch 24" (61 cm.) long beginning
6" (15.2 cm.) from the upper-left edge. The
smaller vertical dimension of the work
suggests that it was cut down. There is a fine
net crackle pattern overall with associated
cupping. The varnish is slightly discolored.

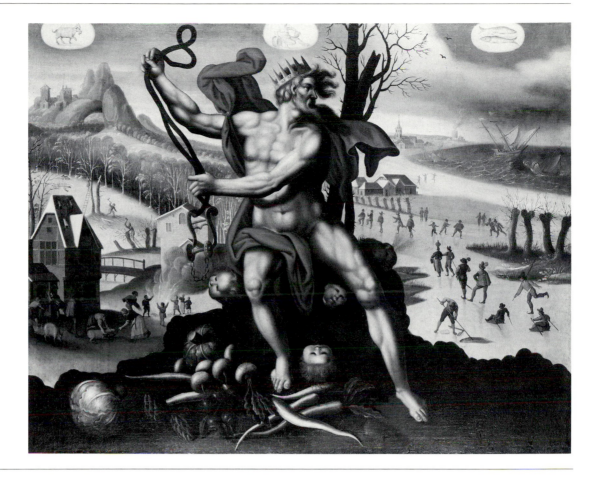

127 COPY AFTER MARTEN DE VOS, POSSIBLY BY DANIEL DE VOS

WINTER FROM THE SERIES "THE FOUR SEASONS"
Oil on canvas, 46 x 59¼" (116.8 x 150.5 cm.)
John W. Pepper Bequest. 35-10-95

Aeolus is seated in the foreground on a storm cloud before a barren tree. The god of the wind is identified by his crown, the bridle held in his hands, the puffing cupids' heads in the cloud, and the winter vegetables at his feet. In the landscape beyond, people butcher animals, gather firewood, spear fish, play on the ice, and watch boats founder in the rough winter seas. Overhead are the zodiac symbols of Capricorn, Aquarius, and Pisces. The original print (fig. 127-1) is titled "Hiems Aeolo S." and inscribed: "See, Aeolus lengthens the bridles of the wild running Boreas; and a gloomy presence wanders over the depressed fields: thus our month does not flourish with rich prosperity. Prescient fates contaminate in turns with sadness."[1]

FIG. 127-1 Adriaen Collaert after Marten de Vos, *Hiems Aeolo S.,* engraving, 7⅞ x 8¾" (186 x 221 mm.), The Witt Library, London.

NOTE
1. "Aeolus en Boreae laxavit frena ruenti, / Tristibus et species tristis oberrat agris: / Sic laetis, ne luxuriet mens nostra secundis, / Admiscent maestas praescia fata vices" (translated by Annawies van den Hoek).

PROVENANCE: John W. Pepper.

LITERATURE: PMA 1965, p. 26 [as unknown Flemish artist].

CONDITION: The painting is wax-resin lined. The lower-right corner is partially detached. The tacking edges are missing. Moderate abrasion is found overall as is a fine net crackle pattern with associated cupping. There are old losses along the edges and scattered throughout. Retouches are discolored. The varnish is slightly discolored.

Born in Hulst on December 9, 1595, Paul was the younger brother of Cornelis de Vos (q.v.). In 1604 he was an apprentice in Antwerp to Denis van Hove (active c. 1604); the following year he entered the atelier of David Remeeus (1559–1626). His sister Margaretha married Frans Snyders (q.v.), in 1611. His connection with Snyders, who was sixteen years his senior and already well established as a painter of animals, may explain why he had such an unusually long period of apprenticeship; De Vos became an independent master only in 1620. Doubtless he retained contact with Snyders, who left De Vos his easel, palette, and other tools of his trade in a will of 1627. On November 15, 1624, De Vos married Isabelle van Waerbeke, who bore ten children; the godfather of their child Peter Paul, born in 1628, was Peter Paul Rubens (q.v.). The preceding year Rubens had testified on De Vos's behalf in the case of an old debt. From the 1630s through the 1650s De Vos and his wife evidently prospered because their names repeatedly appear in documents in Antwerp dealing with the purchase and rental of houses. It was in these years that the marquis de Léganès, president of the Council of Flanders in Madrid, formed his celebrated collection of paintings, in which Paul de Vos was well represented. Between 1633 and 1640 the duke d'Arschot (Philippe d'Arenberg), then residing in Madrid, also commissioned several works from De Vos. Together with Snyders and Rubens, De Vos worked in 1637 and 1638 on the decorations for the Spanish royal residences, Buen Retiro and the Torre de la Parada. The cardinal-infante Ferdinand and other important persons of the day visited De Vos's atelier. He died in Antwerp on June 30, 1678. His estate included hundreds of paintings and sketches, among them a portrait of De Vos painted by Anthony van Dyck (1599–1641).

A painter of animals, hunting scenes, animal fables, still lifes, as well as compositions of arms, armor, and astronomical and musical instruments, De Vos was an artist in the circle of Rubens. In the past his works often have been mistaken for those of his better-known brother-in-law, Snyders. We know that De Vos not only worked for but also collaborated with Rubens; the arms and armor in the latter's *Mars Crowned by Victory* are by De Vos (signed "P. de Vos fecit"; Staatsgalerie, Augsburg, no. 258) and Jean Baptiste Borrekens's painting inventory of June 22, 1668, mentions an unidentified painting by the two men. De Vos had only two recorded pupils, Alexandre Daempt in 1627 and Lancelot van Daelen in 1636.

LITERATURE: P. Rombouts and T. van Lerius, *Les Liggeren et autres archives historiques de la gilde anversoise de Saint Luc*, 2 vols. (The Hague, 1872); F. J. van den Branden, *Geschiedenis der Antwerpsche Schilderschool* (Antwerp, 1883), pp. 679–83; Wurzbach 1906–11, vol. 2, p. 822; Gustav Glück, *Rubens, Van Dyke, und ihr Kreis* (Vienna, 1933), pp. 222, 360; Marguerite Manneback in Thieme-Becker 1907–50, vol. 34 (1940), pp. 556–59; Marguerite Manneback, "Paul de Vos et François Snyders," in *Miscellanea Leo van Puyvelde* (Brussels, 1949), pp. 147–52; Marguerite Manneback in Musées Royaux des Beaux-Arts de Belgique, Brussels, *Le Siècle de Rubens*, October 15–December 12, 1965, pp. 283–85; Svetlana Alpers, *The Decoration of the Torre de la Parada* (London and New York, 1971), pp. 119–21, 203–5; Marie-Louise Hairs, *Dans le sillage de Rubens: Les Peintres d'histoire anversois au XVIIe siècle* (Liège, 1977), p. 17; Edith Greindl, *Les Peintres flamands de nature morte au XVIIe siècle* (Brussels, 1983), pp. 73, 82, 85, 94–95, 105.

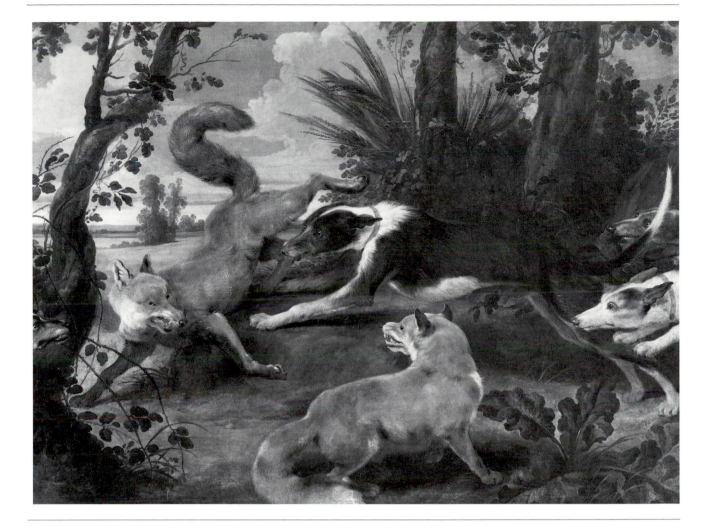

128 PAUL DE VOS

WOLFHOUNDS AND TWO FOXES, 1630s
Oil on canvas, 56½ x 76″ (143.5 x 193 cm.)
Gift of Nicholas Biddle. 57-130-1

Four wolfhounds have surrounded two red foxes in a wooded landscape. In the center a hound has caught the hind leg of one of the foxes in its jaws. The second fox turns and snarls in the lower center. Only the heads and forepaws of the other dogs are visible as they leap in from the left and right. The landscape in the foreground opens to a view of distant fields at the left.

According to a Biddle family legend, this work had been painted by Frans Snyders (q.v.) around 1620 for Philip III of Spain and hung in the palace in Madrid. While both Snyders and Paul de Vos worked for Philip IV and other patrons from Madrid in the 1630s, they are not known to have had earlier contacts with the Spanish court. The story of the commission of the work is probably apocryphal; nonetheless, it is probable that the painting was part of the Spanish royal collections, since it was owned by Joseph Bonaparte, who was made king of Spain by his younger brother Napoleon. After the battle of Waterloo, Joseph took the painting with him to his French estate. Soon thereafter Joseph emigrated to the United States, arriving in New York on August 28, 1815. The picture initially hung in Joseph's house on 260 South Ninth Street in Philadelphia and later at his

FIG. 128-1 Paul de Vos, *Fox,* signed, oil on canvas, 33 x 31⅞" (84 x 81 cm.), Museo del Prado, Madrid, no. 1865.

FIG. 128-2 Paul de Vos, *Fox Hunt,* oil on canvas, 61¾ x 86⅝" (157 x 220 cm.), Museum voor Schone Kunsten, Ghent, inv. no. 1902-B.

FIG. 128-3 Paul de Vos, *Earthly Paradise,* signed, oil on canvas, 66⅛ x 106½" (168 x 270 cm.), Gemäldegalerie Alte Meister, Staatliche Kunstsammlungen, Dresden, no. 1200.

estate Point Breeze at Bordentown, New Jersey. Before returning to Europe in 1832, he gave the painting in a letter dated July 15, 1832, and signed "Joseph, Cte. de Survilliers," to his friend Nicholas Biddle, president of the Second Bank of the United States from 1823 to 1836, who resided at 712 Spruce Street, Philadelphia, and his country house, Andalusia, on the Delaware River in Bucks County, Pennsylvania. In the letter, the picture is described as "a painting by Snyders that would be well placed in your living room or dining room."[1] The painting remained in the Biddles' possession until it was bequeathed in 1957 to the Museum by Nicholas Biddle (1893–1977) of Ambler, Pennsylvania, who retained life interest.

Although the painting has always been attributed to Frans Snyders, it is unsigned and closer in style and subject to hunt scenes by Snyders's younger colleague Paul de Vos. In the past De Vos's works have often been misattributed to the better-known Snyders. The artist's large-scale paintings of dogs pursuing and attacking stags, deer, other game, or turning to fight between themselves closely resemble those of Snyders in their animated design and relation to the landscape, but they are painted with a broader and less assured touch.[2] De Vos's animals are not so intense or stylized but more simply naturalistic, and his colors are often more muted. A prolific painter, De Vos seems to have painted more animal and hunt scenes for the Spanish court than Snyders; at the Torre de la Parada, for example, most, if not all, of the forty-two over-windows and overdoors of animal scenes without human participants were the work of De Vos.[3] The Philadelphia work's theme is also typical of De Vos. While Snyders painted foxes and fox hunts,[4] these subjects were special favorites of De Vos, whose name, of course, means fox; compare especially De Vos's signed *Fox* in Madrid (fig. 128-1) and unsigned *Fox Hunt* in Ghent (fig. 128-2).[5] The latter depicts a lone fox turning in desperation on a pack of pursuing dogs. In conception and design it offers many points of resemblance to the Philadelphia painting. Another similar *Fox Hunt* by De Vos is owned by the Banque de Paris et de Pays-Bas.[6] Finally, as Hella Robels has noted,[7] the attribution to De Vos finds additional support in the repetition of the motif of the fox in the lower center in De Vos's *Earthly Paradise,* in Dresden (fig. 128-3), and *The Fable of the Fox and Stork.*[8] The scarcity of dates on De Vos's works makes dating his works uncertain, but this painting could have originated in the mid- to late 1630s, when he executed hunting scenes for Philip IV and Hispano-Flemish patrons. Hunting in this period and throughout the sixteenth and seventeenth centuries was a pursuit of high seriousness at European courts. It not only served as a form of entertainment, but also offered opportunities for the display and development of courage, strategy, and heroism—attributes of kingship and nobility that might otherwise remain untested in peacetime.[9]

NOTES

1. "Un tableau du Snyders qui sera bien placé dans votre salon, ou dans votre salle à manger." A facsimile of the letter appears in "Joseph Bonaparte, as Recorded in the Private Journal of Nicholas Biddle," introduced by Edward Biddle, *The Pennsylvania Magazine of History and Biography,* vol. 55, no. 219 (July 1931), opposite p. 220.

2. See the signed paintings *Landscape with Game,* oil on canvas, 83½ x 136⅛" (212 x 347 cm.), Museo del Prado, Madrid, no. 1869; *Deer Pursued by the Pack,* oil on canvas, 83½ x 136⅛" (212 x 347 cm.), Museo del Prado, Madrid, no. 1870; *Deer Hunt,* oil on canvas, 85½ x 136⅛" (217 x 347 cm.), Musées Royaux des Beaux-Arts de Belgique, Brussels, no. 2858; oil on canvas, 79⅛ x 135½" (210 x 344 cm.), The Hermitage, Leningrad, no. 605; and oil on canvas, 80¾ x 135¾" (205 x 345 cm.), The Hermitage, Leningrad, no. 603.

3. Svetlana Alpers, *The Decoration of the Torre de la Parada* (London and New York, 1971), p. 119.

4. See, for example, *Foxes Pursued by Dogs,* oil on canvas, 43¾ x 32¼" (111 x 82 cm.), Museo del Prado, Madrid, no. 1752.

5. The latter painting appeared in the Huybrechts sale, Antwerp, May 1902, lot 47, repro., as a work of Snyders. A replica is in the Musée de la Chasse et de la Nature, Paris.

6. Oil on canvas, 66⅞ x 94½" (170 x 240 cm.) (photograph, Witt Library, London); compare also *Fox and Dogs,* attributed to De Vos, Cardons sale, Brussels, June 27, 1921; *Hounds Pouncing on a Fox Standing over a Dead Partridge,* 34¼ x 49¾" (87 x 126.3 cm.), sale, Christie's, London, July 18, 1986, lot 244, repro.; and *Three Foxes Attacking a Hen in an Extensive Landscape,* oil on canvas, 45½ x 72¾" (115.5 x 185 cm.), sale, Sotheby's, New York, November 5, 1986, lot 37A, repro.

7. Letter to the author, November 16, 1981, Philadelphia Museum of Art, accession files.

8. At least two versions of the latter work exist: signed, oil on canvas, 51¼ x 19¾" (130 x 50 cm.), Collection of the marquis of Santo Domingo, Madrid (repro. in Musées Royaux des Beaux-Arts de Belgique, Brussels, *Le Siècle de Rubens,* October 15–December 12, 1965, no. 300); and unsigned (copy ?), oil on canvas, 60 x 44½" (152.3 x 113 cm.), The J. Paul Getty Museum, Malibu, no. 78.PA.195.

9. On hunting at the Spanish court, see Alpers (note 3), pp. 101–3.

PROVENANCE: Possibly royal collections, Madrid; by descent to Joseph Bonaparte, king of Spain; given by Bonaparte to Nicholas Biddle, Philadelphia, 1832; by descent to Nicholas Biddle, Ambler, Pennsylvania.

EXHIBITIONS: The Pennsylvania Academy of the Fine Arts, Philadelphia [and hereafter] possibly 1834 [as "Dogs and Foxes in Landscape," by Frans Snyders, but with no lender's name]; 1857, no. 218 [lent by Edward Biddle]; 1858, no. 244 [lent by Ed. Biddle]; 1859, no. 289½ [lent by E. Biddle]; 1860, no. 226 [lent by E. Biddle].

LITERATURE: "Joseph Bonaparte, as Recorded in the Private Journal of Nicholas Biddle," introduced by Edward Biddle, *The Pennsylvania Magazine of History and Biography,* vol. 55, no. 219 (July 1931), opposite p. 220; Anna Wells Rutledge, *Cumulative Record of Exhibition Catalogues: The Pennsylvania Academy of the Fine Arts, 1807–1870* (Philadelphia, 1955), p. 210; PMA 1965, p. 63; "The Philadelphia Scene," *The Sunday Bulletin,* December 18, 1966, p. 2.

CONDITION: The painting is lined with an aqueous adhesive. It is slack on the stretcher. The primary support is composed of two horizontal pieces joined by a seam approximately 10½" (26 cm.) from the top. The tacking edges are missing. An old tear, 1½" (3.8 cm.) long is just to the right of center. The paint film shows old losses along the seam, at all edges (especially upper right and lower left), along the stretcher at the upper left, and scattered throughout. There is moderate abrasion in the dark colors. Areas of old discolored retouches are visible in the animals, particularly the two dogs at the right, and in the sky at the upper left. Larger areas of overpaint are in the clouds in the center and upper-left corner. There is a fine net crackle pattern with associated cupping overall. The varnish is moderately discolored with older, dark varnish residues.

Probably born in Haarlem, Van Vries was said to be twenty-eight in 1659, when he was married to Maria Arents in Amsterdam. (Reynier Hals served as a witness.) He entered the Leiden guild in 1653 and the Haarlem guild in 1657. On April 23, 1662, he made a will and was mentioned in Amsterdam documents in 1661 and 1667 as living on the Loyerstraat. He later figured in a Leiden document in 1678 and is last mentioned in Amsterdam in 1681. His latest dated picture is also of that year. In 1688 his wife was called a widow.

A landscapist, Van Vries derived his style from Jacob van Ruisdael (q.v.). His work can be confused with that of Gillis Rombouts (1630–1678) and Cornelis Decker (d. 1678). The landscape painter Michiel de Vries (d. before 1702) may have been his brother.

LITERATURE: Van der Willigen (1870) 1970, p. 38; Obreen (1877–90), 1976, vol. 5, p. 215; A. D. de Vries Az., "Biografische aanteekeningen," *Oud Holland,* vol. 4 (1886), p. 298; Wurzbach 1906–11, vol. 2, p. 832; Plietzsch 1960, p. 102; Laurens J. Bol, *Holländische Maler des 17. Jahrhunderts nahe den grossen Meistern: Landschaften und Stilleben* (Brunswick, 1969), pp. 207, 210, 213, 231; F. J. Duparc in Mauritshuis, The Hague, *Hollandse Schilderkunst: Landschappen 17de eeuw* (The Hague, 1980), p. 121; Kurt J. Müllenmeister, *Meer und Land im Licht des 17. Jahrhunderts,* vol. 3 (Bremen, 1981), p. 94.

For additional works by Van Vries in the Philadelphia Museum of Art, see John G. Johnson Collection cat. nos. 581, 580 (attributed to).

129 ROELOF VAN VRIES

LANDSCAPE WITH MEN AND DOGS
Falsely signed lower left: *J Ruisd . . .* (first two letters ligated)
Oil on panel, 16 x 13½" (40.6 x 34.3 cm.)
The John D. McIlhenny Collection. 43-40-38

FIG. 129-1 Roelof van Vries, *Dune Landscape,* signed, oil on panel, 14⅛ x 11⅜" (36 x 29 cm.), formerly Galerie Noortman, Maastricht.

A darkened tree and foliage appear in the left foreground. To the right is a pool of water and behind it a small, lighted hillock rising to the right. A second stand of trees forms the backdrop in the center distance. At the pool appear a man and a dog and on the crest of the hill are two more men and three dogs.

The picture's early provenance is unknown, but it may be identical with a painting that was attributed to Jacob van Ruisdael (q.v.) when it was lent by Max Flersheim to the Rembrandt exhibition in Amsterdam in 1906.[1] The attribution to Ruisdael was first doubted by Seymour Slive,[2] who tentatively suggested Roelof van Vries as an alternative. This attribution is supported by the work's resemblance in style and execution (especially the treatment of the reeds and foliage) to signed works by Van Vries in Budapest,[3] and formerly with Galerie Noortman, Maastricht (fig. 129-1) and Galerie St. Lucas, Vienna (fig. 129-2). Compare also the landscape formerly with the dealer Brod, London.[4]

The signature on the present work may have been altered from that of Roelof van Vries; he often signed "R Vries" or "Vryes" with the first two letters ligated. Only the remnants of another inscription, quite possibly a date, are visible in the lower center.

FIG. 129-2 Roelof van Vries, *Wooded Landscape with a Pond*, signed, oil on panel, 14⅛ x 12¾" (36 x 32.5 cm.), formerly Galerie St. Lucas, Vienna.

NOTES

1. F. Muller & Co., Amsterdam, 1906, no. III. See Hofstede de Groot 1907–28, vol. 4 (1912), no. 623 [as "Sportsmen in a Hilly and Wooded Landscape," signed on the left, oil on panel].

2. Letter to Kathryn Hiesinger, April 3, 1972, Philadelphia Museum of Art, accession files.

3. Signed "R Vries," oil on panel, 20 x 17½" (51 x 44.5 cm.), Szépművészeti Múzeum, Budapest, no. 267; repro. by Agnes Czobar, in Szépművészeti Múzeum, Budapest, *Dutch Landscapes* (Budapest, 1967), no. 31.

4. Catalogue 1977, no. 14, repro.

PROVENANCE: Possibly Max Flersheim, Paris, 1906; purchased by John D. McIlhenny, Philadelphia, from dealers Böhler & Steinmeyer, New York, January 16, 1914.

EXHIBITIONS: Possibly F. Muller & Co., Amsterdam, "Rembrandt Exhibition," 1906, no. III; Pennsylvania Museum (Philadelphia Museum of Art), "John D. McIlhenny Exhibition," March–April 1926.

LITERATURE: Possibly Hofstede de Groot 1907–28, vol. 4 (1912), no. 623 [as Jacob van Ruisdael]; Arthur Edwin Bye, "Paintings in the McIlhenny Bequest and Exhibition," *The Pennsylvania Museum Bulletin* (Philadelphia Museum of Art), vol. 21, no. 100 (February 1926), p. 91, repro. [as Ruisdael]; Jakob Rosenberg, *Jacob van Ruisdael* (Berlin, 1928), no. 363 [as Ruisdael, but not seen by author]; Henri Marceau, "Paintings in the McIlhenny Collection," *Philadelphia Museum Bulletin* (Philadelphia Museum of Art), vol. 39, no. 200 (January 1944), pp. 54, 59 [as Ruisdael, c. 1652–53]; PMA 1965, p. 60 [as Ruisdael].

CONDITION: The vertically grained panel support has been cradled. The paint film is abraded throughout, especially in the trees and sky. Discolored retouches are visible in the sky, trees, and ground cover. The full extent of the overpaint, however, is obscured by the thick, moderately discolored varnish layer.

LITERATURE: Cornelis de Bie, *Het Gulden Cabinet van de edele vry Schilderconst* (Antwerp, 1661; reprint, Soest, 1971), p. 277; Houbraken 1718–21, vol. 2, pp. 77–83, 111, 113, 131, vol. 3, pp. 70, 72; Wurzbach 1906–11, vol. 2, pp. 846–47; Abraham Bredius, "Een testament van Jan Baptist Weenicx," *Oud Holland*, vol. 45 (1928), pp. 177–78; Thieme-Becker 1907–50, vol. 35 (1942), pp. 246–47; Wolfgang Stechow, "Jan Baptist Weenix," *The Art Quarterly*, vol. 11, no. 3 (summer 1948), pp. 181–86; G. J. Hoogewerff, *De Bentvueghels* (The Hague, 1952), pp. 19, 93, 146, 153, 165; Plietzsch 1960, pp. 138–40; Albert Blankert, *Nederlandse 17ᵉ eeuwse Italianiserende landschapschilders* (Utrecht, 1965; reprint, Soest, 1978), pp. 175–76; Andrzej Chudzikowski, "Jean Baptiste Weenix, peintre d'histoire," *Bulletin de Musée National de Varsovie*, vol. 7, no. 1 (1966), pp. 1–10; Rebecca Jean Ginnings, "The Art of Jan Baptist Weenix and Jan Weenix," diss., University of Delaware, Newark, 1970; F. J. Duparc, Jr., "Een teruggevonden schilderij van N. Berchem en J. B. Weenix," *Oud Holland*, vol. 94 (1980), pp. 37–43; Christine Skeeles Schloss, *Travel, Trade, and Temptation: The Dutch Italianate Harbor Scene, 1640–1680* (Ann Arbor, 1982); Christine Skeeles Schloss, "A Note on Jan Baptist Weenix's Patronage in Rome," in *Essays in Northern European Art Presented to Egbert Haverkamp-Begemann on His Sixtieth Birthday*, edited by Anne-Marie Logan (Doornspijk, 1983), pp. 237–38; Sutton et al. 1984, pp. xxxix, 354–55; Scott A. Sullivan, *The Dutch Gamepiece* (Totowa and Montclair, N.J., 1984), pp. 30–32, 47, 62–64, 68–71; Sutton et al. 1987, pp. 520–21.

According to Arnold Houbraken, Weenix was born in Amsterdam in 1621. He was the son of Jan Weenix (d. before 1646), an architect. He was first apprenticed in Amsterdam to the little-known artist Jan Micker (c. 1598–1664); later he studied with the Utrecht history painter Abraham Bloemaert (1564–1651) and finally, for about two years with Claes Cornelisz. Moeyaert (1592/93–1655) in Amsterdam. The influence of the last mentioned is evident in Weenix's early works. At eighteen, Weenix married Josina d'Hondecoeter, the daughter of the landscape painter Gillis de Hondecoeter (c. 1580–1638). The couple had two sons, one of whom, Jan Weenix (q.v.), became a well-known still-life, landscape, and portrait painter. Weenix traveled to Italy in late 1642 or early 1643; in the words of the will that he drafted before departing, he made the trip to "experiment with his art." Houbraken reported that Weenix promised his family that the sojourn would last no longer than four months, but it was protracted to four years. In Rome he joined the Netherlandish artists' society "De Schildersbent," where he became known as "Ratel" (rattle) because of a speech defect. Weenix spent most of this time in Rome, where, according to Houbraken, around 1645, he entered the service of a "Kardinaal Pamfilio." Most writers have assumed that this patron was Cardinal Giovanni Battista Pamphili, who became Pope Innocent X in 1644; however, it is more likely that he was the pope's nephew, Cardinal Camillo Pamphili, who took a greater interest in the arts than the pontiff. Houbraken even stated that it was the cardinal who introduced him into the service of the pope, for whom the artist created a large, unspecified work. Weenix received payments from Pamphili between January 12, 1645, and July 28, 1646. However, in changing his name to Giovanni Battista Weenix (the form of signature he used after returning from Italy) the artist may have wished to honor Innocent X. Weenix was back in Amsterdam by June 1647, when Bartholomeus van der Helst (1613–1670) painted his portrait (now lost, but see the print by Jan Houbraken, in Houbraken 1718–21, vol. 2, opp. p. 80). By 1649 he had settled in Utrecht, where he was elected an officer of the painters' guild. Documents from 1653 show that he was closely involved, as both painter and dealer, with the collector Baron van Wyttenhorst. In 1657 Weenix moved to the Huis ter Mey, near Utrecht, where, according to Houbraken, he died at the age of thirty-nine, hence, in 1660 or 1661. His latest dated painting (fig. 130-2) is inscribed and dated "1658 A° 10m/20d in het huys ter Mey."

Together with Jan Asselijn (1610/15–1652), Jan Both (c. 1618–1652), and Karel Dujardin (c. 1622–1678), Jan Baptist Weenix was a leader of the second generation of the seventeenth-century Dutch Italianate painters. In addition to painting and drawing genre and history subjects set in the Italian Campagna, he executed fanciful views of Mediterranean seaports and dead-game still lifes. His son, Jan Weenix, carried on his art, attracting followers well into the eighteenth century.

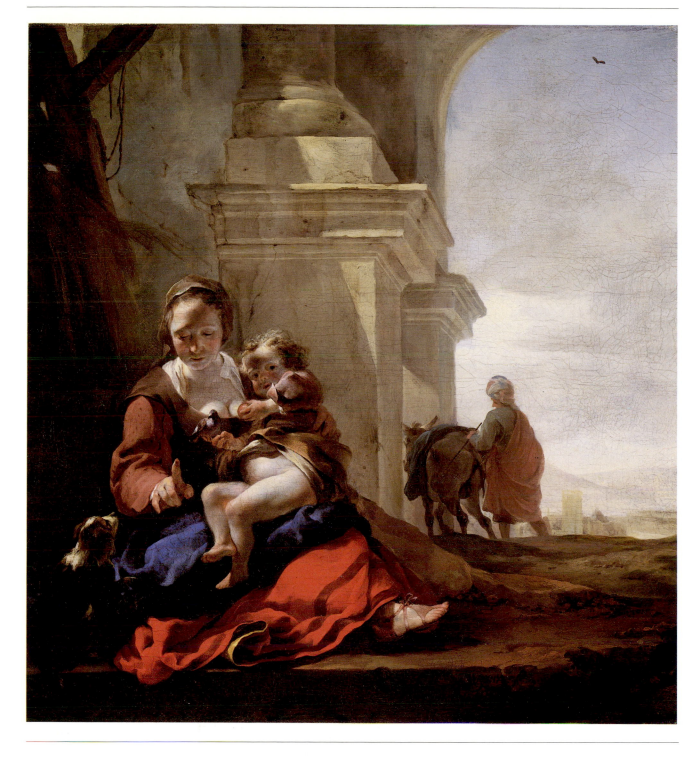

130 JAN BAPTIST WEENIX *REST ON THE FLIGHT INTO EGYPT*, c. 1647–50
Signed lower right: *Gio*[vanni] *Batt*[ist]*a Weenix f.*
Oil on canvas, 19¹³⁄₁₆ x 16⅛″ (50.3 x 41.9 cm.)
Purchased: The George W. Elkins Fund. E1984-1-1

FIG. 130-1 Jan Baptist Weenix, *Mother and Child with a Cat,* signed and dated 1647, oil on canvas, 18¹¹⁄₁₆ x 16⅞" (47.5 x 43 cm.), private collection, New York.

FIG. 130-2 Jan Baptist Weenix, *Italian Landscapes with Inn and Ruins,* signed and dated 1658, oil on panel, 26¹³⁄₁₆ x 34⁵⁄₁₆" (68.2 x 87.2 cm.), Mauritshuis, The Hague, no. 901.

FIG. 130-3 Jan Baptist Weenix, *Mother and Child in the Roman Campagna,* oil on canvas, 26¼ x 31½" (66.7 x 80 cm.), The Detroit Institute of Arts, acc. no. 41.57.

The Virgin sits in the left foreground with the Christ child on her lap. Behind and to the right Joseph leads the donkey away between columns of a massive archway. The Christ child holds an apple and a dove, while the Virgin gestures with outstretched finger to a small dog. A low stone step occupies the immediate foreground; at the upper left is a hayloft and in the right distance a glimpse of town spires and mountains beyond.

The *Rest on the Flight into Egypt* is one of several paintings that Weenix executed following his trip south that featured history or genre figures seated before classical ruins in the Italian Campagna. The painting bears the Italian form of Weenix's signature, which, as Wolfgang Stechow first observed, was adopted by the artist only following his return from Italy.[1] While no works are dated or datable with certainty to the years from 1643 to 1647, when Weenix was abroad, the dating of the Philadelphia work to the years immediately following his return is facilitated by its resemblance in style, palette, and technique to the *Mother and Child with a Cat* of 1647 (fig. 130-1), one of two known works dated that year.[2] The soft, liquid touch and the bright hues of these works contrast with the more minute technique and the harder colors that Weenix was to develop a decade later: for example, in the *Italian Landscape with Inn and Ruins,* dated 1658 (fig. 130-2), the artist's last dated painting. Moreover, the Philadelphia painting seems unlikely to postdate significantly a work like the *Coast Scene with Classical Ruins,* dated 1649, which already exhibits a tighter manner and more elegantly conceived figure types.[3] Thus a date of about 1647–50 seems most acceptable for the *Rest on the Flight into Egypt.*

Close in style to the Philadelphia painting is an undated *Mother and Child in the Roman Campagna* in the Detroit Institute of Arts (fig. 130-3), which shares the primary motif of the mother and child seated before classical architecture as well as the same silvery tonality and supple brushwork. The Detroit painting depicts a secular subject, whereas the presence of Joseph, clad in a turban and loose-fitting drapery, certifies the Philadelphia painting's religious subject. An early conception of the theme may be documented in a red chalk drawing in a private collection in New York (fig. 130-4). Though facing left, the mother and child are again seated with a dog beneath the sketchy indication of monumental architecture. At the woman's side rests a man, very likely Joseph, with a beard, wearing a turban, and lying with his hand on his hip; a third figure is situated in the distance, where Joseph is placed in the Philadelphia painting. In the final painting Weenix enriched the subject with various attributes and gestures. The dove held by the Christ child is the traditional symbol of purity, peace, and the Holy Spirit (John 1:32). The apple held in his other hand no doubt alludes to the fruit of the Tree of Knowledge (Gen. 3:3). The apple symbolized Christ as the new Adam (Song of Sol. 2:3), who took upon himself the burden of man's sins. The suggestion of a cross in the hayloft may prefigure the Crucifixion, Christ's ultimate sacrifice. Moreover, the dog that hearkens to the Madonna's gracefully admonitory gesture could allude to the Christian virtues of obedience and restraint. In a secularized version of the theme by Weenix, in the Wadsworth Atheneum, Hartford (fig. 130-5), a woman disciplines a dog beneath Giovanni da Bologna's sculpture of the *Rape of the Sabine Woman,*[4] the contrast of passion and its control offering obvious moral counterpoint.

FIG. 130-4 Jan Baptist Weenix, *Pastoral Scene (Rest on the Flight into Egypt?)*, chalk on paper, 7⁹⁄₁₆ x 10⁷⁄₈" (19.3 x 27.7 cm.), private collection, New York.

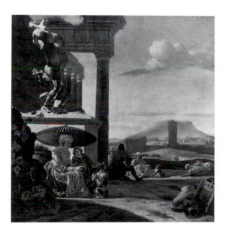

FIG. 130-5 Jan Baptist Weenix, *Figures among Ruins in the Roman Campagna*, c. 1650–55, oil on canvas, 49 x 47½" (124.5 x 120.5 cm.), The Wadsworth Atheneum, Hartford, inv. no. 1937.483.

FIG. 130-6 Cornelis Galle, emblem from *Af-beeldinghe van d'eerste eeuw der Societeyt Iesu*... (Antwerp, 1640).

The motif of an obedient dog sitting up on its hind legs and begging was a common detail in both seventeenth-century Dutch genre paintings and portraiture.[5] A recent study has related this motif to pedagogical theories first propounded by Plutarch in his *Moralia*.[6] Plutarch's treatise on education recalled Aristotle's notion that natural aptitude *(natura)* must be constantly improved by teaching *(ars)* and practice *(exertatio)*. In an emblem (fig. 130-6) engraved by Cornelis Galle for the Dutch edition (1640) of the *Imago primi saeculi societatis Iesu,* a small dog is taught to sit up by the Christian teacher ("door den christlijcken Leeraer"), here visualized as a winged putto.[7] The motif is related in the appended verses to the idea that the discipline taught to children, both in spiritual and secular matters, will be reflected in their behavior as adults. The obedient dog in the pedagogical literature of Jacob Cats and other influential Dutch authors became a symbol of "Leer-sucht," or the willingness to learn.[8] In Weenix's painting, therefore, this detail could be designed to underscore the educational value of Christian discipline.

The principal motif of the Madonna with child and a dog in the Philadelphia painting is repeated in the foreground of an unsigned, larger variant of the Philadelphia design, now in Kassel (fig. 130-7), which alters the setting and possibly the subject. Ruins of the Temple of Vespasian from the Roman Forum (a motif found earlier in Cornelis Poelenburg's art) replace the unidentified architecture in the Philadelphia painting, and the man with a broad-brimmed hat and cape who appears beside the donkey is no longer identifiable as Joseph. The labored execution, particularly in the central motif, suggests that the Kassel painting may be a second version or a copy. Although Weenix is known to have repeated motifs, he rarely copied himself so slavishly. Whether the group of the mother, child, and dog was added by a later hand, presumably to populate a composition deemed too vacant, is unknown; however, a composition by Weenix using smaller figures but also depicting the ruins of the Temple of Vespasian is preserved in the Szépmüvészeti Múzeum, Budapest.[9]

The Philadelphia painting's early provenance, only recently rediscovered, is of particular interest; before 1795 the painting hung in the galleries of the dukes of Braunschweig-Wolfenbüttel at Salzdahlum, the oldest painting collection in Germany (predating, for example, the famous collections in Dresden, Kassel, and Berlin) and one of the greatest collections of Dutch paintings ever assembled. The core of the original collection is now preserved in the Herzog Anton Ulrich Museum in Brunswick, West Germany. Weenix's *Rest on the Flight* figured in the Salzdahlum catalogue of 1776 (with a complete description and the dimensions given as 1'10" by 1'11", supporting the presumption that the canvas may have been cut slightly on the sides) and later in the well-known sales in Brussels of the collections of De Burtin in 1819 and (possibly) Comte F. de Robiano in 1837.[10]

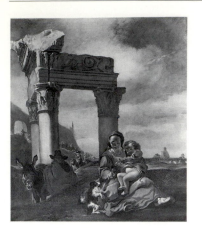

FIG. 130-7 Attributed to Jan Baptist Weenix, *Mother and Child before the Ruins of the Temple of Vespasian in Rome,* oil on canvas, 31¹/₁₆ x 26³/₁₆" (79 x 66.5 cm.), Staatliche Kunstsammlungen, Kassel, inv. no. GK376.

NOTES

1. Wolfgang Stechow, "Jan Baptist Weenix," *The Art Quarterly,* vol. 11, no. 3 (summer 1948), p. 182.

2. See also *Landscape with Ford and Rider,* dated 1647, oil on canvas, 39⅜ x 51¼" (100 x 131.5 cm.), The Hermitage, Leningrad, inv. no. 3740.

3. Oil on canvas, 33½ x 43¹/₁₆" (85.1 x 109.5 cm.), The Wallace Collection, London, no. P117.

4. Now in the Loggia dei Lanzi, Florence.

5. See, for example, Ludolph de Jongh, *Portrait of a Young Boy,* 1661, oil on canvas, 38½ x 28½" (97.8 x 71.4 cm.), Virginia Museum, Richmond, acc. no. 63.54.

6. See Jan Baptist Bedaux, "Beelden van 'leersucht' en tucht. Opvoedingsmetaforen in de Nederlandse schilderkunst van de zeventiende eeuw," *Nederlands Kunsthistorisch Jaarboek,* vol. 33 (1982), pp. 49–74.

7. *Af-beeldinghe van d'eerste eeuw der Societeyt Iesu voor ooghen gestelt door de Duyts-Nederlantsche Provincie der selver Societeyt* (Antwerp, 1640). See Bedaux (note 6), pp. 54–55, fig. 3.

8. See Bedaux (note 6), pp. 56–59. Beneath the figure personifying "Leer-sucht" in the illustration of the "Maeghde-Wapen" (Maiden's Arms) in Jacob Cats's *Houwelyck* (Haarlem, 1642) is a small dog standing on its hind legs; the motif also appears on the frontispiece of the first edition (1625) of the *Houwelyck* (see respectively Bedaux figs. 4 and 5). The thankfulness of the dog, contrasting to man's ingratitude, was also celebrated in religious emblems depicting dogs begging for tidbits; see Jan Claesz. Schaep, *Bloem-tuyntje* (Amsterdam, 1660), no. 24, repro. in P. J. Meertens, *Nederlandse Emblemata* (Leiden, 1983), pp. 153–55. The popularity of the motif among Weenix's contemporary Dutch Italianate painters is evidenced by Karel Dujardin's *Men with a Dog* of c. 1650; repro. in Horst Gerson and J. W. Goodison, *Catalogue of Paintings, Fitzwilliam Museum, Cambridge,* vol. 1 (Cambridge, 1960), no. 362, p. 17.

9. *Ruins of the Temple of Vespasian in Rome,* oil on canvas, 31¹¹/₁₆ x 26⅞" (80.5 x 68.3 cm.), no. 232.

10. On De Burtin, see Eveline Koolhaas, *Revue de culture néerlandaise/Septentrion,* vol. 16, no. 3 (1987), pp. 29–39.

PROVENANCE: Possibly sale, Amsterdam, May 18, 1706, lot 74 [as "Joseph en Marie, zynde een capitaal stuk"]; dukes of Braunschweig-Wolfenbüttel, Salzdahlum, until 1795; sale, De Burtin, Brussels, July 21, 1819, lot 191 [as from Salzdahlum, with the dimensions given as 19¾ x 19¾"]; possibly sale, Comte F. de Robiano, Brussels, May 1, 1837, lot 716 [as from the De Burtin Collection, with the dimensions given as 89 by 105 cm.]; private collection, Europe; Galerie Heim, Paris, by 1975; Christophe Janet Gallery, New York.

EXHIBITIONS: Galerie Heim, Paris, *Le Choix de l'amateur,* June 6–July 31, 1975, no. 20; Christophe Janet Gallery, New York, *The Intimate Vision,* March 19–April 21, 1984.

LITERATURE: *Verzeichnis der Herzoglichen Bilder-Gallerie zu Saltzhalen* (Brunswick, 1776), p. 232, no. 53; Jan Juffermans, "'The Intimate Vision': Dutch Old Master Paintings at Christophe Janet, New York," *Tableau,* vol. 6, no. 4 (February 1984), p. 58, repro.

CONDITION: The painting is structurally sound. The canvas support was recently relined with a wax adhesive. The tacking margins have been extended at the top and bottom and trimmed away along the right and left edges. The paint film is in good state, exhibiting few losses and a consistent craquelure overall except for the blue of the Virgin's clothing, where wider crackle apertures have been inpainted. Retouchings also appear in the child's stomach and leg and over cracks in the sky. The varnish is glossy and relatively colorless.

Described in a document of 1679 as a native of Amsterdam, Jan Weenix was probably born in 1642. The son and pupil of Jan Baptist Weenix (q.v.), and the cousin of Melchior de Hondecoeter (q.v.), he became a member of the Utrecht Saint Luke's Guild in 1664 and was again recorded as a member in 1668. Weenix's earliest dated work, *Shepherds in an Italian Landscape* (location unknown), is from 1660, around the time of Jan Baptist Weenix's death, and, like his other early production, relies heavily on his father's Italianate landscapes with genre figures. There is no proof, however, that the younger Weenix visited Italy himself. Sometime after 1668 he moved to Amsterdam, where he remained for most of his life, marrying Petronella Backer in October 1679. In 1667 and 1668 he received small inheritances, and the following year he witnessed the inventory of the painter Jacob de Hennin in The Hague. The artist's basic stylistic approach to the gamepiece seems to have been formulated in the early 1680s and apparently secured important patrons. Weenix served as court painter from about 1702 to 1712 to the Elector Palatine Johann Wilhelm in Düsseldorf and executed a series of large gamepieces for Schloss Bensberg. He is known to have collaborated with Anthonie Waterloo (1609/10–1690) and Bartholomeus van der Helst (1613–1670). The still-life and portrait painter Dirk van Valkenburgh (1675–1721) was his pupil, and a "Juffrouw Weenix" who painted flower still lifes probably was his daughter. He was buried in Amsterdam on September 19, 1719.

Although dependent on Jan Baptist for some of his themes, designs, and motifs, Jan Weenix, and Hondecoeter, defined the forms taken by the decorative later gamepiece of about 1680 to 1720. Unlike earlier artists of hunting still lifes who depicted game on a table or in a niche, he usually placed his still lifes before a landscape or garden, often with antique statuary, the facade of a classical building, trees and urns, and sometimes with a prospect of a castle or a panorama. The booty also became more elegant, often including peacocks, swans, or prized deer. In addition to dead-game still lifes he painted Italian scenes in his father's manner, pictures of live birds, a few portraits, flower pieces, and genre subjects.

LITERATURE: Houbraken 1718–21, vol. 2, pp. 61–62; Johan van Gool, *De nieuwe schouburg der Nederlantsche kunstschilders en schilderessen* (The Hague, 1750), pp. 79–82; A. D. de Vries Az., "Biografische aanteekeningen betreffende voornamelijk Amsterdamsche schilders," *Oud Holland,* vol. 4 (1886), p. 300; Wurzbach 1906–11, vol. 2, pp. 847–48; Bredius 1915–22, vol. 1 (1915), p. 297, vol. 3 (1917), p. 1013; Thieme-Becker 1907–50, vol. 35 (1942), pp. 245–46; Wolfgang Stechow, "Jan Baptist Weenix," *The Art Quarterly,* vol. 11, no. 1 (winter 1948), pp. 181–98; Ingvar Bergström, *Dutch Still-Life Painting in the Seventeenth Century,* translated by Christine Hedström and Gerald Taylor (London, 1956), pp. 257–59; Neil MacLaren, *The National Gallery Catalogues: The Dutch School* (London, 1960), pp. 447–48; Plietzsch 1960, pp. 159–63; Wolfgang Stechow, "A Wall Paneling by Jan Weenix," *Allen Memorial Art Museum Bulletin,* vol. 27 (fall 1969), pp. 13–23;

Rebecca Jean Ginnings, "The Art of Jan Baptist Weenix and Jan Weenix," diss., University of Delaware, Newark, 1970; Jacques Foucart in Musée de Petit Palais, Paris, *Le Siècle de Rembrandt,* November 17, 1970–February 15, 1971, pp. 236–39, under cat. nos. 228 and 229; Peter Eikemeier, "Der Jagdzyklus des Jan Weenix aus Schloss Bensberg," *Weltkunst,* vol. 48, no. 4 (February 1978), pp. 296–98; Kurt Mullenmeister, *Meer und Land im Licht des 17. Jahrhunderts,* vol. 3, *Tierdarstellungen in Werken niederländischer Künstler N–Z* (Bremen, 1981), pp. 97–98; Christine Schloss, "The Early Italianate Genre Paintings by Jan Weenix (ca. 1642–1719)," *Oud Holland,* vol. 97, no. 2 (1983), pp. 69–97; Scott A. Sullivan, *The Dutch Gamepiece* (Totowa and Montclair, N.J., 1984), pp. 61–67.

For an additional work by Jan Weenix in the Philadelphia Museum of Art, see John G. Johnson Collection cat. no. 633.

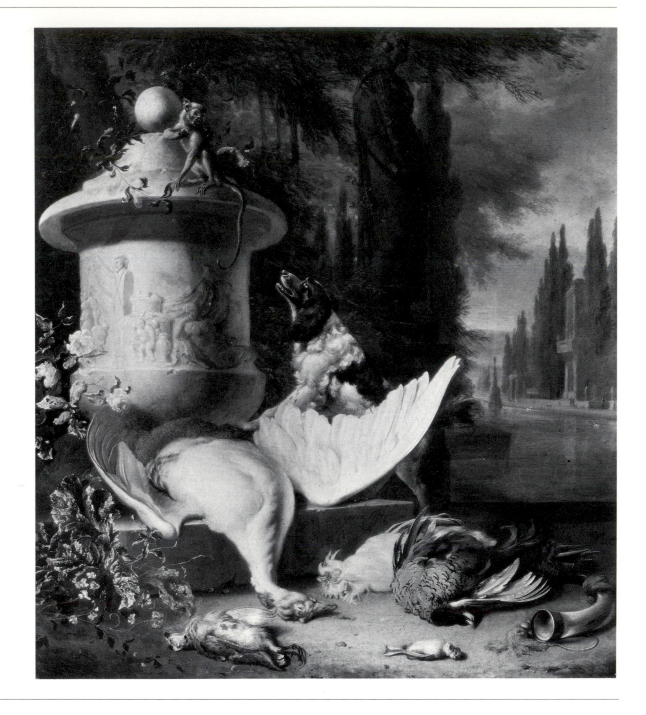

131 JAN WEENIX *DEAD GAME STILL LIFE WITH A MONKEY AND A SPANIEL,* 1700
 Signed and dated lower center on stone step: *J. Weenix f 1700–*
 Oil on canvas, 21½ x 19¾" (54.6 x 50.2 cm.)
 Purchased for the W. P. Wilstach Collection. WOI-I-3

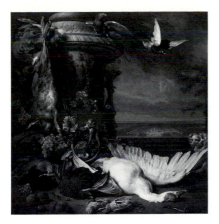

FIG. 131-1 Jan Weenix, *Dead Game Still Life with a Monkey, a Dog, and View of the Estate of Rijxdorp near Wassenaar,* signed and dated 1714, oil on canvas, 67¾ x 63″ (172 x 160 cm.), Rijksmuseum, Amsterdam, no. A462.

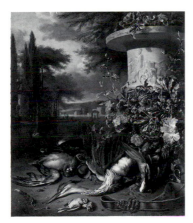

FIG. 131-2 Jan Weenix, *The Falconer's Bag,* signed and dated 1695, oil on canvas, 52¾ x 43¾″ (134 x 111.1 cm.), The Metropolitan Museum of Art, New York, no. 50.55.

In the foreground of a parklike landscape, dead game birds, a white goose, a hunting horn, and bird snares are strewn on the ground beneath a large urn decorated with classical figures (a sleeping Venus, a tiny Bacchus supported by satyrs, and a term). A small monkey has climbed to the top of the urn to escape a spaniel. To the right of a shadowy statue holding a fasces opens a twilight vista with ponds and manicured alleys bordered by poplars.

Under the influence of his father, Jan Baptist Weenix, and his cousin Melchior de Hondecoeter (qq.v.), Jan developed the decorative hunting still life or gamepiece to its greatest refinement. The basic features of his gamepiece designs had emerged by 1682–83,[1] and often involved a dead hare, bird or other booty hung from a branch or piled pyramidally before an antique urn. The technical details of surfaces and textures are minutely observed while the overall atmosphere is romantic and the designs rich but understated. Some of Weenix's early genre scenes and dead gamepieces can be confused with those of his father; in a mature work such as this, however, Jan clearly revealed his more elegant but drier manner. Jan Weenix's style in cabinet-sized pictures of these years approached that of his student, Dirk van Valkenburgh (1675–1721), who is known to have collaborated with his teacher on at least one occasion and who has privately been suggested as the author of Philadelphia's painting. However, the discovery in 1982 of Weenix's characteristic signature and the date 1700 secures the attribution.

Similar, albeit larger, still lifes by Weenix of dead birds with a prominent goose, an urn before a parklike vista, as well as spaniels and other live animals, are in the Rijksmuseum, Amsterdam (fig. 131-1), the Wallace Collection, London,[2] and formerly in the Fröhlich Collection, Vienna.[3] Many of the same motifs recur elsewhere in his work: the monkey and the spaniel, for example, both appear in *Portrait of a Man with a Moor*;[4] the monkey reappears in the Amsterdam and one of the Wallace Collection paintings;[5] several of the game birds are repeated, and even the relief on the urn recurs, in the so-called *Falconer's Bag* of 1695 (fig. 131-2). Like Hondecoeter and other decorative still-life painters of the period, Weenix employed a stock repertory of animal studies to be freely inserted into his compositions. Yet his designs were not entirely predetermined; a large *repentir* on the urn in the Philadelphia painting indicates that originally a peacock was included.

NOTES
1. See, for example, *Still Life with Dead Hare,* signed and dated 1682 or 1683, oil on canvas, 39¾ x 30⅞″ (101 x 78.5 cm.), Staatliche Kunsthalle, Karlsruhe, no. 3485.
2. *Peacock, Dead Game, and Monkey,* oil on canvas, 74¾ x 66¼″ (189.9 x 168.3 cm.), no. P69; and *Dead Goose and Peacock,* signed and dated 1718, oil on canvas, 68¹³⁄₁₆ x 48⅛″ (174.9 x 122.2 cm.), no. P124.
3. In 1938 (photograph, Rijksbureau voor Kunsthistorische Documentatie, The Hague).
4. Signed and dated 1685, oil on canvas, 37½ x 28¾″ (95.5 x 73 cm.), Szépművészeti Múzeum, Budapest, no. 238.
5. No. P69.

PROVENANCE: Possibly sale, F. Muller, Amsterdam; purchased for the W. P. Wilstach Collection, Philadelphia, August 13, 1901.

LITERATURE: Wilstach 1903, no. 204, repro., 1904, no. 290, repro., 1906, no. 314, repro., 1907, no. 325, repro., 1910, no. 451, 1913, no. 468, 1922, no. 341; Thieme-Becker 1907–50, vol. 35 (1942), p. 245; PMA 1965, p. 70.

CONDITION: The canvas has an aged but sound aqueous lining. The tacking edges are missing. The paint film is in excellent state with only a few tiny, old losses. The varnish is dull and moderately discolored.

LITERATURE: Thieme-Becker 1907–50, vol. 35 (1942), p. 284; E. Bénézit, *Dictionnaire critique, et documentaire des peintres, sculpteurs, dessinateurs et graveurs,* vol. 10 (Paris, 1976), p. 674.

Born in Vlaardingen on November 23, 1856, Weiland was a pupil of his uncle Hugo Maarleveld. He studied at the academy in Rotterdam and later taught there. His genre paintings are in the manner of the Hague School. Weiland was buried in The Hague on November 13, 1909.

132 JOHANNES WEILAND

WASHERWOMAN, c. 1900
Signed lower right: *Weiland*
Oil on canvas, 19¾ x 15¾″ (50.2 x 40 cm.)
Gift of Walter Lippincott. 23-59-9

NOTE
1. Signed and dated 1900, oil on canvas, 31⅞ x 27″ (81 x 68.5 cm.), sale, Christie's, Amsterdam, March 18, 1975, lot 101, repro.

PROVENANCE: Walter Lippincott, Philadelphia.

LITERATURE: PMA 1965, p. 70.

CONDITION: The canvas is slightly wrinkled and out of plane. The paint film is abraded along the edges and there is drying crackle at the top edge. A new layer of varnish was applied in 1969.

A woman in a white cap and long workdress leans over a steaming laundry vat. A hamper of clothes and a bucket appear in the foreground and other laundry and kitchen utensils are at the left. The darkened scene is lit by a small window at the upper left. Not only the simple household theme but also the tenebrous palette and broad brushwork of this painting recall earlier works by Jozef Israëls (q.v.) and his circle. The Hague School made a specialty of rustic genre scenes depicting peasant or fisherwomen performing their domestic chores. The laundry theme also had precedents in seventeenth-century Dutch genre painting (for example, Pieter de Hooch) and nineteenth-century French painting (Degas and others). A date of about 1900 is proposed on the basis of the painting's stylistic resemblance to the artist's *Minding the Baby.*[1]

133 COPY AFTER
 ROGIER VAN DER WEYDEN

THE DESCENT FROM THE CROSS, sixteenth century?
Oil on panel, 42½ x 27½″ (108 x 69.9 cm.)
The George Grey Barnard Collection. 45-25-124

The three-quarter-length composition depicts the body of Christ removed
from the cross. Saint Joseph of Arimathea (sometimes identified as
Nicodemus) supports the body at the right while the Virgin clasps her son
at the left. Behind and to the left John comforts the Virgin. In the
background is a glimpse of a town with crenelated battlements.
Surmounting the cross is an ornate titulus inscribed *INRI*.

 This work is one of numerous copies of a lost painting by Rogier van
der Weyden (1399/1400–1464). The editors of the revised edition of Max
Friedländer's *Early Netherlandish Painting* have counted more than one
hundred fifty repetitions of the design.[1] Two variants of the composition
are known: one corresponding to the present design and a second in which
John is omitted and the Virgin crouches down lower. The original of this
second variant is lost too but is also known through many copies.[2] The

original of the variant with John may have been the picture of this description recorded among the paintings given by Philip II to the Escorial in 1574.[3] Quite a few versions of this variant have also been found in Bruges, prompting Friedländer and others to suggest that the original was once preserved in that city. Most of the copies have gold backgrounds, but some, like the Philadelphia work, show landscapes in the distance. The arched top of the Philadelphia panel also reappears elsewhere, often with the same contour, but usually in copies in a triptych format with wings depicting donors or additional saints.[4] The copy that most resembles the Philadelphia painting not only in format and size but also in details such as the titulus and the figure types (for example, the hair of Joseph [or Nicodemus]) is a panel last seen in the T. G. Dawson Collection, Manchester, which Marlier attributes to Pieter Coecke van Aelst (q.v.) and links with two wings in the M. H. de Young Memorial Museum, San Francisco.[5] Like that work, the present copy (as Martin Weinberger first observed in 1941)[6] seems on stylistic grounds to be from the sixteenth century (all the versions with the arched top and titulus seem to be of a later date) and may also once have been part of a triptych. Weinberger's assumption, however, that the work is Spanish in origin should probably be modified to Hispano-Flemish.

NOTES

1. Max J. Friedländer, *Early Netherlandish Painting*, vol. 2, *Rogier van der Weyden and the Master of Flémalle* (New York and Washington, D.C., 1967), pp. 79–80, 94, no. 97, under which the following copies are illustrated and/or listed: a (pl. 112), panel, 33½ x 24⅜" (85 x 63 cm.), Dr. Jurié de Lavandal, Vienna (sold 1918); b (pl. 112), panel, 24⅜ x 18½" (62 x 47 cm.), formerly Wallraf Richartz Museum, Cologne, no. 419; c (pl. 112), panel, 31⅞ x 26⅜" (81 x 67 cm.), Musées de la Ville de Strasbourg, inv. 126; d (pl. 112), panel, 23⅝ x 18⅛" (60 x 46 cm.), Museum of the Cathedral, Bruges; e, panel, 32¼ x 17¾" (82 x 45 cm.), C. S. Arbib sale, Venice, May 18, 1908, lot 569; f, panel, 35⁷⁄₁₆ x 26⅜" (90 x 67 cm.), Brade-Wagner sale, Cologne, October 1897, lot 259; g, panel, 22 x 16½" (56 x 42 cm.), Zélikine sale, Paris, 1908, lot 285; h, De Meulenaere Collection, Brussels; and i, panel, 23¼ x 16¹⁵⁄₁₆" (59 x 43 cm.), F. Doistau sale, Paris, November 22, 1909, lot 17. In addition to these copies, see those discussed and illustrated by Salomon Reinach, "A Lost Picture by Rogier van der Weyden," *The Burlington Magazine*, vol. 43, no. 248 (1923), pp. 214–21; Edouard Salin, "Copies ou variations anciennes d'une oeuvre perdue de Rogier van der Weyden," *Gazette des Beaux-Arts*, 6th ser., vol. 13 (1935), pp. 15–20; Georges Marlier, *La Renaissance flamande: Pierre Coeck d'Alost* (Brussels, 1966), pp. 198–202; Martin Davies, *Rogier van der Weyden: An Essay, with a Critical Catalogue of Paintings Assigned to Him and to Robert Campin* (London, 1972), pp. 238–39; see also sale, Sotheby's, London, October 24, 1984, lot 22; and *The Descent from the Cross* by the Master of the Holy Blood, triptych, tempera and oil on wood, central panel 36 x 28½" (91.4 x 72.4 cm.), The Metropolitan Museum of Art, New York, no. 17.187a–c.
2. See Friedländer (note 1), no. 98 and pl. 111, and the literature cited in note 1.
3. See Davies (note 1), p. 238; see also Zarco Cuevas, *Inventario de las alhajas . . . donados por Felipe II al Monasterio de El Escorial* (1930), no. 1029.
4. See, for example, the triptychs listed by Marlier (note 1), p. 199, nos. 1–6, and those in the museums in Nancy and Louvain (Salin [note 1], figs. 8 and 9).
5. Panel, 42 x 26" (106.7 x 66 cm.). See Marlier (note 1), pp. 199–200, fig. 139.
6. Martin Weinberger, *The George Grey Barnard Collection* (New York, 1941), p. 31.

PROVENANCE: The George Grey Barnard Collection, New York, by 1941.

LITERATURE: Martin Weinberger, *The George Grey Barnard Collection* (New York, 1941), p. 31, no. 124.

CONDITION: The panel support is arched at the top and has been thinned and cradled. The grain runs vertically. In the lower-left corner is a triangular-shaped insert 1¾" (4.4 cm.) wide by 7" (17.8 cm.) high, undoubtedly a later repair. A 12" (30.5 cm.) vertical crack begins at the bottom edge, left of center. The paint film is uneven, showing an area of thick build-up in the folds of the Virgin's gown while other areas are very thinly executed and reveal underdrawing below. Small losses are scattered throughout. The surface has been selectively cleaned; while the varnish layer in the sky and other lighted areas is relatively clean, a thick layer of moderately discolored varnish covers the cross and many of the dark passages.

For additional works by Rogier van der Weyden in the Philadelphia Museum of Art, see John G. Johnson Collection cat. nos. 334, 335, 321 (follower of), 341 (follower of).

LITERATURE: Norbert Lieb in Thieme-Becker 1907–50, vol. 35 (1942), pp. 480–81; Willy Raeber, *Caspar Wolf, 1735–1783* (Munich, 1979).

Born in Saint Gall on November 8, 1698, Weyermann was a pupil of Joachim Franz Beich (1665–1748) in Munich. After a stay in Nuremberg he moved by 1732 to Augsburg, where he married in 1739. A painter and draftsman of landscapes, often with hunting staffage, Weyermann painted in a style reminiscent of that of his teacher and of Anton Faistenberger (1663–1708), whose landscapes resemble those of Gaspard Dughet (1615–1675).

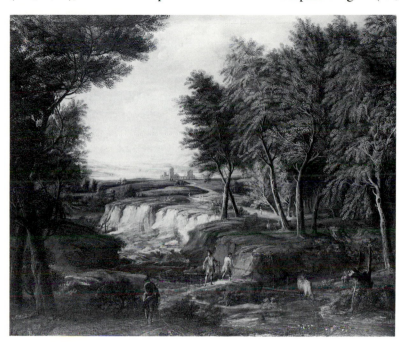

134 JAKOB CHRISTOPH WEYERMANN

LANDSCAPE WITH FIGURES, c. 1730–35
Signed lower right: *Weyerma* [nn]
Oil on canvas, 28¼ x 34½" (71.8 x 87.6 cm.)
Bequest of Robert Nebinger. 89-113

In an ideal southern landscape a stream runs diagonally from upper left to lower right. Trees stand on each bank, and a town appears in the distance. Figures and cattle travel along a road weaving under the trees. In the foreground several men prepare to traverse a simple footbridge.

Since it was acquired by the Museum, this painting has always been assigned to Jacob Campo Weyermann (1677–1747), the still-life painter and author of a chronicle of artists' lives.[1] The painting, however, is surely by the later Augsburg painter Jakob Christoph Weyermann, who painted imaginary landscapes similar to the Philadelphia painting, usually with hunting parties (see fig. 134-1).[2] Gode Krämer of the Städtische Kunstsammlungen, Augsburg, affirms this reassignment, noting that the signature on the painting is typical for Jakob Christoph Weyermann.[3]

FIG. 134-1 Jakob Christoph Weyermann, *Landscape with Hunting Party,* signed and dated 1730, oil on canvas, 44¹/₁₆ x 70¼" (112 x 178.5 cm.), Städtische Kunstsammlungen, Augsburg, inv. no. 6683.

NOTES
1. *De Levens-beschryvingen der Nederlandsche konst-schilders en konst-schilderessen,* 4 vols. (The Hague, 1729–69).
2. Compare also his works in Augsburg and *Landscape with Hunters,* signed and dated 1733, oil on canvas, 44⅞ x 62¼" (114 x 158 cm.), G. Peters, Venlo, in 1936 (photograph, Rijksbureau voor Kunsthistorische Documentatie, The Hague).

3. Letter to the author, September 20, 1984, Philadelphia Museum of Art, accession files.

PROVENANCE: Robert Nebinger.

LITERATURE: PMA 1965, p. 71 [as Jacob Campo Weyermann].

CONDITION: The canvas support has a glue relining that is buckling. The tacking margins were let out and clipped. An old puncture appears in the lower-left center. The paint film is moderately abraded; the figures in the middle ground have become semitransparent. All the edges are overpainted. The varnish layer is uneven and discolored.

Winterhalter was born on April 20, 1805, in the village of Menzenschwand in Baden. Raised on a farm, he entered the Herdersche Kunstinstitut in Freiburg in 1818 where he was instructed in drawing and engraving. He also trained under the portraitist Joseph Karl Stieler (1781–1858), who was famous for his series depicting the most beautiful women in Bavaria at Nymphenburg Castle. In 1824 he obtained a scholarship to the academy in Munich. He studied there with Robert von Langer (1783–1846), while making his living producing lithographic reproductions. In 1828 he moved to Karlsruhe, where he became the drawing instructor to the Grand Duchess Sophie and subsequently was named court painter. He received many commissions for portraits from the ducal family of Baden. These portraits generally postdate his trip in 1833–34 to Italy, where he painted Italian peasants in the style of Léopold Robert (1794–1835). Arriving in Paris in 1834, he made his debut at the Salon of 1835. His subject paintings *Il dolce farniente* of 1836 and *Decameron* of 1837 brought him fame and the support of Louis Philippe, for whom he worked principally as a portraitist. He first journeyed to the English court in 1841 and returned to England again during the unrest of 1848. Between 1842 and 1871, Winterhalter painted more than one hundred paintings for Queen Victoria. In 1852 he traveled to Spain with Eduard Magnus (1799–1872) in the entourage of Queen Isabella. The following year he returned to France and immediately won the patronage of Napoleon III, painting portraits of the emperor and the Empress Eugénie. In 1855 he was asked to execute the now famous, large group portrait of the empress and her ladies-in-waiting (oil on canvas, 118⅛ x 165⅜″ [300 x 420 cm.], Musée National du Château, Compiègne) and portrayed many European heads of state. In the 1850s and 1860s he often traveled to Baden-Baden and in 1868 visited Munich. In 1870 he moved from France to Germany, where he died in Frankfurt three years later.

One of the most sought-after portraitists of his day, Winterhalter served royalty and high society but sometimes was harshly received by critics, who found his art mere dry virtuosity. In his youth he also executed genre scenes. He was related to the artist Hans Thoma (1839–1924), and his younger brother Hermann (1808–1891) was also a painter.

LITERATURE: Emile Bellier de la Chavignerie and Louis Auvray, *Dictionnaire général des artistes de l'école française depuis l'origine des arts du dessin jusqu'à nos jours,* vol. 2 (Paris, 1885), p. 724; Boetticher (1891–1901) 1969, vol. 2, pt. 2, pp. 1026–27; Franz Wild, *Nekrologe und Verzeichnisse der Gemälde von Franz & Hermann Winterhalter* (Zurich, 1894); Armand Dayot, "Winterhalter—Painter to the Second Empire," *International Studio,* vol. 91, no. 377 (October 1928), pp. 39–44; M. Knoedler, London, *Winterhalter Loan Exhibition,* 1937; Arthur von Schneider in Thieme-Becker 1907–50, vol. 36 (1947), pp. 87–89; Odile Sébastiani in Philadelphia Museum of Art, *The Second Empire, 1852–1870: Art in France under Napoleon III,* October 1–November 26, 1978, pp. 357–59, The Detroit Institute of Arts, January 15–March 18, 1979, and Grand Palais, Paris, *L'Art en France sous le Second Empire,* May 11–August 13, 1979, pp. 413–15; National Portrait Gallery, London, *Franz Xaver Winterhalter and the Courts of Europe, 1830–70,* October 30, 1987–January 10, 1988, Petit Palais, Paris, February 11–May 7, 1988 (catalogue by Richard Ormond and Carol Blackett-Ord).

135 FRANZ XAVER WINTERHALTER *COUNTESS MARIE BRANICKA DE BIALACERKIEW,*
 NÉE PRINCESS SAPICKA, 1865
 Signed and dated lower right: *F. Winterhalter 1865. Paris*
 Oil on canvas, 45⅝ x 35⅜″ (115.9 x 89.9 cm.)
 Purchased: Edward G. Budd, Jr., Memorial Fund. 73-252-1

The sitter is viewed three-quarter length and leans against the back of a red velvet chair. She wears a white and pink lace dress, a pearl necklace and pearl earrings, and a turquoise ring. In her right hand she dangles a bouquet of roses.

The twenty-two-year-old sitter is the Polish Countess Marie Branicka de Bialacerkiew, who was born Princess Sapicka. The vital facts of her life have been provided by Jeanne-Marie de Broglie.[1] The princess was born in Paris on September 18, 1843, the daughter of Prince Eustache Sapicka (1797–1860) and Countess Rose Mostowaka, and the great-granddaughter of Prince Alexander Sapicka (1730–1793) and Princess Magdelena Lubomirska. She was married in Paris on December 2, 1862, to her cousin, Count Ladislas Branicki de Bialacerkiew. The couple had three children: Countess Marie Branicka (1863–1941), Prince Georges Radziwill (d. 1918), and Prince Stanislas Radziwill (d. 1919).

Winterhalter painted many members of the Polish aristocracy in Paris, including the Potockis, Krasinkis, and Branickis, many of whom were related by marriage.[2] Well-established socially, these Francophile families were noted for their beauty, wealth, and taste. The Branickis were one of the richest Polish magnate families, having inherited vast estates in the Polish Ukraine and been generously rewarded by Catharine II for their "realistic," which is to say, pro-Russian views. In 1856 Winterhalter even traveled to Warsaw, where many of the portraits of his Polish patrons are still preserved in the National Museum. In his list of Winterhalter's paintings, published in 1894 and stated to have been based on the painter's own list of his works, Franz Wild cited no fewer than eight portraits of Branickis, including the Philadelphia painting.[3]

The socially elevated subject, the painstaking technique, and the forceful palette are all characteristic of Winterhalter's mature art. The studied informality of the sitter's pose is typical of Winterhalter's efforts to enliven the constrained conventions of Second-Empire portraiture. Countess Branicka's pose, with her arms leaning on the back of a chair, descends from seventeenth-century Baroque portraiture and appears earlier in Winterhalter's female portraits; for example, *Princess Anna von Preussen, Landgräfin von Hesse* of 1858.[4]

NOTES
1. Letter, June 24, 1977, Philadelphia Museum of Art, accession files.
2. See National Portrait Gallery, London, *Franz Xaver Winterhalter and the Courts of Europe, 1830–70,* October 30, 1987–January 10, 1988, p. 51.
3. Franz Wild, *Nekrologe und Verzeichnisse der Gemälde von Franz & Hermann Winterhalter* (Zurich, 1894), no. 470; see the annotated edition of Wild, complete with an index, provided by National Portrait Gallery (see note 2), pp. 226–39.
4. Oil on canvas, 57¾ x 45½" (147 x 115.5 cm.), Schloss Fasanerie Museum, Fulda; see National Portrait Gallery (note 2), fig. 42.

PROVENANCE: By descent to the sitter's grandson, Prince Lubomirski; Ferrers' Gallery, London.

LITERATURE: Franz Wild, *Nekrologe und Verzeichnisse der Gemälde von Franz & Hermann Winterhalter* (Zurich, 1894), no. 470; *Annual Report, Bulletin of the Philadelphia Museum of Art,* vol. 69, no. 310 (winter 1975), repro. p. 18; National Portrait Gallery, London, *Franz Xaver Winterhalter and the Courts of Europe, 1830–70,* October 30, 1987—January 10, 1988, pp. 51, 57, 273, no. 470.

CONDITION: The canvas support is wax-resin lined. The tacking edges are present. The background is severely abraded and overpainted. The figure and chair have minor damages throughout, which have been retouched. The face is in better condition than other parts of the painting. The varnish layer is colorless.

Baptized in a Roman Catholic church in Amsterdam on December 19, 1695, Jacob de Wit was first a pupil of Albert van Spiers (c. 1666–1718). In 1708 he went to Antwerp to live with a wealthy art-collecting uncle who enrolled him in the studio of Jan van Hall (1672–1750). In addition to drawing from the nude at the Koninklijke Academy, he copied works by Rubens (q.v.; most important, the ceiling decorations for the Jesuit Church in Antwerp that burned in 1718), Anthony van Dyck (1599–1641), and others. After becoming a master in the Antwerp Saint Luke's Guild in 1713–14, he returned to Amsterdam at the age of twenty-one and almost immediately became fashionable, receiving many commissions, especially for religious paintings. Between 1716 and 1734 he executed numerous works for the Moses and Aaron Church in Amsterdam. In 1720 he married a wealthy Amsterdam woman, Cornelia Leonora van Neck. His grandest commission was an enormous scene, *Moses Choosing the Seventy Elders,* executed for the Amsterdam town hall in 1735–37. The largest portion of his oeuvre is devoted to decorative works, usually of classical or allegorical subjects. Many of his ceiling and wall decorations were executed in grisaille in imitation of plaster and marble bas-reliefs and became known as "witjes" after the artist who made them. These works hung in both public and private buildings. In 1747 De Wit published *Teekenboek der Proportien van 't Menschelijk Lichaam* with engravings executed by his students Jan Punt and Jan Stolker after his academic drawings.

Absorbing influences from Rubens and his circle, as well as the indigenous Dutch classical tradition (Gérard de Lairesse [q.v.] and his followers), De Wit created his own rococo manner and became the greatest eighteenth-century Netherlandish painter of mural decorations.

LITERATURE: Bredius 1915–22, vol. 3 (1917), pp. 737–57; Thieme-Becker 1907–50, vol. 36 (1947), pp. 113–14; Adolph Staring, "Jacob de Wit," *Jaarverslag Konincklijk Oudheidkundig Genootschap,* 1932, pp. 35–38; J. W. Niemeijer, "Twee Beeltenissen van J. de Wit," *Oud Holland,* vol. 73 (1958), p. 247; Adolph Staring, *Jacob de Wit, 1695–1754* (Amsterdam, 1958); Musées Royaux des Beaux-Arts de Belgique, Brussels, *Laurent Delvaux and Jacob de Wit,* 1968–69; E. R. Mandle in Minneapolis Institute of Arts, *Dutch Masterpieces from the Eighteenth Century,* October 7–November 14, 1971, Toledo Museum of Art, December 3, 1971–January 30, 1972, and Philadelphia Museum of Art, February 17–March 19, 1972, pp. 113–15; P. A. Scheen, *Lexicon Nederlandse Beeldende Kunstenaars 1750–1880* (The Hague, 1981), pp. 588–89.

136 JACOB DE WIT

PUTTI WITH SHEEP, 1749

Signed and dated lower right: *JdWit 1749* (first three letters ligated)

Oil on canvas, 48¼ x 39″ (122.6 x 99.1 cm.)

Gift of Mrs. Gordon A. Hardwick and Mrs. W. Newbold Ely in memory of
Mr. and Mrs. Roland L. Taylor. 44-9-5

A grisaille in imitation of an arched niche with sculpted bas-relief, this "witje," so named after the artist, depicts three putti with three sheep. Seated at the right, one putto plays a small horn as the other putti lock arms in an embrace in the center of the scene. A shepherd's staff and a broad-brimmed hat decorated with flowers lie in the foreground and project illusionistically from the niche.

This painting and its companion (see the following painting, no. 137) were among ten paintings, including four grisailles, commissioned by Willem Philips Kops between 1724 and 1752 for his house at 74 Nieuwe Gracht in Haarlem. The entire group remained together until 1906, when it was dispersed at auction. After 1719 and 1720, when De Wit executed ceiling decorations for the Van Schuylenburgh family in Haarlem, his reputation spread rapidly in that city. The Mennonite Kops was only one of a number of rich Haarlem patrons who commissioned works from the Amsterdamer De Wit. Kops had bought the splendid house at 74 Nieuwe Gracht in 1724. The Nieuwe Gracht was a relatively wide canal that had been created during the extension of Haarlem to the north between 1686 and 1689. Unfortunately, the interior of the house was totally remodeled early in this century and the original situations of De Wit's ten paintings lost. Nonetheless, the dates on the works enable us to reconstruct the sequence of Kops's commissions.

The first, in 1724, was for an overdoor of four putti symbolizing the Four Seasons.[1] In 1735 he followed it with a large ceiling decoration representing *Aurora Dispelling the Darkness,* now in the John and Mable Ringling Museum, Sarasota (fig. 136-1).[2] This was the only work for Kops that was not described in 1906 as an overdoor. In 1744 he added a scene described in 1906 as "Four cherubs clambor up a *ballot,* one of them holds up a small toilette mirror while another vainly attempts to see its reflection. A third holds a caduceus. On the ground are books, the winged hat of Mercury, a club, etc."[3] In 1748 he executed another scene of four putti as the Four Seasons (fig. 136-2)[4] and the next year, the present work. The latter's companion (no. 137) was dated the following year. In the same year, 1750, he executed a grisaille of putti (see fig. 137-1) interpreted in 1906, probably correctly, as symbolizing Commerce: "In the center one sees a cupid holding in one hand the caduceus, and listening to the explication of another crouching next to him on the right. Two cupids are busy reading a large *ballot*; nearby, a young bookkeeper writes. A sixth appears at the left holding an anchor. On the ground: mirror, club, Mercury's hat, bottle, etc."[5] A scene of a cherub on a balustrade blowing bubbles with a young girl and boy was added in 1751.[6] Finally, in 1752, he executed a scene of a cherub holding up a myrtle branch with another cherub embracing a young girl with flowers,[7] and a scene of *Procne and Tereus* described as follows: "Procne is seated under a tree and looks lovingly at Tereus who, dressed in a large, red cloak, points toward the tree where he has carved the name of the beautiful daughter of King Pandion. Behind the tree trunk an amor

FIG. 136-1 Jacob de Wit, *Aurora Dispelling the Darkness,* 1735, oil on canvas, 127 x 159″ (322.5 x 403.7 cm.), John and Mable Ringling Museum, Sarasota, inv. no. SN975.

FIG. 136-2 Jacob de Wit, *The Four Seasons,* signed and dated 1748, oil on panel, 29½ x 59⁷⁄₁₆″ (75 x 151 cm.), sale, Hotel Nieuwe Gracht, Amsterdam (F. Muller & Co.), April 25, 1906, lot 169.

brandishes his torch while a second puts his finger to his lips. On the ground a quiver, a bow, and a shepherd's crook."[8]

That all these diverse scenes executed over a period of twenty-eight years should be part of an overall symbolic program seems unlikely. Rather they probably were distributed in the house in rooms whose functions were related to the themes of the decorations. For example, the Philadelphia paintings, the only works clearly designed as pendants, are related by the common theme of music and could have been designed for a music ballroom or similar area. The measurements of the other pictures differ sufficiently as to eliminate the possibility of matching their meanings by identifying companion pieces, although parallels in some of the themes may serve to identify their original locations and functions.

Clearly, temporal and seasonal allusions are offered in the form of the central scene of Aurora (1735) and the Four Seasons paintings (1724 and 1748). The appearance of Pegasus, who Karel van Mander reminds us bore Aurora aloft,[9] in the pendant (no. 137) is less likely to be astrological in meaning than allusive of the Muses and musical and poetic inspiration, a subject complementary to the present work's idyllic pastoral subject. Clearly there also were shared allusions to *vanitas* themes (the soap bubbles in the painting of 1751 and the mirror in that of 1744), as well as to the ideas of commerce and prosperity (the pictures of 1750 and 1744). Finally, the myrtle branch (1752), traditional attribute of Venus and a symbol of everlasting love and specifically conjugal fidelity, can be contrasted with the tragic story of Procne and the adulterous Tereus.[10]

NOTES
1. Signed and dated 1724, oil on canvas, 31⅞ x 59″ (81 x 150 cm.), sale Hotel Nieuwe Gracht, Amsterdam (F. Muller & Co.), April 25, 1906, lot 170; later, sale Horstman, Amsterdam, November 19, 1929, repro.
2. Franklin W. Robinson and William H. Wilson, *Catalogue of the Flemish and Dutch Paintings, 1400–1900: The John and Mable Ringling Museum of Art, Sarasota* (Sarasota, 1980), no. 126. The painting appeared in the 1906 sale as lot 168; later Léon Cardon Collection, Brussels. The work is undated but related to a dated oil sketch; see Adolph Staring, *Jacob de Wit, 1695–1754* (Amsterdam, 1958), p. 149, fig. 48.
3. "Quatre chérubins sont grimpés sur un ballot, l'un d'eux levant un petit miroir de toilette ou un autre tâche en vain de se mirer. Un troisième tient le caducée. Sur le sol des livres, le chapeau ailé de Mercure, tampon, etc." Sale 1906 (see note 1), lot 175; signed and dated, oil on panel, 48½ x 27½″ (123 x 70 cm.).
4. Sale 1906, lot 169, repro.
5. "Au centre on voit un cupidon assis tenant d'une main le caducée et écoutant les explications d'un autre accroupi près de lui, vers la droite. Deux cupidons sont occupés à lier un grand ballot; à côté, un jeune teneur de livres ecrivant. Un sixième est vu à gauche tenant une ancre. Sur le sol: miroir, tampon,

chapeau de Mercure, bouteille, etc." Sale 1906 (see note 1), lot 174, repro.; in 1973 with dealer L. Koetser.
6. Sale 1906 (see note 1), lot 172, repro.; signed and dated, oil on canvas, 35 x 33⅞″ (89 x 86 cm.).
7. Sale 1906 (see note 1), lot 173; signed and dated, oil on canvas, 37⅜ x 33½″ (95 x 85 cm.).
8. "Progné est assise sous un arbre et regarde amoureusement Tereus qui, drapé dans un grand manteau rouge, pointe vers l'arbre où il a incisé le nom de la belle fille du roi Pandion. Derrière le tronc, un amour brandissant son flambeau et un autre, le doigt sur les lèvres. Sur le sol un carquois, un arc et une houlette." Sale 1906 (see note 1), lot 171; signed and dated, oil on canvas, 52⅜ x 39″ (133 x 99 cm.). According to Staring (see note 2), pp. 156–57, the same composition appeared in a work in the collection of Lord Blythwood in 1723, where it was called Tancred and Erminia.
9. See *Wtlegghingh op den Metamorphosis* (Haarlem, 1604), fol. 41v.
10. See Karel van Mander's commentary on the myth in ibid., fols. 56–56v.

PROVENANCE: Painted for Willem Philips Kops of 74 Nieuwe Gracht, Haarlem; sale, Hotel Nieuwe Gracht, Amsterdam (F. Muller & Co.), April 25, 1906, lot 176 (together with

its companion [see no. 137]); Mrs. Gordon A. Harwick and Mrs. W. Newbold Ely.

EXHIBITION: Adjunct exhibition to Philadelphia Museum of Art, "Dutch Masterpieces from the Eighteenth Century," 1972 (no catalogue).

LITERATURE: Adolph Staring, *Jacob de Wit, 1695–1754* (Amsterdam, 1958), p. 155; PMA 1965, p. 71.

CONDITION: The painting was relined with a wax-resin adhesive in 1973. The tacking edges are partially missing. At the time of treatment the paint film revealed cleaving and flaking areas around the edges, which were secured and inpainted. The top corners of the painting have canvas inserts, the inner edges of which roughly parallel the curved upper edge of the painted niche. Scattered losses have been filled. Presently the entire outer border of the niche and particularly the upper-left corner are heavily retouched. The shadows at the upper left of the niche, around the heads of the two putti on the right, and below the central pair's arms have been strengthened. General abrasion is noticeable. The varnish layer is uneven but relatively colorless.

136 JACOB DE WIT

PUTTI WITH SHEEP, 1749
Signed and dated lower right: *JdWit 1749* (first three letters ligated)
Oil on canvas, 48¼ x 39″ (122.6 x 99.1 cm.)
Gift of Mrs. Gordon A. Hardwick and Mrs. W. Newbold Ely in memory of
 Mr. and Mrs. Roland L. Taylor. 44-9-5

137 JACOB DE WIT

FOUR PUTTI WITH MUSICAL INSTRUMENTS, 1750
Signed and dated lower right: *JdWit 1750* (first three letters ligated)
Oil on canvas, 48¼ x 39″ (122.5 x 99.1 cm.)
Gift of Mrs. Gordon A. Hardwick and Mrs. W. Newbold Ely in memory of
 Mr. and Mrs. Roland Taylor. 44-9-6

FIG. 137-1 Jacob de Wit, *Commerce,* signed and dated 1750, oil on canvas, 37 x 56⅛" (94 x 144 cm.), sale, Hotel Nieuwe Gracht, Amsterdam (F. Muller & Co.), April 25, 1906, lot 174.

Within an arched niche, a putto plays a lyre while two others steady the instrument. One of the latter shoulders a tall trumpet. A fourth putto wearing a poet's laurel wreath and holding a rolled parchment stands at the back of the group beneath the image of the winged Pegasus. Although originally a symbol of the thundercloud and morning, Pegasus came, through a mistranslation of his Greek name, to be associated with a spring of water and was believed to have caused the Hippocrene, the fountain of the Muses, to gush forth from Mount Helicon.[1] Thus he came to be interpreted as the symbol of poetic inspiration. The attribute of Apollo, companion to the Muses, and inhabitant of not only Parnassus but also Mount Helicon, was, of course, the lyre, here displayed so prominently.

Identical in size and related in composition and theme to the previous picture of 1749 (no. 136), this work was sold in 1906 as a companion piece.[2] The pair were designed by the artist as decorative pendants for the house of Willem Philips Kops in Haarlem.

NOTES
1. On Pegasus, see Karel van Mander, *Wtlegghingh op den Metamorphosis* (Haarlem, 1604), fol. 41v. See also the statue of Pegasus that surmounts Mount Helicon and the Hippocrene in Maerten van Heemskerk's *Mount Helicon,* dated 1565, Chrysler Museum, Norfolk, Virginia, inv. no. 71.479; see Rainhald Grosshans, *Maerten van Heemskerk: Die Gemälde* (Berlin, 1980), cat. no. 96, fig. 132.
2. Sale, Hotel Nieuwe Gracht, Amsterdam (F. Muller & Co.), April 24, 1906, lot 176.

PROVENANCE: Painted for Willem Philips Kops of 74 Nieuwe Gracht, Haarlem; sale, Hotel Nieuwe Gracht, Amsterdam (F. Muller & Co.), April 25, 1906, lot 176 (together with its companion [see no. 136]); Mrs. Gordon A. Hardwick and Mrs. W. Newbold Ely.

EXHIBITION: Adjunct exhibition to Philadelphia Museum of Art, "Dutch Masterpieces from the Eighteenth Century," 1972 (no catalogue).

LITERATURE: Adolphe Staring, *Jacob de Wit, 1695–1754* (Amsterdam, 1958), p. 155; PMA 1965, p. 71.

CONDITION: Discolored overpaints and varnish were removed from the painting and it was relined in 1973 with a wax-resin adhesive. The original tacking edges are present. There is a crescent-shaped planar deformation at the bottom edge of the painting. The upper curve of this deformation roughly parallels the lower curved edge of the painted niche. The paint film reveals many losses and considerable retouches around the edges. The abrasion and retouches are also extensive in the darks, for example, the shadow of the niche. The lower corners of the niche have been overpainted; originally the shape of the painted niche was curved along its lower edge. Additional smaller retouches appear throughout. Both the signature and the date have been strengthened. The varnish is uneven but relatively colorless.

The eldest son of the little-known Alkmaar painter Pauwels Joosten Wouwermans (d. 1642), Philips was baptized at Haarlem on May 24, 1619. His name was spelled variously but he and his brothers Jan (1629–1666) and Pieter (1623–1682), who were also painters, used only the spellings "Wouwerman" and "Wouwermans." Philips may have been a pupil of his father and, according to Cornelis de Bie (*Het Gulden Cabinet* [Antwerp, 1661; reprint, Soest, 1971], p. 281), he studied with Frans Hals (1581/85–1666). On the basis of a note appended to a copy of Karel van Mander's *Het Schilder-Boeck* (Haarlem, 1603–4) by Wouwermans's German pupil Mathias Scheits in 1679, it has been assumed that he ran away to Hamburg to marry at the age of nineteen (hence in 1638 or 1639) and worked there briefly with Evert Decker (d. 1647), a history painter. By 1640 he had returned to Haarlem and joined the guild there, becoming an officer in 1646. Kort Withold and Nicolaes Fikke were his pupils in 1641 and 1642. In 1645 he bought a large house called "de Croon" in the Grote Houtstraat, which he sold two years later when he moved to the Bakenessergracht. He seems to have remained in his native city for the remainder of his life. A prosperous man, he died there on May 19 and was buried in the Nieuwe Kerk on May 23, 1668.

Highly productive, Wouwermans apparently executed more than one thousand paintings in his forty-eight years. He painted primarily small-scale landscapes with horses (battles, camps, or barn and hunting scenes) but also produced a few religious and mythological scenes. In addition, he painted staffage in the landscapes of Jacob van Ruisdael (q.v.), Jan Wijnants (c. 1625–1684), and Cornelis Decker (d. 1678). Although a painting of his that sold in London (Christie's, October 10, 1972, lot 13) was said to be dated 1639, the earliest certain date is 1646 (National Gallery, London, no. 6236; fig. 138-2; and City Art Gallery, Manchester, Assheton-Bennett Collection). His early works resemble the art of Jan Wijnants and Pieter Verbeeck (c. 1610–c. 1654). While the direction of influence in these cases is unclear, Wouwermans clearly was indebted to the Dutch Italianate painter Pieter van Laer, known as "Bamboccio" (1592/95–1642), whose sketches, Arnold Houbraken informs us, Wouwermans acquired upon the artist's death. In his lifetime and throughout the eighteenth century, Wouwermans's art commanded good prices and seems to have enjoyed high regard. According to Houbraken, he left his daughter (who married the still-life painter Hendrik Fromantiou) a very considerable dowry of twenty-thousand guilders. In addition to his brothers, Wouwermans had many students and followers and his much-sought-after works were frequently engraved, for example, by Jean Moyreau in *Oeuvres de Phpe Wouwermans: Gravées d'après ses meilleurs tableaux* (Paris, 1737).

LITERATURE: Cornelis de Bie, *Het Gulden Cabinet van de edele en vry Schilderconst* (Antwerp, 1661; reprint, Soest, 1971), p. 281; Houbraken 1718–21, vol. 2, pp. 70–75; Van der Willigen (1870) 1970, pp. 336–40; Hofstede de Groot 1908–27, vol. 2 (1909), pp. 249–645; Wurzbach 1906–11, vol. 2, pp. 902–3; Wilhelm von Bode, *Die Meister der holländischen und flämischen Malerschulen* (Leipzig, 1921), pp. 236–43; S. Kalff, "De gebroeders Wouwerman," *Elseviers Maandschrift*, vol. 30 (1920), pp. 96–103; Thieme-Becker 1907–50, vol. 36 (1947), pp. 265–68; Neil MacLaren, *National Gallery Catalogues: The Dutch School* (London, 1960), pp. 462–63; Wolfgang Stechow, *Dutch Landscape Painting of the Seventeenth Century* (London, 1966), pp. 29–31; F. J. Duparc in Mauritshuis, The Hague, *Hollandse schilderkunst: Landschappen 17de eeuw* (The Hague, 1980), pp. 124–30; Sutton et al. 1987, pp. 527–34.

For additional works by Wouwermans in the Philadelphia Museum of Art, see John G. Johnson Collection cat. nos. 615, 616, 620 (follower of), 617 (imitator of).

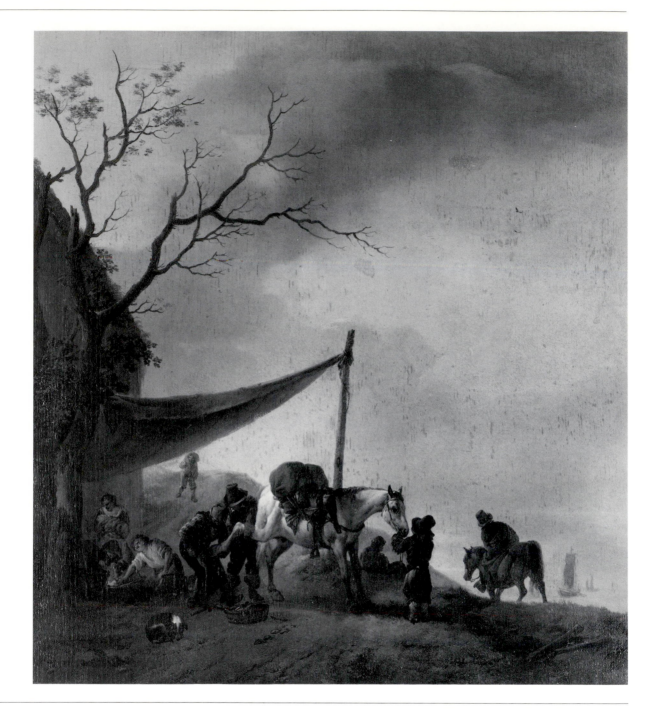

138 PHILIPS WOUWERMANS *THE BLACKSMITH'S SHOP,* late 1640s
 Signed lower left: *PHILS · W* (first four letters ligated)
 Oil on panel, 17¼ x 16⅜″ (43.8 x 41.6 cm.)
 The William L. Elkins Collection. E24-3-40

FIG. 138-1 Philips Wouwermans, *Shoeing a Horse,* oil on panel, 18⅛ x 24⅜″ (46 x 62 cm.), National Gallery, London, no. 2554.

A landscape rising from right to left is bordered by a building and a bare tree on the left while opening onto a stretch of water with sailing vessels just visible over a hillock on the right. In the center a blacksmith wearing a red cap shoes a white horse. A small boy holds the horse's reins as its owner lifts up its right rear hoof to be shod. Beneath a crude tent on the left two figures accompanied by a mother and child tend the smithy's fire. Two travelers, one on foot in the left distance and the other on horseback at the right, are silhouetted against the rosy, twilit sky.

Formerly the painting was labeled at the Museum as by both Jan (1629–1666) and Pieter (1623–1682) Wouwermans; however, it was assigned to Philips at least as early as 1872, when it was examined by A. Febvre. Further, it bears the artist's monogram. In this mark, once wrongly thought to occur only in his later works, all of the letters of the artist's first name (Phil[ip]s) are ligated, the "W" alone standing apart. The monogram clearly differs from that of Pieter Wouwermans, with which it is often confused. Philips Wouwermans painted numerous scenes of rustic ferriers and smithies in picturesque Italianate landscapes.[1] The central white horse, the tent, and the silhouetted figure partially hidden by a hillock are among Wouwermans's preferred motifs. Other paintings by Wouwermans of smithies with comparable designs, but reversed and with horizontal formats, are the pictures formerly in Jhr. A. Loudon's Collection[2] and in the National Gallery, London (fig. 138-1).[3]

Although dating Wouwermans's works is problematic, the present painting seems to be a relatively early work, perhaps of the late 1640s. In discussing the picture in the 1898 Eduard Kums sale, which probably is identical with the Philadelphia painting, C. Hofstede de Groot characterized it as "a good picture of the early period."[4] The combination of closely viewed figures and a low horizon is typical of Wouwermans's early works (see fig. 138-2) as is the painting's thin but deft execution.[5]

FIG. 138-2 Philips Wouwermans, *The Rest,* signed and dated 1646, oil on panel, 12½ x 14³⁄₁₆″ (32 x 36 cm.), Museum der bildenden Künste, Leipzig, inv. no. 825.

NOTES
1. See Hofstede de Groot 1908–27, vol. 2 (1909), nos. 116–69.
2. See Hofstede de Groot 1908–27, vol. 2 (1909), no. 119.
3. Neil MacLaren, *National Gallery Catalogues: The Dutch School* (London, 1960), no. 2554; Hofstede de Groot 1908–27, vol. 2 (1909), no. 134.
4. Hofstede de Groot 1908–27, vol. 2 (1909), no. 168.
5. Compare also the painting dated 1649, 11¹³⁄₁₆ x 10⅝″ (30 x 27 cm.), formerly in the Northbrook Collection, cat. 1889, no. 146.

PROVENANCE: Delahaye, Paris, 1872 [according to expertise by A. Febvre of rue St. George, Paris, June 4, 1872, on paper glued to the reverse of the panel]; probably Eduard Kums sale, Antwerp, May 17, 1898, lot 137 (to Arnold and Tripp);[1] William L. Elkins Collection, Philadelphia.

NOTE TO PROVENANCE
1. Compare Hofstede de Groot 1908–27, vol. 2 (1909), no. 168; the measurements and catalogue description correspond exactly but the river with sailing vessels is said to open on the left rather than the right side of the picture. Note that descriptions often are inadvertently reversed in sales catalogues.

EXHIBITION: Allentown Art Museum, *Seventeenth Century Painters of Haarlem,* 1965, cat. no. 91.

LITERATURE: Probably Hofstede de Groot 1908–27, vol. 2 (1909), no. 168; PMA 1965, p. 72 [as Philips Wouwermans, but incorrectly as on canvas].

CONDITION: The uncradled panel, with vertical grain, is in good condition, although the edges are slightly worn. The paint film is also generally in a good state, but reveals some general abrasion and old losses in the sky and at the lower edge. These losses and thin areas were inpainted when the picture was cleaned in 1967. Additional inpainting is visible along the right and lower edges. The varnish is clear.

LITERATURE: Boetticher (1891–1901) 1969, vol. 2, pt. 2, pp. 1059–60; Reinhard Sebastian Zimmermann, *Erinnerungen eines alten Malers seinen Söhnen Ernst und Alfred erzählt . . .* (1884; reprint, Munich, Berlin, and Leipzig, 1922); A. von Schneider, *Badische Malerie des 19. Jahrhunderts* (Berlin, 1935); Thieme-Becker 1907–50, vol. 36 (1947), p. 516.

Born in Hagnau am Bodensee in 1815, Zimmermann was the father of two other artists, Ernst (1852–1901) and Alfred (1854–1910). After working as a businessman in Meersburg, Remiremont, and Freiburg, he turned to painting in Munich under the influence of his cousin, the animal painter Robert Eberle (1815–1860). At the Munich academy in 1844 he encountered Carolsfeld von Schnorr (1794–1872), Heinrich von Hess (1790–1863), and Clement von Zimmermann (1788–1869). Initially as an artist, he made his living as a portraitist. In 1845 and 1846 he visited Paris, England, and Belgium, then settled in Konstanz, and in 1847 returned to Munich, where he began to paint genre scenes. Named painter to the Baden court in 1861, he specialized in humorous scenes from the everyday life of the upper-Bavarian and Swabian peasantry and *petite bourgeoisie*. He also painted period pieces and architectural scenes, primarily palatial interiors. His memoirs, as told to his children, were published in 1884. He died in Munich on November 16, 1893.

139 REINHARD SEBASTIAN
 ZIMMERMANN

TOO LATE FOR THE CARS, 1855
Signed and dated lower left in script: *R.S. Zimmermann 1855*
Oil on canvas, 27½ x 32¼" (69.9 x 81.9 cm.)
The W. P. Wilstach Collection. W93-1-135

In the foyer of a train station a crowd of four men, two young women, and a little girl evidently have missed the train that is still visible, pulling away in the distance to the right. Two of the men vainly present their tickets to the conductor, who holds keys in his left hand and points with a cigarette in his right to the departed train. Another man, seemingly out of breath, sits holding his chest and mopping his brow. A barking dog lying beside some freight at the lower right adds to the din.

While the anecdotal title "Too Late for the Cars," which the picture carried when first catalogued in 1886, may reflect a trustworthy tradition, the attribution to "R. J. Zimmermann" surely was the result of a misreading of the signature (the form of the "S" could easily be confused with a "J"). In the 1922 Wilstach Collection catalogue and the 1965 Museum *Check List of Paintings* it was assigned to "Richard [August] Zimmermann" (1820–1875), the German landscapist; however, it undoubtedly is the work of the genre-painter Reinhard Sebastian Zimmermann. The signature is his as are the figure types and the entire conception of the theme; compare *Children Preparing for the Epiphany Celebration*,[1] and *German Emigrants Preparing to Leave for New York*,[2] as well as *The Bill* (fig. 139-1). Some of the same models and gestural motifs appear in the last mentioned:

The travelers' picturesque costumes and breathless bewilderment lend the scene a humorous air. In all likelihood Zimmermann wished to imply in his patronizing fashion that such yokels are bound to be left behind in the modern technological era of railroads. According to his memoirs, Zimmermann made a trip out from Munich to the village of Maulbronn and later to Konstanz in the same year, 1855, of this picture's execution.[3] It seems unlikely, however, that the setting records an actual place.

Zimmermann evidently feared that prints after his work might be made without his permission since he inscribed this canvas on the back "Vervielfältigung vorbehalten" (reproduction [rights] reserved) and again signed his name.

NOTES
1. Signed and dated 1859, Staatliche Kunsthalle, Karlsruhe.
2. Sale, Christie's, London, January 17, 1969, lot 37.
3. *Erinnerungen eines alten Malers seinen Söhnen Ernst und Alfred erzählt* ... (1884; reprint, Munich, Berlin, and Leipzig, 1922), pp. 179–80.

PROVENANCE: The W. P. Wilstach Collection, Philadelphia.

LITERATURE: Wilstach 1886, no. 69 [as R. J. Zimmermann, 1855, and hereafter], 1893, no. 127, 1900, no. 174, 1903, no. 218, 1904, no. 304, 1906, no. 328, 1907, no. 337, 1910, no. 465, 1913, no. 482, 1922, no. 354; PMA 1965, p. 72 [as Richard August Zimmermann].

CONDITION: The unlined canvas support is brittle and slack. The paint film exhibits prominent traction crackle, as well as age crackle and wrinkles. The varnish is deeply discolored.

140 UNKNOWN
 SEVENTEENTH-CENTURY
 HAARLEM SCHOOL ARTIST

PORTRAIT OF A SEVENTY-FOUR-YEAR-OLD WOMAN, 1635
Inscribed upper left: *AETATIS 74 1635*
Oil on panel, 12¾ x 10⅜″ (32.4 x 26.4 cm.)
The William L. Elkins Collection. E24-3-75

Viewed to the knees, the subject is seated and turned slightly to the viewer's left. She is dressed in a black gown, white millstone ruff, and white cap. In her left hand she holds a small prayer book and with her right she points to a small Crucifix on a table. Beneath the Crucifix is a coat of arms with a red rose on a white field and three white bones on a dark-blue field.

Although the coat of arms has not been identified, the sitter is probably a Beguine, a member of one of a number of religious communities of laywomen in the Netherlands who, unlike nuns, were not under vows. The painting was sold as a Frans Hals (1581/85–1666) in 1900 and later that year attributed in the Williams L. Elkins Collection catalogue to Jan de Bray (c. 1626/27–1697); however, it has little to do with either of these artists' works. The attribution to Hals was surely nothing more than optimistic guesswork, while the assignment to Jan de Bray probably was suggested by the work's similarity in design to *Portrait of a Seated Woman with a Crucifix* (probably also a Beguine), dated 1668, which was then in the well-known collection of Maurice Kann, Paris.[1] The Haarlem painter Jan de Bray was only eight years old in 1635, the year that appears on the Philadelphia work; obviously, he could not have been its author. Other earlier artists active in Haarlem, where such religious orders were common, and, more rarely, in Amsterdam (for example, Hendrick Gerritsz. Pot, Pieter Codde, and Jan Olis) painted Beguines in similar poses, but none employed a style as broad and coarse as the technique witnessed here.

NOTE
1. Oil on panel, 22 x 13¾″ (56 x 35 cm.), sale, Maurice Kann, Paris, June 1911, lot 4, repro.

PROVENANCE: Sale, Museum Baron van den Bogaerde of Kasteel Heeswijk, F. Muller, Amsterdam, June 19, 1900, lot 26 [as Frans Hals]; William L. Elkins Collection, Philadelphia.

LITERATURE: Elkins 1887–1900, vol. 2, no. 80, repro. [as Jan de Bray].

CONDITION: The vertically grained panel support is cradled and has three open vertical cracks, two from the top edge and one from the bottom edge, which do not run the full length of the panel but which severely disrupt the surface plane. In addition to losses along the cracks, there is some general abrasion of the paint film. The varnish is dull and discolored.

141, UNKNOWN EIGHTEENTH-
142 CENTURY DUTCH OR FLEMISH
 ARTIST

PAIR OF FLOWER STILL LIFES
Oil on canvas, 29 x 38¾" (73.7 x 98.4 cm.), each
The Bloomfield Moore Collection. 83-120, 121

PROVENANCE: The Bloomfield Moore
Collection.

CONDITION: The paintings are lined with
aqueous adhesive. The tacking edges are
missing. They have extensive flake loss,
discolored overpaints, and slightly discolored
varnish.

143 UNKNOWN SEVENTEENTH- *PORTRAIT OF A LADY,* c. 1630–35
 CENTURY DUTCH OR Oil on canvas, 78½ x 46½″ (199.4 x 118.1 cm.)
 FLEMISH ARTIST Purchased for the W. P. Wilstach Collection. W99-1-2

The subject is a full-length portrait of a woman dressed in black with collar and cuffs of white lace. White rosettes adorn each arm and her waist. Her left hand catches her skirt and her right holds a white feather fan. Her hair is short, crimped at each side of the head, and cut in bangs across the forehead. She wears a pearl necklace and bracelets, jeweled rings, earrings, and a large brooch. Behind hangs a brown satin curtain.

When this painting was sold at the Blakeslee sale in New York in 1899, it was identified as a portrait of "Princess Palatine" by "Pietre [*sic*] Codde."

In the 1922 Wilstach Collection catalogue the attribution was demoted to Flemish school and the sitter's identity listed only tentatively, a practice that was followed in the 1965 Museum *Check List of Paintings*. The old attribution to Pieter Codde (1599–1678), an artist known almost exclusively as a genre painter,[1] seems so improbable that it is possibly based on additional support and, ironically, therefore worth analyzing. The attribution may have been inspired only by the sitter's superficial resemblance in costume and hairstyle to the much tinier figures in Codde's genre scenes of about 1630, but it also could acknowledge the fact that Codde painted at least two life-size, full-length group portraits, the so-called *Meager Company* begun by Frans Hals (1581/85–1666) in 1633 and completed by Codde in 1637 and a large *Family Portrait,* signed and dated 1643.[2] At the end of the nineteenth century, when the Philadelphia painting carried the attribution to Codde, the discovery of that painter's authorship of the right-hand side of Hals's painting was relatively recent news.[3] Vincent van Gogh (q.v.) even commented on it in a letter to his brother Theo of October 1885.[4] While the attribution would have been a novel one for the cataloguer of the Blakeslee sale in New York in 1899, it could more conceivably have been the inspiration of the previous owner, the "Comte Davillier," who was probably Baron Jean Charles Davillier (1823–1883), the author of art-historical studies on Velázquez and Mariano Fortuny. Despite the fact that the *Meager Company* proves that Codde was capable of chameleonlike changes of style, his authorship of the Philadelphia painting seems very unlikely. The imposing full-length image is painted in a fastidious manner and adopts the conventions associated with official state portraiture before the impact of Anthony van Dyck's more graceful art. The leading practitioners in the Netherlands of this rather stiffly formal portraiture style were Jan Anthonisz. van Ravesteyn (c. 1572–1657), Michiel Jansz. van Miereveld (1567–1641), and Daniel Mijtens (c. 1590–1647). Women's portraits attributed to Nicolaes Eliasz. Pickenoy (1588–1650/56) and by the Leeuwaarden portraitist Wybrand de Geest (1592–c. 1661) most closely resemble the Philadelphia painting in conception and style, and support the possibility that the subject had a pendant (presumably depicting her husband), but a certain attribution is not possible.[5]

Equally uncertain is the identity of the subject, formerly thought to be Elizabeth, queen of Bohemia. The sitter's earliest recorded identification as the "Princess Palatine" refers to Elizabeth (1596–1662), daughter of the Stuart king James I and wife of Frederick V, the Elector Palatine and leader of the Protestants in Germany. Frederick's assumption of the crown of Bohemia in 1619 initiated the Thirty Years' War. When his armies were routed in Prague the following winter, he and Elizabeth sought refuge in The Hague, where they were known at court as the "Winter King and Queen." Several portraits of Elizabeth are known, including a full-length image by Daniel Mijtens (fig. 143-1);[6] a half-length oval portrait by Gerard van Honthorst (1590–1656; J. L. Henkes sale, Breda [P. Brandt], May 12 and 13, 1964, lot 22); a miniature portrait attributed to Alexander Cooper (c. 1605–1660; Rijksmuseum, Amsterdam, no. A4304); and a sculpted bust dated 1641 and attributed to François Dieussort (active 1646–56; Victoria and Albert Museum, London).[7] Even allowing for the altered hairstyle, the woman in the Philadelphia painting appears to be a different sitter; however, the various images of Elizabeth differ markedly from one another in

FIG. 143-1 Daniel Mijtens, *Elizabeth, Queen of Bohemia,* c. 1626–27, oil on canvas, 77¼ x 45" (196.2 x 114.3 cm.), Collection of Her Majesty Queen Elizabeth II.

appearance. The sitter's costume in the Philadelphia painting is datable to about 1630–35. If she were Elizabeth, an unlikely possibility, this would indicate that the work was probably painted in The Hague.

The symbol of a rampant unicorn or dragon surmounted by a crown that appears in two places on the back of the stretcher may eventually assist in the identification of the sitter.

NOTES

1. On Pieter Codde, see Caroline Bigler Playter, "Willem Duyster and Pieter Codde: The 'Duystere Werelt' of Dutch Genre Painting, c. 1625–1635," diss., Harvard University, 1972; and Sutton et al. 1984, pp. 174–79.

2. The painting's full title is *The Company of Captain Reynier Reael and Lieutenant Cornelis Michielsz. Blaeuw, Amsterdam* (oil on canvas, 82¼ x 168⅞" [209 x 429 cm.], Rijksmuseum, Amsterdam, no. C374). It was commissioned in 1633 but still not completed in 1636, when Hals was enjoined by legal writ to travel to Amsterdam from Haarlem to finish the work. Evidently he never complied and Codde completed the picture the following year. See Seymour Slive, *Frans Hals,* vol. 3 (London and New York, 1974), cat. no. 80. *Family Portrait,* signed and dated 1643, oil on canvas, 52¼ x 75½" (133 x 192 cm.), Gemäldegalerie, Dresden, no. 3489.

3. See P. Scheltema, "De Schilderijen in de Drie Doelens te Amsterdam, beschreven door G. Schaep, 1653," *Aemstels Oudheid,* vol. 7 (1885), pp. 121–25.

4. *The Complete Letters of Vincent Van Gogh,* 2nd ed., translated by Johanna van Gogh-Bonger and C. de Drood, vol. 2 (Greenwich, Conn., 1959), p. 416.

5. Compare the *Portrait of Catarina Hooft,* attributed to Nicolaes Eliasz. Pickenoy, oil on canvas, 191 x 159" (485.5 x 405 cm.), Gemäldegalerie, Staatliche Museum, Berlin (East), cat. no. 753B, and Wybrand de Geest's *Portrait of Sophia van Vervou,* 1632, oil on canvas, 78¾ x 49½" (200 x 126 cm.), Van Harinxmathoe Slooten Stichting, the Netherlands, both of which have pendants; repros. respectively, in Frans Halsmuseum, Haarlem, *Portretten van echt en trouw,* February 15–April 13, 1986, figs. 23b and 24. On Wybrand de Geest, see Lyckle de Vries, *Wybrand de Geest, 'de Friessche adelaar,' portretschilder in Leeuwaarden, 1592–c. 1661* (Leeuwaarden, 1982).

6. See Oliver Millar, *The Tudor, Stuart, and Early Georgian Pictures in the Collection of Her Majesty the Queen* (London, 1963), no. 121, fig. 49; and O. ter Kuile, "Daniel Mijtens, 'His Majesties Picture-Drawer,'" *Nederlands Kunsthistorisch Jaarboek,* vol. 20 (1969), p. 65, no. 43, fig. 29.

7. The last three are illustrated and discussed by C. J. de Bruijn Kops, "Een aan Alexander Cooper toegeschreven portretje van Elizabeth van Bohemen," *Bulletin van het Rijksmuseum,* vol. 19, no. 1 (1971), pp. 3–6, respectively figs. 4, 1, and 5.

PROVENANCE: "Comte Davillier" (probably Baron Jean Charles Davillier); T. J. Blakeslee sale, American Art Association, New York, April 13 and 14, 1899, lot 68 [as Pieter Codde, "'Portrait of Princess Palatine' from the collection of Comte Davillier"]; The W. P. Wilstach Collection, Philadelphia, by 1900.

LITERATURE: Wilstach 1900, no. 34, repro. [as Pieter Codde, "Princess Palatine," and hereafter], 1902, no. 37, repro., 1903, no. 42, repro., 1906, no. 62, repro., 1910, no. 83, 1913, no. 86, 1922, no. 117 [as Flemish school, "'Portrait of a Lady' formerly entitled 'The Princess Palatine'"]; PMA 1965, p. 26 [as seventeenth-century Flemish artist].

CONDITION: The canvas has an aqueous lining. The tacking edges are missing. The paint film reveals losses along the wax-infused edges. The impasto and brushwork were flattened and impressed in an earlier lining. There are damages and discolored repaints in the dress and in the background to the left of the curtain. To the extent that the paint film is visible through the deeply discolored varnish, abrasion appears limited. The varnish was selectively reduced in the face, collar, and proper left cuff. Burned into the back of the stretcher in two places is a symbol of a rampant unicorn or dragon surmounted by a crown.

144 UNKNOWN SEVENTEENTH-
CENTURY FLEMISH ARTIST

PORTRAIT OF A WOMAN
Oil on canvas, 32 x 24¼″ (81.3 x 61.6 cm.)
Bequest of Arthur H. Lea. F38-1-8

The sitter is viewed to the waist and turned slightly to the viewer's left. She wears a broad millstone ruff, gold stomacher, red- and black-embroidered gown, and pearl necklace and earrings. Formerly assigned to Justus Sustermans (1597–1681), the portrait is too weak to support the attribution. It appears to be a copy of an unknown Flemish work of about 1625.

PROVENANCE: Arthur H. Lea.

CONDITION: The unlined canvas support has numerous bulges and an L-shaped tear in the upper-right corner. The paint film is flaking along the right edge and shows extensive overall abrasion. An extremely uneven, thick, discolored varnish layer obscures the surface.

145 UNKNOWN SEVENTEENTH-
CENTURY FLEMISH ARTIST

CRUCIFIXION, WITH A BISHOP SAINT AND A DONOR IN ARMOR, c. 1630
Oil on panel, 13 x 9″ (33 x 23 cm.)
Purchased for the W. P. Wilstach Collection. W02-1-08

At the foot of the central cross kneel a bishop on the left and a knight on
the right, their respective miter and helmet resting on the ground before
them. The bishop wears a gold and red garment over a black robe and the
knight is in silver-colored armor with a red sash. Behind on the left is the
centurion with the lance on horseback, and on the right are two additional
figures, one with a turban, also on horses. Two putti hover above on each
side of the cross. One putto assumes an attitude of prayer, while the other
catches Christ's blood in a chalice. In the sky above the cross God the

FIG. 145-1 Peter Paul Rubens, *Coup de Lance,* 1620, oil on canvas, 169 x 122½" (429 x 311 cm.), Koninklijk Museum voor Schone Kunsten, Antwerp, no. 297.

Father appears, holding an orb. The entire scene is enclosed by a painted gray frame that presumably was designed to imitate an architectural portal. The background is sketchily painted in bluish green.

This oil sketch has previously been catalogued as a work by Anthony van Dyck (1599–1641) dating from about 1628–30. During the years following his return from Italy to Antwerp, Van Dyck was commissioned to paint a number of large altarpieces in the southern Netherlands, of which no fewer than five represent the Crucifixion. These five works of the so-called second Antwerp period, located in Lille, Antwerp, Mechlin, Dendermonde, and Ghent,[1] form a group in which motifs and figural attitudes recur.[2] In addition, individual works in the group recall a *Coup de Lance* (fig. 145-1) by Peter Paul Rubens (q.v.).

The present work is not a historical narrative illustrating a moment in the Crucifixion like the Van Dyck paintings in Lille, Mechlin, and Ghent, or Rubens's *Coup de Lance* but a mystical Crucifixion like Van Dyck's altarpieces in Antwerp and Dendermonde, which include witnesses not present at Golgotha. Although the unidentified bishop and knight kneeling in the foreground as well as the specific composition do not appear elsewhere in the art of Van Dyck or Rubens, the pose of Christ resembles a group of drawings by Rubens and his circle relating to the figure of Christ in the *Coup de Lance.*[3]

Though not by an identifiable hand, this freshly executed little oil sketch is by a Flemish seventeenth-century master probably working about 1630. Supporting the connection with this circle, the panel bears the mark MV (in ligature) of Michiel Vriendt (active 1615–36/37), one of Rubens's panelmakers.[4]

NOTES

1. The five altarpieces are in the Palais des Beaux-Arts, Lille (Gustav Glück, ed., *Klassiker der Kunst,* 2nd ed., vol. 13, *Van Dyck, Des Meisters Gemälde* (Stuttgart and Berlin, 1931], no. 224); Koninklijk Museum voor Schone Kunsten, Antwerp, 1629 (Glück no. 236); St. Rombout's Church, Mechlin (Glück no. 240); Onze-Lieve-Vrouwkerk, Dendermonde (Glück no. 242); and St. Michael's Church, Ghent, 1630 (Glück no. 247). In addition there is a small group of preparatory studies, mentioned and illustrated in the literature cited in note 2.
2. For discussion of this series, see Horst Vey, "Een belangrijke toevoeging aan de verzameling van Dyck tekeningen," *Bulletin Museum Boymans–van Beuningen* (Rotterdam), vol. 10 (1959), pp. 2–22; John Rupert Martin and Gail Feigenbaum, *Van Dyck as Religious Artist* (Princeton, N.J., 1979), pp. 148–61. Vey (n. 53) also mentions a lost Crucifixion that was in the Peter Lely sale of 1682, which may be the work reproduced by Wenzel Hollar in an engraving of 1652 (see Gustav Parthey, *Wenzel Hollar: Beschreibendes Verzeichniss seiner Kupferstiche* [Berlin, 1853], no. 107). In this composition two of the angels catch the blood of Christ.
3. See, for example, Otto Benesch, "Ein Skizzenbuchfragment von Van Dyck," *Belvedere,* vol. 5 (1924), pp. 6–7, with repro. See also Vey (note 2), p. 20, fig. 9. The pose appears (in reverse) in Van Dyck's paintings in Mechlin and Lille (see note 1).
4. G. Gepts, "Tafereelmaker Michiel Vriendt, leverancier van Rubens," *Jaarboek Koninklijk Museum voor Schone Kunsten* (Antwerp, 1954–60), pp. 83–87.

PROVENANCE: Purchased from dealer Dowdeswell, London, for the W. P. Wilstach Collection, Philadelphia, September 27, 1902.

LITERATURE: Wilstach 1903, no. 69 [as Van Dyck, and hereafter], 1904, no. 97, 1906, no. 103, repro., 1907, no. 106, repro., 1910, no. 134, 1913, no. 139, 1922, no. 106, repro. [as c. 1628–30]; Eric Larsen, *Anthony van Dyck* (Milan, 1980), vol. 2, p. 129, no. A32 [as studio of Van Dyck].

CONDITION: The panel support, which has a vertical grain, is arched at the top, unbeveled, uncradled, and generally planar. An old split in the center runs vertically the length of the panel. Black underdrawing on the light-colored ground is visible through thin areas of paint. The paint film is in good condition; some retouches are found in the black robe of the bishop, along a vertical crack in the center of the painting, in Christ's face, and scattered throughout the background. The varnish is dull and moderately discolored.

146 UNKNOWN SEVENTEENTH-
CENTURY FLEMISH ARTIST

*GROUP PORTRAIT OF THE DEACONS OF THE CONFRATERNITY OF THE
HOLY SACRAMENT, 1673*
Inscribed and dated: *1673*
Oil on canvas, 71½ x 80¼" (181.6 x 203.8 cm.)
The W. P. Wilstach Collection. W04-1-52

Nine men, four on the left and five on the right, kneel or stand to each side
of a vision of a monstrance containing the host. Immediately beneath it is
the inscription: "LOF SŸ T HEŸLICH, SACRAMENT" (Praise be to the holy
sacrament) and below that, a four-line verse in Dutch on parchment:

Neither wine, nor Ipocras, nor the grain of wheat and barley—
Is our God in the Last Supper, but bread (transformed through the
Word),
Becomes flesh, wine becomes blood: there it remains, nothing else—
than God, whose flesh, and blood is given us daily.[1]

In the lower center a key to the identities of the deacons in the front
row is provided:

Dekens

(1) Peeter Willemans
[left of center]

(2) Carel Verhuÿck
[right of center]

(3) İōan de Haegh
[far left]

(4) Cornelis Peeters
[far right]

All of the sitters are dressed in black with embroidered white-lace
collars, a costume indigenous to the Lowlands in 1673, the date on the
picture. Each man holds a prayer book, a rosary, or, in the case of Peeter

FIG. 146-1 Pieter van der Plaes, *Syndics of a Brussels Corporation Kneeling before the Virgin and Child,* dated 1647, oil on panel, 78¾ x 112¼" (200 x 285 cm.), Musée Royal des Beaux-Arts, Brussels, no. 355.

FIG. 146-2 Unknown Flemish artist, *Holy Confirmation with Sponsors,* c. 1640, oil on canvas, 41⅝" x 33⅞" (105.7 x 86 cm.), Elvehjem Museum of Art, University of Wisconsin, Madison.

Willemans, a quill pen. The attendant standing at the upper right holds a scepter with a silver scissors in the center and wears a breastplate made of circular medallions, in all likelihood symbols of a tailors' or cloth cutters' guild.

The highly formalized arrangement of the sitters, kneeling piously on each side of a religious image, was a traditional design in ecclesiastical, governmental, and corporate portraiture. It was employed earlier in the century, for example, in portraits of the provost-marshal and aldermen of Paris in which the municipal officials kneel beside an altar or altarpiece depicting religious scenes or a Crucifix.[2] In a large portrait, dated 1647, by the Flemish painter Pieter van der Plaes (c. 1595–1661?) the members of an unidentified Brussels guild or confraternity kneel to each side of a vision of the Madonna and Child enthroned (fig. 146-1). A monstrance or other holy object evidently could be substituted for the central religious scene in these designs; although of different theological content than that of the Philadelphia group portrait, an anonymous Flemish portrait of *A Holy Confirmation with Sponsors,* c. 1640, in the Elvehjem Museum of Art at the University of Wisconsin (fig. 146-2) portrays the young confirmants kneeling on each side of an altarpiece with a prominent monstrance.

Despite the fact that the members' names are known, the seat of the guild whose members are depicted here has not been discovered. Inquiries made to the archives in Brussels and Antwerp suggest that the guild probably was situated in some other Flemish town.[3] Also unknown is the author of the work. In all catalogues of the Wilstach Collection, the painting has been attributed to Lodewyck van der Helst (q.v.), the son and pupil of the famous Amsterdam portraitist Bartholomeus van der Helst (1613–1670). However, the painting's technique bears little resemblance to Lodewyck's manner and still less to his father's fluid style. Further, even during the period of 1672 and 1673—the famous *Rampjaar*—when French troops invaded the Netherlands, it would have been unusual for a Dutch artist to paint a large Catholic group portrait of this type. It seems virtually certain, therefore, that the work is by a Flemish hand.

NOTES
1. "Geen wiin, oft Ipocras, noch Terwe · graen en Liet—/ons Goodt int Avontmael, maer 't Broot (Door 't Woort) herdreven,/Wordt Vleesch, de Wiin Wordt Bloet: daer en Bleef anders niet—/als Godt, wiens Vleesch, en Bloet ons daeghlijckx Wordt Ge · geven."
2. See Georges Lallemand, *The Provost-Marshal and the Aldermen of the City of Paris,* 1611, and the anonymous French portrait of the same subject dated three years later, both in the Musée Carnavalet, Paris; see Anthony Blunt, *Nicolas Poussin,* 2 vols. (Washington, D.C., 1958), vol. 1, p. 18, figs. 12 and 13. The former depicts the Virgin with saints and angels and the latter depicts an Adoration of the Magi in the central altarpiece. In Philippe de Champagne's portrait of the same officials dated 1648 (Musée du Louvre, Paris, inv. no. M.I. 911) the altar supports a Crucifix.
3. I am grateful to H. Coenen of the Institut Royal du Patrimoine Artistique, Brussels, and Nora de Poorter of the Rubenianum in Antwerp for their efforts both to situate and to attribute the painting.

PROVENANCE: John G. Johnson, Philadelphia; gift of John G. Johnson to the W. P. Wilstach Collection, Philadelphia, June 14, 1904.

LITERATURE: Wilstach 1904, no. 124 [as Lodewyck van der Helst, and hereafter], 1906, no. 136, 1907, no. 144, 1910, no. 190, 1913, no. 199, 1922, no. 150; PMA 1965, p. 32.

CONDITION: The canvas support is composed of two pieces stitched vertically at the center. The painting was strip-lined. The original tacking edges are intact but were wrapped farther around the stretcher in remounting, cropping the composition slightly. Discolored inpaint covers numerous small losses; there is extensive abrasion in the faces and hands of the figures. The varnish is dull, uneven, and deeply discolored.

147 UNKNOWN LATE FIFTEENTH- *SAINTS EUSTACE, GEORGE, CHRISTOPHER, AND ACACIUS*
 OR EARLY SIXTEENTH-CENTURY Oil on panel, 27 x 14½ (68.6 x 36.8 cm.)
 GERMAN OR SWISS ARTIST Bequest of Carl Otto Kretzschmar von Kienbusch. 1977-167-1040

Four martyred saints stand in a shallow space with a decorative gold
background. On the left, Saint Eustace, wearing a turban and elaborate
jeweled robes, is identified by his attribute, the head of the stag that
miraculously appeared to him with a Crucifix between its antlers. To the
right, and in the center of the composition, Saint George slays the dragon
with his lance. Behind, the Christ child sits on the shoulders of Saint
Christopher, who holds his staff. At the right, Saint Acacius appears in

FIG. 146-1 Pieter van der Plaes, *Syndics of a Brussels Corporation Kneeling before the Virgin and Child,* dated 1647, oil on panel, 78¾ x 112¼" (200 x 285 cm.), Musée Royal des Beaux-Arts, Brussels, no. 355.

FIG. 146-2 Unknown Flemish artist, *Holy Confirmation with Sponsors,* c. 1640, oil on canvas, 41⅝" x 33⅞" (105.7 x 86 cm.), Elvehjem Museum of Art, University of Wisconsin, Madison.

Willemans, a quill pen. The attendant standing at the upper right holds a scepter with a silver scissors in the center and wears a breastplate made of circular medallions, in all likelihood symbols of a tailors' or cloth cutters' guild.

The highly formalized arrangement of the sitters, kneeling piously on each side of a religious image, was a traditional design in ecclesiastical, governmental, and corporate portraiture. It was employed earlier in the century, for example, in portraits of the provost-marshal and aldermen of Paris in which the municipal officials kneel beside an altar or altarpiece depicting religious scenes or a Crucifix.[2] In a large portrait, dated 1647, by the Flemish painter Pieter van der Plaes (c. 1595–1661?) the members of an unidentified Brussels guild or confraternity kneel to each side of a vision of the Madonna and Child enthroned (fig. 146-1). A monstrance or other holy object evidently could be substituted for the central religious scene in these designs; although of different theological content than that of the Philadelphia group portrait, an anonymous Flemish portrait of *A Holy Confirmation with Sponsors,* c. 1640, in the Elvehjem Museum of Art at the University of Wisconsin (fig. 146-2) portrays the young confirmants kneeling on each side of an altarpiece with a prominent monstrance.

Despite the fact that the members' names are known, the seat of the guild whose members are depicted here has not been discovered. Inquiries made to the archives in Brussels and Antwerp suggest that the guild probably was situated in some other Flemish town.[3] Also unknown is the author of the work. In all catalogues of the Wilstach Collection, the painting has been attributed to Lodewyck van der Helst (q.v.), the son and pupil of the famous Amsterdam portraitist Bartholomeus van der Helst (1613–1670). However, the painting's technique bears little resemblance to Lodewyck's manner and still less to his father's fluid style. Further, even during the period of 1672 and 1673—the famous *Rampjaar*—when French troops invaded the Netherlands, it would have been unusual for a Dutch artist to paint a large Catholic group portrait of this type. It seems virtually certain, therefore, that the work is by a Flemish hand.

NOTES
1. "Geen wiin, oft Ipocras, noch Terwe · graen en Liet—/ons Goodt int Avontmael, maer 't Broot (Door 't Woort) herdreven,/Wordt Vleesch, de Wiin Wordt Bloet: daer en Bleef anders niet—/als Godt, wiens Vleesch, en Bloet ons daeghlijckx Wordt Ge · geven."
2. See Georges Lallemand, *The Provost-Marshal and the Aldermen of the City of Paris,* 1611, and the anonymous French portrait of the same subject dated three years later, both in the Musée Carnavalet, Paris; see Anthony Blunt, *Nicolas Poussin,* 2 vols. (Washington, D.C., 1958), vol. 1, p. 18, figs. 12 and 13. The former depicts the Virgin with saints and angels and the latter depicts an Adoration of the Magi in the central altarpiece. In Philippe de Champagne's portrait of the same officials dated 1648 (Musée du Louvre, Paris, inv. no. M.I. 911) the altar supports a Crucifix.
3. I am grateful to H. Coenen of the Institut Royal du Patrimoine Artistique, Brussels, and Nora de Poorter of the Rubenianum in Antwerp for their efforts both to situate and to attribute the painting.

PROVENANCE: John G. Johnson, Philadelphia; gift of John G. Johnson to the W. P. Wilstach Collection, Philadelphia, June 14, 1904.

LITERATURE: Wilstach 1904, no. 124 [as Lodewyck van der Helst, and hereafter], 1906, no. 136, 1907, no. 144, 1910, no. 190, 1913, no. 199, 1922, no. 150; PMA 1965, p. 32.

CONDITION: The canvas support is composed of two pieces stitched vertically at the center. The painting was strip-lined. The original tacking edges are intact but were wrapped farther around the stretcher in remounting, cropping the composition slightly. Discolored inpaint covers numerous small losses; there is extensive abrasion in the faces and hands of the figures. The varnish is dull, uneven, and deeply discolored.

147 UNKNOWN LATE FIFTEENTH-
OR EARLY SIXTEENTH-CENTURY
GERMAN OR SWISS ARTIST

SAINTS EUSTACE, GEORGE, CHRISTOPHER, AND ACACIUS
Oil on panel, 27 x 14½ (68.6 x 36.8 cm.)
Bequest of Carl Otto Kretzschmar von Kienbusch. 1977-167-1040

Four martyred saints stand in a shallow space with a decorative gold
background. On the left, Saint Eustace, wearing a turban and elaborate
jeweled robes, is identified by his attribute, the head of the stag that
miraculously appeared to him with a Crucifix between its antlers. To the
right, and in the center of the composition, Saint George slays the dragon
with his lance. Behind, the Christ child sits on the shoulders of Saint
Christopher, who holds his staff. At the right, Saint Acacius appears in

jeweled hat and patrician's robes, holding a sword and the thorn branch that are the attributes of his martyrdom. One of ten thousand mythical martyrs said to have been killed on Mount Ararat by a pagan army, Saint Acacius asked God just before their death that whoever would venerate their memory would enjoy health of mind and body.[1]

Wrongly identified as an image of Saint Michael and other saints when sold in New York in 1952, this panel is probably part of a larger altarpiece depicting the Fourteen Holy Helpers (also known as the Fourteen Auxiliary Saints, or, in German, "Vierzehn Nothelfer"), a group of saints who enjoyed a collective cult in the Rhineland from the fourteenth century onward. From Regensburg and Bamberg, this devotion spread throughout Germany and parts of Switzerland, Hungary, and Sweden, reaching its apogee in the later fifteenth century. In the following century, it was attacked by reformers and discouraged by the Council of Trent. The group of fourteen saints varied somewhat in composition from place to place, but in addition to the four saints depicted in this painting, their number usually included saints Barbara, Blaise, Catharine of Alexandria, Cyriacus, Denys, Erasmus, Giles, Margaret of Antioch, Pantaleon, and Vitus. Sometimes substituted were saints Anthony, Leonard, Nicolaes, Sebastian, or Roch. The principle of their selection was their efficacy in the intercession against disease, especially at the hour of death.[2] Depictions of the Fourteen Holy Helpers were regularly produced in Germany and Switzerland from the thirteenth to the sixteenth century.

NOTES

1. See Joseph Braun, *Tracht und Attribute der Heiligen in der Deutschen Kunst* (Stuttgart, 1943), pp. 18–23.
2. See Louis Réau, *Iconographie de l'Art Chrétien*, vol. 3, pt. 2 (Paris, 1958), pp. 680–83; *Lexikon der christlichen Ikonographie*, vol. 8, *Ikonographie der Heiligen* (Rome, Basel, and Vienna, 1976), pp. 546–50; David Hugh Farmer, *The Oxford Dictionary of Saints* (Oxford, 1979), p. 156.

PROVENANCE: Capt. Harold Paikin sale, Parke-Bernet, New York, January 23, 1952, lot 95, to Kienbusch; Carl Otto Kretzschmar von Kienbusch, New York.

CONDITION: The panel support has a vertically oriented grain. It is worm-tunneled, thinned to ⅛" (0.3 cm.) thickness, and mounted on a complex wooden panel structure. This auxiliary support is composed of a four-membered lap-joined strainer fit with an inner panel, composed of four boards oriented horizontally with tongue and groove joins. The painting exhibits long vertical cracks: one extends the full length of the panel through the center, and shorter cracks begin at the top and bottom edges. The paint film has numerous losses. One large fill located at the bottom, left of center, is retouched. Retouches are especially evident in the bottom half, the top center, and along the edges. Abrasion is general in both painted and gilded areas. The varnish is very uneven and deeply discolored.

148 UNKNOWN EIGHTEENTH-
 CENTURY GERMAN ARTIST

PORTRAIT OF A TWENTY-ONE-YEAR-OLD WOMAN, 1721
Inscribed and dated upper right: *1721*
Oil on canvas, 31½ x 25¼" (80 x 64.1 cm.)
Bequest of Mrs. John Harrison. 21-39-48

A young woman, in elaborate local costume, is viewed frontally, half-length,
and with her hands clasped before her. A red curtain is drawn back in the
upper corners. She wears a starched lace cap with flared and ruffled sides
low over her forehead and embroidered-lace cuffs and collar. She holds a
small bouquet of flowers.

The sitter's age and the date of the painting are indicated by an
inscription at the upper right: "AET.21, 1721." Beneath the inscription is an
unidentified coat of arms decorated with an eagle before two trees on a
gold ground surmounted by a helmet and a second eagle's head. The sitter
may be related to the woman depicted in the similarly provincial work
catalogued following (no. 149), but the hand is not necessarily the same,
nor are the canvases likely to be pendants. Their measurements differ and
they are separated in time of execution by twenty-four years.

PROVENANCE: Mrs. John Harrison.

LITERATURE: PMA 1965, p. 27 [as a German
eighteenth-century artist].

CONDITION: The painting is lined with
fabric and an aqueous adhesive. The original
tacking edges are missing. There is evidence
of old flake losses and horizontal stress cracks.
Traction crackle is prominent through the
lower half of the painting. The varnish is dull
and discolored.

149 UNKNOWN EIGHTEENTH-
 CENTURY GERMAN ARTIST

PORTRAIT OF A SEVENTY-ONE-YEAR-OLD WOMAN, 1745
Inscribed and dated upper right: *1745*
Oil on canvas, 33¼ x 26″ (84.4 x 66 cm.)
Bequest of Mrs. John Harrison. 21-39-49

A half-length portrait with an oval composition but on a rectangular format
depicts an elderly woman in elaborate native costume. She wears a black
dress with lace collar and starched white cap and cuffs. In her right hand
she cradles a prayer book.

 The sitter's initials, age, and the date of the painting are indicated by a
Latin inscription in the upper right: "M.W.M./AETATIS.LXXI/MDCCXLV."
The painter's provincial, but strongly individualized hand has not been
identified. The sitter may be related to the young woman depicted in the
preceding painting (no. 148).

PROVENANCE: Mrs. John Harrison.

LITERATURE: PMA 1965, p. 27 [as a German
eighteenth-century artist].

CONDITION: The painting is lined with
fabric and an aqueous adhesive and remains
planar. The original tacking edges are
missing. The paint film has been somewhat
flattened through lining and reveals
prominent age and traction crackle with
associated cupping. Moderate abrasion is
evident in the flesh tones. The varnish is
discolored and extremely dull.

150 UNKNOWN SWEDISH ARTIST?

PORTRAIT OF A QUEEN?, c. 1600
Oil on canvas, 73¼ x 42¼″ (186 x 107.3 cm.)
The Bloomfield Moore Collection. 83-136

The subject is viewed full-length and turned slightly to the viewer's left. She
wears a broad ruff; a long gown with embroidered motifs of flowers, birds,
and animals; and pearls and jewels. In her left hand she holds a fan. Her
right hand rests beside a jeweled crown on a covered table. At the right a
curtain is drawn back and on the left an open window offers a view of the
harbor of a walled city with crenelated battlements.

The sitter is unidentified and the traditional assignment to a Swedish
artist uncertain. The unattributed suggestion (recorded in the Museum
accession files) that the woman might be Queen Christina of Sweden
(reigned 1644–54) is inconsistent with the earlier date (c. 1600) of the sitter's
costume. The painting is related to the following work (no. 151), which is
painted in a comparable, provincial manner on the same format.

PROVENANCE: The Bloomfield Moore
Collection.

CONDITION: The fabric support has an
aqueous lining. The tacking edges are
missing. The painting is slack with corner
draws. The paint film is cracked, with
associated cupping and active cleavage.
Scattered losses are retouched and discolored.
The varnish is dull and discolored.

151 UNKNOWN SWEDISH ARTIST?

PORTRAIT OF A QUEEN?, c. 1600
Oil on canvas, 73¼ x 42¼″ (186 x 107.3 cm.)
The Bloomfield Moore Collection. 83-137

Viewed full-length and turned slightly to the viewer's left, the subject wears a long embroidered gown, broad ruff, pearls, and jewels. Beneath a curtain on the left a jeweled crown rests on a covered table.

The sitter is unidentified and the traditional attribution to a Swedish artist uncertain. The costume is datable to the later sixteenth or early seventeenth century. The schematic handling suggests the work of a provincial artist or possibly a copyist working from a prototype. Compare the preceding painting (no. 150).

PROVENANCE: The Bloomfield Moore Collection.

CONDITION: The painting has an aqueous lining. The tacking edges are missing. There is a draw in the upper-right corner. The paint film is cracked, with associated cupping and active cleavage. Old losses are scattered throughout; some are retouched. The retouches are discolored. The varnish is dull and deeply discolored.

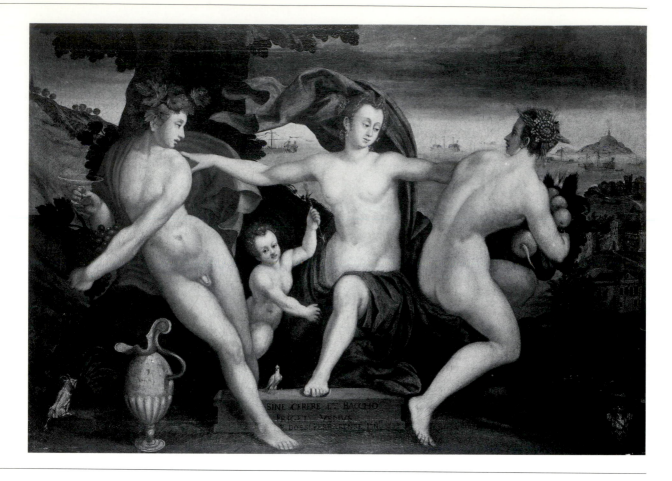

152 UNKNOWN NORTHERN EUROPEAN
ARTIST AFTER GILLIS COIGNET

WITHOUT CERES AND BACCHUS, VENUS GROWS COLD
Inscribed lower center: *SINE CERERE ET BACCHO FRIGET VENUS*
　　　B. DOSSI FERRARENSE PIN. 1553
Oil on canvas, 24¾ x 36⅛" (62.9 x 91.8 cm.)
Purchased for the W. P. Wilstach Collection. W04-1-10

Depicted nude and seated in a landscape, Venus extends her arms toward
the nude figures of Bacchus on the left and Ceres on the right. Cupid sits at
her side holding an arrow. In the lower left is a vase. Tiny animals, probably
attributes of their respective gods, appear beneath Bacchus (a goat), Venus
and Cupid (a dove), and Ceres (an ox or cow?). On the right are
romanesque buildings and battlements, while in the distance large sailing
and rowing boats ply the sea. In the lower right is an unidentified coat of
arms.

When the picture was acquired in 1904 and catalogued in 1910 and 1913
it was assigned to "B[attista] Dossi" on the basis of the inscription in the
lower center. However, Battista's death in 1548 is inconsistent with the date
of 1553 in the inscription. In 1922 the painting was reassigned to an unknown
Flemish artist and its style related to "that of the Pourbus family a
generation before Rubens."[1] The picture was not recorded in the 1965
Museum *Check List of Paintings.*

The composition is copied from a print by Raphael Sadeler (1560–1632)
after Gillis Coignet (1538–1599; see fig. 152-1) that was executed for Emperor
Rudolf II of Prague. The painting's small changes include the addition of
the tiny animals, the seascape and battlements in the distance, and the coat

FIG. 152-1 Raphael Sadeler after Gillis
Coignet, *Without Ceres and Bacchus, Venus
Grows Cold,* engraving.

FIG. 152-2 Søren Kiaer after Gillis Coignet, *Without Ceres and Bacchus, Venus Grows Cold*, oil on panel, 65⅜ x 95¼″ (166 x 242 cm.), Nationalmuseum, Stockholm, no. 385.

of arms. Another larger, painted copy of the print is in the Nationalmuseum, Stockholm (fig. 152-2) and was wrongly attributed to Michiel Jansz. van Miereveld (1567–1641) and Gillis Coignet himself before being recognized as the work of the early sixteenth-century Danish artist Søren Kiaer.[2] That painting, too, diverges from its print source in minor details (changes in the vase and the drapery), but does not include the inscription or coat of arms that are in the Philadelphia painting.

The popular theme, which was also treated at this time by, among others, the Carracci, Hendrik Goltzius, and Peter Paul Rubens (q.v.), is derived from the ancient Roman comedy *The Eunuch* by Terence.

NOTES
1. Wilstach 1922, no. 116.
2. See Görel Cavalli-Björkman, *Dutch and Flemish Paintings. I, c. 1400–c.1600, Nationalmuseum, Stockholm* (Stockholm, 1986), cat. no. 22 [as Gillis Coignet]; Steffen Heiberg, ed., *Christian IV and Europe: The 19th Art Exhibition of the Council of Europe* (Copenhagen, 1988), pp. 74, 75, repro. [as Søren Kiaer].

PROVENANCE: Purchased for the W. P. Wilstach Collection, Philadelphia, January 8, 1904.

LITERATURE: Wilstach 1910, no. 125 [as B. Dossi], 1913, no. 130 [as B. Dossi], 1922, no. 116 [as a Flemish artist].

AMSTERDAM 1976
See De Jongh et al. 1976.

AMSTERDAM, BOSTON, PHILADELPHIA 1987–88
See Sutton et al. 1987.

BLANKERT ET AL. 1980–81
Albert Blankert et al. *Gods, Saints and Heroes: Dutch Painting in the Age of Rembrandt*. Exhibition. National Gallery of Art, Washington, D.C., November 2, 1980–January 4, 1981, The Detroit Institute of Arts, February 16–April 19, 1981, Rijksmuseum, Amsterdam, May 18–July 19, 1981.

BOETTICHER (1891–1901) 1969
Friedrich von Boetticher. *Malerwerke des neunzehnten Jahrhunderts: Beitrag zur Kunstgeschichte*. 4 vols. Dresden, 1891–1901. Reprint in 2 vols. Frankfurt, 1969.

BREDIUS 1915–22
Abraham Bredius. *Künstler-Inventare: Urkunden zur Geschichte der holländischen Kunst des XVIten, XVIIten, und XVIIIten Jahrhunderts*. 8 vols. The Hague, 1915–22.

DESCAMPS 1753–64
Jean Baptiste Descamps. *La Vie des peintres flamands, allemands et hollandais*. 4 vols. Paris, 1753–64.

ELKINS 1887–1900
William L. Elkins. *Catalogue of Paintings in the Private Collection of W. L. Elkins, Montg. Co., Pa. . . . MDCCCLXXXVII–MDCCC*. 2 vols. Paris, 1900.

ELKINS 1924
Catalogue of Paintings in the Elkins Gallery. Philadelphia, 1924.

ELKINS 1925
Catalogue of Paintings in the Elkins Gallery [and] *George W. Elkins Collection: Oil Paintings and Watercolor*. Philadelphia, 1925.

DE LA FAILLE 1970
J.-B. de la Faille. *The Works of Vincent van Gogh: His Paintings and Drawings*. Amsterdam and New York, 1970.

GUDLAUGSSON 1959–60
S. J. Gudlaugsson. *Geraert ter Borch*. 2 vols. The Hague, 1959–60.

THE HAGUE, PARIS, LONDON 1983
Haags Gemeentemuseum, The Hague. *De Haagse School: Hollandse Meesters van de 19de eeuw*. August 5–October 31, 1983, Grand Palais, Paris, *L'Ecole de La Haye*, January 15–March 28, 1983, Royal Academy of Arts, London, *The Hague School*, April 16–July 10, 1983.

HOFSTEDE DE GROOT 1907–28
Cornelis Hofstede de Groot. *Beschreibendes und kritisches Verzeichnis der Werke der hervorragendsten holländischen Maler des XVII. Jahrhunderts*. 10 vols. Esslingen and Paris, 1907–28.

HOFSTEDE DE GROOT 1908–27
Cornelis Hofstede de Groot. *A Catalogue Raisonné of the Works of the Most Eminent Dutch Painters of the Seventeenth Century*. Translated by Edward G. Hawke. 8 vols. London, 1908–27.

VAN HOOGSTRATEN (1678) 1980

Samuel van Hoogstraeten [Hoogstraten]. *Inleyding tot de hooge schoole der schilderkonst: anders de zichtbaere werelt*. Rotterdam, 1678. Reprint. Soest, 1969; Ann Arbor, 1980.

HOUBRAKEN 1718–21

Arnold Houbraken. *De Groote Schouburgh der Nederlantsche Konstschilders en Schilderessen*. 3 vols. Amsterdam, 1718–21. Reprint. Maastricht, 1943–53; Amsterdam, 1976.

IMMERZEEL 1842–43

C. Immerzeel. *De levens en werken der Hollandsche en Vlaamsche kunstschilders, beeldhouwers, graveurs en bouwmeesters van het begin der vijftiende eeuw tot heden*. 3 vols. Amsterdam, 1842–43.

JANTZEN (1910) 1979

Hans Jantzen. *Das niederländische Architekturbild*. Leipzig, 1910. 2nd rev. ed. Brunswick, 1979.

DE JONGH 1967

E. de Jongh. *Zinne- en minnebeelden in de schilderkunst van de zeventiende eeuw*. Amsterdam, 1967.

DE JONGH ET AL. 1976

E. de Jongh et al. *Tot Lering en Vermaak*. Exhibition. Rijksmuseum, Amsterdam, September 16–December 5, 1976.

KRAMM 1857–64

Christiaan Kramm. *De levens en werken der Hollandsche en Vlaamsche kunstschilders, beeldhouwers, graveurs en bouwmeesters, van den vroegsten tot op onzen tijd*. 7 vols. Amsterdam, 1857–64.

VAN MANDER 1603–4

Karel van Mander. *Het Schilder-Boeck*. Haarlem, 1603–4. Reprint. Utrecht, 1969.

OBREEN (1877–90) 1976

F.D.O. Obreen, ed. *Archief voor Nederlandsche Kunstgeschiedenis*. 7 vols. Rotterdam, 1877–90. Reprint. Soest, 1976.

PHILADELPHIA, BERLIN, LONDON 1984

See Sutton et al. 1984.

PLIETZSCH 1960

Eduard Plietzsch. *Holländische und flämische Maler des 17. Jahrhunderts*. Leipzig, 1960.

PMA 1965

Philadelphia Museum of Art. *Check List of Paintings in the Philadelphia Museum of Art*. Philadelphia, 1965.

RISHEL 1971

Joseph J. Rishel. "The Hague School: Some Forgotten Pictures in the Collection." *Bulletin of the Philadelphia Museum of Art*, vol. 66, no. 305 (July–September 1971), pp. 15–27.

RISHEL 1974

Joseph J. Rishel. "Dutch Painting: An Overlooked Aspect of the Collection." *Apollo*, n.s., vol. 100, no. 149 (July 1974), pp. 28–33.

ROSENBERG 1928

Jakob Rosenberg. *Jacob van Ruisdael*. Berlin, 1928.

SMITH 1829–42

J. A. Smith. *A Catalogue Raisonné of the Works of the Most Eminent Dutch, Flemish, and French Painters*. 9 vols. and suppl. London, 1829–42.

SUTTON 1980

Peter C. Sutton. *Pieter de Hooch: Complete Edition with a Catalogue Raisonné*. New York, 1980.

SUTTON ET AL. 1984

Peter C. Sutton et al. *Masters of Seventeenth-Century Dutch Genre Painting*. Exhibition. Philadelphia Museum of Art, March 18–May 13, 1984, Gemäldegalerie, Staatliche Museen Preussischer Kulturbesitz, Berlin (West), *Von Frans Hals bis Vermeer*, June 8–August 12, 1984, Royal Academy of Arts, London, *The Age of Vermeer and De Hooch*, September 7–November 18, 1984.

SUTTON ET AL. 1987

Peter C. Sutton et al. *Master of 17th-Century Dutch Landscape Painting*. Exhibition. Rijksmuseum, Amsterdam, October 2, 1987–January 3, 1988, Museum of Fine Arts, Boston, February 3–May 1, 1988, Philadelphia Museum of Art, June 5– July 31, 1988.

THIEME-BECKER 1907–50

Ulrich Thieme and Felix Becker, eds. *Allgemeines Lexikon der bildenden Künstler von der Antike bis zur Gegenwart*. 37 vols. Leipzig, 1907–50.

THORÉ-BÜRGER 1857

T.E.J. Thoré [W. Bürger]. *Trésors d'art exposés à Manchester en 1857 et provenant des collections royales, des collections publiques et des collections particulières de la Grande-Bretagne*. Paris, 1857.

WAAGEN 1854

G. F. Waagen. *Treasures of Art in Great Britain*. 4 vols. London, 1854.

WASHINGTON, DETROIT, AMSTERDAM 1980–81

See Blankert et al. 1980–81.

WEYERMAN 1729–69

J. C. Weyerman. *De levens beschryvingen der nederlandsche konst-schilders en konst-schilderessen*. 4 vols. The Hague, 1729–69.

VAN DER WILLIGEN (1870) 1970

Adriaan van der Willigen. *Les Artistes de Harlem: Notices historiques avec un précis sur la Gilde de St. Luc*. Haarlem, 1870. Reprint. Nieuwkoop, 1970.

WILSTACH 1886

Catalogue of Paintings and Works of Art, Belonging to Mrs. A. H. Wilstach. (MS). Philadelphia, 1886.

WILSTACH 1893

Catalogue of the W. P. Wilstach Collection, Memorial Hall, Fairmount Park, Philadelphia. Edited by Carol H. Beck. Philadelphia, 1893.

WILSTACH 1897

Catalogue of the W. P. Wilstach Collection, Memorial Hall, Fairmount Park, Philadelphia. Supplement. Edited by Carol H. Beck. Philadelphia, 1897.

WILSTACH 1900

Catalogue of the W. P. Wilstach Collection, Memorial Hall, Fairmount Park, Philadelphia. Edited by Carol H. Beck. Philadelphia, 1900.

WILSTACH 1903

Catalogue of the W. P. Wilstach Collection, Memorial Hall, Fairmount Park, Philadelphia. Edited by Carol H. Beck. Philadelphia, 1903.

WILSTACH 1904

Catalogue of the W. P. Wilstach Collection, Memorial Hall, Fairmount Park, Philadelphia. Edited by Carol H. Beck. Philadelphia, 1904.

WILSTACH 1906

The W. P. Wilstach Collection. Edited by Carol H. Beck. Philadelphia, 1906.

WILSTACH 1907

The W. P. Wilstach Collection. Edited by Carol H. Beck. Philadelphia, 1907.

WILSTACH 1908

The W. P. Wilstach Collection. Edited by Carol H. Beck. Philadelphia, 1908.

WILSTACH 1910

The W. P. Wilstach Collection. Philadelphia, 1910.

WILSTACH 1913

The W. P. Wilstach Collection. Philadelphia, 1913.

WILSTACH 1922

Catalogue of the W. P. Wilstach Collection, Memorial Hall. Compiled by Maurice W. Brockwell with notes appended by Arthur Edwin Bye. Philadelphia, 1922.

WURZBACH 1906–11

Alfred Wurzbach. *Niederländisches Künstler-Lexikon.* 3 vols. Vienna and Leipzig, 1906–11. Reprint. Amsterdam, 1974.

Among a curator's responsibilities, the cataloguing of the permanent collection is perhaps the least glamorous but most fundamental. Constantly preempted by the urgency of special exhibitions, grant applications, or annual reports, progress on these publications is usually fitful. This volume was no exception. Protracted over a decade, the work incurred widespread and varied debts. Rather than risk slighting the contributions of any individual scholar, curator, or archivist by the unintentional omission of his or her name from a list of people, I thank you collectively and credit your valuable insights in the notes to the entries. However, I would like especially to thank Egbert Haverkamp-Begemann, Otto Naumann, and Frits Duparc for sharing their expertise repeatedly and always with patience. The project could not have been realized without a generous cataloguing grant from the National Endowment for the Arts and support from the J. Paul Getty Trust, and grants from CIGNA Foundation and the Andrew W. Mellon Foundation. No less essential were the research facilities of those excellent institutions, the Rijksbureau voor Kunsthistorisches Documentatie, The Hague, the Witt Library of the Courtauld Institute, London, and the Frick Art Reference Library, New York. Marigene Butler and her staff in the Philadelphia Museum of Art Conservation Department, including Terry Lignelli, Jean Rosston, Wendy Samet, and Mark Tucker, ably undertook all technical examinations and assisted extensively in compiling the condition notes. References to related pictures in the John G. Johnson Collection at the Philadelphia Museum of Art were accurately supplied by Lawrence Nichols. Alice Lefton, Margaret Quigley, Marci Rockoff, Michelle Tommasso, and the indefatigable Martha Small assisted in the preparation of the manuscript. Jane Watkins—the most sympathetic and thoughtful of editors—shepherded the manuscript at last into print. For enduring moral support and occasional quiet, my love as always to Bug, Page, and Spencer Burns. And in recognition of the good and glad years in Philadelphia, I would like to dedicate this catalogue to my friends Anne d'Harnoncourt and Joseph Rishel.

Photographs were supplied by the owners except the following: Jörg P. Anders, Berlin, fig. 1-1; Antwerp Archives, fig. 63-1; Tracy Baldwin, Philadelphia, figs. 86-1, 92-4; Paul Bijtebier, Brussels, fig. 122-3; E. Irving Blomstrann, New Britain, Connecticut, fig. 130-5; Will Brown, Philadelphia, nos. 35, 40, 59, 61, 85, 92, 95, 115, 122; A. C. Cooper Ltd., London, fig. 17-1; courtesy A. Dingjan, The Hague, fig. 77-1; Ursula Edelmann, Frankfurt, fig. 61-1; Ralph Kleinhempel, Hamburg, fig. 101-1; Joe Mikuliak, Philadelphia, no. 110; Eric Mitchell, Philadelphia, nos. 5, 24, 28, 56, 66, 80, 84, 89, 90, 103, 130, 132, 141, 142, 143, 144, 147, 149; Prudence Cuming Associates Ltd., London, fig. 16-2; Walter Schmidt, Karlsruhe, fig. 4-1; courtesy Sotheby Parke Bernet, fig. 55-1; Bruce White, fig. 104-1; Graydon Wood, Philadelphia, cover, nos. 36, 39.